PETER LASKO

ARS SACRA
800–1200

THE · PELICAN · HISTORY · OF · ART ·

PUBLISHED BY PENGUIN BOOKS

Penguin Books Ltd, Harmondsworth, Middlesex
Penguin Books Inc., 7110 Ambassador Road, Baltimore, Md 21207, U.S.A.
Penguin Books Australia Ltd, Ringwood, Victoria, Australia

★

Text printed by Richard Clay (The Chaucer Press), Ltd, Bungay, Suffolk
Plates printed by Balding & Mansell Ltd, London
Made and printed in Great Britain

★

First published 1972
Copyright © 1972 Peter Lasko

★

SBN 14 056036 X

TO LYN
LEA, CLAIRE, AND CAROLINE

CONTENTS

Part One

Carolingian Art

Part Two

The Art of the Tenth and Eleventh Centuries

CONTENTS

Part Three

Romanesque Art

The Plates

LIST OF FIGURES

All the drawings were made by Donald Bell-Scott, who also executed the maps

LIST OF PLATES

Unless otherwise noted, copyright in photographs belongs to the gallery, library, museum, or other institution given as the location, by whose courtesy they are reproduced

ABBREVIATIONS

F.M. Bildarchiv Foto Marburg
R.B.C. Rheinisches Bildarchiv, Cologne

20·2 cm. *Hildesheim Cathedral, Treasury* (R.B.C.)

108 Silver candlestick of Bishop Bernward, one of a pair, with two details, *c.* 996/1000. H. 36·8 cm. *Hildesheim, St Magdalen* (R.B.C.; Domschatz, Hildesheim; R.B.C.)

109 Crucifixion. Ivory panel of Bishop Adalbero, 984/1005. 15·2 × 9·2 cm. *Metz, Museum*

110 'Aquilo', detail from the foot of the seven-armed candelabrum, early eleventh century. Bronze gilt. H. of whole candelabrum 230 cm. *Essen Minster* (Foto Liselotte Witzel, Essen)

111 Bronze doors from St Michael's, 1015. H. 472 cm. *Hildesheim Cathedral* (F.M.)

112 Creation of Adam, detail of the bronze doors. *Hildesheim Cathedral* (F.M.)

113 Labours of Adam and Eve, detail of the bronze doors. *Hildesheim Cathedral* (F.M.)

114 Presentation in the Temple, detail of the bronze doors. *Hildesheim Cathedral* (F.M.)

115 Marriage at Cana. Ivory panel, *c.* 1000, in a fourteenth-century silver gilt frame. 17·8 × 14·5 cm. *Cleveland Museum of Art* (Gift of the John Huntington Art and Polytechnic Trust)

116 Marriage at Cana. Ivory panel, *c.* 820/30. 13·8 × 8·3 cm. *London, British Museum*

117 Scenes from the life of Christ. Bronze column, *c.* 1000/10 (?). H. 379 cm. *Hildesheim Cathedral* (Wenmeyer, Hildesheim)

118 Healing of the Blind Man, detail of the bronze column. *Hildesheim Cathedral* (F.M.)

119 River of Paradise, detail of the base of the bronze column. *Hildesheim Cathedral* (F.M.)

120 Virgin and Child, *c.* 1010. Wood. H. 56·5 cm. *Hildesheim Cathedral, Treasury* (R.B.C.)

121 Virgin and Child, *c.* 1010. Ivory. H. 22 cm. *Mainz, Altertumsmuseum* (Mittelrheinisches Landesmuseum, Mainz)

122 Deesis. Book-cover of Bishop Bernward's 'Precious Gospels' (front), *c.* 1000/10 and later additions; central ivory Byzantine, late tenth century. Silver gilt and gems. 28 × 20·5 cm. MS. 18. *Hildesheim Cathedral, Treasury* (F.M.)

123 Book-cover of the Sacramentary of Abbot Erkanbald of Fulda (997–1011), *c.* 1000; central ivory of the Virgin and Child Byzantine, late tenth century. Silver, partly gilt. 22·5 × 17 cm. MS. Lit. 1. *Bamberg, Staatliche Bibliothek*

124 Book-cover of a Gospel Book, *c.* 1000–10. Gold, gems, and pearls. 30·5 × 23·6 cm. MS. Clm. 4454. *Munich, Bayerische Nationalbibliothek*

125 Sword (detail), *c.* 1000, later additions at the top of the scabbard. Gold, with gems and enamel. L. of whole sword 95·5 cm. *Essen Minster, Treasury* (Ann Münchow, Aachen)

126 St Matthew, detail of the pulpit of Henry II, *c.* 1002/14. Bronze gilt. *Aachen, Palace Chapel* (F.M.)

127 Pulpit of Henry II, *c.* 1002/14. Silver and bronze gilt, gems, ivory, and *émail brun*. H. 146 cm. *Aachen, Palace Chapel* (F.M.)

128 Portable altar of the Holy Cross (front), *c.* 1015/20. Gold, gems, and pearls, the centre crystal. 43 × 36 cm. *Munich, Residenz, Treasury* (Hirmer Fotoarchiv, Munich)

129 Portable altar of the Holy Cross (back), *c.* 1015/20. Silver, partly gilt. 43 × 36 cm. *Munich, Residenz, Treasury* (Bayerische Verwaltung der staatl. Schlösser, Gärten und Seen)

130 Christ between Gabriel and Raphael and St Michael and St Benedict. Golden altar frontal of Basel Cathedral, 1022/4 (?). 100 × 178 cm. *Paris, Musée de Cluny* (Giraudon, Paris)

131 Christ in Majesty and scenes from the life of Christ. Golden altar frontal, *c.* 1020. 84 × 125 cm. *Aachen, Palace Chapel* (Ann Münchow, Aachen)

132 Book-cover of the Carolingian Aachen Gospels, *c.* 1020; central ivory of the Virgin and Child Byzantine, late tenth century. Gold, gems, and enamels. 30·8 × 23·7 cm. *Aachen, Palace Chapel, Treasury* (F.M.)

133 'Sternenmantel' of Henry II, *c.* 1020. Silk, with gold thread and appliqué. H. 154 cm. *Bamberg Cathedral, Treasury* (Hirmer Fotoarchiv, Munich)

134 Imperial altar cross (front), *c.* 1023/30, silver foot fourteenth century. Gold, gems, and pearls. H. 77 cm. *Vienna, Weltliche und Geistliche Schatzkammer* (Kunsthistorisches Museum, Vienna)

135 Imperial altar cross (detail of back), *c.* 1023/30. Gold and niello. *Vienna, Weltliche und Geistliche Schatzkammer* (Kunsthistorisches Museum, Vienna)

136 Portable altar of Svanhild, *c.* 1050/75. Ivory, bronze gilt and enamelled inscription. H. 13 cm. *Melk, Stiftskirche* (Joseph Ilias Stiftsbibliothek, Melk)

137 Altar cross of Queen Gisela, *c.* 1006. Gold, gems, pearls, and enamels. H. 44·5 cm. *Munich, Residenz, Treasury* (Bayerische Verwaltung der staatl. Schlösser, Gärten und Seen)

138 Altar cross, *c.* 1024/39; in the centre a Fatimid

enamel. 60 × 130 cm. *Cologne, St Pantaleon* (Ann Münchow, Aachen)

253 Martyrdom of St Stephen. Detail of the roof of the shrine of St Maurinus, *c.* 1165/70. Bronze gilt, *émail brun*, and enamel. *Cologne, St Pantaleon* (R.B.C.)

254 Ascension. Detail of the roof of the shrine of St Alban, 1186. Bronze gilt and enamel. *Cologne, St Pantaleon* (R.B.C.)

255 Domed reliquary from Hochelten, *c.* 1170 (?). Bronze gilt, ivory, and enamel. H. 54·6 cm. *London, Victoria and Albert Museum*

256 Domed reliquary, *c.* 1175/80. Bronze gilt, ivory, and enamel. H. 45·5 cm. *Berlin, Staatliche Museen*

257 Shrine of St Alban, 1186. Bronze gilt, gems, and enamel. L. 153 cm. *Cologne, St Pantaleon* (R.B.C.)

258 Painting of 1764, probably by J. W. Fischer, of the shrine of St Anno from the abbey of St Michael, Siegburg, 1183. L. of shrine 157 cm. *Belecke, parish church* (Wiemer, Belecke)

259 St James the Younger. Spandrel figure of the shrine of St Anno, *c.* 1183. Bronze gilt. *Siegburg, Abtei Michaelsberg* (Ann Münchow, Aachen)

260 St Philip. Spandrel figure of the shrine of St Anno, *c.* 1183. Bronze gilt. *Siegburg, Abtei Michaelsberg* (Ann Münchow, Aachen)

261 Portable altar of St Faith, early twelfth century. Silver gilt, gems, enamels, and alabaster. 29 × 20 cm. *Conques Abbey, Treasury* (Hirmer Fotoarchiv, Munich)

262 Reliquary casket from Champagnat, *c.* 1150 (?). Bronze gilt enamel. H. 12·4 cm. *New York, Metropolitan Museum of Art* (Gift of J. Pierpont Morgan, 1917)

263 Enamelled top of the casket of Santo Domingo, *c.* 1150 (?), ivory casket 1026. Whole top of casket 20 × 34 cm. *Burgos, Museo Arqueológico* (author's photograph)

264 Christ in Majesty and St Paul. Detail of the front of the shrine of Santo Domingo from Silos Abbey, *c.* 1140/50 (?). Bronze gilt and enamel. H. 85 cm. *Burgos, Museo Arqueológico* (Hirmer Fotoarchiv, Munich)

265 Apostle. Detail of the roof of the shrine of Santo Domingo, *c.* 1170/80 (?). Bronze gilt and imitation *émail brun*. Whole panel 55 × 254 cm. *Silos Abbey, Treasury* (author's photograph)

266 Shrine of Santo Domingo from Silos Abbey (front), *c.* 1140/50 (?). Bronze gilt, enamel, and imitation *émail brun*. 85 × 235 cm. *Burgos, Museo Arqueológico* (Hirmer Fotoarchiv, Munich)

267 Antique vase mounted to resemble an eagle *c.* 1130/40. Porphyry, silver gilt mounts. H. 43 cm. *Paris, Louvre* (Service de Documentation Photographique, Paris)

268 Hugo Lasert and St Stephen of Muret. Panel from the altar frontal (?) from Grandmont Abbey, *c.* 1189. Bronze gilt and enamel. 26·4 × 18·2 cm. *Paris, Musée de Cluny* (Service de Documentation Photographique, Paris)

269 John Garnerius of Limoges: Altar cross, *c.* 1190. Bronze gilt and enamel. *Paris, Louvre* (Service de Documentation Photographique, Paris)

270 Plaque from the tomb of Geoffrey of Anjou (d. 1151), *c.* 1151/60. Bronze gilt and enamel. 63 × 33 cm. *Le Mans, Musée*

271 St John. Enamelled panel, *c.* 1200. 24·5 × 11 cm. *London, British Museum*

272 Reliquary shrine, *c.* 1150/70. Bronze gilt and enamel. H. 20 cm. *Nantouillet, parish church* (Archives Photographiques, Paris)

273 Shrine of St Calmine, made for Abbot Peter (1168–81), *c.* 1170/80. Bronze gilt and enamel. H. 46 cm. *Mozac, parish church* (Archives Photographiques, Paris)

274 Scenes from the life of Christ. Ivory comb, *c.* 1120/30. 8·5 × 11·5 cm. *London, Victoria and Albert Museum*

275 Fragment of an inhabited scroll, pierced ivory, *c.* 1130. 6 × 6 cm. *London, British Museum*

276 Portable altar (restored), *c.* 1140/50. Bone. H. of bone panels 8·9 cm. *London, British Museum*

277 Kings. Chessmen from the isle of Lewis, *c.* 1150. Ivory. H. 10·1 cm. *London, British Museum*

278 Ivory carving, fragment of a chair (?), *c.* 1150, with bronze-gilt mount, fourteenth century. H. of whole piece 44·3 cm. *London, British Museum*

279 Henry of Blois, bishop of Winchester (1129–71). Fragment from the shrine of St Swithun, *c.* 1150. Bronze gilt and enamel. L. 17·9 cm. *London, British Museum*

280 Grammar, Rhetoric, and Music. Casket, *c.* 1170/80. Bronze gilt and enamel. 6·1 × 11 cm. *London, Victoria and Albert Museum*

281 Carrying of the Cross. Detail of the lid of the

MAPS

ACKNOWLEDGEMENTS

SINCE the second world war a series of magnificent exhibitions has been held, which have made the writing of this book considerably easier. Not only have they facilitated my study of the material, but the catalogues for these exhibitions edited by scholars of international standing, and helped by specialists too numerous to mention, have been an invaluable help to me. A. Boeckler's catalogue of the exhibition 'Kunst des Frühen Mittelalters' held in Bonn in 1949, shown in the following year in Munich under the title 'Ars Sacra' (to which I am also indebted for my title), began the series, followed by M. Guerin's 'Trésors d'art de la Vallée de la Meuse' (1951–2) and V. Elbern's 'Werdendes Abendland in Rhein und Ruhr' (1956). Then followed the important exhibitions held under the auspices of the Council of Europe, 'Romanesque Art' (Barcelona, 1961, catalogue edited by J. Ainaud de Lasarte), 'Byzantine Art' (Athens, 1964, catalogue edited by M. Chatzidakis), 'Charlemagne' (Aachen, 1965, catalogue edited by W. Braunfels), and others of similar scale of importance such as 'Romanische Kunst in Österreich' (Krems, 1964, catalogue edited by H. Kühnel), 'Les Trésors des Églises de France' (Paris, 1965, catalogue edited by J. Dupont), and 'Kunst und Kultur im Weserraum, 800–1600' (Corvey, 1966, catalogue edited by B. Korzus).

These exhibitions also stimulated a great deal of research and publication, and the extent to which I am indebted to these publications, often in the form of the 'Corpus' modelled on the great pioneering work of Goldschmidt's publication of Ivory Carvings, is made clear by my constant reference to them in my footnotes. Without them it would have been virtually impossible to write this book.

To my colleagues in England and abroad, too many to mention individually, I owe information, stimulating discussions, and guidance, although I must admit that they have not always been able to stop me making mistakes. Among them, I owe the greatest debt to my friends at the Courtauld Institute, Professor George Zarnecki, Christopher Hohler, and Peter Kidson, to Derek Turner, my colleague for many years at the British Museum, and to my colleagues at the University of East Anglia, especially Andrew Martindale, Eric Fernie, and Nigel Morgan.

My thanks are also due to Mrs Judy Nairn, who has done so much more than just seen the book through the press, and to Mrs C. Leder and Miss S. Stow for their efforts to find the necessary illustrations. My thanks also to Mr Donald Bell-Scott for his patience in following my instructions for the drawings in the text. But above all, I owe a great debt of gratitude to Professor Sir Nikolaus Pevsner, my first teacher and my editor, without whose constant encouragement this book would not have been written at all.

P. LASKO

University of East Anglia,
Norwich

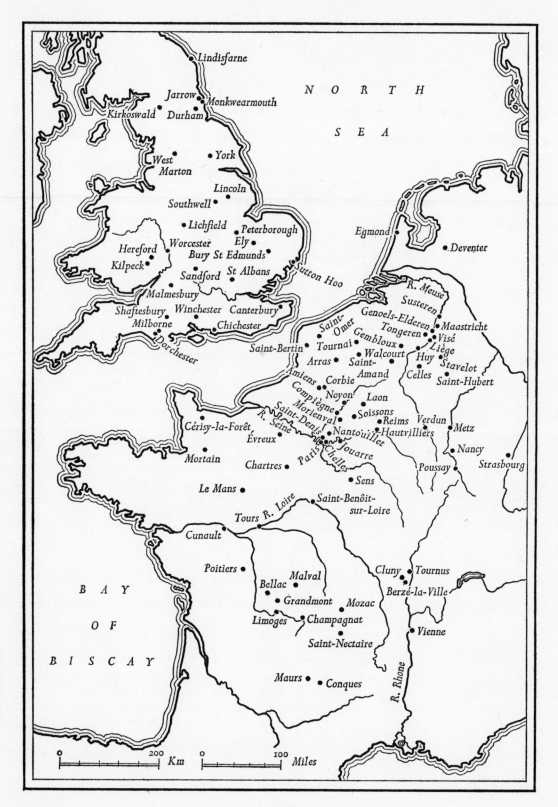

N O R T H

S E A

Lindisfarne

Jarrow • Monkwearmouth
Kirkoswald • Durham
West • York
Marton

Lincoln

Southwell

Lichfield Peterborough
Worcester Ely Egmond
Hereford Bury St Edmunds Deventer
Kilpeck Sandford St Albans Sutton Hoo
Malmesbury R. Meuse
Shaftesbury Winchester Canterbury Susteren
Milborne Chichester Genoels-Elderen Maastricht
Dorchester Saint- Tongeren Visé
Omer Gembloux Liège
Saint-Bertin Tournai Walcourt Huy Stavelot
Arras Saint- Celles Saint-Hubert
Amiens Corbie Amand
Compiègne Noyon Laon
Morienval Soissons Reims Verdun
Cérisy-la-Forêt R. Seine Saint-Denis Nantouillet Hautvilliers Metz
Évreux Paris Chelles Jouarre Poussay Nancy
Mortain Chartres Sens Strasbourg
Le Mans
Saint-Benôit-
Tours R. Loire sur-Loire
Cunault
Poitiers Cluny Tournus
B A Y Malval Berzé-la-Ville
Bellac
O F Grandmont Mozac
Limoges Champagnat Vienne
B I S C A Y Saint-Nectaire

Maurs • Conques R. Rhone

0 ____ 200 0 ____ 100
Km Miles

xxvii

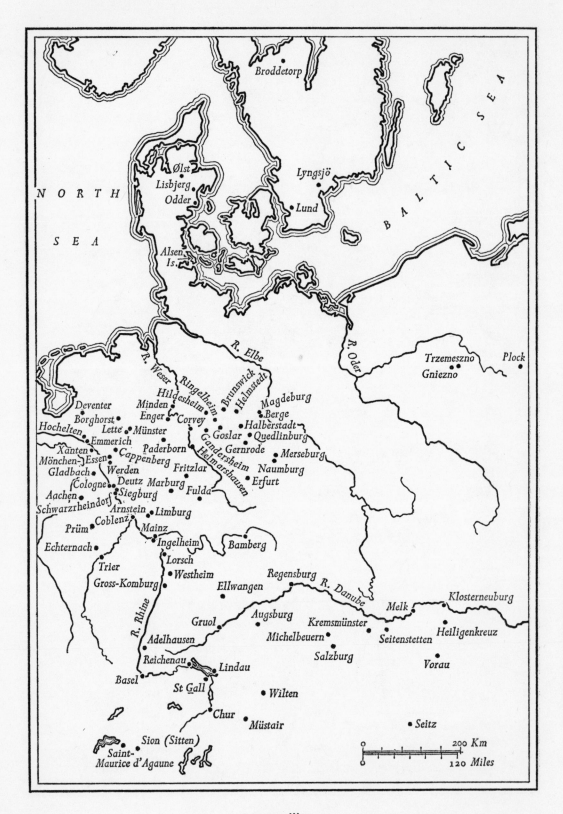

NORTH

SEA

Broddetorp

BALTIC SEA

Ølst
Lisbjerg
Odder

Lyngsjö

Lund

Alsen Is.

R. Weser

R. Elbe

R. Oder

Plock

Trzemeszno

Gniezno

Ringelheim
Brunswick
Helmstedt

Hildesheim
Minden
Enger
Corvey
Goslar

Magdeburg
Berge
Halberstadt
Quedlinburg

Deventer
Borghorst
Lette
Münster
Hochelten
Emmerich
Xanten
Paderborn
Gandersheim
Gernrode
Merseburg
Mönchen-
Gladbach
Essen
Cappenberg
Helmarshausen
Werden
Fritzlar
Naumburg
Deutz
Marburg
Erfurt
Aachen
Cologne
Siegburg
Fulda
Schwarzrheindorf
Arnstein
Limburg
Prüm
Coblenz
Mainz
Echternach
Ingelheim
Bamberg
Trier
Lorsch
Gross-Komburg
Westheim
Regensburg

R. Danube

Ellwangen

Klosterneuburg
Melk

Gruol
Augsburg
Kremsmünster
Seitenstetten
Heiligenkreuz
Adelhausen
Michelbeuern
Salzburg
Vorau
Reichenau
Lindau
Basel
St Gall
Wilten
Chur
Müstair
Seitz
Sion (Sitten)
Saint-Maurice d'Agaune

R. Rhine

200 Km
120 Miles

xxviii

ADRIATIC SEA

TYRRHENIAN SEA

Cividale

Grado

Verona
R. Po
Ravenna
Imola
Modena
Bobbio
Monza
Milan
Galliano
Civate

Città di Castello
Rome

Sant'Angelo in Formis
Salerno

Palermo
Monreale

Km 200
Miles 125

BAY OF BISCAY

Jaca
Pamplona
R. Ebro
San Millán de la Cogolla
Burgos
Silos
Carrizo
León
Astorga
Palencia
Oviedo
Santiago de Compostela
R. Douro
Ávila
Cuenca
R. Tagus

xxix

PREFACE

'Materiam superabat opus'
(The workmanship surpasses the material)
Abbot Suger of Saint-Denis (A.D. 1146)

THIS book deals with the art of the goldsmith, the metalworker, and the ivory carver in the Carolingian, Ottonian, and Romanesque periods – that is in Europe from *c.* 800 to *c.* 1200. It is a period which begins with an idea of a unified Europe, based on the concept of the ancient Roman Empire, and ends with the dawn of today's national states. At the end of this period, around 1200, western European art took a decisive turn towards the naturalism rejected as a dominant characteristic at the end of Antiquity, and began to travel along the road which clearly leads without interruption to the beginning of the present century.

The use of the term 'naturalism' can certainly be justified in the period around 1200. Among the decorative carvings of the Gothic cathedrals of the Île de France and the Champagne, or in the illuminated pages of *herbarii*, there is precise evidence of the interest of artists in the observation and imitation of natural forms. Of course, naturalism is not the only stylistic element of significance at that time. In the search for a more convincing rendering of reality, artists also made use of those styles known to them which appeared to help in the creation of that reality – like the art of Antiquity, the art of the Byzantine heirs of the classical tradition, and the northern classicism of Mosan art, long established in North Western Europe. Moreover, a very fundamental change was taking place. The selection of styles became more self-conscious, and aesthetic aims as distinct from the availability of sources or the need of sources for reasons of content rather than for style, began to be of far greater significance. That does not mean that aesthetic considerations did not play a part during the earlier Middle Ages, but one cannot but feel that the emphasis has shifted. In one way or another, artists in the eight hundred years from *c.* 1200 to the earlier twentieth century sought their inspiration mainly, and often directly, in the natural world around them. Even the traditions of Antiquity, which were, of course, again and again of great importance in this long period, were never treated in slavish imitation, but at least in part as the visual, or one might almost say the 'natural', environment.

In the eight centuries from the fifth century to *c.* 1200, however, artists in Northern Europe sought their inspiration in art and not in nature. The authority of the source was of paramount importance. The choice of source depended on the simple continuity of workshop practice on the one hand, and on dynastic or other historical links on the other. Such determining factors as the creation of a royal or imperial 'image' demanded by patrons also played a part, with the subsequent choice of sources only limited by availability or the accident of survival.

C

I

Under such conditions, it may be argued that there could be little or no stylistic unity in the period. Indeed, such old-established and convenient terms for period styles as 'Romanesque' are seen today to have little unity. Has the softly modelled classicizing style of the Liège font (Plate 169) anything obviously in common with the rigidly defined drawing of Roger of Helmarshausen's portable altar at Paderborn Cathedral (Plate 161)?

If the artistic traditions of the past played such a vital role, it is not surprising that there is much discussion in this book of prototypes, of sources and of stylistic links between one work of art and another and the work of one region and another. Such links in this period are often very real and direct relationships, where the models the artist had in mind when he created his own work were either a very precise part of his training and his experience, or were actually in his hands when he worked. To him, art was an entirely artificial creation, not connected with the everyday environment in which he lived. The period around 400 and again around the year 1200 are indeed watersheds in the history of Western European art.

I have tried in this book to see the so-called minor arts as a continuous and interacting development – a network of creative experiences. To some, this may be a somewhat limited and perhaps even old-fashioned way of seeing early medieval art. No one is more conscious than I am, how much had to be sacrificed to this end. The more detailed religious and historical context and even the content of art has often had to be set aside. Only a little use has been made of the, at times abundant, literary sources, which might have helped to fill many gaps in our knowledge. I have laid greater emphasis on the rich surviving material, because the literary references can often give us little more than quantative information and my first concern has been the visual.

If I am aware of such shortcomings, why did I attempt this kind of book? First and foremost, because it still seems worthwhile to me to emphasize once again that, whatever justification there may be for separating the arts of any period into 'major' and 'minor', there is none in the early Middle Ages. Fortunately, there has been an increasing awareness of the fact that the 'monastic arts' play their full part in the history of medieval art, together with manuscript illumination and 'major' architectural sculpture and wall painting, and are totally integrated with them. Indeed, they are often in the forefront of the creation of new styles, which the so-called 'major' arts take up only later. Perhaps even an enlightened patron found it easier to accept experiment, and visual material of a new and to him unfamiliar kind, on a smaller rather than on a larger scale. Moreover, there is also little doubt that the craftsman working in the luxury trade in precious materials of gold and silver, gems and ivories, enjoyed a comparatively high status in early medieval society. Abbots, bishops, and even archbishops liked to have the practice of these arts and the art of painting of manuscripts attributed to them by their biographers, but none, as far as I know, was proud of his achievement in the much more physical labour of carving stone.

This book, then, is on the whole an unrepentant history of style. If this ignores some

of the developments in art-historical thought seen in this century, in which, for example, as more profound understanding of the art of the past is sought in an analysis of its deeper meaning, especially in its content, I can only claim justification in that a fairly detailed history of style, based on this material, had yet to be written.

PART ONE

CAROLINGIAN ART

THE EIGHTH CENTURY

WHEN Pepin the Short died in 768, his elder son Charles was crowned king at Noyon, and his younger son Carloman at Soissons, and it therefore seemed likely that the Frankish kingdom, so substantially enlarged by Pepin, was once again to suffer the results of the old Frankish tradition which demanded the division of the kingdom between all the sons of the king. But when Carloman died, only three years later, the nobles of his kingdom, wisely refraining from attempting to put his infant son on the throne, paid homage to Charles, so that once again the entire kingdom was in the hands of one man. Thus the political unity and internal peace could be ensured which enabled Charlemagne, in the nearly fifty years he was to reign, not only to establish the greatest empire in Western Europe since the collapse of the Roman Empire, but also to lay the foundations of a cultural renaissance that was to be a decisive factor in European history.

At the beginning of the century, the first of the great revivals of art and learning had taken place in Northern Europe, in the Hiberno-Saxon kingdom of Northumbria, centred on the great monasteries of Monkwearmouth, Jarrow, and the Holy Island of Lindisfarne. Here, a synthesis had been achieved of three major streams: an ancient Celtic tradition was merged with the genius of Germanic decorative styles and with the Christian humanism of the Mediterranean. British churchmen, like the Venerable Bede, took to their homes in the north Late Antique works of art, and especially manuscripts, collected on their frequent journeys to Rome. These were either copied as faithfully as the famous illuminations of the Codex Amiatinus, or were adapted to the more abstract tastes of the north, as in the incomparable Lindisfarne Gospels.[1] In this manuscript, the great achievement of the school reached its peak, and in it also is illustrated the eclecticism of its style. The ancient Celtic tradition of the trumpet spirals, and the decorative emphasis on the beginning of each part of the Gospels with their great initials diminishing slowly in size until they merge into the ordinary lettering of the bulk of the text, is combined with the stylized animal ornament of the Germanic metalworkers, and in the Evangelist portraits, with an adaptation of the figural art of the Mediterranean humanist tradition. The origins of the rich interlace ornament of this school are still not fully understood, but it is clear that it was to become of lasting consequence and to remain influential in Europe for centuries.[2]

This Hiberno-Saxon style was carried by British missionaries to all parts of Europe during the seventh and eighth centuries, as far as Bobbio in the south and Fulda in the east. Its influence on indigenous Frankish art was slight at first, increasing in importance only in the late eighth century. The Merovingian decorative style, most clearly demonstrated in the illuminated manuscripts of the Frankish monasteries, drew its main inspiration from the eastern Mediterranean area, and is likely to have been introduced

into Western Europe by contacts with the monasticism of Egypt, Syria, and Asia Minor. This style was to continue only in provincial centres after the middle of the eighth century; as a source for Carolingian art it was to be swept aside by the far more substantial achievements of Hiberno-Saxon (or, as it is often called, Insular) art on the one hand, and renewed contact with Mediterranean sources on the other.

Insular influence on continental work can be clearly demonstrated by two pieces of outstanding importance. They are the great chalice given by Count Tassilo to his foundation of Kremsmünster between 777 and the Count's death in 788 (Plate 1), and the back cover of the Lindau Gospels, now in the Pierpont Morgan Library in New York (MS. 1), which is related to the chalice (Plate 2).[3] These pieces are the products of craftsmen on the Continent, working under strong Insular influence, in one of the foundations of British missionaries, probably in the South German Alemannic area, perhaps at Salzburg. The niello inlay technique employed, as well as the style, is also found in early Anglo-Saxon metalwork.[4] In the book-cover, however, a technique is also found which is not known in contemporary Insular work: that of cloisonné enamel, in which powdered glass is fused in small cells, usually (as here) of gold, made by strips of gold soldered edge-down on a gold base-plate.[5] The entire book-cover is divided by a large cross, decorated with an enamelled bust of Christ on each of its four arms towards the centre and with bands of cloisonné garnet inlay and cloisonné enamels. The field behind the cross is covered in chip-carved animal ornament. A narrow frame, in part also made of cloisonné enamelled plaques, surrounds the whole. The cloisonné enamelling takes two forms, which have been called 'full' enamel (in German *Vollschmelz*) and 'sunk' enamel (*Senkschmelz*). 'Full' enamel covers the entire plaque, while 'sunk' enamel is 'lowered' into a gold plaque so that the coloured animal or plant motif shows against the plain background of the surrounding gold. The 'full' enamel plaques of the Lindau cover are decorated by snake-like S-shaped animals, with heads turned back to look over their own bodies, a motif which (like the other decorative elements of the cover) derives ultimately from Germanic or Anglo-Saxon beasts. These enamels, found along the upper and lower borders of the cover, are framed with the same pearled wire as the central cross and the small circular gem settings with cell inlay on them. There seems little doubt, therefore, that they are of the same date as the whole cover and not a later addition to it.[6]

The panels with 'sunk' enamel, near the upper and lower extremities of the cross, show brightly-coloured, long-legged birds against the gold background. These strange little enamels are of a very rare type and only appear again on one other piece, a large gold panel which has been re-used as part of the lid of a tenth-century gold and agate casket, now in the Camara Santa at Oviedo, in Spain (Plate 3).[7] Here, the enamels are framed by curving strips of garnet inlay, employing partly simple rectangular and partly stepped cells. Such cells are found in the seventh and eighth century in Frankish, Alemannic, Burgundian, and Langobard jewellery, and were developed to a particularly high degree of technical excellence in Insular workshops,[8] and indeed this very perfection of the Insular cell technique rules out the attribution of the Oviedo plaque to an Anglo-Saxon workshop. The cellwork on the plaque is poorly constructed:

the garnets are roughly cut and the gold cells heavily depressed to contain the stone.[9] The appearance of enamels on the Lindau cover shows clearly that however strong the Insular influence may have been on the Alemannic centres that produced the Tassilo chalice and the Lindau cover, other techniques were added to the repertory on the Continent. It was probably from North Italy that the knowledge of cloisonné enamelling spread to this area. It seems likely, in spite of the very fragmentary evidence that survives, that it was practised in Italy from the sixth century onwards, perhaps through contact with Byzantine jewellers working in the Emperor Justinian's Italian possessions. Such seventh-century pieces as the Castellani brooch in the British Museum (Plate 5) and the small gold mount (Plate 4) found in the grave of the Langobard Count Gisulf (d. 611) seem to support this:[10] the little bird that decorates the latter is particularly close in colour and design to the enamels on the Oviedo plaque, and clearly supports the assumption that our enamels derive from a Byzantine tradition of the sixth and seventh centuries transmitted through northern Italy.[11]

It is usually assumed that the Lindau book-cover is not very much later in date than the Tassilo chalice, but it seems more likely that it ought, in fact, to be placed somewhat later, perhaps c. 800 or even into the first quarter of the ninth century. The 'gripping beast' style of the two roundels in the upper and lower arms of the cross on the cover would certainly be more acceptable at that time. The enamel on the cover is rather peculiar: white and a strange orange, both opaque, and a semi-translucent dark blue are used, especially in the 'sunk' enamels. Although the forms used in these remind one of the Oviedo plaque, the colours in Oviedo are much brighter and more translucent and much more within the Byzantine, or North Italian, tradition. It is therefore per-haps not necessary to see too close a chronological link between the two pieces. Cer-tainly the Oviedo plaque ought – to judge by the garnet inlay – to be dated to the first half of the eighth century.

Another important example of Insular influence on the Continent in the late eighth century is the small portable altar from the abbey of Adelhausen, now in the Augustiner-museum at Freiburg (Plate 9).[12] Again, as well as interlace of a distinctly Insular flavour, enamelling figures prominently in its decoration. It is one of the rare early medieval portable altars, which were especially important in the missionary period, when priests needed to carry dedicated altar tables with them on which to celebrate Mass.[13] The central porphyry altar stone is framed by rectangular silver plaques at each end, decorated by large crosses enamelled, in the main, with brilliant translucent green. These are surrounded by larger crosses, with interlace patterns of undoubtedly Insular origin, executed in chasing, gilding, and niello, filling the remaining corners. The longer sides of the altar are bordered by a continuous band of pairs of cross-patterns in circles of champlevé enamel on copper plaques. The effect, though very similar to the cellwork of cloisonné enamel, is achieved by a mixture of techniques. The cells are in part made of separate strips of copper attached to a base plate or floated in the enamel, and in part carved out of the solid copper plate. This latter, champlevé, technique had a long history in Northern Europe, and seems to have been practised continuously from the La Tène period of the Iron Age onwards. This enamel is always of an opaque kind,

because the translucent effect is only worth achieving when the metal used is gold or silver, which reflects light through the enamel. It would be difficult to date the champlevé plaques on the Adelhausen altar at all precisely, but there is no reason to doubt that they were available in the later eighth century, when the altar was assembled. Simple brooches of the kind found at Westheim, for example, probably as early as the late seventh century, make use of very similar techniques and patterns (Plate 6).[14] Although the strong Insular influence in the interlace ornament on the altar suggests that the piece might have been made in England, the enamelling technique of the cross plaques again points to a North Italian origin, or to an area where enamelling stood under direct Italian influence – most probably in the Alemannic region.

To the same area and the same period, and for the same reason, we must attribute the small silver reliquary at Sion (Sitten) in Switzerland known as the Altheus reliquary (Plate 10). The name of the donor is given in an inscription: ALTHEUS EPISCOPUS, who ruled the see from 780 to 799. The enamels mounted on its front are larger and more ambitious, representing busts of pairs of saints, but their range of colours clearly relates them to this same group – although it may well be that they were produced in northern Italy and imported to the Alemannic area, where they were mounted on this little shrine. With it, a whole series of early reliquaries of similar size and type should be mentioned. They demonstrate both the indigenous Merovingian elements and the Insular influences which created the art of the eighth century in the Frankish kingdom – an art that stands in such marked contrast to the work that Charlemagne's patronage was to create at his court in Aachen.

A fairly large number of small reliquaries from the seventh century onwards has survived.[15] They have been called house-shrines or burse-reliquaries. Often it is difficult to separate these two types very clearly. Basically the house-shrine is a small rectangular box, with a lid in the form of a hipped or pitched roof, usually openable, while burse-reliquaries make no distinction between the container and its roof, but taper gently, in the manner of a pouch, from base to cresting. In the majority of cases, both types are equipped with small hinged latchets to which a strap was attached so that they could be carried. The origins of the two types were probably distinct – the burse being an enriched and more permanent form of a simple pouch made of silk or leather, while the house-shrine is most likely a miniature sarcophagus in which the sacred relics of a saint were laid to rest in much the same way as in larger funerary monuments such as the seventh-century stone sarcophagi in the crypt at Jouarre.[16] What both types have in common is that they are portable, and this seems clearly to emphasize the needs of the missionary period, when such reliquaries were first introduced.

A tremendous increase in missionary activity was brought about by St Columbanus, the Irish monk who arrived in Europe in A.D. 585. In no period of history were more new monasteries founded than in the years between 610 and 640 (St Columbanus himself died in 615 at Bobbio in North Italy). The monasteries in existence in the Frankish kingdom before his arrival numbered about two hundred, but by the end of the seventh century there were more than four hundred.[17] It is not surprising that this rising monastic activity and the ever-increasing cult of relics resulted in the

production of reliquaries. An interest in relics was particularly strong among Irish missionaries, and in their homeland reliquaries survive not only to house relics of the saints' bodies themselves but also objects such as croziers, books, and bells made holy by their close connexion with saints. Even an eighth-century belt-shrine survives, found at Moylough, Co. Sligo.[18]

The techniques employed included embossed, chased, or cast gold, silver- or bronze-gilt, mounted ivory or bone, and garnet or paste inlay – indeed all the techniques so brilliantly developed among the Franks and other Germanic peoples in their secular goldsmith's work and jewellery. Most of these pieces fall outside the scope of this volume, but it is in this tradition, created in Merovingian times, that Carolingian gold-smiths were working in centres other than the Court School – even on into the ninth century.

Two outstanding examples of their work are the burse-reliquary from Enger, now in the Staatliche Museen, Berlin (Plates 7 and 8), and the Pepin reliquary in the treasury of Sainte-Foy at Conques (Plate 12). The Enger burse is decorated with garnet and paste inlay in gold cells, enriched by large gem settings and cloisonné enamels.[19] On the reverse, embossed silver-gilt plaques show triple arcades with Christ between two angels above, and the Virgin and Child, accompanied by two saintly figures, perhaps St Peter and St Paul, below. The whole is crowned by a contemporary, fully modelled cresting of two crouched lions with long trailing tails supporting three more little sitting lions. According to tradition, this was given to Count Widukind on the occasion of his baptism at Attigny in 785 by Charlemagne – a tradition hardly likely to be cor-rect; work produced at the Court School, like the Godescalc Pericopes, was by this time much less bound by Merovingian customs than this reliquary. It seems far more likely, if any connexion with Widukind is to be accepted, that it was given by him to Stift Enger (where he was later buried) in 807, when he founded it. The form of the reliquary and its front, which is a considerably enriched version of earlier Merovingian burse-reliquaries,[20] would certainly support the late-eighth-century date normally suggested. But the reverse, with its embossed figure subjects under architectural arcading, might be taken to support a date in the early ninth century, when some reactions from the Court School were being felt in a more provincial centre. Figure representation on earlier reliquaries is very rare: only three of the surviving pieces show it. One, the late-seventh-century copper-gilt St Mommole reliquary in the abbey church of Saint-Benoît-sur-Loire,[21] has the twelve Apostles on its roof, in a very crude low relief, and patterns on the body both clearly derived from Merovingian manu-scripts and very different in style from the Enger burse. The second, a small burse-reliquary in the Cluny Museum in Paris, shows in a somewhat more sophisticated version of a similar style, a Virgin and Child with St Peter and St Paul.[22] The third, the silver shrine at Mortain, is probably an early-eighth-century Insular product, an attribution supported by a runic inscription of English character.[23] In style of relief and lettering it is related to the fragments of the silver covering for St Cuthbert's portable altar, made in A.D. 698 and found when his tomb was opened at Durham in 1824.[24]

The composition of the Enger reliquary, and in a limited sense the iconography also, bears some resemblance to the main scenes shown on the two ivory book-covers of the Lorsch Gospels (Plate 25), made at the Court School in the first decade of the ninth century, and suggests that a knowledge of these or of the sixth-century models that have been suggested for these covers was beginning to filter through to lesser centres.[25] The cloisonné enamels on the front, with snake-like animals, birds, and fish, have been mentioned before in connexion with the 'full' enamel panels on the Lindau book-cover – clearly they belong to the same tradition.[26] The colour of the enamel is rather more opaque, like that of the book-cover, and curiously ignores the forms of the creatures in its application to the clearly designed cellwork. It cannot be ruled out that the enamel in these pieces is a later, perhaps still ninth-century, restoration of cloisonné work in which, perhaps, the inlay of the kind used on the decorative strips on the front of the reliquary had been lost. Certainly, the animals are restricted to quite separate units of cellwork that could easily be taken off, re-worked, and replaced. It is difficult to understand why the clear patterns of animals should have been so confused by the indiscriminate application of colour, a treatment very different from the clearer use of colour on the Lindau cover.[27]

The second piece to be discussed has suffered even more obviously from later alterations and additions. The small house-shaped reliquary in the treasury at Conques is by tradition called Pepin's reliquary (Plate 12). A connexion with Pepin le Bref, duke of Aquitaine from 761 to 768, has long been dropped by scholars in favour of a link with Pepin I, king of Aquitaine from 817 to 838, son of Louis the Pious, and patron of the abbey. However, the discovery during a recent restoration (in 1954) of an earlier embossed gold plaque of the Crucifixion, cut up into small pieces and used in restoring the shrine, must lead one to reconsider the possibility of an eighth-century date for the first form of the reliquary. It shows a very archaic form of Crucifixion, with Longinus and Stephaton on each side named by inscriptions of distinctly eighth- rather than ninth-century character.[28] This badly preserved relief is also reminiscent rather of the crucified Christ in the Gellone Sacramentary of the late eighth century[29] than of any treatment of the Crucifixion produced during the reign of Louis the Pious. It should also be remembered that the core of the present Pepin reliquary can hardly have supported the gold plaque because both the front, with two deep rectangular niches, and the back, with an arcade of three arches, would not have supported the whole area of the newly discovered plaque. Moreover, the measurements of the incomplete plaque, if restored to its original height, would not fit the present shrine unless the upper part of the Crucifixion were bent back sharply on to the sloping roof. The present reliquary seems therefore to be the work of three periods. The early Crucifixion might have been re-used when the reliquary was drastically remodelled around the middle of the ninth century, but it was certainly discarded by the eleventh century, when the present large Crucifixion with the Virgin and St John was added.[30]

Among all the objects discussed so far that are likely to date from the second half of the eighth century or the early ninth century and so to set the scene for Charlemagne's remarkable revival at his Court School, we have seen a tendency to combine

Merovingian traditions with direct influences from Insular sources on the one hand, and North Italian techniques on the other. In the two ivory plaques that came from the church of St Martin at Genoels-Elderen (now in the Brussels Museum) one other element that was to form such an important part in Charlemagne's renaissance first plays a role: the humanist figural art of the Mediterranean tradition.[31] Both plaques, probably book-covers, show Christian figure scenes against a pierced background, perhaps originally backed by gilt metal. On the one, Christ treading on the beasts, accompanied by two angels, is represented (Plate 11), and on the other the Annunciation above and the Visitation below. The key-pattern border of the one and the interlace border of the other, as well as the palaeographical character of the inscriptions, reveal a strong Insular influence. The figure drawing is of a kind that adapts Mediterranean models to a flat, decorative style. Indeed the strength of the Insular character of the plaques has led to the attribution of the covers to a Northumbrian workshop of the early eighth century.[32] But the stiff, angular drapery style is not all that close to Insular drawing – where there is normally a marked tendency towards a softer parallelism in drapery. Also, it has a really close parallel iconographically and stylistically in an unfinished drawing in the Trier Apocalypse of the early ninth century.[33] This manuscript is not directly connected with the Court School, but is related to another Apocalypse at Cambrai and has been attributed to Trier, northern or eastern France, and even Tours.[34] Moreover, the iconography of the scene of Christ treading the beasts is also close to models known at the Court School, shown by the Oxford book-cover and the Lorsch Gospels cover (Plates 28 and 25).[35]

Like the Enger reliquary, these ivory panels from Genoels-Elderen give us an indication of the kind of work produced in Charlemagne's Empire away from the highly original and creative centre of his court. Little seems to have survived from more provincial centres, but what does, clearly demonstrates the gulf that was to open between the Renovatio under Charlemagne's patronage at Aachen and more provincial styles. Here in the provinces earlier Insular influences and indigenous Merovingian traditions were to continue to dominate well into the ninth century.[36]

THE REIGN OF CHARLEMAGNE

IN Rome, on Christmas day of the year 800, Charlemagne, king of the Franks and the Lombards, was crowned Roman emperor by Pope Leo III. It was the culmination of a lifetime spent in the creation and expansion of an Empire intended to rival the power and glory of the Roman Empire itself. The fourteen years that were left to the emperor in which to consolidate his achievement saw also the major part of his cultural and artistic patronage. At Aachen, the builders were nearing completion of the great chapel of Charlemagne's palace, which had been under construction by 786.[1]

His court scriptorium began its work in the 780s, after Charlemagne's meeting at Parma in 781 with Alcuin, the great British scholar whose reputation as the head of the York school had been established since the sixties. On the same journey to Italy, for the baptism of Pepin and the coronation of his sons Pepin and Louis, the emperor had asked the Italian Paul the Deacon, who had been attached to the court of Lombardy, to return with him to Aachen. It was under the influence of such men that the art of Charlemagne's court first took shape. The Godescalc Book of Pericopes, written and illuminated by the scribe Godescalc between 781 and 783, clearly shows a synthesis of Insular interlace ornament in its decorative frames and its richly ornamented opening pages of script on the one hand, and Italian painterly qualities seen in such manuscripts as the Egino Codex, painted in Verona between c. 796 and 799, and the wall paintings of Cividale on the other.[2] The Godescalc Pericopes also uses a new script, the beautifully clear and legible Carolingian minuscules, which represent a marked break with the lettering employed in Merovingian manuscripts. This script was to remain an outstanding and lasting contribution of the Carolingian era.[3]

With the departure of Alcuin in 796 to the abbey of Tours, where he was to employ his talents, always of a more scholarly than artistic kind, in the editing of the Vulgate text of the Bible, the Italian influence at Charlemagne's court gained further strength. The new generation of artists, now under the leadership of the emperor's biographer Einhard (c. 770–840), turned more and more to Italian models, especially those of northern Italy. Aachen's great chapel, a centrally planned building of magnificent dimensions, had already been based on the model of San Vitale at Ravenna,[4] and now Charlemagne called Italian artists to Aachen to decorate its walls with paintings and its dome with mosaics.[5] No doubt San Vitale was considered a building of the Roman Empire and therefore eminently worthy of imitation in the 'Renovatio' being created in the new imperial centre of the north, the 'second Rome'.

Imitation of the Antique even went as far as the importation of actual classical remains. Einhard tells us that the marble columns, and presumably the Corinthian capitals as well, which we still see at Aachen in the upper gallery of the chapel were imported from Ravenna and Rome.[6] He also speaks of the bronze railings and doors, and the silver and

gold candelabra and sacred vessels with which Charles adorned his palace chapel.[7] A distinction is carefully drawn between the columns that were imported and the rest, and indeed as far as the bronze doors are concerned, fragments of moulds have been found in Aachen to prove that they were made locally.[8] The bronze railings are mounted on the upper floor of the octagon in pairs of equal design facing each other across the central space (Plate 13). Two of these pairs, on the north and south, and on the north-west and the south-east, show most clearly the classical sources employed by the workshop. Tall, slender pilasters, decorated with classical foliage, are surmounted by pure Corinthian capitals carrying an entablature covered with a most subtle and delicate acanthus scroll. It has been pointed out how closely this combination of capital and entablature design is followed in the ivory chalice known as the chalice of St Lebuinus, now at Deventer in the Netherlands (Plate 14).[9] The chalice is mounted with a fourteenth-century silver lip and foot, but the really close similarity of the ivory carving to the bronze railing proves that the carver must have had access to the same patterns as those used by the bronzecasters. Even the squares between the capitals on the chalice, with lines drawn diagonally across them, follow the main design of some of the railings. The old tradition at Deventer that connects the chalice with St Lebuinus, who died in 773 or 784, may therefore be well founded. The chalice is undoubtedly a product of the school of ivory carvers at the court towards the end of the eighth century.[10]

The magnificent Carolingian doors, cast in solid bronze, of which four pairs have survived in the Palace Chapel, are also conceived in the most classical of styles. The largest pair, usually known as the 'Wolf's Door', after the Antique bronze statue of a wolf brought to Aachen by Charlemagne and still in the vestibule of the chapel,[11] was originally placed at the entrance of the church from the vestibule, but is now the main west door in the eighteenth-century west porch. Of the four smaller pairs of doors, originally made for the chapel of St Anne and St Mauritius (later, of St Charlemagne), leading out of the upper gallery, and the chapel of St Hubert and the sacristy, leading out of the main body of the church, three pairs have survived. Two of them, on the north side, in the gallery at the entrance to the chapel of St Anne, and below leading to the chapel of St Hubert, are still in their original positions; the third pair, which once led to the chapel of St Mauritius on the upper floor, is now installed on the north side of the west front (Plate 15). The pair that originally led to the sacristy must have been destroyed during Gothic alterations made to the church. Each half of the Wolf's Door, nearly 4 metres (13 ft) high, is divided into eight equal panels, while each half of the smaller pairs, 2·40 metres (about 8 ft) high, is divided into three panels, a square one at top and bottom, and a larger one in the centre, where the handles are attached. Their ornament, restrained in the extreme, consists merely of the most subtle classical mouldings surrounding the plain panels, and the handles, made of lions' masks carrying rings in their mouths, also follow classical models very closely.[12] In the detailed treatment of the modelling, however, in both the borders and the lions' heads, we can see a more hesitant and a less sculptural treatment than we would expect in any Antique model. In Late Antique ivories of the fifth and sixth centuries, however, we do find similar thin and rather dry and stiff acanthus borders, as well as the egg and dart and beaded

borders, although the exact channelled pattern of the Wolf's Door or the curious acanthus with a pellet between each leaf employed on the three pairs of smaller doors cannot be found on any of the surviving ivories. The channelling does, however, occur on the frame of the centre medallion of the late-fourth-century silver plate found at Cesena in North Italy.[13] That bronze doors of this style did exist in Late Antique times can, however, be shown: the gates to the tomb represented in the fifth-century Ascension ivory at Munich have plain panels with simple mouldings, and lions' masks with rings in their mouths are found on the doors of the tomb in the scene of the Maries at the Tomb on one of the panels of a fifth-century casket now in the British Museum.[14]

The large bronze pine-cone in the vestibule of the Palace Chapel at Aachen, with four small figures representing the four rivers of paradise at the corners of its base, is almost certainly another product of the bronzecasters of the Court School (Plate 17). The fragmentary inscription on its base[15] names Abbot Udalrich as its donor, but Udalrich cannot, unfortunately, be identified with certainty. The fact that the casting of this pine-cone is not of the same high quality as that of the doors and railings need not deter one from attributing it to the same workshop: the problem of casting such a large object, hollow and in the round, presents far greater technical difficulties than the casting of the comparatively thin doors and railings had done.[16] The fact that the base came out of the mould only in part, and that very little of three of the small figures and only half of the fourth came out at all, proves the difficulty the craftsmen encountered. Also, it is really hard to understand why it has been suggested that the cone itself and the base are of different periods. The colour of the metal and the rough surface are identical throughout the whole cast. It seems most likely that the fountain was never completed. No attempt appears to have been made to finish the base by brazing on the missing parts, and most of the cast is rough, as it would normally be when first brought out of the mould, before any of the final chasing and polishing had been undertaken.[17]

The attribution of the entire piece to Charlemagne's time is so much more convincing also in terms of content and meaning. The 'imitatio' of Rome, the establishment of Aachen as the second Rome, the Rome of the north, was always in the emperor's mind. What would suit this purpose better than a copy of the ancient pine-cone fountain erected in the atrium of St Peter's in the fourth century? The Roman fountain, signed by the first-century sculptor P. Cincius Salvius, not only occupied the centre of the atrium and was its main ornament, but had also by the late eighth century, when Charlemagne first saw it, acquired the Christian meaning of the 'Fountain of Life'.[18] The Aachen cone, too, was intended to run with water, because each of its 129 leaves is pierced with a small hole in its tip. The failure of the cast was no doubt responsible for the fact that the necessary plumbing was never undertaken.

Of the furnishings in silver and gold made by the same workshop, and mentioned by Einhard, nothing has survived, but the *Liber Pontificalis* records a large number of gifts made by the emperor to the Holy See after his coronation in Rome,[19] and there is evidence that Charlemagne gave to the church of St Peter an almost life-size representation, wrought in silver, of Christ on the Cross.[20] Such a cross may well have survived in Rome until 1540, when it was melted down and the metal used to replace altar plate

lost in the sack of Rome in 1527. Fortunately it is known what this large crucifix looked like, because a copy was made of it in 1540 before its destruction (Plate 18).[21]

This copy, made of 'cuir-bouilli' leather, mounted on wood, is still in the Vatican. Its style is unmistakably Carolingian, and so little of sixteenth-century Mannerism has crept in that one must assume that it was in fact made by pressing the boiled leather in its malleable state over the original silver cross and its figural decoration. In fact, the use of this unusual technique can really only be explained by the intention of preserving an exact replica of the ancient treasure, by making a kind of 'impression' of the metal-work in leather. It is not known whether such a Carolingian original would have been made of solid silver, or whether it had a fully carved wooden core on which sheet silver was hammered. A full examination of the Vatican copy would make it possible to decide whether an original wooden core has survived, and was only covered by leather in 1540, or whether the modelled leather is simply mounted on an uncarved wooden support, having been pressed on a solid silver original.

It is unfortunate that such important evidence of almost life-size ninth-century sculpture (the crucified Christ is over one metre (about 3 feet 6 in.) in height) should have survived only in a copy, which has clearly lost much of the sharpness of detail and definition in the process. And yet we can get an impression of the competence of Carolingian craftsmen in translating their two-dimensional style, which is known so well in manuscript painting, into fully rounded relief. This piece, simple in its massive forms of the human figure and its restrained treatment of drapery, is not all that closely related to other sculptural work of the Court School, known to us almost exclusively on the miniature scale of the ivory carvers. In spite of the fact that the style of the Vatican cross is not close to known work of the Court School, echoes of it are found soon after the middle of the ninth century in the Court School of Charles the Bald: in the Crucifixion on the later book-cover of the Lindau Gospels (Plate 59),[22] the flutter of the loincloth is more exaggerated, but the basic arrangement with a central knot and zigzag folds descending from it are still to be seen. The modelling of the figure with its high shoulders and rather flabby body shows clearly the continuing tradition of the Vatican figure. It should also be remembered that the art of Charlemagne's Court School was one of the most consistent sources for the School of Charles the Bald.[23]

The whole composition of the Vatican crucifix, with the half-length figures of the risen Christ with sceptre and orb at the top, and the Virgin and St John at the extremities of the cross, has not survived elsewhere in earlier centuries. It should be noted, however, that many examples (albeit without the figure at the top) are found in the twelfth to thirteenth centuries in the Italo-Byzantine painted crucifixes, and that the sources of this type on a monumental scale are not at all well established. The earliest example so far known, with the exception of this Carolingian cross, is the version in embossed bronze-gilt mounted on a wooden base in Milan Cathedral, donated by Archbishop Aribert in the second quarter of the eleventh century.[24] Charlemagne's gift to Pope Leo III, or Pope Leo's gift to St Peter's, may well have been the archetype of the composition, or at least represented its first introduction into the West from eastern sources, where it is known on a miniature scale in bronze pectoral crosses.[25] The representation

of the half-length figures of St Peter and St Paul on the base of the cross, of special significance to the Church of Rome, where the heads of the two saints had appeared on papal bulls since the earliest times, was naturally eliminated in the later widespread use of the type.

Another piece of metalwork which may have been made by the Court School is the bronze equestrian statuette of an emperor crowned and carrying an orb in his left hand (Plate 19). (It now belongs to the Musée Carnavalet, and is to be seen in the Galerie d'Apollon at the Louvre.) Its history cannot be traced further back than the sixteenth century, when it was in the cathedral treasure of Metz.[26] This small statuette, only 29 cm. ($11\frac{1}{2}$ in.) in height, has been the subject of much controversy, and its traditional identification as a portrait of Charlemagne himself has often been doubted. It has been suggested that the horse on which the rider is mounted is a sixteenth-century replacement, but this must be rejected. It is true that the figure and the horse are cast as separate pieces, but the colour of the bronze in both, which suggests a high silver content by its silvery surface, rules out such a possibility. Nor does the style justify the assumption. The modelling of both horse and rider shows a consistent, rather heavy treatment of form, summary and with little detail. The leather straps of the harness are treated in exactly the same way as the garter on the emperor's leg. The folds of flesh at the horse's raised leg are as soft and broad as the drapery of the emperor's cloak. The kind of late classical model which this statuette brings to mind is the ivory five-part diptych from the Barberini Collection, now in the Louvre, which dates from the beginning of the sixth century.[27] Here, in the centre, there is an equestrian representation of the Emperor Constantine which, in the horse's head and in the soft, generalized modelling of the whole body, as well as in such details as the emperor's crown and his close-fitting, cap-like hair, bears a remarkable resemblance to our bronze statuette, in spite of the fact that it is in relief and not in the round. On the bronze, the treatment of the horse's mane is markedly different from that of the hair on the emperor's head: it is more sculptural and also wild. This same difference can be found on the Barberini ivory. The horse's hair on our bronze can also be compared very well to the treatment of the lions' manes on the bronze doors of the Palace Chapel at Aachen, where the same heavy strands and groups of hair are formed, often with curling ends, as between the ears of the statuette's horse. The modelling of the horse's head itself and its eyes are also not at all unlike the masks on the bronze doors.

For the whole statuette, another, more direct model than the Barberini ivory can be suggested. It is known that in 801 Charlemagne brought an important work of art from Ravenna – the life-size bronze equestrian statue of the Emperor Theodoric,[28] probably in fact a late-fifth-century portrait of the Emperor Zeno which was later, perhaps as late as in Charlemagne's time, 'baptized' Theodoric. There can be no doubt of Charlemagne's admiration of Theodoric, who represented to him the first Germanic emperor to have conquered Rome. We know something of this equestrian statue's appearance through Agnellus and Walafrid Strabo. It was a bronze-gilt horse on which the rider sat carrying a shield on his left, and swinging a lance in his raised right hand. In fact, it probably resembled quite closely the Emperor Constantine as he appears on

the Barberini ivory. The statue has unfortunately perished, but its appearance at Aachen, probably set up between the Palace Chapel and the palace, must have created a tremendous impression and may well have inspired this miniature version.[29] A secular equestrian statue conceived fully in the round remains a remarkable achievement at any time between Antiquity and the thirteenth century, and it is therefore no more easily explained at the end than at the beginning of the ninth century.

We know a good deal of Charlemagne's physiognomy: his biographer Einhard has given us a vivid account.[30] 'He was large and strong, and of lofty stature,' he tells us, 'though not disproportionately tall (his height is well known to have been seven times the length of his foot); the upper part of his head was round, his eyes very large and animated, nose a little long, hair fair, and face laughing and merry. Thus his appearance was always stately and dignified, whether he was standing or sitting; although his neck was thick and somewhat short, and his belly rather prominent; but the symmetry of the rest of his body concealed these defects.' Einhard also records that 'He used to wear national, that is to say, the Frankish dress – next to his skin a linen shirt and linen breeches, above these he wore a tunic fringed with silk; while hose fastened by bands covered his lower limbs and shoes his feet . . . and he always had a sword girt about him, usually one with a gold or silver hilt and belt; he sometimes carried a jewelled sword, but only on great feast days or at the reception of ambassadors from foreign nations.'

The sword known as Charlemagne's, preserved in the Imperial Treasury now at Vienna, was given to him, according to legend, by the Arab ruler Harun al Rashid. It is now thought to be of Eastern European origin, and to date from the second rather than the first half of the ninth century.[31] The ornament of the gold hilt, quillon, and sheath is certainly eastern rather than western, and can best be paralleled in finds in Hungary and South Russia. The blade, too, with its inlay in copper and gilt dragons, probably comes from the same part of Europe; the bands set with jewels, however, may be western additions. If the sword is really of the late ninth century, it is difficult to explain how it came to join the Imperial Treasure at Aachen – one may also doubt whether in Eastern Europe ornament can be so closely dated that the early ninth century must be ruled out. As with the enamelled ewer, now at Saint-Maurice d'Agaune, the most likely explanation is surely that this sword was part of the Avar treasure brought to Aachen by Eric of Friuli after the defeat of the Avars in 796.[32] It may well have been the jewelled sword worn by Charlemagne as described by Einhard, and it was certainly the sword which was put about the waist of later German emperors by the archbishop of Cologne during the coronation service.

Whether the word 'portrait' given by Einhard helps us to decide that the equestrian statuette is indeed a representation of Charlemagne, it is difficult to say. The attitude to portraiture in the ninth century, as displayed on seals, coins, or named representations, is not at all consistent. Charlemagne, for example, used a portrait intaglio of the Roman imperial period as a personal signet. Not too much reliance can therefore be placed on any physical resemblance the statuette may bear to the emperor. Although Einhard's description fits the Metz statuette not at all badly, we cannot take it to weigh too much in its favour. But whether it represents him or not is not of prime importance: it is as

evidence of the highly sophisticated attitude towards the classical revival, the Carolingian 'Renovatio', that it makes its greatest contribution. It is in this context, and the existence of a workshop of highly skilled bronzecasters at Charlemagne's court, that the strongest arguments lie for an attribution of the little bronze to the lifetime of Charlemagne himself, rather than to one of his successors.

Little else has survived of the work of these bronzecasters, though one other piece has been attributed to the workshop, and, on the whole, with good reason. It is the so-called throne of Dagobert, once preserved at the abbey of Saint-Denis, near Paris, and now in the Cabinet des Médailles in Paris (Plate 16).[33] The traditional connexion of this gilt-bronze throne with King Dagobert I (622–38) goes back at least as far as the twelfth century, when it is mentioned by Abbot Suger (d. 1151) in the list of treasures of Saint-Denis restored under his direction.[34] It is not surprising that Suger thought the throne to be Dagobert's, for Dagobert had been believed since the ninth century to have been the founder of the abbey, and any ancient object in the monastery naturally tended to be associated with its first royal patron – especially an object so clearly 'royal' in origin. The problem of the date of this throne is complicated by the fact that we do not know to what extent Suger's restoration may have changed its appearance.[35] It has been suggested that he added the arm-rests and the upright back, and indeed their ornament, especially the foliate scroll that decorates the upper sectors of the arm-rests, could certainly date from the twelfth century, but it is not so typical as to rule out a possible early-ninth-century date. Not only does the remarkable resemblance that the chair bears to that in the representation of the enthroned King Lothar I in his Psalter, now in the British Museum (Add. MS. 37768), written soon after 842, show that it is almost certainly at least as old as that, but Lothar's throne is represented without arm-rests or back, which would seem to support the theory that those of Dagobert's chair were added later.[36] But there are other considerations, too. The two heads which act as terminals to the rods that link the sides and back together are really very close to the tradition of head terminals found on other early folding stools, a tradition that was probably no longer available in the twelfth century.[37] This would suggest, at least, that if these parts were added, older remains were re-employed. After all, Suger's restoration may well have been no more than a repair of the stool, in Suger's words 'worn with age and dilapidated'. In the case of Charles the Bald's altar frontal, for instance, Suger quite specifically and proudly speaks of his additions, and one may suspect that, had he added such substantial parts to the chair, he would have said so. Above all, the form of the throne is conceived in the Antique tradition, and it bears the same relationship to Antiquity that we have found in the doors and in the railings of the Palace Chapel. The strips of mouldings that link the legs of the chair, and that are found again in the sides and back of the throne, are much the same in weight and design as the main patterns of the gallery railings.[38]

Thus, although an earlier, perhaps Late Antique, origin for 'Dagobert's throne' cannot be entirely ruled out, it would seem most likely that it is a work of the Court School, and that it has survived substantially in the form in which it was first made. The fact that it became the property of the abbey of Saint-Denis need not weigh against

this. A folding stool of this kind was clearly intended to serve the emperor on his extensive and frequent travels, and is quite distinct from the permanent stone throne that still survives at Aachen. Saint-Denis was visited by Charlemagne only twice in his lifetime, and was not a popular stop on his itinerary, but for some of his successors, especially for Charles the Bald, and for Lothar I, who, as we have seen, almost certainly used it, Saint-Denis ranked high in popularity. It would not be at all surprising that the throne should have found its resting place, with so much of the royal regalia of the kings of France, in the royal abbey of France.[39]

Another important piece which provides evidence of the Court School's attitude to the Carolingian 'Renovatio' must be mentioned here, although it may actually have been produced a little after Charlemagne's death. The piece itself has not survived, but we can form an accurate picture of it with the help of a seventeenth-century drawing made before its destruction.[40] It was a remarkable triumphal arch made of embossed silver, probably on a wooden core, presented by Einhard, the man at the very centre of the court, to Maastricht Cathedral, to serve as a base for an altar cross (Plate 20). This miniature arch closely imitates its monumental ancestors, which could be seen in Rome and many other cities of the Empire. The general proportions and such details as the mouldings to separate the various stages of the arch and the rectangular label in its top storey, called the attic, to accommodate the dedicatory inscription, all follow the model faithfully; but the pictorial subject matter is not the battle triumphs of Imperial Rome, but the victory of Christianity. Among these representations, we find on the inside of the arch an equestrian figure which is not dissimilar to the small bronze statuette in the Louvre – another possible piece of evidence to support an early date for it. Whether or not a direct connexion is acceptable, this miniature version of a monumental classical theme provides a remarkable parallel to the miniature bronze of a type of equestrian monument known in Antiquity on a life-size or over-life-size scale. Both the evidence for Einhard's triumphal arch and Charlemagne's statuette are unique survivals of their age, and they may well have been unique creations in their own time.[41]

In the attempted revival of the grandeur of Antiquity at Charlemagne's court the models were not always the purest, nor were they slavishly copied. What was copied at Aachen at the Palace Chapel itself, for example, was not the Byzantine transparency or the Byzantine fluidity of space brought about by the rich colour of San Vitale's shimmering mosaics, but only its centralized octagonal plan and a simplified version of its elevation. On this plan a building of immense strength was created instead. The walls are more solid, the piers more hefty, and the niches, semicircular in plan, which give the model its subtlety, have been eliminated. The whole atmosphere of this northern version was far more sombre, far more heavy.

What is true of the architecture of Aachen, is true of all the arts of the period. In manuscript illumination, heavy colour and rich decoration replace the light atmospheric treatment of Late Antique impressionism as well as the penmanship and playful multi-coloured washes of the Merovingian eighth-century style. This sombre, 'imperial' colouring seems to be a contribution of the Court School. None of the models, as far as we know them, seems to be cast in quite such a mould. Although it is in illumination

that we see this most clearly, the same is true of the metalwork and ivory carving of the Court School. Very little of the work of the goldsmiths at Charlémagne's court has survived, but we do know not only that it existed, but also what form some of it must have taken, because it plays such an important part in the decorative vocabulary of the illuminators of the Court School.

The rich and varied borders and frames painted in the pages of the manuscripts show that the illuminators used highly sophisticated jewellers' work for their inspiration. Antique intaglio gems set at intervals between small pearls strung on wire and laid in lozenge patterns, and panels of filigree in scrolls and foliate forms, are among the decoration most commonly used.[42] Other classical patterns such as egg and dart, bead and reel, and so on, also used on the bronze doors at Aachen, and especially the stiff acanthus leaf borders, are also popular with the illuminators,[43] but the borders of the manuscripts above all show their derivation from goldsmiths' techniques, and in this, these enrichments are peculiar to the Court School.[44] They do not appear to have been taken from the manuscript sources of the school, but must have been derived from the contemporary goldsmiths' works that were no doubt available at the court.

Three pieces of jewelled metalwork have been traditionally attributed to the lifetime of Charlemagne. The first is a small gold reliquary, known as 'Charlemagne's Amulet' (Plate 21).[45] It was preserved in the Aachen treasury until 1804, when it was given by the chapter to the Empress Josephine, wife of Napoleon, at the same time as the twelfth-century reliquary of the 'Arm of Charlemagne'.[46] It remained in the possession of the House of Bonaparte until, it is said, it was given by the Empress Eugénie to Reims Cathedral. The reliquary was made in the shape of a little ampulla, with a short neck and two small handles, so popular from the earliest Christian period onwards. This form was well known in northern Italy, and Charlemagne himself may well have seen the large collection of sixth-century lead pilgrims' ampullae brought from the Christian East which have been preserved to this day in the treasury at Monza. Like Charlemagne's Amulet, these too seem to have been worn on chains round the neck, and in one case such a chain still survives.[47]

The amulet was originally made to contain a lock of the Virgin's hair, but today encloses fragments of the True Cross, which can be seen through the large gems mounted on the front and back. The gold chain is attached to the two small handles, and the golden container is richly decorated with filigree and set with gems and pearls on all its surfaces. It is tempting to see in this small object, traditionally associated with Charlemagne, an actually surviving example of all those jewellers' techniques copied in the illuminated manuscripts: the pearled wire filigree in foliate patterns so difficult to parallel in the eighth century, the broader embossed type of foliage decoration between gems set in plain bands of gold surrounded by a single pearled wire, the 'acanthus' claw settings of the large crystals, are all found on this one small piece. Many of these techniques can be found here and there in earlier jewellery, but their combination and the rich, crowded effect is unprecedented and lays the foundation for the style of jewelled decoration of the whole of the ninth century. Much of the decoration of this jewellery is so in character with art at Charlemagne's court in general and with so much

of the painted decoration in the Court School illuminated manuscripts in particular, that in this case the traditional attribution of this reliquary to Charlemagne's time is entirely acceptable.

The second piece to be considered is the magnificent ewer-reliquary, now one of the major prizes of the rich treasury of the abbey of Saint-Maurice d'Agaune in Switzerland (Plate 22).[48] According to a verbal tradition in the abbey, the ewer was a present to Charlemagne from the Calif Harun al Rashid. Its date and provenance have been subjects of debate for well over a hundred years. Its origin has been given as 'oriental', from Persian to Sassanian and Early Islamic; as 'Middle Eastern', from Alexandrian to Byzantine; and it has even been thought to be a western copy of an eastern model. It has been dated from as early as the fourth to as late as the twelfth century. More recently it has been suggested that the large and splendid cloisonné enamels and the metalwork in which they are set are not of the same origin and date: the enamels are said to have originally decorated a sceptre which may have been part of the Avar treasure captured by Charlemagne in his campaign of 795–6 and distributed to members of his court and to the great abbeys and churches of his Empire.[49] According to this theory, the enamels were the products of one of the great artistic centres of the Early Islamic period in the Near East (cloisonné enamel may possibly have decorated some of the gold vessels of the Nagy-Szent-Miklos treasure); the sceptre itself may have been damaged and then dismantled and the enamels re-employed by a Carolingian goldsmith to decorate a ewer intended as a cruet for the celebration of the mass. This explanation is certainly an attractive one. It would enable us to see work of the Carolingian period in the gold decorative frame, without the embarrassment of having to accept the highly decorative and competent cloisonné enamels as a product of a western school. Clearly the enamels can only be explained in a Middle Eastern context, but at the same time much of the rest of the metalwork can be paralleled in the West: the heavy, pearled wire, the serrated band filigree of the panels between the enamels of the neck, the settings of the jewels in plain bands set off by a single ring of pearled wire, and the stiff acanthus can all be compared convincingly to western ninth-century goldsmiths' work. Perhaps the strongest piece of evidence that the ewer in its present form cannot be later than the ninth century is the fact that the two gold panels decorated with plant motifs inlaid in niello that replace lost enamels on each side nearest the foot, cannot be other than Carolingian. They can be compared in the most convincing way with the back of the ninth-century strap end from Alsen in Denmark.[50] The technical information gathered in the full examination of the ewer also demonstrates that almost certainly the enamels were not designed to decorate the ewer as it stands, but were re-used – so much in its assembly of parts looks like improvisation. The large hemispherical enamels on the side, with the square-cut base, do not fit happily into their circular frame; they are fixed against the flat body of the ewer, and the space between is filled by wax poured in.[51] Considering the quality of the goldsmith's work, it is surprising to find this kind of clumsy makeshift in the assembly. And yet it is difficult to understand why such fragments should have been assembled in Northern Europe to look so much like a Middle Eastern ewer.[52] One can compare parts of the metalwork with northern techniques, but the total effect

is difficult to parallel in known northern workshops, and, indeed, none attributed to the Court School can be compared to it. The broad acanthus frame does of course resemble the acanthus borders of Carolingian ivories, but never are these set against the curious pierced half-round frame found on the ewer. This kind of illusionistic effect is not found in the north, but does resemble the decorative treatment found in Middle Eastern stucco-work, especially that executed at Khirbat-al-Mafjar in 724–43.[53] In the end, it must remain a possibility that the whole ewer as it stands today, even if made up of disparate pieces, was part of the Avar treasure. Indeed, its technical details could have provided a welcome source and much inspiration for northern goldsmiths.

A third piece, of which only a small fragment has survived, is known as the 'Escrain de Charlemagne' or shrine of Charlemagne.[54] In 1794, before its destruction in the French Revolution, a drawing, later coloured, was made of it by E. Labarre (Plate 23). Until then it had been preserved in the abbey of Saint-Denis, where the inventory of 1505 describes it as silver-gilt. The inventory of 1739 described it, no doubt correctly, as of gold. The traditional connexion with Charlemagne does not go back into the earlier Middle Ages; the older chronicle of Saint-Denis, which only survives in the thirteenth-century version of the *Grandes Chroniques de France*, speaks of it as a donation of Charles the Bald. Both traditions may well be true, and the shrine may have been among the relics and treasures taken in 876 by Charles the Bald from Aachen to be presented to Saint-Denis.[55] As we know the shrine today, from the eighteenth-century drawing, the skeleton of arches is mounted on top of an oblong 'box' reliquary, which by 1505 contained relics of St George, St Theodore, and St Apollinaris. This lower part is clearly a restoration of the fourteenth century, and the period of the Abbot Philippe de Villette (1363–98) has been suggested.[56] But a reliquary box of some kind must have existed before this restoration, and the thirteenth-century chronicle gives us a summary description of it as a 'vessel', silver within and without, covered with bands of gold set with great sapphires, emeralds, and pearls and containing the arm of St Apollinaris the martyr, the first Archbishop of Ravenna and a disciple of St Peter. There is no mention of St George and St Theodore, but they may have been added later. The fact that relics of all three of these saints were among those collected together at Aachen by Charlemagne lends support to the theory that the reliquary was originally at Aachen and was later given to Saint-Denis by Charles the Bald.[57] The shrine is described in an even older text, which was added on the endpapers of a ninth-century manuscript, probably early in the tenth century.[58] The description is a very full one, beginning with the words 'In gypsa super altare'. It has been suggested that the word 'gypsa' must be a misreading for 'capsa', because the object is made of metal and has nothing to do with gypsum or plaster. But this is probably not so. The 'gypsa' is an example of the use of 'gypseae fenestrae', which is derived from the practice of filling windows in early times with thin plates of moonstone (like a plaster of Paris, a form of calcium sulphate).[59] The description begins then with the words 'In the window above the altar', and the altar mentioned is probably the very reliquary box on which this structure was mounted. A 'window' is indeed an excellent description of the scaffold-like structure of the shrine of Charlemagne. The drawing by which we know the shrine does not provide us

with any evidence, but it is of course possible that the whole structure was originally filled with thin plaques of moonstone, making its resemblance to a window even closer.[60]

The small fragment that survived the destruction of the reliquary enables us to check the accuracy of Labarre's drawing, and gives us some idea of the high technical quality of the work (Plate 24). The drawing would seem to make the work appear somewhat more delicate than it was. A closer examination of the fragment, however, must raise doubts whether it is actually the crest drawn by Labarre. The small round pellets that are used to strengthen the attachment of the frames of the subsidiary gems are a continuous line of pearled wire, and the two triangular stones at the bottom have become a single stone in the drawing. It is, of course, possible that Labarre was not that accurate, but can one really assume that the great gem in the centre, which in the drawing shows a male head(?) cut at the neck, with inscriptions at the top and base,[61] could have been intended by Labarre to represent the larger female head with drapery below the neck and a Greek inscription on the side on the surviving crest? Surely the whole drawing seems too accurate in its details to be guilty of such an error. A closer examination of the drawing might provide the answer. It has, of course, always been recognized that the lower part of the reliquary was added in the fourteenth century, but surely many of the pendant jewels were also added to the structure then. Most, if not indeed all, of the jewels suspended from the smaller arches look very like fourteenth- to fifteenth-century jewellery.[62] It is equally difficult to accept the gems mounted along the roof-lines of the structure and between the smaller arches throughout. They and the two large gems which look like Antique urns mounted at the top corners may well be of post-medieval date. The same applies to the small oval brooch fixed below the pendant jewel of the centre arch of the second storey: the drawing seems to make it quite clear that this jewel used the black and white painted enamel so commonly found in seventeenth-century jewellery.[63]

On the evidence of the drawing an elaborate enrichment of the shrine seems to have taken place in the seventeenth century, and it is probable that the crest drawn by Labarre was then added to the reliquary. Indeed, it would explain why the remaining crest survived at all. When the shrine was sent to the mint to be destroyed, the original crest was not sent because it had been separated from the reliquary earlier in its history. In the surviving piece, the large gem is set, as are the smaller ones surrounding it, in a very plain gold rim of a kind not unlike settings popular in North Italy from the Late Antique and Byzantine periods onwards; but it is treated rather more roughly and made in thicker metal than one would expect in an Italian workshop. The intaglio gem, probably an aquamarine, is a first-century portrait of Julia, daughter of the Emperor Titus, signed by the Greek engraver Evodos. It is set against a gold foil background which makes the head appear in relief, and its use at the very top of the shrine may well mean that it was re-interpreted by the Carolingians as a portrait of the Virgin, who enjoyed a special veneration at Aachen, where major relics (including her robe) are still preserved in her shrine, into which they were translated in 1238 from the reliquary which is known to have existed in Charlemagne's time.[64] Even the tenth-century description of the 'crest' draws special attention to this intaglio and singles it

out as 'a gem more noble than the rest'. The belief that the Virgin was intended to be symbolized in this imperial portrait may be supported by the fact that the small gem mounted centrally above it bears the ancient inscription A M Θ X, for ʼΑγια Ματηρ Θεου Χριστου' – 'Holy Mother of God Christ', while its reverse is engraved with a dolphin.

The shrine of Charlemagne has been compared to the golden altar frontal given by Charles the Bald to Saint-Denis, probably in 867, which was also destroyed in the French Revolution. What this frontal looked like, we know only from a fifteenth-century painting in the National Gallery in London, where St Giles is seen celebrating Mass in front of the high altar of Saint-Denis (Plate 57).[65] The similarities between the two works have often been pointed out. In both, major arches are subdivided by three minor arcades and a votive crown is suspended above them – and all this is set with gems. There is, of course, a major distinction between them, in that in the frontal this jewelled work is set against a solid gold background embossed with figure-work. Also, there is no sign of the panels of filigree which are set between large gems on the horizontal architraves on Charlemagne's shrine. Nor is the treatment of architectural detail at all similar in the two: on the frontal, the logic of architectural members such as capitals and imposts is carefully preserved, while on the shrine such details are treated in a perfunctory fashion. The characteristic jewel settings with a lobed frame alternating with plain settings on the frontal are also absent on the shrine. Admittedly, these arguments are based only on a painting, but the descriptions in the inventory of Saint-Denis of 1634 and in Doublet's *History of Saint-Denis* of 1625 support the view that the details of jewelled decoration, although greatly abbreviated in the number of stones employed, are fairly accurate in the Flemish painting, in marked contrast to the adaptation of the figure style of the frontal to fifteenth-century taste. Nor is there any evidence to suggest that Abbot Suger altered that part of the frontal considerably in the twelfth century. But even with evidence within such limitations, the difference between the two works argues strongly against attributing them both to one workshop or even to the same period: in its unique quality, in its unusual and splendid design, in its reduction of architectural design to a jewelled miniature scale, the shrine of Charlemagne may well take its place convincingly alongside the work of the Court School of Aachen.

Ivory carving was certainly also carried out in the court's scriptorium: not only are the covers of the manuscripts themselves evidence of this, but their style also is close to that of the illuminators, and use was made of the same models.[66] The covers of only two of these manuscripts have survived, but both are of outstanding importance in helping to define two distinct styles of carving in this crucial period. The first is very closely related to the style of the illuminations themselves, and is represented in the imposing front and back covers which originally decorated the Lorsch Gospels.[67] The manuscript itself has survived in two parts: the Gospels of St Luke and St John are now in the Vatican together with the back cover, although separated from it; the Gospels of St Matthew and St Mark are in the National Library, Bucharest, while the front cover belonging to them is in the Victoria and Albert Museum in London. The entire area of both covers is decorated by a five-part diptych of the form popular in the Late Antique

period. The front cover shows the seated Virgin and Child in the centre, with St John the Baptist pointing to the Child on the left, and the Prophet Zacharias as a priest with censer and incense box on the right – all three under arches carried on elaborate columns. Above, two flying angels carry a medallion between them with a bust of Christ within, and below is shown the Nativity and the Annunciation to the Shepherds. The back cover is by a different hand (Plate 25). In the three large panels the carving is somewhat flatter, sharper, and more linear, with a greater tendency to parallelism in the folds of drapery. In the centre, again under arches, a youthful, beardless Christ is shown treading on the lion and the dragon, with the asp and the basilisk in the field. This representation of Christ as victor over evil is based on the text of Psalm 90, verse 13: 'Thou shalt walk upon the asp and the basilisk: and thou shalt trample under foot the lion and the dragon'. The angels who in the psalm are said to have been given 'charge over thee, to keep thee in all thy ways' are shown flanking Christ on each side. Above, flying angels carry a medallion with a jewelled equal-armed cross, and below, the story of the Nativity is continued with the Three Kings before Herod and their Adoration of the Child.[68] It is generally agreed that both covers are closely based on East Christian prototypes of the sixth century, both in iconography and style.[69] Stylistically, the front panel of the throne of Maximian, archbishop of Ravenna, dated 545–53 provides a really close parallel in the treatment of standing figures under arches, in the treatment of drapery, and even in the facial type of St John the Baptist, who appears in the centre position on the chair.[70] The throne was to be seen at Ravenna from the middle of the sixth century, and its influence was undoubtedly to be felt not only at Ravenna itself, but in the whole of northern Italy. Other pieces, like the diptych of Christ and the Virgin now in Berlin,[71] which has also been associated with Maximian on the strength of a fragmentary monogram, testify to the existence of a group of ivory carvings in Ravenna in the sixth century which might well have included the five-part diptychs which provided the models for the carvers at Charlemagne's court. Again it seems that the 'eastern' models on which the Court School drew were available in Italy, rather than being imported directly from Constantinople. The craftsmen in the Court School adapted for their purposes an eastern style at least two hundred years old, and were not, like the painters of the Vienna Treasury Gospels[72] also working at Charlemagne's court, steeped in the living art of Constantinople, the living tradition of Late Antique art.

The style of the Lorsch Gospels covers, close as it is to the Maximian group, and clearly as it is derived from the art of northern Italy, is even closer to the illuminations within the major books of the Court School. The treatment of drapery, the plump faces with large staring eyes, the long curving fingers, the scalloped form of the halos, the highly decorative treatment of the columns and arches, the curious little abbreviated buildings and squat round towers of the narrative scenes below – all can be closely paralleled in the illuminations of the school. It is quite certain that identical models served both the illuminators and the carvers, and one is even tempted to suggest that one and the same craftsmen worked in both media.

The only other ivory carvings directly connected with the Court School manuscripts are the two panels in the Louvre which once decorated the covers of the Dagulf Psalter,

now in Vienna (Plate 26).[73] This was presented to Pope Hadrian I by Charlemagne, certainly before, although probably not much before, the former's death in 795. It is somewhat earlier than the Lorsch Gospels, and one may detect certain stylistic traits of the later Lorsch covers incipient in it. The drapery is nothing like as rich or, one might almost say, as 'oriental' as the Lorsch style, but some of its flutter and deep ripples, especially at the hems and belts, seems to foreshadow the later, more extravagant variety of it. The round, child-like faces of the little figures on the Dagulf Psalter also point towards the later cover of the Lorsch Gospels, but in the latter they have become more flat, more mask-like. Each of the two Louvre panels is divided into two square picture spaces by thick, rather fleshy acanthus borders. The four scenes on them are praised in the dedicatory verse in the Dagulf Psalter, which proves that these ivories once decorated its cover. The pages of the Psalter measure 19·2 by 12 cm. (about 7½ by 4¾ in.) and the panels of ivory are each only 16·8 cm. high and 8·1 cm. wide (about 6½ by 3¼ in.). Clearly they must have been mounted in a frame to fill the entire cover, and there can be little doubt that this frame would have been of goldsmith's work. It is very unfortunate indeed that this part of the cover has been destroyed; many of the problems of the Court School's goldsmiths' work might have been solved had it survived intact.

The subjects shown in the four scenes are all suitably connected with the Psalter between its covers. On the upper part of the major panel, probably once the front cover, King David gives instructions to four scribes to copy the Psalter, and below the king is shown playing the harp and singing the psalms surrounded by his musicians. On the back cover, the priest Boniface is represented handing a letter to St Jerome from Pope Damasus, asking him to correct the translation of the Psalms, and below St Jerome is dictating his corrected translation to the scribes. The figures completely fill the square area they inhabit, leaving only a small strip above their heads to give an abbreviated architectural setting to the scenes. The proportions of the figures are squat, but their movement is remarkably free within their restricted space, and their bodies are fully articulated. They lack the imperial grandeur of the large hieratic images of the Lorsch covers, but they are not unlike the smaller figures in the Nativity scenes in the lower registers, where there is something of the same busy human activity. This difference was just as marked between the large 'official' figures and the subsidiary figures on the diptychs of the Early Christian period, and it may well be that the Carolingian carvers took over this tendency from their models.

The kind of models that inspired the square scenes on the covers of the Dagulf Psalter were no doubt the small square scenes, usually illustrating the life of Christ, on Late Antique five-part diptychs. The Court School illumination also provides some parallels for our ivory panels: the acanthus frames, interrupted by small roundels with tiny carved heads in them, or the small square frames, which in the ivories are filled with the hand of God in one, the lamb of Christ in the other, can be found again in manuscripts of the school.[74] But the crowded scenes cannot be paralleled, because the Gospel Books that have survived are restricted to the representations of the Evangelists. Only in the tiny marginal scenes in the Soissons Gospels or the scenes incorporated in

the initials of the Harley Gospel Book can we guess that models similar to those that formulated the style of our ivories were available in the scriptorium.

Not many of the ivories in the so-called Ada Group are close enough in style to these two certain works of the Court School to be attributed to the same workshop, although the clear differences between the two book-covers seen so far must act as a warning not to assume that the style of the school was at all uniform and well defined. Clearly, the influence of the variety of models upon which the school was able to draw, and the fact that Charlemagne could assemble talents from many parts of his Empire, did not make for uniformity at Aachen. Nor was the school long-lived enough to resolve its rich repertoire into a synthesis acceptable to all who worked in it. Not even a second generation was to have time to gain a foothold in the mere twenty years or so that imperial patronage was centred in the area.

Very close to the Lorsch cover is the fragment of a leaf of a diptych with St Michael killing the dragon, now in Leipzig.[75] The rich draperies, the scalloped halo, the large, prehensile hand, and the sheer magnificence of the whole conception resemble the front cover of the Lorsch Gospels. One might even notice a slight Insular feeling in the fine little dragon at the saint's feet, in the head of the beast, and in the spiral at the join of the tail and body, perhaps a significant point in view of the eclectic character of the Court School. Unfortunately nothing is known of the earlier history of the St Michael diptych beyond the fact that it was published as being at Leipzig as early as 1759. On the back of the panel, however, there is an engraved inscription which shows that the ivory panel was re-used after having served as a consular diptych of Messius Phoebus Severus, the West Roman consul of the year 470. No carving but the inscription survives, and it seems that if the ivory was at all decorated in its first use, it must have been painted and not carved. This kind of re-use of the material of Antiquity, of which there is evidence in a number of other pieces, does not appear to have been at all rare. It is a curious sidelight on the Carolingian Renaissance that craftsmen and their patrons were prepared to destroy works of Antiquity to give them the material to create work of their own time, in which one of their primary aims was to restore the grandeur of the past. Clearly it was no antiquarian attitude that was uppermost in their minds, but a re-interpretation, a re-creation of Antiquity, in which their own contemporary values were intended to be expressed, even if the mould into which they were cast was modelled on the great imperial past.

Few of the other ivories that may be linked stylistically with the Lorsch covers are either close enough, or of high enough quality, to be attributed to the Court School.[76] Nor can we attribute much more to the slightly earlier phase of the school on the strength of the Dagulf cover. Again, only one other panel is really closely associated with it: the tall, upright leaf in the Museo Nazionale at Florence (Plate 27), which is divided into two fields by a broad, rather heavy border, interrupted by small squares in which small female heads are represented.[77] These are exactly similar to the small squares in the frames of the Dagulf covers, in which the hand of God is shown in one and the Agnus Dei in the other, and which as we have seen are also found in the manuscripts of the Court School. The style is difficult to compare, because the single figures in

the Florence leaf cannot give the same crowded effect, and the armour worn by the two major figures cannot be easily compared to the draperies of the Dagulf figures. And yet the fall of cloth in the chlamys, especially behind the back of the warriors, has much of the character of the Psalter panels, and the rather stiff, plump figures in both works are not at all dissimilar. But there is another reason for associating the Florence panel with the Court School. The subject depicted has always been thought to represent two Virtues at the moment of victory over Vices, but it has now been demonstrated most convincingly that the panel is in fact a kind of double portrait of the Emperor Charlemagne himself, victorious over the barbarians, probably in imitation of a similar lost Late Antique prototype, perhaps of the Emperor Anastasius.[78] Such a subject must surely have been carved in the imperial workshop in the early years of the ninth century, when Charlemagne was at the height of his power.

An ivory book-cover (Plate 28) now in the Bodleian Library at Oxford (MS. Douce 176) is let into a modern binding, but the manuscript itself is of early-ninth-century date, and has been attributed to Chelles, near Paris.[79] Its style is somewhat nearer to the Dagulf covers than to the Lorsch ivories, although the rich draperies of the central figure of Christ treading on the beasts come close to the Court School manuscripts. It fills admirably a position between the two styles we have been able to establish at the court. The small, stumpy figures and the curious square opening carried on columns behind the main figure and in the small scene on the right, the Adoration of the Kings, are exactly similar to the architectural backgrounds of the scenes on the Dagulf covers. In the Oxford book-cover we are able to bring into discussion once again the dependence of the Court School on Late Antique models. Not only is the form of the whole panel an imitation of the Late Antique five-part diptych, but six of the scenes from the life of Christ surrounding the centre are clearly copies of two surviving fragments of five-part diptychs of the early fifth century, one now in Berlin and the other in the Louvre.[80] It is also interesting to note that three more of the scenes on the Oxford panel, not found on the two Early Christian fragments – the Annunciation in the top centre, the Nativity at the top right, and the Adoration of the Magi below that – are probably also derived from a similar Late Antique source, because another small Carolingian fragment of three scenes from a five-part diptych, now in the British Museum, must have used this same Late Antique source.[81]

The relationship between the British Museum fragment and the Oxford book-cover is especially close in the figure of the angel in the Annunciation, and for example in the use of part of the walls of the city of Bethlehem in the composition of the Nativity scene. The figure of St John in the Nativity and the whole of the Adoration of the Magi are reversed. The early model of these three scenes has unfortunately not survived, but was no doubt available in the Court School when the Oxford panel was carved, and was used again for the British Museum fragment. The adaptation of Late Antique models by the Carolingian carvers of these pieces is very immediate. The style of the Oxford panel is admittedly somewhat cruder, more crowded, and less fully rounded than that of the fifth-century panels, but taking into account the smaller scale of the ninth-century work, a remarkably able imitation of the Early Christian style has been

achieved, showing a full appreciation of the lively narrative quality and of the pictorial concept of a free, natural scene in a border that acts like a window frame – all in the Mediterranean humanist tradition. Against this, the British Museum panel, although clearly related to the Court School in its drapery style and in such details as the scalloped haloes, no longer tries to achieve illusionistic effects of this kind, but treats its figures, of ambiguous scale, symbolically and statically, against a neutral background not in the least suggestive of depth. Its contact with the Late Antique is therefore in iconography more than in style, and it may therefore be a little later in date than the Oxford cover.

Only one other pair of ivory panels, still in the treasury at Aachen, where they decorate the covers of a fourteenth-century manuscript and are enclosed in a four-teenth-century silver frame, might be attributed to the Court School.[82] In shape and size, these panels imitate the consular diptychs of the Early Christian period. On each, in three square areas separated by rich acanthus borders, one above the other, scenes of the appearance of Christ after the Resurrection are represented. The small, squat figures, the crowded scenes, the diminutive architectural backgrounds, are in keeping with the style of the Court School, but the drapery, although rich and full of movement like other work of the school, is perhaps somewhat more jagged and angular and not quite as turbulent. Here again, the main motivation is the imitation of the Antique in the sense we have just described; and yet it is not easy to find Early Christian ivories that would make convincing models. It is true that each scene taken by itself has all the hall-marks of Late Antique derivation, but in all the many surviving ivories of the Early Christian period, not one leaf of a diptych survives which is divided into three scenes in this way.[83]

In the absence then of any certain fifth-century models for the whole composition of the Aachen diptych, the most likely explanation is that the panels are enlargements of such pieces as the Berlin fragment of three scenes, which was originally part of a five-part diptych. Another possibility is that the Carolingian carvers added the frames to a model of the late fourth century, such as the diptych in the Museo Nazionale, Florence, with scenes of paradise on one side and three scenes from the life of St Paul on the other.[84] Here the three scenes are placed one above the other, without the tidy decor-ative divisions we find in the Aachen diptych. Again this seems unlikely, especially as another ivory diptych with scenes from the life of Christ, now in the treasury of Milan Cathedral, which follows just this kind of Late Antique tradition without feeling the need to divide the scenes into compartments, is now generally accepted to be a Carol-ingian copy, rather than a Late Antique original.[85] Its style is not far removed from the Aachen covers under discussion, and there may well be a connexion between this work and the Court School. Both models and intentions, and indeed also style, are much the same in the Milan and the Aachen diptychs, and undoubtedly both belong in the early ninth century, especially as the close imitation of the Antique plays such as important part in their creation.[86]

Among the activities of the Court School in Charlemagne's lifetime, one more style of manuscript painting which seems to have been developed in the last years of the emperor's life must be mentioned. It is a style completely different, and not only of

tremendous significance in itself, but of great importance to our understanding of the Carolingian 'Renovatio', and a most important factor in the later development of ninth- and even tenth-century art. The group consists of only four manuscripts. They are related textually to the Court School manuscripts of about A.D. 800, but not artistically, except for some similarities in the simpler decorative initials.[87] Instead of the rich imperial style of the Court School, heavy with ornament and painted decoration derived from a combination of Insular and North Italian sources, the masters of this group worked in a style, and what is of even greater significance, a technique, directly in descent from Late Antique art. The clue to the introduction of this style at Charlemagne's court may be given by the name 'Demetrius' written in gold rustic capitals at the beginning of the Gospel of St Luke in the Coronation Gospels,[88] preserved in the Imperial Treasury at Vienna ever since its alleged discovery on Charlemagne's knees when his tomb was opened at Aachen by Otto III. The name Demetrius certainly suggests that a Greek artist or scribe was engaged on its production, in spite of the fact that it is written in Latin. It may well be that Greek artists were encouraged to come to Charlemagne's court when Iconoclasm was enforced again at Constantinople in 802, after the short respite which began with the Council of Nicaea in 787 and ceased with the fall of the Empress Irene.[89]

The inspiration of Late Antique art was always strong at Aachen, but it had so far been provided by models carefully, often painstakingly, imitated by court artists and drawn exclusively from or through Italy. Even the 'eastern' or 'Byzantine' elements were derived from Rome and especially Ravenna. The ivory throne of Maximian may be a work of Byzantine carvers, but its strong influence on the master of the Lorsch book-cover was the effect of Italian, not Byzantine, influence at Aachen. The clear distinction one must make here is that between the influence of models – often models of considerable age when they were imitated – and the influence of the living tradition of Late Antique art. In the paintings of this second Court School, it was the latter that was at work. These painters were not merely copying models, but were trained in the tradition of Late Antique illusionistic or almost 'impressionistic' painting. Not only do their figures follow the outlines of ancient models, as did those of their contemporaries at the Court School, but their technique shows their intimate knowledge of the technical tradition of Antique painting. This kind of influence is only possible when painters are trained generation after generation in workshop practices. It seems probable that this kind of continuity from the fifth to the ninth centuries could only have been available at the imperial court of Constantinople, the eastern Roman capital. These paintings are 'foreigners' at the court of Charlemagne – they are not part of the northern tradition, and their production ceases when the painters who created them died or left the court. Their impact, however, was to be felt in the next generation, when new styles were fostered under the patronage of Charlemagne's son, Louis the Pious.

THE REIGN OF LOUIS THE PIOUS

WITH the death of the Emperor Charlemagne, the simplicity of the centralization of the most creative forces of the whole Empire in one school – the Court School – came to an end. In the lifetime of Charlemagne, the art of the court was inspired by and pushed towards the ideals of a classical revival with such rapidity and single-minded purpose, that the self-conscious art it created set it apart from other work produced in the rest of Europe. Indeed, much of the work which may have been made in the first quarter of the ninth century in centres other than the Court School would quite naturally seem to belong to the eighth century in its continuity of techniques and styles untouched by the activities and the new styles introduced at the court. The back cover of the Lindau Gospels and the Enger burse-reliquary might well have been two such pieces. Carolingian art spread rapidly within a generation of the death of Charlemagne, and we must attempt to trace the creation of the new styles and schools which were the result of this dispersion of patronage during Louis's reign.

The character of Louis the Pious, who succeeded his father in 814, and who ruled the Empire until his death in 840, had a totally different impact on the artistic and intellectual life of the Empire. One of the most obvious differences was that he did not seek to enhance the material splendour of the imperial court by commissioning extravagant and luxurious works of art as his father had done. This may to some degree have been caused by considerable economic changes during his reign. The wealth of Charlemagne's court had in no small measure been due to the booty captured by his armies during the rapid expansion of his Empire, especially in the last quarter of the eighth century, culminating in the enormous treasure captured from the Avars in 795. Fifteen wagons drawn by four oxen each were needed to carry the loot of gold, silver, and precious garments to Aachen.[1] But Louis's contribution to learning was formidable and, indeed, probably far more profound than that of Charlemagne. His love of books was more for the learning they contained than for the external splendour they displayed. He knew both Latin and Greek, but understood Greek better than he could speak it.[2] Latin he spoke as well as his native tongue. His biographer also makes quite clear that he was not particularly impressed by worldly splendour. On the death of his father, he arrived at Aachen thirty days after leaving Aquitaine, and with great speed ordered all his father's personal treasures in gold, silver, and precious stones, and all property, to be shown to him. He gave his sisters the part due to them under the law, and what remained he ordered to be given away 'pro anima patris'. The greatest part of the treasure he sent to Rome in the time of Pope Leo III (d. 816); the rest he distributed to 'all priests and poor, strangers, widows, and orphans, keeping nothing for himself except one silver table'.[3] This he kept for himself for love of his father, but he redeemed it in money to be added to that given to the poor. He also gave the Court School

E 33

'Soissons' Gospels to the abbey of Saint-Médard at Soissons[4] on the occasion of the translation of St Sebastian in 827.

The years of comparative peace and prosperity, the early years of Louis's reign, before the troubles of the last ten years of his life, were the most creative. In the late thirties, the three sons of Louis attempted more than once to overthrow their father. These and subsequent quarrels among them and their successors were a constant source of weakness throughout the remainder of the ninth century. Taken together with the constant attacks of the external enemies of the Empire, the Northmen, the Arabs, and the Magyars, this produced a restless and unstable period.

There is no doubt that the Utrecht Psalter style was created during the reign of Louis the Pious. It is often called the 'Reims' style, because of its connexion with Ebbo of Reims, friend and librarian to the emperor, who played much the same role under Louis as Einhard had played under Charlemagne. In 810 Ebbo had been created archbishop of Reims, and one of the major manuscripts in the new style, the Ebbo Gospels, was written and illuminated in the abbey of Hautvilliers, some thirty miles from Reims, under and by Abbot Peter, and dedicated to the Archbishop.[5] The suggestion that this manuscript should be dated before 824, because the dedication poem does not contain any reference to Ebbo's missionary activities in Denmark which he began in that year, cannot be accepted. The dedicatory poem is couched only in the most general terms, and no specific facts in the archbishop's life are mentioned at all. All we can say is that it must have been written before Ebbo's expulsion from the see of Reims in 845.[6] Clearly the technique, the masterly painting seen in the Ebbo Gospels, is based on the classical idiom so fully understood in the Vienna Treasury Gospels and its related manuscripts written in Charlemagne's lifetime. The form of expression, however, is developed away from the calm dignity of the Court School towards an excited, at times almost hysterical intensity. It might be said that the 'impressionism' of the Vienna Gospels is transformed into the 'expressionism' of the so-called Reims style.

Much has been written about the Utrecht Psalter and the sources of its style and iconography,[7] but the more research that has gone into tracing them, the more original has the work seemed to become. The illustrations have proved themselves to be more than purely illustrations of the text they accompany:[8] in fact, they are a scholarly commentary in their own right. The iconography is drawn from a great variety of sources, and also the scenes seem to illustrate not only the Gallican version of the Psalter as given in the text, but also, in some instances, the Hebraic text of the Psalter, far less well known in the West and no doubt available only in a scholarly library. All this must be considered with the question of the place of origin of the school. It seems clear that the artists were trained in the first decade of the century in the scriptorium of the Vienna Treasury Gospels, and that these Gospels continued to be available and to exercise a decisive influence on the iconographic type of the Evangelist portraits used by the school. Clearly the compilers of the Utrecht Psalter were not only scholars of unusual ability and wide learning, but also had a very large variety of models available to them, such as could only be found in a centre of considerable learning. There is relatively little evidence that Reims was such a centre of learning at this period.[9]

On the other hand, something is known of the love for learning and books on the part of the Emperor Louis. We know that not only had Louis encouraged learning, and learning of a much higher quality and wider horizon than that fostered by his father ever since he befriended Benedict of Aniane in his Kingdom of Aquitaine in the early years of the century, but also that he continued to foster the growth of his own library and the Imperial Library after his succession to the title.[10] He made serious attempts to reform the monastic orders, and to insist on entry to the priesthood by the men who were appointed to positions of power in the large monasteries and sees. In one word, the many activities that earned him the appellation 'the Pious' in history are in keeping with a man keen on the pursuit of learning. It is completely in character both with the man and with the period that the books produced by a scriptorium under his patronage should be learned rather than ostentatious – more like the Utrecht Psalter and far less like the magnificent witnesses of imperial splendour that we have in the Court School of Charlemagne. Finally one should remember that the Vienna Treasury Gospels are necessary as a source for the whole school. If that codex, or codices very like it, or the sources that had been available for their production, were available anywhere in the period, they must have been in the hands of the emperor. Where could this scriptorium have been? One cannot do more than guess. Louis's favourite palace at Ingelheim must be a possibility, and the long established centre of Aachen might also be worthy of consideration.

The Utrecht Psalter is drawn in brown bistre throughout. The small figures and closely bunched groups of figures enact the narrative content of the scenes in unframed compositions loosely distributed across the page, resulting in a subtle and varied balance of masses. Flimsy and transparent architectural structures and elements of landscape like rocks and trees are drawn with the same delicate, illusionistic touch as the figures themselves, with their hunched backs, flying draperies, and gesticulating, almost dancing postures. All parts of the decoration are swept along in the same joyous, ecstatic movement. Something of the same nervous intensity and emphasis on linear qualities is also seen in the golden front panel of the Sant'Ambrogio Altar in Milan, only a little later in time (c. 850) (Plate 46), and the pictorial compositions of the Psalter have been compared with Roman stuccoes of the first century[11] – indications that its connexion with the western classical art of Italy is perhaps closer than the emphasis on Byzantine sources so often stressed in the past has encouraged us to assume. Whatever its stylistic antecedents may have been, its importance to the subsequent development of early medieval art can hardly be overestimated. In this style, North Western Europe seems to have found the really satisfactory synthesis of classical art and northern expressive intention, sought ever since the first works of art in the Mediterranean classical tradition reached the north during the seventh century.

The Utrecht Psalter served as a source, both of style and iconography, for a group of ivory carvings of the finest quality, used as decoration on the covers of a number of manuscripts, all of them said to have been made for Louis's youngest son, Charles the Bald, in the decade following 860 (Plates 29, 30, and 32).[12] There is no doubt that these books were produced in a court school directly under the patronage of Charles.[13] Five

make up the group. Three of them are known to be by the scribe Liuthard, and the covers of all but one are either still decorated by 'Utrecht' style ivories or may have been so originally. It is for this reason that the group of ivories has been named the Liuthard group. And yet one must raise the question whether these ivories could not have been carved earlier than the books were written which they were finally used to decorate. Much may be argued in favour of such a view – first of all the close relationship with the Utrecht Psalter, a manuscript of c. 820–30. In addition, the ivories form an astonishingly homogeneous group. Of the six panels, five are very similar in size[14] and four illustrate psalms. The psalms illustrated on the two panels on the Psalter of Charles the Bald in Paris (Bib. Nat. lat. 1152) – the only manuscript which still has the ivories in their original setting on the covers – are Psalm 56 on the front (Plate 30) and Psalm 50 on the back. The covers of the Prayer Book of Charles the Bald, now in Munich, are claimed to have been once decorated by two panels (now in the Zürich Landesmuseum) illustrating Psalm 26 (Plate 32) and Psalm 24. It is difficult to see why these particular psalms should have been chosen to be illustrated on these particular books – they are not at all obvious choices. The fifth panel, now in the British Museum, most probably decorated the front cover of a Gospel Book now in Darmstadt (MS. 746) and illustrates the Marriage at Cana – again a far from obvious choice[15] for a Gospel Book (Plate 116). It should also be remembered that all four psalm illustrations are taken directly from the Utrecht Psalter versions, and that the style of the ivories is as direct a translation into three dimensions of the Utrecht style as seems possible, but that the illuminations of the Liuthard books, executed c. 860–70, do not at all resemble the style. This last fact is very unusual – it is far more common that at least a measure of similarity exists between the cover and the illuminations, when the covers are made for the book in question at the time of its production. All this might suggest that this group of ivories was carved for some other purpose, perhaps as part of a large cycle of psalm and New Testament illustrations, and that the pieces were later re-used in Charles the Bald's School to decorate the covers of the manuscripts produced in the second half of the ninth century.

Further evidence is provided by the sixth, much larger carving, belonging to the same group (Plate 29 and frontispiece). With its separate but contemporary acanthus frame, it measures 31 cm. in height and 21 cm. in width (about $12\frac{1}{4}$ by $8\frac{1}{4}$ in.).[16] Its subject is a rich and very elaborate form of the Crucifixion, combined with the Three Maries at the Tomb and the resurrection of the saints after the resurrection of Christ (Matthew 28, 52–3) as well as other details. This great panel was re-used in the early eleventh century as the front cover of a Gospel Book given before 1014 by the Emperor Henry II to Bamberg (Munich, Bayerische Staatsbibliothek Clm. 4452). It has been claimed that this major piece of our group was also originally connected with the Court School of Charles the Bald, and that it decorated the back cover of Charles's Gospel Book, the famous Codex Aureus from Regensburg, now in Munich (Bayerische Staatsbibliothek Clm. 14000).[17]

Stylistically this great ivory Crucifixion panel is as close to the Utrecht Psalter as the other, smaller ivories of the group, and indeed there can be little doubt that it is by the

same hand as the two panels on the Psalter of Charles the Bald. Iconographically, how-
ever, its sources can be only partially defined with any certainty, although its relationship
to other ninth-century ivories is of considerable importance, especially for their relative
dating. The most important connexion is with a small group of ivory carvings, which
have survived separated from manuscripts and with no external evidence either for date
or provenance – their style cannot even be found in any of the hitherto defined manu-
script styles of the ninth century. And yet the relationship of their iconography with the
Liuthard Crucifixion panel on the one hand and the Early Christian ivory of about A.D.
400 now at Munich, usually known as the 'Munich Ascension', on the other,[18] leaves
little room for doubt that this small group must be earlier than the so-called Liuthard
group.[19]

The most important panel in the group is in the Liverpool Public Museums (Plate 31).[20]
It shows a Crucifixion with the Virgin, St John, and Stephaton and Longinus, with the
Three Maries at the Tomb below. This latter scene is an almost line-for-line imitation of
the Early Christian ivory at Munich, and indeed one can hardly doubt that it was this
particular fifth-century ivory that was known to the Carolingian carver.[21] Moreover
the link is even stronger, for the Carolingian companion piece to the Liverpool ivory,
carved with the Ascension, and now in the Staatliche Museen, Berlin,[22] seems to show
at least some reflection of the iconographic type of the Ascension represented on the
early Munich panel. Also the treatment of relief and the division of the separate scenes
by a line of soft mounds are common to the Early Christian model and to the ninth-
century carvings. The type of Crucifixion figures on the Liverpool panel, showing the
suffering figure of Christ with flowing hair on his shoulders and the head falling on to his
right shoulder, is an innovation, taking its place for the first time alongside the trium-
phant, upright, Christ, so far the only iconographic type used in the Carolingian
Renaissance.[23] The origin of this new type is not traceable among the Early Christian
pictorial representations that have survived, but the fact that so much else in these
ivories seems to be derived from a western Early Christian prototype might lead one to
speculate that this type of the human, suffering Christ may also have been known in the
West in Early Christian times.[24]

Clearly related to the Liverpool/Berlin pair, and in the same 'Early Christian' style,
are the Crucifixion panel in the British Museum (Plate 33) and the Ascension panel in
the Kunsthistorisches Museum, Vienna (Plate 34).[25] The British Museum panel has a
crucified Christ of a very similar type, although his loincloth is treated differently, very
similar personifications of the sun and moon above the cross, the same 'Antique' label
for the titulus at the head of the cross, and an almost precisely similar treatment of the
ground. The figures of Mary and John, and the two Roman soldiers Stephaton and
Longinus, although treated in the same soft, fully modelled 'Early Christian' style, are
derived from a different model. The two soldiers seem to be in much the same poses as
on the Liverpool panel, but seen from the front instead of from the back. Somewhat
further removed, but still in the same group, is the Vienna panel of the Ascension
(Plate 34). The iconographic type, especially the main figure of the ascending Christ and
the whole concept of the modelling, must still be related to our group, although some

aspects of it, like the wavy parallel cloud lines at the top, the heavy jowl of the head of the Virgin in the centre below, and the bulbous, balloon-like clouds in the centre, lead us on to two different groups of ivory carvings, which have been connected with Metz and which have been called the earlier and the later Metz schools.[26]

It is in this connexion with the Metz School, which owed its origin to Drogo, bishop from 823 to 844, and archbishop from 844 to 855, that we may find some clue to the provenance of our group and its possible patron. Undoubtedly Drogo was closely connected with the court and the Emperor Louis the Pious, whose half-brother he was and who had appointed him to the bishopric. There is, unfortunately, no direct proof that this vital little group was connected with the court of Louis – and yet circumstantial evidence must surely lead us to such a conclusion. The Utrecht Psalter and the manuscripts which continued the style of the Vienna Treasury Gospels – an imperial possession – in the second quarter of the century[27] prove that the spirit of classical revival and the use of western Antique prototypes was encouraged by the emperor.

There remains the problem of the relative chronology of this 'Court' group with the group related to the Utrecht Psalter, known as the 'Liuthard' group. Clearly, the large Crucifixion ivory now on Henry II's Pericopes (Plate 29) reflects a number of iconographic features of both the Utrecht Psalter and this 'Court' group of ivories, and they may therefore be a parallel development using similar sources. It should be remembered, however, that in the British Museum Crucifixion (Plate 33), the figures of Stephaton and Longinus are seen facing forward and resemble the large ivory very closely, and may well have provided the model. Finally, the fact that the Early Christian models are followed so much more faithfully in this group of ivories must encourage one to believe that it is earlier in date than the 'Liuthard' group, where such models are far more fully adapted to the Carolingian idiom.

The very precise imitation of the Late Antique found in these 'Court' ivories was to be, in the last years of Louis's reign and in the years immediately following, under Lothar I, a very strong element in the beginnings of the school of Metz. It is important to make clear here that very strong classical elements to be found in the art of Metz in the late thirties and early forties of the ninth century find their true root in the fostering of such styles during Louis the Pious's reign, and may well have been initiated soon after the installation of the emperor's half-brother, Drogo, as bishop of Metz in 823.

Our knowledge of the art of metalwork in this vital period is even more scanty. It is perhaps not altogether out of keeping with what we know of the character of Louis the Pious that his patronage in this field was less lavish than that of his father. Only two important pieces, the Ardenne Cross (Plate 36) now in the Nuremberg Museum and the burse-reliquary of St Stephen in the Imperial Treasury in Vienna (Plate 35), may be attributed to his reign. It is unfortunate that neither can with certainty be connected with imperial patronage.

The processional or altar cross, said to have come from a monastery in the Ardennes, is decorated on its front in the centre with a large cabochon crystal, surrounded by gems.[28] On its elegant, elongated arms there is a central row of major gems accompanied by two rows of smaller settings, interrupted by small hemispherical metal forms supporting

raised crossed wires. Both the gem settings, with their broad, simple frames surrounded by a fairly heavily pearled wire, and these small raised cross motifs can best be dated into the second quarter of the century. The settings are clearly still related to the even simpler indented frames we saw used in the Court School of Charlemagne,[29] but also foreshadow the much heavier settings we shall see in the time of Charles the Bald, for example on the cover of Charles's Psalter, in the Bibliothèque Nationale. The 'raised cross' motif is also found on the same book-cover, but is here again much heavier, cruder, and less sensitively applied. Used in a lighter and more delicate fashion, the same motif in a more elaborate form is found in the golden altar in Sant'Ambrogio in Milan, a work completed before the middle of the century.[30] Further support for a date in the forties of the ninth century comes from the acanthus scroll on the reverse of the cross, which has been compared to manuscript illuminations of the school of Tours, under Abbot Adalhard (834–43) and even Abbot Fridugisus (807–34) (Figure 1).[31] The Ardenne Cross is the earliest example of a jewelled cross to survive, with the exception of the eighth-century Rupertus Cross at Salzburg.[32]

Three other early altar crosses, including the famous Cross of St Eligius (d. 660) already mentioned in the literature of the ninth century, survived in the treasury of Saint-Denis until the French Revolution. Although all are known (though from very inadequate illustrations), they do not help us much in dating the Ardenne Cross; it might just be claimed that the general proportions of the so-called Cross of Charlemagne at Saint-Denis were not unlike those of the Ardenne Cross.[33] Nor can one see any real or immediate connexion with another tradition of altar crosses, probably of Byzantine origin, of which an early example is the Cross of Desiderio in the Museo Cristiano at Brescia, which was to have influence on the early crosses of Spain.[34] In the Ardenne Cross, we therefore have the earliest surviving example of a tradition of jewelled crosses that were to form such an important part of any enrichment of the high altars of the early medieval Church.

The second piece of the period is the magnificent gold burse-reliquary of St Stephen, now a part of the Imperial Treasury at Vienna (Plate 35).[35] In type it is clearly related to the Enger reliquary already discussed (Plates 7 and 8).[36] The front is enriched with jewels set in broad, plain indented settings, while the sides are more simply decorated with round medallions in gold foil, decorated with four figural scenes, regularly repeated, and struck from dies: a goddess of revenge (MALIS VINDICTA), a fisherman, an equestrian figure with a falcon, and an archer aiming at a bird in a tree. Similar roundels once partly decorated the back of the reliquary, as well as two roundels with eagles, as can still be seen on the wooden core, now covered by a stamped metal sheet, restored in the early nineteenth century.[37] Unfortunately, little is known of the earlier history of this reliquary. Until 1794 it was part of the Imperial Treasury at Aachen, together with the so-called sword of Charlemagne and the Coronation Gospels. Were it not for a relic discovered during an examination in 1924, sealed with an early-twelfth-century seal of the cathedral chapter of Worms, one would not have doubted the traditional direct connexion of this reliquary with Charlemagne or Louis the Pious. It is, of course, not impossible that a relic acquired in the twelfth century was added to

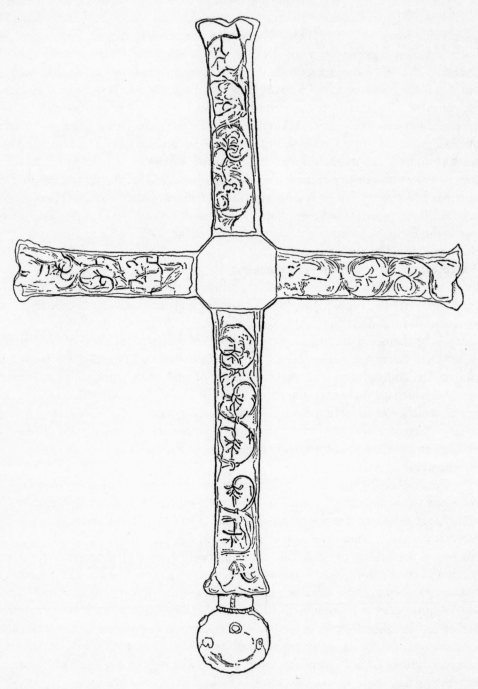

Figure 1. 'Ardenne' processional cross (back), *c.* 830. *Nuremberg, Germanisches National-Museum*

the stock already held within the reliquary – such later additions are not at all unusual in the medieval period. One obvious occasion when such a relic might have been acquired by a German emperor was the Concordat of Worms, held in 1122, when Pope Calixtus II and Henry V settled the long-drawn-out Investiture conflict between State and Church. Whether the relic only or the whole reliquary was given to the emperor on that occasion – or, indeed, either – must remain in doubt. Certainly a doubt must also remain whether the St Stephen reliquary was the result of imperial patronage, or even whether it was in imperial possession before the twelfth century. Its style of decoration enables us to date it without question into the first half of the ninth century, and almost certainly into the reign of Louis the Pious. It is in this connexion that one might remember the interest of Louis and his half-brother, Drogo, in the see of Metz. By tradition the reliquary contained earth soaked in the blood of the first Christian martyr, St Stephen, and the real home of the cult of this martyr north of the Alps, ever since its foundation in the fourth century, had been the cathedral church of Saint-Étienne at Metz.[38] One can see in the figures of the small roundels on the side of the reliquary a style that shows the same deep understanding of classical sources that we have seen in the art of the time of Louis the Pious in ivory carving.[39] The comparisons that have been made, for example, between the fisherman roundel and imitation gems painted in the pages of the Soissons and Lorsch Gospels of the Court School of Charlemagne are utterly convincing.[40] But the 'goddess of revenge' roundel does display a subtlety which goes beyond that of the Court School. It is not at all like the hunchbacked expressiveness of the Utrecht Style, but it does approach, very closely, the early impressionist style of Metz and, more particularly, the style of the Lothar Crystal in the British Museum, of only slightly later date (Plate 45).[41]

In the present state of our knowledge, we cannot fully understand the vital period of the reign of Louis the Pious. What we do know of it, and of the character of the emperor, would make us believe that his tastes would tend towards supporting the imitation of classical forms and an attempt at a thorough and scholarly understanding of such forms. He was even buried in a Late Antique Gallo-Roman sarcophagus.[42] Beyond this perhaps somewhat academic love of the past, the creation of the Utrecht Psalter style, which was to exert such a long-lasting and compelling influence on the art of North Western Europe, is one of the great and undeniable achievements of his reign.

THE REIGN OF LOTHAR I

The Schools of Metz and Tours

By the Treaty of Verdun in 843, the Empire was divided into three parts among the surviving sons of Louis the Pious. The eldest, Lothar I, received, along with the title of emperor, in which he had been associated with his father since 817 and which gave him only an ill-defined authority over his brothers, the centre-lands of the Empire. These consisted of a comparatively narrow strip of land from the Low Countries in the north to Central Italy in the south, without any regard for natural boundaries of any kind. His brother, Louis 'the German', received the eastern part of the Empire, made up almost entirely of Germanic peoples, while their younger half-brother, Charles the Bald, the only son of Louis's second marriage to Judith, was given the kingdom of the West Franks, almost entirely inhabited by people of Romance stock. For better or worse, the first step had been taken towards defining the future areas of France and Germany. How little the signatories of the Treaty of Verdun were aware of nations as such, however, can be seen by the lands given to the Emperor Lothar I, whose kingdom contained Frisians, Flemings, Walloons, Germans, Provençaux, and Italians. When Lothar died in 855, his kingdom was again divided among his three sons. Louis II received Italy – along with the imperial dignity, which was now of even less practical or political value – while Charles took the territory from the Jura to the Mediterranean and Lothar II the area from the Jura to the North Sea – to be known as Lotharingia. When Charles died in 863, his two brothers divided his kingdom between themselves, and when Lothar II died only six years later, it should have been reunited under Lothar I's only remaining son, Louis II of Italy. But his stronger uncles, Louis the German and Charles the Bald, did not wish to see the revival of a powerful central kingdom north of the Alps, and at the Treaty of Meerssen in 870 they divided Lotharingia between themselves: thus another and perhaps even more decisive step had been taken towards the division of Europe into the national states of France, Germany, and Italy. The attempts in the last quarter of the ninth century to re-unite the Empire of Charlemagne and Louis the Pious under Charles the Fat (884–7) and Charles the Simple (898–922) did not meet with any but the most fleeting success, and with the election of Duke Conrad the eastern kingdom broke finally with the Carolingian dynasty, and thereafter one could indeed speak of Germany and France.

It was at about the time of Louis the Pious's death that these territorial divisions of the Empire first began to have any significance in the history of Carolingian art. Louis was the second and, as it happens, the last emperor of the dynasty to have any real power of control over the whole of the Empire, and with it, control over the whole of its as yet limited creative output. It was not until after Louis's death that Lothar I in the central,

Louis the German in the eastern, and Charles the Bald in the western kingdom began to exercise their patronage and to encourage that of the great churchmen in the important monastic centres, among the chief of which were Tours, Corbie, Saint-Amand, and Saint-Denis in the west, Corvey, St Gall, and Fulda in the east, Metz in the north, and Milan in the south of the central kingdom. Their development begins in the second quarter of the century and can be traced even more fully in the second half of the ninth century.

Among all these, the earliest to rise to importance was undoubtedly Metz. It has already been said that its connexions with the imperial court must have been close in the time of Louis's reign, and there is no reason to suppose that it did not continue to enjoy the patronage of the Emperor Lothar I until his death in 855. Drogo, its great archbishop, who had been appointed to the bishopric in 823, was not only the half-brother of the Emperor Louis, but also chaplain to Lothar I. It was no doubt at Lothar's request that Pope Sergius II granted Drogo the pallium in 844.

Fortunately a number of ivory carvings have survived as book-covers on manuscripts written for Metz. Few of them can be dated precisely, but about their provenance, at least, there can be little doubt. The most important of them is the great Sacramentary written for Archbishop Drogo himself, and now in the Bibliothèque Nationale in Paris (lat. 9428). The original ivory covers, both back and front, have survived, although unfortunately they were reset on a new binding in the eighteenth century. Each cover is decorated by nine self-contained scenes set in three rows of three, originally mounted in frames set with precious stones, still seen by Meurisse in the seventeenth century.[1] The front cover (Plate 37) includes scenes of the Baptism of Christ and Christ's appearance to the Disciples, along with the consecration of the holy water, the oil, a church, and a deacon, while the back cover represents different moments of the Mass. It is clear that the subjects on both front and back are no longer in their original order, mistakes no doubt having been made when they were remounted in their present frames.

Iconographically, this series of reliefs is the oldest and most complete representation of the order of the Mass that has come down to us, together with the painted initials inside this Sacramentary with which it is closely related.[2] The treatment of these scenes is different from anything discussed so far. The relief is flat and broad and the figures are thickset, yet freely and rapidly put together, in an impressionistic manner. Perhaps the best comparison to the style is provided by the illuminations in the codex itself – certainly a stylistic relationship exists, as well as the iconographic one, between the ivories and the richly decorated initials of the Sacramentary. The painter's style in the Sacramentary is not untouched by the free, painterly style of the court art of Louis the Pious, although the figures are not identical to the spiky creations of the Utrecht Psalter. They are not drawn calligraphically with a pen but brushed in in broad masses, with impressionistic accents. The translation of this painterly style into the reliefs of the cover cannot claim the high quality or astounding ability we saw in the Liuthard group's creation of a three-dimensional equivalent of the Utrecht Psalter style, and yet something of the broad, shimmering quality of the Sacramentary miniatures is certainly reflected in these reliefs. The fact that the background of the reliefs is pierced may also have

originally added something to this effect. The background was originally almost certainly gold foil, or perhaps gilt-bronze, and the introduction of such an insubstantial, glittering effect is completely in keeping with the impressionism of its painterly style. The fact that the archbishop is seen wearing the pallium granted him in 844 on both the covers and in the illuminations makes it probable that the codex can be dated between 844 and the death of Drogo in 855. A date early in this bracket would seem to fit all the facts admirably.[3]

Another manuscript in the Bibliothèque Nationale (lat. 9388), a Gospel Book, has on its front cover another set of ivory panels with a pierced background and in a style close to the covers of the Sacramentary and even closer to the illuminations inside it.[4] The ivory carving is here livelier, less thickset and less stiff, giving an even more successful translation of the Metz illuminations into sculptural form. The panels – three scenes from the Gospels: the Betrayal, the Denial of St Peter, and the Crucifixion – are surrounded by a magnificently carved broad border of acanthus scroll. This rich vine scroll is as characteristic of Metz illumination as the figure style already mentioned. Another cover, clearly the second of the pair and also surrounded by a rich border, with a vine scroll twisting around a single stem, survives on a tenth-century book (Paris, Bibliothèque Nationale lat. 9393) on which, judging by the metal surround now found on it, it was mounted in the eighteenth century (Plate 38).[5] In spite of this later remounting, the original gilt-bronze background for the pierced ivory carving still survives. Three more scenes from the Gospels are represented on it – the Annunciation, the Adoration of the Magi, and the Massacre of the Innocents. There seems little doubt that both covers originally belonged to the Gospel Book on which one of the covers is still to be found (lat. 9388), although the metal framework of the latter must have been added early in the eleventh century. This manuscript may be a little earlier than the Drogo Sacramentary – it is now dated to the early forties of the century.[6]

It has already been said that this style, with its impressionistic flavour, had much in common with the Late Antique taste of the Emperor Louis's period and that it is likely that Late Antique sources at the court, or through the court, played their part at Metz in its creation.[7] Another ivory book-cover, now in the City and University Library at Frankfurt am Main, should be mentioned to lend further support to this view (Plate 39). The design of the whole cover is based on the Late Antique five-part diptych, which had already influenced the Court School of Charlemagne earlier in the century.[8] It is surrounded by a series of small scenes from the Gospels, which are not far removed in style from the Drogo Sacramentary reliefs: the rudimentary form of the architectural details, the thickset figures, and the characteristic rather ugly heads are all closely related. Had the background of these small scenes also been pierced, as it is on the Sacramentary, the common origin of these ivories in one workshop would never have been doubted. By a different hand, and of much finer quality, is the large central scene. Here the Late Antique inspiration is far clearer. The contrapposto of the figure of Christ, the free flow of naturalistic drapery, the characterization of the heads all speak of a close following of a Late Antique model. Even if the stylistic relationship between this Frankfurt ivory and the Drogo Sacramentary cover is not close enough to be quite certain

that they come from one school, the evidence is surely sufficient to see in them contemporary works of closely related schools. If any other link between them exists, it must be explained in terms of a relationship between the Metz School and the Court School of Louis the Pious.

Another pair of ivory carvings that provides even more vital evidence of such a link is that which decorates a so-called 'Late Ada School' Gospel Book now in Munich (Clm. 4451). On the back cover is shown the Annunciation with the Nativity below, and on the front the entire panel is taken up with the Baptism of Christ (Plate 40).[9] The relationship with the Frankfurt cover is surely clear. The free-moving, statuesque figures of the Annunciation, with their rich multiplicity of drapery folds, show precisely the same intimate contact with the Late Antique. The panel of the Baptism, on the other hand, brings us close to the Munich Ascension group of the period of Louis the Pious. The curious wavy parallel lines in the cloud formation and the bulbous divisions they form between figures, as well as the heavier relief of the figures themselves, remind us most strikingly of the Ascension relief in the panel in the Kunsthistorisches Museum (Plate 34). The heavy jowls of the Virgin on the Vienna relief are only one step nearer the typical head of the slightly later Metz ivories than the Virgin of the Annunciation on the Munich panel. In these panels, the interchange of stylistic details between the school of the Emperor Louis and the early, formative years of the Metz Style is most clearly shown.[10] The relative dating of these panels is by no means easy, when only the Drogo Sacramentary is firmly dated. The stylistic contact with the earlier Munich Ascension group produced under the Emperor Louis's patronage seems to support a sequence in which the Frankfurt cover is perhaps the earliest of the Metz group, with the Munich (Clm. 4451) panels next, leading up to the Drogo Sacramentary and the Paris Gospel Book (lat. 9388) on the one hand and the so-called later Metz ivories on the other. In view of this later development, it would seem that none of the group we have so far discussed is likely to be much later than the Drogo Sacramentary; in other words, none is later than the middle of the ninth century.

The so-called Later Metz School of ivory carving[11] is usually dated to the later ninth century, when Metz had become part of the eastern Empire after the Treaty of Meerssen in 870, and continuing well on into the tenth century. The most homogeneous part of this group is a number of upright Crucifixion plaques employed as front covers to manuscripts, usually with another panel with scenes from the New Testament making the back cover. It has not been thought possible to date any of them at all precisely; and yet in the case of at least one of them,[12] and, indeed, one of the finest quality, the manuscript within the cover and the metalwork frame around it allow us to be much more precise. This panel, of outstanding importance for the entire group, is the front cover (one of the few that has survived virtually unchanged) of a manuscript in the Bibliothèque Nationale (lat. 9383) (Plate 41). The ivory is mounted in a gold frame, set with cloisonné enamels of foliate design. The manuscript itself, a purple Gospel Book, is of the Metz School and has been dated to about 840, if anything somewhat earlier than the Drogo Sacramentary.[13] The gold frame and its enamels seem to be entirely consistent with the date of the purple manuscript. The pale colour of the enamels

and their soft, flaccid flower designs, especially the scrolling of the ends of some of the gold cloisons to make discs of gold, are very similar indeed to the enamels on the contemporary golden altar of Sant'Ambrogio in Milan (Plate 46). The heavy embossed acanthus leaf-forms found between the enamels are also typical of the ninth rather than the tenth century and are very like the decoration between the gems on the Amulet of Charlemagne, now at Reims (Plate 21).[14] This evidence of influence from North Italy in the metalwork is most consistent with the strong Late Antique strain in the ivories we have been discussing. The prototypes of these ivories are very likely to have come to the north through contacts with Italy, and perhaps particularly Milan. If one takes this together with the fact that the manuscript still associated with this cover dates from c. 840, one cannot escape the conclusion that the Crucifixion panel and its pair, taken from the back of this manuscript and used as the front cover of a tenth-century book at Metz (Paris, Bibliothèque Nationale lat. 9390), must date from about the middle of the ninth century.[15] This is of importance not only for the beginning of this phase of the Metz School, but also as additional support for the comparatively early date for the Liuthard group discussed earlier.[16]

There can hardly be any doubt that the large Liuthard Crucifixion panel in Munich (Bayerische Staatsbibliothek Clm. 4452) (Plate 29 and frontispiece) was responsible for the introduction of the rich iconographic themes no later than c. 850, most parts of which are used again in this Metz Crucifixion.[17] Many ivories of this Metz group have survived, and most of the closely related examples may well date from the decades following the middle of the century. Before Metz fell to the eastern Empire and the rule of Louis the German, it was still to enjoy the short-lived patronage of Lothar II. After the Treaty of Meerssen in 870, a new impetus may well have given the style a fresh sense of direction. In this late phase of the Metz Style, an enrichment of technique took place: inlay with gold foil already found on some of the earlier Crucifixion panels was further developed, and beads and glass were added, especially to the borders. Together with this kind of surface enrichment a growing tendency to isolate figures, to increase their solidity and volume, is found, preparing the way for the changes that were to come in the tenth century.

Important though the developments at Metz were, it was not the only school active in the period of the reign of Lothar I. One manuscript of outstanding importance clearly demonstrates the spread of patronage to a greater number of centres. A Gospel Book dedicated to the emperor, with a full page miniature showing him enthroned, was written and illustrated at Tours, a centre of learning and book production.[18] Its scriptorium was first founded by Charlemagne under Alcuin, but did not begin to produce important illuminated books until the 840s, under Abbot Adelhard, during the reign of Charles the Bald, in whose kingdom it remained an important centre till its destruction by the Danes in 853. Little else besides manuscripts can be attributed to this great centre, but of its other products the most important piece that may have been made there is the ivory flabellum handle in the Museo Nazionale in Florence (Plate 42).[19] It is a unique survival of a Carolingian liturgical fan, circular and folding, of illuminated vellum, in an ivory case with a long bone handle; it was used during the Mass to keep flies and insects

off the altar, the chalice, and the host. The case is decorated on two sides by rich in-
inhabited vine and acanthus scrolls, on the other two with six scenes from the Eclogues
(or Pastoral Poems) of Virgil. On one of the knops of the handle, a dedicatory inscription
reads: IOHEL ME SCAE FECIT IN HONORE MARIAE. In the eighteenth century the
flabellum was preserved in Saint-Philibert at Tournus, where Martène and Durand saw
it,[20] but because St Valerianus, one of the major saints of Tournus, is not depicted on it,
it is believed that the flabellum was brought there by the monks of the community
of Saint-Philibert who occupied Noirmoutier, Grandlieu, and Cunault in turn, until
they moved to Tournus in 875. The donor, IOHEL of the inscription, is thought to have
been the Abbot Gelo, who ruled the community at Cunault about the middle of the
ninth century; and Cunault was not only dedicated to the Virgin but close to Tours and
intimately linked with it.[21] The subjects represented predispose one to assume that a
Late Antique source was used, and indeed the style can be paralleled among ivories of
the sixth century usually attributed to Egypt.[22] Perhaps even closer is a small ivory box
which contained relics when found in the cathedral of Chur in Switzerland, and which
is likely to be of western origin and of the fifth century.[23] Here again the close connexions
with North Italy, and between Tours and Milan in particular, may be the answer.
This flabellum, therefore, is the only piece for which some external evidence exists that
it may have been carved at (or by a monk from) Tours.

If, indeed, we can accept it, a number of other carvings can be associated with it.
The finest is the Late Antique leaf of a diptych of Areobindus, Consul at Constantinople
in 506, now in the Louvre, Paris, carved on the reverse with a superb representation of
Paradise (Plate 43).[24] The two figures of Adam and Eve at the top of the panel have
much in common with the figures on the flabellum, and the extremely rich and varied
vine and acanthus scrollwork in the broad frame are clearly based on very similar Late
Antique sources in both pieces.[25] The rich, elaborate inhabited scroll found on one side
of the flabellum is also quite close to the inhabited scroll on a panel in the Cluny Museum.
Its companion piece is decorated with four roundels, two decorated with acanthus only
and two with representations of a centaur holding a bow and arrow, and a monster,
a goat with a dragon's tail.[26] The panels were re-carved and are of the usual shape for
a consular diptych – even the remains of the fixtures of hinges testify to this earlier
use. The remains of carving on the reverse, planed down, cannot, however, be of Late
Antique date. It is still possible to recognize in them scenes from the life of Christ, in-
cluding the Annunciation, the Crucifixion, and Noli me tangere on one, and the Bap-
tism and the Ascension on the other. In their present state, in which little is recognizable
beyond the rough outlines of the figures and their rather curious pearled haloes, it would
be difficult to be certain when these panels were re-used for the first time after their
Late Antique consular origin, but almost certainly it would have been in pre-Carolin-
gian times.[27] The second re-carving of the ninth century, in a style very close to the group
of ivories attributed to Tours, has reduced the panels to an unusual thinness, resulting in
the carver actually, here and there, breaking through the material. Not only is the
acanthus of the very rich kind seen on the Tours flabellum, but the figure and animal
style, with its broad, flat masses and elaborate, lively poses, though less ably handled

than in the Louvre panel and less closely based on Late Antique models, is still close enough to them to be attributed to the same school.

During the reign of Lothar I, until his death in 855, we have seen the continuation of the strong interest in classical sources that had also characterized the period immediately preceding it. Neither during the reign of Louis the Pious nor in the greater diversification under Lothar I does any really dominant style emerge. If anything, the greater centralization earlier in the century tended to give a sense of unity to the work, although much of this unity is only deceptive. Not even under Charlemagne did court artists manage to create a style that wholly suited their purpose – even then, the Court School existed alongside the far more classically-minded artists of the Coronation Gospels group. Perhaps a somewhat more creative style was to be developed under Charles the Bald's patronage in the second half of the century, but even that was not to be a really dominant force, and not until the tenth century did Europe create a true synthesis between its own aspirations and the classical past, in which the classical styles really became absorbed and fully utilized rather than copied or even aped. The promise of the Utrecht Style stands alone in this sense. After the destruction by the Norsemen in 853 the abbey of Tours did not recover for a considerable time, and the patronage of Charles the Bald, direct or indirect, through its great abbots Count Vivian (844–51) and Adelhard (834–43) seems to have been transferred to another centre – most probably Saint-Denis.[28] In the second half of the century Tours, therefore, did not play a part, but Metz was to continue for a time as the centre under Lothar II.

The importance of the short period of Lothar II's reign, from the death of his father in 855 to his own death in 869, is not one that we can assess at all clearly. It was overshadowed by the long-drawn-out and bitter quarrels over King Lothar's divorce. It may well be that we can connect one of the outstanding works of art to have survived from his reign with these quarrels. The emperor, it seems, had compelled his son Lothar to marry one Theutberga, sister of one of his vassals, the duke of Jurane Burgundy. Lothar, who appears to have been devoted to his mistress Waldrada, by whom he had a son, attempted immediately after his father's death to rid himself of his unwanted wife. By a series of synods, Lothar tried to nullify his marriage, accusing Theutberga of adultery and even of incest with her brother. In 861 he was successful, and proceeded to marry Waldrada. The tenacious Theutberga appealed to Pope Nicholas I (858–67), and her case was supported by Archbishop Hincmar in a treatise, *De divortio Lotharii*, which he wrote in 863. This treatise no doubt pleased Hincmar's patron, Charles the Bald, quite considerably, as he hoped to succeed to Lotharingia if Lothar died without legal heir – Theutberga having been proved to be barren by then. The pope sent legates to Lotharingia to hold a council, but it seems that they were bribed and Lothar was declared to have married Waldrada before his marriage to Theutberga, and her marriage was therefore not valid. This ruse incensed Pope Nicholas even more: he called an Italian synod to Rome in 863 and there not only quashed the Lotharingian proceedings but deposed the two archbishops responsible, Gunther of Cologne and Theutgand of Mainz, and his own legates. A new legate was sent to Lotharingia and Lothar had to submit to the pope's judgement and take back his wife Theutberga in 865.[29] It was probably on this

occasion that the great circular rock crystal now in the British Museum was carved (Plates 44 and 45).[30]

This magnificent piece, 10·5 cm. (4 in.) in diameter and now mounted in a copper-gilt frame of the fifteenth century, is inscribed around the central medallion with the legend 'LOTHARIUS REX FRANCORUM FIERI IUSSIT'.[31] The subject depicted on the crystal is the story of Susanna, in eight episodes, ending in the centre with the liberated Susanna, cleared of the charges of adultery against her brought by the two false Elders. The relevance to Theutberga's ordeals and her re-instatement and the condemnation of the two archbishops who laid false charges against her is surely too precise for this to be a random choice of subject. The reconciliation of Lothar and Theutberga took place at Metz, and in the Lothar Crystal we have surely a present made at the order of Lothar to prove his willingness at the time to accept the pope's judgement. The style of the engraving is certainly in keeping with products of the Metz School, and the engraver who worked for Lothar II may well have been working at Metz, certainly in Lotharingia. The figure of Susanna in the scene where she is brought before the Elders in the House of Joachim (Plate 44) is very similar to the Virgin of the Crucifixion in the ivory cover of the Paris manuscript of the middle of the century (lat. 9383) (Plate 41). Both figures have a very similar arrangement of drapery with a cloth covering their heads, and the heavy jaw so typical of Metz ivories, and the type of architectural structure shown in the panel that formed the original back cover of the same manuscript (now Paris, lat. 9390) is also similar to the crystal in treatment, form, and scale.

Similarities between the schools of Metz and Tours have been noted more than once, perhaps brought about by their use of similar classical sources and encouraged by the patronage of the Emperor Lothar extended to both centres. In the case of the Lothar Crystal it is again clear that similar work, perhaps also cut in crystal, was known at Tours, where manuscript copies of such crystals survive today.[32] Certainly engraved crystals were extremely popular in the Carolingian period. Another small crystal, with a portrait of King Lothar and a legend surrounding the head,[33] was no doubt engraved in the same workshop for Lothar II. In the late tenth century it was mounted in the gold altar cross, known as the Lothar Cross, in the Treasury of Aachen (Plate 95).[34] It was never intended as a seal, because the legend is not cut in reverse, but, like the inscription on the large crystal, is to be read from the front, with the engraved images facing the onlooker. Two more relatively large pieces of engraved crystal belong to the same group and were no doubt carved in the second half of the ninth century. One showing the Crucifixion with the Virgin and St John and Stephaton and Longinus, now in the Bibliothèque Nationale in Paris,[35] is again typical of the iconography of the Metz School and in style very close to the Lothar Crystal. The other, also undoubtedly from the same school, showing the Baptism of Christ, is in the collection of the Municipal Museum at Rouen.[36] The School of Metz finally lost most of its impetus when the royal and imperial patronage it had enjoyed for more than thirty years ceased after the Treaty of Meerssen in 870, and the kingdom of Lotharingia was divided between Louis the German and Charles the Bald.

The School of Milan

While during the reign of Lothar I, and before that under his father, Louis the Pious, North Western Europe had seen the creation of styles largely dependent on the ideas of classical revival that had also inspired the Court School of Charlemagne, one of the greatest works of art of the period was being made in one of the major cities of North Italy – Milan. The golden altar of Sant'Ambrogio seems to owe little, if anything, to the artistic centres of North West Europe.[37] It is not altogether surprising that the first result of the easing of the centralizing grip on the creative effort of the Empire in the ninth century should have been felt in North Italy. It has been pointed out more than once that it was in North Italy that the north sought most of its Late Antique sources, and, indeed, it was in the great cities of North Italy, like Ravenna, Cividale, and Milan, that the traditions and the models of the classical past were enshrined. As soon as the imperial court ceased to demand the migration of all its talents to the north, the creative potential of these centres was bound to assert itself.

The outstanding witness to this is the golden altar or 'Paliotto' of Sant'Ambrogio (Plate 46), commissioned by Angilbert II, Archbishop of Milan from 824 to 859.[38] An inscription in Latin hexameters surrounding the three major panels of the back says that the archbishop dedicated the altar in honour of St Ambrose while he occupied 'the chief place of the see', and two scenes in circular frames on the back of the altar show Angilbert receiving the altar from the craftsman Wolvinius, and then handing it to St Ambrose (Plate 47). The altar is built over the tomb of St Ambrose and the two early martyrs Gervase and Protase, the original patrons of the church when it was first founded in 386. It is a reliquary altar of the confessio type so popular in Italy,[39] with two doors in the side facing the apse of the church which can be opened, and which give access to the top of the tomb of the patron saints. All four sides of the altar are richly decorated. The front (Plate 46) bears reliefs embossed in sheet gold and is divided into three large panels, the centre one again divided into an equal-armed cross by a border made of gold, cloisonné enamels, and gems set in filigree. In the centre of the cross is an oval frame with the figure of Christ enthroned. In the four arms are the four symbols of the Evangelists, while the four remaining corners are filled by groups of three Apostles, making a full choir of twelve. In the two flanking panels, divided by the same richly en-amelled frames, are twelve scenes from the life of Christ,[40] the fullest assembly of scenes of this subject to have survived from the first half of the ninth century. The sides and back are embossed in silver, partly gilt, with the dividing bands made of enamels and panels of filigree set with gems; the whole effect is somewhat less rich than that of the front. The same richness in colour and detail of the frames of the front is found again in the jewelled crosses in the centre of each of the narrower side panels, which show saints and angels adoring the 'crux gemmata' (Plate 48). On the back, again of three main sections, the two doors of the confessio in the centre have four large round panels, with St Michael and St Gabriel in the top two and the dedicatory panels already mentioned below. Each of the sides has six scenes from the life and miracles of St Ambrose.[41]

The altar has undergone a number of restorations, the most important probably after the collapse of the crossing dome of Sant'Ambrogio in 1196. The broad, plain, simple mouldings, with two hollows separated by a roll moulding and with panels of filigree across them, probably date from this period, when the four panels must have been re-assembled.[42] But apart from this, and apart from the four late-sixteenth-century or early-seventeenth-century scenes, only minor damage to the reliefs, especially to those on the front, has occurred over the centuries.

A most striking characteristic of the altar is the difference in style between the front panels, executed in gold, and the remaining three sides. On the front, we see drawing in a nervous outline and a restless quality of light and movement. The panels are filled with richly narrative subject matter and a minimum of plain background is visible in most of the scenes. The back and sides, however, show scenes with heavier figures, with clearer and more compact outlines and with striking patterns resulting from the sil-houetting of figures and objects against the undisturbed surface of plain background. Noticeable, too, is the use of tituli (i.e. captions) along the base of each of the scenes. On the strength of these differences, attempts have been made to see in the two styles the work of two different periods, as much as two hundred years apart,[43] but it is now general-ly agreed that such a solution is extremely unlikely. Difficult though it may be to find parallels in the ninth century for these two styles, it is no easier to place either of them in a later period. Nor should one exaggerate the differences between them. Clearly they are not by the same hand, but there is little doubt that there is considerable cross-influence between them: the curly-bearded heads of the Apostles on the front closely resemble the heads of the busts of saints in the circles on the sides, and the ribbed haloes with a row of punched dots surrounding them are common to both styles. Also some of the broader figures on the front, like the Angel and the Virgin in the Annunciation scene, are not all that different from the style of the back, and, indeed, the less crowded composition of this panel and the Nativity scene next to it come quite close to the simplicity of the pic-torial style of the St Ambrose scenes. Certainly there can be little doubt that all the reliefs of the altar are from a single workshop.

Of the greatest importance are both the extensive iconographic programme of the altar and the accomplished use of the many goldsmiths' techniques, and these two aspects have naturally been the subject of much research. We have in the nine Carolingian reliefs of the front a unique survival of scenes from the life of Christ, all the more important because the ninth-century cycles that have survived in the north almost exclusively illustrate scenes from the Old Testament.[44] And yet on the rare occasions that a New Testament subject appears at this time in the north, for example the Marriage at Cana on an ivory panel in the British Museum (Plate 116),[45] the iconographic sources do not seem to differ a great deal from those that inspired the Milan altar. The lower part of the British Museum ivory has a similar row of jars in the front, and the same pose of the servant pouring water into jars found on the altar, but repeated twice. The Cruci-fixion scene on the altar also has the two soldiers with spear and sponge so popular in the north in the group of ivories we have called the 'Court Group' of Louis the Pious, and it is interesting to note that on the Milan altar one is seen from the front and the other

from the back, and in the same group of northern ivories both views are known.[46] There seems little doubt that the iconographic traditions on which the goldsmiths of the Milan altar drew were those of the Late Antique, and it is not at all surprising that such sources were available to them in Milan in greater number than in the north; the great Ambrosian library may well have contained Early Christian manuscripts which form a background to the iconographic tradition we can see in the altar.

It may be worth while to make two or three more points in this connexion. In the scene of the Nativity, the ox is shown not behind the crib with the Christ Child alongside the ass, as is normally the case, but lying down in front of it. Of the very rare occasions that one meets this peculiarity, three are to be found in Ottonian illumination of the early eleventh century and the fourth is the Milan altar.[47] If, as we must, we reject the possibility that the golden altar is of Ottonian rather than Carolingian date, we can only assume that a link exists between the Ottonian examples and our altar, and that that link must be a common source. That the sources of Ottonian illumination included a very strong reliance on Late Antique manuscripts in general and many connexions with North Italy in particular, is generally agreed.[48]

Another scene on the altar which we must consider is the Healing of the blind man of Siloe. On the right of the scene appears a kind of hut, from which a bunch of leaves issues at the apex. Above that we see the blind man bathing his eyes in the pool of Siloe, as instructed by Our Lord.[49] Such huts are shown in Early Christian manuscripts, for example in the Vatican Library *Virgilius Romanus*,[50] but are not normally part of the scene in medieval art, to which the richly narrative vein of Early Christian iconography is rarely transmitted in every detail. The bunch of leaves at the top of the hut can be explained by looking at an exactly similar hut in the eleventh-century frescoes of Sant'Angelo in Formis,[51] which are based very exactly on an Early Christian cycle, or a Middle Byzantine version of it. Such a hut can here be seen embracing the trunk of a palm tree, and it is these palm leaves at the top that explain the curious bunch at the apex of the hut. In the same cycle of frescoes the scene of the healing of the blind man omits the hut we have on the altar, but the spread of the leaves at its peak has been utilized as a pattern on the body of the fountain in which the blind man is washing.[52] Further evidence of this early model comes from the same scene on the Salerno ivory antependium,[53] another late-eleventh-century work in the same area of Italy (Plate 146). Here the foliage pattern of our hut acts as a kind of base to the fountain, and it is there merely because the early model included a hut below the fountain which has here been omitted. All this shows clearly that on the Milan altar, in which a complete and logical version of the scene is given, the Carolingian goldsmith worked with a good early model and used it more directly than the eleventh-century artists whose work clearly shows the loss of details due to the many intermediary copies.

One more example of the close connexion between the Milan altar and its Late Antique models shall be given. On the front of the altar, as we have seen, we have Christ in Majesty, surrounded by the symbols of the four Evangelists and a choir of twelve Apostles. Although the formal arrangement of this altar is difficult to parallel, the subject itself is popular in the decoration of apses in Early Christian churches,

especially in Italy.[54] Incidentally, it is in the field of northern wall painting, of which almost nothing but descriptions has survived from the Carolingian period, that we might expect Italian iconography to have its strongest influence. Italian supremacy in this field in the ninth century is undisputed, and Charlemagne himself called Italians to Aachen to decorate his chapel with mosaics and wall paintings.

The subject in the centre of our altar was, therefore, certainly known elsewhere in Carolingian times, and again it is derived without a doubt from Early Christian prototypes. An early surviving example can be seen in the fifth-century apse mosaic of Santa Pudenziana in Rome,[55] where all the elements of our composition are present, unfortunately in a completely different form. But the connexion is not all that remote, as one detail is found which also appears on our altar: the Evangelist symbols are in each case given three pairs of wings instead of one, as is far more usual. This typical western Early Christian feature can also be seen on the ivory panel in the Castello Sforzesco in Milan, from the Trivulzio Collection.[56] Dated about 400, this ivory is closely related to a group of ivory carvings, one of which – the Munich Ascension panel – we have seen strongly influencing the group of ivories of about 820. But western Early Christian models were not the only sources available to master Wolvinius in Milan: at least two scenes on the front of the altar, the Presentation in the Temple and the Expulsion of the Moneylenders, show a very close relationship to Byzantine versions of these subjects created after the end of Iconoclasm in 843.[57] Features such as the architectural backgrounds in the upper parts of the scenes of the life of St Ambrose on the back of the altar, as well as the resemblance of some of the pictorial compositions of these scenes to scenes from a cycle on the life of Christ, point in the same direction, and lead us to the conclusion that in at least some of the scenes, the latest Byzantine versions were available to the Milan goldsmith.[58] This may permit us to date the altar a little more closely. One should perhaps allow a few years after the end of the period of Iconoclasm in Constantinople in 843 for the creation of the new Byzantine iconographic schemes and their introduction to the West: little or none of their influence is noticeable, for example, in the Tours manuscripts of the 840s, but by the 870s, in the Bible of San Paolo fuori le Mura, it was clearly available to western illuminators.[59] The Milan altar must certainly be dated before the death of Angilbertus in 859, but the element of Byzantine influence might mean that it could not have been made before the late forties.

This rather lengthy excursion into iconography is justified if it helps to prove the unique position held by the altogether outstanding golden altar of Milan. It is a work of art that stands in the closest proximity to the kind of North Italian traditions and Late Antique sources that have been shown to be fundamental to the whole creation of Carolingian art. In style also, if any period comes close to providing models for Wolvinius and his collaborators, it is once again western Early Christian art. The nervous, elongated figures of the front of the altar, with the restless, sparkling movement and the rich pictorial composition, are as close as is anything to, for example, the Late Antique silver box at San Nazaro Maggiore in Milan,[60] while the broad, simple forms, with large plain areas of background, in the scenes of the life and miracles of St Ambrose

may owe something to such Early Christian ivories as the two fragments of a fifth-century five-part diptych, one of which survives in Berlin and the other in the Louvre.[61]

The second important aspect of the altar, as we have said, is the technical mastery it shows in enamelling, filigree, and goldsmiths' work. We have already indicated that it seems probable that the goldsmiths' work executed in the north at Charlemagne's court was not unconnected with the rich borders painted in the Court School manuscripts, and that much of the origin of these manuscripts must be sought in North Italy. The Milan altar, in the fact that such mastery of material is likely to be based on well-established workshop traditions, must go a long way towards proving the continuing tradition of goldsmiths' skill in North Italy, probably a living tradition reaching back into the Byzantine past.[62] The fact that enamelling plays such a small part in goldsmiths' work in the north,[63] and that none of the pieces associated with the Court School makes use of enamel, also seems to show that Wolvinius was drawing mainly on indigenous tradition. This can certainly be claimed for the purely decorative techniques employed on the altar. But even in the embossed figure-work of the scenes from the life of Christ and the life and miracles of St Ambrose, little survives from northern schools that can be compared to it in scale, iconography, or sheer technical perfection, certainly before the middle of the ninth century.[64] Comparisons that have been made with the so-called School of Reims, now generally attributed to the Court School of Charles the Bald (and some scholars have even suggested that Wolvinius must have been trained there), are not at all convincing chronologically or even stylistically. Northern metalwork of this school is certainly unthinkable without the strong influence of the Utrecht Psalter style: the slight, swaying, elegant figures, the flutter of drapery, show this clearly. But in the Milan altar a far stronger, more robust figure style is employed, with a characteristic use of sweeping, flatly modelled folds, bordered by a sharp, knife-edge line, scored into the metal from behind. The figures stand solidly, with legs well apart, and show none of the sway of the figures in the Utrecht Psalter, who seem to taper downwards almost to a point. Quite apart from the difference in style in the surviving works, the northern school does not reach its full flowering till the seventies – or at best sixties – of the ninth century, at least a decade later than the Milan altar. Even the connexions in iconography which have been shown to exist with the manuscripts of Tours[65] are difficult to substantiate, in view of the fact that the relevant Tours manuscripts can hardly antedate the altar by more than a few years, if at all. It might not be far-fetched to see these undoubted connexions in terms of Tours's debt to Milan. It can, of course, always be argued that northern work has not survived, but on present evidence, the Milan altar proves a standard of workmanship unequalled anywhere in North Western Europe in the middle of the ninth century. When the influence of the goldsmiths' techniques used with such mastery on the Milan altar can be observed in work made north of the Alps, and it only appears spasmodically, it must be the direct result of North Italian and, more precisely, Milanese influence. One such example has been mentioned earlier, the book-cover of the Metz school[66] now in Paris (Bibliothèque Nationale lat. 9383) (Plate 41). But, on the whole, enamelling does not seem to have gained any immediate popularity in the north.

Indeed, it was not to become a technique of major importance in any northern school until the later tenth century.[67]

In Italy, however, a number of important pieces produced in the ninth century may be related to the golden altar, and they provide evidence for the use of enamelling in Italy well before the middle of the century. An object of outstanding importance is the large reliquary cross from the Sancta Sanctorum Chapel of the Lateran, now in the Vatican Museum (Plate 49). Its dedicatory inscription securely dates it to the years 817–24, in which Paschal I occupied the papal throne.[68] Here the technique of 'full' enamel is used for an extensive and remarkable display of figure scenes. On the front of the cross, in the centre, is shown the Nativity. On the upper arm are the Annunciation and the Visitation, below the Presentation in the Temple and the Baptism, on the right the Adoration, and on the left the Transfiguration(?). Certainly the colours, especially the vivid, translucent green and rich violet, are like those used on the Milan altar, but it would be unwise to press the comparison too far. The Roman cross is at the same time far more ambitious and yet technically inferior to the Milanese enamels. The Milanese craftsmen attempted no figure-work of such complexity – in fact only on the small roundels with female busts that decorate the rear doors of their altar did they employ figure representation at all. But though less adventurous, they certainly handled their material more expertly. The bad pitting of the surface and unevenness of texture of the cross has been at least partly avoided in the decorative plaques made some twenty years later.

The much smaller pectoral reliquary known as the Beresford Hope Cross, now in the Victoria and Albert Museum,[69] is very closely related to the Vatican cross – indeed, one is tempted, in spite of the great scarcity of such survivals, to see in it a product of the same workshop. On the front is the Crucifixion, with busts of Our Lady and St John in the extremities, and on the reverse the full-length figure of Our Lady, in the pose of an Orans, with busts of Christ above her and three saints on the remaining arms of the cross.[70]

There remain two pieces to be mentioned, both much closer in style to the decorative enamelling on the Milan altar. A pendant votive cross in the Victoria and Albert Museum[71] is unusual in the use of bronze instead of gold for its enamels and its setting, but the plant motifs of its decorative panels are very close indeed to some of those used on the altar. Moreover, the donation of votive crosses and crowns has a long history in Italy and in Spain, where quite a number of such gifts still survive. Even more striking is the similarity of the enamel plaques on the so-called Iron Crown preserved in the cathedral of Monza (Plate 50). According to legend, the crown was used for the coronation of Italian kings and emperors in the early Middle Ages. Since the fifteenth century it has been identified with the Crown of the Langobards, and since the sixteenth century (no doubt due to the narrow iron band inside) it has been accepted as a reliquary of a Nail of the True Cross. It may well have been given to Monza either by Berengar I, king of Italy from 888 and emperor from 911 until his death in 924, or by his mother, Gisela, a daughter of Louis the Pious. The latter has been suggested because such diadems were more frequently worn by women.[72] It is, of course, also possible or even probable that it was

conceived as a reliquary and that it was always a votive object rather than a crown for personal use: indeed, it is difficult to account for the plain, rough iron ring within it in any other way. The crown is made of six curved plaques, linked by hinges. Each plaque is decorated on one side by a narrow vertical strip set with three cabochon gems or one gem and two gilt rosettes, while the remainder has four similar gilt rosettes surrounding a central gem setting between gold cloisonné enamels with a floreate design. The rosettes are of a very heavy, almost clumsy design and unlike any other work, but the enamels are very closely linked in design, colour, and technique with the decorative enamels of the Milan altar and must surely have been made in the same workshop at much the same time, either just before or just after the middle of the ninth century.

Other pieces of enamel made in the same workshop appear on the Pepin reliquary in the treasury at Conques (Plate 12), whose earlier history has already been mentioned.[73] Here, two oddly shaped pieces serve as capitals on the reverse of the shrine, another two pieces of the same shape are mounted in the two niches to each side of the Crucifixion on the front, and yet another four smaller ones are mounted on the shrine, one on the front in the centre of the top band of filigree and three inside the three arcades on the back. These enamels exactly repeat the gold pattern on a translucent green base that is found on the borders of the central Christ in Majesty of the Milan altar, or a translucent violet base also found on the altar. The obvious fact that they are not designed for the places they now occupy might lead one to suppose that they were merely loose pieces available at any date later than the mid ninth century. The little shrine is, as has been said, clearly not all of one date. The large figures of the Crucifixion with the Virgin and St John on the front, as well as all the fine filigree on the roof and the applied bands set with gems and raised on arcades of pearled wire, are undoubtedly of the early eleventh century.[74] But the whole shape and size of the shrine is still very like the portable reliquaries of the eighth and early ninth centuries, and some of its elements, like the two birds in the roof of the back and especially the chequer pattern behind them and again inside the niches of the front and the reverse and the twisted columns of the arcade on the back, suggest a ninth- rather than an eleventh-century date.[75] The simple, rather soft pattern of the enamelled wings of the birds on the rear of the roof seems to be typical of ninth-century work too.

The chequer pattern also links this reliquary with another piece in the Conques treasury, and both pieces must, one feels, be near-contemporary. This is the Bégon reliquary of St Vincent, a piece that has also been attributed either to the ninth or to the eleventh century (Plate 51).[76] An inscription proves this silver-gilt reliquary to have been offered by an Abbot Bégon. Unfortunately three abbots of that name are recorded at Conques – the first in 880, the second about 980, and the third between 1087 and 1106. The form of the reliquary itself, known as the 'Lantern of St Vincent', is of great interest. Its relics are displayed in a circular glass drum, surrounded by six columns, carrying a conical roof covered in tiles, all set on a high, square base. Its architectural inspiration is obvious: it is clearly a miniature version of a Roman funerary monument, an eminently suitable model of which a major first-century example still survives in southern France, the tomb of Caius and Lucius at Saint Rémy, near Arles.[77] All the elements of the Roman

tomb are clearly repeated – the square base, the drum surrounded by columns, the conical roof. This in itself would seem to argue for a ninth- rather than an eleventh-century date for the reliquary, when one remembers the miniature triumphal arch that Einhard donated to Maastricht Cathedral (Plate 20). The self-conscious use of a classical model would seem to fit in very well with a family tradition that might have been within the living memory of men like Bégon I, who could have known Pepin II, or even Pepin I (d. 838), son of Louis the Pious. Moreover, additional weighty evidence has been put forward to support a ninth-century date. The bust, repeated six times around the drum of the reliquary, almost certainly represents Christ blessing, and before the tenth century the abbey of Conques was dedicated to the Saviour. Also, the body of St Vincent was raised in 855 by the monk Andaldus of Conques at Valencia – a perfect opportunity for Bégon I to have acquired a small relic of the saint for which to order this container.[78] Clearly the six busts around the drum are part of the original decoration, while the circular plaque with Samson and the Lion on the square base is a twelfth-century addition, probably of the second quarter.[79] The rather fragmentary figure of Christ enthroned on the adjoining side, with the serpent and the dragon beneath his feet and the figure of St John the Baptist on the next side, are more difficult to date. Certainly they show far less of the subtlety and delicacy of modelling which characterize the six busts: the relief is flatter and broader, and the draperies form a flat, rather regular pattern, in keeping with late-eleventh-century styles, and comparable to the relief figures of the Moissac cloisters. It is likely, therefore, that they are late-eleventh-century additions. The busts, on the other hand, with their oval faces, narrowly set eyes, and long noses, and especially the occasional knife-edge sharpness in their drapery, remind one far more of the illusionistic modelling of the Milan altar.[80] Finally, in view of the obvious link in the use of the identical chequer pattern on both the St Vincent Lantern and the Pepin reliquary, and the use of mid-ninth-century enamels on the latter, it seems likely that the lantern was made and the Pepin reliquary almost completely re-made under Abbot Bégon I, very soon after the middle of the ninth century, by goldsmiths who had knowledge of the Milanese workshop that produced the golden altar.

It is tempting to link two more well-known pieces with the same workshop – the so-called Eagle fibulas, said to be part of the treasure of the wife of Conrad II, the empress Gisela, who died in 1043. One of these is now in the Altertumsmuseum in Mainz (Plate 52), the other in the Staatliche Museen in Berlin.[81] The connexion of the eagle motif with the German imperial tradition is quite unfounded, because both fibulas show peacocks, not eagles: in both cases, the top of the head of the bird is decorated with those small tufts of feathers that only occur in peacocks, and therefore their meaning is far more likely to be Christian, the peacock being the symbol of paradise. Both fibulas also use as edging a decorative technique that occurs on the filigree plaques on the borders of the Milan altar, a kind of corrugated gold foil.[82] The cloisonné enamelled wings and tails of the peacocks are also, both in colour and in the cell technique, far more like the soft, rather flaccid cells of the Milan altar, and particularly resemble the birds' wings on the Pepin reliquary rather than the hard, precise, and rigid cell-work of tenth century enamelling. A Carolingian rather than an Ottonian date is further supported by the

remarkable similarity the border of the Mainz fibula bears to one of the border decorations of the British Museum Gospels (Harley 2788) of the Court School of Charlemagne (Figure 2).[83] Once again, one must recall that it was the traditions of goldsmiths' work as practised in North Italy that provided the north with so much of its decorative repertoire.

Figure 2. Border decoration of Harley MS. 2788, folios 107 verso and 108 (*top*), and of an Eagle fibula from the 'Gisela Treasure' (*bottom*), c. 850(?). *London, British Museum, and Mainz, Altertums-museum*

Before leaving the work of ninth-century Italian goldsmiths, one more outstanding piece must be mentioned – the burse-reliquary of the tooth of St John the Baptist in the treasury of Monza Cathedral (Plates 53 and 54).[84] The front, heavily encrusted with a bewildering array of filigree and studded with gems, is a piece of almost barbaric splendour. It is all but certain that two other pieces in the Monza treasury, the silver mounting of the handle of the so-called 'comb of Theodelinda' and the votive cross traditionally connected with Berengar I, though far less elaborate, were made in the same workshop.[85] The foliate claw settings of the cross are like the large gem settings on the burse, and the strange filigree, almost like wrought-iron work, on the reliquary seems to be used also on the comb. But connexions with the Milan altar can also be found: the triangular motifs between the gems mounted in the border of the reliquary are made of the same tripartite wire as the larger 'raised' star patterns on the altar.[86] Moreover, the small lions on the cresting of the burse are in the same tradition as the cresting of the Enger reliquary (Plates 7 and 8). But even older traditions, especially of Byzantine goldsmiths' work, play a part in its techniques – the stringing of small seed pearls on gold wire around gem settings and along borders is a clear example.[87] The dating of the burse is by no means certain, although it must be either ninth- or tenth-century. It is especially the rather crude representation of the Crucifixion with the Virgin and St John on its reverse, executed in a curious technique of pointillist punching, that would support the earlier rather than the later date (Plate 54). Longinus and Stephaton, as well as the large classical busts personifying the sun and moon, look Carolingian rather than tenth-century. The upright, rather fleshy figure of Christ and the loincloth, knotted on his left hip with a cascade of cloth below the knot, certainly reveal the same iconographic traditions as the Crucifixion of the Milan altar and would be difficult to parallel very much later than the second half

of the ninth century. The burse might well have been a gift by Berengar I, king of Italy. The piece possesses undoubtedly imperial splendour.

The influence of North Italy has always seemed to be of importance, even if only indirect sources, like manuscripts, have supplied us with the evidence. The Milan altar, however, is a concrete example of the outstanding work that could be produced there. It has been possible to link with it a number of other works as far afield as the alpine region and the Rouergue to the west, and it will be possible to follow its influence eventually even to St Gall, north of the Alps, and Oviedo in Spain.

THE REIGN OF CHARLES THE BALD

At the Treaty of Verdun in 843 Charles the Bald, the youngest son of Louis the Pious by his second wife, Judith, was given the western part of the divided Empire. This included Neustria, Aquitaine, and the Spanish March, while Burgundy and Provence became part of the Central Kingdom of Lothar I. Charles's share was by no means a united realm. Besides suffering more than a fair share of the constant attacks of Norsemen endured by the whole Empire, Charles needed some years to eliminate the claims of his nephew, Pepin II, to the kingdom of Aquitaine and was forced to admit the independence of the Breton kingdom. Also, he found it extremely difficult to control his own unruly aristocracy. Politically, his position improved much after the final defeat of Pepin in 864, and more particularly after the death of Lothar II in 869 without a legitimate heir. In the same year, disregarding the claims of Lothar's brother, Louis II, Charles was crowned king of Lotharingia in Metz, but finally had to accept a division of the kingdom between himself and Louis the German at the Treaty of Meerssen in 870.

Culturally, the disappearance of Lotharingia as an independent kingdom after the successful patronage of Lothar I and Lothar II enabled Charles to concentrate a vigorous school under his own auspices. One of the most important products of his Court School, the Codex Aureus dated 870, now in Munich (Clm. 14000), is unrivalled in its wealth of decoration and the splendour of its golden cover (Plate 55 and front cover).[1] Manuscripts produced earlier in his reign, like the large Bible dedicated to Charles by Abbot Vivian of Tours and written and illuminated there about 845, are far more modest in their decoration. Even the earliest book that can be definitely connected with direct court patronage, the small Prayer Book now in the Munich treasury of the Residenz, is a far less ambitious work, probably made soon after 850 and certainly before 869, when Charles's wife, Irmintrude, died.[2] Its style of decoration, however, shows clearly the beginnings of the eclecticism which was to be characteristic of Charles's court art. The painterly treatment reminds one in part of the Metz School, and has something of the impressionistic touches of the Reims style, while the rich borders, based on the designs of goldsmiths' work, and the sombre colours continue a tradition that eventually goes back to both the Court Schools of Charlemagne himself. Indeed the whole intention of sumptuous splendour which was developed to an ever-increasing pitch in Charles's Court School has an earlier parallel in Carolingian times only in the art of his grandfather's court. But its sources were not Antiquity and the goldsmiths' work and ivory carving of North Italy that had dominated the schools at Aachen under Charlemagne, but the Carolingian styles themselves that had been developed in the first half of the century, raised to a new intensity of courtly ostentation.

The willingness of this school to accept the best from its own immediate past is

clearly shown by the readiness with which the ivory panels carved some forty years earlier in the Reims style were utilized as covers for the small Prayer Book in Munich and the covers of the Psalter of Charles the Bald, now in the Bibliothèque Nationale (lat. 1152), where broad silver borders had to be made to adapt the small ivory panels for the larger manuscript (Plate 30).[3] These borders, originally gilt and set with gems, are relatively unimaginative works made by less than averagely gifted craftsmen. The gem settings with a broad border surrounded by heavy pearled wire of the front cover are developed from work like the Ardenne Cross made in the time of Louis the Pious (Plate 36). The 'raised cross' motif, surmounted by a small sphere found between the gems, also stems from the same tradition and gives further support for an early date in Charles's reign for these covers. The simple, rather crude filigree that fills the border of the back cover is made of very heavy pearled wire and laid in simple, rather commonplace scroll patterns that find their closest parallels in brooches found in Northern Europe, like the Kirkoswald brooch found with coins of about 850–60 in Cumberland.[4] The Psalter itself, in its decoration very similar to the Prayer Book already mentioned, also refers to Charles's first wife, Irmintrude, and is therefore one of the earlier works of the Court School. Although the scribe Liuthard, who is named in the Psalter, is no doubt still the same who produced the Codex Aureus in 870, the cover is surely strong evidence that it must have been produced some years earlier, when Charles had not yet assembled the goldsmiths of high quality who were to produce incomparably superior work in the seventies. Average goldsmith's work of this kind, combined with re-used ivory panels, hardly provides us with evidence of the creative forces Charles was to be able to commission later, after the Treaty of Meerssen.[5]

One more piece may belong to this earlier period of Charles's reign; the large oval crystal carved with the Crucifixion, now in the British Museum (Plate 56). Until the French Revolution this crystal was in the treasury of Saint-Denis, of which Charles the Bald was lay abbot.[6] Like many other gifts, it may well have been presented by Charles to the abbey which above all others benefited so much from his generosity.[7] Certainly the style of the crucified figure of Christ on the crystal is very close indeed to the Crucifixion on Charles's Prayer Book (folio 39 recto), where the same rather elongated figure, with gently inclined head and long hair, softly modelled body, loincloth knotted on his left hip, and thin, long legs is to be found. The coiled snake at the foot of the cross also appears on both representations.[8]

The scale of gifts to Saint-Denis is one of the factors that has led scholars to suggest that it was here that Charles's Court School had its permanent quarters.[9] It is true that the community of Saint-Denis suffered considerable attacks by Northmen during Charles's reign and may not have been an ideal place at which to settle the scriptorium and a school of goldsmiths[10] – certainly the fifties and sixties saw at least three major attacks and an evacuation – but after Charles became lay abbot in 867 and fortified the abbey in 869, a period of comparative peace reigned until the last serious attack in 885, when the monks once more had to retire to Reims with their relics and treasures. Only once in that period of nearly twenty years did invaders re-appear – in 876. They forced the monks to flee for a short time to Concevreux, but Saint-Denis is said to have been

miraculously left untouched.[11] When Charles took over the abbacy after the death of his cousin Louis in 867, he left the administration to the provost, the dean and the treasurer and put his Mayor of the Palace in charge of military defence. He also held his plenary court at the abbey four times a year, and in general it may be said that it came under the direct control of the monarchy and therefore may well have acted as a centre for the royal patronage of the arts.

Certainly it is likely that the great golden altar frontal given to the abbey, on the evidence of Abbot Suger, by Charles the Bald was actually made there.[12] Like nearly all the other great treasures of Saint-Denis, this frontal was destroyed in the French Revolution, but it is known from the description in inventories and from a Flemish painting by the 'Master of the Mass of St Giles' in the National Gallery in London of about 1500 (Plate 57).[13] When compared to the detailed description of the inventories enumerating each gem, it becomes clear that the picture we have of the altar, based on the sixteenth-century painting, is somewhat inadequate. It would seem that only in the broadest outlines should we trust it, and certainly in the sheer quantity of jewelled decoration, it gives us only a very abbreviated version.[14] Moreover the painting shows the frontal reframed (fourteenth century?) and set on the altar as a retable in late medieval fashion.[15] And yet, apart from the unique survival of the golden altar of Sant'Ambrogio in Milan, we have a more complete visual impression of Charles's frontal in this painting than of any other early medieval altar in precious metal. It also provides us with sufficient evidence, in spite of the obvious adaptation of the Carolingian style of the embossed figures to sixteenth-century forms, of the iconography of the original and perhaps even of some of the techniques employed in the setting of gems and in the broad outlines of the architectual structure of its decoration. Clearly, these goldsmiths were working in far more sophisticated traditions of Carolingian goldsmiths' work than those that had produced the modest covers of Charles the Bald's Psalter. This new wealth of motifs and taste for almost barbaric splendour have their closest parallels on the one hand in the Court School of Charlemagne early in the century and on the other in the Milan altar and the pieces associated with it. Evidence for an interest in the rich decorative art of Charlemagne's Court School can be found abundantly in Charles the Bald's scriptorium, and indeed there is even evidence of a wider interest in his illustrious grandfather: in the charter that he granted in 877 to Compiègne, his favourite foundation late in life, he states specifically that he wishes to follow the example of Charlemagne when founding the Palace Chapel and present a large number of relics to this new church,[16] most of which he removed from Aachen for that purpose.

If the intention was in general to follow the example of the earlier Court School, the techniques available may well have been imported once more from North Italy, where the Milan altar gives us evidence of the existence of the necessary skills. It has already been shown that on at least one book-cover produced at Metz soon after the middle of the century (Paris, Bibliothèque Nationale MS. lat. 9383) (Plate 41) the use of enamel plaques proved the direct influence of Milanese goldsmiths' work. It is therefore particularly unfortunate that one cannot be certain whether cloisonné enamel was used on Charles's altar frontal. Certainly the decoration running just inside the three major

THE REIGN OF CHARLES THE BALD

arches that divide it, with pairs of small crosses between gem settings, could be interpreted as enamel, but no support for this is given by the description in the inventory.[17] Nor is the detail available to us sufficiently reliable to see any precise similarities in technique between Milanese practices and the frontal.[18] But at least it might be said that the two votive crowns that form so prominent a part of the decorative scheme may well be taken as evidence of renewed North Italian influence. Their use was, of course, known to the goldsmiths from the 'Escrain de Charlemagne', certainly at Saint-Denis no later than 876, but their actual form is far closer to surviving examples in North Italy than to the simple rings used on the 'Escrain'.[19]

It must have been after 867, when Charles became abbot of Saint-Denis, that he gave the frontal to the church to enrich the high altar. It is unlikely that such a valuable gift would have been made in the earlier period of his reign, when the attacks of the Northmen were such a constant threat, and almost certain that it must have been presented after October 865, when the Northmen are said to have stayed in the abbey for twenty days, pillaging and stealing everything movable.[20] Alternatively the altar may have been given in 876, along with the three important relics already mentioned and other parts of the Imperial Treasure which Charles removed from Aachen in that year.[21] Unfortunately, our knowledge of the detail of the altar is not good enough to attempt to decide the question by comparing it to the dated book-cover of the Codex Aureus. All one can say with some degree of certainty is that it must have been made later than the covers of the Psalter in Paris, and probably after 865.

With the Codex Aureus of St Emmeram we have a work that has not only survived in almost perfect condition, but is also precisely dated (Plate 55 and front cover). According to the colophon at the end, it was written by the brothers Beringar and Liuthard in the year 870.[22] By the tenth century it was at the abbey of St Emmeram in Regensburg, where a sheet was inserted (folio 1) on which the Abbot Ramwold (979–1001) is represented, who is said to have restored the codex.[23] It was probably at this time that the large ivory panel with the Crucifixion discussed earlier was removed from it.[24] Later this was used to decorate the Book of Pericopes given by Henry II to Bamberg, the occasion being either its foundation in 1007 or its consecration in 1012.[25] This gold cover, decorated with superb embossed figure subjects and richly set with gems, certainly shows that by 870 a wealth of creative talent was available in Charles's Court School, and it also shows the eclectic nature of this talent. In the goldsmiths' techniques employed, one sees a version of the large broad-bordered mounts that decorated Charles's Psalter, enriched by fine filigree, in which the ends of each strand carry small pearls of silver as they had done in much cruder form on the same earlier cover. The same increased refinement and enrichment can be seen in the claws of the gem-settings themselves, no longer the simple bands of the earlier cover but formed as carefully chiselled upright acanthus leaves and palmettes, as they occur earlier only on the centre mount of the Ardenne Cross and Charlemagne's Talisman, where the finer form of filigree, enriched by silver pearls, is also found. The increased heightening and broadening of mounts for both gems and pearls continues a tendency that began with the burse-reliquary of St Stephen and the Ardenne Cross and was brought into Charles's Court School with the cover of his

Psalter. The use of fully formed small chalices to raise and support the gems surrounding the centre panel and the large rectangular gems that form a cross within the outer frame is one of the splendid and unique features of this cover.

In the figure of the Christ in Majesty in the centre and the four Evangelists and scenes from the Gospels surrounding it[26] we have the earliest Carolingian embossed figure-work of 'court' quality to have survived north of the Alps; it is not surprising, therefore, that it has not been easy to find sources for the work. The perfection of its technique certainly proves that it was well established by this time, but the destruction of such pieces as Einhard's silver triumphal arch and a large number of other less well documented pieces does not enable us to trace the development preceding it. Certainly there is no really close, direct link between the book-cover of the Codex Aureus and the Milan altar.[27] Stylistically there can be no doubt that fundamentally the figure scenes and the four Evangelist figures derive in part from the so-called Reims tradition and in part from that of Tours: the elongated, elegant forms, the flutter of drapery at the hems, and the expressive gestures and hunched shoulders are all foreshadowed in the Utrecht Psalter, while the close, tightly stretched parallel folds, especially of the Christ in Majesty, closely resemble the same Majesty figures in the Tours manuscripts of the second quarter of the ninth century. Models for some of the elements of the Evangelists can be found in both the Tours and Reims traditions. In the Vivian Bible and the Dufay Gospels[28] some links exist in pose and drapery, while the thin tall lecterns and the use of a scroll instead of a codex for the St Matthew are also known in the Reims tradition, for example in the figure of St John in the Ebbo Gospels.[29] The curious small architectural structures, however, are a rare accompaniment for Evangelists and appear earlier only in one manuscript of the School of Tours, the Prüm Gospels, now in Berlin (Staatsbibliothek theol. lat. fol. 733). Here, they seem only to be used to fill the empty space on one or both sides of the Evangelists, and no direct pictorial parallel can be drawn between them and the Codex Aureus.[30] Indeed, time and again in this codex, in some of its goldsmiths' techniques and the decorative forms in its illumination, in the pictorial forms of its cover as well as its illuminated pages, we are faced by work for which we have no precise models. Even if we bear in mind the enormous scale of the losses in the field of early medieval art, we are driven to the conclusion that a wide eclecticism led to an unusually high degree of originality at Charles's court. This impression is further strengthened by the variety of individual achievement that any group of work attributed to the school contains. Even in one work, like the codex, the reliefs of the cover, though they bear a family resemblance to the illuminations within the book, display clearly the imprint of an artist's personal style, distinct from that of the scriptorium.

This same individuality of style can be seen in other pieces of goldsmiths' work which nevertheless cannot be very far removed in provenance or period from the cover. The first of these is the Arnulf Ciborium in the treasury of the Residenz in Munich (Plate 58). An inscription on the lower edge of the upper storey states that this remarkable object was given by King Arnulf.[31] Arnulf was an illegitimate son of Carloman, king of Bavaria. He succeeded on the death of his father in 880 only to the border duchy of

Carinthia; the kingship of Bavaria fell to Louis II the younger, king of Saxony, and from him passed to Charles the Fat in 882. It was not until 887 that Arnulf of Carinthia was elected king by the German nobles after having deposed the Emperor Charles the Fat, and in 896 he became emperor. The gift must therefore have been made between 887 and 896, and indeed, in the eleventh century, in the *Vita S. Emmeramii*, it is recorded that Arnulf gave his *Ornatus palatii* to the abbey of St Emmeram in 893. This ciborium was therefore presented together with the Codex Aureus, and like the codex it may have come into the possession of Arnulf after Charles the Bald's death in 877, the inscription merely having been added to the piece on the occasion of the gift in 893.[32] If this is so, it may, however, be considered that it is strange that the inscription does not mention the Emperor Charles, and it cannot be ruled out that the piece was commissioned by Arnulf after 887. Certainly there are no obvious signs of the inscription having been added later. The colour of the gold sheet used is identical with the remainder of the work, and it fits admirably in length on the sides and back of the ciborium, leaving the front edge to carry a fine decorative strip, heavily encrusted with jewels. Similar jewelled strips are found on the uprights and the horizontal cornice of the lower part of the front only, which does not suggest that such strips had to be removed to make room for a later inscription. While the decorative details of the piece, like filigree and gem settings, do not at all resemble those used on the Codex Aureus cover, and need not have been made in the same workshop, the figure subjects from the New Testament that decorate the roof are certainly near enough in style to the Codex Aureus to see in them work that must derive from one tradition. The heavily beaded frames of the scenes are the same, and the relationship of figures to architecture and the compositional treatment very close. But the actual handling of the figures is more subtle on the ciborium, the drawing more lively, with a lighter, more vivid touch. The flutter of drapery is more pronounced, and the impression is gained that the Reims tradition is more strongly emphasized than that of Tours – exactly the reverse from the situation in the Codex Aureus, where the tougher, more tense lines of the Tours style have the upper hand. Along the front edge of the small portable altar which the whole ciborium serves to enrich, five small panels of cloisonné enamel of a very simple star pattern survive. They are the only enamels used in the work that can be linked with the traditions founded by Charles the Bald's patronage. Their mere existence serves to remind us again that a knowledge of the techniques of North Italian goldsmiths may have played a part, however remotely, in this tradition. In one other point, Arnulf's ciborium is typical of Carolingian goldsmiths' work: it creates a miniature version of a large architectural concept in the way that Einhard's gift to Maastricht had reduced the Roman triumphal arch to become a base for an altar cross, and Bégon's lantern of St Vincent at Conques reduced a Roman funeral monument to become a small reliquary.[33] But while in these two pieces the art of Antiquity had served self-consciously as a model, now the contemporary, truly Carolingian idiom was preferred, although it may be true that the ciborium as a structure over the high altar was in the second half of the ninth century more commonly found in the churches of Italy than in those north of the Alps.

The third major product of goldsmiths' work that is likely to have been made in the

Court School of Charles the Bald is the front cover of the Lindau Gospels (Plate 59).[34] The style of the flying angels to each side of the Crucifixion, the crouching figures of the Virgin and St John, and the curiously duplicated figure of St Mary Magdalen(?) at the foot of the Cross must be part of the eclectic style of Charles's school. The thin elegance of these figures, with small round heads with pointed features, and thin drapery, tightly wound around firm limbs and fluttering at the edges, is closer to the style of the Codex Aureus than to that of the Arnulf Ciborium. The figure of the crucified Christ, standing erect on the Cross, with eyes wide open and drops of blood issuing from the wounds in his hands, feet, and side, formed almost like pyramids of heavy pearls, reminds one, in spite of the obvious relationship to the rest of the cover's figures, of the ivory panel of the Crucifixion in Berlin,[35] belonging to the Court School of Charlemagne, i.e the beginning of the century. The head of Christ, however, and its almond-shaped eyes, thin, beardless chin, delicate nose, arched eyebrows, and bunched hair on the shoulders show the workshop style of the Codex Aureus Christ in Majesty quite clearly. And yet the decorative goldsmiths' work is very unlike that of the larger cover. It is true that the smaller circular gem settings are of the kind characteristic of the Court School, with a broad, flat band, bordered by a heavy pearled wire that had been developed early in the school, but the whole effect of the border is totally different from that of the Codex Aureus. Instead of the hard angularity and strict order of the Codex Aureus cover, there is here a thick layer of acanthus foliage, spread over the whole ground in rich profusion.[36] The filigree, used only on the frame of the inner cross and the halo of Christ, is quite different in type – a flat serrated band, rather than a pearled wire – and not enriched by the small silver pearls so prominent on the Codex Aureus. In general terms, although not in detail, this richer effect is based more on the Metz book-cover of about the middle of the century discussed earlier[37] than on any other work at Charles's Court School known to us. Maybe the goldsmiths' decoration of such manuscripts as the Drogo Sacramentary, had they survived, might have explained this richly decorative treatment, perhaps introduced into Charles's Court School after Metz had become part of the eastern Kingdom in 870.[38]

Somewhat more closely connected with the goldsmith's work of the Codex Aureus is the antique serpentine dish known as the paten of Charles the Bald (Plate 60) which survived the destruction of the treasure of Saint-Denis and is now in the Louvre. The Alexandrian carved sardonyx cup of the first century, now in the Cabinet des Médailles in Paris, probably served as the chalice to go with the paten.[39] The serpentine dish was inlaid with small gold dolphins in Antiquity, but the gold rim was added by one of Charles's goldsmiths. Between the gems are small plain settings for flower patterns, hearts, and three-leaved patterns, filled with cut garnets which resemble similar-shaped garnets on the Codex Aureus, where they are mounted vertically between the miniature chalices that support the centre frame around the Christ in Majesty, and horizontally between the large oval gem settings of the outer border. But in much of its detail, and again in general feeling, this border differs once more from the remaining work of the Court School. Even the similar garnet mounts are not enriched by a pearled wire as in the Codex Aureus, but are kept severely restrained, as, indeed, are the rest of the gem

mounts on this piece. Surrounding the whole border, on its edge, we find a series of loops which originally held a wire strung with small pearls. This technique, as well as the total simplicity of the piece, is evidence of a Byzantine tradition of goldsmiths' work that reaches back to the sixth or seventh century in northern Italy.[40] It seems that yet another tradition, of which we have had no evidence hitherto, was here exploited by the goldsmiths patronized by Charles the Bald.

Charles's patronage seems to have particularly encouraged work in precious metals and manuscript illumination, while ivory carving, so popular in the preceding reigns and in other centres, was neglected. The panels used on some of the books associated with the court, as I have tried to show, were almost certainly earlier pieces re-used in the late sixties of the century, while from the two major book-covers and the ciborium which have been discussed, ivory carvings are conspicuously absent. The later work in the Metz tradition and style clearly found no favour at Charles's court. It is however possible that one small group of carvings that has survived may have been the work of craftsmen not ignorant of the trends of development followed in the Court School. Unfortunately none of the four pieces in this group is of any known provenance and any link with the Court School can rest only on stylistic evidence. Three panels, one in the Louvre, one in the Victoria and Albert Museum (Plate 61), and one in the Museo Nazionale in Florence, show the Crucifixion with the Resurrection below, while the fourth, also in Florence, shows a more unusual subject, King David enthroned.[41] This group certainly shows much the same stylistic mixture that characterizes the Court School. The plump figure of the crucified Christ echoes the Court School of Charlemagne, and the large angels grouped to each side above the Cross are strongly reminiscent of the Utrecht Psalter style, while in the drapery the thin parallelism of the tight folds shows just the same mixture of Tours and Reims elements that seemed to occur in other work of the Court School. The preference for metalwork we have noticed at the court might well explain the enrichment of the borders of these ivories by designs based on goldsmiths' patterns, which are, or were, inlaid with gold leaf[42] and small fragments of glass or gems. The 'gem'-encrusted border of the cross of the Crucifixion on the first Florence panel certainly reminds one of the enriched frame of the cross of the Lindau book-cover. The richly decorated throne on which King David sits on the other panel in Florence is very similar to the throne that Charles himself occupies in the dedication page (folio 5 verso) of the Codex Aureus, as are indeed the treatment of drapery, the large, downward-sloping feet of the seated figure, and, above all, the large crown, set well down on the brow. Even the thin acanthus, with sharply serrated edges fanning out from the centre, along the inner frame of the ivories is characteristic of Charles's illuminators.[43] Again the drapery style and the lively stance of the short-legged figures that accompany King David are surely very like those of the musicians in Charles the Bald's Psalter.[44] It is really very unfortunate that no historical evidence can be cited to support a connexion with Charles's Court School, which the style of these panels so vividly suggests.

For convenience, the work done for Charles the Bald has been called the product of a school, and on the whole the suggestion that its centre may have been at the abbey of

Saint-Denis has been accepted. Yet, though linked here and there by strong ties of style and decoration, it has little homogeneity. Much of this may be due to the multiplicity of the sources used at Saint-Denis, the essential eclecticism that has been mentioned many times before. But it would be wrong not to emphasize once more that such eclecticism is often the basis of real creativity in medieval art, and there can be no doubt that the flowering in the third quarter of the ninth century, much of it directly supported by the last great king of the Carolingian lineage, created a truly Carolingian art. It sums up, as it were, many of the earlier individual trends, often self-consciously chosen, and only tentatively explored and absorbed, into something sumptuous and self-confident, in which more room was found for individual originality than before. Perhaps none of the pieces are in themselves as creative or as important to succeeding centuries as the Vienna Treasury Gospels or the Utrecht Psalter, but their total impact is one of an art that has reached its full maturity.

THE LATE CAROLINGIAN PERIOD

WITH the death of Charles the Bald in 877, the Carolingian dynasty lost its last great patron of the arts. Neither his own son, Louis II the Stammerer, nor his grandsons, nor the descendants of his half-brother, Louis the German, who had died in 876, were able to create sufficient stability for any length of time to encourage the arts at their courts. Indeed, the rule of the late Carolingians rarely lasted more than two or three years and the fratricidal struggles for supremacy seem to have occupied their entire energies. In 884 the West Frankish nobles elected the remaining German Carolingian, Charles III the Fat of Swabia, a weak and ineffectual ruler, as their emperor, and the entire Carolingian Empire was once more united under one man – but for only three years, which served to prove that such unity was no longer a practical possibility and that the dynasty was no longer capable of producing a ruler that could make it a reality.

The absence of centralized and consistent patronage within the Carolingian Empire towards the end of the ninth century resulted in a marked reduction of output, and the dissipation of effort into a number of isolated streams which did little more than continue the trends active in the third quarter of the century. Only here and there is there a suspicion that new developments were in the air, with tendencies that were to bear full fruit later, in the tenth century. There can be little doubt that the most important of these streams is that usually known as the later Metz School. A large number of ivory carvings have been attributed to it, the majority of them panels, which almost certainly served as book-covers:[1] indeed, of the forty pieces listed by Goldschmidt in his great corpus as being of this school or more or less dependent on it, some twenty-eight are book-covers, eleven of them still, or recorded to have been, on manuscripts.

Stylistically this large group of ivories is far from homogeneous, and the term 'school' can be little more than a convenience. It is true that the style was certainly developed at Metz during the reign of Lothar I, and one of the Crucifixion panels has already been attributed, on the strength of the manuscript it decorates (Paris, Bibliothèque Nationale lat. 9383) (Plate 41)[2] and the richly ornamented metalwork frame that surrounds it, to soon after the middle of the century. It provides a convenient starting point for a discussion of this large group. Clearly, iconographically this panel is the earliest in a series which is continued or reflected in at least seven other panels[3] and in the Crucifixions that decorate the liturgical comb in the Schnütgen Museum in Cologne and the casket in the Brunswick Museum.[4] Most of the iconographic features of the panel and the companion piece that belongs to it and formed the back cover of the same manuscript[5] are found in the later versions: for example the figure of Synagogue carrying a flag appears on both panels in the Victoria and Albert Museum (G.I, nos. 85, 88), in Paris (G.I, no. 86) (Plate 62), and at Gannat (G.I, no. 89), and the figures rising out of tombs built like small circular towers reappear in four out of the six panels. But in one or two

features the early panel differs from all those that follow. The Evangelists and their symbols over the top of the Cross are replaced in all the later versions by large figures of angels, either standing or descending in flight, and, perhaps most significantly, the loincloth of the crucified Christ is knotted in the centre in the Paris (lat. 9383) panel (Plate 41) and knotted on Christ's left hip in all the later panels. In this, the early panel follows the Early Carolingian type, while the later ones follow a tradition which seems to have been introduced in the Utrecht Psalter and which, after also appearing on the Milan altar, is found in a number of works produced in Charles the Bald's Court School, for example the large crystal from Saint-Denis, now in the British Museum (Plate 56), and the king's own Prayer Book, now in Munich.[6]

Clearly then, the traditions introduced at Charles's Court School in the sixties, perhaps the late sixties, were the same traditions that were instrumental in altering the forms used in the Metz School soon after the middle of the ninth century.[7] But this group of Crucifixions and the other panels associated with them are related stylistically as well as iconographically. They must have been carved within a relatively short space of time – probably in the sixties and seventies of the century. In the heavy, rounded loops of drapery, particularly noticeable in the book-cover belonging to the early Paris lat. 9383, can be seen a strong resemblance to Lothar's Psalter, now in the British Museum (Add. MS. 37768), illuminated soon after 842[8] – yet another confirmation of the date of this style. The provenance of the Psalter is unfortunately not certain – Aachen has been suggested – but what is certain is that both the Paris bookcovers and the Psalter are works produced during the reign of Lothar I, in a style developed in Lotharingia in the forties and fifties. Only one other panel in the group is still found on a manuscript, and that can be dated fairly definitely to about 860 – again, an entirely acceptable date well within the span of time suggested for the group.[9] It seems likely, therefore, that this whole group of book-covers was carved, as one would expect, before Metz ceased to be an important centre for the production of fine books in 870.[10]

In this Lotharingian style of the third quarter of the ninth century are found the seeds of a style that was to develop into the more three-dimensional forms that were to characterize the work of the second half of the tenth century.[11] If, indeed, the tendency most progressive in this group is an increase in volume, a more block-like, shorter figure in a more contained outline, then a panel in the 'late' Metz group may be cited which illustrates this development. It is preserved in Florence, in the Museo Nazionale (Plate 63),[12] and is still clearly related to the Metz style, but the figures are shorter, more thickset, and the relief is more pronounced, with some of the legs modelled fully in the round.[13] Such a panel may well date from c. 900 or even later.

After 870, it has been shown, the major patronage available in the Western Kingdom was that of Charles the Bald – probably at Saint-Denis – and a decline of quality and quantity must have been the inevitable result at Metz. That one of the best panels, in a style showing the Lotharingian tradition based on Lothar I's Psalter most clearly, is still to be found in a manuscript written at Fulda in the late ninth century[14] may be taken as evidence that some of the carvers trained at Metz may have worked in important

monastic centres like Fulda in Louis the German's Kingdom after the Treaty of Meerssen (Plate 67). The very variety of styles, though differences between the panels are often subtle, and the widely differing manuscript styles associated with them, suggest a dispersal of the talent fostered at Metz into a wide area. That this area was mostly located in the Rhineland and east of it, is suggested by the fact that the contribution of the Metz style to the developments of the mid tenth century was mainly available in those regions, rather than in the western half of the Carolingian Empire.

The influence of the art of Charles the Bald's Court School can also be seen clearly towards the end of the ninth century in one of the great monasteries of the south-east, St Gall. Two large ivory panels, surrounded by a silver-gilt decorative border, are found on a Gospel Book in the St Gall Library, written by the monk Lintram, about 900.[15] It can be deduced from the holes in the edges of the two panels that they were first made as a diptych and only later adapted to decorate this codex. Documentary evidence also tells us that these panels were probably carved by a monk named Tuotilo, who is recorded at St Gall between 895 and 912 (Plate 64).[16]

On the front cover a Christ in Majesty appears, surrounded by the four Evangelists and their symbols, two cherubim, and the personifications of Oceanos and Gaia, while on the back there is the Assumption of the Virgin between four angels and two scenes from the legend of St Gall. The Assumption scene is not only rarely represented in the West, but in this form unique,[17] while the scenes from the life of the founder, based on the biography of the same by Wettin and Walafrid,[18] are also individual creations not known in any other pictorial version. The debt that Tuotilo owes to the traditions of Charles the Bald's Court School is clear, both in iconography and style. The four Evangelists are based closely on the Codex Aureus cover, and it has even been suggested that the codex itself may have been the source and that it might have gone to St Gall after the death of Charles in 877 and stayed there until Arnulf presented it to St Emmeram in 893.[19] The two personifications of the sea god and earth goddess also echo the Utrecht tradition, known at Charles's court as well as in the Metz School, while the rich decorative acanthus panels link Tuotilo's style with the Tours tradition, again probably transmitted through Saint-Denis or Metz. His figure style is certainly a drier, harder version of the Codex Aureus style, and Tuotilo might well have received his training at Charles's court in the late seventies.

A number of other ivory panels have been attributed to Tuotilo or his school at St Gall. Among them, the purely decorative pair of panels on a ninth-century Gospel of St John[20] in the St Gall Library (cod. 60) shows the same hand that carved the acanthus panels on the Tuotilo diptych, and the panel with the Crucifixion and the Three Maries at the Tomb, now in the National Museum at Budapest (no. 26), is certainly very close to the curiously light figure style of the diptych, although the hand is perhaps not quite as skilled as that of Tuotilo himself. Another group of three ivories has been attributed to St Gall: one with the Annunciation in Berlin, another with the Three Maries at the Tomb in the Victoria and Albert Museum, and a third in the Liverpool Museum.[21] All three are still strongly linked with ninth-century traditions. In the exaggerated movement of the angel and in the architectural detail, the Annunciation is an immediate

descendant of the Utrecht style; the Ascension in its composition makes use of the Early Christian sources that had inspired the work during the reign of Louis the Pious;[22] and the Three Maries at the Tomb in London is not only copied in a manuscript illumination drawn by the scribe Harsker (986–1017) at St Gall[23] but also has much of the fine parallelism of drapery and light figure drawing of St Gall and is closely linked iconographically with the same subject on the Budapest panel. It would not seem impossible to date these panels, where such strong echoes of earlier Carolingian styles are still to be found, into the late ninth rather than into the tenth century.

In the silver-gilt frames of the Tuotilo book-cover, one more connexion of interest should be mentioned. The frame of the front cover has suffered considerably from later (twelfth-century?) restoration, clearly visible in the original (several of the large flowers in a square are crudely nailed on and are of a far more yellow colour than the rest of the work), but the back cover survives virtually intact. The deep reddish colour of its gilding, and more particularly the technique employed, is very close to some of the decorative goldsmiths' work on the Milan altar. Only on the golden altar does one find foliage motifs of this kind, not embossed out of a simple sheet of metal, but each made separately and soldered on to a flat sheet. It is perhaps not surprising that a North Italian goldsmith should have worked at St Gall, the major monastery on one of the most popular routes that link the Carolingian Empire with the North Italian lands.

In one other area in Europe, somewhat remote from the northern Carolingian centres that have hitherto concerned us, a strong influence of Italian goldsmiths' work was felt in the ninth and early tenth centuries. Two remarkable crosses survive in the Camara Santa in Oviedo, and a third is known from descriptions and photographs taken before its disappearance from the treasury of the cathedral of Santiago de Compostela in 1906.[24] They not only give us a glimpse of the splendid achievements that the royal patronage of the Asturian kings of northern Spain was able to promote in what one might have thought to be a minor centre, but are also well documented by inscriptions. The earliest cross is one of the two at Oviedo. It is known as the Cross of Angels, and was presented to the cathedral by Alfonso II in 808 (Plate 65). It is large (46·5 cm., or 18 in., high), with a prong driven into its base at a later date to fix it to a staff for processional purposes or to a base for use on the high altar. Originally it was probably intended to be suspended over the high altar. On a wooden core, covered with sheet gold, the front is decorated with rich filigree and gems, while the reverse carries the inscription and has at the centre a splendid Antique cameo, surrounded by a double border made of small pearls strung on wire, the same borders being used for four large gems set at the ends of each of the arms of the cross. It has been shown that the extremely rich and varied filigree decoration of the front cannot be derived from Visigothic metalwork, and that close parallels to it can only be found in Frankish, and especially Lombard, jewellery of the seventh rather than the eighth century.[25] The strings of pearls around the settings and the settings themselves are of the Byzantine type we have mentioned before[26] and the shape of the whole cross, with its central disc and expanding arms, goes back to the so-called Cross of Desiderius in the Museo Cristiano at Brescia, which no doubt also enshrines a Byzantine tradition active in northern Italy in the eighth century.[27] Three

small loops still survive under each of the lateral arms of the cross, from which jewels were suspended with perhaps the alpha and omega, the symbols of the beginning and the end, in the centre between them. Here again, the Byzantine or eastern Mediterranean source is emphasized, probably transmitted through the votive crosses of northern Italy or perhaps Visigothic Spain itself.[28]

The second cross was presented to Santiago Cathedral by King Alfonso III in 874 and was an almost exact copy of the Cross of the Angels in both size and decoration, with only one important difference – instead of the cameo in the centre at the back, a small rectangular brooch was mounted, decorated with an enamel plaque with two small birds facing each other, surrounded by a frame of sixteen mounted pearls all within a pearled wire border. It is unfortunate that this small piece no longer survives, but even on the evidence of the poor photograph we have, there is little doubt that it belongs to the group of eighth-century enamels discussed earlier[29] and that the whole brooch was re-used on this cross as a centre jewel, a place graced by another 'Antique' piece on the Cross of Angels which was being copied.

The twenty-eight enamel plaques found on the last and largest of the three crosses, the Cross of Victory given by the same King Alfonso III to the cathedral of Oviedo in 908, two years before his death, represent a new and certain link with Carolingian enamelling in northern Italy (Plate 66). The enamels, all found on the front of the cross, show animal, bird, fish, and foliate motifs. They are in the 'full' enamel technique and their range of colour, especially the translucent green of most of the backgrounds, reminds one inevitably of the decorative enamels of the golden altar in Milan. The forms of the creatures used may recall the animal forms we have discussed on eighth-century or early-ninth-century pieces, such as the older Lindau book-cover or the Enger reliquary,[30] but their cell structure is far more sophisticated and their drawing more accomplished. Whereas the Milan altar makes use only of abstract patterns or foliate motifs in its enamels, the Cross of Victory may be taken to show that animal motifs of this kind are likely to have been in use also, probably in Italy as well as in Spain. The Cross of Victory also demonstrates most vividly the intricate and varied relationship between Carolingian goldsmiths' work throughout Europe. Not only do the enamels prove a link with North Italy, but the shape of the cross itself, with its elegant proportions, reminds one of the Ardenne Cross of the time of Louis the Pious (Plate 36),[31] while the garnets, set in simple shapes, are exactly like such garnets on the Codex Aureus cover or the paten of Charles the Bald, and the magnificent filigree on the back of the Cross of Victory can also be paralleled in Charles the Bald's Court School.[32] But in spite of these similarities to northern Europe, the whole delicate glittering effect of the Oviedo Cross recalls Byzantine gold-work rather than the more robust and heavy work of the north – perhaps, after all, the resemblance between Spain and Carolingian France should only serve to remind us of the debt Carolingian goldsmiths everywhere owed to the Byzantine tradition that remained alive in Italy, its roots firmly in the Late Antique. In this, after all, the techniques and forms of expression used by goldsmiths only ran parallel to all of Carolingian pictorial imagery, which had been inspired by precisely the same Late Antique and Byzantine traditions.

PART TWO

THE ART OF
THE TENTH AND ELEVENTH
CENTURIES

THE REIGN OF HENRY I

AT the beginning of the tenth century, the disintegration of the Carolingian Empire seemed to be complete. The internal political situation in both the eastern and western halves of the old Empire was chaotic, and Europe was under constant attack by her external enemies: the Norsemen in the west and the Slavs and Magyars in the east. In the west, Charles the Simple, grandson of Charles the Bald, ruled not a kingdom but a collection of fiefs which was not to achieve even a semblance of unity for another hundred years, when the throne passed to the Capetian dynasty. Perhaps the most important event of Charles the Simple's reign took place in 910, when he met Rollo, the leader of a marauding band of Norsemen, at Saint-Clair-sur-Epte and allowed him to settle his followers in the lower valley of the Seine, founding the future duchy of Normandy.

In the east, the last of the Carolingians, Louis the Child, died in the same year, and the assembled nobles of the eastern Franks met at Forchheim and elected one of their own number, Conrad, duke of Franconia, as their king. The seven years of his reign were not enough even to begin to solve the problems that surrounded him. His energies were largely devoted to attempting to impose his rule on the nobles who had elected him, which left him with little to protect his kingdom against the invasions from the east by the Magyars, a Mongolian race that had settled in the Pannonian plain and first appeared on the middle Danube in 896. By 913 their destructive raids brought them as far west as the Rhineland, and in 917 they even burnt Basel, the south-westernmost city of Conrad's kingdom. In the following year Conrad died, and the nobles assembled at Fritzlar elected Henry, duke of Saxony, following the advice of the dying king, who considered Henry the strongest and most capable, although – or perhaps just because – he had been Conrad's most obstinate enemy and had defeated the king's expedition against him only a few years before.

With Henry I a process of consolidation began. In 928 Henry finally re-united Lotharingia with his kingdom through the marriage of his daughter Gerberge to Duke Gisilbrecht, in 929 he defeated the Slavs on the Elbe, in 933 he inflicted the first real defeat on the Magyars on the Unstrut in Thuringia, and in 934 he led a successful expedition against the Danes in Friesland – the foundations on which his son, Otto I, was to build the new Holy Roman Empire were laid. Of even greater importance than these great events was Henry's reorganization of the means of government. He initiated that close cooperation between Church and State in which the king was accepted as divinely appointed 'ruler' of the Church, as *rex et sacerdos*, marked out as God's vicar on earth, great princes of the Church and their clergy serving as a kind of civil service, working closely with a reinvigorated royal chancellery.[1] The king, for his part, protected the Church and her property and accepted the brief to create a Christian society.[2]

Virtually nothing survives on which to base any opinion of Henry as a patron of the arts. His main interest was in the consolidation of the eastern frontier – especially that of his own duchy of Saxony. He is known to have built castles at Quedlinburg, Goslar, Nordhausen, Duderstadt, Gronau, and Pölde and defensive walls for the city of Merseburg.[3] Among his religious foundations, the monastery of St Servatius at Quedlinburg (founded in 922) was his favourite, and both he and his wife were buried there.

The early tenth century is one of the darkest periods in the history of European art. In manuscript illumination the generally accepted opinion is that Carolingian art came to an end at the close of the ninth century and European illumination had to start again from the beginning.[4] Some scholars believe that certain Carolingian schools lived on into the early tenth century, but that even so there was a definite decline, and old famous centres ceased to produce fine manuscripts. Nowhere did any work go beyond the achievements of the Carolingian schools.[5] It is this situation that one must bear in mind when discussing the ivory carvings of the so-called 'later Metz School'. The majority of these carvings were made to decorate covers of manuscripts, and it is unreasonable to assume that such covers would have been made at Metz in any numbers when the production of fine books had virtually ceased.[6]

In manuscript painting it was certainly in the great 'state' monasteries of the eastern kingdom at Fulda, St Gall, and in the Weser region, particularly at Corvey, that the transition was first made from the Carolingian to the Ottonian period,[7] and it is among the later Metz ivories that the first steps are taken that lead to the characteristics of the tenth-century styles. No doubt carvers from the school of Metz continued to exercise their craft after the Treaty of Meerssen (870) and the decline of manuscript production there. It can only be put forward as a supposition that some of these carvers found employment in such monasteries as Corvey or Fulda. Certainly one Fulda manuscript of the late ninth century now in Würzburg, mentioned earlier (Plate 67),[8] has its cover decorated by an ivory of the so-called 'later Metz School'. The fragments of the filigree frame at the top have been thought to be a somewhat later addition[9] but may well date from the turn of the century and be contemporary with the first use of this panel at Fulda. In the style of the ivory carving, this panel is still closely linked with the Metz School of the third quarter of the ninth century, and indeed it might have been carved at Metz at that time and only later brought to Fulda and used to decorate the manuscript cover. Alternatively it may have been carved by a Metz craftsman at Fulda soon after 870.

It is, however, among some of the ivories of the so-called 'later Metz School' that positive stylistic developments towards tenth-century forms become clearer. These panels – most of them much smaller than those discussed earlier and therefore perhaps intended for less splendid manuscripts – were made to decorate book-covers, either singly or in pairs.[10] They are all now in museum collections and nothing precise is known of their provenance. Iconographically they are certainly interrelated and appear to depend on the Metz tradition. For example, the scene of the Healing of the Blind Man on two of the pieces, now in the Victoria and Albert Museum (G.I, no. 104) (Plate 68) and in the British Museum (G.I, no. 102) (Plate 69), has much in common with the

same scene on the larger panel on the Fulda manuscript just mentioned. But in a broader sense this whole group of carvings follows the Metz tradition in the crowding of the scenes, with human beings dominating the available space and a kind of shorthand use of architectural detail. Their style, too, is clearly rooted in Metz School antecedents. The broad, square-jawed faces and the thick, blanket-like drapery with rich parallel folds originated at Metz in the third quarter of the ninth century. In panels like the one in Berlin (G.I, no. 81) or in the Victoria and Albert Museum (G.I, no. 118) the close relationship with the ninth-century style is still very obvious, while in others, like the pair of panels in the British Museum (G.I, nos. 102, 103) (Plates 69 and 70), the figures have become far more squat, the drapery style has hardened and dried up, the placing of the figures has become far more rigid, and the composition is far less fluid. It is in these harder more block-like figures that the stylistic tendencies of the tenth century begin to show. In such compact figures, with hair rather like a close-fitting cap and rendered in rounded lumps, as on one of the figures on the extreme lower right of the Entry into Jerusalem (G.I, no. 103), the style becomes comparable to the tenth-century panels which are believed to have formed part of an antependium or an ambo presented by Otto I to Magdeburg Cathedral (Plate 79).[11]

Where these British Museum panels were produced and whether they are late examples of the Carolingian tradition, or whether they were carved as late as the second half of the tenth century and formed part of a revival of Carolingian styles of which there is evidence in such manuscripts as the Gero Codex at Darmstadt or the Codex Wittekindeus illuminated at Fulda (now in Berlin), is not at all certain.[12] Moreover, these 'Metz' traditions are not the only links with the ninth century. The traditions of the 'Reims' style, which have been traced from the Court School of Louis the Pious through the Court School of Charles the Bald to the monastic school of St Gall, also affected the tenth century and underwent the same transformation towards a more massive figure style and a more rigid composition. The ivory reliquary casket at Quedlinburg and the four loose panels of another, very similar casket, three now in Munich and one in Berlin (Plates 71 and 72), may be examples of this tendency.[13] One need only compare the angel of the Annunciation on the small panel once in Berlin (G.I, no. 125) (Plate 73), belonging to the group of carvings attributed to St Gall, with one of the Apostles on the front of the Quedlinburg casket. Both have the same flow of drapery, the same rhythmic movement of the figure, and the same agitated flutter of drapery. And yet the Quedlinburg Apostles are that much more thickset and solid, and more rigidly confined in their arcades. The space in which both the angel and the Virgin of the Annunciation move is much more fluid and indeterminate, and their relationship with the architectural background illusionistically pictorial, in the true Reims tradition. The Quedlinburg casket has been attributed to the monastery of Fulda, and, parallels have been drawn between it and Fulda manuscripts of the late tenth century.[14] The dating of this casket is far from easy, and the internal evidence it presents very difficult to assess. It might well be one of the three ivory 'shrines' recorded in an early-eleventh-century inventory of the Quedlinburg treasury. An inscription on its base records that a restoration was undertaken under Abbess Agnes (1184–1203). No doubt at least parts of the

silver-gilt mounts decorated with rich double and triple stranded foliate filigree were added then, but the panels of translucent enamel and parts of the metal mounts are certainly of much earlier date.[15] Certainly the filigree around the base, with simple loops in heavy twisted wire, and the square flowers along the lower strip and the right-hand strip on the front look a good deal earlier than the rest of the decoration, and could easily date from the earlier tenth century.[16] The character of the enamels, with their rather loose and broad, simple forms, is certainly much closer to the ninth-century tradition of the Milan altar and especially the Metz book-cover (Paris, Bibliothèque Nationale lat. 9383) (Plate 41), than to the German enamelling of the late tenth century. Quite apart from the probably quite early date of the metal mounts of the Quedlinburg casket, it should be remembered that this enrichment was already secondary. The unmounted pieces in Munich and Berlin show the borders of the ivory with engraved decoration, no doubt originally inlaid with glass, paste, and gold leaf. A restoration undertaken in 1855 has shown that the Quedlinburg casket had exactly similar border decoration before it was covered up by the metalwork.[17] This kind of border decoration inevitably reminds one of later Metz ivories like the Brunswick casket and related pieces (G.I, no. 96), but the actual forms used, in spite of the similarity of technique, are quite different. The same decoration, in a much better state of preservation, is, however, found on a large liturgical comb now in the Victoria and Albert Museum, and indeed shows that this comb must have been made in the same workshop as the two caskets.[18] Again the best comparisons for this decoration seem to support an early date for the casket. An almost identical use of snakes with dotted bodies wound around stems can be found in the Folchard Psalter, illuminated at St Gall between 855 and 895, and the carved fleshy, long-stemmed acanthus on the Victoria and Albert comb is also found in the spandrels of the Folchard litany.[19]

One of the strongest arguments for a date late in the tenth century for these reliquaries has been the fact that the arcade under which the Apostles are standing shows a use of alternating piers and columns. In architecture, this alternating system is thought to have been introduced during the tenth century – the earliest surviving building to use it being St Cyriacus at Gernrode, begun in 961.[20] But it may well be that Magdeburg, begun in 955, or even Quedlinburg itself (after 922), neither of which survive, may have made use of the alternating system. Nor need a small ivory casket be based on any direct relation to architecture in this. In the purely decorative use of canon tables in manuscripts, one quite frequently gets the impression that columns are treated with patterns that make the supports appear alternately flat and round. It may well be that this sort of thing inspired the more decorative treatment of architecture itself.

According to tradition, the Quedlinburg casket was presented to the abbey by Otto I, although it was certainly far more favoured by its founder, Henry, and the Munich and Berlin fragments are thought to have been given to Bamberg by Kunigunde, wife of Henry II. Another ivory casket is by tradition said to have been given to Quedlinburg by Henry I, although in its present form it dates from the thirteenth century.[21] A far more likely reliquary casket to have been given by its founder is the one still in Quedlinburg, while the other panels of a casket made at the same time (now in Munich)

remained in the Imperial Treasury until a far later date, when the casket was finally presented by Henry II, with so much else, to his favourite Bamberg. Certainly one need not doubt that this style, in which the Reims tradition played such a vital part, was practised at Fulda.[22]

The work we have discussed here remains, it is true, uncertain in date and provenance. Most of it is normally dated far later, often well into the second half of the tenth century.[23] Nevertheless, it is in these pieces that the clearest links with the Carolingian traditions can be established, and on this basis they deserve discussion early in the history of the tenth century.[24] Nor can the alternative date for the Quedlinburg casket be quite as late as the turn from the tenth to the eleventh century. The whole tendency of the period is then towards a massive and yet rather flat relief, developed from the surface into the material, and an intention to show the human figure in vivid movement developed out of the material is repressed in favour of surface pattern (see for example Plate 104). This tendency towards the isolated display of the figure, placed in careful and studied surface relationships, can be clearly seen in late-tenth-century copies of Carolingian panels, even in the areas where such Carolingian traditions were most firmly rooted and most carefully revived – for example in Lower Lotharingia. An ivory panel with the Miracle of Cana, now in the Cleveland Museum of Art (G.I, no. 47) (Plate 115), which is an exact copy made in the Lorraine area, perhaps at Liège c. 1000, of the Carolingian panel now in the British Museum (G.I, no. 46) (Plate 116), shows this transformation from a rhythmic, intricate spatial relationship into a flat display of isolated figures.[25]

Other ivories attributed to the school of Fulda, like the covers of a Sacramentary written at Corvey, now in Munich (Clm. 10077), and the four panels now in Berlin,[26] are much closer to this transformation into the late-tenth-century style. It is this, which seems so much out of keeping with the rich interplay of forms in figures, curtains, and arcades, which characterizes the Quedlinburg casket and makes a date as late as the turn of the century very unlikely for it. It may well be better to see this casket, therefore, as a work of the beginning of the tenth century. One can see in it an understanding of the highest aspirations of Late Carolingian rather than Ottonian art.

CHAPTER 8

THE REIGN OF OTTO I

OTTO the Great, who gave his name to the whole 'Ottonian' period, ably continued the work begun by his father. By the time he died in 973, the kingdom of the eastern Franks had become the Empire and the undisputed leader of Western Christendom, based on the model of Charlemagne's great achievement. Indeed, symbolically, at the very beginning of his reign, in 936, Otto chose to be crowned king in Charlemagne's Palace Chapel at Aachen. But the centre of gravity of the new Empire was in the east. In 955, at the Battle on the Lechfeld, Otto decisively defeated the Magyars. After that, in 968, he proceeded to secure the eastern boundaries by the establishment of bishoprics at Merseburg, Meissen, and Zeitz (later Naumburg), and in the same year achieved an archbishopric for his favourite city of Magdeburg. In the architectural history of Europe these eastern foundations were to be of the greatest importance.

The most successful aspect of Otto's reign was the continued integration of the Church into the fabric of government. The princes of the Church, themselves the nominees of the emperor, were expected to provide not only cash for the imperial treasury and entertainment for the peripatetic imperial court but also a full complement of men-at-arms whenever the host might take the field. Often archbishops and bishops themselves might take part in fighting, and some, like Bruno of Cologne, Otto's brother, were feudal lords as well as prelates – Bruno also holding the Duchy of Lotharingia. The effect of Otto's use of the Church as a pillar of the secular government was to spread the patronage of the arts far wider than had been the case in the Carolingian period. Another development to have a similar effect was the great movement of monastic reform which began in the tenth century. In 910 William Duke of Aquitaine founded a new kind of independent monastery at Cluny, in French Burgundy, while soon after similar reforms were being preached in Lotharingia by St Gerard of Brogue (d. 959) and St John of Vandières at Gorze (d. c. 975). But these movements did not achieve maturity until the eleventh century, and their full impact was not felt until the breakdown of the Ottonian cooperation between State and Church during the Investiture conflict which began in the later eleventh century. During the tenth century, the reform movement was still firmly in the hands of the princes of the Church, who were closely linked, by blood and common interest, to the imperial power. These princes, rather than the abbots of the monastic reform, created centres of artistic patronage – veritable courts, vying in splendour with the royal courts of the Carolingian period. Such courts were created, for example, at Trier under Egbert, at Paderborn under Meinwerk, at Hildesheim under Bernward, or by the great ladies of the Ottonian aristocracy like Mathilde, grand-daughter of Otto I, at Essen, or her sister Adelheid, who was abbess simultaneously of Quedlinburg, Gernrode, Vreden, and Gandersheim. Ottonian art was indeed an aristocratic art.

Two tendencies were of tremendous art-historical importance during Otto I's reign. One was the renewed contact with Italy, with a first campaign in 951, when the pope asked the help of the king against the Lombards, which resulted in Otto's acceptance of the Lombard crown in Pavia, and later his imperial coronation in Rome in 962. The other was a new close relationship with the Byzantine court, which culminated in the marriage of Otto's son, the later Emperor Otto II, to Theophanu, probably the daughter of the Eastern Emperor Romanos II (d. 963) and niece of the reigning Emperor John Zimisces.[1] Once again, the north was only able to begin a renewal of creative activity by contact with the Mediterranean humanist tradition. Historians have often been critical of the Ottonians, especially Otto II and Otto III, for their at times almost exclusive interest in the shifting shoals of Italian affairs, but however dangerous this may have been for the political stability of Europe, its effect was of inestimable value to the cultural development of the north.

The great achievements of Ottonian art derived from three major sources: the northern Carolingian heritage, the Late Antique and its continuing traditions in Italy, and the imperial art of the Byzantine court, itself the heir of the Antique, so brilliantly revived under the Macedonian Emperors after the final abandonment of Iconoclasm in 842. Of these three sources, it has been shown that Carolingian traditions, particularly those of Metz and Reims, were very much alive in the early tenth century, and they were to continue to be an important factor throughout the century in the great monasteries of the Eastern Kingdom, at Corvey, Fulda, and St Gall.

However, when one comes to consider one of the most important objects that has been attributed to the period of Otto the Great, the imperial crown, now in the Imperial Treasury at Vienna, it is at once clear that it is not the Carolingian tradition that lies behind it (Plate 75). Obviously it has been tempting to associate this great relic of the medieval imperial concept with the founder of the Ottonian dynasty, the first emperor, Otto the Great, and it is now almost universally accepted that it was made for his imperial coronation of 962.[2] The historical evidence has been the subject of controversy. It hinges on the translation of Liutprand of Cremona's short account of Otto I's imperial coronation in Rome in the third chapter of his *Historia Ottonis*. The future emperor arrives in Rome, 'Ubi miro ornatu novoque apparatu susceptus ab eodem summo pontifice et universali papa Iohanne unctionem suscepit imperii'.[3] One view of these words is that Otto was 'vested with wonderful robes and new insignia at the imperial unction given him by Pope John', and that Otto must have brought these 'new insignia' with him to Rome, including the surviving imperial crown.[4] But a very careful analysis of the text has challenged this translation fundamentally.[5] First, the meaning must be that the *ornatus* and *apparatus* were presented by the person who received Otto – Pope John – and were therefore not brought to Italy by the new emperor. Secondly, there must be some doubt what precisely is meant by *ornatus* and *apparatus*. It is therefore suggested that Liutprand's text should be taken to mean: 'There he was welcomed with marvellous ceremony and unexampled pomp, and was anointed as emperor by John, the supreme bishop and universal pope'.[6] It must be admitted that the textual evidence for our crown is therefore far from compelling. Certainly, even if it is argued that

novoque apparatu means 'new insignia' rather than 'unexampled pomp', then it was the pope who supplied it and not the emperor who brought it.[7] Indeed, evidence seems very clear that at least in the case of the Emperors Henry II, Conrad II, Henry III, Henry IV, and Henry V, it was the pope and not the emperor who provided the crown for the imperial coronation, and this custom was probably far older.[8]

On internal evidence only, the crown must be older than the reign of Conrad II (1024–39). The arch that now spans the crown from front to back bears the inscription CHUONRADUS DEI GRATIA ROMANORU(M) IMPERATOR AUG(USTUS), which must have been added after Conrad's imperial coronation in 1027. This inscription, executed in small pearls strung on wire and surrounded by somewhat larger looped strings of pearls, is clearly technically different from the rest of the crown, which must therefore be at least as early as the reign of Henry II. While it is not possible to point to any goldsmith's work which clearly links the crown to an earlier tradition, the cloisonné enamels have been compared with the enamels on the first altar cross of the Abbess Mathilde of Essen, which can be dated to the years 973 to 982, and therefore the crown is said to be at least as early as *c.* 980.[9] It has also been shown that the small cross mounted on the front is a later addition too (Plate 81).[10] The techniques employed on this little cross, especially the claw settings of the jewels, are quite close to the main body of the crown and cannot be of a very much later period, or, what is more likely, imitated the earlier style of the crown and were intended to harmonize with it. The engraved representation of the Crucifixion on the reverse of the cross (Plate 82) is certainly in a style of no later than about the year 1000,[11] and the small cones of filigree are found in large number on the work commissioned during the reigns of Otto II, Otto III, and Henry II. That the little cross is not a product of the same goldsmith as the body of the crown can also be demonstrated. The pearls, which are superficially mounted in an identical fashion, are, in fact, raised on four small pillars on the crown, but are carried on circles of filigree on the cross. Moreover, the total visual effect of the small cross is one of far greater thinness and delicacy than the very heavy appearance of the crown, where virtually none of the background decorated by foliate scroll filigree can be seen, except at the very edges. If then this small cross was added nearer the end of the century, the crown must again be at least as old as *c.* 980.

The crown is constructed of eight plates linked by hinges, of which four, including the two larger ones facing back and front, are enriched by jewels and pearls, while the remaining four are mounted with large cloisonné enamels representing on the right-hand side Christ enthroned, flanked by two cherubim, and Isaiah with the ailing King Ezechias (IV Kings 20, 6), and on the left King David and King Solomon.[12] It has perhaps not been sufficiently emphasized in the extensive literature on this crown just how remarkable these enamels are in a German context early in the second half of the tenth century.[13] They are in the technique of 'sunk' enamel (Senkschmelz) described earlier.[14] The earliest large-scale use of it north of the Alps is in the four Evangelist symbols on the sides of the portable altar and reliquary of St Andrew commissioned by Archbishop Egbert of Trier (977–93) (Plate 89).[15] Somewhat later, the same technique is again used on the altar cross with large enamels, presented to Essen by Abbess Mathilde

(Plate 96),[16] but in general it can be said that 'sunk' enamel enjoyed its greatest popularity in Byzantium, though limited use of it had been made in the north on a small scale, as in the bird and animal plaques on the older Lindau book-cover (Plate 2).[17] Slightly more popular in Carolingian times had been the 'full' enamel (Vollschmelz), but even in this the decorative use had been more widespread than the figurative.[18] Its most ambitious employment is on the Altheus reliquary at Sion (Switzerland), where pairs of half-figures of saints are represented, as has been said, under strong North Italian influence (Plate 10).[19] It is undoubtedly this kind of Carolingian 'full' enamel, rooted in North Italy, that lies behind the large figurative enamels on the Essen crosses given by Mathilde (Plate 93),[20] and the 'sunk' enamels on the imperial crown are not in the same tradition.

In the tenth century, the earliest use of cloisonné enamel in the north is probably that on the objects associated with Gauzelin bishop of Toul (922–62). A Gospel Book illuminated at Tours in the second quarter of the ninth century which belonged to him (now in Nancy Cathedral) was, according to tradition, fitted with a new cover by order of the Bishop (Plate 74). It has four engraved Evangelists surrounding a central cross, and within a frame decorated with jewelled panels and simple, very open filigree[21] – the source for the Evangelist portraits is also found in the Tours tradition.[22] At the centre of the cover there are four circular enamelled decorative bosses, and a very modest representation of the Virgin on a circular disc in 'sunk' enamel, which may well date from the lifetime of the bishop or perhaps a little earlier.[23]

A gold chalice and paten, now also in the treasury of Nancy Cathedral, have been attributed by tradition to the same bishop (Plate 78).[24] Both the gem settings and the delicate, rather loose and open filigree on these two pieces compare very well with the book-cover and could well have originated in the same workshop. The double-twisted rope filigree around the base of the chalice and above its central knop, as well as the clear and heavy corrugated gold foil borders, show clearly the strong links with Carolingian traditions, and the latter feature especially with North Italy, where this technique was first used on the Milan golden altar. The small, square decorative enamels with abstract, foliate, and animal forms also provide a chronological link between the Milan enamels and those of a much more precise form used in the late tenth century, especially on the cover of the Codex Aureus from Echternach (Plate 92).[25]

Another disc with 'sunk' enamel decoration, certainly no later than the first half of the tenth century, is mounted on the back of the St Peter reliquary now in the treasury of Minden Cathedral.[26] It is decorated with four radially placed nimbed half-figures, each flanked by two winged dragons. The small house-shrine itself dates from about the middle of the eleventh century, but this disc and the two small brooches on each side of it are earlier fragments re-used. These two brooches, which may have come out of the same context as the enamelled disc, are executed in a very rare technique. The intertwined foliate and animal forms are embossed, and after being edged by pearled wire they were soldered separately to a back-plate. This technique, as well as the kind of animal heads, is found on yet another book-cover from Sion Cathedral (Switzerland), now in the Victoria and Albert Museum (Plate 77).[27] This cover was much altered in the twelfth century, when the central Christ enthroned was added, but the early

enamelled inscription that survives around this figure proves that the four Evangelist symbols must have appeared originally. The frame, with its delicate panels in the technique just described and large foliate decorative cloisonné enamels, survives in its original form. The technique again points to northern Italian sources: the corrugated gold foil and the 'applied' embossed work were first used on the Milan altar, and the latter appeared later on the Tuotilo cover at St Gall.[28] The colour of the enamels is far more milky and opaque than the more usual translucent enamelling and reminds one strongly of the range of colours employed early in the Carolingian period in Italian enamels like the Beresford Hope Cross in the Victoria and Albert Museum.[29] In both these features, the book-cover is unusual, and therefore difficult to date. It is interesting to note that it is said that this cover and the early-tenth-century manuscript under it were given to Sion by King Rudolf II of Burgundy (911–37). If, indeed, this tradition may be believed, the strong Italianate features of the decoration might be explained by Rudolf's involvement in Italian affairs which culminated in his acceptance of the Lombard crown in Pavia in 922.[30]

The very modest little enamels which have been described here are all that can be produced to try to explain the appearance of the splendid figural plaques on the imperial crown. Obviously the history of enamelling is beset by the difficulty of lost material, but there can hardly be any doubt that in the end the enamels on the crown must be based on Byzantine prototypes – it is only in Byzantium that we have evidence of large-scale figurative enamels in the late ninth and early tenth centuries.[31] But it should also be remembered that the so-called 'Pax of Chiavenna' of the late tenth century and the book-cover given by Archbishop Aribert (1018–45) to Milan Cathedral (Plate 76)[32] are decorated with large 'sunk' and 'full' enamel plaques. These pieces, obviously made in North Italy, may, it is true, represent a renewed contact with Byzantine goldsmiths in the late tenth century, but they may also be evidence of a continuing Carolingian tradition in northern Italy. Certainly the appearance of the small plaques executed in green translucent enamel with decoration in pure gold may be taken as strong evidence of a continuing Carolingian tradition there. They are found on the ninth-century Milan altar, but are never used by Byzantine enamellers. Technically, it should also be said, the enamels on the imperial crown are nearer the Aribert book-cover than any others (Plate 76) – both show similar cell structure and are particularly close in the mass of blowholes that appear in both works.

One more point might be made about the iconography of the enamels on the crown. Both King Solomon and King David are shown wearing a short chlamys with a decorative square on the centre of the breast, known as a *tablion*. The representation of a *tablion* on the royal costume is extremely rare north of the Alps[33] but appears frequently in North Italy, especially in Early Christian, Byzantine, and Byzantine-inspired works of art. Moreover, although no exact parallel to the general form of the crown survives, it is true to say that enamels rounded at the top are used in Byzantine crowns in the eleventh century.[34] Thus what evidence exists, and it must be admitted that it is far from conclusive, does suggest that it is far more likely that the German imperial crown was made in Italy, under strong Byzantine influence, in the second half of the tenth

century. Its appearance in Germany among the imperial insignia, certainly before about 980, would help to explain the popularity that cloisonné enamelling was to achieve there.

The same links with North Italy and strong Byzantine influence in the goldsmith's work commissioned by the German imperial court can be traced in the gold treasure found in Mainz.[35] The treasure, no doubt imperial in origin and collected over a long period,[36] might well have been buried or otherwise hidden during the second half of the eleventh century. One of the most magnificent pieces can be attributed to the same workshop as the imperial crown. It is a breast ornament, made of gold chains joined by links set with pearls, gems, or intaglios, and carved pendant gems. Near its lower part is a large gem in a pierced crescent-shaped setting, bordered by a string of small pearls (Plate 80). This piece and other gem settings show the same techniques employed on the crown, especially the double rings of thick pearled wire, joined by small spheres of gold, and centrally pierced pearls held in place by a horizontal gold wire. One or two features, however, show that this piece is likely to have been made a little later than the crown: the small cones of coiled wire surmounted by a gold pearl, for example, are not used on the crown, and became more popular in goldsmiths' work about the turn of the century. It has always been recognized that this gold ornament, and indeed the splendid necklace that is also part of the treasure, both probably originally stitched to a cloth base, are clearly in the Byzantine fashion of court dress, where such a breast ornament is known as a *lorum*.[37] Its popularity at the Ottonian court was well established by the reign of Otto II, almost certainly as a result of the appearance of Theophanu in 972. One can hardly doubt that the goldsmith who made these pieces was in close touch with Byzantine traditions and probably learned his craft in Italy. The same is true of other pieces in the same treasure. The crescent earrings for example, some with cloisonné enamels on the reverse, are only the latest in a long tradition that reaches back to the Mediterranean Late Antique. Certainly no trace of northern influence can be seen here.[38] Even the magnificent large circular brooch in the treasure has been shown to be based almost certainly on work like the Towneley brooch in the British Museum,[39] which has been attributed to a northern Italian workshop under Byzantine influence but may be metropolitan Byzantine. When compared to the 'Gisela' brooch, the Towneley brooch appears more delicate in construction, employing a different range of techniques, with much less filigree. It seems far more likely that the British Museum brooch is an example of the kind of Byzantine jewellery which served as models for western goldsmiths, almost certainly working in northern Italy. The very fine cloisonné enamel in the centre of the Towneley brooch, with a most delicate foliate pattern employing a very subdued range of colours, is also very different from any western work. In the entire Mainz treasure, the only clear evidence of northern workmanship or tradition is to be found in four out of the nine finger rings, two where the bezel is supported by small dragons – a form that is known in Carolingian examples[40] – and two more where intertwined bird and foliate scrolls decorate the hoop.[41]

The only other work of major importance attributed to the reign of Otto I is the so-called 'Ivory Antependium', said to have been given by him to his favourite Magdeburg

(Plate 79). As a monastery, it was founded in 937 by Otto and his wife Edgith, the daughter of Edward of England, and dedicated to St Peter, St Mauritius, and St Innocent. In 955, shortly before the Battle on the Lechfeld, Otto began the building of a large cathedral and decided to make Magdeburg an archbishopric, but because of opposition from the archbishop of Mainz and the bishop of Halberstadt, this was not ratified until the Synod of Ravenna in 968, six years after Otto's imperial coronation. Otto's great building has not survived. A fire broke out on Good Friday 1207, and the remains were pulled down to make way for a complete rebuilding.

From the start, Otto intended the cathedral to serve as his and his queen's burial place and to be of unrivalled magnificence. The west façade opened on to a great atrium, which led to a circular baptistery dedicated to St Nicholas. Valuable Italian stone was imported for its building. No doubt the internal fittings for it matched the grandeur of its structure. One such fitting might have been an antependium made of ivory mounted in a metalwork frame. Sixteen carved panels survive, each just under 13 cm. high and 12 cm. wide (about 5 by 4¾ in.),[42] decorated with scenes from the life of Christ ranging from the Visitation (G.III, no. 301) to the scene of Doubting Thomas (G.III, no. 303), the Traditio Legis, and a dedication scene. Even though they are the largest surviving assemblage of New Testament scenes of earlier date than the Egbert Codex of c. 980, they represent less than half the panels that would have been required to decorate even a small antependium.[43] Almost certainly they would have been mounted in a metalwork frame which would have covered up the major part of the broad frame that now surrounds them.[44] One alternative suggestion has been that they were mounted on a bishop's throne rather than an antependium,[45] but bearing in mind the strong emphasis in the surviving panels on subjects depicting Christ's ministry, it might well have been more fitting for them to have been mounted on a pulpit.[46] The association of the panels with Magdeburg is based mainly on the fact that four of them (G.II, nos. 4, 10, 14, 15) were re-used on the cover of the Codex Wittekindeus (now in Berlin) in the eleventh century.[47] This cover no longer survives in its original form, but it was carefully described in the eighteenth century,[48] when it still showed jewelled decoration set in silver and gold and including figures of saints, among them St Mauritius, and an inscription stating that the cover was commissioned by Archbishop Engilhardus. No doubt this was Engilhard of Magdeburg (1052–63), and this is supported by the saints who appeared on the cover – all of them connected with Magdeburg and the abbey of Enger, which belonged to Magdeburg and which was the later home of the Codex Wittekindeus. It might well be that the antependium or pulpit was damaged by the fire of 1049 at Magdeburg and that fragments were used after that to decorate this book-cover, while another eight panels, for example, were later used to decorate a sixteenth-century reliquary in the Hallische Heiltum.[49]

Another reason for associating this group of ivories with Magdeburg, and indeed with Otto the Great, is the dedication panel, now in the Metropolitan Museum in New York (Plate 79), formerly in the abbey of Seitenstetten in Austria, showing a king wearing a crown with an arch over it, like the imperial crown, although in all other respects it differs from this crown. The argument that it must have been carved after the imperial

coronation of 962 is therefore not at all compelling. The king offers a church to Christ enthroned, presented by a saint and an angel, with St Peter and two other saints attending on the opposite side. The saintly patron of the king has been identified as St Mauritius, who appears wearing a similar tunic and chlamys on another Ottonian panel,[50] where he is named by inscription. If this does indeed represent St Mauritius – which cannot be much more than supposition – then the identification of this panel as a dedication scene in which Otto I presents his favourite foundation, Magdeburg, to Christ, attended by two of the patrons of his new cathedral, St Mauritius and St Peter, may be accepted. The angel has been said to be St Michael, the patron of a chapel very near the cathedral,[51] while one of the other two saints behind St Peter would be the third patron of Magdeburg, St Innocent. No doubt the figure represented is one of the Ottonian rulers, and if the association with Magdeburg is convincing, then it is its founder Otto I himself. But it must be remembered that such a dedication panel could have been carved at a later period: whether it was actually produced in the time of Otto the Great must depend in the end on the style of the panels, and what little we know of New Testament iconography in current use in the first half of the tenth century. The few New Testament scenes used in the late Metz ivories provide no obvious parallels. The Raising of Lazarus, for example, on the British Museum panel (G.I, no. 102) has little in common with the same scene among the Magdeburg panels (G.II, no. 14). Here and there, however, there are some details which suggest that similar sources were used by the carvers: for instance the building in the background of the Healing of the Blind Man on the same British Museum panel shows a gateway flanked by two tall slim towers, and a similar structure appears in the scene of the Healing of the Youth of Nain on the antependium (G.II, no. 6). The only really extensive series of New Testament scenes almost certainly of Carolingian date is the wall paintings in St John at Müstair, in Switzerland.[52] Here sixty-two scenes were depicted – a cycle of about the same number as any antependium or pulpit at Magdeburg might have required. Indeed, seven of the fifteen scenes at Magdeburg were also shown in the Müstair cycle and four more almost certainly were. But unfortunately there is little evidence of any really close connexion between the sources used in the two cycles. This might be of some importance when the attribution of the Magdeburg ivories to an Italian centre – Milan is most commonly cited – is considered, because undoubtedly the Müstair paintings are closely linked with Italian traditions.[53] The iconographic evidence is therefore negative rather than positive. There is no evidence of any strong Italian influence and, it should also be said, virtually no connexion with the sources that were available in Germany, under the patronage of Egbert of Trier, for such manuscripts as the famous Egbert Codex illuminated about 980.[54]

For the style, the evidence is not much easier to interpret. The main characteristics are the very heavy, stiff, and massive figures, with extremely clear and flat treatment of drapery, their display in simple but powerful compositions, normally on a single plane, and the use of a pierced background, either in abstract chequerboard or cross or rather confused fleshy foliate patterns. No doubt the pierced background was originally backed by gold or gilt metal. In this, the Metz tradition comes to mind, for only in the very splendid productions of the earlier Metz School is this exploitation of the rich

combination of gold and pierced ivory at all common. It is also in the later so-called 'Metz' panels, particularly the pair of panels in the British Museum (G.I, nos. 102, 103) (Plate 69), that the broadening of the figure – the flat display form – and the simplified, clear arrangement of drapery in thin, comparatively uncomplicated folds are first found. The large round heads, with cap-like hair, carved in short 'lumps' of curls or in thin parallel lines, is also foreshadowed in these panels. Of course, the British Museum panels are not yet as dry in manner, and something of the fluid drapery of the Metz tradition is still to be seen in them, but of all the carvings of the late ninth and early tenth centuries, they show most clearly that in the end the main source for the style of the Magdeburg antependium must be sought in the northern Carolingian tradition. However, this does not exclude some Italian influence. It is difficult to find anything like the fleshy foliate scrolls in the north, and some panels almost certainly carved in northern Italy have been suggested as their source.[55] It is true that the pair of panels in the Musée des Antiquités in Lyon,[56] with the four Evangelists, depicts them surrounded by fleshy foliate scrolls, not unlike those on some of our panels. But the treatment of the figures is very different from the much harder and more compact forms of the Magdeburg panels and provides a much less satisfactory source than the Metz panels. Also, none of the Italian panels have pierced backgrounds, or use the abstract chequer-board or cross patterns. These pierced cross patterns appear in a very rudimentary form however on one book-cover, probably produced in Lotharingia, now in Noyon Cathedral and originally from Morienval, dating from the late ninth or early tenth century.[57] The whole of both covers of this Gospel Book is leather-bound (probably originally in red?) and overlaid with a sheet of horn, bordered by strips of pierced ivory. The horn is pierced with cross and step patterns in a crude way, similar to the Magdeburg panels.[58] Thus, to attribute the Magdeburg panels to a workshop in Italy seems to be unjustified. The main sources for the style are, undoubtedly, in the Metz/Lorraine area, and are the result of the Carolingian tradition, which influenced the eastern kingdom alongside the 'Reims' tradition in the early tenth century.[59]

One more panel carved in the workshop of the Magdeburg antependium, now in the Cleveland Museum, but not belonging to the same series, should be mentioned. It shows a standing figure of Christ, with twelve small busts of the Apostles breaking, as it were, out of the background to each side of the figure. The flat, broad treatment of the figure is identical with the Magdeburg figures, and the small busts have the same cap-like treatment of the hair as those of the antependium. It has been shown that the small busts in the background of a panel are found frequently, albeit not usually in quite such large numbers, in Byzantine carvings of the ninth and tenth centuries.[60] But it should also be said that the heavy acanthus border that surrounds the panel is in the typical Carolingian Metz tradition and never found in Byzantine or, for that matter, Italian ivories. Again, therefore, we have a basically northern tradition, with some Byzantine influence, almost certainly transmitted through northern Italy.

When and where could these ivories have been carved? The association with the cathedral at Magdeburg suggests a date certainly no earlier than 955 and more likely nearer the date of the installation of the first archbishop in 968. Certainly by this time

the contacts with Italy were close enough to explain the Italian influence we have noted, and, indeed, Italian material was imported for the building itself. There is no reason to doubt that the work was commissioned by Otto I, who is therefore the emperor represented on the dedication panel in New York. When considering the home of the workshop, we come up against a perennial problem of Ottonian art, especially when dealing with imperial commissions: either goldsmiths and ivory carvers might have practised their art while on the move with the peripatetic imperial court, or the Ottonian emperors gave their commissions to various abbeys patronized by them. Such factors make it of less importance to determine the location of any imperial workshop than to try to find where craftsmen might have been trained, what sources were available to them, and to what influences they were subjected. If these criteria are applied, the carvers who worked on the Magdeburg antependium were of northern origin and their training was rooted in the Carolingian Lorraine tradition, but they were not untouched by North Italian and even some Byzantine influence. The power of these influences was to grow considerably in the last quarter of the tenth century during the reigns of Otto II and Otto III.

CHAPTER 9

THE REIGNS OF OTTO II AND OTTO III

DURING the first seven years of Otto II's rule, the emperor dealt successfully with the internal revolt of the duke of Bavaria and the attempts of Lothar, king of France, to win Lotharingia once more for the western kingdom. He subdued the Danes to the north and the Bohemians and Poles to the east, and established bishoprics at Prague for Bohemia, at Olomouc (Olmütz) for Moravia, and at Odense on the island of Fyn for the Danes – using the same means as his father had done before him to safeguard his eastern boundaries. His position in Germany was then secure, and in November 980 he crossed the Alps to Italy once more. He had been crowned co-emperor in Rome in 967 and had married his Greek princess, Theophanu, in Rome only a year before his father's death in 973. This time, Otto hoped to conquer the southern part of Italy. He never returned to Germany; dying in 983, he was buried in an Antique sarcophagus in the atrium in front of St Peter's in Rome.[1]

A number of ivory carvings can be associated with the emperor's visit to Milan in 980. An ivory situla or holy water bucket, now in the Milan Cathedral treasury, bears an inscription which states that Archbishop Gotfredus of Milan (975–80) had it made for the reception of the emperor and presented it to the church of Sant'Ambrogio (where it remained until the eighteenth century) (Plate 83).[2] Although Gotfredus died shortly before, it seems likely that it was intended for Otto II's reception in 980. The bucket is carved with five arcades, under which the Virgin and Child and the four Evangelists are seated. The handle, in the form of two dragons, and the lion heads by which it is attached to the bucket are cast in silver and gilt. The style of these figures has often been linked with that of the panels of the Magdeburg antependium,[3] but some very fundamental differences of approach make an attribution to the same workshop impossible. Instead of the dry, rigid treatment of drapery on the earlier antependium, the Milan figures portray rich and lively forms, elaborate in their arrangement and always drawn with a very thorough understanding of classical costume. Moreover, the relief is far more pronounced, with heads like that of the Virgin, facing forward, giving an illusion almost of free-standing sculpture. The difference between this Milanese style and that of the antependium becomes very clear when one tries to define the sources used for both styles. It has already been shown that the Magdeburg panels must, at least to some extent, depend on the late Metz style. This is not the case in Milan. There is no sign of the hard, thickset figures, no sign of the enormous hands or the regular 'blobs' of hair. The sources for Milan are to be found far more satisfactorily in the Byzantine carvings of the tenth century. The flat, overlapping folds, increasing in width towards the hem, the square, flat footstools decorated along their edge, and the well articulated figures may be compared very convincingly with such Byzantine ivories as the Harbaville Triptych, now in the Louvre.[4] When one compares the same Byzantine

ivories with the Magdeburg panels, the far more northern appearance of these becomes obvious.

The strong Byzantine influence on this Milanese style is shown even more clearly in a panel no doubt carved in the same workshop and set into the cover of a twelfth-century manuscript from Siegburg now in the British Museum (Plate 84).[5] The head of St Matthew closely resembles those of the Evangelists on the bucket, but the somewhat less fussy treatment of drapery and the simple grandeur of the standing figure comes even nearer to the standing figures of the Harbaville Triptych. Only the heavy acanthus frame shows that some Carolingian influence was also felt at Milan, although its very simple, rather flat treatment clearly shows that the carver was less familiar with this motif than his northern contemporaries.

A small panel now in the Castello Sforzesco in Milan[6] is by the same workshop, if not indeed by the same hand, as the situla (Plate 85). It shows a Christ in Majesty attended by St Mauritius and the Virgin, with an emperor to the left and, to the right, an empress presenting her infant son kneeling below. A large inscription below reads: OTTO IMPERATOR. Most probably it shows Otto II with Theophanu and their infant son, later Otto III, born in July 980. The panel originally no doubt decorated a book-cover, and the presence of St Mauritius and the Virgin may mean that such a cover was given by Otto to one of his favourite abbeys, either that of Einsiedeln in Switzerland,[7] which was dedicated to these saints, or perhaps to the abbey of St Mauritius in Milan.[8]

Yet another ivory situla is closely related to the same group of carvings. It first appeared in 1856 at Aachen and, after being in the Basilewski Collection and the Hermitage in Leningrad, was purchased by the Victoria and Albert Museum in London in 1933 (Plate 86). It bears three lines of inscriptions, the upper two rows being adapted from the fifth book of the *Carmen Paschale*, a hexameter rendering of the events of the Old and New Testaments written by Sedulius Scotus in the fifth century. The end of the inscription, near the base of the bucket, reads 'May the Father, who added thrice five to the years of Ezechias, grant many lustres to the august Otto. Reverently, Caesar, the anointing-vessel wishes to be remembered for its art.'[9] Attempts have been made to associate this bucket also with Otto II's visit to Milan in 980, because the Old Testament King Ezechias quoted in the inscription was twenty-five years of age when he came to the throne and secured the deliverance of Jerusalem from the Assyrians, and Otto was twenty-five years of age in 980 and was about to free southern Italy from the yoke of Islam.[10] But this Old Testament king, as we have seen, appears with Solomon and David on the imperial crown, and is mentioned more than once in the coronation liturgy.[11] The reference to 'anointing', as well as the reference to King Ezechias, may well be taken to suggest that the bucket was intended to serve at a coronation service. The coronation of Otto II at Aachen, or the imperial coronation in Rome in 967, is surely too early a date for the bucket, but the coronation of Otto III on Christmas Day 983 at Aachen, where he was sent by Otto II after the Diet of Verona in the same year, may well have been the occasion for which Otto II ordered the situla to be carved in Milan.[12] In style, the Basilewski situla is certainly related to other Milanese ivories. The angels to each side of the Virgin on the archbishop's situla, for example, closely resemble the figure of

93

Judas receiving the thirty pieces of silver, and the high priest's crown copies precisely the crown worn by the imperial personages on the Castello Sforzesco panel. It is true, however, that the drapery of the smaller, livelier figures on the Basilewski situla is handled in a less rigid, indeed in a less 'Byzantine' fashion. The reason for this is no great difference of style, but the influence of the precise model used for most of the iconography of the bucket. The scenes of Judas receiving thirty pieces of silver, Christ washing the feet of Peter, or the Two Maries at the Tomb,[13] for example, are all taken most exactly from the diptych which still survives in the treasury of Milan Cathedral and was formerly preserved in Sant'Ambrogio in Milan. This diptych may be a fifth-century carving, although it is now usually thought to be a Carolingian copy of a fifth-century original.[14] It is certainly a piece in which the North Italian Late Antique traditions were transmitted to the tenth century, and the Basilewski situla clearly owes its looser, more fluid figure style entirely to it.

One more ivory panel, now in the Cluny Museum in Paris, closely associated with court circles must be mentioned (Plate 87). It illustrates well the growing importance of Byzantine art at the court. On it, Christ is shown crowning Otto II and Theophanu, while at the base the kneeling figure of the donor is carved. A Greek inscription reads: 'O Lord, help your servant John.' This is usually believed to refer to John Philagathos, bishop of Piacenza, a member of Otto II's court and one of Otto III's tutors. An inscription in the upper part of the field, written in a mixture of Greek and Latin letters, identifies the two figures as 'Otto Imperator Romanorum Augustus' and 'Theophanu imperatrix Augustus [sic]'. As Otto II made use of the title 'Imperator Romanorum' only after 982, the panel should be attributed to the very last year of his reign. It was obviously carved by a Greek craftsman trained in the Byzantine tradition, as its style, composition, and setting all closely resemble the imperial Byzantine panel showing Christ crowning the Emperor Romanos II and his consort Eudoxia, now in the Cabinet des Médailles in Paris, carved between 959 and 963.[15] This was the first time that a Byzantine ivory carving had been used to decorate a book-cover, but the fashion was to increase in the later tenth and early eleventh centuries.

A splendid crown has also been attributed to the period of Otto II. Unfortunately we know only a drawing of it, made before its destruction between 1532 and 1540. It was then a part of the 'Hallisches Heiltum', placed on a later bust reliquary of St John the Baptist which belonged originally to the abbey of Berge, near Magdeburg. The sixteenth-century description of the treasure states that it was given to Berge by the Emperor Otto,[16] and the careful drawing of it gives us no cause to doubt this tradition. The settings of the jewels and the fine filigree which decorated the body of the crown indicate a development away from the much heavier treatment of the Viennese imperial crown towards more refined workmanship. Typical of this development, and, indeed, closely related to the drawing, is the small crown that survives at Essen, now set on the head of the 'Golden Virgin', which shows clearly that its size was somewhat reduced to fit this reliquary at a later stage of its life (Plate 88).[17] It seems very probable that it originally belonged to Otto III, who was only three years old at his coronation at Aachen in 983, and it may indeed have been made for that very occasion. One feature,

that of the gem settings, where the stones are held by looped wires, can be seen both on the drawing of the larger crown of Otto II and on the small surviving crown. Only in the extensive use of pearls strung on wire on the Essen crown do they differ to any marked degree. Again, with so little goldsmiths' work surviving, it would be very difficult to be certain where the goldsmiths who made these crowns were trained. It is true, however, that the stringing of pearls on wire has a more lasting tradition behind it in northern Italy – for example on the burse-reliquary at Monza, where, incidentally, small spheres of gold raised on triple strands of channelled gold strip also appear for the first time (Plate 53).[18] Somewhat more elaborate versions of the same little structures are used on the Essen crown. The gem settings made of looped wire were also used on the large round brooch in the 'Gisela' treasure, for which, it has already been suggested, Italian goldsmiths were probably responsible.[19]

It must be remembered that by the 980s new centres of patronage were developing rapidly north of the Alps, especially under Archbishop Egbert at Trier and Abbess Mathilde at Essen. These new centres, as we shall see, were the result of extensive influence from the Mediterranean world, and it is conceivable that Otto III's crown could have been made in one of them, more particularly that established by Mathilde. But on the whole, it would seem more likely that it was precisely the importation from Italy of such magnificent pieces as the imperial crown, Otto II's and Otto III's crowns, and such imperial jewellery as the so-called 'Gisela' treasure, that led to the establishment of these northern workshops and provided their inspiration.

The Patronage of Egbert, Archbishop of Trier

In 977 Egbert was made Archbishop of Trier by Otto II after only one year as the head of the German imperial chancellery. He had been born about 950 and was educated in his father's foundation, Egmond Abbey, in Flanders.[20] He probably entered the imperial service in Otto I's time and went to Italy with Otto II and Theophanu in 980, hardly for the first time. He attended the diet at Verona in 983 and on his return to Germany in the same year, after the death of Otto II, supported Henry the Wrangler's claim to the regency. In 985 he made his peace with Theophanu and Archbishop Willigis of Mainz at Frankfurt, but seems to have played no part in politics thereafter. He died in December 993 and was buried in the chapel of St Andrew in his cathedral of Trier.

Under his rule, Trier became a flourishing centre for scholarship and the arts. Not only have we the evidence of surviving illuminated manuscripts, precious reliquaries, and ivory carvings, but the literary sources demonstrate clearly that only a small fraction of the work commissioned in Trier remains. We read of gold and silver reliquaries, crosses, and Gospel Books with jewelled covers being carried in procession. The archbishop's own gifts to his church included gold and silver crosses, and even the abbey of Egmond received a gold cross and a silver reliquary from him. The fame of Trier spread beyond its own diocese, and from the letters of Gerbert of Aurillac we learn that Adalbero, archbishop of Reims, had a golden cross of his own design made at Trier.[21]

Three outstanding pieces of goldsmiths' work commissioned by Egbert still survive.

One thing all three have in common is the use of magnificently luminous translucent enamels of both the 'sunk' and 'full' kind. But even in these enamels differences of workmanship are very obvious, and in the gem settings, filigree, and a large variety of different decorative motifs the work shows astonishingly little unity. Each seems to have been made in a totally different workshop, using different sources, techniques, and principles of composition, and indeed, if the evidence for Archbishop Egbert as the donor for all three pieces were not so overwhelming, no one would have dared to attribute them all to one centre. It is true that they may be of fairly widely differing dates. All three must, of course, have been made during Egbert's episcopacy of 977–93, but only one of them, the staff-reliquary of St Peter, now in the Limburg Cathedral Treasury, is dated by inscription to 988 (Plate 90).[22] According to legend, the staff itself was given by St Peter to Eucharius and Valerius, the first and second bishops of Trier, who brought their companion St Maternus, the first bishop of Cologne, back to life by touching him with it. It remained in Trier until it was taken to Metz for safekeeping during a Norman raid, and in the tenth century Archbishop Bruno (d. 965) took it to his cathedral at Cologne. His successor, Archbishop Warin, returned part of it to Trier in 980, and Egbert mounted it in 988 in its present form.[23] The full length of the staff is covered in gold foil, decorated with busts in relief of ten popes and ten archbishops of Trier – unfortunately they have been flattened, so that next to nothing remains of them. The staff is capped by a sphere, divided into eight trapeze-shaped areas by straps set with gems alternating with pearls and decorated with serrated-edged filigree. The trapeze-shaped areas are taken up by 'full' enamel plaques, with broad plain gold frames, and depict in the upper half the four Evangelist symbols, and in the lower St Peter with SS. Valerius, Eucharius, and Maternus. Below this, on the neck of the staff, two rows of six trapezoid enamelled panels show the twelve Apostles, separated by groups of six closely bunched gem and pearl settings in pyramid form.

The larger gem settings on the central band of the neck decoration and on the sphere are raised on arcades of twisted wire, and these, as well as some of the less elaborate mounts, include a strip of coiled gold wire similar to the settings on the crown of Otto II. On the crown, however, these coils of wire serve in most cases to hold the gems themselves, while on St Peter's staff they decorate only the collar of the setting and are neatly contained by a twisted wire above and below them. This shows a tendency towards greater severity in the handling of goldsmiths' techniques, and some of the richness and ostentatious display of the crown or even of parts of the 'Gisela' treasure, like the great round brooches, are here replaced by more disciplined and well-balanced and altogether less riotous forms. It is precisely in this more restrained and 'cooler', usually carefully balanced symmetry that the northern Carolingian traditions seem to re-assert themselves. The very rigid filigree design on the main band between the Apostle plaques on the neck, for example, reminds one of the filigree surrounding the central disc with the Virgin on the Gauzelin book-cover at Nancy, dating from the first half of the century (Plate 74).

This tendency towards restraint and severity and the influence of northern Carolingian traditions is carried even further in parts of the most important surviving piece

made for Egbert, the portable altar and reliquary of the sandal of St Andrew (Plate 89).[24] All along the frames of the main rectangular box of the reliquary, enamelled plaques alternate with plaques set with large or smaller gems, decorated with very simple, plain, and severe scrolls of filigree. On each plaque, set with one of the smaller gems, four flat, heart-shaped garnets are placed radially. Both these very simple forms of filigree and the heart-shaped garnets seem to be derived from the work made in the ninth century in the Court School of Charles the Bald. Heart-shaped garnets appear on the paten of Charles the Bald (Plate 60),[25] and filigree applied with similar severity and precision can be seen on the cover of the Codex Aureus from St Emmeram (Plate 55).[26] These links with Carolingian tradition are further emphasized by the cut garnets that decorate the lid of the third object commissioned by Egbert, the reliquary of the Holy Nail, still at Trier (Plate 91).[27] Here the garnets are shaped and given foliate forms exactly like those on the same two pieces from Charles the Bald's workshop.

The decorative enamels on the reliquary of St Andrew are of two quite distinct kinds. On the long sides of the box, small, delicate patterns are framed by wide gold frames, quite unlike any other earlier decorative enamels that have survived.[28] On the shorter sides of the altar, 'full' enamel plaques are used, which must ultimately be derived from the patterns on the Milan altar in Italy, or the same tradition in the form in which it was known in the north, on the mid-ninth-century Metz book-cover now in Paris (Plate 41).[29] The actual foliate forms used by the Trier goldsmith, however, are far harder, more 'metallic' than the ninth-century examples on which they are based. And again, this increase in severity and precision is taken even further in the magnificent Nail reliquary, where the enamels attain a kind of technical perfection that is astounding in its own right.

The four enamels of the Evangelist symbols on the sides of the casket are among the largest figurative 'sunk' enamels made north of the Alps. The free handling of the cell structures, with many 'wavy' lines, and the technical mastery with which the enamel itself is fused show that northern goldsmiths were already surpassing their southern masters. Even eleventh-century Italian and Byzantine enamels were not handled more skilfully. Nevertheless, the debt these goldsmiths owed to Mediterranean inspiration is clear: not only to Byzantine enamellers, who had already more than a century of work-shop traditions in the production of large figurative cloisonné enamels behind them, but also to those working in other techniques. This is shown most convincingly by the tremendously rich decoration of the two shorter sides of the St Andrew reliquary. On one, two large saltire crosses (perhaps because of St Andrew?) are made of pearls strung on gold wire,[30] and similar small pearls split up the other into a series of small arches, around a garnet brooch, a pre-Carolingian relic with a Byzantine coin of Justinian II at its centre.[31] The pattern of this latter side is surely one taken from Byzantine silk. It appears, for example, on the saddle of the tenth-century elephant silk found in the shrine of Charlemagne at Aachen,[32] and an imitation of a Byzantine purple silk which covers the background of the so-called Bible of St Bernward of Hildesheim of the early eleventh century[33] shows exactly the same pattern, even with 'pearled' borders to the arches. The Byzantine origin of these sides is underlined by the technique of thin pierced

gold that is laid over the red glass, and the patterns of this gold. As well as the four Evangelist symbols that surround the Frankish brooch, we find animals and birds, singly and in pairs, adossed or affronted, animals or birds facing trees, and pure foliate scrolls. Not only the technique, with gold foil cut out by chisel, but most of these patterns can be found on Byzantine jewellery as early as the sixth and seventh centuries. Crescent-shaped earrings and necklace links, as they are preserved in the British Museum[34] and in the Dumbarton Oaks Collection at Washington,[35] provide very precise models for these ornamental details.

The whole altar rests on four feet of gilt bronze, in the form of crouching lions with rings in their mouths, supporting short columns of baluster shape, ringed by pearl wire. The lions' heads with rings are, of course, derived from door-knockers already known in Carolingian times in the bronze doors at Aachen Palace Chapel, and the motif of crouching lions carrying columns is, ultimately, also inspired by a classical model.[36]

The goldsmith who worked on Egbert's reliquary must also have been commissioned by the regent, the Empress Theophanu, to make the book-cover of the Codex Aureus from Echternach (Plate 92).[37] She appears as donor along with her son, Otto III, who is described as 'Rex'. The saints who are represented on this cover in embossed gold are all closely connected with the abbey of Echternach, near Trier. The Virgin and St Peter are the patrons, St Willibrord is its founder, St Boniface and St Liudger were members of the same mission as the founder, and St Benedict made the rule under which the abbey lived. The manuscript which is now under this cover was written later, between 1053 and 1056, but the cover must date from between Otto III's royal coronation of 983 and Theophanu's death in 991. The centre ivory of the Crucifixion was probably carved for its present position when the cover was re-used, between 1053 and 1056.[38] The technical perfection and rigid design of the enamels and their rich and vivid range of colours, as well as the decorative plaques, set with gems, heart-shaped garnets, and simple filigree between them, prove this cover to be from the same workshop as the St Andrew reliquary.

One more fragment may be attributed to Trier. It is a small frame, probably origin-ally part of a book-cover, from the Beuth-Schinkel Collection, now in the Staatliche Museen, Berlin.[39] It has been suggested that this fragment is by the master of the Egbert shrine, perhaps made somewhat earlier than his splendid reliquary.[40] And indeed, in the looser use of filigree and the resemblance of the small decorative enamels to those on the Gauzelin chalice and paten there may well be an indication that some of these techniques were already established at Trier by the beginning of Egbert's reign. One more feature on the little frame, the use of corrugated gold foil at its inner edge, also found in the Gauzelin pieces, would support this assumption, though the heart-shaped garnets on the frame point forward to the later Egbert workshop.[41]

But in spite of such slight indications of the beginnings of northern traditions, there can be no doubt that it was the renewed contact with Italy after the imperial coronation in 962, and more intensively in the last years of Otto II's reign under the strong influence of Theophanu's Byzantine taste, which led to the flowering of goldsmiths' work in Germany. In this, the inspiration of imported masterpieces like the imperial crown,

Otto II and Otto III's crowns, and the bulk of the Gisela treasure played a major role. The dates at which Egbert's commissions were given are unfortunately not recorded, with the exception of the staff of St Peter. The close relationship to the imperial court that would seem to have been essential and which is attested by the Echternach book-cover would make it likely that the workshop was active either before the death of Otto II in 983, or after the reconciliation of Egbert with Theophanu in 985, after Egbert's support of Henry the Wrangler's claims to the regency, and perhaps even the crown, in 983–4. Both the date of the staff, which is 988, and an even more compelling reason, the appearance of Otto III on the Echternach cover, make the early period of Egbert's reign, from 977 to 983, impossible. It is true that the staff may have been worked by a different hand from the other three pieces (and almost certainly, but for the enamels, was), and one should not be more precise than to place the work between *c.* 985 and Theophanu's death in 991, or, in the case of the Nail reliquary, Egbert's death in 993. But, with the less consummate skill in the enamelling on the staff in mind, one can argue that the Trier workshop reached its peak between 988 and 991.

The Patronage of Mathilde, Abbess of Essen

The enamels on the staff of St Peter were, however, not the earliest Ottonian enamels made north of the Alps. In 973, Mathilde, one of Otto the Great's grand-daughters, became abbess of Essen. She donated together with her brother Otto, duke of Bavaria and Swabia, a magnificent gold cross to her church (Plate 93). On the cross, near its base, a large rectangular enamel shows Mathilde and Otto holding a staff surmounted by a cross between them – almost in the manner of Constantine and Helena with the True Cross. Duke Otto died in 982, and the cross is therefore not likely to have been offered any later than that year. It is the first of a whole series of splendid Ottonian altar crosses to have survived, no less than four in the treasury of Essen Minster alone. The ends are elaborately moulded in almost classical manner, overlaid by a flat triangular field, and the figure of Christ in embossed gold is surrounded by a frame of gems alternating with paired pearls. The titulus at the top is in delicate cloisonné enamel, and the crossed halo of Christ is set with jewels and filigree and was originally surrounded by a string of pearls. Below the feet of Christ, a coiled snake appears. Both for this motif, and for the whole concept of Christ on a jewelled cross, the antecedents are Carolingian, especially the School of Charles the Bald – the later Lindau book-cover being the closest parallel. The coiled snake figures prominently on ivories in the style of the Reims School. The style of the figure of Christ resembles to a marked extent that of the famous wooden crucifix given to Cologne Cathedral by Archbishop Gero (969–76).[42] The slightly sagging, suffering figure of Christ, with its softly modelled torso, the loin-cloth knotted on his right hip, is the one that was to dominate the representation of the crucified Christ in the Rhineland for more than half a century.[43]

There seems little doubt that the patronage of Mathilde of Essen, so closely linked by family ties to the imperial court, was responsible for the first flowering of goldsmiths' art in the Rhineland, nearly ten years earlier than Egbert's great workshop at Trier.

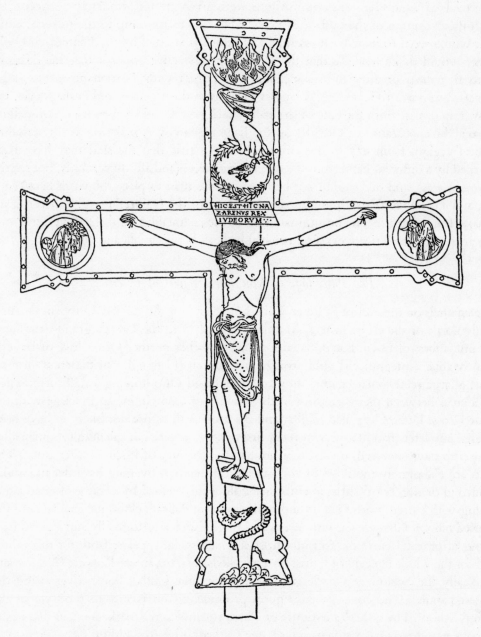

Figure 3. Lothar Cross (back), *c*. 985/91. *Aachen, Palace Chapel, Treasury*

Whether her goldsmiths worked at Essen itself, or at near-by Cologne, as has been suggested, is not at all certain.[44] Far more important, however, are the close links that can be shown to exist between it and the court. Perhaps one of the most magnificent gifts made by the imperial court to any church is the so-called Lothar Cross in the Aachen Treasury (Plate 95). This gold altar cross, jewelled on its front, with a great Antique cameo of the Emperor Augustus at the centre[45] and a superb engraved figure of Christ on the reverse (Figure 3), is, in its main structure at the ends of the cross, identical with Mathilde's cross. Also, in the filigree on Mathilde's cross – for example on the triangular pieces – one can see that the strands of the scroll, where they bifurcate, cross over one another. This curious feature is also found on the Aachen cross.[46] Although only a very small amount of enamel is used, on the mouldings at the ends of the cross, it is of outstanding quality and of a pattern that shows its immediate derivation from Byzantine sources. This blue and white stepped cross pattern is most popular on high-class Byzantine work, as, for example, on the Limburg reliquary of the Holy Cross, made at Constantinople between 945 and 989.[47] The same very strong Byzantine influence is also to be found in the silver-gilt engraved Crucifixion on the reverse – where the coiled snake around the foot of the cross again looks very like the snake on Mathilde's first cross. It is difficult to see why the Aachen cross is always dated as late as c. 1000 and believed to be the gift of Otto III to Aachen when he opened the tomb of his great predecessor, Charlemagne, in that year.[48] In its clear articulation at the ends, it is much closer to Mathilde's cross made before 982. Neither of the Essen crosses made later in the century articulates the ends with quite such care; they only retain the outline in a flat and simplified form. There seems certainly no reason to date it any later than the eighties, perhaps given by the Empress Theophanu between 985 and her death in 991. It is even tempting to see the Lothar Cross as the model for the first cross of Mathilde, which would mean that it was given to Aachen very late in the reign of Otto II.[49]

The second splendid altar cross must have been presented to Essen by Abbess Mathilde before her death in 1011 (Plate 94). It also has a large rectangular enamel on the lower arm of the front, representing Mathilde before the Virgin and Child, and its design is based on the earlier cross. Along the edges of the jewelled frame, gems alternate with small rectangular decorative enamels, the ends are simplified, the workmanship is on the whole less impressive, and the cast crucifix figure now on the cross is a replacement of the second half of the eleventh century. Almost certainly, this cross is somewhat later in date, probably of the early eleventh century. The engraved back plate certainly shows a more advanced style of ornament when compared to the very simple foliate scroll engraved on the reverse of the first cross (Figure 4).

Far more puzzling is the third great cross in the Essen treasury (Plate 96).[50] No inscription tells us whether this, too, was given to Essen by her generous abbess, Mathilde. The large enamels that decorate it, the Crucifixion with the Virgin and St John in the centre, and the Evangelist symbols at the four extremities, are comparable only to the magnificent 'sunk' enamel plaques on Egbert's St Andrew reliquary. Such a comparison, however, shows clearly that the Trier workshop achieved a greater degree of refinement and precision. It is true that the alternation of gems and enamels in its

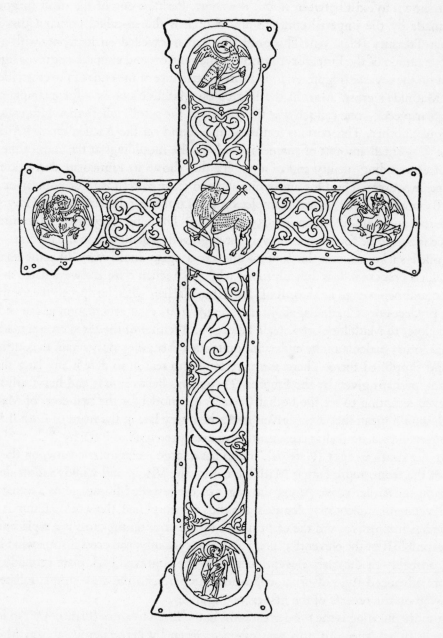

Figure 4. Altar crosses of Abbess Mathilde and Duke Otto (back), 973/82 (*above*) and 973/1011 (*right*).
Essen Minster, Treasury

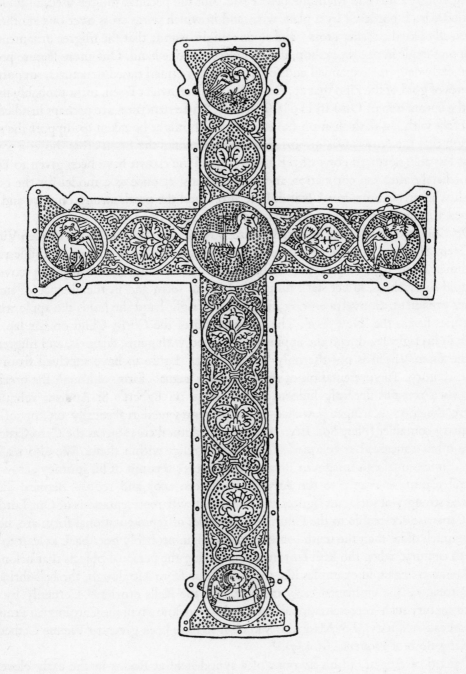

borders tempts one to see this cross nearer in date to Mathilde's second cross than to the one given by Otto and Mathilde before 982. But the peculiar filigree used, in which a pearled wire is bordered by a plain wire, and in which wires cross over one another, is all exactly like the earlier cross – and so one might assume that the filigree ornament on both was made in one workshop, if not, indeed, by one hand. One more feature points to an early date: the expanded ends of the cross have small raised structures, supporting spheres of gold of the kind that appear on the small crown at Essen, most probably made for the coronation of Otto III in 983 (Plate 88). These structures are perhaps handled on the cross with less dash than on the crown, which might be taken to support the suggestion that the crown was imported from Italy, while the Essen cross shows a somewhat less able northern copy of this motif. Could the crown have been given to Essen immediately after the coronation and served almost at once as a model for the goldsmith who created the cross? If it did, he also found the pearls strung on wire and the looped wire gem settings to his liking and made use of these too.

Otto III's crown, suitably reduced in size, now sits on the head of the Golden Virgin of Essen. She, too, must have entered Essen Minster while the Abbess Mathilde ruled the house (Plate 97). Only just under life size, with a wooden core completely covered by gold sheet, she is, in her stark simplicity both in form and in the absence of superfluous ornament, an overpowering image. In her right hand she holds the apple which identifies her as the 'New Eve'. The crossed halo of the Christ Child on her lap, the book in his right hand, and the apple are decorated with gems, enamels, and filigree.

The Essen Virgin is not the only 'monumental' figure to have survived from the tenth century. The presentation of the relic in its 'actual' form, although the precious relic itself remains decently hidden, is also found on Egbert's St Andrew reliquary, where the foot wearing a jewelled sandal is represented realistically on top of the reliquary container (Plate 89). Even such large sculptural creations as the Gero Crucifix were often conceived as reliquaries and carried relics within them. We also read of three-dimensional cult images in Bernard of Angers's account of his journey across the central plateau in France to the Auvergne between 1007 and 1020.[51] Bernard disapproved strongly of such cult figures and stated that only representations of Our Lord on the Cross are acceptable to the Church. Reliquaries of representational form are, however, much older than the tenth century: their origin probably goes back at least to the eighth century, when the Irish custom of enshrining the personal objects that belonged to the saints began, in examples like the belt-shrine from Moylough, the bell-shrine of St Patrick, or the enshrined early croziers, like the Kells crozier.[52] Certainly by the ninth century such 'representational' reliquaries were known in the Carolingian Empire, and a head-reliquary of St Mauritius is known to have been given to Vienne Cathedral by King Boso of Provence (d. 887).[53]

Bernard of Angers, in his account of a synod held at Rodez in the early eleventh century, gives us a vivid impression of the large number of monumental reliquaries in use at the time. He relates that the delegates brought the relics of their saints with them, either in shrines or in 'reliquaries in the form of gilt statues'. An assembly of saints was divided among the tents and pavilions at the foot of the hill on which the city stands:

there were 'the golden majesty of St Marius', the follower of St Austremoine, the first bishop of Clermont and patron of the abbey of Vabres in the Rouergue; 'the gold majesty of St Amand', the second bishop of Rodez; 'the golden shrine of St Saturnin', the first bishop of Toulouse; and a golden image of the Virgin and 'the golden majesty of St Faith'.[54] On the golden reliquary of St Faith at Conques, the only one of these to survive (Plate 98), the full-length figure is seated on a high throne. The monks of Conques acquired the saint's relics between 863 and 883, and the present reliquary was probably given to the abbey by Bishop Étienne II of Clermont-Ferrand (940–84). Certainly, again according to Bernard of Angers,[55] the statue must already have been in existence soon after 984, because two doves were added to the arms of her throne by Bernard of Beaulieu, who was elected abbot in that year. The head of St Faith is a re-used fifth-century Roman gold parade helmet, into which enamelled eyes were set, and the figure has been enormously enriched by the many gems, parts of reliquaries, etc. presented to her by the pilgrims that have come to worship her over the centuries. The double-arched crown she wears, and the broad strips of filigree set with gems that border the neck, the sleeves, the hem, and the throne, were all probably added in the late tenth century. The arms and hands are a somewhat disturbing restoration.[56]

Under the wealth of decorative enrichment, it is virtually impossible to analyse the style of the mid-tenth-century figure, but it is clear that it has a very rigid structure compared to the Essen Virgin's much more fluid and sensitively modelled forms. The same rather barbaric rigidity is found in one or two more three-quarter-length reliquary figures, which give us some idea of the kind of reliquary 'idol' described by Bernard of Angers. The reliquary of St Césaire at Maurs may well be basically of this early date, although some of the decorative metalwork, especially on the borders of his chasuble, may be attributed to a twelfth-century restoration of the figure. The corpus of the reliquary of St Baudime at Saint-Nectaire, however, is undoubtedly of the tenth century (Plate 99). Here, too, the figure has suffered much restoration. The head, probably originally in wood, was replaced by a somewhat ill-fitting bronze-gilt head made in the second half of the twelfth century. The hands are almost certainly of even more recent date, but the very flat treatment of the figure itself, with delicately drawn edges to the drapery, clearly represents the early stage of the development of a relief style which was to produce work in the early eleventh century like the silver Beaulieu Virgin in France and the Basel antependium in Germany.[57] In such a detail as the chequerboard pattern below the arms, and indeed in the handling of the relief in general, ninth-century traditions like that of the Bégon reliquary at Conques still play a considerable part. Of the strict organization of forms standing in a predetermined relationship to one another, which was to be the hallmark of the later Ottonian style, one finds only the most tentative beginnings in this figure. The forms on the Saint-Nectaire reliquary are only loosely related, more reminiscent of the lively drawing of the Reims style. On the Essen Virgin, however, the far more three-dimensional sculptural values, though still fluid, are beginning to be carefully balanced against one another. The rounded rhythms of the figure gain the upper hand over the almost irrelevant and accidental fall of drapery folds over these forms. The Essen figure takes another step towards the

realization of Ottonian formal organization, but does not yet bring the organization of surface pattern into full harmony with the underlying forms. In that, it is distinctly immature in the Ottonian sense, and the attribution of the figure to the early period of Mathilde's reign, between 973 and 982, is far more convincing than the more normally given date of *c.* 1000.[58]

<p align="center">*</p>

The same development towards the stricter organization of form can be traced in ivory carving in the last quarter of the tenth century. The first group to show it has been associated with the Trier illuminator known as the 'Gregory Master', named after a leaf showing St Gregory and the scribe, once part of a manuscript of the *Registrum Gregorii*, written for Egbert of Trier about 983.[59] This illuminator is one of the few personalities that it has been possible to isolate in Ottonian art. His style introduces a relative spatial precision and an understanding of the articulation of the human figure based on a fundamental understanding of Late Antique art. His palette and his skilful use of aerial perspective, as well as the sources of his iconography, all emphasize his debt to Late Antiquity,[60] and make the existence of a Late Antique Gospel Book in the 980s virtually a certainty, either at Trier or, more probably, at the court, but available to the Trier scriptorium.[61] Certainly the iconographic sources used for the ninth-century Milan altar must have been available to Ottonian illuminators. One particular scene on the Milan altar, the Nativity, makes this very obvious. The ox is shown lying down in front of the crib with the Christ Child, instead of standing alongside the ass at the back.[62] Now the same extremely rare arrangement appears in the same scene in three manuscripts, a Salzburg Gospel Book, a Gospel Book now in Cologne, and a Collectarium in Hildesheim.[63] All three are eleventh-century manuscripts, although the Hildesheim Collectarium, which is based both in style and iconography on the Lectionary made for Henry II between 1007 and 1014 (Munich, Clm. 4452), has been attributed to the early twelfth century.[64]

Three ivory panels can be most closely associated with the Gregory Master's illuminations, although one hesitates to see the same hand at work.[65] The first is a panel with the Presentation in the Temple, perhaps a fragment of a reliquary casket, now in Berlin (Plate 100).[66] The rounded, smooth forms, flattened by the drapery stretched over them, contrasted with rich details of drapery in the hollows of the figure or spread over the background, can be compared to the Gregory Master's style in the Crucifixion in the Chantilly Sacramentary (Cod. 1447) or the personifications of the four parts of the Empire paying homage to the Emperor Otto II in the single leaf at Chantilly, once probably part of the *Registrum Gregorii* itself.[67] But such a comparison shows at once that although both styles draw upon a classical understanding of the articulation of figures by a clear rendering of drapery patterns, the Gregory Master's figures appear elegant and poised next to the somewhat clumsy and almost rustic creations of the ivory carver. The flat, broad heads do not look like the Gregory Master's thin, refined, and delicately modelled ones and the simplified drapery, painted with a deft impressionistic touch, almost in the true classical, painterly tradition, is replaced in the ivory by a search for

<p align="center">106</p>

weight and mass, and a much greater emphasis on movement.[68] The second panel, showing only a figure of St Nazarius, now in Hannover, treats form in much the same heavy way.[69] An eighteenth- or nineteenth-century inscription on the back testifies that the panel once decorated the cover of a manuscript in the treasury of Trier Cathedral. Trier also played a part in the legend of St Nazarius, although his veneration was more deeply rooted at the abbey of Lorsch, which was dedicated to him, and at Milan, where St Ambrose is said to have discovered his tomb in A.D. 395.[70] Perhaps we should remember the standing figure, surrounded by an acanthus border, carved in Milan in the 980s and now on the cover of Harley MS. 2889 in the British Museum. Some influence from the workshop that carved ivory for the imperial court could certainly be expected alongside the strong Italian influences in the goldsmiths' work already described. St Nazarius seems to be intended to stand on a plinth in the Byzantine manner, although this is misunderstood: and the large inscription scattered over the background is almost certainly a northern adaptation of the common Byzantine feature.

The third piece, and perhaps the one closest to the Gregory Master's personal style, is a panel, now in Berlin, with a representation of the Annunciation. Unfortunately nothing is known of its provenance.[71] The absence of wings on the figure of the angel points clearly to a very direct knowledge of the Late Antique, and in the delicacy of drawing, especially of the heads, there is a marked resemblance to the hand of the Gregory Master himself.

A number of ivory carvings may be related to these three panels of the late eighties of the century. In their flat, massive forms, two of the Magi shown on a panel now in the British Museum are close in style to the St Nazarius panel, and might be attributed to the same workshop (Plate 101).[72] The more delicately carved heads, however, and the architectural details of the background and the acanthus frame, all show a stronger reminiscence of northern Carolingian tradition. The panel must have been part of a very splendid composition – perhaps a kind of five-part diptych with the enthroned Virgin and Child in the centre – akin to the great ninth-century ivory cover that survives from the Lorsch Gospels.[73]

Two more panels, both carved with Evangelists and their symbols, must be related to this group. The better of the two, mounted on a book-cover in the cathedral treasury of Halberstadt in the thirteenth century, shows St John, with a small crouching scribe to his right (Plate 102).[74] The broad face of the saint, with hair fitting his head like a cap, resembles that of St Nazarius, and the rounded forms and sense of movement remind one of the Presentation panel. The drapery of the Evangelist is handled with an even greater precision than on the panels discussed so far. The strange landscape setting is also found on the second panel, showing St Mark and his symbol, now in the Landesmuseum in Münster.[75] Although it is far less skilfully carved, especially in the main figure, it makes use of the same remarkable illusionistic treatment of the landscape, with imaginatively drawn fragments of townscape and parts of city walls, receding one behind the other. This is a translation of Late Antique painterly qualities into relief form, which equals the parallel achievements of the early Metz School or the ivories in the style of the Utrecht Psalter in the first half of the ninth century, when manuscript

models were also transferred into relief carvings. These two Evangelist panels show clearly that they, too, must be based on a renewed contact with the Late Antique. The broad, plain frame of the Halberstadt panel suggests a possible link with the traditions of the school that carved the Magdeburg antependium more than seventy years earlier, but the fuller relief and more complicated drapery structure should perhaps lead one to date the panel into the last decade of the century.

This same absorption of early models and an increasing interest in three-dimensional values can also be seen in three more very large panels of exceptional quality. Again, there is no evidence of provenance. One, with St Gregory, is now in Vienna (Plate 104),[76] and the other two originally formed the front and back cover of a Sacramentary and are decorated with unusual liturgical subjects, probably the beginning of the Mass (Plate 105) and a choir singing the Psalms.[77] When compared with those discussed so far, the strong northern Carolingian traditions in these panels become obvious. The stiff, heavy acanthus of the frames is only a somewhat more precise treatment of this Carolingian motif, and the stiff postures of the figures in the two liturgical panels, the flat treatment of broad, overlapping folds, show both the tradition of the Magdeburg antependium and the influence of the Milan School. The continuing presence of the Magdeburg style is also very obvious in the close-fitting hair, and especially the regular 'blobs' of hair. The softer, more rhythmic treatment of drapery in the Gregory panel is that of a different hand, more aware of the style introduced in the eighties of the century. There remains the heavy architectural detail in all three panels. It has been pointed out correctly that the closest parallel to this can be found on early Byzantine ivories, as for example in the two panels showing heavily robed empresses, one in Vienna, the other in the Bargello in Florence.[78] This emphasis on a rather heavy, imperial style in the Byzantine taste would strongly support an attribution of these panels to an imperial workshop working for the Empress Theophanu shortly before her death in 991, or for her son, Otto III. There is no doubt that panels of such remarkable grandeur and quality must have been among the best that could be produced in the Empire towards the end of the tenth century.

The reign of Otto III was too short to add a great deal. He took the government into his own hands when only fourteen years of age, in 994, was crowned emperor in Rome by his own nominee, his cousin, Bruno of Carinthia – Pope Gregory V – in 996, and died only six years later, in 1002. Had he lived longer, his contribution might indeed have been great. The last twenty years of the century had seen an outburst of creative activity as a direct result of the renewed contact with Italy and the close relationship with the Byzantine court. Otto's ambitions were identical with those of his great ancestor, Charlemagne, whose tomb he so dearly wished to see that he sought it in Aachen, opened it, and took a gold cross from Charlemagne's neck and placed it around his own.[79] He inscribed one of his seals with Charlemagne's own great phrase, 'Renovatio imperii Romanorum', and placed both the German and the Italian chancelleries under one man, his own chaplain, Heribert, archbishop of Cologne, for the first time since the Carolingian era. Like Charlemagne, he collected men around him from all parts of the Empire, not just the Saxon homelands – Gerbert of Aurillac, Hugh,

marquess of Tuscany, Peter, bishop of Como. Thietmar, bishop of Merseburg, says of him that he had the intention to restore in his day the ancient Roman traditions which had fallen into disuse.

After the imperial coronation, Otto spent only a few months north of the Alps. One of the few works that must have been made for him there was the great Gospel Book now in Munich (Clm. 4453) (Plate 103). The gold cover of this manuscript[80] is not obviously linked with any of the workshops we have described. Jewels are arranged on a plain gold ground, roughly in lines, and an effect is achieved more by a rich display of colour than by any formal pattern. Only details, like the small pyramids of pearled wire, indicate any knowledge of the goldsmiths' techniques that had been employed on earlier imperial commissions, like the Aachen Lothar Cross. But, as might have been expected, it is Byzantine taste that dominates its design. The mounting of gems, isolated against a gold background, is known in Byzantine pieces like the tenth-century silver-gilt reliquary of the True Cross in the treasury of St Mark's in Venice.[81] More obvious, and entirely unexpected, is the mounting of a tenth-century Byzantine ivory carving of the Dormition of the Virgin in the centre of the cover, and above it a tenth-century Byzantine heliotrope cameo of St John the Baptist. It may not have been the first time a Byzantine carving was mounted on a book-cover in northern Europe – the panel with Otto II and Theophanu in the Cluny Museum was probably that – but while his father's panel was an adaptation of a Byzantine formula for his own use, Otto III's book-cover marks an unquestioning acceptance of a Byzantine work of art – perhaps thought to be superior to any panel that might have been carved in the north. During the reign of his successor, Henry II, this trend was, in the main, to be reversed; but the impetus already given by Mediterranean humanism in the last quarter of the tenth century proved sufficient for Ottonian art in the north to create some of its finest works in the early eleventh century.

THE REIGN OF HENRY II

WHEN Otto III died unexpectedly in Italy at the age of only twenty-one, in January 1002, he was unmarried and had no natural successor. With his death, the direct line of the Ottonian emperors of the Saxon dynasty came to an end, and at least two men with strong claims to the throne presented themselves. One was Otto, duke of Carinthia, who was a descendant of Otto I's daughter, Luitgard. The other was Henry, duke of Bavaria, son of Henry the Wrangler and grandson of Otto I's younger brother, Henry. Descent only partly determined the succession; there had also to be election by the German nobles. Fortunately there was no real rivalry between Otto and Henry. Duke Otto, a man of at least fifty, declined to stand for election and urged Henry to secure the throne for himself.

Therefore, when Henry took possession of the imperial insignia as soon as Otto III's body reached Augsburg on its way north to Aachen for burial, it must have seemed that his election was a foregone conclusion. But Herman II, duke of Swabia, and others entered the field, and in spite of an election held at Mainz and Henry's subsequent consecration by Archbishop Willigis of Mainz on 7 June 1002, it was not until the end of the year that he secured the support of the whole of the kingdom. He achieved this partly by force of arms, but more often by skilful diplomacy and judicious promises.

In character, Henry II was a very different man from Otto III. He was at home in his native Saxony rather than in Italy, enjoyed the chase, and was not above playing practical jokes. Whereas Otto dreamed of a revival of the Roman Empire and a renewal of Rome as its capital, Henry brought a shrewd and practical mind to his problems. He had a passion for law and order, and his zeal as a reformer of the Church, as well as his generosity to the Church and a reputation for piety, eventually led to his canonization in 1146.

The history of his reign seems chaotic, but at all times the king's purpose was to bring about a more settled state of affairs. His attempts to reform the Church were linked with an extension of royal control over the bishoprics and abbeys of Germany, pursued with astonishing persistence. Henry's intention to rule with the help of the ecclesiastical hierarchy was even more clear-cut than Otto the Great's had been, and by constant pressure, compromise, or even bribery, Henry succeeded in placing his nominees in every key post in the kingdom.

Wars were continuous almost throughout his entire reign on his eastern borders; and moreover early on Henry lost control over Lombardy. Although he regained the Lombard crown in 1004 at Pavia and was crowned emperor by Pope Benedict VIII in 1014 in Rome, Henry spent little time in Italy. A great deal of evidence survives in the treasuries and libraries of Germany to prove both the lavish generosity of his patronage and its concentration on the Church in his kingdom north of the Alps, but bearing in

mind the political instability at the beginning of his reign and the slow build-up of his ecclesiastical control, it is not surprising that the bulk of it should have come fairly late in his life.

By 993, however, one of the most outstanding patrons among the German bishops of noble birth, St Bernward of Hildesheim, had already been elected to his see. In 987 he had joined the Imperial Chapel and Chancellery, and with the Greek, John of Calabria, was entrusted by Theophanu with the education of the seven-year-old Otto III. Between 987 and 993 he shared in the travels of the court, and probably went frequently to Italy – certainly he was in Rome with Theophanu in 989, returning in the following year to Germany. His biographer, Thangmar, records yet another visit to Rome in 1001 in order to present his case for the rights of the bishop of Hildesheim over the convent of Gandersheim. Bernward's close relationship with the late-tenth-century court gave him every opportunity to aspire to the same high cultural standards.

The Patronage of St Bernward of Hildesheim

The most outstanding contribution to Ottonian art that must be attributed to the Hildesheim workshop, and it seems almost immediately after Bernward's elevation, is the introduction of cire-perdue casting. Three pieces, all cast in silver and partly gilt, must have been made soon after 993. The earliest is probably a crozier head, which bears an only partially surviving inscription on the ring at its base: + ERK – BALD A–B, which has been read, no doubt correctly, as ERKANBALD(US) ABB(AS) (Plate 106). Erkanbaldus, who became abbot of Fulda in 996,[1] was a relative of Bernward. When he became archbishop of Mainz in 1011, Bernward consecrated him, although he was not the most senior of the bishops in the Mainz metropolitan see. It seems therefore very possible that it was also Bernward who consecrated him abbot at Fulda and presented him with this splendid crozier. The crook itself is fashioned of a twisted tree, with the Fall of Adam and Eve represented on the stem, above a decorative knop, pierced and interlaced with bands, foliate forms, and small half-length figures representing the four rivers of paradise. In the centre of the curved crook, God the Father is shown condemning Adam after the Fall, with a book in his hands indicating the future redemption by the word. By the same hand is a pair of silver candlesticks said to have been found in Bernward's sarcophagus, together with a censer that no longer survives, when the saint's remains were translated in 1194 (Plate 108).[2] The two tall candlesticks, 36·8 cm. (about 14 in.) high, are formed of thin stems decorated with twisted inhabited branches of a tree, in which small figures are climbing up towards the light. A central knop decorates each shaft, with another at each end, a wax-pan at the top, and a triangular base carried on lions' feet, with three nude men riding dragons. Not only are the style and casting technique identical with those of the crozier, but both candlesticks bear an inscription that proves that they were made for Bishop Bernward.[3]

With only one exception,[4] no major work in cast cire-perdue bronze survives from the period following the impressive activity of bronze casting at the Court School of Charlemagne at Aachen some two hundred years earlier. What could have been the

sources for the renewed activity in this field? It seems that in the earliest pieces produced at Hildesheim, an interest is shown in purely decorative motifs like the inhabited scroll, reminding one strongly of northern Insular and Carolingian traditions which are most likely to have survived into the late tenth century in simple decorative castings for secular use. A small pierced bronze plaque, probably a horse-harness ornament, in the Halle Landesmuseum, found in the Harz region, has been cited as an example of the kind of material in which the knowledge of casting techniques continued to be kept alive in the intervening centuries.[5] A passage in the *Vita Bernwardi* points to another possible source for Bernward's interest in this technique. When one reads: 'thus, when he found a rare and exceptional piece among overseas and Scottish vessels presented to his royal majesty as special gifts, he knew how to make use of it somehow',[6] one is struck by the fact that this very special reference to imported pieces from Britain might be of some significance. There is certainly evidence that bronze casting of a high standard, often gilt or inlaid with silver, was practised in Britain in the later tenth century. A number of bronze castings in the 'Winchester style', including two very splendid tower-like censer covers decorated with pierced foliate and bird designs and inlaid silver, a small gilt cruet, and a number of related strap-ends and other small decorative bronzes testify to a close relationship in Britain between small secular and relatively unimportant products and much more ambitious ecclesiastical patronage.[7] There is also a close stylistic relationship between a pair of candlesticks now at Kremsmünster and British tenth-century metalwork on the one hand and Bernward's candlesticks on the other. The tall, slim Kremsmünster candlesticks are in type, proportion, and structure very like Bernward's.[8] The style of their ornament, however, is more restrained and far less ambitious. Certainly one can find close parallels to it in tenth-century British art, and it has been pointed out that this may have been the result of continued relations between Kremsmünster and Anglo-Saxon England, which had been so close during the Early Carolingian period.[9] Even the acanthus ornament used in Bernward's workshop, especially, for example, on the underside of the drip-pans of the candlesticks, where it is executed in flat relief, bears some relation to the 'Winchester' type of acanthus. Double-stranded tendrils bound by rings, with rather flat, broad leaves symmetrically arranged, come very close to the kind of foliate decoration employed in Winchester manuscripts illuminated in the last quarter of the tenth century.[10] Even Bernward's figure style is not unlike that of ivories like the small triangular plaque found in Winchester:[11] something of the same lively, delicate handling of the figure is present, with a strong sense of relief almost detached from its background. Yet the resemblance is not strong enough to see any immediate connexion between Hildesheim and the Anglo-Saxon style.[12] A far more likely explanation lies in the fact that both the 'Winchester' style and the Hildesheim workshop drew much of their inspiration from the Carolingian tradition, especially that of the 'Reims' style. The back view of the small climbing figures of the shafts of the candlesticks may be compared very well with the figures of Stephaton and Longinus on the Crucifixion panel in the Bayerisches Nationalmuseum in Munich[13] and also with the style of the book-covers of the Sacramentary in the Munich Staatsbibliothek, Clm. 10077.[14] It has already

been pointed out that it was precisely this style of ivory carving that found a new lease of life in Lower Saxony, especially at Fulda in the tenth century,[15] and it is therefore not at all surprising that this renewed interest in Carolingian models, so clearly shown by the Codex Wittekindeus, which closely imitates a manuscript of the Court School of Charlemagne,[16] would also have provided the main basis for Bishop Bernward's workshop at Hildesheim.

But, as had been the case in the earlier tenth century, not only the style of Reims played a formative role in the creation of new styles. The strong tradition of the Metz School, rooted in Lotharingia, is never far below the surface in the later tenth century. In the magnificent small silver-gilt cross now in the cathedral treasury at Hildesheim, mounted on a fourteenth-century foot, the figure of the crucified Christ shows clearly that its sources are to be found there (Plate 107).[17] On the reverse of the cross an inscription reads: BERNVVARDUS PRESVL FECIT HOC, and goes on to list a number of other relics in the crucifix, including those of St Lawrence, St Stephen, and St Dionysius, as well as relics of the True Cross (Figure 5).[18] In Thangmar's life of St Bernward we are told that the bishop undertook a pilgrimage to Paris and to Saint-Martin at Tours immediately after taking part in Henry II's campaign in Flanders in the years 1006 and 1007, and that he acquired, among others, some relics of St Dionysius at his tomb at Saint-Denis. It is therefore very likely that the new relics were housed in this cross soon after his return, late in 1007 or in 1008. Christ's arms are stiffly outstretched, and his head hangs well down in front of his right shoulder. The upper part of his body is emaciated, and the large, rounded belly swings forward from the Cross and to his left. His thighs show through the large loincloth looped and knotted on the left hip, while the sharply modelled lower legs bend back towards his right, with large, well-formed feet, supported on a supadeum. Its small, almost miniature, scale does not prevent this figure from achieving a powerful, even monumental effect, and with the great Gero Crucifix, carved only two generations earlier, it is among the most impressive images of the crucified Christ to have been created in the Ottonian period. The swing of the figure and the design of the loincloth are most closely foreshadowed by the so-called Adalbero Crucifixion plaque in the Metz Museum (Plate 109),[19] which followed the iconography of the Metz book-covers, especially that now in the Victoria and Albert Museum (G.I, no. 85), very closely. A significant addition is the row of four seated Evangelists with the heads of their symbols – a type that has been called anthropomorphic.[20] What sources might have been available to the Lotharingian carver it is difficult to say. Early examples of the type are relatively rare and found only in some Early Carolingian and Insular manuscripts and in somewhat greater number in Spain.[21] More certain is that this panel might well have served as a source for the school of Helmarshausen in Lower Saxony, where this iconography was to become popular by the early twelfth century.[22] The style of the panel shows those tendencies of greater relief and more precise formal relationships that characterize the work of the tenth century, although it should be said at once that in the Lorraine area, where this style is at home, it maintains a closer relationship to its models and achieves a subtlety and refinement very different from the cruder, more massive forms developed in Germany. One cannot be certain

K

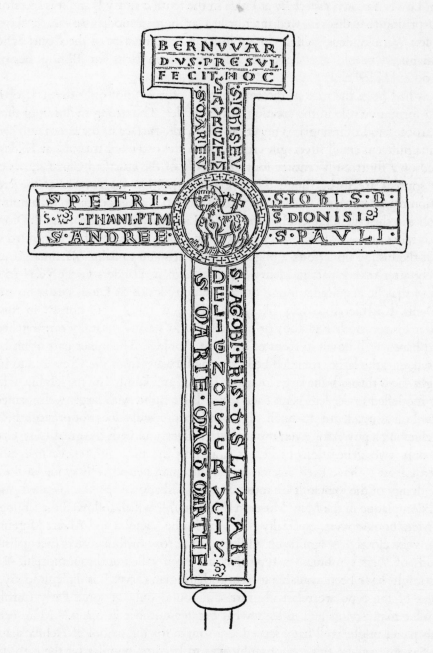

Figure 5. Silver crucifix of Bishop Bernward (back), 1007/8. *Hildesheim Cathedral, Treasury*

of the date of the Metz panel. The inscription placed around the framed bust of the donor at the base of the column that carries the cross reads: ADALBERO CRUCIS XPI SERVUS, but unfortunately Adalbero is one of the most common names in the tenth century: there were bishops of that name at Trier, Brescia, Basel, and Verdun, two at Metz, and the famous archbishop of Reims who died in 989. Because the panel is said to have been found in the sacristy of Metz Cathedral, it is likely to have been carved for a Metz bishop, either Adalbero I, who held the see from 929 to 962, or Adalbero II, who ruled from 984 to 1005. Of these two, the later is usually accepted. The fact that the border acanthus ornament is a very precise copy of the border found on the ivories that decorate the cover of Charles the Bald's Psalter (Paris, Bibliothèque Nationale lat. 1152) (Plate 30), which was then in the library at Metz, lends further support to this attribution.[23]

But even if one makes allowance for this Lotharingian influence on Bernward's crucifix, it must be said that it remains a figure far superior in emotional expression to its models. In part, this may be the result of isolating the figure of the Saviour, which tends to disappear in the rich iconographic programme of the ivory panel. But surely a transformation has also taken place, in which the smooth, classical ivory figure has become a passionate personal statement of faith, and in which a creative artist's contribution is unmistakable.

A work which best bridges the gap between Bernward's small-scale silver casts and the later monumental bronze doors for St Michael, Hildesheim, and the huge bronze column base for a crucified Christ is the great bronze-gilt seven-armed candelabrum, more than seven feet high, in Essen Minster (Figure 6). Although in detail the style of the candelabrum bears only slight resemblances to the Hildesheim workshop, the mere fact that it is cast in cire-perdue bronze leads one to connect its manufacture with Hildesheim.[24] An inscription around the stem near the base tells us that it was commissioned by the Abbess Mathilde, whose other rich gifts to her convent have already been described.[25] The candelabrum stands on a square base supported on four claws, and the rising stem and its seven branches are interrupted by a number of cast openwork knops of square, oval, and hexagonal outline. Each of the seven drip-pans is carried on openwork capitals. On the corners of the base, small cast figures representing the four winds are seated, only one of which survives undamaged. The scroll across its knees is inscribed 'Aquilo', identifying the satyr-like figure as the north wind (Plate 110).[26] It is in these figures that we see the closest relationship with the figure style of Bernward's candlesticks: they have the same thin, rounded limbs, heads with large, globular eyes, and summary treatment of bodies. The drapery of the Essen figures, however, is flatter and broader than the more lively, richer treatment found at Hildesheim, and closer, therefore, to the style current in the ivory carvings commissioned by the court towards the end of the tenth century. The pierced knops are all decorated with very precisely designed and crisply executed foliage patterns, symmetrically arranged. The curious shapes, some built up of squares and triangles resulting in an hexagonal outline, remind one of the conical roofs of the 'Winchester' censers mentioned earlier – as, indeed, does the openwork casting technique. Moreover, where the straight lines

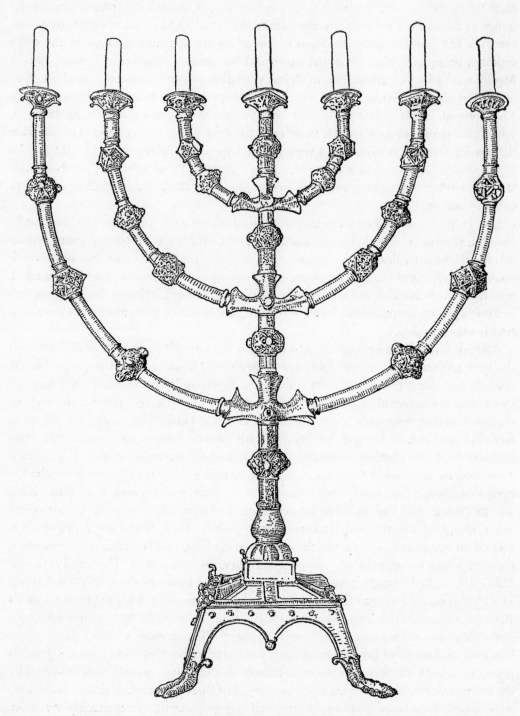

Figure 6. Seven-armed candelabrum, early eleventh century. *Essen Minster*

meet on the more elaborate pieces, small knobs are found on the Essen candelabrum, while the Anglo-Saxon censers use small leaf forms or animal heads, which in their turn bear some resemblance to the rows of seven animal heads that decorate the Essen base. Unfortunately, the leaf-forms at Essen are very different, both in the precision of their casting and design and in the foliage patterns employed, from the censers, where animal forms are never absent from the panels.[27] Some sources nearer at hand provide quite satisfactory parallels to some of the foliate forms used: a book-cover of the early eleventh century in the Wolfenbüttel Library has been shown to use very similar leaf forms in an embossed technique;[28] and the capitals just under the drip-pans also may be compared to stone capitals or imposts carved in Lower Saxony in the first half of the eleventh century, for example the imposts at St Servatius, Quedlinburg.[29] Much of the detail in the Essen candelabrum may therefore be derived from the decorative vocabulary already well established in the Lower Saxon area by the early eleventh century, but the fact that many of these forms were ultimately of Byzantine origin, as has been claimed, cannot be denied.[30] The close connexions of the abbess Mathilde with the court may well have facilitated the introduction of such sources. The renewed interest in casting that we have seen developed in Bernward's workshop at Hildesheim may well be connected with the production of the Essen candelabrum in a general way, but the very slight resemblances of style are hardly sufficient to attribute it to Hildesheim, and there seems little doubt that it was made at Essen itself, probably by an itinerant master – certainly no other piece survives which could be attributed to the same workshop.[31]

The activities at Hildesheim, however, can be shown to have continued for at least another decade. A small bronze crucifix figure from the abbey of Ringelheim, still preserved there in the parish church, provides a link between the early small-scale silver casts and the beginning of very large-scale bronze castings at Hildesheim. Just over 7 in. high (18·2 cm.), this small bronze is more delicately modelled than Bernward's silver crucifix: its gentler form, especially the fluid treatment of the loincloth, comes much nearer to the style of the great doors of St Michael at Hildesheim, for example the figure of Adam hoeing in the field (Plate 113). When the figure was given to Ringelheim is uncertain, but it might be remembered that Bernward's sister Judith was abbess of Ringelheim until her death in March 1000, and relations between the abbeys may have been close beyond that date.[32]

By 1015, Bishop Bernward had commissioned the magnificent pair of doors for his foundation, the abbey of St Michael (Plates 111–14). These doors are now preserved in the cathedral, where they were taken by Bishop Godehard, probably before 1035, to grace the entrance to the nave from his 'paradise with high towers' – the 'Westwerk' of his cathedral. It has been suggested that originally, at St Michael, the doors were mounted in two separate doorways, some eight bays of the wall-arcade apart, in the south wall of the abbey church.[33] The inscription of the slightly broader frame across the centre of the door must have been added after the doors were moved by Bishop Godehard. It was certainly added after Bernward's death – it speaks of his name as 'of holy memory' and tells us that Bernward had the doors mounted in the façade of his 'Temple of the Angel' (St Michael) in 1015.[34]

The huge doors are nearly 5 metres (about 15 ft) high and each one of them seems to be cast in one piece, even including the lion's head that carries the loose ring handle. On the left wing eight scenes from the Old Testament are represented, from the Creation of Adam at the top to Cain's murder of Abel at the bottom, and on the right wing the scenes begin with the Annunciation at the bottom and continue to the Noli me tangere at the top. The iconographic programme is clearly a carefully constructed one, in which scenes on each wing at the same level form a subtle thesis and antithesis – for example, the Fall of Man is found opposite the Crucifixion, contrasting the Fall in the Old Testament with the Redemption in the New, and the Expulsion from Paradise is compared to the Presentation of the Saviour in the Temple. The whole theme of the two doors is one of Fall and Redemption – of decline, emphasized by running the scenes downwards, and of new hope, with the scenes rising towards the top. So close is the relationship of scenes, that one finds it difficult to believe that they were ever placed eight bays apart – surely they were designed to be seen as a pair of doors. Bernward's personal interest in the workshops at Hildesheim, vouchsafed by his biographer, would obviously support the assumption that he devised this highly intelligent programme personally.[35]

Great bronze doors were not new to Bishop Bernward. The splendid doors at Aachen made for Charlemagne were, of course, well known to him, and when he installed his friend and relative, Erkanbald, as archbishop of Mainz in 1011 he must have seen the large bronze doors made for that cathedral by commission of Archbishop Willigis (975–1011).[36] But in both these cases the doors, although cast in bronze in one piece, were not decorated by figural scenes. At Augsburg, however, a large pair of bronze doors decorated with reliefs had been made in the early eleventh century. Here, the technique differed considerably from that of the Hildesheim workshop. Thirty-five panels are embossed with single subjects (some are repeated twice) like Samson and the lion, King David, a centaur, a lion, and single warriors, and these panels are mounted on a wooden core, with a flat framework between them, decorated at intersections by small cast human heads. The relief is rather flat and summary, and the technique and structure of the whole pair is closely related to that of Byzantine doors found in Italy.[37] Clearly there is no direct connexion between the Augsburg and the Hildesheim doors, but that bronze doors were being fitted was probably known to Bernward. It should also be remembered that he must have seen the fourth-century wooden doors of Sant' Ambrogio in Milan and the fifth-century wooden doors of Santa Sabina in Rome.[38] The latter, especially, might have been of interest to him, because both Old and New Testament scenes were on it, perhaps with a similar programme of thesis and antithesis. But only the ideas could have been derived from such sources – in style and in layout, none provides any inspiration for the Hildesheim achievement.

In general approach, the style of all the scenes on the doors of St Michael is surprisingly uniform. The strong relief of the figures is contrasted by a flatter, 'paler' treatment of decorative or architectural settings. The figures are spaced out in each scene, and a refined and deliberate balance between them and the plain areas and decorative detail is achieved. It seems almost as if the climax of the story, the Passion,

shown in the two scenes of Christ before Pilate and the Crucifixion, has been accorded a special emphasis by a richer display of contrasts in light and shade, achieved by a denser grouping of figures. The handling of the relief, firmly attached to the background in the lower part of the figures and growing out of the background towards the head and shoulders, so that every head is modelled fully in three dimensions, is another feature that underlines the homogeneity of the style. Nevertheless, the hands of individual sculptors can be identified in the details of drapery, physiognomy, and setting. Clearly the master who modelled the stiff drapery, almost like plate-armour, of the high priest in the Presentation scene could not be the same that modelled the fluid, soft drapery of the Adam hoeing in the fields. And yet it cannot be said too often, the total effect of both doors achieves a uniformity that must indicate that a single mind exercised considerable control over the whole work. Whether this was Bernward himself cannot, of course, be stated dogmatically, but it might be worth while to remember that Bernward's biographer tells us that the bishop spent much time in his workshops and was a practising artist in his own right, although he did not achieve 'the peaks of perfection'. The kind of control exercised by the eminent bishop could easily have extended beyond establishing the programme towards a general overseeing of the work which resulted in the open layout and the same overall development of relief.[39]

The doors must have been cast between Bernward's return from Mainz in 1011 and 1015, when they were installed. It has not been possible to find very precise sources for either the iconography or the style. Iconographically the Carolingian traditions of the Genesis cycles in the great Bibles illuminated in the Tours scriptorium come to mind at once: not only can individual scenes be compared, but the whole structure of the illuminated page, divided up into three or four long rectangular frames, bears a general resemblance to the doors. Of the idea of a continuous narrative, derived from the Early Christian rotulus, and still so obvious in the Bibles, a vestige remains in the first scene of the doors, the Creation of Adam, where Adam appears twice, once in the process of being created, the second time behind the tree on the right, about to meet God the Father – a scene which is also part of the cycle in the Bible from San Paolo fuori le Mura, based on Tours tradition, written for Charles the Bald, probably at Saint-Denis about 870.[40] These Bibles cannot have been the direct source, however, or not the only source. The scenes of Abel and Cain's sacrifice and of Cain slaying Abel are not represented in them.[41] The pictorial tradition must, however, have been very close to them, for the relationship between figures and landscape setting is similar, and so are details of composition, especially compared with the Charles the Bald Bible.[42]

Unfortunately no direct evidence for a similar tradition survives for the New Testament scenes. The Early Christian New Testament cycle introduced at the imperial court in the last quarter of the tenth century seems to have had very little effect on the Hildesheim workshop, and only in some of the landscape and architectural settings can a faint echo of an influence be traced – mushroom-like trees and arches with heavy, square castellations which appear in the manuscripts connected with the court are used in some of the panels on the doors.[43] But no really close iconographical links exist. That the sources for the New Testament iconography at Hildesheim may have been

long established Carolingian types is suggested by the connexions with the Lorraine region. We have already seen that the small silver crucifix made for Bernward was based on a Lotharingian ivory panel, probably made for Bishop Adalbero II of Metz. There is also a marked resemblance in the treatment of space, the architectural setting, and the spreading of the figure subject across the picture between the Hildesheim door – for example in the scene with the Three Magi – to the Lotharingian ivory panel with the Marriage at Cana, now in the Cleveland Museum (Plate 115).[44]

This ivory is clearly an Ottonian copy of the Carolingian panel in the style of the Utrecht Psalter, with the same subject, now in the British Museum (Plate 116).[45] In spite of the transformation of the style into a characteristically Ottonian form, in which the illusionistic treatment of relief of the Carolingian panel is changed into one of spatial clarity, created by a firm, flat figure style with architectural features lucidly displayed across the plane of the relief, the basic Carolingian iconographic tradition is carefully preserved. The style of the Lotharingian panel was obviously a strong, perhaps the strongest single influence on the Hildesheim doors, and the tenacity of the survival of Carolingian traditions in that region, often in style but even more persistently in iconography, would support the suggestion that the sources for Hildesheim are likely to be there. But Lower Lorraine was not the only influence on the remarkably eclectic style of the Hildesheim doors: very close parallels can also be found in the very few fragments of monumental stone sculpture that survive from the late tenth century, from St Pantaleon in Cologne, now in the Diocesan Museum. The head of Christ in the scene of the Noli me tangere in the doors has been compared very convincingly with the most completely preserved head from St Pantaleon.[46] There is good reason for this influence from Cologne, for Goderamus of St Pantaleon, later appointed first abbot of St Michael at Hildesheim, was called to Hildesheim by Bishop Bernward, together with several brothers, in 996.

Another remarkable product of major bronze casting of the same workshop is the great bronze column that once supported a crucifix, which is also preserved in the cathedral of Hildesheim (Plates 117–19). This huge column, more than twelve feet high, cast in a single hollow piece, with only the base cast separately, is decorated with a continuous band of twenty-four scenes of Christ's ministry, beginning at the bottom with the Baptism in the River Jordan, and ending with the Entry into Jerusalem at the top. The capital now at the top was added to the column in 1871: the original crucifix it carried was destroyed in 1544, and the original capital lost in 1650, when a wooden replacement was carved, which might have been used as a model in 1871 and therefore may be closely based on the original design. At first sight, the relief style differs considerably from that of the doors.[47] The figures are developed out of the background to the same height for their entire length, instead of the increasing relief on the doors leading to heads being fully three-dimensional. Also, instead of the sophisticated balance between relief and flat background on the doors, the column is covered much more evenly and densely by the continuous procession of the narrative. And yet a careful comparison between individual heads and figures can show that the two works are related. For example, the head of Pilate on the doors is as roughly cut into the wax,

as heavy in its forms, as thick in its details (such as the beard), as the one completely surviving three-dimensional figure on the column, one of the four rivers of paradise, seated on the base.[48] Particularly close are the panels with the sacrifice of Cain and Abel and the murder that follows and the Christ before Pilate scene on the doors to many of the figures on the column,[49] and it would not seem impossible that at least one of the hands that worked on the doors also played a part in the production of the column.[50]

But the existing Hildesheim traditions cannot explain the column entirely. The most obvious source is, of course, the great classical columns that celebrate the triumphs of the Roman emperors, the most famous one, no doubt well known to Bernward of Hildesheim, being Trajan's Column in Rome, set up in A.D. 137. Again, in the broadest sense, the contact with classical Italy underlies Bernward's achievement – the column represents the Triumph of Christ in his worldly deeds, leading to the Passion, and summed up in the Crucifixion which once formed its climax, both in meaning and in visual impact. Just as this concept of the adaptation of Antiquity to a new Christian purpose is rooted in the Carolingian period – the miniature triumphal arch made for Einhard is the most striking example – so, too, the art of Hildesheim seems to derive much of its direct sources from the Carolingian tradition. The dense figure composition of the column, and, indeed, some of the detailed treatment, especially the broad, rather round and flat heads with short, thick beards and large eyes, owe much to the ivories of the Metz School.[51] Again, the direct sources of the iconography of the column are as difficult to determine as those of the New Testament door had been. Unfortunately no scene is common to both the door and the column, but some of the architectural detail and a few mushroom-like trees, as well as the treatment of the ground on which the figures enact their scenes, seem to suggest that an identical New Testament cycle might have been used. If so, it seems that the column, with its tighter grouping of figures and more fluid narrative style, kept closer to the source than the door, where all superfluous figures were rigorously suppressed. Just as the style of the column is reminiscent of Metz, what few indications there are suggest that the iconography might have come, at least in part, from the same Metz tradition which has been shown to have played such a major formative role earlier in the tenth century.[52] Both the Baptism scene and the Nativity on the Metz casket at Brunswick[53] have features in common with Hildesheim work. On the column, the Baptism has an attendant angel with nimbus and with hands covered, the water rising to the chest of the nude Christ, the river god Jordan, with the water flowing from his urn, and the dove descending with spread wings from above – all as on the Brunswick casket, where a very similar dove appears on the lid. The elements of the Nativity scene on the door, although somewhat differently arranged, all appear on the side of the casket. The Virgin reclining on a day bed, the swaddled child in the crib, and the seated St Joseph, with his head supported by his hand, all are similar, and even the far more unusual servant girl appears in both, behind the bed on the casket, but in the middle of the scene on the door. Certainly these comparisons are at least as close or closer than any that can be made with the New Testament iconography of the later tenth century in the manuscripts at Trier or those connected with the imperial court.[54]

To date the column is not easy. The close dependence of the relief style on the Metz tradition seems to support an early rather than a late date in Bernward's life, and the fact that its basic inspiration was that of Rome might also be taken to point the same way. Although it is true that the hollow column was technically a more difficult cast to make than the doors, the cruder and flatter relief and the far less subtle surface finish support the possibility that the column was the first monumental cast attempted in Bernward's workshop. It could then have been cast either for St Michael's, begun in 1007, or, if it was intended for his cathedral church, it might have been made between his return from Rome in 1001 – with the grandeur fresh in his mind – and his departure for service with Henry II in 1006.

Another convincing link with the Middle Rhine region is seen at Hildesheim, in the wooden core of a seated Virgin and Child,[55] also undoubtedly made for Bishop Bernward (Plate 120). Originally the group was covered in sheet gold, like the Essen Virgin and the Conques St Faith, but only small fragments of it survive. The heads, three of the four hands, and the major part of the throne have also been lost. Some of the drapery folds, especially the double lines of the sleeves of the Virgin's cloak, show that the carver was not unaware of the style in use among the bronze casters of the door, but the group as a whole differs substantially from the productions of the metalworkers. The restrained outline, the controlled, heavy forms and strict frontality of this group are in marked contrast to the freedom of movement expressed in the figures of Eve suckling Cain or the Virgin and Child on the door (Plate 113). Much closer to it is the ivory Virgin and Child now in the Altertumsmuseum, Mainz (Plate 121).[56] The drapery of the Christ Child, the subtle arrangement of the head shawl falling over the Virgin's shoulders, the composition, the massive, rounded forms – all this is identical in the Mainz and the Hildesheim groups. The Mainz Virgin has long been attributed to Trier and has also been linked with the group of ivories attributed to the workshop of the Gregory Master,[57] but when compared to panels really close to the Gregory Master's style, the Mainz Virgin seems more rigid, the forms far heavier, and the relief far more pronounced. The full release of the Mainz Virgin's head from its background, while the lower part of the figure is tied well into the ivory panel, foreshadows the treatment of relief on the Hildesheim doors. On the other hand, the classical calm of the figure has none of the illusionistic 'flickering' quality of the Hildesheim bronze. That this classical calm and smooth development of form is derived from the Trier School, where Early Christian models are so fully assimilated, still seems convincing, although the increase of weight and volume might indicate that a date more nearly contemporary with the Hildesheim Virgin at the end of the first decade of the eleventh century would be more acceptable than a date in line with the Gregory Master's activity in the eighties of the tenth century.[58]

Bernward's close connexions with the court, especially during the reign of Otto III, seem to have had little effect on artistic activity at Hildesheim. It is true, of course, that most of the imperial patronage had been concentrated on goldsmiths' work, and comparatively little survives from Hildesheim in this category.[59] The large altar cross, which it has been thought was made to receive a particle of the Holy Cross given to Bernward

by Otto III, now preserved in St Magdalen at Hildesheim[60] has been shown to be a work of the twelfth century.[61] Two book-covers, however, do survive, and both are decorated on their front with tenth-century Byzantine ivories: the smaller Bernward Gospels, in the Hildesheim Cathedral Treasury (No. 13), has a Crucifixion panel, and the larger 'Precious Gospels' of Bernward, also in the cathedral (No. 18) (Plate 122), a 'Deesis', that is Christ standing between the Virgin and St John the Baptist.[62] The mere fact that Byzantine ivories appear here reminds one of the imperial book-cover of Otto III, which had used a panel with the Death of the Virgin, and it may well be that Bernward had acquired these ivories at the court before his elevation to Hildesheim. The smaller cover, made at the beginning of the eleventh century, was completely restored in the thirteenth century, and only the back cover, with a simple foliate pattern border surrounding Bernward's monogram in *émail brun*, remains unchanged. The larger cover, made soon after the manuscript had been written in the first decade of the century under the deacon Guntbald (d. 1011), also suffered restoration in the early thirteenth century, when the roundels with the Evangelist symbols were added.[63] The very heavy filigree, of several strands of pearled wire soldered together and here and there with one strand crossing another, is faintly reminiscent of the character of the filigree on two of the crosses made for Essen under Mathilde. But one cannot really compare the rather pedestrian work of the Hildesheim cover with the brilliant technical mastery at Essen.[64]

Evidence of some knowledge of Byzantine ivories at Hildesheim, other than those mounted on these two book-covers, is the back cover of Bernward's 'Precious Gospels'. Framed by an inscription naming Bernward as donor[65] stands the figure of the Virgin with the Child on her right arm, engraved on a silver-gilt sheet cut out and mounted on a velvet background, on which the original inscription (now scattered) reads MP ΘΥ, for the Greek ΜΑΤΕΡ ΘΕΟΥ, Mother of God. The type is known in Byzantine art as Hodegetria – the 'One Who Shows the Way' – and this engraving copies closely a type well represented on ivories, for example in the collections in Paris, Brussels, and Leningrad.[66] Such engraved silver was also gaining great popularity among the works commissioned by Henry II at much the same time. Compared to these, the Hildesheim engraver's work cannot but appear provincial. It was in the casting of silver and bronze that Bishop Bernward's workshop made its most important contribution – a contribution which was to exert the most lasting influence on Ottonian and even on Romanesque art. With the great doors and the triumphal column, Hildesheim sculptors took the first steps towards a new monumental art, without which the achievements in architectural sculpture of the late eleventh and early twelfth centuries would hardly have been possible.

Court Patronage

On the basis of surviving work, there can be no doubt that Henry II's place as the greatest patron of the arts among the Ottonian emperors is unassailable. His reign, from 1002 to 1024, although longer than that of Otto II and Otto III combined, was

nevertheless comparatively short if we bear in mind the reign of Otto the Great (936–73) or that of his great Carolingian forerunner, Charlemagne. No doubt at least in part he is favoured by the accident of survival: at least three of his major commissions – two golden altar frontals and one pulpit – have come down to us, and many of his rich gifts to his favourite foundation at Bamberg have been preserved. The outburst of creative activity during his reign was, of course, based on the foundations laid by his predecessors, who by their energy and their passion for the cultural heritage of the Mediterranean opened up rich sources for northern centres, which Henry's success in stabilizing the Empire north of the Alps, after the neglect of the two later Ottos, enabled to develop their potential henceforth.

Henry II's earliest patronage suggests that there may have been some continuity with the traditions established by his predecessor, Otto III. Two book-covers, both gifts to Bamberg Cathedral begun in 1007 and consecrated in 1012, are now in the Bayerische Staatsbibliothek in Munich. In both, the illuminations are obviously based, in style and iconography, on the work of the imperial scriptorium, probably established by Otto II and continued under Otto III.[67] The same impression of continuity is given by the goldsmiths' work. The cover of a Book of Pericopes made for Henry's own use and, according to its dedicatory verses, presented to Bamberg, employs as a centrepiece the large Carolingian ivory associated originally with the Codex Aureus of Regensburg written for Charles the Bald in 870 (Plate 29 and frontispiece).[68] In the surrounding gold border, twelve Byzantine cloisonné enamels are re-used, with three-quarter representations of Christ and eleven Apostles. In the corners, circular 'full' enamels with the Evangelist symbols are mounted, and a niello inscription on a gold strip, naming Henry as donor, surrounds the ivory.[69] The twelve Byzantine enamels have been thought originally to have decorated a crown, but could hardly have been large enough for this purpose. They are certainly an import from the east, and it is tempting to see in them a part of the imperial treasure which Henry acquired in Augsburg in 1002, when Otto III's body was on its way for burial at Aachen.[70] Besides this possible direct connexion with the imperial court, the four symbols of the Evangelists at the corners are in the tradition of enamelling found in Trier commissions closely connected with the court, and even more particularly those of the Abbess Mathilde at Essen, made in a workshop that owed much to Mathilde's close relationship to the court. It should also be pointed out that the rather free scattering of jewel settings on the plain gold ground of the border, which depends for its effect more on colour than on form and pattern, is found only in one other cover, that of Otto III's Gospel Book in Munich (Clm. 4453) (Plate 103).[71] In Otto's cover, small pyramids of gold spheres and cones of pearled wire appear between the gems, while on Henry's, small triangular bridges of wire perform the same decorative function. Only the narrower frame of the later cover gives a more crowded impression to what is basically a similar approach to decoration.

A second cover decorates a Gospel Book illuminated in the same scriptorium at very much the same time – in the first decade of the eleventh century (Plate 124).[72] The whole field is divided by a 'crux gemmata',[73] inscribed in a border of equal width. Both the border and the cross are decorated with a very delicate, open, foliate scroll

filigree, which in character is close to the delicacy with which the Lothar Cross at Aachen had been worked. Indeed, the whole effect of the cover, with its emphasis on carefully placed gem mounts and a total absence of any figural decoration, reminds one of the cool abstraction of the magnificent Lothar Cross. The rectangular fields in the four quarters of the cross are decorated by scrolls inhabited by quadrupeds or birds stamped from moulds in gold foil – a decorative treatment found on no other book-cover in the Ottonian period. The technique is, however, that of the sheath of a great sword now in Essen Minster,[74] which was probably given to Essen by the Abbess Mathilde, and which was most likely made by court goldsmiths around the turn of the century (Plate 125). The filigree decoration of the hilt is again of the delicate open kind we find on Henry II's book-cover, and some small decorative enamels mounted on the quillon clearly demonstrate the connexion with the other gifts Mathilde made to Essen. The actual details of the animal forms used on the book-cover cannot be compared very closely with those on the sheath, but the evidence of technique and general style suggests strongly that the goldsmith who worked the book-cover learned his craft in the imperial workshop. The immediate source for the animal style on the book-cover, especially of the almost heraldic lion-like quadrupeds, was most likely a manuscript like the Otto III Gospels in Munich, where similar creatures are found.[75]

Among the large, important donations made by Henry, only the great ambo or pulpit he presented to the Palace Chapel at Aachen is certain to have been made fairly early in his reign (Plate 127). The inscription records the donor as 'REX PIUS HEINRICUS', and the ambo must therefore have been made before Henry's imperial coronation in 1014.[76] It is now mounted on a corbel at the south-west corner of the Gothic choir, where it was probably placed after the completion of the choir in 1414. Its original position is not known for certain, but it has been argued convincingly that it must have stood between the two piers of the central octagon which led to the small rectangular Carolingian choir.[77] The type of pulpit is well known from carved marble examples in northern Italy, among which the late-sixth-century one at Santi Giovanni e Paolo at Ravenna not only shows a similar trefoil shape, but is also decorated with square fields of ornament divided by a broad framework.[78]

The main composition of the curved central portion is a great 'crux gemmata' of five square fields, surrounded by the four Evangelists, of which only the St Matthew in the top left corner is original, the other three being modern restorations.[79] In this, it follows a composition well established by the tenth century, for example in the Gauzelin book-cover at Nancy Cathedral (Plate 74)[80] – the whole pulpit being considered a 'cover' for the spoken word, in the way a book-cover enshrines the written word. The large scale of the work led to great vessels of semi-precious stones being mounted instead of the gems of a book-cover. In general type as well as iconography, the ambo is clearly based on older traditions, Carolingian or even pre-Carolingian in origin. In the only surviving figural panel, the Evangelist St Matthew, the contacts with Carolingian models are obvious (Plate 126).[81] The thin, elongated figure, with tight stretched drapery in thin parallel folds revealing the figure below, is strongly reminiscent of the later examples of the style of Reims, like the cover of the Codex Aureus of St

Emmeram. But this basic figure style has been adapted to the early eleventh century. The architectural setting, derived from the same Carolingian tradition, is now treated not as a drop-cloth in a second plane behind the figure, but as a coherent spatial setting, creating an almost fully three-dimensional semicircle in which the figure is seated. Such treatment shows that the spatial experiments of the Gregory Master had not been in vain. Not much of the goldsmith's decorative work has survived the restorations, but the heavy double-stranded filigree on the small original fragment reminds one of the work of the imperial workshop, like that on the Essen crosses, and again suggests a continuation of this workshop early in Henry's reign. It also seems very probable that the six very large sixth-century pagan ivory carvings which decorate the two outer sides of the ambo[82] were a part of the imperial treasure acquired by Henry in Augsburg in 1002. Some connexion with contemporary work at Hildesheim is also likely. The heavy filigree of the framework of the ambo is certainly also very close to the front cover of Bernward's 'Precious Gospels' (Plate 122).[83] Perhaps of greater importance is the use of a new decorative technique on the ambo – that of *émail brun*, which also appears in a somewhat rough form on the back cover of Bernward's smaller Gospels.[84] This technique has, in spite of its name, little to do with enamel. It is achieved by covering parts of the copper sheet with linseed oil, set off by gilding, the whole then being heated to burn away the mercury of the gilding and the linseed oil, leaving the copper a rich brown colour in contrast to the gold.[85] In the twelfth century it gains far greater importance alongside champlevé enamelling, and its early large-scale use on the ambo is exceptional.

Only one other piece has survived which might be connected with this workshop: the reliquary of St Willibrord in St Martin at Emmerich. It is difficult to reconstruct this reliquary, for its present form is the result of very substantial alterations undertaken in the fifteenth century.[86] The reverse originally showed a Crucifixion, shortened by about one-third of its total height in the fifteenth century, surrounded by the four Evangelist symbols, all in *émail brun*. On the front appear further reliefs of the Evangelist symbols, this time in gold, which originally might have surrounded a Christ in Majesty at the centre. Parts of the filigree border survive, which in their thin and open design and delicacy come very close to Henry II's book-cover at Munich (Clm. 4454). The shape of the whole must have been similar to that of the burse-reliquaries of the Carolingian period. The inscription on the back shows that the original very unusual shape of the top has been preserved. The style of the relief of the front and the gilt drawing on the back are somewhat rudimentary, and it would be difficult to attribute the work directly to the royal workshop, but because of its use of Carolingian sources and the rare *émail brun* technique and delicate filigree, the goldsmith who created it may have been connected with work commissioned by Henry II in the early eleventh century.[87]

The portable altar of the Holy Cross, now in the Reiche Kapelle in Munich, is a later piece in a more mature style, no longer directly dependent on the imperial workshop at the end of the century (Plate 128): in it elements entirely characteristic of the period of Henry's reign begin to emerge. The inscription shows it to have been commissioned by Henry after his imperial coronation in 1014,[88] and it was one of the many

gifts Henry made to his favourite Bamberg.[89] The object, made of two pieces hinged like a folder, has the character both of a reliquary and of a portable altar. One inscription, now mounted around the crystal 'window', refers to the donor and to the particle of the Holy Cross which was originally housed in a cross-shaped cavity in the lower leaf, and the other, calling the object an 'altar', is mounted on the back of the lower leaf, which names the same relic again, as well as a number of others also preserved in the reliquary, probably in cavities in the back leaf, now covered with silk. The reliquary presents us with some difficulties of reconstruction, because it is no longer in its original state in all its parts.[90] The most obvious difficulty lies in the fact that the large rectangular crystal, with its very precisely bevelled edge, can hardly be of Ottonian date, nor is such an ostentatious display likely at this early time. Only in the Early Gothic period did it become customary to allow the relic itself to be displayed to the faithful; up to the late twelfth century, it was usually decently hidden from view, at best replaced with a representation of it in the form of the reliquary itself, as for example in the numerous arm- or head-reliquaries of the period.[91] The combination of the elements of a reliquary with those of a portable altar, however, is well known in the early Middle Ages.[92] It seems likely, therefore, that this was originally mounted with an altar stone on its front in place of the crystal window, which would make its use as a portable altar possible, while the relic of the True Cross, hidden by a solid lid, would make the whole object resemble very closely the Byzantine type of flat box-reliquary of the Holy Cross known as a 'Staurothek'.[93]

In spite of these alterations, Henry's Cross reliquary retains much of its original character. The main features of its decoration – the rich jewel settings of the lid and the line engraving that is found around the relic of the True Cross and on the back of the whole reliquary – show that a style was being developed that was to be a decisive influence in many of the most important works commissioned by the emperor in the last fifteen years of his life.

In the goldsmith's work of the larger frame, precious stones are set on large circular tables raised on delicate arcades, while on the same frame, similar circular mounts carry clusters of smaller stones. In both there is an increase in rich, three-dimensional articulation, which in its complexity and its weight suggests a new influence from earlier styles, especially of the Carolingian period. It has already been mentioned that on an earlier book-cover, made for Henry's Pericopes, now in Munich, the Carolingian ivory used as a centre piece may originally have been mounted on the back cover of the Codex Aureus of Regensburg. Although unproved, it would have been virtually a certainty that the ivory came into the possession of Regensburg along with Charles the Bald's famous codex, the Arnulf Ciborium, and other Carolingian pieces which reached Regensburg as Arnulf's gifts in 893.[94]

The use of this ivory in one of Henry's major commissions certainly suggests that the goldsmiths working for him knew the Codex Aureus well. Both in the severity of decorative structure, its weight and volume, and in individual features like the great 'table' mounts, close links with Charles the Bald's Carolingian style can be detected in Henry's reliquary altar. In the smaller circular mounts between the larger gem settings,

a slight echo of earlier-tenth-century practice can also be seen. Two rings of pearled wire are linked by a regularly spaced row of gold spheres, just like the mounts on the imperial crown; but instead of the openwork effect of the crown, Henry's reliquary has again the more solid, three-dimensional character that predominates in the work. The same strict order and heavy three-dimensional treatment is found in the gold frame added to a ninth-century Metz manuscript cover, now in Paris.[95] The large table mounts, placed in alternation with pairs of similarly constructed smaller mounts, are covered in very precise filigree foliate scrolls and twisted wire pyramids. The same 'beehives', as they are sometimes called, were used earlier by the imperial goldsmiths in Otto III's time – on the Aachen Lothar Cross, for example – and became increasingly popular in Henry's earlier commissions, like the Munich cover, cod. lat. 4454. It is often suggested that the frame of the Paris cover might have served as a model for Henry's Cross reliquary;[96] but the increased severity of the work of the frame, which makes the Cross reliquary appear far closer to the tradition of the earlier commissions in Henry's reign, like the cover of the Munich Pericopes, would strongly support a placing of the Metz cover rather later than the imperial gift to Bamberg. It is perhaps a somewhat provincial reflection of goldsmiths' work done for the court.

Another piece, certainly made directly for the court, is the crown said to have been made for Henry's queen, Kunigunde,[97] now in the treasury of the Munich Residenz. This also came from Bamberg, where it seems to have been adapted in the thirteenth century to be worn as a head-reliquary of the queen herself, who was canonized in 1200.[98] In spite of many losses and alterations, the crown still retains a character very close to Henry's Cross reliquary. Typical are the large mounts, raised on high arcades, and enriched by 'beehive' mounts and triple-stranded bridges. A slightly freer handling of forms, however, lacking the harder and stricter precision of the Cross reliquary, might well be seen as a link between the court's earlier, pre-1014 commissions and the Cross reliquary itself. The looser and experimental composition of the crown, in five different patterns on its five hinged panels, often leaving somewhat awkward spaces to be decorated by gems of unequal size, would seem to support a slightly earlier date, perhaps towards the end of the first decade of the eleventh century. It might well have been made for the occasion of the imperial coronation at Rome in 1014, when Kunigunde accompanied her husband and was anointed by his side in St Peter's.[99]

The tendency towards a harder, more precise structure that we have seen in the design of the purely decorative elements of the Cross reliquary when compared to the looser, more colourful, and more delicate earlier work in Henry's reign, is also found in the figure style. As a technique, engraving had previously found favour among the goldsmiths working for the court – one should remember the remarkable quality of the Crucifixion on the reverse of the Lothar Cross – and for Mathilde of Essen, where the back of each of the great altar crosses was decorated by engraving. In all of these, a fluid style of drawing was achieved, ranging from the soft Byzantinism of the Aachen Lothar Cross on the one hand (Figure 3), to the deft, broken touches or swift curves of the Evangelist symbols on the earliest Mathilde Cross on the other (Figure 4A). In

this latter style, the earlier-tenth-century tradition of the Evangelists on the Gauzelin book-cover can still be seen, perhaps a little modified by the stronger 'Reims' tradition so evident in the lively drawing style of the illuminators working in Lower Saxony in the later tenth century.[100]

This style of engraving is already given a firmer structure on the cover of a Sacramentary believed to have been written for Abbot Erkanbaldus of Fulda (997–1011) (now Bamberg, Staatliche Bibliothek MS. Lit. 1), where a tenth-century centre panel of a Byzantine triptych showing the Virgin and Child is surrounded by an engraved silver frame, partly gilt, with four crowned female busts in roundels at the corners, probably intended as Virtues, and scrolls inhabited by figures, birds, and lions (Plate 123).[101] Crowned female busts, in Byzantine costume of a type already well established in the court art of the last quarter of the tenth century,[102] were to become very popular in the work commissioned by Henry II. They appear engraved on one of Henry's earliest pieces, the back cover of his Book of Pericopes in Munich, and later in a series of works like the Watterbach portable altar in the Bayerisches Nationalmuseum in Munich and on the back of the Munich Cross reliquary,[103] and in relief on the golden altar frontal given by Henry II to Basel Cathedral.[104] In the figure style of the earliest piece in this series, Erkanbald's Sacramentary in Bamberg, one can see, especially in the two figures in the lower part of the frame, a new precision of drawing, far more aware of formal values. The thighs and stomachs of the figures are clearly outlined by closely spaced parallel folds, replacing the more fluttery and impressionistic treatment of the figure on the back of the early Essen cross. This tendency, which in the last analysis is the result of an interest in late classical sources, so strong in the late seventies and eighties of the century, probably first arose at the court, because it is seen in the engraving of the crucified Christ on the back of the small cross added to the imperial crown, almost certainly no later than the reign of Otto III (Plate 82). Here, the hard, square-jawed face first appears that was to be so typical of the work produced later in Henry's reign. The drawing of this figure is, however, still lighter and freer in touch, and less strongly stylized than the later versions of it, which reach their hardest, most abstract stage in the engravings on the back of the great reliquary altar cross in the Imperial Treasury in Vienna, a work completed in the reign of Henry's successor, Conrad II (Plate 135).[105] The characteristic 'double line' drawing of the Apostles and the Evangelist symbols on this cross is already in evidence in the four Evangelists surrounding the relic of the Holy Cross on Henry's portable altar. The engraved scene on the back of this altar, showing the Sacrifice of Isaac and Ecclesia receiving the Blood of the Lamb in a chalice accompanied by the priests Melchisedech and Aaron, is in a slightly less rigid style, in which the drapery still flutters a little more freely, especially in the two angels holding the Holy Lamb (Plate 129). Movement has not yet been quite frozen into the hierarchic rigidity of the later phase of the style, and it retains something of the earlier lively touches of the ancient 'Reims' tradition.

The drawing that underlies the majestic relief figures of the golden altar frontal of Basel Cathedral, now in the Cluny Museum in Paris, has reached much the same stage of development (Plate 130). Here and there, especially in the cloak of the figure of

Christ in the centre, the same lively touches of the Carolingian tradition can still be sensed, and yet the clearly defined forms of the limbs, the stomachs, and especially the heads, and the clarity of the outline of the figures silhouetted against the plain background, all aim at the new formal rigidity. In the rich, inhabited foliate scrolls and the four busts in roundels with the four Cardinal Virtues, the relationship with the leaf-forms, scrolls, and decorative repertoire of the engravings is at its most obvious. The dependence of these forms on Byzantine influences has been most clearly demonstrated,[106] and the tiny donor figures of the emperor and empress also reflect in their devout poses a Byzantine practice – the *proskynesis*. The iconography of the antependium is an unusual one. Christ appears as Salvator Mundi in the centre under a somewhat larger arch, accompanied by the archangels Michael to his right and Gabriel and Raphael to his left, and St Benedict on his extreme right. The inscription above and below runs as follows: QUIS SICUT HEL FORTIS MEDICUS SOTER BENEDICTUS/PROSPICE TER-RIGENAS CLEMENS MEDIATOR USIAS (Who is blessed like the powerful God, like the healing Saviour, take care of those born on earth, merciful mediator of the divine power) and includes a play of words on 'Benedictus' as 'blessed' and no doubt also as a reference to St Benedict as the only terrestrial figure shown besides the donors. It is tempting to see in this an allusion to the intervention of St Benedict as a healer when disease struck a disastrous blow at Henry II's troops in southern Italy in 1021–2, and therefore to attribute the gift to the last two years of Henry's life, after his return from the ill-fated campaign in 1022. Usually the antependium is believed to have been given to Basel on the occasion of the consecration of the church in 1019, when the emperor was present.[107]

Towards the end of his life Henry also made a number of major gifts to the Palace Chapel at Aachen, the most outstanding among them another golden antependium, usually known as the 'Pala d'Oro' of Aachen. Unfortunately it has not survived in its original framework, but is now seen in a plain wooden frame made in 1950 (Plate 131).[108] The four Evangelist symbols around the central Christ in Majesty were probably first mounted in that position in 1480, when the frontal was converted into a retable.[109] Originally these roundels must have been mounted on a wide outer frame, in the corners, where they are found in a number of Scandinavian Romanesque altar frontals which clearly derive from this Ottonian tradition.[110] The decoration of this original frame must almost certainly have looked very like that of the Basel altar, with inhabited scrollwork, and possibly might have included *émail brun* decoration of the kind found on the earlier ambo at Aachen given by Henry. Again, both these decorative techniques are found in later Scandinavian descendants.

The analysis of the figure style of the golden altar is made more difficult by the poor state of its preservation. Much of the liveliness and lightness of touch of the original drawing, which can still be seen in those minor passages of the reliefs which have suffered less at the hands of later restorers,[111] has been lost. Indeed, the often quoted resemblance to the illuminations of the imperial scriptorium of the last quarter of the tenth century[112] may well be almost entirely due to the bulbous forms and large smooth areas produced by insensitive restoration, from which the major figures, including the

central Christ in Majesty, have suffered most severely. Recent detailed work on the altar, especially on the sources of its iconography, has shown that all its links are with Carolingian narrative traditions transmitted through the scriptorium at Fulda active in the late tenth and early eleventh century.[113] The basic design, with its rectangular scenes from the life of Christ to each side of the Christ in Majesty, also certainly follows the type already established in the ninth century in the golden altar of Milan. In as far as it is possible to judge the style of the frontal at all, the tendencies towards a more precise spatial formulation and a stricter simplicity of outline and massing of the figure, already noted in the slightly earlier relief on the Aachen pulpit, can also be seen.

One can, however, see this style more clearly in a pair of book-covers made by the same workshop, because they have been less harshly restored.[114] Both front and back covers were made for the ancient Carolingian Gospel Book of the Aachen treasury. On the front (Plate 132) a late-tenth-century Byzantine ivory triptych of the Virgin and Child is surrounded by the four Evangelist symbols and four scenes from the life of Christ in embossed gold reliefs, themselves surrounded by a jewelled border. Four small strips dividing the scenes into cross form are set with cabochon gems in very simple mounts alternating with very delicate, circular cloisonné enamels of floriate designs. The extreme delicacy of these tiny enamels and the subdued range of opaque colours used suggest that they may be imports from the Christian East.[115] In the gold reliefs, the forms are less bulbous than in the altar frontal and retain far more of the liveliness of drawing found on a larger scale in the Basel antependium. With this book-cover in mind, the origin of both of Henry's golden altars in one workshop seems more acceptable.

The original silver back cover, with the wings of the Byzantine Virgin and Child panel, emphasizes once more the close relationship with Fulda. A book-cover with a circular ivory representation of the Crucifixion of the Fulda group of carvings, now in Munich, has four angels in embossed silver around it, which are very close in style to the four Evangelists on the Aachen cover.[116]

Among the many gifts made by Henry II to Bamberg, four splendid vestments, of the greatest rarity in the early Middle Ages, have survived.[117] Two large embroidered copes are the most magnificent. The first, known as the 'Sternenmantel' (star-cloak) (Plate 133), bears an inscription on its outer border which shows it to have been made for the emperor as a gift from Ismahel, duke of Apulia, who died in 1020 at Bamberg. Pictorial motifs and inscriptions are embroidered in gold thread and appliqué originally on deep purple silk. The remarkable iconography shows Christ as ruler of the universe, with a Christ in Majesty between Evangelist symbols, cherubim and seraphim, and the Virgin and St John the Baptist, surrounded by representations of the heavenly bodies: the sun, moon, and signs of the Zodiac. The second cope, also embroidered in gold on, originally, blue-black silk, shows scenes from the lives of Christ – especially those related to Advent – and of St Peter and St Paul, patrons of Bamberg. According to tradition (which can only be taken back to 1448), it was the cope of the Empress Kunigunde. The decoration certainly shows it to be contemporary with Henry's cope and a product of the same workshop. It is often difficult to make stylistic

judgements of embroidery, but the large lettering on the 'Sternenmantel' can be very closely paralleled in Regensburg illumination, and it is generally accepted that both vestments were made in the first quarter of the eleventh century.

*

Two more objects can be attributed to a Regensburg workshop. The first is the book-box made for the superb Evangelistary commissioned by Abbess Uta of Niedermünster (1002–25), one of the finest products of the Regensburg scriptorium. The front is dominated by a large figure in very high relief of Christ enthroned.[118] Of the two large cloisonné enamels which decorate the border, the one with Christ blessing on the left was certainly imported from northern Italy and always part of the decoration – the filigree panel adjoining it makes allowance for its lobed frame.[119] Other small square cloisonné enamels with foliate and animal patterns scattered over the box might have been added later, but those of the halo of Christ, clearly made for their present position, suggest that such enamels were also produced locally, perhaps by a craftsman from Italy. Very similar enamels also appear on the altar cross donated by Queen Gisela of Hungary, sister of Henry II, to the tomb of her mother, Gisela of Burgundy, duchess of Bavaria, who died in 1006 (Plate 137).[120] They are set around the whole cross and each is surrounded by small seed pearls strung on wire – a technique also found on the Uta book-box around the halo and the book held by Christ. The large crucifix figure on the cross, cast in gold, contains relics. It is almost fully three-dimensional and surprisingly rigid in its forms, but the small figures of Gisela and her mother by the feet of the corpus, with their softly modelled limbs and fluttery draperies, seem much more in keeping with a date early in the century. There is no evidence at all of any alteration in the cross which might have suggested that the corpus was restored, perhaps later in the eleventh century, when the rigidity of its form would seem to be more easily acceptable: it would appear to be a case either of a very careful later restoration, or of a remarkably early appearance of the harder, more linear, almost sterile style which was to be developed in the second half of the eleventh century. The stronger weight and volume which also characterize the corpus are more in keeping with the Christ on the Uta book-box, and other pieces made in the first quarter of the eleventh century such as the restoration of the Crucifixion on the front of the Pepin reliquary at Conques, or the book-cover from Maastricht now in the Louvre.[121]

The varied character of the many works commissioned by Henry II, and the different styles employed in them, seem to deny the existence of a single imperial workshop. Even the arguments for bringing a number of pieces together as of 'Fulda' provenance tend to define a general source, especially of iconography, rather than a precise stylistic 'school' relationship. It can be put forward that Bishop Bernward's patronage at Hildesheim did not create a uniform picture either, although in that case a common provenance in one centre is certain; and yet even at Hildesheim a more consistent development is discernible than in Henry's commissions. It seems virtually certain, therefore, that many of the emperor's gifts were made in many different places. The Basel frontal is likely to have been made at Basel, while the almost precisely contemporary

work on the Pala d'Oro and the Gospels book-cover was undertaken at Aachen. The Aachen pulpit, made some ten years earlier, does not have any real connexions with this later group and there seems, therefore, to be no evidence of any workshop continuity even at this ancient centre. Regensburg, one of Henry's favourite foundations, was also clearly a centre of production and was no doubt responsible for transmitting Carolingian traditions into the early eleventh century in parallel with Fulda. It is during the reign of Henry, then, that one can see the first signs of a tradition of regional styles in process of creation, replacing the heavily centralized fusion of styles achieved in the patronage of his imperial predecessors. It was this increasing development of indigenous regional styles that was to distinguish Romanesque art from that of the Ottonian period.

THE LATE OTTONIAN PERIOD

WHEN Henry II died in 1024, the Saxon dynasty came to an end. In the same year, at Oppenheim on the Rhine between Mainz and Worms, the German nobles assembled and elected the Franconian Conrad as their king. Two years later Conrad II accepted the Italian crown in Milan, and on Easter Sunday 1027 he was crowned emperor in Rome by Pope John XIX, in the presence of King Rudolf of Burgundy and King Canute of Denmark and England.

The tradition of imperial patronage was continued during the reign of Conrad II (1024–39), although probably not on the generous scale established by Henry II. Perhaps the most obvious example of such uninterrupted patronage is the great altar cross of the Imperial Treasury in Vienna, work on which might even have been begun before Henry's death (Plate 134).[1] The inscription on its side, however, shows that it was added to the imperial treasure by Conrad.[2] It is a reliquary cross which was intended to enshrine in its horizontal arm one of the most important imperial relics, the Holy Lance, which had been part of the imperial treasure since the time of Henry I, who had acquired it from Rudolf of Burgundy.[3] In the lower upright part of the cross relics of the Holy Cross were preserved, and in the smaller compartments within the square endings at the top and on the right, other relics were enclosed. The front is richly studded with pearls and gems in gold settings – a 'crux gemmata'. The style of filigree and settings clearly shows a striking similarity with Henry II's Holy Cross reliquary (Plate 128). The reverse is decorated with niello (Plate 135). In the centre is the Agnus Dei, and on the arms of the cross eleven Apostles are shown seated, with the twelfth, St Matthew, serving also as an Evangelist symbol on the lower square extremity with the remaining symbols on the other three. Here the continuation of the style of Henry II's Holy Cross reliquary is even more obvious. The Apostles are drawn with the frequent characteristic 'double line' that had been used both on the reverse of the Cross reliquary (Plate 129) and on the drawing of the four Evangelists under the rock crystal. Even the curtains to each side of the seated Apostles and the arrangement of drapery over the knees on the imperial cross are, it seems, directly derived from the reliquary. The curious little star-shaped ornaments in the background of three of the four Evangelists appear again on the cross in the spandrels of the Evangelist symbols and the central Agnus Dei. Thus there cannot be any doubt that both pieces were created in at least the same imperial workshop, if not by the same hand, and it must also be likely that it produced the new arch for the imperial crown, which must have been added soon after Conrad's coronation in Rome in 1027 (Plate 75).[4] It is set with gems and has the following inscription placed on it in seed pearls strung on wire – a technique also heavily employed on the imperial altar cross: CHVONRADVS DEI GRATIA ROMANORV(M) IMPERATOR AVG(VSTVS).

Only one other object can be attributed to the period of Conrad's reign, the altar cross preserved in the parish church of Borghorst in Westphalia (Plate 138).[5] It is engraved on the reverse with the Abbess Bertha ascending towards the hand of God. On the front, a gold embossed scene of the Crucifixion and figures of SS. Cosmas, Peter, Paul, and Damian are mounted, as well as a scene, in the same style, of Henry II being received by two angels. Inscriptions identify the saints and the latter scene. In the centre and below it, two small carved Fatimid rock-crystal bottles have been mounted to serve as containers for relics – probably the 'de ligno dñi, di spondia dñi' mentioned in the engraved inscriptions on the back. It has been suggested that the gold reliefs on the front were added to the cross which was made for the Abbess Bertha, who died in 988,[6] but the filigree and gem settings accommodate the reliefs and the crystal bottles on the front and the engravings on the back also take note of the holes pierced for the rock-crystals. More important still, the figure of Bertha on the reverse is drawn in almost precisely the same way as the figure of the emperor on the front, and it seems most likely that her appearance is, like that of Henry, a posthumous dedication.[7] The gem settings and the filigree are rather rough and simple, and of little aid in dating. The figures on the front are not well preserved, but they show clearly the strong relief and simplicity, almost severity, of form which had already been developed earlier in the century on the donor figures of the Gisela Cross in Munich, and the pieces related to it (Plate 137).[8] Indeed, such figures are really a three-dimensional version of the clear-cut drawing style of the Apostles on the back of the imperial cross: they have the same rather dumpy proportions, the same simplicity of structure and form.[9] It was a style that originated in the golden altar of the Palace Chapel at Aachen, and which dominated Ottonian art in the second third of the century.

Around 1030, Gertrude, the wife of Count Liudolf of Brunswick, founded the cathedral of St Blaise at Brunswick. She donated a number of precious objects to the treasury of the cathedral, and laid with them the foundation of the great Guelph Treasure, which was to continue to grow in wealth until the end of the Middle Ages.[10] Among her gifts, perhaps the most outstanding was a golden portable altar, now in the Cleveland Museum, Ohio (Plate 140).[11] On the top, the altar stone is surrounded by an inscription framed in a simple running scroll of filigree.[12] Its sides are decorated by standing figures in relief under an arcade. Both top and bottom edges are chamfered out, and are decorated with gem settings alternating with pairs of pearls. The whole reliquary altar may have been originally carried on small feet at the four corners, but the plain sheet of silver which now covers the whole base, and which may well be ancient, shows no holes at the corners where such feet could have been fixed. These features create a type which transformed the simple, box-like shape of the earlier portable altar of St Andrew at Trier into the thoroughly structured and almost architecturally conceived portable altars of the Romanesque period.

The most richly ornamented side of the altar, showing Christ flanked by three Apostles to each side, has the entire arcade decorated with cloisonné enamels.[13] On the opposite side, the remaining six Apostles flank the standing figure of the Virgin, under an arcade embossed in relief. On the shorter, right-hand side Constantine and Helena

adore the True Cross, represented in cloisonné enamel, accompanied by St Sigismund of Burgundy and St Adelheid, and to the left are five archangels, with St Michael in the centre.[14] The arcades on both the shorter sides are decorated with niello. The figures are embossed in high relief, with the rather large heads and the clearly defined forms of the Borghorst cross. Something of the traditions of the golden altar of Basel in the Cluny Museum (Plate 130) can still be detected in the spread of drapery into the field behind the figure. The gem settings are identical throughout the altar, in rectangular panels with two rings of pearled wire surrounding each stone and a thin strip of corrugated gold foil between them – a technique which is employed on a few of the settings of gems on the front of the imperial cross – but the whole character of the goldsmith's work is flatter and somewhat more severe and less rich and flamboyant than that of the cross. Gertrude's portable altar is likely to have been made no later than the thirties of the century.[15]

It is tempting to link Gertrude's altar with the workshop that produced a number of splendid pieces for the Abbess Theophanu of Essen, who rivalled her predecessor Abbess Mathilde in the generosity of her patronage. The tradition of gold cloisonné enamelling, which had been established in Mathilde's time at Essen, would, at first sight, seem to make such a link possible. But although they appear on two out of three pieces known to have been given to Essen by Theophanu, who ruled the house from 1039 to 1056, it seems possible that enamels were no longer produced in her time at Essen. The small decorative enamels on her great reliquary altar cross (Plate 139) seem to have been made for a different object and might well be fragments surviving from a somewhat earlier period.[16] The slight curvature of the six pieces mounted near the top of the cross and on its cross arm show clearly that they were destined for another position. There is also a marked difference of style in the delicate filigree around the central crystal and at the extremities of the cross, and the very much thicker, stronger filigree along the centre. It has been suggested convincingly that the latter were added in the middle of the twelfth century, when the engraved reverse was restored.[17] The re-use of small enamels might lead one to suspect that the workshop preferred not to make such enamels for the new altar cross. It should also be noted that the magnificent book-cover made for Theophanu around the middle of the century does not include any enamel in its decoration (Plate 141). In the centre a large ivory is mounted, with the Crucifixion, the Ascension above and the Nativity below, and the four Evangelists in the corners. The composition is exactly paralleled in another ivory, now in the Royal Museum at Brussels, which was carved in the Liège area (Plate 173).[18] Its border is set with gems. Around the centre is figurework in embossed gold, with a Christ in Glory between angels at the top, St Peter and St Paul to the left, and St Cosmas and St Damian to the right, all under architectural arcades. Below, a Virgin and Child are enthroned, with the Abbess Theophanu at her feet, presented by St Pinnosa on the left and St Waldburg on the right. A fairly deeply chamfered frame, decorated with filigree and stamped ornament, surrounds the whole. When compared to the Gertrude altar the relief of Theophanu's book-cover is less pronounced, the draperies have become sharper and slightly more rigid, and the figures move with more vigour, almost violence: the book-cover seems to lead on to the

harder, more abstract forms, with an emphasis on parallel lines, found in the second half of the eleventh century.

The bronze crucifix, just over half life-size, now preserved in the church of St Liudger at Essen-Werden was brought to Werden only in 1547, when the abbey of St Liudger at Helmstedt in Lower Saxony was threatened by the Reformation (Plate 143).[19] The figure is stiff and upright, the ribs and chest muscles rigid and repetitive. The loin-cloth is precise in its overlapping folds and sharply drawn with almost knife-edge pleats. The elegance of the figure is emphasized by its long and thin shins and its small head, modelled with large and expressive features. The hardness of line takes the tendencies in the Theophanu book-cover and develops them fully – as do the contemporary stone carvings of seated figures, probably from the tomb of St Liudger, at Essen-Werden,[20] or the Cologne illuminations of the second half of the century, which were developing the same characteristics.[21] Such connexions, however, can hardly prove sufficient to attribute the Werden crucifix to a workshop either at Werden or Cologne. This harder, at times almost sterile, Late Ottonian style was widespread in the Empire. It is true, Helmstedt in Lower Saxony had close and brotherly ties with Essen-Werden, but the style was certainly also known in the eastern lands of the Empire: at Merseburg, for example, the bronze tomb slab of Rudolf of Swabia, who died in 1080,[22] shows much the same strange mixture of sterility and elegance. There is also evidence of large-scale bronze-casting in Saxony, where both parts of the imperial throne and the so-called Krodo Altar survive at Goslar.[23] Of the two works, the Krodo Altar, cast in bronze and kept in the museum, is the more remarkable structure (Plate 145). A large, box-like altar table is supported at each corner by a fully three-dimensional kneeling figure.[24] The sides of the box are pierced by holes of various sizes and shapes, arranged sym-metrically, which must originally have been set with semi-precious stones, perhaps vessels, and glass achieving a jewelled effect, rather like that of Henry II's pulpit at Aachen. The kneeling atlas-like figures wear loincloths very similar in their overlapping and sharp-edged folds to those of the Werden crucifix. But in volume they are thickset and rounder in form than the more emaciated lines of the crucifix figure. In this, they compare with other Late Ottonian work, which continues in the second half of the century the earlier rounded, simple forms. Indeed, if anything, the sculptural style of the sixties and seventies of the century simplifies these forms even further. Much as the drapery is given such hard-edged, straight and parallel pleats on the one hand, the more rounded, more three-dimensionally conceived figures develop rounded forms in ever more simplified, often concentrically drawn lines, on the other. When one compares the wooden core of the Virgin and Child commissioned by Bishop Imad of Paderborn about 1060 (Plate 142)[25] with the ivory Virgin and Child of around 1010 in the Mainz Museum (Plate 121),[26] one can see how the drapery is reduced to a few bold lines, and the edges of the cloth no longer show any vestiges of the earlier flutter. Everything is reduced to the simplest possible statement of its volume, and the balance of one shape and volume with another. Such a self-conscious and controlled balance of volumes forms one of the fundamental sources for the Romanesque style of the twelfth century.

The same balance of rounded forms can be seen in other work of the third quarter of the eleventh century. In ivory carving, a number of pieces survive which in part are still found mounted on complete portable altars, or are often fragments of such altars.[27] Among them, the portable altar preserved in the abbey of Melk bears an inscription which mentions as donor Svanhild, wife of Count Ernest the Brave, markgrave of Austria, who is recorded from 1056 to 1076, which would seem to make its origin in the third quarter of the century very likely (Plate 136). The altar is decorated with walrus ivory on the top, round the stone, and along the sides. On the top flying angels carry medallions with the Lamb at the top and the hand of God below, and on strips along the sides are carved the four Evangelists, their symbols, and two busts of saints – the one on the left being St Cyriacus, whose relics are enshrined in the altar. Along the sides of the altar, scenes from the life of Christ are represented in a continuous sequence, beginning with the Annunciation, the scenes being interrupted at intervals by narrow architectural motifs. The decoration of the second narrow side is missing, but probably showed as the final scene the Crucifixion, as is the case on other altars in the group. The figures are small and rounded, the narrative lively and crowded. The altar resembles in general outline the portable altar of Gertrude and is carried on four bronze-gilt claw feet. But the strict, architectural organization of the Gertrude altar is not achieved in any of the altars of the group. The material employed throughout is walrus ivory, more often found in schools in touch with the North Sea. The iconographic models used seem also to point to North Western Europe, following for the most part the cycles known in the Metz School firmly established in Lower Lorraine and the Rhineland, and the suggestion that the centre of production of this group might have been Cologne has much to commend it.[28]

In style and iconography, the pair of wooden doors made for the church of St Maria im Kapitol in Cologne are also closely related, and strengthen this attribution (Plate 144). Each wing is divided by bands of pierced strapwork into eight horizontal fields, with the second and third, fifth and sixth, and bottom panels again subdivided vertically, making thirteen panels on each door. Scenes from the life of Christ provide the subject matter, with the Annunciation to the Baptism on the left door and the Entry into Jerusalem to Pentecost on the right. On the four panels of the lowest register, of which only three survive in fragmentary condition, nine figures of standing saints were originally shown.[29] The rounded, simplified, and fully modelled figures, with rather large heads, pressed together in crowded compositions, closely resemble the compositions on the sides of the Melk altar. These doors, which were intended for the northern of the three apses at the east end of St Maria im Kapitol, are likely to have been placed in position by the time the church was finally consecrated in 1065. They may even have been already in place when the first consecration of the eastern parts was celebrated in 1049.[30]

The feeling for three-dimensional form is only one of the features in which the Romanesque style is foreshadowed around the middle of the eleventh century. In a group of ivories which must also have been carved towards the middle of the century something is to be found of the power of expression and controlled distortion, composed

within a frame and related to it, which was to characterize Romanesque art. Outstanding even in this superb group of carvings is the central ivory panel with the Crucifixion that was added to the book-cover originally made in the time of Egbert of Trier, but re-used for the Codex Aureus written at Echternach between 1053 and 1056 (Plate 92).[31] There can be little doubt that the ivory was carved when the book-cover was adapted to its new manuscript.[32] To place the whole group into a stylistic context at any time in the late tenth or early eleventh century is not easy, nor is it all that much easier to see it as work of around the middle of the century.[33] Perhaps the reflections of the style to be found in Spanish ivories in the early fifties give as good an indication of its date as can be found.[34] Here, too, something of the expressive power and violent forms of this style can be seen. Perhaps a possible connexion with Flanders, north-eastern France, or even England should also be mentioned. The rich and powerful carving on the lid of a casket attributed to Arras, with a Christ enthroned carried by pairs of angels above and below, comes close to achieving a similar positive style.[35]

In northern France and England, the late Winchester style was also moving in the same direction. The ivory carving of King David on the cover of a Psalter from Saint-Bertin or the illuminations of the Hereford Troper, both in the British Museum,[36] seem to approach the strong and expressive mood of the Echternach ivory at about the same time.

It may be difficult to see the tough, aggressive style of the Echternach ivory and the almost child-like simplicity and doll-like work of Cologne as contemporary phenomena. But in this very diversity, one of the major characteristics of Ottonian art reveals itself. The centralized patronage and clear development of style in the Carolingian period are replaced during the tenth and eleventh centuries by a looser and far more complex situation. Patronage, often still on a personal level, is nevertheless of a less consistent kind, and a constant interchange of creative personalities results in a somewhat chaotic and fragmented picture. Contemporary styles differ, often fundamentally, in different parts of Europe and even within the Empire. Such variety of style speaks of a period uncertain in its aims, experimental in outlook, and lacking in cohesion and purpose. In the Carolingian period cohesion had largely been the result of a self-conscious patronage with the clear purpose of promoting an imperial or royal image in terms of a great classical past. In the Romanesque period which was to follow, the cohesion became local, due to new economic expansion and the resulting wealth which ensured continuity of a locally based patronage. In the Carolingian period, 'schools' had been a reality, because individual patronage was continuous in its aims; Romanesque 'schools' were to be a reality because whole areas like Burgundy, or the Meuse valley, or Cologne, were able to support continuous creative activity. The Ottonian period, especially after the death of Otto III, provided no continuity in either sense. Individual imperial and aristocratic patronage tended to be more restricted and scattered, and the independence and wealth of monastic institutions was not yet sufficiently established to allow continuous internal development.

The Ottonian contribution to early medieval art may therefore have been somewhat fragmentary, but it was also highly creative. The Carolingian period had been truly a

re-birth. At Charlemagne's court, the term 'Renovatio' was used as self-consciously as the art of Antiquity and the Byzantine Antique were made to serve as material to copy. The Ottonian emperors, especially Otto II and Otto III and the Regent Theophanu, no doubt used Byzantine and Late Antique sources no less self-consciously, and imported them with the same aims as the Carolingian emperors, but such hothouse productions as those of the Carolingian courts were never the result. In part, no doubt, the strength of the northern, already indigenous Carolingian tradition itself assured for artists a creative self-confidence which never allowed the naïvety of simple 'revival'. Even when the influence of Late Antique styles and Middle Byzantine iconography were at their most powerful, Ottonian pictorial imagery always underwent fundamental adaptation – its style is unmistakably Ottonian. The light, impressionistic touches of Late Antiquity are transformed into firm, three-dimensional form, where the human figure dominates its environment, and a solid narrative element or abstract pictorial form always over-rides any attempt at naturalism or illusionism. It is in this transformation of even the most fluid of styles towards a firm pictorial structure, and in the domination of the picture space by the human figure in the service of expressive narrative, that the first steps towards Romanesque were most obviously taken.

PART THREE

ROMANESQUE ART

INTRODUCTION AND ITALY

THE definition of the style known as 'Romanesque' is difficult in purely formal terms. Most of the characteristics normally seen in Romanesque were already present in the Ottonian period: the emphasis on high, almost free-standing relief, the strict and linear definition of surface pattern carefully related to the frame, a tendency towards hieratic symmetry and heavy, almost oppressive symbolism, a splendid balance of pure, often primary colours – all these can be found to a greater or lesser extent in the various styles of Ottonian art. In the study of the history of architecture, it is nearly always recognized that it would be difficult to see any break in the development of the great medieval church from the late tenth century, when the organization of plans and elevations underwent a fundamental change towards a carefully balanced relationship of parts to the whole and when a sculptural treatment of the wall itself was introduced, to the early twelfth century, when more elaborate and sophisticated versions of similar controlled balances and sculptural treatment were employed. Romanesque architecture can only be understood as a continuous development out of the fundamental experiments of the late tenth century.[1]

In the figurative arts, if seen only as a stylistic development in purely formal terms, the same holds true. But, although it is difficult to define the Romanesque style in these terms, a change of fundamental importance takes place in the second half of the eleventh century. Art is no longer created in short bursts of activity as a direct result of the patronage of enlightened, cultured, and wealthy individuals; it is no longer fostered, one might even say somewhat artificially fostered, by artists and craftsmen called together from different centres, arbitrarily selected by the personal tastes and preferences of patrons; it begins to take on a regional character. The growth of the independence and wealth of monasteries and of cities resulted in the creation of regional schools, the product of a far more continuous and more widely based local patronage.

The first important steps towards new styles were taken in three regions: in northern Spain, in the heartland of the Ottonian Empire – Saxony – and in Lotharingia. In Italy, too, similar developments were taking place in the eleventh century, but it was particularly in wall painting and manuscript illumination that the Italian contribution was to be of great importance to northern Europe.[2]

Unfortunately virtually no Italian metalwork of the eleventh century has survived, except for some due to personal patronage, like the splendid book-cover commissioned by Archbishop Aribert of Milan (1018–45) (Plate 76).[3] The full cloisonné enamels and the simple gem settings and filigree decoration of the front cover serve mainly to give evidence of the fact that such traditions of cloisonné enamelling were no doubt already long established in northern Italy.[4] The reverse cover in embossed silver shows Aribert presenting his book to Christ, with St John and the Virgin on either side, above the three

patron saints of his metropolitan see, St Gervasius, St Protasius, and St Ambrose. It is crude, provincial, and rather sterile work. The whole is clearly Late Ottonian rather than Early Romanesque in character.

More relevant to the emergence of Romanesque is a group of ivory carvings in which the remains of a large antependium now in the cathedral of Salerno occupy a central position (Plate 146).[5] A large number of panels survives in Salerno, most of them mounted in the form of an antependium in a modern wooden frame. Neither the original use to which they were put, nor their date, is at all certain. Mounted on the frame are twelve horizontal rectangular panels, each with two scenes from the Old Testament, separated by a column, beginning with the Creation cycle in Genesis and ending with scenes from the story of Moses in Exodus, as well as seventeen upright rectangular panels, each with two or three scenes from the New Testament beginning with the Visitation and ending with an eighteenth panel on which only the Ascension is shown. Two long narrow strips with foliate scrolls as well as twelve small square, rhomboid, and circular plaques with bust portraits, mostly of Apostles, are also now mounted on the antependium. Four more complete Old Testament panels and two half-panels, and one more half-panel and two fragments of New Testament scenes, as as well as a piece of the ornamental strip, are preserved in the treasury of Salerno Cathedral and in other collections.[6]

Even in its incomplete form, the Salerno cycle is an extensive one – thirty-four Old and forty New Testament scenes. It must originally have decorated a large object such as a pulpit, an altar, or an episcopal throne of the kind that has survived in Ravenna.[7] The iconography of these ivories draws on a rich narrative source, and includes a number of very rare subjects such as Abraham building the Tabernacle, or two angels ministering to Christ (Matthew 4, 2). Such a cycle is likely to have been an Early Christian one and was probably transmitted by an Early Christian Gospel Book.[8] In style, too, the Salerno ivories are not without influence from Early Christian sources. Though the figure carving is on the whole rather clumsy and crude, the articulation of the figures, the smooth overlapping folds, and the well understood draping of the figures all speak of a close contact with the classical tradition. Certain details of iconography point in the same direction. The scene of Christ appearing to the Apostles (G.IV, nos. 126, 44) repeats the subject and the form of a tenth-century Byzantine ivory panel in the Cluny Museum in Paris, and the scene of the Maries at the Tomb of the Risen Christ shows only two instead of the far more common three Maries – a peculiarity which occurs also on the Early Christian panel now in the Castello Sforzesco in Milan.[9] The high altar of Salerno was dedicated in 1084, a date that would seem acceptable for these carvings.

The curious architectural structures that appear on many of the Salerno panels, domed, usually with walls on a hexagonal plan, with large doors in the front, are derived from another group of even more controversial Italian ivory carvings. These for the most part depict the legend of St Mark and have been thought by some scholars to have decorated the bishop's throne given by the Emperor Heraklius (613–629/30) to the cathedral of Grado, and to have been carved in Alexandria about A.D. 600.[10] Others

have argued for a date in the late eleventh century or even later, mostly admitting, however, that Early Christian models were the main sources of the style.[11] It may well be that the group of carvings is not as homogeneous as has been believed. There are certainly some very strong stylistic divergencies within it – for example, the panel with the Annunciation in the Trivulzio Collection in Milan (G.IV, no. 123) shows a great deal more decorative detail in its background than any of the other panels, although its figure style closely follows that of the main panels with the story of St Mark in the Archaeological Museum at Milan (G.IV, nos. 112–15). One possible answer to the difference of opinion among scholars may be that, while some of the panels are of Early Christian date, others are eleventh-century imitations of the style. A comparison of one of the small panels with St Menas as an orant flanked by two camels in the Archaeological Museum in Milan (Plate 148) (G.IV, no. 120) with a similar panel, albeit without the animals, in the Cluny Museum (Plate 149) (G.IV, no. 119) may be the best way of supporting such a theory. The Milan panel is, purely technically, one of the best carvings in the group. The detail is handled with remarkable delicacy, the relief is somewhat deeper than on most of the larger panels, the architectural background is well understood and assured in execution, and the *clavi* and *orticuli* on the tunic are very accurate. The Greek inscription on the frame also makes the attribution of this piece to the eastern Mediterranean more likely, and perhaps the particular veneration of St Mark at his major shrine at Karm Aba-Mina near Alexandria could be taken to support the frequent attribution of this style to Alexandria.[12]

In contrast, the Cluny version is far less well understood. The architectural detail is somewhat muddled and attempts a more ambitious three-dimensional effect. Moreover the figure of the saint is flatter, and the drapery, especially the chlamys on his left shoulder, more schematic and wooden. In the case of this particular comparison, what might be taken to be the contrast between a sixth-century original and an eleventh-century imitation can be argued fairly convincingly, but if one attempts to divide the whole of the group into two such categories, it becomes more difficult. Two small panels with prophets, one in the Côte Collection at Lyon, showing Joel holding a scroll with a Greek inscription, and the other in the Museo Archeologico in Milan, would both have to be Early Christian, and indeed seem to have something of the soft and easy rhythms less possible in the late period.[13]

Perhaps the most difficult panel to place would be the piece in the Victoria and Albert Museum, showing St Peter dictating the gospels to St Mark in Rome in the presence of an archangel (Plate 147).[14] The panel again has a Greek inscription on the upper frame, and most of its detail, especially the wings of the angel and the Corinthian capitals at the top, displays the kind of finesse which bring it closer to the St Menas panel than to the Cluny panel. But at the same time the London panel shows a degree of misunderstanding in spatial relationship – in the seated St Peter, for example – and a harsh approach to drapery that link it far more closely to the other major panels of the St Mark legend in Milan. Moreover, the curious boneless, twisted, long-fingered hands, which do not appear on the St Menas panel and its near relations, appear on the London panel as well as on most of the cruder, late-looking panels. If no simple division into two groups is

convincing, then the balance of evidence seems to favour an early rather than a late date for the whole group, and the assumption that in the Salerno ivories we see a true reflection of such Early Christian models as these, in an unmistakably eleventh-century form, may well be more correct.

It is very difficult to explain quite why the Salerno ivories – on the whole rather poor in quality – are relevant to the creation of Romanesque. True, at best, they are only a parallel development to the more important, more consistent moves in this direction in Spain, Saxony, and Lotharingia, but what they have in common with the work in these regions is their indigenous quality – they are unmistakably Italian. It is, in other words, because they are more obviously typical of the region in which they were produced than of any particular centre of patronage. What links these ivories with the strict formal discipline of the emergent Romanesque is first and foremost the elements of the Italian classical tradition, both in its Early Christian and its later Byzantine form, which they so clearly incorporate. Precisely in the same way, these elements were also partly responsible for precocious Romanesque monumental sculpture in Apulia and Emilia, and especially in the work of Wiligelmo of Modena.[15]

SPAIN AND FRANCE: THE ELEVENTH CENTURY

THE eleventh century in Spain saw the continuous expansion of the Christian kingdoms of León and Castille, Navarre and Aragon, at the expense of the Islamic rulers of the Iberian peninsula – the 'Reconquista'. With a fervour equalled only by the later Crusades against the infidel in the Holy Land, Christian arms had succeeded in recapturing more than half of the peninsula by the early twelfth century. By the time Alfonso VI, king of León and Castille, died in 1109, his kingdom extended as far south as the river Tajo and beyond, to Calatrava.

The military expansion of the northern Spanish kingdoms was linked with the growth in popularity of the famous pilgrimage to the shrine of St James at Compostela, and the influence of reformed monasticism promoted by the great abbey of Cluny and other religious orders.[1] In the first half of the eleventh century the Cluniac movement, which during the tenth century had simply been concerned with giving a stricter liturgical monastic life to smaller, less well disciplined houses, began, under its great Abbot Odilo (994–1049), to achieve far greater control and organization. Cluny now bound monasteries to herself as direct and continuing dependencies, and under Odilo's successor, Abbot Hugh, who ruled Cluny from 1049 to 1109, reached her greatest power and influence.[2] The Christian rulers of Spain, through close contacts with the Cluniacs, who provided so many eminent churchmen for the reform of old and the foundation of new monastic houses, created many contacts with older centres of culture in Europe. Connexions with the Empire were also undoubtedly close. Clementia, wife of Robert II, count of Flanders, was the sister of Raymond, who was the first husband of Urraca, queen of Castille (1109–26). German pilgrims were numerous among those who made the journey to Santiago, and Baldwin, count of Flanders, took the road in 1084.[3] The kings of León and Castille, the most important house in northern Spain, were also closely linked with the abbey of Cluny, especially after 1080, when Alfonso VI (1065–1109) married Constance of Burgundy, a niece of Abbot Hugh. In 1077 Alfonso had doubled the annual payment made to Cluny by his father Ferdinand I (1038–65), which became henceforth 1,000 metcales or dinars, a very considerable sum.[4]

The rise of León as a great artistic centre towards the middle of the eleventh century was the result of the munificent patronage of the collegiate church of San Isidoro by a new and powerful dynasty founded by Fernando I and his queen Sancha, who brought the kingdom of León to join that of Castille with her marriage to Fernando in 1032. A previous church on the site had been dedicated to St John the Baptist and St Pelagius of Córdoba. At the end of the tenth century, this modest church was destroyed by Almanzûr during his incursion into León. Queen Sancha's father, Alfonso V of León, had begun rebuilding, but the church was given an altogether new importance when Fernando obtained the relics of the great St Isidore of Seville, as tribute from Abbed

Motátid (1042–69),[5] and decided to build to the west of the new church his dynasty's mausoleum, the famous Panteón de los Reyes, with its astonishing range of carved historiated capitals.[6] The new church was consecrated in 1063.

Four years previously, Fernando I and Sancha had donated a new reliquary for the ancient relics of the foundation of St John the Baptist and St Pelagius, presumably before the arrival of the new relics of St Isidore (Plate 150). The wooden casket, decorated with twelve ivory plaques of standing Apostles under arches, four to each of the long sides and two to each of the shorter, still survives in the treasury of San Isidoro. The centre of the truncated-cone lid is occupied by a plaque with the Agnus Dei, surrounded by the four Evangelist symbols, and on each of the long sides one of the two archangels is accompanied by two angels, each shown in rectangular plaques, flanked by the four rivers of paradise in triangular panels. On the shorter sides of the lid three more panels on each side depict seraphim and angels. Originally the casket was ornamented with silver-gilt, of which only tiny fragments survive.[7] This original decoration could still be seen in the sixteenth century by Ambrosio de Morales, who also read and recorded the dedicatory inscription naming Fernando and Sancha as donors in the year 1059.[8] Slight scratched lines on the sides of the casket show that the metal decoration took the form of a larger arcade over the Apostle panels. These, and the form of the casket as a whole, show that the reliquary is part of the traditional type of house-shrine, although it is much larger (length 48 cm., or 19 in.) than any of the earlier pieces. Although caskets of this type were not uncommon in the Iberian peninsula in the tenth and eleventh centuries,[9] the origins of the figure style of the Apostles are more difficult to define. The horseshoe arches over the standing figures show clearly that the panels are part of contemporary Spanish tradition – they are common both in architecture and in manuscript illumination. Nor is the style of the *Libro de Horas*, written by Petrus and illuminated by Fructuosus for Ferdinand and Sancha in 1055 (now in the University Library, Santiago da Compostela), unrelated to the Apostle figures.[10] The hard, strong, linear drapery patterns, the 'T' folds at the hems, the precisely contained outlines of the figures on the dedication page of the manuscripts are very like the ivory carvings, although the big, violent forms of the heads and the large feet and hands of the Apostles have no counterpart in the, on the whole, thinner and more elegant illumination. It is these strong, almost brutal forms that remind one of the group of ivory carvings around the Crucifixion plaque, carved in the Ottonian Empire, when the tenth-century book-cover of Theophanu was adapted for the Echternach Gospels (now in the Germanisches National-Museum, Nuremberg) towards the middle of the eleventh century (Plate 92).[11] Here the same heavy features appear, and also the same stylized treatment of hair, rather contorted large hands and feet, and even the technical trick of outlining folds with small nicks made into their edge with a graver. It seems hardly possible that these León ivories could have been carved without influence from the almost exactly contemporary Late Ottonian workshop.

The case for German influence is also made stronger by the clear stylistic evidence for more such influence in the metalwork commissioned by Ferdinand and Sancha for their collegiate church. In 1063 the royal pair donated a new silver, partly gilt, shrine

for St Isidore, decorated with figure reliefs, foliate bands, chequer patterns, and roundels with foliate niello inlay (Plate 151). The rectangular figure scenes on its sides are taken from Genesis, from the Creation of Adam to the rare scene of God the Father clothing Adam and Eve, and the Expulsion from Paradise. Of the eight scenes originally designed, three to each long side and one on each end of the reliquary chest, one, now mounted on the back, shows the donor, alongside five more that survive.[12] On the lid five standing figures are separated by panels of foliage, and on two of the sloping edges two Evangelist symbols are mounted. The shrine has suffered a great deal of alteration, and none of the major figure scenes appears to be in its original position. Mounted on the long front edge of the lid are Late Gothic decorative details, and in two of the figure relief areas on the front of the shrine, sheets with decorative niello roundels, perhaps originally on the roof. The standing figures, now on the top of the reliquary lid, slope inwards and were probably originally mounted on one side of the sloping lid before it was reduced in height.

And yet enough survives to make this a most important object. Indeed, it is the earliest surviving reliquary-shrine and it takes the first steps towards the monumental house-shrines of the twelfth century. It is considerably larger than any other surviving eleventh-century house-shrine and it attempts to articulate the sides of the casket with architectural detail. To each side of the figure scenes, embossed columns are placed against a chequered background. The small fragment of silver that survives on the reliquary of St John and St Pelagius proves that similar chequer patterns were already employed on that shrine; both were drawing on a much older technical tradition, employed on the reliquary of St Vincent and the Pepin reliquary both in the treasury of Conques.[13] The most outstanding characteristic of the reliquary, however, is the remarkable resemblance of its figure style to the style of Bernward's bronze doors at Hildesheim.[14] The high relief of the heads – that of Ferdinand, for example, is fully free-standing – tapering to a fairly low relief at the feet, the rather bulbous treatment of the nude with spindly arms and pronounced knee joints, the round, large heads with large features, all are closely related to the style of the Hildesheim Genesis reliefs (Plate 112). Even the decorative foliate scrolls and summary treatment of trees are not far removed from such details on the bronze doors. There can be little doubt that the goldsmith who worked the shrine of St Isidore had seen the metalwork of Lower Saxony, if indeed he had not actually been trained in the Hildesheim workshop. His work, however, also differs in some respects. The clothed figures are much more strictly organized in their drapery patterns, and the lively narrative elements assembled so loosely in Bernward's doors are more controlled and more precisely related to their frames. The large inscriptions in the field of some of the compositions serve to destroy any of the illusion of space still so evident in the earlier work, and the decorative scrolls and trees are treated with precision and strict symmetry. In a word, the Late Antique elements transmitted from the Carolingian tradition still so evident in the bronze doors have been replaced by the hard, balanced patterns of a nascent Romanesque.

The same spirit pervades another magnificent gift made by Fernando and Sancha to their favourite foundation – the large, 52 cm. (20 in.) high ivory altar cross, now in the

Museo Arqueológico Nacional in Madrid (Plate 152).[15] An inscription at the base names both the king and his queen, and a document proves this cross to have been given to San Isidoro at its re-dedication on 21 December 1063.[16] This remarkable survival, one of only three early medieval ivory altar crosses to have come down to us, is carved on both sides. The front carries a large corpus; below it is a figure of Adam in a square frame, and above a figure of the risen Christ with a cross staff in his hand is surmounted in the border by the Dove of the Holy Ghost flanked by two angels.[17] On the edge of the cross small figures are carved, sometimes intertwined with beasts, those on the left representing the rising elect, those on the right the fallen damned. On the back, the Agnus Dei occupies the centre, with the four Evangelist beasts, one at each extremity. A rich, thoroughly Romanesque inhabited scroll fills the remaining arms and the stem of the cross. Despite the greater skill of carving evident in the detail – especially the edge of the front and the scroll on the back – the piece is clearly related to the workshop that had carved the panels for the reliquary of St John and St Pelagius some four years earlier. The fleshy acanthus border on the back, the rugged figure of the small risen Christ on the front, and the strict, formal patterns of the loincloth and the head of the corpus all derive from the earlier work. But what had been uncertain, almost experimental, in the approach of the workshop is now handled with an assured skill and consummate ease. Evidence of the Ottonian influence which played such an important part in the formation of the León workshops can still be detected in the whole proportion of the cross, and especially in the formation of the terminals – which resemble closely the capital-like structure of the crosses commissioned by the Abbess Mathilde of Essen.

One more casket, which in style certainly belongs to this group of works and which was originally the property of the treasury of San Isidoro at León and may therefore have been given to the church by the same munificent donors, is now in the Museo Arqueológico Nacional in Madrid. The casket is made up of fragments,[18] including seven upright panels, carved with seven of the eight beatitudes personified (Matthew 5, 3–10) accompanied by an angel (Plate 153). They each appear under an arch surmounted by an architectural canopy carried on twisted columns. The figure style is livelier and thinner and more linear than that of the earlier Apostles, and relates therefore more closely to contemporary manuscript illustration in Spain, but it also resembles that of the risen Christ on the Madrid cross. It might therefore argue for a date quite close to the dedication of 1063 when so much else was given to the church by Fernando and Sancha. The architectural detail has also been convincingly compared to contempory Spanish manuscripts.[19]

Not very closely related to the León workshop, but nevertheless under its influence and drawing on much the same sources for its style, is the great reliquary shrine made for their patron saint at San Millán de la Cogolla in the neighbouring kingdom of Aragon (Plates 155 and 156). The relics of San Millán were translated from Suso to Cogolla under King García Sanchez III (1035–54). The new church was dedicated in 1067, but the great shrine could not have been complete by then: among the ivory panels that decorate it, one shows the Abbot Blasius, who ruled the abbey from 1070 to 1080, another King Sancho IV (1054–76) and his wife Plasencia, who is referred

to as 'divae memoriae'. The likely date for the completion of the shrine therefore seems to be in the late seventies. Both the style and the extremely rich and elaborate decoration of the large reliquary support a later rather than an earlier date. The complete shrine survived until the early ninteenth century, when it was robbed of all its precious metals and gems and some of the ivory panels were taken away. Some, but not all, have since appeared in public collections in New York, Leningrad, Florence, and Berlin.[20] The panels remaining at San Millán were mounted on a nineteenth-century casket. Fortunately, a very full description of the shrine before its destruction, published by Prudencio de Sandoval in 1601,[21] enables us to reconstruct it in its main outlines. On each of the long sides six upright ivory panels were mounted, with five somewhat wider panels in a register below them,[22] all depicting scenes from the life of San Millán. At each end and between each ivory panel on both registers, small single figures of embossed gold (or was it silver gilt?) appeared, making thirteen such figures on each long side of the reliquary. The gable-ends were decorated with numerous ivory panels (one of them depicting the death of San Millán), gold embossed reliefs, gems, and crystals. Enamelled strips with inscriptions which suggest that the single figures on one of the long sides were Apostles, and on the other prophets, are also mentioned.[23]

Like those of León, the shrine of San Millán was the result, at least in part, of royal patronage. One of the small panels in a gable-end shows 'Ranimirus Rex' carrying a bag of money in his hand (probably Ramiro I, king of Aragon, who died in 1063), while Sancho IV and his wife Plasencia, probably the main donors, were represented on each side of the Christ in Majesty on the opposite gable-end. Alongside Ramiro, a number of other small panels seem to represent minor donors – for example Count Gundinsalvus and Countess Sancha – as well as members of the San Millán community including the later famous St Domingo of Silos, and various men connected with the making of the shrine, including the Master Engoloram and his son Redolfo (fragment now in Leningrad), probably the carvers of the ivory. A unique representation of the acquisition of the ivory tusk is also represented (now in Berlin), showing an equestrian figure with a huge tusk on his shoulder – with an inscription, recorded by Sandoval, which reads: 'Vigilanus negotiator'. On the major gable-end, alongside the royal patrons and adoring the Christ in Majesty, is the figure of Abbot Blasius (1070–80) stretched out in prayer with the inscription 'Blasius Abbas huius operis effector', and a figure on the opposite side in the same pose, inscribed 'Munio scriba politor supplex' (both panels still at San Millán), is perhaps the scribe, who supplied the inscriptions and who may have supervised the iconography of the shrine.

Of the original wealth of metalwork, only a single fragment survives in the frame of the Christ in Majesty now at Dumbarton Oaks, Washington, D.C. (Plate 156), which is made of wood inlaid with silver and copper wire. The craftsman responsible for the work may well be another figure represented on one of the small ivory panels, where a Benedictine monk is shown with a chisel in his hand accompanied by a man carrying a pair of pincers, with an inscription reading 'Munius Procer' (now in Leningrad). Another panel, mentioned by Sandoval but now lost, showed another, unfortunately unnamed, craftsman, carrying a hammer and pincers, accompanied by a figure

named 'Simeone discipulo', who was most probably a metalworker connected with the work. Not enough survives to be at all certain of the tradition in which the San Millán goldsmiths were working, but the filigree frame of the Christ in Majesty panel bears no resemblance whatsoever to the broad, embossed techniques of the master of the shrine of St Isidore at León. The simple looped inlaid pattern of heavy filigree wire and the heavy beaded border which encloses it are perhaps in too simple a style to attribute the work to any centre, but in design it is certainly very like the frame of the front cover of the Gregorian Sacramentary given by King Berengar to the cathedral of San Giovanni Battista at Monza in the early tenth century, which is a work rooted in the Late Carolingian tradition.[24] This tradition is not found in any of the Late Carolingian goldsmiths' work in Spain,[25] and seems therefore to be an eleventh-century introduction. Unfortunately no centre elsewhere in Europe seems to be known to have had links with quite such an early and out-of-date tradition in the eleventh century, so that the resemblance to the Monza book-cover may be no more than fortuitous; unfortunately it certainly does not help to define the sources of the San Millán metalworkers.

The ivory carvers are more obviously linked with the already established León style. The architectural details and the form of the inscription on the San Millán panels may be compared to the Beatitudes casket at Madrid, and such technical details as the black bead eyes and the small nicks along the edges of the drapery continue the customs of the León School. The treatment of figures at San Millán, however, is heftier, rounder, and more deeply undercut, and the lively deep linearity of the León surface pattern is replaced by a far more restrained and thinner, almost engraved surface on the San Millán shrine, resulting in a style with more body and volume.

It is in this tendency towards a more controlled surface pattern, in which the figure is articulated by the drawing of drapery patterns that outline the main parts of the body below, that the development towards the later-eleventh-century style reveals itself. The work that shows this tendency most clearly is the great Arca Santa at Oviedo (Plate 157). It is a large reliquary casket, the size of an altar, covered on the front and sides with embossed figure scenes. On the top the silver sheet is engraved with a large Crucifixion: Christ with St Mary and St John and Stephaton and Longinus in the centre, and smaller scenes of the two crucified thieves. Two angels appear above the thief on the left, two devils over the cross of the unrepentant thief on the right. Above the thieves on each side are two large angels with censers. Four lines of inscription surround these scenes on all four sides, giving details of the relics the Arca contains and the names of the donors Alfonso VI and his sister Urraca as well as the date A.D. 1075 (Era 1113).[26] Broad bands with decorative cufic inscriptions frame the front and sides. On the front a Christ in Majesty in a mandorla is supported by four angels between the twelve Apostles, six each side under superimposed triple arcades.[27] On the right side the Visitation, the Annunciation to the Shepherds, and the Annunciation to the Virgin are shown above, the Nativity and the Flight into Egypt below. The single figure of the Virgin's Mother, Anna, appears twice, once on the left of the Flight and a second time under a separate arcade, facing outwards away from the Annunciation. On the left side, the ascending Christ in a mandorla supported by two angels on the right and St

Michael between a cherub and a seraph are represented above eight standing Apostles: SS. John, Peter, James, Andrew, Philip, Matthew, and Thomas.[28]

Technically and in style, the Oviedo reliquary is very different from the León shrine completed barely eight years earlier – only the chequer pattern used as a background of the figure of King Fernando and elsewhere in the shrine of St Isidore is used again, covering the entire back panel of the Arca. The drapery treatment is far more detailed, no longer showing the broad, simple forms of the León reliquary, and the relief is of consistent depth, with heads no more raised than the rest of the figures. The Oviedo figures lay even greater emphasis on the articulation of parts, by a greater contrast of massed and bunched folds against very plain areas over stomachs and thighs. The liveliness of drapery patterns, of shooting and flying folds is paralleled by extremely active poses, including the violently crossed legs which were to become a hallmark of the stone sculpture of the pilgrimage road in the next generation. The sources of this style can be most clearly seen in the flat drawing in the same style engraved on the top of the Arca, especially in the large censing angels, who show clearly the influence of the illuminators of the Book of Hours written for Fernando of León in 1055 which has already been mentioned in connexion with the reliquary of St John the Baptist and St Pelagius.[29] Only the firmer line and stronger, more formal approach is indicative of a later date.

This tendency is shown more completely and in a fully developed form in work around the end of the century. Outstanding is the shrine of St Felix made for the abbey of San Millán de la Cogolla (Plate 154). This shrine, too, fell victim to the Peninsular War, and four surviving ivory panels were mounted in a new wooden casket at the beginning of the nineteenth century; a fifth was in the Figdor Collection, Vienna.[30] These ivories clearly follow the tradition of the earlier San Millán shrine: similar crowded narrative with fragmentary architectural settings is used, carved on panels of ivory made up of several smaller pieces. But differences are obvious too. The earlier black beads inlaid in eyes are not used, and heads are larger and more firmly modelled, with hair and beards laid in strict patterns. Poses are less awkward, and the drapery is clearly carved in 'double line' folds, parallel and of simple pattern.[31] The large Christ in Majesty from the gable-end of the San Millán shrine of the seventies has much of the character of this style in an incipient form (Plate 156), and other ivories carved in Spain in this period maintain Spanish traditions of the previous generation even more precisely. The small crucified Christ in the museum of San Marco at León, originally from the Cistercian monastery of Carrizo, has all the precision of pattern of the St Felix shrine, especially in the beard and hair of his large head, but the drapery of the loincloth retains something of the fussy, thin detail so typical of the earlier San Millán reliquary.[32] Another panel, now in the Metropolitan Museum, New York, with two scenes, the Road to Emmaus above and the Noli me tangere below, with a companion piece of similar size of which only the lower half with the Three Maries at the Tomb survives,[33] is typical of the Spanish tradition (Plate 159). Here, the lively expressive movement of the Arca Santa at Oviedo is combined with the 'double fold' and the thick, fleshy relief of the St Felix shrine. Other pieces, like the large upright panel with a Christ in Majesty

accompanied by St Peter and St Paul and framed by the four Evangelist symbols, with angels and the Agnus Dei above, show clearly the full formal discipline of the Romanesque, with details such as the carving of the heads still very like those on the casket with the Beatitudes in Madrid (Plate 153).[34]

A work of much poorer quality, though of much the same kind, is a book-cover with a broad silver-gilt frame surrounding a small ivory Crucifixion scene below very unusual kneeling (donor?) figures on clouds. An inscription names Queen Felicia, probably the wife of King Sancho Ramirez (1063–94), as the donor.[35] Queen Felicia died in 1085, and the cover was no doubt produced near the end of her life. One small fragment of enamel is mounted, like a gem, among the loose filigree of the broad border. Another piece mounted with small decorative enamels is the richly decorated chalice in the treasury of San Isidoro in León. Of two pieces of agate, perhaps of Roman origin, mounted in gold, the inscription IN NOMINE DNI VRRAGA FERDINANDI shows that it was the gift to León before her death in 1101 of Urraca, most probably the daughter of Fernando I and the sister of Alfonso VI who had also joined her brother in the gift of the Arca Santa to Oviedo. If anything, the style of the metalwork is in keeping with the early eleventh rather than the early twelfth century. Although nothing survives in Spain with which one can compare it, most of the details of its decoration can be seen on early-eleventh-century work in Germany: for example the pyramids of twisted filigree ('beehives') and the open arcades of the foot, as well as the open, serrated edge filigree, all exist on work done for the courts of Otto III and Henry II.[36]

The appearance of enamel used decoratively raises the question whether enamelling was practised in Spain by the turn of the century – a question that might be of some importance to its later history in Spain and southern France. It has already been noted that Sandoval, in his description of the shrine of San Millán, mentions enamelled strips with inscriptions. Ambrosio de Morales also describes four reliquary caskets of SS. Silvester, Susanna, Cucuphas, and Fructuosus that he saw at Santiago in the sixteenth century. The relics had been brought there by Bishop Gelmirez in 1102, and de Morales states that those of St Silvester and St Susanna were decorated with enamels.[37] It is moreover possible to attribute to this early period the metal strips decorated with champlevé enamel which were made to strengthen the edges of an Islamic ivory casket of the mid eleventh century from Palencia Cathedral (now in the Archaeological Museum in Madrid). The patterns used are simple geometrical ones of interlocking rectangular blocks and zigzags with a limited range of colours – white, blue, turquoise, and dark red. Small studs of bronze are reserved – a technique probably intended to key the enamel. These patterns have been compared very convincingly with details in an early-twelfth-century Beatus manuscript in the British Museum, where not only very similar interlocking patterns are used, but even the 'bronze studs' of the enamel are imitated.[38] Thus there seems little doubt that at least simple patterns of this kind were enamelled in Spain by the late eleventh century.

Moreover other evidence of early champlevé enamelling in southern Europe can be found in southern France. In the treasury of the abbey of Conques is a wooden reliquary casket, covered in leather and studded with silver nails and decorated with thirty-one

enamelled medallions, which was discovered in the wall of the choir in 1875.[39] Birds, winged bi- and quadrupeds, and symmetrical foliage patterns are represented on the medallions in simple, broad colours (Plate 158). Although the technique employed is champlevé, the gilt-bronze backgrounds and the thin stays left standing between the colours are reminiscent of cloisonné enamelling, and enamels of this kind clearly imitate the earlier gold cloisonné technique.[40] On the edge of two of the medallions these inscriptions are found: + SCRINIA CONCHARVM MONSTRANT OPVS VNDIQUE CLARVM// + HOC ORNAMENTUM BONE SIT FACII MONIMENTVM. It seems therefore that the casket was commissioned by Abbot Boniface, who ruled from 1107 to 1118.

Certainly, the links between France and Spain in the early twelfth century were close indeed, not only in metalwork, but also in architecture and monumental sculpture. A portable altar, also in the rich treasury of the abbey of Conques, is dated by an inscription to the year 1100 (Plate 160). The name of the donor, the Abbot Bégon III, who ruled from 1087 to 1107, is also given.[41] Only small fragments of the original filigree of simple foliage pattern survive on the edges of the upper frame. On the thickness of the altar, busts of Christ, the Virgin, St Faith, and other saints as well as the twelve Apostles are shown under an arcade in nielloed engraving on silver sheet, partly gilt. The saints are named in inscriptions, also in niello, along the lower edge. The drawing is of high quality, in a single, strong outline, making much use of the 'double line' for interior folds found on Spanish ivories of around 1100, for example on the shrine of St Felix at San Millán de la Cogolla. The character of the heads, and the use of highly decorated arches and columns in the arcade, are also comparable. It would clearly be foolhardy to attempt to define any hard and fast differences between northern Spanish and southern French workshops or indeed styles at this period.

Most of the earlier pieces discussed here were the result of royal patronage. On this ground, as well as the strong dependence on contemporary work in the Ottonian Empire, one may well claim that this work cannot be called Romanesque. But whereas the Late Ottonian period in Germany leads in the second half of the eleventh century into a curious isolation and sterility of style, in Spain the patronage of kings appears to have penetrated the whole area, linking León with work at Oviedo and Navarre and even as far afield as Conques. All this work portrays elements of a continuous stylistic development into the early twelfth century, which enables us to recognize for the first time a clearly defined regional style – a style, moreover, which was to be of considerable importance as a parallel to, and even as a source for, the rapidly expanding major achievements of northern Spain and southern France in the field of monumental architectural sculpture. In this sculpture, especially in the decorative detail used, much influence from the highly skilled carvers of the Islamic south of Spain can be seen.[42] In ivory carving and metalwork surprisingly little, if any, such influence is found. If any of the superbly skilled Islamic ivory carvers so active in the first half of the eleventh century at Cuenca were drawn to the north to work for Christian patrons, nothing of their Islamic style came with them. Only once, in the highly decorative cufic inscription on the frame of the Arca Santa at Oviedo, are we at all reminded of the existence of the highly civilized Islamic society of the south.

GERMANY: ROGER OF HELMARSHAUSEN

AT the abbey of Helmarshausen, the goldsmith Roger made for Bishop Henry of Werl (1084–1127) of Paderborn a portable altar dedicated to St Kilian and St Liborius (Plate 161). Bishop Henry is drawn in niello on a silver plaque on the top of the altar, accompanied by the inscription: HEINRIC' EPS . . . DIRIGATUR ORATIO MEA SICVT INCENSVM IN CONSPECTV TVO DNE DS. The precise dating is given by a document of 15 August 1100 in which Bishop Henry makes over the church of Deisel near Helmarshausen and tithes of Muthen to the abbey in payment for a golden cross and a 'scrinium' dedicated to St Kilian and St Liborius, made by Roger.[1] Apart from this documentary reference which enables us to attribute the Paderborn altar to him, nothing is known of Roger. Evidence has been brought forward to see in Roger the author of the *De Diversis Artibus*, written by a monk and priest whose name in religion was Theophilus.[2] In this treatise, instructions are given on the techniques employed by medieval craftsmen in three books, the first on painting, the second on glassworking, and the third, the longest and most detailed, on the large variety of techniques employed in goldsmiths' work and bronze casting. It describes the refining and gilding of silver, gold, and bronze, how to make metalworkers' tools and niello, settings for gems, pearls, and enamels, how to execute die stamping, chasing, punched and embossed work, and open and cast work, and gives careful instructions on how to design large and small chalices, patens, a censer, altar frontals, book-covers, and reliquaries as well as secular work like ornamental saddles, furniture decorated with metal fittings, and horse-trappings. It even gives instructions on how to build an organ and all its parts – even the bellows – and how to cast church bells of various sizes. Theophilus was certainly a working craftsman. In the preface to book I on painting, he writes: '. . . I have written the things collected here out of no love for human approbation nor greed for temporal gain, and I have not appropriated anything precious or rare, nor kept silent about something reserved especially for myself from malice and envy. . . .'[3] Clearly he claims here that he has selflessly written down all he knows and kept no methods secret only for his own use. The date of the treatise has been estimated as early as the ninth or as late as the thirteenth century, but recent examination of all the internal evidence has made out a very convincing case for the early twelfth century and for a German provenance of the text.[4] Although absolute proof is not available, the circumstantial evidence for seeing in Roger of Helmarshausen and Theophilus one and the same person is strong.

Many of the techniques described in the treatise are used on the Paderborn altar. On the top, surrounding the green marble altar stone, nielloed plaques with representations of Bishop Meinwerk and Bishop Henry of Paderborn are mounted, and on the long sides ten Apostles are engraved, seated under an arcade (Plate 162). Of the short sides, the back has three arcades with the figures of the Virgin, St John, and St James

under them, all raised in flat relief, with the drawing engraved and inlaid with niello; the front, the embossed figure of Christ in Majesty in a mandorla decorated with wire filigree, and set with gems and pearls, flanked by standing figures of St Kilian and St Liborius, also raised in full relief. The twelve Apostles are named in a nielloed inscription along the upper edge, and the dedicatory inscription occupies the lower edge.[5] On the base, on an engraved bronze plaque, the donor is shown standing under an arcade. The bronze feet, partly gilt, partly silvered, in chequer patterns are in the form of triple claws.[6]

The form of the portable altar – with the lid hinged, which makes it also a small reliquary chest – was already well established in the Late Ottonian period.[7] The sources of its iconography can also be found there. But the sources of Roger's figure style cannot be so easily determined. The stiff, straight lines of Late Ottonian figure drawing, with drapery treated almost like a thin linear net overlying and flattening the form or with folds gently overlapping one another,[8] Roger transforms into a lively, expressive style, in which the parts of the body are outlined and articulated by a preconceived pattern of clinging folds, which have been characterized as 'nested V-folds'.[9] This may be seen as one of the aspects of a general tendency throughout Europe around 1100 to learn that the representation of the human figure would gain in plasticity if the drapery patterns revealed rather than concealed the figure below them. Broadly the tendency is put down to Byzantine influence,[10] but it is also recognized that this is an over-simplification.[11] First, the forms of 'panel' drapery, developed in the north, are not all of one kind. Three distinct styles have been suggested: a 'clinging curvilinear' style of the kind developed in the Bury Bible of c. 1135 (Cambridge, Corpus Christi College MS. 2), a 'multilinear' style used in Burgundy in the Cluny Lectionary (Paris, Bibliothèque Nationale MS. nouv. acq. lat. 2246) and the frescoes at Berzé-la-Ville, both of the early twelfth century, and the 'nested V-folds'.[12] Secondly, although there seems to be general agreement that the ultimate derivation of these styles must be from Byzantine art, a more precise formulation of what those sources were and by what route they were introduced into northern Europe is still highly controversial.

In the case of Roger, it has been suggested that the immediate source for his style was the work of the Mosan area, especially the abbey of Stavelot, where a great two-volume Bible was illuminated by 1097 (London, British Museum Add. MS. 28106–7). Both the Jeremiah initial (vol. 1, folio 161) and the full-page Christ in Majesty (vol. 2, folio 136) have been quoted as probable sources.[13] Indeed relations between Helmarshausen and Stavelot were very close in the late eleventh century; at the request of Abbot Thietmar (1081–1112), Abbot Rudolf of Stavelot gave relics of St Remaclus to Helmarshausen, and the feast of Stavelot's patron saint was celebrated henceforth in Helmarshausen. However, the elements of the 'nested V-fold' style in the Stavelot Bible are found only in a very few instances, and in view of the fact that they are virtually contemporary, one cannot rule out the possibility that it may be the influence of Helmarshausen that is felt in the Mosan area rather than the reverse. The nested folds that appear on the Christ in Majesty are combined at Stavelot with a very strong Ottonian tradition of the soft, Lotharingian classicizing style,[14] while in Roger's work they form a consistent whole, with a hard, linear decorative approach, in which the

longer lines are often broken up by a short 'horizontal' stroke across the fold. It is also impossible to find such a thoroughly systematized decorative treatment of the human figure in any Byzantine style early enough to have influenced Lower Saxony by the end of the eleventh century. Even those works that most nearly approach such a system, such as the mosaics of Daphni[15] or illuminations like the early-eleventh-century Gospel Book in Paris (Bibliothèque Nationale gr. 64) or mid-eleventh-century wall painting like that at St Sophia, Ohrid,[16] do not show the systematic use of the characteristic horizontal breaks found in Roger's style. Byzantine art of the eleventh century tends to retain a much more classical fluidity of line, by no means as abstract as the stylized German drawing. It is only in the 'provincial' Italian reflections of Byzantine art that the hardness and abstraction of Byzantine models approaches the trend expressed in Roger's art.[17]

Nowhere else in Europe did Byzantine art so thoroughly permeate indigenous styles. Italian fresco painters were particularly open to the constant competition of Greek mosaicists from at least the late eleventh century onwards, and 'every Italian artist', as has been said, 'had to work out, so to speak, his own solution of Byzantinism'.[18] It seems probable that it is in the wealth of Italian monumental painting, both in Italy and north of the Alps, of which only a tiny minority of works has survived, that the basic sources of the Helmarshausen style were to be found. Here and there in the extant wall paintings some of Roger's characteristics can be seen in embryo; for example, the typical 'horizontal' breaks in folds of drapery are to be seen as early as c. 1007 in the hem of the garment of the Prophet Jeremiah in the apse of San Vincenzo at Galliano, as well as a general stiffening and almost 'metallic' hardening of drapery treatment.[19] Other cycles, such as those in the lower church of San Clemente in Rome and the earliest work at Sant'Angelo in Formis (near Capua), show similar tendencies.[20] A reflection, and one that comes very close to the Helmarshausen style, of such Italian wall paintings can perhaps be seen in the Christ in Majesty page of the St Castor Bible of Coblenz (Pommersfelden, Graf Schönborn Library cod. 333, folio 2), painted most probably no later than the early twelfth century.[21]

To sum up then, it seems likely that Roger's style was the result of Byzantine influence transmitted through Italy in parallel with similar influences felt also in the Mosan area, in Burgundy, in England, and especially in the South German schools of illumination at Salzburg and Regensburg.[22] Finally it is worthwhile to mention the fact that Theophilus in his treatise was well aware of the importance of the 'Greeks' and of Italy. In the introduction to book I he mentions the 'various colours' that 'Greece' possessed, and 'the gold embellishments Italy applies to various vessels or to the carving of gems and ivories', as well as Russian enamelling and niello, Arabian art and embossed work, and French esteem of stained-glass windows.[23] Greek parchment made from linen rags (i.e. paper) is also mentioned, and Theophilus advises the use of Greek foliage as a decoration on the bowl of the large chalice. It must have been a well-known type, because he gives no instructions how to draw it.[24] If indeed Theophilus and Roger were the same person, clearly his awareness of what other cultures had to offer was considerable and a close contact with Mediterranean sources not at all surprising.

Another portable altar, that from the abbey of Abdinghof now in the possession of the Franciscan church at Paderborn, is undoubtedly also the work of Roger (Plate 163). Its sides are decorated with continuous scenes of openwork bronze-gilt. On one long side are two scenes from the life of St Felix of Aquileia, on the other the martyrdom of St Blaise of Sebaste in three episodes. On the shorter sides the trial and martyrdom of an un-nimbed saint (St Paul?) and a baptism by St Peter and the martyrdom of a monk are shown. On the lid, in superimposed arcades next to the altar stone, St Paul and St Felix and St Peter and St Blaise, the patrons of Abdinghof, are represented.[25] The figure style, although in a more lively narrative version, less strictly organized, is identical with Bishop Henry's altar: the same carefully articulated figures, the same severe heads and at times contorted poses occur. The date of the Abdinghof altar, however, is less certain than its authorship. The fact that a freer style with greater movement is employed may incline one to date it later than the cathedral altar, but the more elaborate techniques and the use of embossed figures on the work of 1100 may suggest that Bishop Henry's altar is the more mature, later work. But when so little survives of Roger's life work such arguments carry little weight.[26]

Another major piece attributed to Roger is the book-cover of the Gospels from Helmarshausen, now in the cathedral library of Trier (cod. 139, olim 110, treasury no. 68) (Plate 168).[27] An equal-armed cross within a frame, all of broad silver-gilt bands, set with gems, pearls, and small decorative cloisonné enamels, divides the area. In the four remaining upright rectangular panels are mounted the four Evangelist symbols in copper-gilt relief. The cross as a decoration of a book-cover is of ancient origin, found as early as the seventh-century cover of Theodelinda,[28] and combined with the four Evangelist symbols appears already in the Late Carolingian period, for example in the simple copper-gilt cover in the Victoria and Albert Museum.[29] Indeed this version, with the three-quarter-length St Matthew symbol, the large 'flying' wings, and the symbols with books, seems very close to the kind of source used by Roger. The fact that each symbol has three pairs of wings and that they carry books points to an ultimate Early Christian archetype.[30] Three pairs of wings are a feature of a type of Early Christian symbol, seen for example in the mosaics of Santa Pudenziana in Rome and the ivory panel in the Castello Sforzesco in Milan, with the Two Maries at the Tomb. Other features of the style also indicate close study of early sources: the scalloped haloes, the highly naturalistic treatment of wings and especially the feathers of the eagle's body, and even the head of the St Matthew symbol, with large eyes and pupils marked just under the heavy eyelids, remind one very vividly of Early Christian ivories.[31] In the treatment of the drapery of the angel, the unmistakable hand of Roger is seen, and the filigree employed on the cover, with single strands of beaded wire ending in tight curls surmounted by a single bead, the whole bordered by a rather heavy pearled wire, is exactly like the filigree of the halo and mandorla of the Christ in Majesty of the Paderborn Cathedral altar. It is also of interest that the small cloisonné enamels set between gems and pearls used purely decoratively are described fully by Theophilus in his description of how to decorate a golden chalice.[32]

Two more pieces come very close to Roger's style and may well be by his hand – the

processional or altar cross in the collection of the Museum für Kunsthandwerk at Frankfurt and the crucifix figure probably from a similar cross, now in the museum at St Louis (Missouri).[33] The Frankfurt bronze-gilt cross has square, expanded terminals and a square field of the same size at the centre, and is therefore a type of cross already known in a Late Ottonian context.[34] On the front, the four terminals show and always did show the four Evangelist symbols, although the present niello plaques were added early this century.[35] The corpus is a figure of restrained outline, slight sway, and with the rib basket abstracted to a pattern. Christ's large head is inclined gently towards his right shoulder. Above the delicate, thin legs, the loincloth is of a somewhat softer, less linear style than Roger's other relief work. The crucifix figure in the St Louis Museum, although just a little heavier in proportion, has an almost identical treatment of the loincloth, and, although the head is more firmly modelled and even larger in proportion to the figure, must surely have been made in the same workshop and may even be by Roger's hand. But it is in the engraving on the back of the Frankfurt cross that the clearest evidence of Roger's own hand can be found (Plate 164). The foliage patterns on the arms of the cross, with a small equal-armed cross in the centre of each flat leaf, against a punched background, are identical with the foliage scrolls in the spandrels of Bishop Henry's portable altar. The rays of light behind the central Agnus Dei also repeat precisely the background of the seated Apostles on the altar.

Another three pieces must be attributed to Roger of Helmarshausen's workshop, even though the evidence of his own hand is less compelling. The copper-gilt back plate of a cross very similar to that now in Frankfurt includes a standing figure of St Modoaldus, whose relics were translated to Helmarshausen from Trier in 1107 (Plate 165). The ends of the cross are engraved with anthropomorphic representations of the four Evangelist portraits.[36] These show the typical drapery treatment with horizontal breaks, but the figure of the standing saint is drawn on a somewhat smoother, less strictly controlled line. The clumsier drawing of the background of the central Agnus Dei, and the more star-like drawing of the small crosses inside the leaf ornament, shows that a different hand is at work, although the cross may well have been made soon after the arrival of the relics in 1107. A fragment also in the Schnütgen Museum in Cologne, with a bronze-gilt embossed Christ in Majesty, is also very closely related to Roger's work. Christ is shown with an inscribed scroll across his knees referring to the separation of wheat from chaff, and with a *ventilabrum* (a winnowing shovel) in his right hand (Luke 3, 17). Only the somewhat carelessly handled detail of the piece, especially the throne, prevents one from seeing the hand of the master in it.

But the most interesting piece in this workshop group is the gold reliquary cross from the church of St Dionysius at Enger, now in the Staatliche Museen in Berlin.[37] It is somewhat smaller in dimensions, the square terminals are much heavier in proportion, and the front is covered in gold filigree with gem settings and a circular crystal with a ninth-century engraving of an angel as lector in the centre covering a small relic of the True Cross on a gold background inscribed in niello + DE LIGNO DNI (Plate 166). On the back an Agnus Dei occupies the centre, with anthropomorphic symbols of the four Evangelists at the extremities.[38] Neither the filigree, the gem mounts (Plate 167), nor

the figure drawing of the back of the cross is very like the work on the Paderborn altar. The simple answer seems to be that the cross was made by a different, and one must admit very considerable, artist, a contemporary of Roger. Certainly something of Roger's system of drapery treatment, with a less pronounced use of nested folds and horizontal breaks, is employed in the Evangelist symbols. The strong reminiscences of Ottonian styles and techniques might lead one to date this cross somewhat earlier than the turn of the century. The centre crystal is held by foliate claws exactly like those found in imperial jewellery[39] of the late tenth century, where strings of small pearls surrounding gem settings, and raised settings, were also popular. The heavy striped backgrounds of the Evangelist symbols remind one of such backgrounds in the illumination of Hildesheim early in the eleventh century, or that of Corvey, closely related to Helmarshausen, of the late tenth century.[40] The fact that the manuscript of *c.* 1100 under Roger's metalwork cover is very much a work within the same Saxon tradition may be taken to lend further support to the possibility that an as yet less completely developed style, closer to well established indigenous sources, existed before the end of the eleventh century at Helmarshausen. It may even be possible that in the Enger cross we have an early work by Roger himself.

With the establishment of the style of Roger of Helmarshausen in Lower Saxony, the foundations of the Romanesque style were firmly laid in Germany. His influence was to be enormously important during the twelfth century, and was still felt in some of the finest work commissioned late in the twelfth century by Henry the Lion.[41]

CHAPTER 15

LOTHARINGIA: RAINER OF HUY

THE creation of the Romanesque in Germany is associated with the name of Roger of Helmarshausen. In Lower Lotharingia, especially in the Mosan area centred on the city of Liège on the river Meuse, the same importance is attached to the name of Rainer of Huy. The bronze font commissioned by Abbot Hellinus (1107–18) for his church of Notre-Dame-aux-Fonts, now in the church of St Bartholomew at Liège, laid the foundations of a style very different from that of Roger, although no less influential (Plate 169).[1] Through it, a northern 'classical' style, established in the Lotharingian region since the Carolingian period, was transmitted to the twelfth century – a style that was not only to dominate the whole of the Mosan area for several generations, but was also to prove to be one of the main formative influences on the so-called Transitional style of the later twelfth century.[2]

Apart from the fact that 'Reinerus avrifaber' appears as a witness on a charter of the church of Notre Dame at Huy signed by Bishop Albero I of Liège in 1125, nothing is known of him. Indeed, the evidence naming Rainer of Huy as the man responsible for the Liège font is far from conclusive. The contemporary rhymed chronicle written by a canon of the cathedral of Saint-Lambert at Liège describes the font very fully and states that it was made in the time of, and by, Abbot Hellinus, who died in the year 1118, and no mention of any other craftsman is made.[3] Rainer's name is not found until the fifteenth century, when the Liège chronicle, under the year 1137, states that Rainer of Huy made it by order of Bishop Albero of Liège, who at that date would have to be Albero II, as the first bishop of that name died in 1128. So, although the font must be accepted to be of the time of Abbot Hellinus and made between 1107 and 1118, the name of Rainer as the craftsman who created it is doubtful. It has, however, been accepted for so long that it remains a convenient name to attach to it, as long as it is remembered that the figure of Rainer is not of the same historical standing as that of Roger of Helmarshausen.

The font itself is a magnificent bowl, just over one metre (about 3ft 6in.) in diameter, cast in a single piece, and supported originally on twelve half-length oxen in the round (of which ten survive), on analogy with the 'Molten Sea' which King Solomon had constructed for the forecourt of the Temple in Jerusalem. In this the Fathers of the Church had already seen an archetype of the Baptism, and in the twelve oxen supporting it forerunners of the Apostles.[4] On the sides of the bowl, between simple, plain 'classical' mouldings, five scenes are shown: St John the Baptist preaching and baptizing the publican, the Baptism of Christ, and two more scenes of baptism, that of Cornelius by St Peter and that of the philosopher Crato by St John the Evangelist. The scenes are modelled in remarkably high relief and only interrupted by slender trees. Explanatory inscriptions accompany each scene, and others are placed along the top and bottom

edge of the bowl.[5] The figures occupy the whole available height, and are placed on an undulating ground line which is continuous around the bowl, just above the lower moulding. Heads, arms, and legs and parts of the trees are at times modelled in full three dimensions, entirely released from the plain background: the background is in no sense illusionistic, as it had been so often in Ottonian work. In the bronze doors of Hildesheim, for example, relief tends to grow out of the background, perpetuating a Late Antique illusionistic pictorial tradition; but in the font the solid 'wall' against which the action is placed sets a finite limit, the entire scene being enacted in front of this limit, breaking out towards the spectator and invading the real world. The modelling itself is extraordinarily soft and gentle. The figures move with ease and self-confidence; they are restrained in gesture and even turn their backs towards us and stand in a perfectly balanced contrapposto. Drapery folds tend towards parallelism, with delicate distinctions for pull, fall, and loop. The compositions are rhythmically interrelated, with subtle spatial movements within the limited, real space created by the figures themselves. Even the small head of God the Father in the scene of the Baptism of Christ appears to break out of the upper moulding, well in front of the solid, inviolate bowl of the font. Rainer deals with solid, three-dimensional form, with sculptural reality, not with pictorial illusion. It is in this preference for the tactile against the optical that the font breaks most clearly with the tradition that had dominated European art since the Late Antique. Yet, instead of accepting the strict, abstract patterns of the emerging Romanesque, Rainer stays deeply rooted in the classicism of the Ottonian period, especially that of the Lotharingian region. The soft naturalism of his drapery and the slender limbs of his figures continue a local tradition that reaches back to the late tenth century and through this even to the first essays in classical Mediterranean humanism of the Carolingian period, particularly in the time of Louis the Pious.[6]

A group of ivory carvings in what has been called the 'small figure' style continued this early tradition in the eleventh century.[7] Their dating, however, remains controversial, especially that of one of the most important pieces in the group, the book-cover of Bishop Notger (Plate 170). On an upright panel, a Christ in Majesty is enthroned, surrounded by the four Evangelist symbols. A cleric kneels below, a throne behind him and a small chapel in front. An inscription is engraved on the frame: EN EGO NOTKERUS PECCATI PONDERE PRESSUS/ AD TE FLECTO GENV QUI TERRES OMNIA NVTV.[8] The manuscript and its cover are said to have belonged to the church of St John at Liège, which was founded by Notger and dedicated in 982, and most scholars accept that the cover was carved in the lifetime of the bishop, between 972 and 1008, thus making it the earliest example of the group.[9] But perhaps the most serious objection to seeing the ivory as the donation of Notger lies in the fact that the kneeling figure, who must surely, in view of the inscription, be meant to represent the bishop himself, is shown with a halo.[10] Compelling historical arguments have been advanced for dating the panel between 1101 and 1107 instead,[11] and the background for them is as follows.

The sin for which Notger appears to be doing penance may well be his destruction of Chèvremont, a stronghold in the hands of the opponents of the Emperor Otto III.

Bishop Notger was asked to baptize one of the children of the lord of Chèvremont. He entered the castle with a number of clerics who had hidden swords under their vestments, surprised the lord, and took over the castle, destroying the buildings, including three chapels, one of which was dedicated to St John the Evangelist. Later, repenting this deed, Notger founded a new church of St John in Liège. The occasion when the ivory panel recalling the sin and the repentance of the bishop might have been carved was the dispute in Liège about the right of baptism between the parish church of Notre Dame-aux-Fonts[12] and the chapel of St Adalbert. The latter, a dependency of St John the Evangelist, claimed that Notger had granted it the right of baptism and that a synod held by Bishop Otbert in 1101, and a second hearing in 1107, had upheld and confirmed this right. Now it is suggested that the ivory might have been carved to support the case of St Adalbert, by showing Bishop Notger kneeling in front of his foundation, with the charter in his hand.[13] It is, of course, impossible to prove the late date of the Notger relief on the basis of this evidence, but stylistic analysis may well lend further support to it. The style of the relief certainly has much in common with the Liège font, and to see contemporary works in these two monuments is not at all difficult and even desirable. The kneeling figure in particular has much the same ease of movement and soft modelling as the figures on the font. The simple, classical moulding of the frame repeats those of the font, and the head of the Christ in Majesty may be compared most convincingly to the Christ of the font's baptism scene (Plate 169).[14] The treatment of relief, with a strong feeling for the balance of forms set against a plain background with the same kind of isolation of forms in front of it, is found in both. It seems hardly conceivable that more than a century should separate these two superb works of art.

How does the Notger plaque relate to the other pieces in the 'small figure' group? Surely none is stylistically as closely related to the Liège font. It has often been said that the ivory on the centre of the book-cover now in Oxford[15] is very similar to the Notger panel, and usually it is understood that the Oxford plaque derives from the other (Plate 171),[16] but analysis of the two panels does not at all support this assumption: the rich, broad, acanthus border is far more traditional, and the personifications of Oceanus and the earth goddess Gaia below the Christ in Majesty are obviously based on Carolingian archetypes. The closest parallels to the acanthus are the thick, fleshy Ottonian copies of the far more feathery originals on Carolingian panels – for example the Schnütgen Museum Ascension panel and the late-tenth-century Nazarius plaque in the Kestner Museum at Hannover.[17] The personifications below Christ may be compared to a whole series – no less than seven – of such figures on Carolingian ivories of the Metz and Utrecht Psalter groups, every time accompanying the Crucifixion,[18] except in the case of the Christ in Majesty on the Tuotilo cover at St Gall (Plate 64), where the ivory is based on the Codex Aureus cover made at Charles the Bald's court in 870 and the figures of Gaia and Oceanus were most likely added from the same manuscript.[19] Another curious point should also be noted. In all the surviving examples in ivory, the figure of Gaia appears on the right, and that of Oceanus on the left – the opposite arrangement to that of the Oxford panel. One can only suppose that the model used

by the carver was a two-dimensional one reversed in the tracing, rather than another carving. The Evangelist symbols on the Oxford panel are certainly similar to the Notger ivory, but the angel of St Matthew is shown full-length on the former and only three-quarter-length on the latter, which might well argue that the Notger panel's more abbreviated form is more likely to derive from the Oxford panel. The treatment of drapery in the two panels is not all that close in the lower part of the Christ figure, although the general pose and passages of the upper parts of the body, especially the thin loop from the left shoulder, suggest a common prototype.[20]

Finally, the whole concept of relief in the Notger panel approaches that of Rainer's font, whereas that of the Oxford panel is less pronounced in character, and far more traditional, being developed out of the panel rather than 'placed in front' of it. The Oxford ivory is mounted in the centre of a broad bronze-gilt frame, engraved with the four Evangelists under arcades in the corners, a Christ in a mandorla held by two angels at the centre above, and a half-length angel under an arch below. On the left a saintly bishop is shown about to receive the book held by a donor on the right, with a crown held over his head by the hand of God the Father. None of the attempts to identify the donor have so far proved convincing.[21] The resulting dates for the whole codex – and we must agree that the work is all of one time – extend from as early as *c.* 1000 to as late as *c.* 1130. But the manuscript has recently been attributed to the second half of the eleventh century,[22] and indeed a date soon after the middle of the century seems entirely acceptable. The style of the engraving, too, can be paralleled most convincingly in Mosan illumination of the second quarter of the eleventh century. The St Matthew in the Gospel Book from Gembloux (Brussels, Bibliothèque Royale MS. 5573)[23] with short double lines articulating the drapery over the thighs comes very close indeed to the style of the engraved Evangelists on the cover. Thus there seems little doubt that the Oxford cover must be dated into the second third of the eleventh century.

Another important plaque of the 'small figure' group, which might help to clarify the position in the eleventh century, is the Crucifixion panel in the museum of the church of Notre-Dame at Tongeren (Tongres) (Plate 172),[24] the only important panel, alongside the Notger ivory, to use a plain moulded border. In any analysis of relief and space in this panel, the relationship with Rainer's font becomes obvious. The placing of figures in front of a 'separate' plain background, the soft modelling of figures with easy and gently turning poses, and the use of a continuous, wavy base line for the main figures are all very similar to the font. In the almost ribbed treatment of drapery, the influence of the Oxford panel seems possible. The same is true of the personifications of Gaia and Oceanus; although they are here shown facing inwards as in all earlier examples they are not reversed as on the Oxford ivory. The close comparisons that can be made with Metz ivories of around the middle of the ninth century reinforce the directness of this link with earlier Carolingian prototypes. The female figures, heavily draped, their cloaks passed over their heads and swung around the neck, are a clear demonstration of ancestry in this Metz tradition, which is the basis for the whole development of the 'small figure' style. The most obvious connexion between the earlier traditions and the eleventh century is found in the Adalbero panel in the Metz Museum (Plate 109),

dated quite firmly to the late tenth century. Not only is this iconographically linked with the whole series of ninth-century Metz Crucifixion panels, but its style is clearly a refinement of the wider background of the Lotharingian tradition in contact with the equally important Utrecht panel group.[25]

In the Adalbero Crucifixion, alongside the Liège copies of Carolingian prototypes already mentioned,[26] we have the sources of the small figure style which must have been developed in the second quarter of the eleventh century, when the foundation of the monastery of Saint-Jacques in 1015 and the church of Saint-Laurent in 1034 provided possible workshops at Liège.[27] The earliest examples, alongside the Oxford book-cover, are the small panels in the Staatliche Museen in Berlin,[28] and the pair of ivories divided between the Musées Royaux in Brussels (Plate 173) and the treasury of Liège Cathedral.[29] Many of the characteristics already described can be seen in these four panels, but compared to the Tongeren plaque they are much more strongly dependent on Carolingian models – and not only in the rather spiky, detailed use of acanthus in the border. It is always claimed that the Brussels Crucifixion panel must be earlier than the dated book-cover of Theophanu at Essen (1039–56) (Plate 141),[30] whose iconography is identical. There are, however, differences. The crucified Christ wears a loincloth at Essen, whereas he wears a long colobium in the Brussels version. In the Brussels ivory, the risen Christ breaks open the gates of Hell at the very top of the composition, but at Essen these gates are misunderstood and are represented as books. One must doubt that the Theophanu ivory is a direct copy of the Brussels ivory; it would seem far more likely that both derive from a common prototype, and there is therefore no compelling reason to date the Brussels example earlier.[31] Thus a date for these ivories late in the second quarter or even early in the second half of the eleventh century, and in the last quarter of the century for the Tongeren plaque, seems appropriate. With such a distribution of work in the eleventh century, the appearance of the Liège font, which has always seemed so isolated, with all its sources almost a hundred years earlier, is much easier to understand, and, indeed, only really made possible.

Support for seeing such a degree of creative activity in the Liège area in the second half of the eleventh century comes from an unexpected quarter. There is in the British Museum[32] a small morse ivory panel with a king in a short tunic, holding a sceptre in his right hand and standing under an arcade (Plate 174). This is one of a small group of carvings that must be attributed to an English workshop probably active late in the second half of the eleventh century. The fact that a fragment of another panel of exactly similar size, carved with an almost identical king, was found in the cloister garth of Lichfield Cathedral in the nineteenth century[33] makes an English origin of these carvings likely. Also, the British Museum king stands on a large leaf of 'Winchester' style acanthus. The refined limbs and the gently carved drapery of the kings also remind one of the Liège ivories we have discussed, though the treatment of the heads is less summary than in the Liège ivories, and seems in a more naturalistic tradition difficult to find in the eleventh century. The small ivory crucifix in the treasury of St Servatius at Maastricht, probably also made in Lower Lorraine in the early eleventh century, or the head of the tomb slab of Rudolf of Swabia of c. 1080 in the cathedral of Merseburg,[34]

might be quoted as work with similar classicizing characteristics. In England such naturalistic treatment can be found in the illumination of the Canterbury scriptorium late in the eleventh and early in the twelfth century,[35] or – perhaps more immediately relevant – in the 'Winchester' style crucifix in the Victoria and Albert Museum of the early eleventh century.[36]

Closely related to the two kings, who probably decorated the sides of a portable altar of the kind so well known in the Late Ottonian period, is a small reliquary cross in a private collection in Dublin (Plate 175).[37] It is worked in two hinged halves of morse ivory, with the crucified Christ on the front, and on the reverse the Agnus Dei in a central quatrefoil surrounded by the four Evangelist symbols. Again, the delicacy of the carving, especially of the corpus, and the strong contrast of a very high relief against a plain and uncluttered background, although not by any means identical with the Liège style, points to the period when craftsmen in North Western Europe were coming to terms with a new, more controlled, and fundamentally more abstract art, while still rooted in the classicizing styles long established in both Lotharingia and England. In both areas, soon after the turn of the century, a harder, more schematic approach was to be accepted.

It is into this Early Romanesque period, as yet tentative in its application of the panel drapery style so wholeheartedly accepted by Roger of Helmarshausen, that one is also tempted to date the magnificent large morse ivory altar cross recently purchased by the Metropolitan Museum in New York,[38] although a date in the late twelfth century has been proposed (Plate 177).[39] The cross is richly decorated on both sides and nearly 60 cm. (2 ft) high. On the front, the missing corpus was originally attached to a 'ragged staff' cross ending in four square terminals with the Ascension at the top, the Deposition and Lamentation on the right, the Three Maries at the Tomb and the ascending Christ on the left, and Christ before Pilate below. In a large, elaborate roundel at the centre is the Raising of the Brazen Serpent. On the back, the centre roundel has an Agnus Dei, and large Evangelist symbols are on the square end terminals (Plate 178).[40] On the upright stem twelve busts of prophets are shown in rectangular frames, and six more full-length prophets are carved along the arms. Almost every figure carries a scroll with inscriptions, and inscriptions of more general significance are placed on the front alongside the *lignum vitae* and along the edges of the cross. The full significance and the sources of these inscriptions still await a thorough study.[41] The cross certainly shows, here and there, slight beginnings of the 'dampfold' style that was to dominate English art from about 1135 onwards, when the Bury Bible was illuminated by the painter Hugo,[42] but it hardly represents a fully developed form of it. Figures like the high priest, just below the Ascension at the top of the cross, with his softly modelled chlamys and close-fitting crown with crossed arches, compare very well with the British Museum king (Plate 174). The V-shaped folds of the prophet just to the left of Moses in the centre circle of the front of the cross can be compared, for example, with the central Apostle of the right-hand group above the Crucifixion in the Brussels ivory panel (Plate 173), as can the 'encircling' fold of Christ's colobium with the seated angel on the cross in the Three Maries at the Tomb scene. Really remarkably close is the treatment of heads in the

Brussels panel of about the mid eleventh century and the heads on the cross – they have the same rather plump, round faces, large, almost globular eyes, and wavy, close-fitting hair – though it is true, of course, that some of the figures, for example the striding figure of Moses in the centre disk, show a greater acceptance of the Early Romanesque rhythms, and that the rounded 'clinging curvilinear' style of panel drapery appears in a very tentative form – for example on the shoulder of the angel of the Tomb.

It seems that the style of the New York cross would fit admirably between the Liège ivories and their English relatives of the second half of the eleventh century and the full acceptance of the dampfold style in England in the 1130s.[43] An early- rather than a late-twelfth-century date can be supported on general grounds. The form of the cross, with its square terminals, is also based fundamentally on an eleventh-century tradition established by the imperial cross in Vienna, which enjoyed great popularity in the early twelfth century, for example in the school of Roger of Helmarshausen. In the later twelfth century, this type is found only in pieces of minor importance.[44] Also only three major altar crosses worked in ivory have survived, and both the others are of eleventh-century date – the Madrid cross of Fernando and Sancha of 1063 (Plate 152) and the Copenhagen cross of Queen Gunhild, daughter of King Swend Estridsen of Denmark, who died in 1076 (Plate 176).[45] The Copenhagen cross is also richly decorated with figure scenes in the centre and in the circular terminals, and bears long inscriptions. The style has been compared to that of the St Albans Psalter, although the manuscript is dated more than forty years later,[46] but its elements, such as the strong emphasis on profile heads, are completely absent from English art of the eleventh century, and it therefore seems likely that the Scandinavian craftsmen drew on the same sources as the English illuminator of the Psalter a generation later.[47] With the introduction of this thoroughly Romanesque style in England by 1123 and the development of the rich 'clinging curvilinear' style of the Bury Bible in the thirties, the course of English art is fully determined and seems to leave little room for a style as searching and as tentative as that of the great New York altar cross.

EILBERTUS OF COLOGNE AND THE 'SKETCHY' STYLE

THE first half of the twelfth century is a period in which it is difficult to trace any consistent development – a period in which a great many styles existed alongside one another. At the beginning of the century, in the major centres, the clearly defined style of Roger of Helmarshausen and Rainer of Huy had been created. Soon after, mainly in the second quarter of the century, new styles were developed in other northern centres. To characterize these local styles is not always easy, because close contacts often existed between them, the influences of the two major styles of the early twelfth century are nearly always felt in them, and on major commissions, craftsmen trained in different areas frequently worked together.

Nevertheless, it is possible to follow a third major stylistic tendency through this period, alongside the Mosan 'classicizing' style of the Liège font and the panel drapery style of Lower Saxony. This third style has been called 'der zeichnerische Stil' – 'the sketchy style'.[1] It is difficult to define, perhaps mainly because it is the least obvious and most varied of styles. It is almost easier to say what it is not, than what it is – it is not 'panel drapery', and it is not the soft, well-balanced classicizing tradition so deeply rooted in Lotharingia, but it is almost everything else. Its immediate sources are also hard to trace, but one must suppose that it is fundamentally a continuation into the twelfth century of the tradition of lively linear expression first developed in the Utrecht Psalter style of the ninth century which later dominated the art of the British Isles and northern France in the tenth and eleventh centuries. It is clearly one of the most important contributions of Carolingian art to the twelfth century, no less important than the gentle classicism of the Metz tradition, which itself was not untouched by it.[2]

As has been said, 'the historical contribution of the Reims tradition is that its liberating influence prevented both the laboured classicism and solemn monumentality of the Court School of Charlemagne and the rigid discipline and hieratic order of Byzantine art from making the Romanesque style a mere sterile formalism'.[3] To that might be added that one of the most important Late Ottonian 'linear' styles, that of Cologne, could certainly not have achieved this end.[4] Indeed, the influence of the Reims tradition was of such great importance because it helped to prevent the sterile formalism of so much of Late Ottonian art from turning the emerging Romanesque into mere rigid pattern-making.

Where exactly the qualities of lively expressive drawing were kept alive in the eleventh century, and where this style was available as a source for artists of the early twelfth century, is again difficult to say. In England, the lasting influence of the Winchester Style has long been recognized[5] and traced at least into the early twelfth century,

especially in manuscript illumination, and the fortunate survival of a series of Scandinavian bronze-gilt altar frontals provides evidence of its continuation in metalwork also.[6] Although not dated on external evidence, the oldest of them is almost certainly the frontal and retable from the church of Lisbjerg, just north of Aarhus in Jutland (Copenhagen, Nationalmuseet) (Plate 179). The retable on the top of the altar shows Christ enthroned in the centre, with six Apostles each side under an arcade, surmounted by a large semicircular arch resting on two medallions showing the Sacrifice of Isaac and Lazarus in Abraham's bosom. Within the arch, a large Crucifixion, earlier in date, was mounted when the altar was assembled in the twelfth century. A cresting of seven arches appears on top of the arch, with Christ enthroned between the Virgin and St John the Baptist, St Cosmas and St Damian, and two kneeling angels. On the frontal, the Virgin and Child are seated in the centre, under a portal symbolizing the Heavenly Jerusalem.[7] The whole is in turn divided by diagonals. In the resulting small fields, two cherubim and six prophets are shown as well as the Annunciation, Death, and Assumption of the Virgin. In the two flanking parts, each divided into six rectangular panels, St Brigida and St Tekla and ten female figures representing the Virtues are shown. Roundels with the four Evangelist symbols are mounted at the corners of the broad frame, and there are roundels at the top with the Agnus Dei and at the bottom with two fighting lions.

The ornamental framework is enormously rich, in *émail brun* on very slightly embossed relief or on the flat. The patterns include roundels with animals or foliate designs, foliate scrolls, and knot- and band-work, but above all elaborate interlace, some inhabited by human beings and winged dragons. The character of these violent interlaced ribbon animals, in strongly contrasting thick and thin forms, is clearly derived from Scandinavian 'Urnes' style ornament of the second half of the eleventh century, but the human figures, the winged dragons, and the fleshy plant elements with ringed stems, often called 'Byzantine blossoms', were most likely introduced into the basically Scandinavian pattern during the first half of the twelfth century, most probably through English manuscript illumination. Similar inhabited scrolls appear on wooden stave churches of Norway by about 1140.[8] Although the Lisbjerg altar on the whole seems at first sight to date from around 1100, these richer ornamental details make a date late in the second quarter of the century more likely. The large crucifix, which must be of a somewhat earlier date, because it was cut down to fit its present place in the centre of the retable, may therefore date from the early years of the century. The rigidity of its style suggests that the livelier drawing of the frontal may be the result of the same English contacts that enriched the ornamental vocabulary.

The centre panel of the frontal, divided by a lozenge frame and diagonals, is reminiscent of the earliest golden altar to have survived, the mid-ninth-century Paliotto at Milan, where the side panels are divided in the same way (Plate 48).[9] The Lisbjerg frontal is clearly part of a long tradition reaching back to Carolingian times, through the Ottonian period, when the golden altar at Aachen continued the basic design of dividing the area by framework into twelve rectangular panels to each side of the central scene. At Aachen, the four Evangelist symbols in roundels, mounted at least since the fourteenth

century near the central Christ in Majesty (Plate 131), were probably originally fixed at the corners of a broad frame, as at Lisbjerg.[10] That this design for altar frontals continued into the twelfth century elsewhere in Europe also can be proved, in spite of the very few examples to have survived: the Arca Santa in the Camara Santa at Oviedo (Plate 157), although strictly speaking a reliquary chest and not an altar, makes use of much the same layout, and in Italy the silver frontal at Città di Castello,[11] of mid-twelfth-century date, with a central Christ in Majesty and scenes from the life of Christ to each side, continues the tradition faithfully.

In its figure style, the Lisbjerg altar reveals its dependence on the expressive Reims tradition. The vivid drawing, with multilinear folds, flying drapery in funnelled bunches, and zigzag edges resembles the style of the Carilef Bible most closely.[12] Some of the figures are somewhat more massive, more brutal, but the slim Apostles of the retable even have a great deal of the brittle elegance of the Anglo-Norman style. In spite of its rather late date, one can hardly doubt that this altar reflects, at least in part, the style of English metalwork of around 1100, of which so little has survived. Virtually the only piece still in existence is the famous bronze-gilt candlestick given by Prior Peter (1104–13) to St Peter at Gloucester.[13] In its basic structure it resembles Bernward of Hildesheim's silver candlestick of the early eleventh century,[14] but its elaborate technique of pierced hollow casting results in a far more effective sculptural treatment and an astonishing play of glittering light and shade. When compared to the Lisbjerg altar, its dependence on Winchester foliage ornament, for example in the forms supporting the grease-pan, is far greater.[15] The whole concept of the candlestick is a subtle three-dimensional version of the interlaced inhabited scroll, in which just those elements that are intrusions into the purely Scandinavian ribbon animals on the Jutish altar – the winged dragons and the 'Byzantine blossom' – are most prominent. Unfortunately only one small draped figure, that of the angel of St Matthew on the central knop, enables us to make a comparison with the figure style,[16] and although drapery does appear to fly away from the sleeves, and some bunched pleats appear next to the angel's right leg, the more rounded treatment of form has moved beyond the linear style of the late eleventh century.[17] In this tendency the Gloucester candlestick comes closer to the English 'classicizing' style, linked with Mosan work such as the New York ivory altar cross.[18] One small, but significant feature might be pointed out: the curious treatment of wings in the Evangelist symbols, where a kind of 'second' wing is superimposed over the larger, lower part of the wing, is found on both the New York cross and the Gloucester candlestick.[19]

In Scandinavia, this development towards greater solidity and sculptural form is also seen in another frontal, the Broddetorp altar, probably not very much later in date, where at the same time the vivid and lively drapery treatment is preserved (Plate 180). It is of interest that in the ornamental vocabulary of this altar 'Winchester' acanthus borders are far more widely employed, showing that direct English influence is even stronger here than in the Lisbjerg altar.[20] Its iconography is somewhat more traditional, with a central Christ in Majesty in a mandorla carried by four angels. Above, the sun and moon represented by chariots appear, and scenes from the life of Christ are shown

to each side, with the twelve Apostles seated in pairs in six panels below. The four Evangelist symbols, in roundels, are again mounted at the corners of the broad frame. Across the top of the altar table a band with ornament with small 'turrets' at the ends acts as a base for a large and splendid crucifix.

A magnificent large carving in whalebone of the Adoration of the Magi, now in the Victoria and Albert Museum,[21] which it has proved difficult to relate at all precisely to other pieces, belongs in general terms very much in this stylistic milieu. Its vivid drawing is overlaid with rich surface decoration, and the decorative frieze at the base, for example, has become aware of three-dimensional values – a growing preoccupation in most styles in the second and third decade, of the century. The richly patterned effects of this carving can certainly be compared with the panel in the centre of the book-cover now in the Darmstadt Museum (Plate 181), and a crucifix in the Louvre. Both these carvings, and others in a group surrounding them, all still very obviously based on the multilinear drawing style of the Reims tradition, are, significantly, also carved in whalebone or walrus ivory.[22] Compared with the Darmstadt panel, the Adoration plaque is less deep in relief and less consistent and accomplished, more tentative in its search for stylistic unity. The Darmstadt Crucifixion, with its broad frame in a hard, patterned style and its sure handling of deep relief, seems carved in a more developed style. It was remounted in the fourteenth century with eight Mosan enamels on the back of a Gospel Book, to which it might well have belonged from the start. The Evangelist portraits appear twice in this manuscript, once in a full-page version in 'clinging curvilinear' style and a second time in the initial of each gospel, in a richly ornamented linear style very close to that of the ivory carving.[23] The larger versions of the Evangelists may well be not very far removed in date from the Bury Bible in England, i.e. c. 1135. The attribution of this manuscript to a Flemish scriptorium is supported by a dedicatory inscription[24] on folio 5 recto referring to 'Sybil', who, it has been suggested, may be identified as Sybil of Flanders, wife of Count Dietrich of Flanders, who became abbess of the Lazarus Convent in Jerusalem, where she died in 1163. The same name appears as the donor of the Louvre crucifix, which undoubtedly belongs to the same group of ivory carvings.[25] All this supports an attribution of the Darmstadt manuscript, and therefore the carvings, to a Flemish centre – Saint-Omer has been suggested[26] – and a date before Sybil of Flanders's departure for the Holy Land, in the second quarter of the twelfth century. The Adoration panel in London seems to be early in the series – probably of the second decade of the century.

In Normandy and northern France, as well as in Flanders and England, the linear style enjoyed a long life, lasting at least well into the second half of the eleventh century.[27] Indeed, the attribution in the past of Norman manuscripts to English scriptoria like Durham was based on their obvious dependence on the 'Winchester' version of the Reims tradition, which seems to have been preserved in even greater purity in Northern Europe than in England. Recent research has revealed the not altogether surprising fact that in the very homeland of the tradition, at Reims itself, in the vital period from c. 1050 to the early twelfth century, manuscript illumination kept alive a direct link with Carolingian traditions.[28] It has also been shown that the closest relations existed

between the abbey of Saint-Rémy at Reims and the important Mosan abbey of Saint-Hubert in the Ardennes.[29]

It is centres such as these that must have provided the models for Cologne and, through Cologne, for Hildesheim, where such styles were dominant by the middle of the century: one need only compare some of the engraved figures of the portable altar of Eilbertus of Cologne, for instance the ascending Christ in the lower right hand corner of the top of the altar (Plate 183), with the angel of St Matthew in the Carilef Bible.[30] In both figures lively, fluttering draperies are used to give vivacity and movement, although it is true, of course, that the Eilbertus version of the style in this particular figure, and to an even greater extent in other figures on top of this altar, is more strictly controlled and is more aware of weight and mass than the late-eleventh-century drawing from Normandy. Some of the Eilbertus figures reveal the influence of both the Mosan and Helmarshausen styles: the 'nested V-folds' can be seen clearly in the St Andrew just above the central Christ in Majesty, and the rhythmic flowing draperies of the Mosan style for example in the St Matthew, below the left-hand corner of the central panel. In the centre of the top of the altar a painting on vellum of Christ in Majesty surrounded by the four Evangelist symbols is mounted under rock crystal, which acts as an altar stone. This illumination has been compared to a manuscript from the abbey of St Vitus at Mönchen-Gladbach, now in the Darmstadt Landesmuseum, cod. 508 (AE. 680), and indeed there can be little doubt that both the Christ in Majesty representations were painted by the same master.[31]

Little is known of the history of the Eilbertus altar. At least from 1482 it was part of the Guelph Treasure in the cathedral of St Blaise at Brunswick.[32] On the base plate, around the little trap door leading to the enclosed relics, which have not survived, is the inscription EILBERTVS COLONIENSIS ME FECIT, perhaps more likely to be the signature of a craftsman working away from home. On the top, the twelve Apostles in champlevé enamel around the central Christ in Majesty are flanked by two long enamelled strips with four scenes on each: on the left the Annunciation, the Visitation, the Nativity, and the Presentation in the Temple, and on the right the Crucifixion, the Three Maries at the Tomb, Christ in Limbo, and the Ascension. The figures on all these enamels are engraved on reserved gilt copper, with coloured backgrounds mainly in blue and green. These colours appear in most cases as a kind of square 'internal frame', separated by a thin white line. This form of 'boxed' background became a common feature in both enamelling and manuscript illumination in the second quarter of the twelfth century, and has been seen as a part of the Ottonian concept of flat, stratified, 'layered' pictorial space.[33] Certainly it is common in the Regensburg School of the eleventh century, although there patterns rather than plain blue and green are used. Blue and green superimposed squares, separated by a thin white line, more precisely comparable to the Eilbertus enamels, are, however, frequent in Ottonian initials.[34] Perhaps the earliest use in illumination with a figure subject, instead of a purely decorative initial, is in the Coblenz Bible at Pommersfelden,[35] whose links with Italy are with wall painting, where this kind of background is certainly found, for instance at San Vincenzo at Galliano in the early and at Sant'Elia in the later eleventh century.[36] The use of it on

the Eilbertus altar therefore, in the final analysis, is most probably due to the Italian influences which were so important in Germany at the turn of the eleventh to the twelfth century.

An enamelled inscription on the edges of the top of the altar refers to the Apostles on the top, and one on the edge of the base to the standing prophets represented between pilasters all round the altar (Plate 182).[37] These figures, in enamel on a plain gilt ground, with their names vertically inscribed, successfully imitate Byzantine cloisonné enamels in champlevé technique. The use of light and dark shades of the same colour in adjoining folds, a feature of Byzantine enamels of the tenth and eleventh century – for example in the Holy Cross reliquary in the Limburg treasury – and of Byzantine step patterns on all but the corner pilasters is also imitated.[38] In the case of the step pattern, even the technique resembles the original Byzantine practice, except that the work is in copper instead of gold, and the total area of the pattern is cut out of a solid sheet of copper instead of being sunk in sheet gold, or a tray being made out of gold sheet. The base plate of the Eilbertus altar is ornamented with leaves in roundels executed in *émail brun*, and three holes at each of the four corners are evidence of the fact that originally the whole altar was raised on bronze gilt feet, most probably in the form of dragons, as they have survived on a number of related portable altars.

Unfortunately there is no historical or internal evidence which enables one to date the altar at all precisely. The painted centre panel certainly links the altar to Cologne illumination of about 1140, the date ascribed to the Mönchen-Gladbach manuscript by the same illuminator.[39] The name 'Coloniensis', taken together with the evidence of the manuscript, strongly suggests that the master was trained or worked in Cologne, although it does not prove it. The drawing in the enamels is somewhat tentative, lacking the assurance of a fully developed and long established style, and, with elements of both Mosan and Helmarshausen origin which are not fully absorbed, certainly shows inconsistencies. But the brilliance of its colour, its ambitious attempt to rival the visual effect of the more precious material of cloisonné enamelling, the clarity of its architectural articulation by strong pilasters carrying fully modelled leaf capitals, with corners even emphasized by a splendid scroll, the elaborate pictorial wealth of its top, with that superb invention of a crystal altar stone allowing a fine illumination to be seen through it – all this puts the altar into a class of its own. Other pieces, like another enamelled portable altar in the Guelph Treasure, decorated with the Cardinal Virtues, are very close to its style of drawing, but none can match its general splendour (Plate 216). One has little doubt that Eilbertus was the master, and that much else in Lower Saxony is only a pale imitation of his work. There can be no doubt that by the time the patronage of Henry the Lion encouraged artistic activity at Hildesheim or perhaps at Brunswick, his favourite seat, where the 'sketchy' style was continued in its purest form, the style of Eilbertus must have been well established.[40] The style of illumination of *c.* 1140 is, if anything, a little too late for Eilbertus, rather than too early.

Support for a date *c.* 1130–40 can be obtained from the one major work of the Cologne area which is dated by documentary evidence – the great shrine of St Victor at Xanten of 1129 or very soon after (Plate 184).[41] The shrine is today but a shadow of its former

self.[42] Only six embossed silver figures of standing Apostles, sixteen enamelled pilasters and enamelled inscriptions along its longer sides, and one more Apostle on the end wall survive of its twelfth-century decoration.[43] The enamelled pilasters, in bases, capitals, and mouldings, resemble the Eilbertus altar very closely, and the similarity of the inscriptions in both pieces is such that they may well have been engraved and enamelled by the same hand. The treatment of the drapery of the Apostle figures is also clearly in a similar linear 'sketchy' style to the figurative enamels of the Eilbertus altar, bearing in mind the difference of scale and technique. Some of the standing figures on the altar, for instance the female figures attending the Annunciation and the Visitation, have a similar restrained outline and heavy ornamental borders to their garments. The slightly more classical calm of the Xanten Apostles, the more regular and better organized handling of their garments, and the rounded cap-like treatment of their hair with wavy strands framing their faces, suggest some contact with Rainer of Huy's style, which by the second quarter of the century was already spreading beyond the valley of the Meuse, while elements of the Cologne 'sketchy' style were by then beginning to play a part in the Mosan area itself.[44] It is all the more unfortunate that the Xanten shrine has not survived in more complete form, for it may well be the earliest of the true house-shrines of the Romanesque period.[45] In scale, it approaches the great shrines of the second half of the twelfth century and represents a great increase in monumentality over the 'miniature' house-shrines of the tenth and eleventh centuries. The first steps towards an increase in size had been taken in the reliquary of St Isidore at León,[46] which might originally have had a fairly steep, though almost certainly a hipped, roof. The wooden core of a fairly large hipped-roof house-shrine which survives at Cérisy-la-Forêt in Normandy, judging by the form of the carved capitals of the arcade along its side, may well date from the early twelfth century.[47] This is only one of the many reliquaries in this category which, had they survived, might have filled the gaps in our knowledge about the origins of the house-shrine.[48]

In the Eilbertus altar and the Xanten shrine, one of the most favoured twelfth-century techniques, that of champlevé enamelling, appears to find its earliest use in the Romanesque art of northern Europe. Both the step patterns and the prophets of the portable altar suggest that it originated in an attempt to imitate the more expensive cloisonné technique, so popular in the court-inspired art of the eleventh century. But it must be remembered that it is champlevé and not true cloisonné enamelling. This ancient technique[49] seems to have been revived in both Southern and Northern Europe around 1100. The circumstances surrounding its establishment, and the development of new ways of using it, are still very difficult to define – virtually nothing that can be called 'experimental' has survived.

A number of small reliquary caskets, in which it might be possible to see the earliest attempts to transfer the effects of 'full' enamel cloisonné to the champlevé technique, have been thought to date from about 1100 and have been attributed to North Germany or Denmark.[50] The drawing on them is extremely clumsy, the colour cool, mottled, and applied in simple, large masses. One of the best examples of the group is preserved in the Guelph Treasure (Plate 185). It has a truncated pyramidal lid, crowned by a large

globular bronze-gilt finial, which probably originally had a cross fixed into the slot cut into the top. On the lid, the Holy Ghost in the form of a stylized eagle is surrounded by the four Evangelist symbols. On the front, Christ in Majesty, in a mandorla, is flanked by two angels and two Apostles; nine more Apostles appear under arcades around the other three sides. The full champlevé panels are fixed to the wooden core by nails with very large globular heads, closely set to form a decorative border.[51] The figures are squat, simply drawn images, with internal drawing reduced to the barest minimum. The simplicity, even crudity, of the drawing would support the notion that this kind of enamelling represents the earliest experiments in the revival of the technique. And yet there seem to exist no links between this style and the beginnings of enamelling of very high technical skill at Cologne, and in the Mosan region. Even if the enamels of this group are the incunabula of the champlevé technique, they serve merely to prove that the technique was established by the early twelfth century, and in no way to explain the origins of any of the styles of the second quarter of the century.[52]

The small reliquary casket of St Andrew in the treasury of St Servatius at Siegburg, however, presents a more serious problem (Plate 193).[53] The very limited range of cool colours – only light and dark blue, turquoise, and a greyish white are used – and the mottled character of the enamel link it technically with this 'northern German' group. But the figures are not in 'full' enamel but reserved in gilt against a coloured background, like those on the top of the Eilbertus altar.[54] The style of drawing, at first sight rather clumsy, and the composition of the scenes on the casket are most difficult to date. It seems as if characteristics of both the early and the late twelfth century are present.[55]

The top is framed, and the whole area divided up into six main scenes, by a narrow gilt band bearing inscriptions. In the centre is a Christ in Majesty, surrounded by the four Evangelist symbols above and a Crucifixion below. At the top left Christ is represented with St Peter and St Paul, and at the bottom right the Annunciation to the Shepherds. The Nativity is shown in two parts, with the Virgin and St John, three angels, and a prophet in the area at the top right, and Christ in the crib with ox and ass and three angels in the field to the left, below. Four large enamel plaques decorate the upright parts of the casket, showing on the front the Last Supper, on the back two angels, on the left side Christ seated between thirteen Apostles, and on the right side the Virgin and Child between St Peter and St Paul and two other saints.

The whole design of the casket is remarkably fluid, with the bands on the top drawn loosely across the surface and only roughly symmetrical. The scene of Christ among the Apostles even stretches across two sides of the reliquary, and no attempt is made in any way to articulate the composition. It is difficult to see how a work of c. 1200 could be quite so undisciplined. The way that scenes are drawn as an almost continuous narrative – and a very rich narrative at that – seems to echo work of the second half of the eleventh century, like the ivory portable altar at Melk (Plate 136), rather than the carefully balanced and architecturally structured compositions of the end of the twelfth century. The rough and lively drawing of the figures is at times – for instance in the figure of St John in the Crucifixion scene – remarkably close to the most extreme forms of the

'sketchy' style on which Eilbertus based his own work. The frequent use of double lines in drapery, common around 1100, is also very difficult to parallel around 1200. But there are what appear to be late elements in the style also. In some figures a strong feeling for light and shade seems to dominate the drawing – in the reclining Virgin, the Evangelist symbols, and the figure of St Paul on the top of the casket, for example. Such a use of massed lines to create volume is not likely to have been understood before the eighties of the century – but one may be permitted to question whether it is an intentional feature of this remarkably personal style. If it is, the generally accepted late date of the St Andrew casket must be allowed to stand; but it does just seem possible that this casket is a unique survival of an early use of champlevé enamelling in a style that served as a source for Eilbertus and those who followed him in Lower Saxony.

The imitation of Byzantine cloisonné enamelling developed in Cologne is also found in another region in Germany on an important work, probably about contemporary with the Xanten reliquary: the great bronze gilt altar frontal made for Gross-Komburg, just south of Schwäbish Hall (Plate 186). The four Evangelist symbols, with the twelve Apostles in two registers each side, surround a standing figure of Christ in a mandorla. The Apostles stand against plain backgrounds, their names embossed on each side of their heads. The simple framework is decorated with bands of enamel, and inscriptions are placed all round, on the inner sloping edge of the frame, and round Christ's mandorla.[56] As in the pilasters of the Cologne altar, the step patterns on parts of the framework are imitations of Byzantine work, technically as well as in design. Models for the repeated roundels filled with rosettes and other patterns used in the enamelled decorative strips of the framework can also be found in Byzantine metalwork and ivories.[57] But it is not only in these details that the frontal shows the direct influence of Byzantine art. In the figures, the Carolingian tradition of expressive drawing previously discussed is replaced by a massive, almost stolid calm, with firm outlines and high, yet flat relief. The Byzantine influence in these figures may be direct, or may have been transmitted through Ottonian work. The most obvious comparison that springs to mind is with the golden altar frontal from Basel Cathedral now in the Cluny Museum in Paris (Plate 130). But even this shows more rather than less of the lighter touches of Carolingian drawing which are so notably absent from the Komburg frontal. Other Ottonian work, more deeply penetrated by Byzantine influences, such as the ivory panel representing St Matthew, probably carved in Milan, let into the cover of the British Museum MS. Harley 2889 from Siegburg (Plate 84),[58] illustrates the kind of model available to the Komburg goldsmith. Not only the broad, flat folds of drapery and restrained outline appear here, but even the small platform, expanding towards the rear, is found in both. The fact that the Evangelist symbols round the central Christ in Majesty are each given three pairs of wings again points to Italy as the probable immediate source of this style.[59] It has recently been very convincingly argued that the Byzantine influence at Komburg may have been transmitted through the scriptorium at Salzburg, where such influences were dominant from the eleventh to the early twelfth century.[60] One of the only two miniatures to survive from the Bible in the abbey of Michelbeuern near Salzburg shows a series of four standing prophets under an arcade,

holding scrolls, who can be compared to the Gross-Komburg frontal,[61] and this Bible has been dated into the second quarter of the twelfth century. Moreover another very significant point emphasizes the dependence of the frontal on a Byzantine model: the twelve Apostles include St James the Younger and St Thaddeus (St Jude), two Apostles who are replaced in Byzantine custom by the Evangelists Luke and Mark.[62] Now, on the frontal, only two figure types are repeated: St James the Elder and St James the Younger are exactly the same, and St Thaddeus is almost exactly a mirror image of St Thomas. This strongly suggests that it was these two figures that were not available in the model in a form that could be used for the frontal, and had therefore to be repeated from figures already used in the remaining ten types.

No documentary evidence exists to link the frontal with Abbot Hertwig of Gross-Komburg, who was responsible for other gifts to the community, but there can be little doubt that it was made during his abbacy. Hertwig is first mentioned in 1108, but probably began his rule about 1104; he is last mentioned in 1138 and probably died within a few years of that date. His successor, Adalbert, is not recorded until 1149.[63]

The great circular bronze candelabrum at Gross-Komburg, 4·65 m. (15 ft 3 in.) in diameter, bears an inscription naming Abbot Hertwig as donor (Plate 187).[64] Of the five bands, together 33 cm. (13 in.) high, two bear the inscription, and the central, uppermost, and lowest are made of pierced scrollwork. Along the bands twelve towers are spaced equally, with large circular medallions half-way between, decorated with busts of prophets. A cresting of trefoils and flowers along the upper edge carries forty-eight candles, four to each section between the towers. The inscription makes it quite clear that the whole immense structure symbolizes the Heavenly Jerusalem.[65] The gates, windows, and medallions of the towers, both inside and out, held thirty-six standing figures embossed and cut out of bronze, of which only one has been lost. All but three warriors in armour are nimbed male and female saints, and the twelve busts in the upper storeys of some of the towers[66] represent warrior saints or angels. Two of the standing saints are bishops, three male saints carry a cross or palm and are therefore martyrs, and two female saints carry jars of ointment of the kind normally carried by the Maries at the Sepulchre, but none of them can be identified. The twelve towers are intended to represent the twelve gates of Jerusalem of the Apocalyptic vision and symbolize the twelve Apostles, and the saintly figures as a whole represent the Just, who inhabit the walls of the holy city, as described in the prophetic vision of Isaiah (chapter 60).

Although the many figures of the candelabrum are far more varied in style, there are certainly some that can be compared to the Apostles of the frontal. The broad, almost flat treatment of overlapping, perhaps somewhat less ably handled, can be seen in one of the bishops (Plate 189), and the large bulbous eyes of the central Christ are found in one or two of the female saints. Both the main stylistic sources of the frontal, Ottonian and Byzantine, are further emphasized in the candelabrum. The armour of the warrior saints, shown as rows of small rounded plates, is unknown in the West, but is typically Byzantine.[67]

The whole design of the candelabrum follows the type of which an earlier example

survives at the cathedral of Hildesheim, probably made in the time of Bishop Hezilo (1054–79).[68] Although there is no direct evidence that Abbot Hertwig donated the frontal as well as the candelabrum, there is documentary evidence of a golden cross, set with gems, given by the same abbot, and the sixteenth-century chronicler Widmann, who saw the cross and recorded its dedicatory inscription, also mentions another, smaller frontal with the same iconography made for Klein-Komburg as a gift from Hertwig.[69] Stylistically, too, the relationships between the two surviving works seem close enough for both to have been produced at much the same time. The fact that the frontal shows a more consistent style, so closely linked with Ottonian tradition,[70] might be taken to support the view that it is the earlier work, and that other stylistic elements were introduced into the workshop when the larger candelabrum was attempted. Although little of the 'sketchy' style discussed earlier in this chapter can be found in the frontal, some of the thinner, more elegant standing figures in the towers, like the female saints carrying jars of ointment (Plate 188) or one or two of the male martyrs, are far more nervously drawn and have thin, multilinear drapery much more like the Cologne style of the Xanten shrine. The individuality of the Komburg workshop, however, makes such links fairly tenuous, and the relationships with Salzburg remain the more convincing.[71]

Although the 'sketchy' style of Eilbertus of Cologne was to be of considerable importance to the development of the art of Lower Saxony in the second half of the century, in Cologne itself another style, more interested in formal, three-dimensional values, was established in the second quarter. The illumination mounted in the centre of the top of the Eilbertus altar indicates clearly that interest in weight and mass, as well as in linear qualities, was alive. The most outstanding examples of this are a series of walrus ivory carvings in what has been called the 'gestichelte' ('pricked') style. The group consists of eleven pieces, to which another five are more or less closely related.[72] The main group of eleven is extremely closely knit. They are all large, almost square panels, made up of a number of pieces, as walrus ivory can never be more than a few centimetres in width. Some survive with ornamental frames, others without. Where in three cases (Nativity (Plate 191), Three Maries, Ascension) the same scene is represented, the same or very closely related iconography is employed. It is perhaps possible to see two hands at work. The figures of the two panels in the Metropolitan Museum in New York, with the Three Maries at the Tomb and Doubting Thomas, are somewhat harder and more elongated than those of the other nine panels. A twelfth work, a number of pieces remounted in the sixteenth century on a manuscript cover in the Darmstadt Museum (cod. 508) (Plate 190), and a thirteenth, four panels with the four Evangelists on a book-cover in the Diocesan Museum at Utrecht, are so close to the nine panels that they may well be by the same hand. The term 'pricked' style has been coined because of the characteristic small nicks carved along the folds of drapery in all the pieces.[73] The handling of deep relief is remarkably able throughout, the drapery patterns are rich and varied, and the iconography ambitious and full of narrative interest. It has been suggested that five pieces, all of much the same size, approximately 21 cm. high and 20 cm. wide (7¾ by 7¼ in.), may have decorated a large antependium

of the kind made most probably at Salerno,[74] and that four somewhat smaller panels once decorated a Gospel Book.[75]

Dates ranging from about 1110–30 to the second half of the twelfth century have been put forward for the group.[76] The set of nine carvings mounted on the manuscripts in the Darmstadt Museum (cod. 508, A.E. 680), showing a Christ in Majesty in the centre, flanked by St Mary and St Vitus, the patron saint of the abbey of Mönchen-Gladbach, and surrounded by the four Evangelist symbols, with the Dove of the Holy Ghost above and an Ecclesia below, might help to support an earlier rather than a later date within that wide bracket. The ivories were mounted on this manuscript by the Gladbach Abbot Jacobus de Heggen (1574–83), whose coat of arms appears in the pediment above and whose name is inscribed below (Plate 190). The pediment is carried on twelfth-century columns, which were originally probably part of a Romanesque house-shrine. The carvings are known to have belonged to another Gladbach manuscript (now in the Landes-bibliothek at Darmstadt, cod. 530) dated c. 1130–40,[77] and there is no reason to doubt that the ivories were part of an original cover made for the Cologne manuscript.

This Cologne style certainly, on the face of it, bears little resemblance to Master Eilbertus's almost exactly contemporary work, and yet in the broadest terms both are based on elements of the Ottonian tradition. The whole form of the Eilbertus altar, and the imitation of Byzantine cloisonné enamelling, which had also been such a popular technique in Ottonian art, shows its adherence to this tradition, and the ivory carvings, particularly in their iconography, seem to rely on the same sources. The 'walled' town that surrounds the Nativity (Plate 191) or the triple arches with architectural canopies in the Adoration of the Magi are common features of the imperial Ottonian scriptorium. But the resemblance to the manuscripts goes further. The bulbous capitals of the arcade in the Adoration of the Magi, with small leaves turned down at the top, and the curious treatment of space, in which the figures appear to float in front of the architectural setting, all suggest that this sculptor must have known manuscripts like the Egbert Codex from Trier and the Gospels of Otto III now in Munich (Clm. 4453).[78] Even something of the 'classical' rhythmic articulation of the figures and the drapery treatment of the imperial Ottonian manuscripts has penetrated this Cologne style. Indeed, if Ottonian art were not invoked for the sources of this style, it would be difficult to account for the many Early Christian traits that it shows. The rounded heads, with heavy-lidded eyes and fleshy features, are almost closer to the Early Christian archetypes of this style than to any of the Ottonian intermediaries.[79] This important group of ivory carvings therefore takes its place alongside the Helmarshausen and Mosan styles in reinterpreting for the twelfth century the indigenous classical tradition of North Western Europe.

MOSAN ART: THE TWELFTH CENTURY

ALTHOUGH for the whole of the twelfth century in the Mosan area the influence of Rainer of Huy was to be all-pervasive, remarkably little has survived which can be attributed to him or his workshop.

A small bronze crucifix in the Schnütgen Museum in Cologne is the only bronze casting generally accepted to be by the master of the Liège font (Plate 192).[1] The smooth, broad, yet delicate modelling of the body and the loincloth is certainly very close to that of the font, and the head especially, with the close-fitting hair, large eyes, and prominent mouth, makes the attribution convincing. Of the fair number of small early-twelfth-century crucifixfigures that survive one or two more can be attributed to the same workshop, and others were strongly influenced by it. One, now in the Musées Royaux in Brussels, may well be cast from the same mould as that in Cologne; it only differs in the more detailed surface-chasing worked after casting.[2] Others – one in the Hunt Collection, Dublin,[3] and two more in the Brussels Museum[4] – are examples of the strong and direct influence the workshop of the Liège font exercised in the first half of the century.

A small censer in the Lille Museum bears an inscription which unfortunately does not make it clear whether the 'Reiner' mentioned is the craftsman or the donor of the piece (Plate 194). Opinions differ as to whether the piece should be attributed to the early or the later twelfth century.[5] The spherical bowl is divided into three semicircular lunettes in each half, in which facing animals in foliate scrolls are represented in openwork. The whole is surmounted by a small architectural structure against which the Three Children of Israel are seated, with the angel (his wings are missing) who has descended into their 'Fiery Furnace' seated above. The surface of these small figures in the round is much rubbed, but the relief was probably always rather smooth and gentle, and folds like those pulled across the knees of the angel are not out of keeping with Rainer's font. Admittedly similar figures still occur after the middle of the century, and the scale of these figures and their condition hardly permit a final judgement. It might just be added that the symmetrically disposed lions and winged animals and the strange and varied leaf forms are not a normal part of the well established Mosan decorative vocabulary of the second half of the century. The openwork is, of course, conditioned by the fact that the object is a censer, but this, too, is not at all common in the second half of the century. No other work can even be considered for attribution to Rainer's workshop.

The house-shrine of St Hadelin, originally made for the abbey of Celles, near Dinant,[6] was taken in 1338 to the church of St Martin at Visé (where it now is) by twelve canons after a quarrel with the lay abbot of Celles. On the sides of the shrine, eight scenes in embossed silver from the life of St Hadelin are separated by columns and framed by explanatory inscriptions above and below (Plates 196 and 197). The decoration of the

sloping roof was destroyed during the French Revolution in 1793. On the ends of the shrine, the triumphant Christ treading on the beasts (Plate 195) and Christ crowning St Remaclus and St Hadelin are represented, surrounded by inscriptions in *émail brun*, a technique also employed in the decorative framework of the sides and the haloes of St Hadelin.

The style of the two major scenes on the front and back of the shrine is very different and of much earlier date than that of the sides, which might lead one to the deduction that an older, eleventh-century shrine was remodelled in the twelfth century by the addition of new scenes along the sides. But the 'older' ends do show some inconsistencies. The inscriptions do not fit their space at all well, and some strips have been crudely trimmed.[7] Also, the triumphant Christ is a little too tall for his allotted space, and parts of his nimbus are covered by the framework. It is therefore possible that the end pieces were re-used when an entirely new shrine was constructed in the early twelfth century.[8] However, the composition of the front panel, with the larger figure of Christ and the smaller figures of saints to each side, fits the 'gabled' panel very well, and it would be difficult to reconstruct any earlier reliquary from which these end pieces would have been transferred, which differed fundamentally from the present one. Moreover, some of the strips of inscriptions surrounding the ends fit exactly, and have not been trimmed. The first line in each case, for instance, determines the width of the panels precisely. The argument that these strips do not fit must assume that the inscriptions are contemporary with the relief figures, and not the twelfth-century form of the shrine. Yet the cresting, in the form of a running foliate scroll, is made of one piece with the upper, sloping strip of inscription and must always have been part of a 'sloping roof' structure.[9] These sloping parts of the inscriptions are the ones most severely trimmed, and one need only suppose that the pitch of the roof of the reliquary was lowered somewhat to account both for the trimming of the inscriptions and the reduction of space available for the triumphant Christ. There is even some evidence that the long sides of the shrine were not fundamentally changed. Delicate, thin, running foliate scrolls appear on the bevelled frames of the end pieces, and they seem to be entirely in keeping with the character of the early figure reliefs (Plates 195 and 197). Embossed running scrolls of precisely the same form also appear in parts of the bevelled frame of the sides of the shrine, while in other parts of the same frame a much fleshier, thicker decoration appears, with symmetrically disposed leaves, like those on the Xanten shrine (Plate 184).[10] It is therefore very likely that these earlier decorative strips survived the extensive remodelling of the sides, when the figure reliefs, the columns separating them, the inscriptions, and the delicate *émail brun* decorative strips that frame the whole of the sides were added to the shrine. But it must seem likely that the earlier shrine of St Hadelin did not, except for lowering the pitch of the roof, differ very much in form from the existing shrine. The fact that the Visé shrine has figure scenes on its sides instead of single figures, as at Xanten, supports the hypothesis that the remodelling adhered to an earlier tradition, probably only replacing then existing narrative scenes. The only major shrine of the eleventh century to have survived, that of St Isidore at León of 1063,[11] certainly had such scenes on its sides (Plate 151). Fragments of another, admittedly rather smaller one made in North

Western Europe, now at the abbey of Susteren, some twenty miles north of Maastricht, are also decorated with narrative scenes, and this shrine has been dated to the late tenth century.[12] So it is probably correct to see in the Visé shrine a work basically of the eleventh century only remodelled in the twelfth, and thus the earliest surviving monumental house-shrine and one of the models for the development of this type in the Romanesque period.[13]

There is little that can be compared stylistically with the earlier gable-end reliefs. The wooden cult figure of the Virgin and Child of Walcourt, covered in sheet-silver and preserved in the church of Saint-Materne,[14] can be related to other figures, like the Imad Madonna at Paderborn (Plate 142),[15] and must date from about the middle of the eleventh century. It can do little more than indicate that goldsmiths were working in this area. The heads of Christ in both representations on the Visé shrine, with their large, hard features, their eyebrows meeting over their eyes, and their oval, rather shapeless form, although not by the same hand, may be compared with the ivory panel of Christ in Majesty in the Rouen Museum, which belongs to the group of 'small figure' ivories and dates from early in the second half of the eleventh century.[16] On what is perforce insufficient evidence, the date c. 1075 that has been suggested for the earlier parts of the Visé shrine, and therefore its first design also, can be accepted.[17] Of major significance is the fact that these earlier parts of the shrine were made at a time when the style of Rainer of Huy had not yet been created, whereas the figure scenes on the sides of the shrine would not have been possible without it. The master in whose work the influence of Rainer of Huy is most obvious was responsible for four of the eight scenes: St Hadelin receiving pupils at Celles, St Hadelin visiting St Remaclus at Stavelot, the Miracle of the Spring (Plate 197), and St Hadelin healing a mute woman. In these panels was established what might almost be called the hallmark of the Mosan relief style for more than fifty years to come. Although it would hardly have been possible to develop it without the work of Rainer as a source, it would nevertheless be wrong to deny the Visé master's very considerable achievement in creating this astonishingly influential formula. Once one's eye is attuned to his style in the structure of the figure, the handling of drapery forms, and the distinctive modelling of the head, recognition of the Mosan style and its influence in other areas is easy. His figures move with the gentle ease of the Liège font, although perhaps their poses are somewhat less varied and adventurous and their proportions less elegant than those of the original. The soft, pulled draperies of Rainer's style have been hardened a little, and follow more simple preconceived patterns, in which the fold that loops around the knee, emphasizing the contrapposto of the figure, becomes more obvious, although the source of this motif also in the font cannot be denied. The proportionally large heads, rounded, almost chubby, with strongly marked, heavily lidded eyes, small, straight noses, and rounded short lips, framed by bunched hair and beards, seem somehow to be the children of the more serious and more varied heads of Rainer's font. In the treatment of relief, the Hadelin master also learned his skill in Rainer's workshop. His figures enact their allotted parts on an undulating ground in front of an inviolate surface, almost entirely detached from the background, just like those on the font. By the stricter divisions of space by columns, a more clearly structured

composition results, in which the flowing narrative of the font is replaced by a firmer, more Romanesque pattern, related to a well defined frame. In the placing of small, neat inscriptions on the background, the solid rays issuing from the hand of God, and the tree in the scene of St Hadelin receiving pupils, the debt to Rainer's font is again emphasized.

The remaining four scenes from the life of St Hadelin are more obviously by different hands than is often the case. Two of them, showing St Hadelin raising Guiza and the death of the saint (Plate 196), are by one master, whose hand is most obvious in the heavy inscriptions in large letters on the backgrounds. His relief style is less clearly defined, the figures appearing more obviously raised from the background, forming a continuous undulating surface. The draperies do not articulate and do not define the parts of the figures as systematically. The flat, overlapping folds in the two standing figures in the scene of the death of St Hadelin owe more to the Late Ottonian tradition, ultimately derived from the long, flat, parallel Byzantine treatment of drapery, and the whole effect is far more linear, more like the 'sketchy' style. The third hand, responsible for the Dream of St Hadelin and Hadelin's visit to Pippin at Celles, may well be that of an assistant, influenced by both the major masters of the shrine, working in a less well defined and somewhat clumsy style.[18] The inscriptions are once more treated differently – this time they follow the outline of figures and haloes.

The date of the remodelling of the shrine is not recorded, but it is generally accepted to have taken place in the second quarter of the twelfth century. Its stylistic dependence on the Liège font makes a date much earlier than 1125 unlikely, and the contacts with the 'sketchy' style to which attention has been drawn would make a date contemporary with the Xanten shrine in the early thirties of the century very probable.[19]

A notable feature of the shrine of St Hadelin is the complete absence of any champlevé enamelling in its figurative or ornamental decoration, although the technique must have been practised in the area by then. The earliest dated piece on which typically Mosan champlevé enamelling is employed is the head-reliquary of Pope Alexander, ordered by one of the most important patrons of the arts in the twelfth century – Abbot Wibald of Stavelot. Born in 1098, he studied under Robert of Saint-Laurent de Liège, took the habit at Waulsort, and was made abbot of the important abbey of Stavelot in 1130. He had already attracted the attention of the court and was to be counsellor to three emperors, often acting as special emissary in delicate negotiations. He accompanied Lothar II (1125–37) to southern Italy, where he was appointed abbot of Monte Cassino, a post he held for only a few months. He then went with Conrad III (1138–52) on the second Crusade and acted as papal legate in the war on the eastern frontier against the Wends in 1147. In 1146 he was made abbot of Corvey, and he ruled both houses until his death. He announced the election of Frederick Barbarossa (1152–90) to the pope and was sent by the emperor on an embassy to Constantinople in 1155–6 in order to negotiate a marriage of Frederick to the niece of the Emperor Manuel Comnenus. After a second embassy to Constantinople, he died in Asia Minor at Bitolia on 19 July 1158. His body was brought home in 1159, and 26 July he was interred at his favourite Stavelot.[20]

The Alexander head-reliquary was completed for Wibald in 1145, and on the 13th of April the relics of the saint were deposited in it (Plate 198).[21] The almost life-size head of silver gilt wears a collar decorated with enamel plaques, and is mounted on a square box carried on dragons[22] which is decorated on all four sides with small plaques of enamel, three to each side. Between them, gems are held by hatched gilt-bronze plaques with holes cut into them. Again in enamel, on the front St Alexander is flanked by St Eventius and St Theodolus, and on the back, in the centre, a personification of Holy Wisdom appears. To each side of her and on the two sides the eight gifts of the Holy Spirit are represented, each holding a panel with words referring to the Beatitudes as given in the gospel of St Matthew (Chapter 5, 3–10).[23] Like the enamels on the sides of the Eilbertus altar (Plate 182), these panels look like imitations of Byzantine cloisonné. Bust portraits on a gold background are typical of Byzantine enamels, and the placing of inscriptions vertically in the field must, in the end, have been derived from this source too. But the drawing of the heads, engraved and filled with dark blue enamel, is unmistakably Mosan in character. The round eyes, the arched eyebrows, the short noses and smooth, rounded cheeks, all are a two-dimensional version of the heads of the Visé shrine. There are no models for this technique of engraved heads and hands combined with 'full' enamel for haloes and drapery, either in Byzantine enamelling or any earlier western practice – it is an invention of the Mosan area.

The head-reliquary of Alexander is not the only important work commissioned by Abbot Wibald for his abbey of Stavelot. The greatest of them was undoubtedly the retable of St Remaclus, and a house-shrine enclosed within it. Neither survives, and indeed neither appears to have been in existence when Martène and Durand described the treasure of the abbey that they saw on their visit in 1718 (published in 1724): what the two Benedictines described was the later shrine of Remaclus made in 1263–8, which is still in the abbey,[24] and a golden retable on the high altar, showing the Pentecost with the principal mysteries of the Passion and Resurrection of Our Saviour with the Abbot Wibald on one side and the Empress Irene on the other.[25]

The great Remaclus retable ordered by Wibald was nearly 3 m. (about 10 ft) square, and a drawing of it made in 1661, not based on the original retable but on an earlier drawing,[26] has fortunately survived (Plate 199).[27] Whatever its sources, the accuracy of the 1661 drawing is proved by the two circular discs enamelled with half-length winged representations of Faith and Charity which are the only fragments of the retable to come down to us (Plate 200).[28] They were originally mounted in the spandrels of the porch-like structure surrounding the twelfth-century house-shrine, seen with its principal end on. More enamels of the same kind were mounted on the retable, one in the centre of the same porch, showing the Dove of the Holy Ghost, and others above it. There, Christ appears in the centre, with four Virtues and the four Evangelist symbols around him, and the four rivers of paradise, two below the central group and two in the corners of the large arch that caps the whole altar. The rest of the decoration of the retable, apart from some small enamelled panels, consists of large embossed silver-gilt(?) scenes: in the lunette, angels above, Enoch and Elias on the left, and an angel appearing to St Remaclus on the right; below, framed by broad embossed foliate scroll borders, eight scenes from

the life of St Remaclus.[29] An inscription on the outer frame of the upper arch records that the work was given by Abbot Wibald, and on the inner frame of the same arch, sixty-three possessions of the abbey of Stavelot are listed. The retable was therefore certainly executed before the abbot's death in 1158, but a more precise date cannot be determined with certainty. It is said that Canon Aubert Le Mire (1573–1640) believed the work to date from about 1135, but it is not known what evidence was available to him.[30] An inscription recorded by an anonymous author in his 'De fundatoribus . . . abbatiae Stabulensis', which survives in manuscript, states that Wibald's gift was made 'sub auspiciis imperatorum Frederici Romanorum et Manuelis Graecorum' in 1156,[31] but this was probably on the second retable with Pentecost and the Passion of Our Lord. It is this second retable that could not have been made before Wibald's return from his first visit to the Byzantine court in 1155–6.[32]

An additional piece of evidence often quoted in connexion with the Remaclus retable is the famous letter written by Wibald in 1148 and addressed to 'Dear Son "G", goldsmith', in which the abbot requests that the objects ordered long ago should be delivered with all haste. This goldsmith 'G' is often believed to be a Canon Godefroid, whose death is recorded for 25 October in the register of the monastery of Neufmoûtier, near Huy, written in the late twelfth century. Added to this register, in a hand of about 1240, is a note saying that Godefroid, citizen of Huy, had no equal as a goldsmith and that he made many shrines in many places and objects for kings. Also, in the inventory of the treasury of the church of Notre Dame at Huy, written in 1274, it is recorded that the shrines of St Domitian and St Mangold were made by a Godefroid on the order of Bishop Raoul of Zähringen in 1173. More details of the life of the goldsmith Godefroid are given by the chronicler Jean d'Outremeuse (1338–1400) in his *Chronique en bref*, not noted for its accuracy. Godefroid, the finest goldsmith in the world, is said to have served the Emperor Lothar and King Conrad, and to have returned in his old age to Huy in 1173, after an absence of twenty-three years, to make two shrines of St Domitian and St Mangold. On the basis of this evidence, a huge œuvre has been attributed to Godefroid of Huy (also called Godefroid de Claire), ranging from the head-reliquary of Alexander in 1145 to the Huy shrines of 1173,[33] and this, in turn, has been criticized and reappraised.[34] On the whole, the introduction of the personality of Godefroid has hindered rather than helped our understanding of the development of the Mosan style in this vital period.[35]

If indeed, and there is no evidence for this, the unfinished work to which the letter of 1148 referred was the Remaclus retable, then this major piece had been commissioned several years earlier, and was perhaps partially complete by 1148. The two surviving enamels hardly give us enough evidence to date the retable, and it would be difficult to be certain whether the roundels are earlier or later than the enamels on the head-reliquary of Alexander of 1145, although they are certainly likely to have been made in the same workshop. One fact, however, may be emphasized. The retable surrounds a house-shrine, and the head of it is carefully represented on the 1661 drawing.[36] It is clear that the space for it is carefully reserved in the retable, and it must be assumed that the retable was made either for an existing shrine, or at least with it. Its design is advanced

in terms of the typology of the Romanesque house-shrine. A figure of Christ is flanked by St Peter and St Remaclus, all standing under a triple arch, within a square panel in an ornamental frame set with gems in groups of five. Both the roof and, especially, the base are architecturally articulated. The triangular space above the main figures had an oval setting carried by two angels, and the edges of the steep roof are decorated with cresting, surmounted by a large knop. This more systematic approach, with its logical, architecturally designed elements, is very different from the simple single area of the Visé shrine of St Hadelin, and comes much closer to the design of the ends of the shrine of St Heribert in Deutz, where at one end the seated St Heribert appears in a rectangular frame, only slightly penetrated by the circular frame of the bust of Christ, and at the other the Virgin and Child are seated under a triple arch (Plate 212). It is difficult to be certain when this more architectural approach was first introduced, but the shrine of St Victor at Xanten (Plate 184) has a projecting base and roof, and at one end a rectangular area surmounted by a triangular pediment framed by pierced cresting, just like the drawing of the Stavelot shrine. The Xanten shrine has of course suffered heavily in later restorations, but most of the decorative strips that divide this end seem to be of the twelfth century, and it is fairly safe to assume that its basic underlying structure was not substantially altered later.[37] The more elaborate triple arch within the rectangle in the Stavelot shrine therefore makes a date in the forties or early fifties, contemporary with the whole retable, very acceptable.

Another piece almost certainly given to the abbey of Stavelot by Abbot Wibald is the Holy Cross reliquary in the form of a triptych, now in the Pierpont Morgan Library in New York (Plate 202).[38] In the centre field, a scalloped frame surrounds two small eleventh-century Byzantine reliquaries, also triptychs, perhaps suggesting the form of the whole to the western goldsmiths. On the wings, between two columns sheathed in silver, six circular enamels are mounted with scenes of the conversion of the Emperor Constantine and the invention of the Holy Cross by the Empress Helen.[39] It would seem very likely that Abbot Wibald acquired these small Byzantine reliquaries on his embassy to the court of the Emperor Manuel Comnenus in 1154 and had them mounted in their present form between his return to Stavelot in 1156 and his death in 1158. The style of the circular enamels is in its drawing and in the small squat letters of its inscriptions in the field very close to the two surviving enamels of the Remaclus retable – only the rich narrative content of its scenes perhaps makes them appear a little more technically experienced. The enamels of the head-reliquary of Alexander of 1145 already show most of the characteristics we associate with mature Mosan enamelling, especially in the drawing of the heads.

A group of twelve enamelled panels is closely associated in style with these works commissioned for Stavelot. All are of the same size (10·2 by 10·2 cm., or 4 by 4 in.), all have a heavy pearled border, and all were fixed by means of four holes along each of their sides. Four of them, now in the Metropolitan Museum in New York, show scenes from the New Testament (Baptism (Plate 203), Crucifixion, Three Maries at the Tomb, and Pentecost), and two more, one in the Victoria and Albert, the other in the British Museum, represent scenes from the Old Testament (Moses and the Brazen Serpent and

the Cleansing of Naaman in the river Jordan) (Plate 204). The others are the Ascent of Alexander in a chariot, Samson and the Lion, and a man riding a camel (all in the Victoria and Albert Museum, London), a man slaying a dragon, a centaur hunting, and SS. Sebastian, Livinius, and Tranquillinus (all in the Louvre, Paris). Technically they form a homogeneous group, and are likely originally to have decorated a single object.[40]

Moreover all have a narrow enamelled border in blue or green and white, but some differences of style can be seen. The head and body of Christ in the Crucifixion panel are rendered in 'full' enamel, but in the Baptism only engraved in line filled with dark blue enamel. The quality of drawing in, for instance, the man riding a camel or in the centaur is not of the high standard found in the Pentecost panel or the Baptism. And yet the heads in the Naaman panel are indistinguishable from those on the panel with Moses and the Brazen Serpent, and the architectural details of setting of the Three Maries at the Tomb are very like those of the Pentecost panel. A technical point, somewhat unusual in Mosan enamels, is also worth mentioning. A semi-translucent dark red enamel is used, with what appears to be a silvery underlay to produce a shimmering effect of reflected light, in the Alexander and the Naaman plaques, and most vividly in the Pentecost panel, where another translucent colour, a pale green, is also used. The colours throughout, not only of this group, but also of the other works made for Stavelot already mentioned, are typical of Mosan enamelling. They are rich and luminous and range from white to pale and dark blue, yellow to light and dark green, turquoise, vermilion, and rose madder. More often than not more than one colour is found in one cell, the most popular combinations being graduations from white to blue, yellow to green, and blue to turquoise.[41] One cannot really doubt that this group of panels was made in one workshop, and, indeed, that this workshop also produced the enamels for the Stavelot triptych and the Remaclus retable. No doubt more than one craftsman worked on them, and one is reminded of Abbot Suger's statement, that when he called enamellers from Lotharingia to Saint-Denis to decorate the base of a crucifix for him in the years 1145–7, there were five, and at other times seven, men employed on the work.[42] This passage in Suger's Administration of Saint-Denis also proves that the skill of enamelling was well established in Lotharingia by the forties and even known about outside the area.

The base of the crucifix is described by Suger as follows:

And barely within two years were we able to have completed . . . the pedestal [of the Golden Crucifix] adorned with the four Evangelists; and the pillar upon which the sacred image stands, enamelled with exquisite workmanship, and [on it] the history of the Saviour, with the testimonies of the allegories from the Old Testament indicated, and the capital above, looking up, with its images, to the Death of the Lord.[43]

Suger's great cross and its base no longer survive – they fell victim to the religious wars in France in the sixteenth century – but a detailed description is found in an inventory written in 1634 at Saint-Denis, based on an earlier text.[44] The wording is unfortunately

not all that clear, but it is essential to any attempt to visualize the great crucifix. The text begins:

Above the crypt, on the pavement in front of the altar of the relics of St Denis, St Rusticus, and St Elesetherius, and above the door of the crypt, is a square column of gilded copper laid on wood, set on a pedestal and base with four dragons, and on top of this pedestal are four figures of the four Evangelists, having at their feet the eagle, the lion, the angel, and the bull, and between the figures are three leaves and a space without a leaf where the fourth used to be, the whole also of gilded copper in relief. The said foot is ornamented on each face with seventeen enamels of gilded copper depicting many figures.

It goes on a little later:

Between the enamels on each face there are also six other square plaques and two half-plaques, also of gilded copper, and ornamented altogether with twenty-seven pieces of chalcedony, eleven cornelians, six agates, two in the form of cameos showing the head of a man, five onyxes, seven amethysts, four garnets, six jaspers and one emerald coloured rock-crystal, the next being mother of pearl, crystals, glass, and a Spanish turquoise.

Again, later:

The capital of the said column is also covered with gilded copper, and there are four figures of prophets, that on the side facing the altar of the saints holding an inscription containing the words 'Vere filius Dei erat iste', and in the border of this capital at the top are twelve enamels of gilded copper and at the bottom six other enamels underneath the prophets . . . and six spaces where six enamels are missing.[45]

The inventory continues with descriptions of the 'crucifix of hollow gold, its crown also of gold' and of all the gems, semi-precious stones, pearls, and enamels in settings found on the cross, the loincloth, and elsewhere, each item being valued.

From all this it can be concluded that the enamels which decorated the pedestal were square, and that there were seventeen on each of its four sides, making a total of at least sixty-eight figure subjects dealing with the history of the Saviour and 'allegories' from the Old Testament. On top of the pedestal sat the four Evangelists with their symbols at their feet. Between the enamels, copper gilt plaques holding gems were mounted, probably gem settings of the same kind as on the Alexander reliquary and the Stavelot triptych, and the whole base was carried on four dragons.

Some of these facts fit the surviving group of twelve enamels very well. They are square, and out of the very small number of panels still extant, two with scenes from the New Testament, the Baptism (Plate 203) and the Crucifixion, are paralleled by Old Testament prefigurations; Naaman cleansed in the River Jordan (Plate 204) and the Brazen Serpent. Moreover, the Ascent of Alexander may well have been used to pair with Christ's Ascension, and Samson and the Lion as a prefiguration of Christ in Limbo.[46] The fact that seventeen square panels appeared on each side proves that they could not all have been pairs – at least one and possibly five panels must have belonged to a different cycle, or have been individual subjects. Perhaps the Louvre panel with St Sebastian and his companion St Tranquillinus and St Livinus, an Irish missionary martyred

Figure 7. Crucifix of Abbot Suger of Saint-Denis (reconstruction), 1145–7

in Flanders near Alost, is one of these single panels, of which there must have been at least four and possibly twenty.[47] That this group of enamels might once have decorated Suger's great crucifix at Saint-Denis (Figure 7) cannot, of course, be more than speculation, but a date in the forties seems more satisfactory than the one in the sixties which is usually assumed.[48] The more subtle treatment of form and more ambitious, more detailed compositions, and often more elongated figures of the Stavelot triptych of about 1156–8 seem more likely to be later than earlier than these plaques.[49]

Enamelling in this idiom continued to enjoy great popularity in the Mosan area well into the third quarter of the twelfth century, and to exert a considerable influence elsewhere in Europe, especially in the Rhineland. Few of the many surviving pieces can be dated on other than stylistic grounds. Among the finest are the shaped plaques added to Bishop Notger's book-cover, with the four rivers of paradise at the corners and four Virtues surrounding the central ivory panel (Plate 170).[50] The narrow blue and white frames continue the tradition of the square panels, and in the fully enamelled figures of the Virtues against a gilt background, with engraved heads, arms, and hands, the close resemblance to the earlier panels is obvious. The personifications of the rivers are also drawn in a style very similar, for instance, to the figure of Christ in the Baptism plaque, but instead of being placed on a gilt copper ground, they are reserved on a background of full colour: green, red, and blue. The effect is one of great richness. A date about 1150 would seem to be likely.[51]

From this experiment with gilt figures reserved against a fully coloured background a new Mosan style and technique was developed which was to reach its final flowering in the work of Nicholas of Verdun. The outstanding piece in this technique, probably dating from the sixties, is the portable altar from Stavelot, now in the Brussels Museum (Plate 205).[52] The whole piece is richly enamelled. On the top a crystal altar stone over a relic is surrounded by a quatrefoil with representations of Ecclesia and Synagogue and Samson carrying the gates of Gaza and Jonah and the Whale. Four scenes from the Old Testament prefiguring the Passion and six scenes from the life of Christ complete the decoration. Around the sides of the altar are scenes of the martyrdom of the twelve Apostles. The whole altar is carried by full-length figures of the four Evangelists, seated at the corners. A large number of figures on this altar are rendered in reserved gilt, with internal drawing engraved and filled with red or blue enamel, others are enamelled with only the heads and hands reserved, and all are set against fully enamelled backgrounds, mostly of blue and green. The drawing of drapery is here beginning to break away from firm preconceived patterns towards loose, accidental folds. Cloth falls freely over belts. Although patterns still exist, remnants of panel drapery of a hard 'nested V-fold' kind can still be seen, and loops around the relaxed knees of standing figures still maintain the traditions of the Visé shrine; the great difference is in the fact that the drapery looks so much freer. Thin hairlines play around thick, broad lines, and small accidental flicks, not part of a predetermined pattern, enliven the figures. The first steps towards less formal, freer forms of expression are taken. And yet the small, fully three-dimensional figures of the Evangelists at the corners are still relatively stiff, modelled with admittedly soft, but strictly controlled draperies. Their Mosan character, especially in the heads, is

unmistakable. It is interesting to compare them to the Evangelists who perform the same function on the cross base now in the Museum at Saint-Omer (Plate 207).[53] It has been claimed, because they are so much more accomplished, that the Saint-Omer figures are later in date than the Stavelot altar.[54] There is no doubt about their superiority in quality. Detail is far more subtle – compare, for instance, the reading desks. In the cross foot they are finely worked with elaborate stems, moulded and decorated; but in the altar a single plain upright beam carries the board. The differentiation of the Evangelists' heads on the Saint-Omer piece is equally fine, and the movement of the figures is varied, twisted, and highly expressive. The Saint-Omer foot is certainly, in sheer quality, one of the masterpieces of the twelfth century, the Stavelot altar by comparison crude, and of rough, almost rustic simplicity. But can this comparison be used to establish their relative dates? The enamelling on the cross foot employs full-colour figures on a gilt background. Speckled enamel is used, but the drawing of heads still strongly resembles the earlier enamels. The broad, simple drawing of the figures shows nothing of the free play of folds introduced by the Stavelot altar. The wings of the Evangelist symbols are still of the stunted kind used in the Remaclus roundels. The drapery of the Evangelists on the Saint-Omer foot is handled in soft, generous loops, which is characteristic of the development of sculptural form in the Mosan area in the generation after the Visé shrine. It cannot be over-emphasized with what consummate skill this style is handled in the Saint-Omer piece, but comparatively little of the free play of accidental folds, or the multiplicity of folds developed in the sixties of the century, appears. Their closest relatives are the figures of the Pentecost retable from Coblenz (Plate 208), or even more particularly the seated Apostles on the sides of the Deutz shrine of St Heribert (Plate 210).[55]

The copper gilt Pentecost retable, now in the Cluny Museum in Paris, is said to have come from St Castor in Coblenz, but is undoubtedly a work of Mosan craftsmen (Plate 208).[56] Nothing shows this more clearly than the unmistakable 'Mosan' heads of the retable, almost interchangeable with those of the major master of the Visé shrine. The Apostles are seated in pairs in six panels, separated by columns, reacting with vivid gestures to the holy message. In a semicircular lunette that breaks out of the frame above, the bust of Christ dominates the retable.[57] Only the large enamelled haloes of the Apostles, added probably later in the twelfth century, interrupt the soft, rhythmic composition in complete harmony with the gentle, curved lines of the draperies of individual figures.[58] These figures achieve with ease all that is attempted in the Visé shrine. The style is here fully understood, and no vestige of any of the awkwardness often associated with the formative years of any style remains. The goldsmith is working well within the limits of a well-established tradition. A date in the late fifties of the century seems reasonable.[59]

The copper gilt Holy Cross triptych in the church of the Holy Cross at Liège must date from about the same time or a little earlier.[60] Its forms are somewhat more delicate than those of the retable, which may merely be the result of working on a much smaller scale, and the heads and drapery patterns are again clearly in the Mosan tradition. The vocabulary of decorative detail used in the framework is somewhat closer to the type

used on the Stavelot triptych than to that of the Coblenz retable, where the thicker, fleshy paired leaves may indicate some contact with Rhineland practice.[61] For that reason, a slightly earlier date for the Liège reliquary may be advanced – perhaps the early fifties. Such a date could receive support from an unexpected source – the seal-dies engraved for Frederick I Barbarossa in 1152. Both the wax seal and the gold bull made for the king under the supervision of Wibald of Stavelot in Lotharingia are very close indeed to the style of the half-length Apostle figures of the wings of the Holy Cross reliquary at Liège,[62] a style still found unchanged in the small half-length figures in embossed silver on the sides of the arm-reliquary of the Emperor Charlemagne made c. 1166 (Plate 206).[63] Nothing shows better the continuation of what may well be the personal style of a single craftsman over a period of at least fifteen years.[64]

Virtually overlapping with this conservative element of a long-living Mosan tradition, rooted in the second quarter of the century, and continuing beyond the arm-reliquary to the shrines of St Domitian and St Mangold of Huy of 1173, is a style most clearly seen in the great house-shrine of St Servatius made for the church of St Servatius at Maastricht (Plate 209). The shrine was probably intended, together with the four smaller reliquaries of SS. Monulph, Valentine, Gondulph, and Candidus now in the Brussels Museum, to form part of a new arrangement of the major relics in the new choir of St Servatius, probably completed in the late sixties,[65] and is therefore likely to have been made around 1170. The basic structure of the Servatius shrine resembles that of the late Huy shrines attributed to Godefroid de Claire, which unfortunately survive only as comparative ruins, both shortened by half a bay and repeatedly altered, drastically in the sixteenth century and many times subsequently.[66] As in the Huy shrines, the seated figures on the sides of the Maastricht shrine are arranged in pairs, in the former in rectangular fields separated by double colonnettes, in the latter under two arches supported by a flat pilaster in the centre.[67] The six pairs of Apostles are then framed by a flat strip decorated in part with *émail brun*, making little attempt to articulate the shrine architecturally. Indeed, so little interest in the architectural structure of this shrine is shown that in the major end-pieces the cresting of the edges of the roof is carried right down the sides to the base, which does not project at all. On the roof, embossed groups of elect and damned are shown in circular medallions, three to each side, with scenes from the Last Judgement between them. Not all the relief work is by one hand. The master most closely linked with the gentle, rhythmic Mosan relief style, as for example in the Coblenz retable (Plate 208), was responsible for the Apostles Paul and James, John and Bartholomew. Only in the heads can one see a greater degree of individual differentiation than in the retable.[68] In the standing St Servatius between two angels and in the reliefs of the roof (Plate 201) as well as in the Apostles on the opposite side, a very considerable change of style has taken place, perhaps because they were worked by a craftsman of a younger generation. Instead of the generous, almost bulbous forms of the Apostles on the right-hand side, with their soft loops of thick drapery, a tighter, harder drawing style dominates. The material is thinner, the folds are multiplied, and touches of accidental breaks in the pattern of folds occur. The heads, although hard and at times rather rigid and staring in their expression, are nevertheless far less stereotyped, and a degree of free naturalism is to be

P

seen occasionally (for example in the three heads below the feet of St Servatius and his angels) which is totally alien to the accepted formulas of the previous generation. The differences between these two styles are very fundamental. Whereas the traditional Mosan style is entirely concerned with formal values, this new approach is aware of the play of light across a work and the optical, illusionistic effects it is possible to achieve, especially in glittering precious materials. The sources of this change of style, which may be traced in nearly all parts of Europe and in all techniques in the decades after about 1170, have not yet been sufficiently studied. Broadly, both the influence of Byzantine art and a renewed interest in the linear drawing style of the Reims tradition, still active in Cologne and, especially, in Lower Saxony, must have played a part.[69]

It is against this background that one of the major works created by Mosan goldsmiths, the shrine of St Heribert at Deutz, just across the river from Cologne, must be studied (Plates 210–12). This important shrine is not dated by any direct documentary evidence, but could not have been made any earlier than the raising of St Heribert, founder of the abbey of Deutz, which took place in 1147, under Abbot Gerlach.[70] A short statement recording the date of this translation is found in the Codex Thiodorici, written by the sacristan of Deutz between 1164 and 1167.[71] The same codex contains a *Series abbatum Tuitiensium*, in which the main events of Abbot Gerlach's life and those of his successor Abbot Hartpern are recorded. It has been argued that if either of these abbots had been responsible for the shrine of their patron saint, the fact would have been mentioned, and that therefore the shrine must be later than 1164 and most probably later than 1167.[72] But at best, any argument *ex silentio* must be open to question. Indeed, in the *Series abbatum*, one of the most important events in the life of Abbot Gerlach, the raising of the patron saint in 1147, is not even mentioned – and a special entry recording the fact in a few lines appears later under its own heading. It is, perhaps, not uncommon that the facts known to everyone – the most obvious events – seem less worthy of record to the contemporary historian. Against Thiodoricus's silence must be set the likelihood of the patron saint of an important abbey being kept in an undecorated wooden sarcophagus for at least twenty years.[73]

Although a post-1167 date would make the Deutz shrine virtually contemporary with the Servatius shrine, it is generally agreed that it must be at least somewhat earlier.[74] Along the sides, the twelve Apostles, embossed in silver-gilt, are seated in rectangular fields, separated by narrow champlevé enamel panels with standing prophets. On the roof twelve slightly dished circular enamels showing scenes from the life of St Heribert are mounted (Plate 211), on one side separated by decorative enamelled strips with capitals and bases and with Virtues and Vices in combat, and on the other with angels in semicircular plaques at top and bottom. Decorative embossed scrollwork, including figurative roundels, forms the background. At one end, the Virgin and Child are seated under a triple arch, accompanied by two standing angels; at the other, the seated St Heribert receives the crozier and a book from Charity and Humility (Plate 212). Cresting enriched by large crystals surmounts the roof, and both the base and cornice of the shrine project strongly.[75]

Not all the sculptural decoration seems to be by the same hand. The major master

probably made the Heribert relief and the Apostles Thomas, Bartholomew, and John the Evangelist as well as James, Andrew, and Peter. The main relief at the other end, the Virgin and Child and the Apostles Simon, Philip, Paul, James, and Judas, may well be the work of one other master.[76]

The Heribert shrine is a work of the greatest importance for the twelfth century. It is at one and the same time a high point of achievement reached by Mosan goldsmiths, and a source for many of the developments that dominate the second half of the century. It brings the finest Mosan art into the Rhineland, and promotes a fruitful synthesis with indigenous styles. The soft, classicizing relief style of Mosan sculpture is obvious in the seated Apostles on its sides. Seated Apostles as the major element in decorating the sides of a house-shrine had already been employed east of the Rhine in the shrine of St Gode-hard made at Hildesheim in the early thirties of the century, and this, and the architectural structure of the whole building, have been seen as a German contribution to the development of this type of shrine.[77] But the 'pictorial', colourful treatment of the sides of the shrine, with rectangular fields instead of the architectural arcade employed in Hildesheim, may be closer to a Mosan tradition than is generally recognized – the missing evidence of the sides of the shrine made for Stavelot should not be forgotten. Elements that make up the design of the end of this shrine, which appears on the seventeenth-century drawing (Plate 199), are certainly comparable to the Deutz shrine: the rectangular field with a pediment above is seen in the Heribert end, and the triple arch of the other end with the seated Virgin is used at Stavelot as an interior division below the pediment. Projection of both roof and base is also seen at Stavelot. The continuing popularity of circular decorative plaques on the roof in the Mosan area[78] also suggests that this feature was a Mosan contribution. It is all this, which was so popular in Wibald's patronage, as well as the plentiful use of champlevé enamels in the decoration of a shrine, that makes the Heribert shrine so unusual among the surviving material; we may well have at Deutz a shrine which was a close relative of the one made for Stavelot in the fifties of the century. There seems to be no reason to date it any later.

But the Heribert shrine is not only Mosan, though both in the enamels and in the larger embossed figures the influence of local styles breaks through. In the Servatius shrine, it has been suggested that it was the linear 'sketchy' style which had been, at least in part, responsible for breaking up the set patterns of the classicizing Mosan tradition, reaching back to the Liège font and beyond. The first and less profound contact with this tendency may be seen in the Deutz shrine. In figures like the seated Heribert (Plate 212) or the Virgin and Child, the strict patterns imposed on the purer Mosan figures of, for instance, the Coblenz retable begin to break down. A degree of agitation, a breath of a new wind, seems to blow across them. This loosening of formula is, as has been said before, the main contribution of the lively and expressive linear tradition of the Reims style, which was always at hand to prevent the formal patterns of the Romanesque from developing into sterility. Elements of the influence of the Helmarshausen 'nested V-fold' style can also be seen, especially in some of the engraved figures on the circular enamels of the roof, which in the main are so closely related to the Mosan enamelling of the Stavelot triptych. The two men building the abbey of Deutz show this clearly (Plate 211). But the

uncompromising hardness of Roger's style is not accepted. The movements of the figures are less angular, and the soft loops of cloth falling over the belt are more in line with the loosening of stylized forms also seen in more developed form in the Stavelot portable altar. This tendency is even more accentuated in the small square panels with Virtues overcoming Vices on the decorative strips on the roof of the same shrine. Here the 'nested V-fold' style is transformed into rhythmic, almost violently curved linear drawing, later further developed in the Cologne workshop that produced the portable altar of St Gregory at Siegburg.[79]

Because all these styles are in the Deutz shrine, in a formative, immature stage, it should be seen as a source for many of the styles of the sixties. It is difficult to believe that work began on it any later than the early fifties, and it seems preferable to date it in the main as contemporary with the patronage of Wibald of Stavelot late in his life. Certainly, the influence of the masters of the Deutz shrine was widespread and fully effective by the sixties of the twelfth century.

THE EMPIRE: THE TWELFTH CENTURY

THE EAST

THE style created by Roger of Helmarshausen at the beginning of the twelfth century was no less influential than that of Rainer of Huy. At almost exactly the same time as the house-shrines of St Hadelin at Visé and St Victor at Xanten were being constructed, a follower of Roger built the house-shrine of St Godehard for the cathedral of Hildesheim (Plate 213). Unfortunately this shrine has suffered very considerable restoration, especially in the eighteenth century, when most of the structural elements were completely re-cast.[1] It was at this late period that all the gem settings were added to it. This restoration must have destroyed the architectural treatment of the arcades of one of the sides of the reliquary, where single Apostles are now seated under unarticulated arches. On the other side and at one of the ends, columns survive with moulded bases and elaborate, cast Corinthian capitals between the seated Apostles and standing figures of three bishops at that end. In fact, alongside the narrative scenes of the Visé shrine and the standing Apostles of the Xanten shrine, the seated Apostles of Hildesheim, under three-dimensional architectural arcades, created the idiom that was to dominate the design of house-shrines henceforth. There can be little doubt that this was taken over from the small-scale engraved version of the same iconography on Roger's portable altar of St Kilian and St Liborius at Paderborn (Plate 161); one need only compare the seated St Matthew on the Godehard shrine (Plate 214) with the St Philip of the portable altar (Plate 162), with its almost identical arrangement of drapery, to see that the Godehard shrine does little more than translate the two-dimensional engraving into relief.[2] The imitation of marbled columns on the end and much other decorative detail on the Godehard shrine are also close to the Paderborn altar, especially in the borders of costumes. Particularly rewarding is a comparison between the St Godehard on the shrine and the St Kilian on the altar. Both are standing figures vested as bishops, with small pointed sandals peeping out from under the alb. They also have in common borders with small crosses and the general concept of a rather puppet-like figure, and the filigree on the book held by the bishop shows that in this detail, too, the master of the shrine derives his technique from the altar, where very similar filigree is used on the mandorla of the Christ in Majesty. On the whole the altar is of a higher standard of delicacy in detail, which although it may in part be due to its smaller scale, suggests that the work at Hildesheim was exe-cuted by a follower rather than by Roger of Helmarshausen himself.

The shrine is low and broad in proportion. At the ends, the main scenes are framed by a wide rectangular border. At the head end, a Christ in Majesty, surrounded by four anthropomorphic Evangelist symbols,[3] is accompanied by the Virgin and St John the Baptist.[4] Above, in the pediment, is a half-length figure of an angel with an orb and a

broken sceptre, and at the opposite end are three standing bishops (Plate 213), St Gode-
hard (1022–38) in the centre and Bernhardus (1130–53) on the left, both with inscrip-
tions, and on the right another, believed to be Pope Innocent (1130–43), who was
responsible for the canonization of Godehard at Reims in 1131. The body of the patron
saint of the cathedral was raised in 1132 and the shrine is likely to have been ready to
receive him by then or to have been completed very soon after that date.

On the roof, imitation of tiles is the only decoration, emphasizing the architectural
concept of the design. The unusually high cresting along the ridges of the roof includes
engraved half-length angels, and is surmounted by large crystals. The base projects with
a bevelled edge and the roof projects marginally. This and the design of the head and
foot ends relate this shrine to the almost contemporary one at Xanten (Plate 184), and
the whole architecturally orientated design makes the shrine of St Godehard the most
important source, alongside the Deutz shrine, for the second half of the century.

The same workshop was responsible for another major shrine at Hildesheim, that of
St Epiphanius. Comparisons of individual figures, especially the heads, jutting forward
with staring eyes and bushy eyebrows, clearly show the same hand at work. This
reliquary has also suffered dreadfully in restoration, but the main outlines of its design
show clearly that it is, and always was, far less architectural in its design. On one long
side, a half-length figure of Christ is shown in the centre over the gatehouse of a city,
with the five foolish Virgins on his left facing a closed gate, while the five wise nimbed
Virgins on his right are faced by an open door. On the opposite side another
parable, that of the Talents, which follows that of the wise and foolish virgins in the
gospel of St Matthew (chapter 25), is represented.[5] Both long sides are therefore con-
ceived as single narrative scenes, a pictorial form not known on any other medieval
house-shrine, although one might be permitted to speculate that this is likely to be an
earlier rather than a later tradition. It is therefore not inconceivable that it was the
Epiphanius shrine that was the first work made by a craftsman of Roger's circle at
Hildesheim – there is certainly no reason to date it any later than the much more pro-
gressive design of the shrine of St Godehard.

These two major shrines at Hildesheim are not the earliest results of contact with the
Helmarshausen workshop. Its influence is even more direct, and an altogether higher
standard of workmanship is achieved, in three circular copper gilt liturgical fans, each
decorated with a cross in silver gilt filigree and set with crystals and gems.[6] Two of them,
of identical size (33 cm. (13 in.) in diameter), with identical filigree crosses mounted on
their obverse and very similar decorative engraving on their reverse, were probably
made as a pair (Plate 215). The design of the pierced ornamental foliate scrolls that fill
the quarters between the arms of the cross differs: in one the tendrils are ribbed, and in
the other they are softer and flatter, with thin engraved lines at the edges. The filigree
of open, simple design, with small silver 'pearls' at the ends of the scrolls, may be com-
pared to that of Roger's Paderborn altar or Trier book-cover (Plates 161 and 168). Even
closer to the same altar are the engraved scrolls on a background of circular punchwork
found on the reverse of both fans (Figure 8). Foliage and scrolls, both in the form of
leaves and in the way they are drawn, with short, comma-like lines at the end of each

part of each leaf, are almost identical with the decoration on Roger's portable altar.[7] It would not be inconceivable that this pair of flabelli was made in Roger's workshop early in the twelfth century and only acquired by the cathedral in the way Bishop Henry of Werl of Paderborn ordered the portable altar. The third flabellum is different in design and larger (41·5 cm. (16⅜ in.) in diameter). The filigree cross is thinner, and the quarters between the arms of the cross are subdivided by triangular filigree 'rays'. The pierced

Figure 8. Flabellum (back), c. 1110/30, *Hildesheim Cathedral, Treasury*, and decorative border strip of the portable altar of Henry of Werl, bishop of Paderborn (1084–1127), 1100 with later additions, *Paderborn Cathedral, Treasury*

scrollwork background is flatter, harder, and less ably handled, and may be compared to such decorative work as the cresting of the St Godehard shrine. It is likely to have been made by the same workshop as the Hildesheim shrines, in the third decade of the century.[8]

Towards the middle of the century, it was not Roger's panel drapery style but the 'sketchy' style of Eilbertus of Cologne that dominated the arts in Lower Saxony. The style of Roger, so clearly seen in the two shrines and the flabelli at the cathedral, may have been the result of a single direct contact with the Helmarshausen workshop. It has already been suggested that the casket of St Andrew now at Siegburg (Plate 193) might have been made by a craftsman at home in this region.[9]

An enamelled casket, originally in the Sigmaringen Collection and now in the Museum für Kunsthandwerk in Frankfurt, is a work in which the free drawing of this tradition is seen (Plate 217). The large nail-heads and the heads of dragons at the end of the heavily beaded edges of the roof of the Frankfurt casket link it with the early North

German or Danish group mentioned earlier (Plate 185),[10] but its drawing is of far better quality. Although rather mottled enamel of white and two shades of blue is used, as in the northern group and in the St Andrew casket at Siegburg, the figures are reserved in gilt and engraved in a style much closer to the Eilbertus altar. The drawing is stricter and the forms more clearly grouped than in the looser, sketchier Eilbertus style, which might be taken to indicate a date nearer the middle of the century. The casket is recorded to have come from Gruol, near Haigerloch-Sigmaringen in southern Swabia,[11] but the suggestion that it may be a local South German product is difficult to substantiate.[12]

More clearly linked with the Cologne tradition of the Eilbertus altar are a number of works in the Guelph Treasure, especially the portable altar decorated with the Cardinal Virtues, which has even been attributed to Eilbertus himself (Plate 216).[13] On the top, the circular altar stone is surrounded by the Evangelist symbols in engraved gilt bronze, with the standing figures of the four Cardinal Virtues – Prudentia, Temperantia, Fortitudo, and Justitia – two to each side, in 'full' enamel with only the heads reserved in gilt metal. The interior drawing of these figures is comparatively simple, leaving rather broad, uninterrupted mottled areas of enamel, which might well be thought to support the existence of an earlier local tradition of champlevé enamelling of the kind found on the group of so-called Danish caskets. The embossed gilt metal on the bevelled edges of the altar is much closer to the Eilbertus altar. Even closer, and the basis of the attribution to Eilbertus himself, are the enamelled plaques on the sides, with a Christ in Majesty on one long side, with the Virgin on his right and St John the Baptist on his left and two Apostles each side. The remaining eight Apostles also appeared, four to each of the short sides, but four of them on one side are missing. On the other long side, the Virgin and Child are seated in the centre between the four Evangelists, named by inscriptions. The engraving of this side comes closest to the style of Eilbertus on the top of his altar, but the drawing is heavier and more deeply engraved, lacking the lightness of the master's touch, and the enamel is certainly less ably handled. Especially noticeable is the thinner, better controlled use of the white line separating the colours of the background and the absence of the subtle, graduated and merged colours on the Eilbertus altar. It seems more likely, therefore, that the Cardinal Virtues altar was made by a close follower rather than by Eilbertus himself.

This relationship raises the whole problem of the beginnings of the patronage of Henry the Lion in Lower Saxony.[14] The Guelph Treasure, now dispersed to a number of public and private collections, was originally the treasure of the cathedral of St Blaise at Brunswick. Its name is the result of the unusual circumstance that the bulk of the treasure was assembled, from the eleventh to the fourteenth century, through the patronage of members of the Guelph dynasty, or to be more exact of the Brunones and Guelph dynasties, the later House of Brunswick-Lüneburg.[15] The Eilbertus altar itself was certainly part of this treasure in the later Middle Ages (Plate 182).[16] The fact that the influence of Eilbertus is as strong as it is in the Cardinal Virtues altar does suggest that the master worked, at least for a time, in Lower Saxony, where his style continued to be influential throughout the third quarter of the twelfth century. It is, of course, not

possible that the Eilbertus altar was made for Henry the Lion, the great patron of the
arts in the second half of the century, because he was not born until 1129. The older
cathedral of Brunswick, however, begun soon after the marriage in 1127 of Henry's
parents, Gertrude of the Brunone family and the Guelph Henry the Proud, duke of
Bavaria, was consecrated in 1137,[17] and it is for this church that the Eilbertus altar is
likely to have been acquired, perhaps from near-by Hildesheim, at a time when Bruns-
wick itself had not yet become the artistic centre it was later to be under Henry the
Lion. The evidence for Hildesheim as a centre of importance after the production of the
two shrines of St Godehard and St Epiphanius is not very good. The fact that none of
the work attributed to Hildesheim in the third quarter of the century shows any sign
of influence of the panel drapery so wholeheartedly accepted in the two shrines, does
not inspire confidence in Hildesheim as the centre of production. Only the acceptance of
an earlier tradition of enamelling, centred around the 'northern' caskets, would make it
more likely.[18] It is not possible at present to be dogmatic about precisely where the
'sketchy' style enamels, predominantly with white, light and dark blue, and green back-
grounds and reserved gilt figures, were made. It may well be nearest the truth to postu-
late itinerant groups of workmen working throughout Lower Saxony and Westphalia,
and perhaps even father south, at Fulda or even in Bavaria (Zwiefalten?). Nevertheless,
a few more pieces, some of which can be connected with Hildesheim, should be
mentioned, and the centre is so well established in modern critical literature that it may
be worthwhile to continue to use the designation 'Hildesheim' for much of this work,
even if it is to be descriptive of a style rather than of a definite provenance.[19]

In the treasury of Hildesheim six splendid, unusually large (39 cm. long, 14 cm.
wide; 15 by 5½ in.) unattached panels survive, each decorated with three scenes from
the life of Christ (Plate 218). On four panels the scenes are arranged horizontally, on
two vertically. It is not known what kind of object these enamels originally decorated,
but a portable altar is, in view of their size, unlikely.[20] The figures are reserved against
enamel backgrounds, some having the internal rectangular frames in two colours separ-
ated by a thin white line, handled almost with the precision of the Eilbertus altar. The
drawing style is firmer, deeper, and of a more continuous and softer rhythm than the
casket with the Cardinal Virtues in the Guelph Treasure. Both the more systematically
organized folds and the rounded faces with carefully drawn hair and beards[21] are un-
doubtedly influenced by Mosan art, directly or, more probably, indirectly through the
Rhineland. These enamels almost certainly still belong to the years around the middle
of the century.

Perhaps contemporary with these enamels and also linked with the style introduced
into Lower Saxony by the Eilbertus altar is a group of three small portable altars and a
reliquary, perhaps not obviously of Hildesheim provenance, although they have been
attributed to at least this region.[22] One is the portable altar from Stift Vorau (founded in
1163) near Vienna (Plate 219); another, with very similar Apostles seated on semicircles
along the sides, from the Martin Le Roy Collection, is now in the Louvre, Paris.[23] A
third, with Apostles under identical arcades and in a similar style, only engraved instead
of being enamelled like the other two, survives at Lette (founded in 1133) in Westphalia

in the diocese of Münster. The small house-shaped reliquary is preserved in the same church, decorated with engraved gilt-copper panels with Apostles and, on the roof, scenes from the life of Christ, two of which are enamelled.[24] The style of engraving in all these pieces is of a fairly loose character, lightly sketched and with few of the soft, rhythmic patterns found on the Hildesheim panels. Here and there, especially in the seated Apostles, just a little of the 'nested V-folds' of the Helmarshausen tradition can be seen. This connexion with the Helmarshausen tradition is also underlined by the anthropomorphic Evangelist symbols on the lid of the Vorau altar, around the Christ in Majesty. Engraving with similar stylistic roots, although perhaps not untouched by the style of the large panels in the Hildesheim Cathedral treasury, is found in a group of four small trapezoid panels of far higher quality than the Vorau group. Three panels, with bust portraits of two Apostles and Christ, are in the Städtisches Museum at Bamberg and another Apostle plaque belonging to them is in the Kestner Museum in Hannover, which strongly suggests that they are all that survives of the decoration of an important reliquary once in the cathedral treasure of Bamberg.[25]

More closely linked with Hildesheim, and important because it can be dated precisely, is the book-cover of the Ratmann Codex in the Hildesheim Cathedral treasury (Plate 220).[26] The manuscript, a Sacramentary, was written by 'frater Ratmanus, presbyter et monachus' of the abbey of St Michael at Hildesheim, and on folio 1 an inscription by Abbot Franco states that the book was completed in 1159. Although the decoration of the cover is not in enamel but in pierced bronze gilt (opus interrasile, as it is called by Theophilus), both the foliate patterns of the border and the engraved figure of the standing Christ treading the beasts (Psalm 90, 13) are important evidence of Hildesheim work of c. 1160. In the border, the symmetrically drawn large blossoms show that decorative enamelled strips of the kind used on the right-hand roof of the Heribert shrine at Deutz were already known at Hildesheim by 1159.[27] The figure of Christ is delicate, drawn with a free and light line. Tiny hairlines enliven the drapery by adding accidental touches, and the cloth appears thin and fluttering. As well as these qualities of the 'sketchy' style, some underlying basic structure of drapery patterns is also accepted in this figure. One might characterize this style as a synthesis of the free handling of line of the 'sketchy' style with the sense of volume and classicizing pattern of the Mosan tradition. Certainly nothing of the hard abstractions of the 'nested V-fold' style is to be found at Hildesheim at this time. Somewhat more personal, with a more expressionist characterization of individual heads, the small portable altar with Abraham and Melchisedek in the Guelph Treasure clearly portrays the same tendencies in enamel work.[28]

In another group of works from this region, the links with the Mosan tradition are even stronger. The semicircular fragments of the same size, one with the Crucifixion in the Cluny Museum, Paris (Plate 221), the other in the Brussels Museum with twelve circles in a foliate scroll depicting busts of the Virtues, are probably the earliest pieces. The inscription in the border shows clearly that the panels originally decorated a reliquary containing various relics, including a particle of the Holy Cross, a part of the tomb of Our Lord, and pieces of his hair and vestments.[29] In the Crucifixion with

Ecclesia and Synagogue, as well as the Virgin and St John and a kneeling donor at the foot of the cross, the figure style is dominated by the preconceived patterns of drapery that articulate the movement of figures. In the crucified Christ, the soft form and the round head with small features are clearly derived from Mosan models of the second quarter of the century. The richer and more extended palette of the back panel, employing red, white, pale yellow, and green, also indicates a departure from the more normal local restriction to white, blue, and green found on the front panel.

On two book-covers, almost certainly originally from Hildesheim and now in the cathedral treasure of Trier, the further development of this extraordinarily eclectic style in Lower Saxony can be shown. Both covers are decorated with ivory carvings as well as bronze-gilt filigree, gems, and enamels. Both were given to Trier in 1799 by the Paderborn Cathedral canon, Count Christoph of Kesselstatt, and the first, a Gospel Book (Codex 141, olim 126), has an entry in a fourteenth-century hand stating that it belonged to the church of St Godehard at Hildesheim (Plate 222).[30] The filigree, in simple, open patterns in which the ends of scrolls are emphasized by small silver pearls, continues the Helmarshausen tradition. The small rectangular panels of walrus ivory set into the frame, the four Evangelist symbols at the corners, Ecclesia and Synagogue on the sides, and the Virgin above and a saintly bishop, almost certainly St Godehard, below, are worked in very high relief and must surely be seen as rather poor, provincial reflections of the Cologne ivories of the so-called 'pricked' style of the second quarter of the century.[31]

The larger ivory Crucifixion on the second book-cover (Codex 140, olim 129) from the same workshop further strengthens this assumption (Plate 223).[32] In the large enamel in the centre of Codex 141, three horizontal scenes are shown, with the Crucifixion in the centre, Mary Magdalen and Christ above, and the Three Maries at the Tomb below. In the Crucifixion the resemblance to the iconography of the semicircular Cluny plaque is obvious – it is virtually identical, even to the exact position of the falling crown of the Synagogue. And although the 'Mosan' style of the figures is clearly continued, the detailed treatment of the interior drawing has developed away from a linear definition of forms to a far more optical one. The bunches of folds no longer define forms but are massed in such a way that they tend to produce an effect of light and shade, giving an illusion of three-dimensional form. The lines that make up these 'shaded' areas vary considerably in thickness, and one suspects that the work of the master of the Stavelot portable altar of the sixties of the century (Plate 205) was not unknown to this master. The influence of the Stavelot style was, however, not fully understood in Lower Saxony; its rich variety and 'accidental' naturalism are not further developed here, as they were to be in Cologne and especially in the work of Nicholas of Verdun. Once the notion that the modelling of form could be achieved by light and shade instead of linear means was accepted, the strong local tradition of delicate line-drawing was adapted to this purpose. A number of works which ought to be dated to the decade c. 1160–70 show this quite clearly. The four small rectangular enamelled panels in the border of the Trier Codex 140, showing St John the Baptist, Moses, and two prophets, are an almost perfect illustration of this transition (Plate 223). In the figure of St John in the lower

frame, the older, purely linear style can be seen. The forms of the limbs are defined by patterns drawn in evenly spaced lines – there is no sense in which these lines can be conceived of as light and shade. In the case of the figure of Moses at the top of the cover and even more markedly in the prophet in this left frame, the thin lines are bunched so closely under the left hand and along the sides of the legs, leaving the most prominent parts of the figure quite free of any interior drawing, that the figure is really modelled entirely in light and shade, in which individual folds are hardly represented at all, except at the edges, where the lively old zigzag survives.

This new and basically more naturalistic approach to figure drawing is clearly seen in yet another, much damaged reliquary in the Guelph Treasure, the St Walpurgis casket.[33] In the small upright plaques with standing Apostles around the lower part the drawing closely resembles that of the second Hildesheim book-cover. But the most outstanding example of this style is the Henry II reliquary, now in the Louvre (Plate 224). A double-sided quatrefoil is mounted on a dished circular base carried on three bronze gilt feet.[34] On the base, in circular medallions, the warrior saints Gereon, Mauritius, Eustace, and Sebastian are represented. On one side of the reliquary itself Christ is enthroned, named REX REGUM, with King Oswald on his right and Kings Sigismund and 'Eugeus' on his left, all without haloes. On the reverse, in identical posture, the saintly Emperor Henry II appears, with his wife, the Empress Kunigunde, on his right and a figure presenting the reliquary to the emperor, named by inscription 'Welandus monachus', which has led to the whole group of enamels being named the 'Weland' group.[35] There can be little doubt that this truly aristocratic reliquary must be connected with Henry the Lion, the great patron of Brunswick Cathedral. Towards the middle of the century Henry had founded the city of Brunswick and built new defences for the ancient castle of Dankwarderode there, which became his favourite seat. In 1166 he put up in front of this castle an astonishing over-life-size bronze lion, a powerful symbol of his rule, conceived as a piece of fully three-dimensional statuary.[36] The same symbol of the duke's power appears on his coins. It may well be true that the Louvre reliquary's aristocratic subject matter simply symbolizes Henry the Lion's imperial ambitions,[37] but there may be an additional reason for this reliquary's iconography. In 1168 Henry married as his second wife Mathilde, daughter of King Henry II of England, and after that he maintained close relationships with the English court. He spent most of the years 1180 to 1185 there in exile when he was banished from the Empire by the Emperor Frederick Barbarossa and stripped of his possessions, except for Brunswick-Lüneburg, which was returned to him in 1181. Emperor Henry was also Duke Henry's namesake, and the three kings that accompany Christ would be of greater significance to a possible English recipient of such a gift. Oswald, king of Northumbria, and 'Eugeus', who is difficult to identify with certainty, but is perhaps the legendary Welsh King Owain Jindder, son of Macsen Wledigs, whom tradition asserts to have been supreme ruler of Britain, which he made independent of Rome,[38] are obvious choices. Sigismund, the sixth-century Burgundian king, was also related to both the English royal house and the Guelphs through Otto the Great, whose daughter was married to Aethelstan of Wessex. Moreover, important relics of this saint were in the possession of Henry the Lion's

family, the most outstanding being housed in the late-eleventh-century arm-reliquary in the Guelph Treasure, and the inclusion of a small relic of this king would be desirable in any important gift. Unfortunately nothing is known of the history of the reliquary before its acquisition by the Louvre in 1851. The fine drawing style of the piece would make a date for or soon after the wedding of 1168 very acceptable.[39]

A whole series of five arm-reliquaries, two of which bear inscriptions proving them to have been given by Henry the Lion, survive in the Guelph Treasure. All but one certainly date from the period of Duke Henry's greatest power and influence, before his fall in 1180. It is also documented that Henry brought back important relics, including arm relics, after his return from the Holy Land and Constantinople in 1173, which might well mean that they were enshrined after that year, in which Henry also took the decision to replace the cathedral of Brunswick by a larger and more splendid building.[40] The inscription DVX HEINRICVS ME FIERI IVSSIT AD HONOREM DEI appears on the arm-reliquaries of St Innocent and of St Theodore. Another, that of St Caesar, was made in the same workshop.[41] Of the five arm-reliquaries, that of St Lawrence in Berlin (Plate 227) and that of the Apostles in Cleveland (Plate 226) are the more important. In their general structure they resemble each other, but the handling of the drapery on the wide oversleeve, even on this large scale, is much more varied, freer, more 'accidental', in the Apostle arm. This same quality can also be seen on the small busts of the Apostles under arches on the base and in circular frames made of a foliate scroll along the top along the upper and lower edges of the oversleeve. These small embossed reliefs show great variety of poses and well characterized heads with a very free handling of thick, rich drapery, which could hardly be dated any earlier than the very late seventies and most probably is evidence that the reliquary is as late as *c.* 1185–95, made between Henry's return from exile and his death. But the pattern at the wrist is still similar to the one used around the circular altar stone of the earlier Virtues portable altar of the Guelph Treasure, and the pattern of the champlevé decorative plaques along the upright edge of the arm is found again on the other arm-reliquary, that of St Lawrence. The inscription giving St Lawrence's name and the crystal window on the side showing the relic were added in the fourteenth century, and it is very likely that the reliquary was originally made to contain the relics of St Bartholomew, which were transferred to a new reliquary in the later Middle Ages.[42]

The structure of the arm is enriched by the addition of a third sleeve, of pure gold sheet, decorated with a stamped pattern of small squares, each decorated by a small rosette. The second sleeve is decorated in the same way, but made of nielloed silver with gilt rosettes, and on the borders of both are mounted die-stamped panels decorated with dragons with foliate tails and one showing Samson and the Lion.[43] The lower edge has decorative foliate panels like those of the Apostle arm, interrupted by rectangular nielloed silver panels of the same size with busts of Apostles and angels. It is the use of the niello technique in small, tight spiral foliate patterns on the background of these Apostle panels that links this arm with a number of other pieces. The most important is the St Oswald reliquary at Hildesheim; others are the so-called Bernward paten from the Guelph Treasure, now in the Cleveland Museum, and two splendid chalices, one from

Wilten Abbey, near Innsbruck, the other from Trzemeszno, now in Gniezno Cathedral treasury in Poland.

This group has much decorative and technical detail in common, but also displays variety in its figure styles. The individual pieces are found scattered throughout Europe, as far west as Cologne, south as Wilten, north as Gotland, and east as Trzemeszno, which might well prove capable of explanation only through the many personal and political ties of such a patron as Duke Henry of Saxony and Bavaria at the height of his power. The eclectic nature and rich variety of the styles already noted in Lower Saxony would also support an attribution to the twin centres of Hildesheim and Brunswick, where Henry's support and encouragement were most likely.

The earliest pieces of the group are probably the two chalices at Wilten and Trzemeszno. The Wilten chalice, now in the Kunsthistorisches Museum, Vienna, was made for Berthold of Zähringen (1148–84), who is named in the inscription[44] on the chalice (Plate 228). Berthold was one of the great princes of the Church and often in the company of Henry the Lion, whose great gifts to Wilten he witnessed in a document of 1166.[45] On the foot of the chalice fifteen scenes from the Creation to the Brazen Serpent are represented in small medallions against a background of nielloed spiral decoration. Just below the knop, decorated with the four rivers of paradise embossed in a foliate scroll, the four Cardinal Virtues are engraved under arches. On the cup, again against a nielloed ground, eighteen scenes from the Annunciation to the Carrying of the Cross are shown, New Testament types of the anti-types of the Old Testament that appear on the foot. The iconography is continued with the Crucifixion in relief on the underside of the paten which belongs to this chalice, with the elect and the damned engraved on the rim, and the Three Maries at the Tomb on the centre of the top, surrounded by the four appearances of the risen Christ ending in the Ascension. The origins of the decorative treatment of the chalice are difficult to place. As far as the figure style of the engraved scenes is concerned, the connexions with Lower Saxony, especially the group around the Vorau casket in Vienna (Plate 219), are clear.[46] The loose, free drawing style of the work influenced by Eilbertus is its most likely source. But the placing of these figures against a background of tight spiral and foliate decoration executed in niello, and of scenes in roundels made of simple silver bands, looped or twisted as they are in the foot, is, it seems, an entirely new departure.[47] The technique of niello inlay, using remarkably similar spiral and foliate forms, does occur on contemporary Islamic metalwork, becoming increasingly popular in the thirteenth century.[48] In addition, the 'vignettes' made of looped frames in this Near Eastern work are too closely related to ignore.[49] The date of the Wilten chalice within the time of Berthold's long tenure of office is, of course, certain, and the figure style of the engravings would make the sixties of the century likely.[50]

Closest in style to the Wilten chalice is the silver chalice from Trzemeszno Abbey (Plate 225). It may well have been a gift from Henry the Lion: political ties between him and the Polish King Boleslaw IV (1146–73) were close and in 1157 Henry was instrumental in replacing Boleslaw on his throne. The abbey of Trzemeszno was refounded by Boleslaw Wrymouth (1102–39) with the help of monks called from Arronaise in Flanders, and its church rebuilt, being completed early in the reign of his son Boleslaw

IV in a style directly imported from Saxony.[51] The decorative spirals of the chalice, inlaid in niello, and the engraved figures reserved in gilt follow precisely the technical pattern of the Wilten example, but the figure drawing is more accomplished, with a softer, more rhythmic flow of drapery patterns, clearly in closer touch with Mosan models. The very small scenes of the Wilten chalice have been abandoned in favour of a more architectural division into fewer and larger scenes. On the knop the four rivers of paradise are again shown, and just below it the four Cardinal Virtues appear, as on the Austrian chalice, but on the bowl only six scenes of the Old and New Testament are separated by columns, all related to the Eucharist miracle.[52] On the foot, eight large arcades enclose figures representing the eight Beatitudes. The silver-gilt paten belonging to this chalice shows the Crucifixion, accompanied by Ecclesia and Synagogue, in the centre, and nine Old Testament scenes, all prefigurations of the New Testament, on the rim. The engraving is of even finer quality than that of the chalice, whose relatively simple drapery patterns are here enriched by a greater variety of line, suggesting shadows by thicker lines which appear to lend a greater volume to its elegant figures. There is little doubt that neither the chalice nor, especially, the paten of Trzemeszno can have been made any earlier than about 1170.

The Oswald reliquary in the cathedral treasury of Hildesheim is part of the same group (Plate 229). This octagonal, domed structure is surmounted by a head in the round, wearing a large crown.[53] Around the body of the reliquary eight silver plaques with niello inlay show eight seated kings, seven of them English: St Oswald, St Edmund, St Canute, St Alfred, St Edward, St Aethelbert, Aethelwold, and Sigismund. In the lunettes around the dome the four rivers of paradise alternate with the four Evangelist symbols. The roof is decorated with tile and lattice patterns. The same nielloed spiral background appears on three of the figure panels behind the engraved representations of the rivers of paradise which are clearly based on the Eilbertus tradition of Lower Saxony. The eight major panels around the body of the reliquary, however, differ very considerably from this indigenous tradition: the drawing is far more curvilinear, the draperies sweep around the large, impressive figures, oval and lentoid forms define parts of their anatomy.

It is this style of drawing, as well as its iconography, that has led to the tentative attribution of the reliquary to an English workshop.[54] However, the comparisons one can make with English illumination, for example that of the Bury Bible or the Lambeth Bible, are not altogether convincing. The drapery patterns lack the logic of the English style, and the Saxon style of the rivers of paradise is unknown in England – nor indeed is there any real evidence that niello spiral decoration was known in English metalwork. Nevertheless, the close connexions of Henry's court with England make the acquisition of the major relic in the shrine as well as artistic contacts with England likely at any time after his marriage to Mathilde in 1168. It is in the eclecticism of the workshops patronized by Henry, where Mosan, Rhenish, English, and even Middle Eastern influences must have been available, that the style of the Oswald reliquary was most likely to have been created, probably in the same decade, 1170–80, that saw the Trzemeszno chalice made. The same workshop also produced the so-called Bernward paten of the Guelph Treasure,

now in the Cleveland Museum (Plate 230).[55] The silver paten itself, according to a tradition that goes back at least to the thirteenth century, is a relic of the saintly bishop of Hildesheim, but the superb engraving and niello inlay that decorate it cannot be any earlier than the Oswald reliquary. Engraved in the centre is Christ showing his wounds, surrounded by eight lobes in which the four Evangelist symbols and the four Cardinal Virtues appear against the usual nielloed spiral decoration. The draperies of the seated Christ are in a similar rich, curvilinear style to the Oswald reliquary kings but freer and less rigidly controlled, while in the minor figures almost certainly the same hand is found which engraved the rivers of paradise of the Oswald reliquary.

All these important works are woven together in a tapestry of technique, style, similarity of decoration, and sources, none of which individually convinces one of the pattern of a single workshop. The only consistent thread that runs through them is Henry the Lion's patronage – apparently the results of an active life with contacts all over Europe and even beyond. But no really indigenous and cohesive style was created. Abbot Suger's patronage at Saint-Denis is characterized by the same failure to create a whole out of the work of many craftsmen whose individual styles were rooted in the traditions of their places of origin. But the variety of styles practised in eastern Germany during Henry's lifetime, which spanned the whole of the second half of the century, is not even exhausted by the pieces assembled around Henry's towering figure.

The close relationship, especially in ecclesiastical circles, between Saxony and Poland is illustrated by two important pairs of bronze doors. The earlier are the portals made for the Romanesque cathedral of Plock on the Vistula, consecrated in 1141 (Plate 231). The eleventh-century bronze Saxon doors commissioned by Bernward at Hildesheim were cast in one piece, but the Plock doors were assembled from individual plates mounted on a wooden base. Twenty-two square (mostly made up of a narrow and a wider piece) and three rectangular panels of double their size make up the two wings, but not all the panels are in their original positions: at least three were added in the fourteenth century, when the doors were taken to Novgorod.[56] Originally there were only two of the larger scenes, one at the head of each wing, the Ascension on the left,[57] and on the right a Christ in a mandorla carried by four angels and surrounded by the four Evangelist symbols (Plate 234). It is difficult to reconstruct a satisfactory iconographic scheme out of the surviving panels; for the most part they illustrate the life of Christ, with just three scenes from the Old Testament (Creation of Eve, Fall of Man, and Ascent of Elias), one panel with Virtues defeating Vices, one with three warriors, and a large number of single figures, some warriors, others clerics. Among these single figures, Bishop Alexander of Plock (1129–56) and Bishop Wichman of Magdeburg (1152–92) appear, both identified by inscriptions. Wichman is shown without the pallium he received in 1154, and the doors therefore appear to have been a gift from Wichman to Alexander in the years 1152–4.[58] That large scale bronze-casting was practised at Magdeburg is also proved by the life-size tomb effigy of Archbishop Frederick of Wettin, who died in 1152. The style of this figure combines a head of remarkably naturalistic, almost portrait-like presence with a block-like simplicity of the figure which is not unlike the style of the doors.[59]

The technique of fixing cast panels to a wooden base, rare in the north, was in common use in Italy, both in imported Byzantine portals and in Italian examples.[60] Indeed the doors of the church of San Zeno at Verona (Plate 233), assembled in this way, are closely related in style to those made for Plock. At Verona two quite distinct styles are found, which have been taken to be the result of enlarging the doors towards the end of the twelfth century.[61] The earlier, seen in the portals, probably made for the church which was constructed about 1125–35, is the one to compare to the Plock doors (Plate 235).[62] The block-like figures, with smooth, long passages of overlapping draperies, edged by broad decorative borders, are curiously isolated from their backgrounds in both the Plock and the Verona doors. Both pairs of portals also frame their pictorial panels with decorative borders of semicircular section and of very similar interlace and foliage patterns, pierced at Verona but solid at Plock. One can hardly doubt that craftsmen from Verona travelled north to work on the Plock doors at Magdeburg soon after the middle of the century.[63]

The bronze doors at Gniezno in Poland were cast in two solid pieces in the twelfth century for an eleventh-century building,[64] and the pair is now incorporated in the fourteenth-century cathedral built on the same site (Plate 232). Nine scenes from the life of St Adalbert, the Apostle of the Slavs and patron of Gniezno, are represented on each door. After the relics of St Adalbert had been taken to Prague from Gniezno in 1038 by Duke Břatislav of Bohemia, the reinvigoration under Boleslaw III of the cult of the saint in Poland became important to help press the see of Gniezno's claim to lead the mission to Pomerania in rivalry with Magdeburg. In due course, in 1127, the head of Adalbert was discovered in Gniezno – a claim that was countered by Prague in 1143 by the announcement that the saint's head had been found there. It has been suggested that the doors were likely to have been cast soon after 1127 as part of the campaign to re-establish Gniezno's claims to the relics.[65] The left door has scenes of Adalbert's birth, childhood, and youth; the right deals with his mission to the Prussians, his martyrdom, and his burial in Gniezno Cathedral. A broad frame decorated with an inhabited scroll of elaborate foliage forms surrounds each wing.

Close comparisons can be made, especially in these decorative frames, with Mosan sculpture and manuscript illumination, and such western manuscripts have even survived in Polish libraries.[66] It seems likely therefore that the craftsmen who cast the Gniezno doors were linked not with Saxony but farther west, with the Rhineland/Meuse region. In the figure style, which varies very much in quality in different scenes, this connexion is not so easy to substantiate. Some of the scenes from the early life of Adalbert, under very simple double arches, are so crudely drawn that they are difficult to parallel any-where.[67] Certainly they contain stylistic traits that would make a date c. 1130 very acceptable, but other scenes, like those of Adalbert's mission to Prussia, even though the modelling and especially the casting is so poor that even style is obscured, contain figures that have a softness of drapery of a free and naturalistic character that could hardly occur before about 1175 (Plate 236).[68] Less certain is the derivation of the style entirely from the Mosan area. It would at any rate be more likely that the connexion with the far west should be with the Rhineland rather than the Meuse region, for it was in the

Cologne workshops that this kind of naturalism was developed in the late seventies and early eighties.

In Lower Saxony, the large-scale bronze casting at Magdeburg had shown Italian influence, which throughout the twelfth century was of such importance to German architecture and sculpture. The bronze lion monument placed by Henry the Lion in front of his castle at Dankwarderode in 1166 may also owe something to such southern inspiration.[69] On a similar scale, closer to architectural sculpture than to goldsmiths' work, is the great candleholder at Erfurt Cathedral, inscribed, perhaps by craftsman and donor, WOLFRAMVS, HILTIBVRC. H. Two Erfurt documents of 1157 mention a 'Wolramus scultetus' who might well have been responsible for this strange figure, who holds a candle-spike in each of his two raised hands, with a third attached rather awkwardly behind his head. It has been called a portrait of Wolfram and also, perhaps more convincingly, a Jesse.[70] Stylistically it is closely related to sculptural monuments like the tomb slabs of abbesses at Gernrode of the second quarter of the twelfth century. It is not surprising, however, that at the somewhat later date of the work an increasing softness of some passages, especially the drapery of the long sleeves, is found.[71]

More typical of the tradition of goldsmiths' work in Lower Saxony is a series of works that have survived in the treasury of the church of St Peter at Fritzlar. It is in these pieces that the importance of the influence of Roger of Helmarshausen in eastern Germany, stretching well into the second half of the century, can be demonstrated. The earliest is a large altar cross with enlarged rectangular fields at the ends of its four arms, the front decorated with gilt copper filigree and set with gems, including a fine Antique cameo near the base.[72] At the centre a relic of the Holy Cross is mounted under crystal. A gilt bronze foot engraved with busts of four Virtues, an enamelled knop above, supports the cross. The gilt bronze back is engraved with the four Evangelist symbols, a standing figure of St Peter, and an Agnus Dei in a central circle. It is in this reverse of the cross that its dependence on the work of Roger of Helmarshausen's workshop is most clearly evident.[73] The style of drawing, with its 'nested V-folds' and horizontal breaks, the symmetrical foliate scrolls against a punched background, and the zoomorphic symbols are all clearly based on the Helmarshausen tradition. The standing figure of St Peter follows the pattern set by the St Modoaldus cross of about 1110 now in the Schnütgen Museum in Cologne.[74] But the Fritzlar cross must be a little later than Roger's immediate workshop. The foliage patterns of the short arms of the cross are somewhat richer, with the ends of leaves turned over, and the forms of the little crosses in the centre of leaves, for instance, much less hard and precise. The central disc enclosing the Agnus Dei is reduced in size and lacks the patterned background. The well-fitting foot of the cross, which seems always to have been part of it, has a knop decorated with step-pattern cloisonné enamel, which is not likely to be much earlier than about 1130, and the rather thicker, heavier engraving of the figures and the decorative borders of the foot also seem to be more comparable perhaps to the top of the Hildesheim portable altar from the Guelph Treasure decorated with the four Cardinal Virtues.[75] A date in the second quarter of the century would seem to be the most likely. There is little doubt that the goldsmith

was trained in the Helmarshausen workshop, but where he worked is difficult to deter-
mine. At Hildesheim, the contemporary Godehard shrine is certainly not comparable.
At Fritzlar itself a workshop was unlikely, as the church was served by secular canons.[76]
It must be a possibility that a workshop existed further south, at Fulda in Franconia,
even as early as the second quarter of the century, which was later to supply two major
pieces to the Fritzlar church around 1170. But a continuation of work at Helmarshausen
itself cannot be ruled out.

Of poorer quality, but probably no later in date, and from the same workshop, is
a small portable altar at Fritzlar. On the top is an *émail brun* plate decorated with the four
Evangelist symbols, again in zoomorphic form, enclosed in circles and surrounded by a
delicate foliage scroll. A small circular altar stone occupies the centre. Originally a Cruci-
fixion with the Virgin and St John, all in the round, was mounted in slots on top of the
altar, but only the figure of the Evangelist now survives. On the front and sides of the
altar busts of the twelve Apostles are engraved, gilt, and again on an *émail brun* back-
ground. The flat rear of the altar is not decorated.[77] Only in the small figure of St John
can one detect some family resemblance with the other figures modelled in the round
by another follower of Roger, who worked on the shrine of St Godehard at Hildesheim
at much the same time.

The *émail brun* foliate scroll on the top of this altar leads in technique, and even in
the use of similar simple, rather thin leaves, to the inhabited scroll pattern on the reverse
of the disc reliquary also at Fritzlar. It is true that the latter (Plate 237) is far superior
in quality, but technical points such as the sharply engraved lines of the pattern (not by
any means a common or indeed necessary part of the *émail brun* technique) do suggest a
continuity of workshop practice.[78] The whole has been thought to be a miniature version
of the kind of large retable that has survived in Saxony at Erfurt Cathedral,[79] and were
it not for the rarity of the form of the Fritzlar reliquary, one would be rather tempted to
see the Erfurt retable itself as an enlarged reliquary. The Stavelot retable of St Remaclus,[80]
also of this shape, was certainly designed in a goldsmith's workshop and primarily con-
ceived as a reliquary structure.[81] The lunette on the front of the Fritzlar piece is filled
with an embossed silver Christ Pantocrator in the upper half of a mandorla, with a bust
of an angel to each side. Below that, an arcade with twelve standing Apostles is carved in
bone. The borders are set with die-stamped discs with busts of angels and crowned heads,
foliate scrolls, and champlevé enamels with foliage patterns. Mounted above is an
openwork crest to which an earlier fragment, probably the crest of a Frankish reliquary
of the eighth century, has been added.

It has been shown that the die-stamped discs of angels and royal heads bear a remark-
able resemblance to coins minted at Fulda, and one cannot doubt that this reliquary was
made there.[82] The brakteates (one-sided coins) minted in the time of Abbot Burkhard,
between 1168 and 1176, and the halfpenny of Frederick I of the same period[83] are even
likely to have been stamped from dies made by the same hand as those used to decorate
the Fritzlar reliquary. To support this attribution, the larger relief figures in the lunette
can also be compared to the stone reliefs in the walls of the transept and nave at the
church of Petersberg, just outside Fulda.[84] The relief with an enthroned Christ in a broad

ornamented frame has something of the same heavy, thick, almost clumsy fall of drapery, the same scalloped halo and beaded edges at the neck and belt, and the same plump face, with large eyes, their pupils marked. It seems very likely that the sculptor followed a model provided by the Fulda goldsmiths.[85] In the use of decorative champlevé plaques, which are very like the Cologne enamels of around 1170 of the so-called 'Fredericus' group, the presence at Fulda of craftsmen trained in Cologne is revealed. The same can be said with even greater conviction of the bone carvings on the disc reliquary. Indeed, the rather stiff little figures of Apostles under an arcade are among the best of the large group of such carvings that has been attributed to Cologne.[86]

One more piece in the same treasury of St Peter at Fritzlar is a splendid silver-gilt chalice, embossed on the cup with the twelve Apostles seated under an arcade, and on the foot with foliage scrolls, geometric patterns of the kind used frequently in decorative enamels, and six busts of angels (Plate 238). Clearly it was made in the same workshop as the disc reliquary, although the handling of forms is somewhat more generous and less heavy and the freer flow of drapery seems to be aware of the greater naturalism that was being developed elsewhere.[87] But in spite of the gentle rhythms typical of the period around 1180, the last remnants of rigid drapery patterns of the Helmarshausen tradition can still, even at this late date, be clearly recognized.[88]

THE WEST

The work of Eilbertus of Cologne was a major influence not only in Lower Saxony; together with that of the masters of the Deutz shrine, it also laid the foundations for the great contribution to Romanesque art made in the Rhineland in the second half of the twelfth century. The enamelling on two portable altars, one preserved in the treasury of St Servatius at Siegburg and the other in the former abbey church of St Vitus at Mönchen-Gladbach, illustrate the development of Eilbertus's drawing style around 1160.[89]

On the top of the Mönchen-Gladbach altar, four enamelled plaques surround the altar stone of *verde antico*. They show the Sacrifice of Isaac between Melchisedek and Abel above, and below the Crucifixion between Ecclesia and Synagogue. To the sides of the stone, the four prophets Moses and Zacharia, Job and Isaiah are represented. On the long sides the twelve Apostles are seated under white enamel arcades, six to each side, worked on a single panel. On the short 'front' of the altar, under a triple arcade, a Christ in Majesty is shown between the Virgin and St John the Baptist and St Michael and St Stephen (Plate 245), and on the rear the Three Maries at the Tomb. All figures are in engraved reserved gilt against backgrounds of white, blue, and green, sometimes with the colours separated from each other by metal stays, sometimes softly merging into one another. Broad, flat palmettes decorated the borders in enamel on the top and in embossed gilt bronze on the bevelled edges. The whole altar is carried on four exceptionally well modelled gilt dragons. The rather mottled enamel, its chromatic range, and the use of square interior frames and two-coloured backgrounds relate this work to enamels in

Lower Saxony, where the followers of the Eilbertus tradition arrived at a similar style. But in the style of drawing of the engraved figures a softer, more rhythmic line is developed in Cologne. The more 'sketchy' elements of the Saxon version are replaced here by a stricter adherence to the well defined patterns and soft round heads of the Mosan type. Touches of the variety of thick and thin lines, albeit not yet as fully developed as in the Stavelot altar, also emphasize the strong Mosan influence felt in the Rhineland after the middle of the century.

The other portable altar, at Siegburg, dedicated to St Mauritius, is very closely related to the Mönchen-Gladbach altar (Plate 239).[90] Again four panels surround the altar stone. To the left is the Crucifixion with God the Father and the dove of the Holy Ghost, inscribed as 'Trinitas', above, and Adam in his tomb below. On the right the Three Maries at the Tomb are shown with the Ascension above and Christ with Mary Magdalen below. Above and below the porphyry stone, the twelve Apostles are seated under arcades. On the long sides of the altar there are five, on the short sides three individual plaques with standing prophets holding scrolls, separated by thin enamelled strip pilasters. Rather dry and hard die-stamped palmettes decorate the bevelled edges.

It is in its style of engraving that the Mauritius altar most resembles the Mönchen-Gladbach altar, but even here a somewhat greater freedom of handling is apparent. In the seated Apostles, for instance, the Mauritius altar makes use of a more vivid variety of poses – including violently crossed legs in one figure in the lower group – and a greater multiplicity of sketchy lines, which places it a little closer to the Eilbertus tradition. The same may be said of its structure of separate panels separated by 'pilaster' strips on the sides.

Perhaps it is here that mention should be made of the enamelled triptych in the Victoria and Albert Museum in London (Plate 241). This triptych was acquired from the Shrewsbury family of Alton Towers in 1858, but unfortunately nothing more is known of its history. It is normally attributed to the Mosan region,[91] and the typological iconography and the division of the composition into geometrical areas – squares, circles, semicircles, and diamonds – by coloured and gilt bands, some bearing inscriptions, are indeed popular in Mosan illumination, although no other examples in enamel have survived.[92] Against this, it should be noted that the decorative use of a simple four-leaved flower is unknown in other Mosan enamels, but appears in much the same form on the top of the Mauritius altar. Also, the drawing of the figures in reserved gilt is much closer to the Eilbertus tradition than it is to the Stavelot altar – it is thin and sketchy and the colour scale is cool, with a predominance of blue, green, and white, quite different from the warm, rich, and varied palette of Mosan enamellers and far closer to the range employed in Cologne. The main argument for attributing this triptych to a Mosan workshop rests on the stamped and engraved gilt bronze framework.[93] The patterns used here are certainly identical with those of the borders of the triptych in the Petit Palais in Paris and close to the St Andrew diptych in Trier,[94] but there must be some doubt whether the large enamelled plaques were originally mounted in this frame, which is too large for them. The centre panel is surrounded by poor quality strips of *émail brun*, the wings have had a strip (with very untypically Mosan gem mountings) added below,

and the curvature at the top does not fit and has had to be filled with a small, awkward piece of hatched bronze gilt, which is missing on the right leaf. The enamelled left part also has a small piece cut out of its inner frame which looks suspiciously as if it once accommodated a small hinge which might originally have joined the wing directly to the central panel. Finally, the nails that now fix it to the wooden base are clumsy and unevenly spaced.[95] Without the frame, the links with Mosan art are far less compelling, and a Cologne origin somewhat earlier than the Mauritius altar, about the middle of the century, altogether more likely.

In the so-called 'Gregorius' portable altar in the Siegburg treasury (Plate 240) and the pieces that can be associated with it, both a new and distinctive decorative vocabulary and a new figure style are developed. The sources of these new styles are varied and include primarily an even closer relationship with Mosan art. The outstanding example of this phase of Rhenish development is the shrine of St Heribert at Deutz,[96] and indeed the closest links in figure style can be detected between the Deutz shrine and the Gregorius altar. It is in the small square panels showing Virtues defeating Vices on the left roof of the Heribert shrine (Plate 211)[97] that a rhythmic, rounded, almost shorthand drawing style is used in figures in violent movement, very similar to the figures on the Gregorius altar, where this style is only somewhat smoother, softer, and more elegant.

The altar probably only became a reliquary of the saintly Pope Gregory in the Gothic period, when the inscription 'ALTARE PORTATILE STI GREGORII PAPAE URBIS ROMANAE . . .', which appears on a vellum authentification framed in the central trap-door of the base plate, was written.[98] Among the Apostles and the many saints shown along the outer edge of the lid, all of whom (including St Heribert, canonized in 1147) were especially venerated in Cologne and Siegburg, Gregory does not appear. Along the shorter sides next to the altar stone, eight scenes from Annunciation to the Three Maries at the Tomb are shown against blue and green backgrounds separated by a white line, which continues the well established Eilbertus tradition. The same inner frames appear on the sides of the altar with figures of standing prophets, separated by very thin pilasters each with a tiny scrolled capital and base.

It is in the decorative detail that the Gregory Master's style is most clearly defined. Along the edges of the bevelled projections and between the saints of the top of the altar a characteristic flat foliate scroll is engraved, filled with bright primary colours or white enamel, unmixed in each 'cell'. The scrolls on the lid are tightly spiralled, and although patterns differ within each scroll, they are almost invariably precisely symmetrical in arrangement. A hard, exact, and unmistakable leaf form with a zigzag edge is used throughout. It is only in the corner pilasters of the Eilbertus altar that anything like the same leaf, also filled with pure colour, appears earlier, albeit in a much less highly developed form. The use of foliate scrolls as a background to figures is found in a great variety of forms in almost all parts of Europe and even beyond, in Byzantine and Islamic styles,[99] but really close comparisons with the Gregory Master's style can only be found in Rhenish manuscript illumination, which itself was under strong Mosan influence.

In a number of manuscripts written for the abbey of Arnstein near Coblenz around 1175 very much the same scrollwork and even something of the smooth elegance of

figure drawing of the Gregory Master can be seen.[100] If anything, the scrolls and especially the leaf-forms of the Arnstein manuscripts are more elaborate and varied in detail, and the figure drawing shows more continuity of line, with little of the earlier 'nested V-fold' style which still remains in the Gregory Master's work. This and the direct influence of the Deutz shrine makes a date in the decade 1160–70 for the Gregorius altar very probable. Further support for a relatively early date[101] is given by the appearance of a few decorative enamel plaques with zigzag foliage on the front of the Maurinus shrine in St Pantaleon at Cologne, which is normally dated about 1170.[102]

The clearer, and above all firmer, structure of the figure style found in the Arnstein Bible of c. 1175 is approached even more closely by the drawing style of the Darmstadt tower reliquary (Plate 242). In the decorative scrollwork behind the figures of the prophets,[103] and elsewhere, the closer relationship with the Gregory altar is obvious, but the engraved figures are clearly by a different master. The engraving is deeper, and the lines are multiplied and bunched, more continuous and more varied in thickness. The modelling of the figure is far more three-dimensional, and weight and volume are emphasized by an appreciation of the effects of light and shade produced by this bunching of the folds.[104] It is, however, possible to see in one or two figures of prophets something of the earlier style of the Gregory Master: the figure of Sophonias, for instance, still makes use of the curious, almost abbreviated 'nested V-folds', although even here the general effect is nevertheless firmer, harder, and less flaccid than that of the earlier style.

A number of other pieces can, on the strength of their distinct decorative vocabulary, be attributed to the same workshop, which seems to have been active for about two decades. Among them, only an upright enamelled plaque now in the Musée Condé at Chantilly is of a high enough quality to be attributed to the Gregory Master himself (Plate 243). It is decorated with three scenes in the centre – the Crucifixion, the Three Maries at the Tomb, and the Ascension – surrounded by twelve scenes of the Old Testament typologically related to the Crucifixion, including the Sacrifice of Isaac and the Marking of the T cross at Passover. The whole is surrounded by the scrollwork typical of the group.[105] The other pieces are not all of high quality. The typical scrollwork appears again in the portable altar preserved in St Maria im Kapitol in Cologne.[106] The figures here are rather roughly drawn, but in style close to the Darmstadt reliquary. More interesting is the portable altar of St Victor at Xanten (Plate 244).[107] The decorative strips along the edges of the altar are firmly of the 'Gregory' workshop tradition, but the style of drawing, particularly of the seated Apostles to each side of the Virgin and Christ in the two long sides, is of high quality and individuality. The drapery is in sweeping curves, with fine, bunched 'dark' areas, creating the volume of the figures. Indeed it is remarkably close to the drawing style of Lower Saxony, especially that of the Bernward paten now in Cleveland (Plate 230). This connexion with Lower Saxony is reinforced by the enamelled background and the enamelled columns between the figures: both the broad, heavy capitals and bases and the strongly constructed areas of rather mottled enamel are close to Saxon work. In date, however, the sophisticated drawing style of this altar would place it late in the development, probably in the late seventies.[108]

The importance of the influence of Mosan art in the Rhineland after the mid century

has already been emphasized more than once. Without it, the Deutz shrine or even the Gregory Master's workshop would have been impossible, and in the work resulting from the patronage of the Emperor Frederick Barbarossa, this fusion of Mosan and Rhenish styles is even more heavily biased in favour of Mosan artists. Frederick's patronage however cannot rival that of Henry the Lion in extent or importance – the emperor's interest in Italian politics throughout his long reign, from 1152 till his death on the third Crusade in 1190, may have precluded that.

At the very beginning of his reign, Frederick ordered his seal-dies through his close friend and adviser the Abbot Wibald of Stavelot, and the contact with Mosan artists established in this way seems to have persisted.[109] When in the sixties, probably after the canonization of Charlemagne in January 1166, Frederick and his wife Beatrix commissioned a great candelabrum for the Palace Chapel at Aachen, the engraving, the only figure work to survive on the candelabrum, was executed by a Mosan artist (Plates 246 and 247). The design of the whole work, however, followed an old German tradition. It is a more elaborate version of the candelabrum made for Gross-Komburg some thirty years earlier (Plate 187).[110] Instead of the twelve towers at Gross-Komburg, Aachen has sixteen, eight larger, each of three storeys, four on a square base and four on a quatrefoil, and eight smaller, circular structures. At Gross-Komburg the whole structure is circular, but at Aachen each part of the rim between the towers is a segment of a circle. Three candles between each tower make a total of forty-eight, the same number as at Gross-Komburg, where four candles are fixed between each of the twelve towers. Unfortunately all the silver decoration at Aachen, which included relief figures of warriors, patriarchs, prophets, and Apostles, and a central strip of pierced scrollwork between the two strips carrying the dedicatory inscription, was destroyed in the eighteenth century,[111] and the only figure decoration to survive is on the engraved bronze gilt base plates to each of the towers. Each of the smaller circular towers is decorated with a scene from the life of Christ: the Annunciation, Nativity, Adoration of the Magi, Crucifixion (Plate 247), Three Maries at the Tomb, Ascension, Pentecost, and a Christ in Majesty. On the bases of the larger towers the eight Beatitudes are personified in elaborate pierced square and quatrefoil panels. The superb drawing of most of these decorative panels,[112] gentle and elegant, is in the pure classicizing Mosan style found in contemporary Liège manuscripts and metalwork.[113] The pierced bronze gilt panel with the four rivers of paradise in the Musée de Cluny in Paris, probably from the back cover of a manuscript, only very little earlier in date, may also be compared.[114] The inscription, in two bands around the whole candelabrum, gives the names of emperor and empress as donors and makes clear, as in the case of Gross-Komburg, that the whole is conceived as a representation of the Heavenly Jerusalem.[115] In an Aachen necrologium of the late twelfth century the death of Wibertus, brother of the canon Stephan, is recorded, and it is stated that Wibertus 'expended great trouble and work on the candelabrum, the roof of the whole church, a gilt cross on the tower, and the bells, and completed them all successfully', which does not make it clear whether this Wibertus was the craftsman responsible or the clerk of the works under whom the work was done.

The parcel-gilt silver bowl known as 'Frederick's Baptism Bowl', engraved in the

centre with the scene of the emperor's baptism attended by his godfather, Otto of Cappenberg, shows a very similar style of drawing and is usually attributed to the same workshop, even the same hand, responsible for the engraving of the candelabrum.[116] The inscription around the central scene states that the bowl was intended as a gift to Otto; this must have been made after Frederick's imperial coronation in 1155, because the figure on the font is described as 'Fredericus Imperator'. The drawing, of necessity smaller, finer, and more delicate than that of the candelabrum, is also somewhat freer. The well defined Mosan patterns of drapery arrangement are less pronounced, and something of the softness of the Cologne style of the Gregory Master is noticeable, especially in the figure of Otto. In the heads, however, the resemblance to the Aachen work is very clear.

In the will of Otto of Cappenberg, the bowl is mentioned as a gift to his foundation at Cappenberg together with the head described by Otto as an 'effigy of the emperor' (Plate 248).[117] The powerfully modelled bronze gilt head, the eyes and the imperial diadem, in silver, now lost, is set on a base with three 'caryatid' angels and castellated walls interrupted by four small towers, the whole carried on four dragons. The name 'Otto' is engraved on the base below a fourth figure, now missing, and it may be assumed that this represented the donor. An inscription added to the piece by Otto reinterprets it as a head-reliquary of St John the Evangelist. Stylistically there is little to support the view that the base was a later addition, but if indeed the fourth missing figure represented Otto as donor, then clearly it must have been added. The style of the head is remarkable. The violent forms, large features, and heavily emphasized eyes make this a powerful image, and it is not surprising that it has been claimed that it attempted something like a portrait of the emperor.[118] Certainly it is difficult to see any relation in the forms either of head or base with those of the Aachen workshop, or any of its Mosan antecedents, but the angels of the base can certainly be compared to the bronze reliquary casket now in the cathedral treasure at Xanten, attributed both on its style and iconography to Lower Saxony.[119] This would seem to support the view that the base might have been added at Cappenberg just before Otto's death in 1171.[120]

If the head itself, however, is to be western rather than Saxon, which is, after all, more likely if indeed Otto received it as a gift from the emperor, then only in Flanders or northern France is anything like its style known. Work of the second quarter of the century such as the *Liber Floridus* from Saint-Omer (Ghent, University Library MS. 16), and metalwork such as the aquamaniles in the Victoria and Albert Museum and in Vienna that may be associated with it,[121] hard in line and strong in form, may be seen as possible sources of the style of Barbarossa's head some thirty years later. Nevertheless, this astonishing head remains, in the third quarter of the century, an isolated piece, powerful and individual.

Other work probably commissioned by Frederick is easier to place within a well-known context. Two enamelled armillae (bracelets or arm ornaments), one decorated with the Crucifixion (Plate 249), the other with the Resurrection, were probably originally part of a splendid imperial vestment,[122] as another two pieces of very similar shape certainly were. Although they are now lost, eighteenth-century drawings and

descriptions have survived which prove them to have been worn, probably on the upper arms, attached by thongs, then still extant. They were decorated with enamelled scenes of the Nativity (Plate 250) and the Presentation in the Temple.[123] The style of the earlier extant pair is in the pure Mosan tradition. The colours are fused against a gilt background with a pearled bronze-gilt border,[124] and heads, hands, and the body of the crucified Christ are engraved and filled with dark blue enamel. The pieces are probably not by the same hand – the range of colour in the Crucifixion is less close to the normal earlier Mosan palette. Before being in the Hermitage at Leningrad, they were preserved in the cathedral of Vladimir and may originally have arrived in Russia through Prince Andrew Bogoloubski (1157–74), whose embassy visited the court of the Emperor Frederick Barbarossa at Aachen in 1165.[125] If indeed this very likely hypothesis can be accepted to account for the presence of these enamels in Russia, it is of considerable importance to the dating of Mosan enamelling. The elegant style of figure drawing and the physiognomy, especially of the head of Christ on both panels, is characteristic of the strong Byzantine influence which was to be an essential part of the sources of the art of Nicholas of Verdun. If this influence could be shown to be already effective in the early sixties, it would place the early work of Nicholas at Klosterneuburg, dated 1181, in a much more satisfactory context, by providing us with the work of a generation which could have trained an artist like Nicholas.[126]

Another imperial commission shows much the same dependence on Mosan influence. When Frederick's great ancestor Charlemagne was canonized in January 1166 after his body had been raised at Aachen in December 1165, a new reliquary was made to receive one of his arms (Plate 206).[127] Embossed silver plaques of the emperor himself and his wife Beatrix of Burgundy appear next to the archangels Michael and Gabriel on each side of the Virgin, to whom the Palace Chapel at Aachen was dedicated. On the other long side, again as busts under a continuous arcade, Christ is flanked by St Peter and St Paul and the Emperor Conrad III and his brother Duke Frederick of Swabia. On the two short sides, other ancestors of the emperor were represented; Louis the Pious on one and Otto III on the other. The style of these panels is unmistakably Mosan; they have the soft classicism and the rounded heads with prominent features so well established in the Mosan area by the fifties of the century. The very close resemblance of these reliefs to various imperial seals cut between 1152 and 1154 and ordered through Abbot Wibald of Stavelot has been pointed out, and one can hardly doubt that they were the work of the same goldsmith. The design of the flat-topped casket as a whole, as has also been shown, may well have been suggested by the well-known type of Byzantine ivory casket still popular in the Christian East in the Comnene period,[128] another proof of the interest in precisely definable Byzantine models as early as c. 1165.

In spite of these clear links with Mosan work in the figure style of the arm-reliquary, it is difficult to attribute it to a Mosan workshop. Paradoxically it is in the decorative champlevé enamelling, an art so highly developed in that region, that one finds a style totally different from any known Mosan work. The large, fleshy, rather flaccid flower forms, with turned-over leaves with rounded scalloped edges, and especially the pale, almost milky colour are completely different from the hard, precise, and geometrically

divided forms and deep, rich colours of contemporary decorative Mosan enamels on, for instance, the Servatius shrine at Maastricht. It is true, of course, that the fusion of colours, like blue and white, or yellow and light and dark green, in one cell was well known in Mosan figure styles, but it seems never to have been used in purely decorative foliage patterns. One cannot doubt that this new decorative vocabulary derived its technical equipment from Mosan workshops, but its forms are of a different gender from those of the Mosan region.

Only on the Deutz shrine made in Cologne can one find anything at all like these leaf forms. On the left roof, for instance, between the small panels with Virtues fighting Vices are large leaves, overlapping and fleshy, with scalloped edges, which have some of the qualities of this kind of decoration (Plate 211). There are as yet none of the long, sprouting stems so much part of the more fully developed style of the enamels on the arm-reliquary, but the foliage forms of the cast cresting do come very close to those of these enamels. Their most likely immediate source was manuscript illumination, where they were well established by the middle of the twelfth century, and clearly the same manuscript models were already available to the painters who decorated the walls of the lower church at Schwarzrheindorf between 1151 and 1156, where such decorative foliage appears in profusion.[129] Decorative enamelling of this kind was to become almost a hallmark of the Cologne workshops active from c. 1170 onwards. Whether the arm-reliquary of Charlemagne was made in a Cologne workshop with the co-operation of Mosan workmen, or whether the decorative enamels were a new creation of the Mosan region, it remains a fact that once these forms were developed, it was in the Cologne area that they were to bear fruit.

A book-cover now in the Schnütgen Museum in Cologne shows much the same fusion of Cologne and Mosan elements. It was made for a Carolingian Gospel Book which was undoubtedly in a Cologne church by the tenth century, when its Evangelist portraits served as a model for an ivory carving.[130] Both in the head and in the soft, rhythmic drapery the embossed central Christ in Majesty shows strong Mosan influence, and the small square decorative enamels of the frame present a somewhat less fully developed form of this kind of Cologne enamels and should therefore be dated c. 1160-70. The representations of the four winds at the corners, with backgrounds of internal frames in two colours separated by a white strip, and indeed the rather clumsy internal drawing of drapery, reveal the debt they also owe to the Eilbertus tradition of much the same stage of development seen in the contemporary Guelph Treasure portable altar with the Cardinal Virtues, made in Lower Saxony.

The pale, almost insipid colour and the fleshy foliate forms of the purely decorative panels are found again on the antependium of the church of St Ursula in Cologne and on the two earliest of the important series of Cologne house-shrines, the shrine of St Aetherius made for St Ursula (Plate 251) and the Maurinus shrine from St Pantaleon (Plate 252).[131] Of the St Ursula antependium, only the decorative framework has survived.[132] The central quatrefoil originally held a Christ in Majesty surrounded by the four Evangelist symbols and flanked by the twelve Apostles in groups of three under the arcades to each side. The decorative enamels, especially the large panels forming the

arcades with rich foliate scrolls against a blue background and the narrow flat pilasters supporting them, are exactly similar to those on the sides of the Maurinus shrine in St Pantaleon, where they are used alternately with angels with spread wings neatly filling the entire spandrels.[133] In the second major work to have been made by this workshop, the Aetherius shrine in St Ursula (Plate 251), the same arcades appear on what is a different, indeed unique, house-shrine. The roof is semicircular in section, and the short body is crossed by a transept, occupying two of the six bays of each long side. At one end there is a quatrefoil, like the centre of the St Ursula antependium, which originally contained a Christ in Majesty surrounded by the four Evangelist symbols. On the opposite short side, inscriptions still found on the triple arch show that St Ursula and St Cordula were represented on each side of the Virgin.[134] The roof is covered with a network of circular enamelled discs with symmetrical foliage motifs in embossed copper gilt between them. As in the case of all but the Deutz shrine and the shrine of the Three Kings in Cologne Cathedral[135] and later house-shrines, the main figure decoration originally under the arcades has unfortunately been lost. The cast bronze gilt cresting of the roof, interrupted by small crystals, is of simple, symmetrically disposed foliage S forms – a pattern also found on many of the die-stamped strips on the bevelled edges. Crystals of the same kind had already been used in the crest of the Deutz shrine, and among the decorative enamels also some of the neat geometrical patterns already developed in the latter continued to be used alongside the soft, luxurious foliage patterns characteristic of this Cologne workshop.

The importance of the Heribert shrine as a source for this Cologne workshop is further emphasized by an analysis of the second early shrine made there, the Maurinus shrine in St Pantaleon (Plate 252). Even more obviously, the small decorative enamels of the framework often repeat the geometrical ornaments of the Deutz shrine, both in pattern and colour. Small crystals are again included in the cresting of the roof, which is this time more elaborate and taller, with symmetrically designed winged dragons along the length and foliage patterns similar to those of the Deutz shrine at the gable-ends (Plate 212). The six circular enamels of the roof of the Heribert shrine are replaced by a more elaborate series of five quatrefoils framing scenes of martyrdoms in embossed bronze gilt. On the long sides seven arches are enclosed in a flat frame, decorated at each end by large enamels showing the archangel Michael and a cherub on one side and a seraph and the archangel Gabriel on the other. These enamel plaques are clearly directly related in both colour and style to the large prophets on the sides of the Heribert shrine.

Inscriptions prove that originally Christ was represented on the major short side, flanked on the left by St Maurinus.[136] At the opposite end Bruno, archbishop of Cologne and founder of St Pantaleon, was shown as a saint on one side of a central figure, most probably the Virgin, and St Lawrence on the other. Along the left side there were the figures of St John the Baptist and the Apostles Peter, Andrew, James, John, Philip, and Thomas, and on the right the Apostles Paul, James, Matthew, Simon, Jude, Bartholomew, and Matthias. On the base, under St John, is a small engraved gilt plaque showing a kneeling figure with the inscription 'HERLIVVS PRIOR', holding a scroll inscribed

'S. JOHANNES ORA PRO ME': a Frater Herlinus appears in the *Sillabus Abbatum* in the years 1176–81, but no prior of that name is recorded. To the left of this figure the bust of another has been added – probably not much later, to judge by the style of engraving – also with hands raised in prayer and inscribed FRIDERICVS. The whole group used to be called the Fridericus group on the basis that this figure was the craftsman in charge of the workshop, to whom the whole of the earlier Gregorius group was also attributed,[137] but it is now generally agreed that Fridericus is more likely to have been part-donor of the shrine with Prior Herlinus: certainly it can no longer be maintained that the bulk of Cologne metalwork, from the portable altars at Siegburg to the work of the eighties of the century, was created in a Pantaleon workshop under one craftsman.[138]

Before considering the figure style of the scenes on the roof of the Maurinus shrine two more important reliquaries must be mentioned, one of which does provide some additional evidence of date. The earlier of the two, originally in the convent of Hochelten in the Lower Rhine region and now in the Victoria and Albert Museum (Plate 255), is in the shape of a small church on a Greek cross plan, covered by a ribbed dome.[139] The roofs of the structure are all made of splendid enamels decorated in part with foliate patterns very like those on the other pieces of the group. Enamelled columns like those on the corners of the Aetherius shrine support the arcades of the lower part, surmounted by large Corinthian capitals in cast gilt bronze, of more elaborate form than those of the shrine in St Ursula (Plate 251). The figured decoration is not made of precious metal but carved in walrus ivory, for which reason probably it has survived. Around the dome are seated Christ and eleven of the Apostles, and at the four ends under triangular pediments are represented the Nativity, the Three Magi, the Crucifixion, and the Three Maries at the Tomb.[140] Between these panels, sixteen figures of standing prophets, each with an inscribed scroll, appear in front of enamelled backgrounds. Compared with other 'round' reliquaries such as the Darmstadt Tower or the St Oswald reliquary at Hildesheim, the treatment is far more architectural. It is clearly seen as a small building, and for that reason much more like the so-called Anastasius reliquary at Aachen, of eastern Mediterranean provenance, made in the early eleventh century:[141] the domed roof especially, decorated in the early piece with nielloed symmetrical scrolls and carried on an arcade, is so close to the Romanesque work that it may well have served as its model. In a more general sense, the design of the whole structure could hardly have been conceived without some knowledge of Byzantine architectural forms.

The ivory carvings are of considerably higher quality than most of those that may be attributed to Cologne in the second half of the twelfth century.[142] In them there is little of the loosening of style, the freer treatment of draperies, that has been noted in the drawing style of the seventies or even sixties of the century. For all its competence, even gentle elegance, the drapery is drawn in rigidly predetermined patterns, predictable and unadventurous. In other ivories closely related to the Hochelten reliquary, such as the small reliquaries in the form of a church, one in the Brussels, the other in the Darmstadt Museum,[143] the smoother rhythms of Mosan origin, in a strong classicizing tradition, predominate. They are in a late form of the Liège style of the middle of the century and may well date from about 1180.

The domed reliquary of the Guelph Treasure,[144] of precisely the same structure as the Hochelten reliquary, may help in dating (Plate 256). In 1482 it contained the head of St Gregory Nazianzus, acquired by Henry the Lion in Constantinople in 1172–3, and it is therefore likely that Henry commissioned it from a Cologne workshop after his return and before his fall from power in 1180. The architectural details are almost identical to those of the Hochelten reliquary, although some of the die-stamping is more mechanical and of poorer quality. That the enameller learned his craft in the 'Gregorius' workshop is proved by the zigzag-edged leaves and pure colours of the roof enamels – and their thin and rather brittle forms probably indicate a late date. The ivories are more deeply cut and richer and freer in drapery patterns and also therefore later than the Hochelten carvings. If then the Guelph reliquary may be dated to c. 1175–80, the Hochelten reliquary is probably to be placed no later than around 1170, a date generally given to all the work in the group. Although differences can be seen by comparing individual features – for instance the highly developed capitals of the Hochelten reliquary with those on the Aetherius shrine, or the far more architectural structure of the domed reliquaries with the flat, almost pictorial rather than sculptural treatment of the St Ursula antependium and the Maurinus shrine – these may not be of any great chronological significance. However, bearing in mind the date of c. 1166 for the Charlemagne arm-reliquary, and the placing of the Deutz shrine into the decade from 1150 to 1160, it is not impossible that work on the Maurinus shrine and the Ursula antependium was in progress in the late sixties.

The only figure style in embossed metalwork that has survived in the group is on the roof of the Maurinus shrine. On the left of the roof, the martyrdoms of SS. Peter, Bartholomew, Stephen (Plate 253), Lawrence, and Vincent(?) are shown, and on the right those of SS. Paul, Andrew, Maurinus, John the Evangelist, and one other unidentified saint. Between these scenes, smaller half-length figures, including Virtues, angels, and saints appear. The reliefs on the left of the roof are probably all that remains of the original decoration.[145] Small, animated figures with large heads and delicate limbs enact the scenes, all restricted to three participants. The rounded heads with the prominent features, especially those of the small busts between the scenes, are clearly indebted to the Mosan tradition. The drapery also is only slightly more lively and erratic than on parts of the Heribert shrine, for example the Apostles on the left side. When compared, for instance, with the far more freely handled drawing of the engravings on the portable altar of Stavelot, a date in the late sixties for these reliefs also is acceptable.

The four large reliefs on each of the roofs of the St Alban shrine, also in the treasury of St Pantaleon, which can be said with some certainty to have been completed by 1186, prove that a new generation is at work (Plate 254).[146] The whole shrine, with six bays of triple arches on double columns with rich capitals, deeply undercut, and deep recesses under the eaves, is of an altogether different order of architectural awareness (Plate 257). In the spandrels of the long sides are enamelled concave panels, each under its own arch, on the left side with seven nimbed doves symbolizing the gifts of the Holy Spirit and on the right with seven Virtues. At the major end, the centre was occupied by St Alban, flanked by St Germanus and St Theophanu. At the opposite end a Christ in Majesty with

the four Evangelist symbols occupied a quatrefoil of the kind found earlier on the Aetherius shrine. On the long sides originally twelve major saints of the Cologne region were seated, on the left SS. Martin, Kunibert, Severin, Maria, Ursula, and Cecilia, and on the right SS. Peter, Andrew, Gereon, Mauritius, Pantaleon, and George. The eight rectangular panels on the roof, the only figural decoration to survive, show the Nativity, Crucifixion, Resurrection, and Ascension (Plate 254) on the right, and on the left scenes from the life of St Alban, his instruction and baptism, judgement, flagellation, and martyrdom. According to the *Sillabus Abbatum* of St Pantaleon the shrine was made under Abbot Henry of Hürne (1169–96), who is probably represented adoring Christ in the Crucifixion scene, and a printed source of 1657 gives the date of the translation of St Alban as 1186.[147]

Many decorative panels with foliage motifs continue the style of the Maurinus shrine, and the rather clumsily enamelled thick draperies of the Virtues in the spandrels are not very different from its large figurative enamels. But other decorative work, like the heavily modelled crests at the gable-ends, the many more geometric patterns, the more extensive palette, and the finely drawn animal ornament, proves the St Alban shrine to be later. The triple arcades and double columns on the sides link it with that of St Anno now at Siegburg, completed by 1183 (Plate 258), and above all with work of Nicholas of Verdun, who completed his ambo for Klosterneuburg in 1181.[148] The use of decorative enamels in gilt metal on a dark blue background, with finely drawn thin foliate scrolls, a type first developed by Nicholas, also proves this relationship.[149] The figure scenes on the roofs are far more pictorially conceived, with rich narrative content and a new degree of illusionism in the handling of pictorial depth. The individual figures are draped with loose, freely and accidentally arranged falls of cloth. It is not a linear pattern that dominates these figures any longer, but a sparkling and convincing play of light and shade, creating an illusion of real substance and depth in spite of the fact that the quality is by no means high: the heads are somewhat large and at times even clumsy, and details of figures often rather dull and repetitive. But here and there in the rich variety of treatment – for example in the three female figures to the left of the Crucifixion or in the unusual iconography of the Nativity – one can sense that what might be called an average workshop was employing models of really high quality and of a very highly developed naturalism in style not untouched by the fundamental reorientation undertaken by Nicholas of Verdun in his early work at Klosterneuburg.

If any of the surviving house-shrines can be placed between the work of the so-called Fridericus group around 1170 and the early eighties, at least in type, even if not in strict chronology, it is the shrine of St Mauritius and St Innocent, now in St Servatius, Siegburg.[150] Six bays are separated by thin, enamelled columns that carry the slightly projecting cornice of the roof directly, without arches. In this, it adheres to the older tradition of rectangular fields on the long sides, as in the Xanten and Deutz shrines. The roof is divided into much smaller panels, seven each side, and therefore lacks the clearer structural relationship achieved in the St Alban shrine. Richer treatment, more in line with the later period, is reserved for the two ends, both showing triple arches with areas above them set richly with filigree and gems. In strictly chronological terms the

shrine cannot be any earlier than the St Anno shrine because one of the saints originally on its lesser end was in fact St Anno, who was not canonized until 1183; but in structure and design it must be typical of somewhat less ambitious shrines of the seventies of the century.[151]

Although not even the roof reliefs of the shrine of St Anno have come down to us, it remains in its details the most splendid of the survivals of this period (Plates 258–60). We are also fortunate to have some eighteenth-century pictorial evidence of what it looked like before it was robbed of all its major figural work between 1803 and 1812.[152] Along its sides, under triple arches carried on double columns, a series of twelve historical and legendary archbishops of Cologne were seated: on the right Maternus, Severin, Evergislus, Kunibert, Agilolf, and Heribert, and on the left (left to right) Demetrius, Vitalis, Victor, Benignus, Innocent, and Mauritius. In the spandrels between the arches three-quarter-length gilt bronze figures still survive, on the right the Apostles Peter, Andrew, Thomas, Philip, and James (the Elder) between the anthropomorphic Evangelist symbols of St John and St Luke, and on the left, between the symbols of St Mark and St Matthew, the Apostles Simon, Judas, Bartholomew, James (the Younger), and Paul. On the roof there were ten square scenes from the life of St Anno, five to each side – the number of scenes found on the Deutz shrine. At the major end, St Anno, archbishop of Cologne and founder of the abbey of St Michael at Siegburg (1056–75), stood between two angels, with a bust of Christ between angels above. At the opposite end, St Michael was seated between the archangels Gabriel and Raphael, with the Virgin between St Seraphia and St Sabina. At the feet of St Michael appeared a figure inscribed HENRICVS CVSTOS, not recorded elsewhere and probably a donor.

The eighteenth-century drawing and paintings show that the large figures were seated in lively and varied poses, of great sculptural presence, breaking well out of their frames, and that the scenes on the roof were pictorially conceived like those of the St Alban shrine. The seated archbishops and the powerful figures of the ends are far more strongly developed than any of the figures that survive on earlier shrines, like that at Deutz, or the Mosan shrine of St Servatius at Maastricht, and can only be linked with the massive figural decoration of the shrine of the Three Kings at Cologne, which may in part follow them directly.[153]

Although this evidence can give us some general impression of the high quality and sculptural scale of the decoration, it does not suffice to make really convincing stylistic judgements. Some of the minor figural work does, however, survive. The roof crests, especially at the gable-ends, show a remarkable competence in handling human nude and animal forms in foliage scrolls, realized fully in three dimensions. The nudes are of almost classical stature, posed with great variety and with a degree of naturalistic modelling of detail unknown in earlier medieval art. The spandrel figures on the left side (Plate 259), probably by two hands, still retain something of the relative stiffness, with large heads, precisely drawn features and hair, and some remnants of the drapery patterns that dominated the early years of the second half of the century, so competently handled on the Deutz shrine. Those on the right side (Plate 260), however, are men of a different world. Their heads are differentiated in physiognomy, and they are completely

at ease in their poses, draped in richly channelled cloth, with broken folds falling naturalistically around their elegant, softly modelled figures. It is for these figures – as well as in the nudes of the crests – that an attribution to Nicholas of Verdun springs to mind.[154] Some of the decorative enamels, with gilt scrolls against a gold background and some human heads mounted on the frames of the roof, again emphasize the connexion with Nicholas of Verdun's style, although it may be too rash to attribute them to his hand when they are compared carefully with the magnificent enamels at Klosterneuburg, which bear his individual stamp.

The Anno shrine was made under Abbot Gerhardt I (1172–85), probably, as has already been said, at the time of Anno's canonization and translation in 1183. It is therefore also probable that it was made in Cologne after Nicholas's return from Klosterneuburg, where he completed his work in 1181. Even if it must remain in doubt whether Nicholas of Verdun played any part in the workshop that produced the Anno shrine, some of the finest figures on it could not have been created without an understanding of the achievements of his generation.[155]

FRANCE AND SPAIN: THE TWELFTH CENTURY

IT can hardly be claimed that the promise shown in the work of northern Spain and southern France towards the year 1100 was fulfilled in the twelfth century. The astonishing precocity of metal workers and ivory carvers of the second half of the eleventh century seems to have led to the creation of Romanesque sculpture in those regions, rather than to the establishment of the monastic arts to rival the achievements of the Meuse valley, the Rhineland, or even England. It is no doubt true, however, that the losses suffered by church treasuries during the French Revolution were almost as great as those sustained in England during the Reformation some two hundred years earlier, and that the surviving material gives us only a partial and distorted picture.

The early inventories of the royal abbey of Saint-Denis near Paris give some idea of such losses.[1] The abbey achieved pre-eminence under its great abbot, Suger, who ruled the house from 1122 until his death in 1151. An able administrator and statesman as well as one of the great patrons of the arts in the twelfth century, Suger served two kings of France, Louis VI (1108–37) and Louis VII (1137–80), and acted as regent during the latter's absence from France on the second Crusade of 1147. Suger's account of 'What was Done under his Administration', written between 1144 and 1146/7, is a unique document of medieval patronage.[2] It is of interest to note that the enormously important contribution to the creation of a new style of architectural design and sculptural decoration achieved by Suger's architects in the rebuilding of the west front of Saint-Denis from 1137 to 1140 and the choir between 1140 and 1144, is described in only a few words in a chapter of his book.[3] Of the choir it is said that 'It [i.e. the help of God] allowed that the whole magnificent building [be completed] in three years and three months, from the crypt below to the summit of the vaults above, elaborated with the variety of so many arches and columns, including even the consummation of the roof'. Only in the dedication verses, which Suger also quotes, is the choir described again: 'and bright is the noble edifice which is pervaded by the new light; which stands enlarged in our time.' The great figure portals of the new west front, which set the pattern for Gothic church façades in France and throughout most of Europe for over two hundred years, are not mentioned at all, but the gilt-bronze doors cast for the main portal and the mosaic set up over the north door, 'though contrary to modern custom', are described. Suger also quotes the verses engraved on these 'cast and gilded' doors, and they illustrate his attitude admirably:

> Whoever thou art, if thou seekest to extol the glory of these doors,
> Marvel not at the gold and the expense, but at the craftsmanship of the work,
> Bright is the noble work; but being nobly bright, the work
> Should brighten the minds, so that they may travel through the true lights
> To the True Light where Christ is the true door,

In what manner it be inherent in this world the golden door defines:
The dull mind rises to truth through that which is material,
And, in seeing this light, is resurrected from its former submersion.[4]

More than four-fifths of Suger's descriptive text is devoted to an account of the holy vessels, the altar furniture, the great golden crucifix,[5] the additions made to the golden altar frontal of Charles the Bald, and the restorations of other ancient possessions of the abbey – a telling testimony to the relative importance Suger (and no doubt others in his time) attached to the embellishment of precious vessels and church furnishings on the one hand, and to the structure or sculptural decoration of architecture on the other.

Only four of the pieces added to the treasury of Saint-Denis by Abbot Suger and described by him in his book have survived to the present day.[6] All four were basically more ancient vessels, mounted with precious metals and gems and adapted to a new use. Suger's chalice, now in the National Gallery in Washington,[7] is an Antique fluted agate bowl, to which a silver-gilt knop and foot have been added, held in place by two handles joining them to a rim. Precious stones and filigree decorated all its metal parts, and one of the five embossed medallions on the foot, with a bust of Christ, is original.[8] Two more vessels are now in the Louvre. To one, probably a Fatimid rock-crystal of the tenth or eleventh century, known as Queen Eleanor's Vase because it was a wedding present to her first husband, King Louis VII, Suger added a silver-gilt foot and long neck, again decorated with filigree and gems.[9] The height added to the vase suggests that it may have been intended as a pair with a third vessel mounted in a similar way by Suger, an Antique sardonyx jug, made into a ewer for sacramental wine. The last vessel, also presented to the Louvre, is an Antique porphyry vase, converted into the shape of an eagle by the addition of silver-gilt feet, tail, wings, neck, and head (Plate 267). It is inscribed at the base of the neck:

INCLVDI GEMMIS LAPIS ISTE MERETVR ET AVRO:
MARMOR ERAT SED IN HIS MARMORE CARIOR EST

and mentioned by Suger in his book in the following words: 'And further we adapted for the service of the altar, with the aid of gold and silver material, a porphyry vase made admirably by the hand of the sculptor and polisher, after it had lain idly in a chest for many years, converting it from a flagon into the shape of an eagle.'[10]

Of these four pieces, the famous Eagle Vase is by far the most successful. The somewhat characterless opulence of the two ewers and the chalice has been avoided, and the simple and severe lines of wings and head have been married magnificently to the restrained outline of the Antique porphyry, creating a truly royal image. All this speaks of Suger's taste for the extravagant and his cultivated interest in Antiquity, a taste to which his particular interest in collecting gems and Antique cameos and intaglios – albeit occasionally acquired somewhat unscrupulously – testifies.[11] But one cannot help the impression that Suger's patronage is somewhat artificial, as well as ostentatious. With the exception of the eagle, the goldsmiths' work is rather unimaginative and dull – though the quality of the work on the chalice is superior to that on the two ewers – and

there is none of the consistency which one would expect from a well established workshop. For his great golden crucifix, Suger was obliged to call enamellers from Lorraine to decorate the foot – he tells us that sometimes five, sometimes seven men were engaged on the work – another sign that he was not able to rely on a local workshop.[12]

An impression of the dearth of great workshops in France during the Romanesque period is further reinforced by the fact that few objects of importance seem to have been added in the twelfth century to those treasuries which have survived relatively unscathed to the present day. The abbey of Conques, for example, added only one portable altar during the first half of the century, at a time when its wealth enabled it to build a sculptured west portal of superb quality and vast dimension. Indeed, France and northern Spain appear to have been able to make a distinctive contribution to the twelfth century only in the field of champlevé enamelling, which was to develop into the kind of work known as 'Limoges' enamelling. By the late twelfth century this work was well established in the Limousin, where an output of almost industrial proportions during the thirteenth and fourteenth centuries resulted, with few exceptions, in an almost inevitable decline in quality. No doubt also, once the style of work had gained its enormous popularity by supplying the needs of smaller churches cheaply, it was imitated in many other centres.[13]

The discussion of Limoges enamelling has been bedevilled by controversy over whether the beginnings of the style are to be found in northern Spain or at Limoges and, indeed, whether the bulk of the later work is to be attributed to Spain or to Limoges.[14] More balanced views tend to be put forward now which rightly make less of the differences between southern France and northern Spain, and speak of travelling workshops, especially during the formative years, patronized in the whole area.[15]

The one portable altar added to the ancient treasury of Conques in the early twelfth century is set with enamel plaques on a broad silver-gilt frame around the altar stone, decorated with filigree and gems (Plate 261). Although it does not bear any inscription, it is not likely to be much later in date than the slightly smaller altar given by Abbot Bégon III in the year 1100 (Plate 160).[16] The clear, simple patterns of filigree do not differ significantly from the small remnants of filigree on Bégon's altar. In the centre at the top is a round medallion with Christ, and the only roundel in 'full' as distinct from 'sunk' enamel, showing the Agnus Dei, is in the centre below. At the corners circular medallions of the four Evangelist symbols appear, and of the four rectangular plaques with busts of saints, two are named by inscriptions engraved in the field, the Virgin on the right, and St Faith, the patron saint of Conques, after whom the altar is named, on the left.

The decorative effect of the enamels on St Faith's portable altar resembles that of the reliquary chest given by Bégon's successor, Abbot Boniface, during his time of office from 1107 to 1119 (Plate 158).[17] The enamels of both are basically imitations of Byzantine cloisonné in the decorative effect achieved by placing simple forms and bright colours against a gilt background, but in the case of the St Faith altar the imitation extends even to the technique itself. The plaques are made of two sheets of copper, brazed together, with the outline of each figure cut out of the upper sheet – a simplified copy of the 'sunk' enamel technique of gold cloisonné.[18] This technique, in which only the

copper and opaque enamel of champlevé enamelling is adopted in what remains funda-
mentally an earlier cloisonné tradition, might be taken to argue that the portable altar of
St Faith should be dated even somewhere earlier than Boniface's reliquary chest. Certain-
ly there seems little reason to date the altar any later than the first quarter of the twelfth
century.

The small house-shaped reliquary preserved in the parish church of Bellac in the
Limousin is decorated with slightly domed circular enamelled medallions, three on the
front and three on each slope of the roof, with one at each end, mounted on a closely
hatched bronze gilt base, set with precious stones in very simple band settings.[19] On the
front, in the centre, is a bust of Christ, with the Agnus Dei above him on the roof and
the four Evangelist symbols around them. On the right end is the Virgin, on the left
another representation of the Lamb. On the back are lions, and birds drinking from the
Fountain of Life. In the use of domed circular medallions and a restricted palette of only
four colours, namely blue, green, turquoise, and pinkish white, as well as of rather
flaccid, rounded forms, the Bellac casket seems to follow the style of the reliquary chest
of Abbot Boniface, in perhaps a somewhat less expert manner.[20] There seems little reason
to doubt that these pieces were local products.[21]

With the small house-shaped reliquary casket from the Bardac Collection, now in the
Metropolitan Museum in New York, the problems become more difficult. Its decora-
tion links it closely with the so-called altar frontal from Santo Domingo de Silos, now in
the Burgos Museum, and the casket of Santo Domingo in the same museum. The Bardac
casket is made entirely of six panels of champlevé enamel. On the front, a three-quarter-
length Christ is enthroned between an alpha and omega with the Virgin on his right
and St Martial on his left. Above, on the roof, the hand of God is flanked by two angels
swinging censers. On the reverse of the casket, the four Evangelist symbols are shown,
two on the roof and two on the back (Plate 262). Between each pair of symbols are
elegant symmetrical foliate scrolls, the lower with a pair of identical winged dragons
with human heads facing each other. On the ends, St Peter and St Paul are represented
three-quarter-length. It has been shown that up to the middle of the nineteenth century
this casket was preserved in the parish church of Champagnat near Limoges, where the
archivist A. Bosvieux saw it and recorded it in his notebook.[22]

The presence of St Martial, patron of the cathedral of Limoges and apostle to the
Limousin, would also seem to underline the local origin of the Bardac piece. But the
same arguments in reverse can be applied to the casket of Santo Domingo at Burgos.
Carved in ivory by a Moslem craftsman, probably at Cuenca, about the year 1026, the
casket was repaired during the twelfth century and a champlevé enamel plaque added
to one side, showing Santo Domingo of Silos standing in the centre flanked by two
angels, and another to the top with the Agnus Dei between two winged dragons with
foliate tails (Plate 263). An enamelled strip with foliate scrolls was fixed along the back,
and various edges were strengthened with gilt-bronze strips engraved with the vermi-
culé pattern which had already been used on the Arca Santa at Oviedo in the late
eleventh century.[23] Here, too, evidence for local manufacture is surely strong, and yet a
careful comparison of the two pieces leads to the impression that both caskets were made

at least in the same workshop, if not by the same craftsman. The simple, bright colours are identical, the foliate scrolls and dragons are drawn with identical elegance of line, and the figure drawing is extremely close in the two pieces, both in the heads, with their curious dotted eyes, and in the lively, almost fluttering draperies. One small detail on the Champagnat casket perhaps strengthens the case for a southern rather than a more northern home for the workshop: the Virgin seems to carry in her left hand a curious object which also occurs in Catalan frescoes (Tahull and San Pere de Burgal), and has been identified as the Holy Grail.[24]

In its decorative details, especially the broad borders above and below, engraved with vermiculé pattern, interrupted by rectangular panels with foliate scrolls and winged dragons, the large fragment known as an 'altar frontal' in the Burgos Museum (Plate 266) is clearly the product of the same workshop, but its figure style differs from that on the two caskets. The piece presents very considerable difficulties. In the centre is a Christ in Majesty in a mandorla, surrounded by the four Evangelist symbols (Plate 264). To each side, under an arcade of elaborately pierced bronze-gilt columns and arches surmounted by embossed architectural canopies, six of the twelve Apostles are represented. The figures and their haloes are in champlevé enamel, but the heads are in strong bronze gilt relief. Below the lower decorative border, the wooden base on which the metal is mounted is cut into nine arches, of which the outer two are not complete, which suggests that the sides have been trimmed somewhat. Three small fragments of vermiculé decoration show how these arches were originally decorated, and two spandrels have remnants of their original decoration, a kind of chequerboard in gilt and *émail brun*. The same technique is employed for two narrow strips of foliate scroll at each end of the piece, which are clearly not in their original position.[25] This chequerboard pattern, the vermiculé decorative frame, and the *émail brun* technique are all found also on another long narrow panel, still preserved in Santo Domingo at Silos, which once formed part of the same structure as the Burgos 'frontal' (Plate 265). The Silos panel shows an Agnus Dei in the centre, and again the twelve Apostles, six each side, under an architectural arcade, this time of triple arches.[26] A careful examination of the two panels has shown that the piece still at Silos was at some time fixed obliquely to the top of the Burgos panel, forming a sloping roof to it. Also, holes in the underside of the springers indicate that the arches of the Burgos panel were most probably originally carried on metal columns, and it is therefore suggested that the two pieces were designed to form the front of a kind of architecturally conceived cover over the tomb of Santo Domingo at Silos, of the kind which still survives from the late twelfth century in stone over the tomb of San Vicente at Ávila, where the back, perhaps against a wall, remained undecorated.[27]

Although one cannot doubt that the two panels were at one time fixed together in this way, it is difficult to believe that they were originally designed for such a position. Not only is it strange that the twelve Apostles should appear twice in such close proximity, but the style of the two panels differs very considerably, and although it is just possible that they may have been made at about the same time, the drawing of the figures on the Silos panel certainly looks very much later than that on the Burgos Museum piece. The Silos figures are tall and elegant, with rhythmically drawn draperies

in long and sweeping lines – almost a 'curvilinear' dampfold style. The heads, with plain haloes, are drawn with a light, impressionistic touch. In contrast, the enamelled figures at Burgos are stiff and a little awkward in their poses. The large heads with their elaborate haloes are in strong relief, with prominent eyes and heavy features, and the draperies are heavily patterned, approaching the 'nested V-fold' style. The treatment of the two arcades also differs: the former is in rather severe, simple forms, the latter elaborate and highly decorative. In a word, the Silos panel seems characteristic of the second half of the century, perhaps the late seventies or even eighties, and the Burgos panel of the first half, perhaps the forties or fifties. Indeed, if the Burgos Apostles are compared to the smaller figures on the Champagnat and Silos caskets, they seem distinctly earlier in style. The freer, almost fluttery and much less abstract treatment of draperies and the lively movement of the small figures would seem to place the caskets later than the Burgos Apostles, early in the second half of the century.

But difficulties are encountered with such a chronology when the decorative framework is considered. The rectangular decorative plaques on the Burgos panel, with symmetrically displayed birds and dragons with foliate tails, elegantly drawn and enamelled in pure, single colours in each cell, are very closely related to some of the decoration on the two small caskets, and cannot be substantially different in date. It might be argued, however, that the decorative frames of the Burgos panel were added when the Apostles, the arcade, and the Christ in Majesty were re-set for their position on the tomb of Santo Domingo and that the new panel for the roof of the tomb was added later in the century, probably in the eighties. Only the strips set with gems which make up the mandorla of the Christ in Majesty would then present further difficulties, because the vermiculé decoration on these is identical with the remaining decoration. They might, of course, have been added when the enamels were re-used in the eighties.[28] In spite of the very few remaining works in enamel, it would then seem likely that a continuous tradition existed in northern Spain, probably centred in Castille, which was operative from the second quarter until at least the end of the third quarter of the century.[29]

The exceptionally large enamelled plaque made to decorate the tomb of Geoffrey of Anjou in the church of Saint-Julien at Le Mans, now in the museum there, is one of the very few pieces where some external evidence of date is available (Plate 270). Geoffrey, father of Henry II of England, died in 1151. About 1155 Thomas de Locher, who had been Geoffrey's chaplain, mentions an epitaph which may well be the wording found on this enamel. The tomb is probably no later than c. 1180, when Jean de Marmoutier completed his life of Geoffrey, begun in 1164, in which he describes his tomb.[30] It seems possible that this astonishing large enamel plaque, measuring 63 by 33 cm. (25 by 13 in.), was made during the fifties of the century. Although it is difficult to compare it to other enamels – nothing of its size or style has survived – there is in the municipal library at Le Mans (cod. 263) a manuscript with an illumination showing Pliny dedicating his Natural History to the Emperor Vespasian which closely resembles the style of the enamel and has been dated to c. 1150.[31] The rich, almost overloaded overall decoration of the page, the block-like drawing of the figures, the hard precision of the heads, and details like the architectural canopies, the helmet worn by Pliny, and even the almost

heraldic charges on the shield – everything links enamel and illumination so closely that one could imagine the same hand at work. Only the drapery of the enamel is just a little simpler and less compartmentalized – perhaps only due to the need to simplify drawing in the champlevé technique. In a purely technical detail of some importance, this enamel differs from those belonging to the 'Silos' group. In the lower part of Geoffrey's garments two colours, blue and white, are fired within the same cell. This mixing of colours within one cell, and perhaps especially the edging of pale blue with white, had by the middle of the century long been practised in Mosan enamelling, and it seems possible therefore that some contact, however slight, might have existed between the two major styles of twelfth-century enamelling shortly after 1150.[32]

Although English influence has been seen in the Pliny manuscript at Le Mans,[33] the same cannot be said for Geoffrey's enamelled tomb plaque – at least no evidence has survived that suggests it. The same is true of two large enamels, now in the Cluny Museum, which not only originated in the lands acquired by the English king through his marriage to Eleanor of Anjou in 1152, but were also made for the abbey of Grandmont, which enjoyed the continuing patronage of the Plantagenets. The two enamels, made with the help of funds donated by Henry II, may indeed have decorated the high altar of the abbey.[34] Again, no evidence is extant which would suggest that the arts in the English king's possessions in France were linked in any special sense with developments in England: far more important were the indigenous regional styles and their traditional connexions.

One of the two surviving panels from Grandmont has the Adoration of the Magi, the other a saintly figure speaking to a hermit (Plate 268). The latter is engraved with the inscription: + NIGOLASERT PARLA AMNETEVEDEMVRET. It has long been thought that this difficult inscription proves that St Stephen of Muret, the founder of the order of Grandmont, is shown speaking to St Nicholas of Bari and the fact that St Stephen appears without a halo proves that the panel was made before his canonization in 1189. However, a more recent and convincing reading of the inscription interprets the saintly figure as St Stephen and the hermit as Hugo Lasert, a favourite companion of the saint,[35] which means that the panel is likely to have been made soon after the canonization as part of the decoration of the high altar frontal of the church at Grandmont.[36] The figures are in 'full' enamel against a plain gilt ground, framed by an arcade with an architectural canopy. The use of pale blue draperies edged narrowly by white and the pinkish-white flesh tint of the heads, as well as something of the hardness of the drawing of the features, still reminds one of Geoffrey of Anjou's tomb plaque. But the draperies fall with far gentler ease, and the figures incline their heads in human sympathy. Nothing of the rigidity of the earlier figure remains. On the panel with the Adoration of the Magi, only one figure, that of the infant Christ, is treated differently: the body is engraved only, not enamelled, and the head is in relief. The drawing here is reminiscent of Mosan drapery patterns – especially the loops of cloth around the knees – and the head in relief, a technique used in the Silos group even before the middle of the century, emphasizes the continuation of earlier traditions in this style, which seems somewhat provincial and even retarded when seen in a wide context.

The style of the heads in the Grandmont panels is also seen in a number of other works, none of which can be dated on any external evidence. A whole group of altar crosses, some perhaps even somewhat earlier in date than the Cluny panels,[37] has the head of Christ drawn very like the head of St Stephen of Muret, and uses a very similar flesh tint. One particular example, from the Doistan Collection,[38] now in the Louvre, might almost be the work of the same craftsman (Plate 269); the fall of the loincloth, although somewhat more elaborate, resembles the style of the Grandmont panel. Very similar heads appear again on a series of four panels which no doubt once framed a fifth Crucifixion panel no longer extant. Two of them, now in the British Museum, show the Virgin and St John (Plate 271), the third, in the Kofler Collection at Lucerne, two censing angels, and the fourth, in the Museo Sacro Vaticano in Rome, Adam in his tomb.[39] All four panels have identical frames of dark blue decorated with gilt interlace and white dots, and the same restricted palette of light and dark blues and green with almost white flesh tints. The drapery is similar to that of the Grandmont panels, but handled with greater ease, the pose of the two large standing figures of the Virgin and St John is particularly elegant, and all in all one might see in these panels the mature achievement of a craftsman trained in the workshop of the Grandmont master, perhaps active towards the end of the century. One other feature is of great importance: the gilt background is engraved with an assured rendering of the vermiculé pattern so popular in Spain and no doubt introduced into the Limoges region well before the end of the century.[40]

A whole series of reliquary caskets form a quite distinct group, although the style of drawing shows clearly that the work covers a considerable span of time. Among the earliest must be the Resurrection casket in the parish church of Nantouillet (Plate 272). Here, the sharp compartmented drapery is still reminiscent of the 'nested V-fold' style of the first half of the century, and shows little of the softer rhythms and the naturalistic, smooth fall of drapery that characterized the work of the last quarter of the century. It seems likely, therefore, that the vermiculé background was introduced into the Limousin during the third quarter of the century. But Spain did not provide the only source for this group: the drawing of the heads, engraved and filled with dark blue enamel, must be evidence of some contact with Mosan practice, perhaps through the work of Mosan enamellers called to Saint-Denis by Abbot Suger a generation earlier. It would perhaps not be too fanciful to see in the Nantouillet casket (Plate 272) a reflection in the Limousin of Mosan enamelling at much the same time as such a reflection was to be seen in the Henry of Blois enamels for the shrine of St Swithun at Winchester,[41] although it must be admitted that the English connexion with the Mosan style is considerably closer.

The hardness of drawing, even abstraction, of the Nantouillet casket became gentler and more flowing in the last quarter of the century. Reliquaries like the chasse of St Stephen from the church of Malval,[42] the casket in the National Gallery, Washington, and the reliquary in Copenhagen illustrate the steps on the way to the Grandmont style.[43]

Enough has already been said to show that the term 'Limoges' enamelling is a vast over-simplification, at least for the twelfth century. Yet a third style, and one which can

really be said to have laid the foundations of what is rightly known as 'Limoges' enamelling, was being developed in the Limoges area in the decade before 1180. Perhaps the best work to illustrate it is the shrine of St Calmine in the parish church of Mozac (Plate 273). Among its inscriptions is one which states that it was made for Abbot Peter of Mozac, surely the third abbot of this name, who ruled the abbey from 1168 to 1181.[44] Nearly all the figures are in bronze gilt relief, engraved with delicate drapery patterns, against the dark blue enamelled background with its multi-coloured roundels, bands, and foliate scrolls so typical of Limoges. On the front, the Crucifixion with the Virgin and St John is flanked by six Apostles under arcades; the remaining six Apostles appear on the roof on each side of a Christ in Majesty. On one end the Virgin and Child are seen in a mandorla, on the other St Austremoine. On the back St Calmine and St Namadie direct the construction of the monasteries of Chaffre, Tulle, and Mozac, and on the roof are the ascension of the saints and Abbot Peter directing the construction of their reliquary.

The modelled drawing of the figures, with drapery patterns strongly influenced by Mosan traditions, is thoroughly in keeping with a date in the seventies of the century. Indeed, it would surely be extraordinarily late for such a style if one were to attribute the work to Abbot Peter IV, elected in 1243 or 1244, or even Peter V (1257–67), to whom this reliquary is often attributed. This relief style, too, may be traced to the end of the century and beyond, entirely in keeping with stylistic trends elsewhere in Europe. The rich, bunched folds of the Transitional style[45] are seen, for example, in the seated figure of St Paul in the Cluny Museum in Paris, and the shrine of St Fauste, also in the Cluny Museum, in its sketchy engraving shows typically Gothic forms, with sweeping lines of drapery, bunched over the belt and full of accidental, illusionistic detail. With such pieces, the foundation of the massive output of Limoges enamel in the thirteenth and fourteenth century was laid.[46]

ENGLAND[1] AND SCANDINAVIA: THE TWELFTH CENTURY

PITIFULLY little of the once rich contents of English treasuries survived the dissolution of the monasteries in the sixteenth century. Medieval inventories give one an indication of the wealth carried away by the remarkably efficient commissioners of Henry VIII, who were responsible for transferring everything of value to the Royal Mint in the years 1536 to 1540. The treasure of Canterbury Cathedral alone was said[2] to have needed twenty-four carts to carry it to London. The few pieces that survive prove that this material was also often of very high quality. English twelfth-century manuscript illumination, which, being of little or no intrinsic material value, has come down to us in fair measure, is additional proof that English Romanesque art was in no way inferior to the achievements of the Continent of Europe. But the fragmentary remains, mainly of small-scale works, are difficult to group and can only be understood alongside the more plentiful continental material and English manuscript illumination.

Mature English Romanesque was established in two important, almost contemporary manuscripts of very different styles, the St Albans Psalter, now in the library of St Godehard at Hildesheim, and the Bury Bible, now MS. 2 of Corpus Christi College, Cambridge.[3] The St Albans Psalter can be dated to 1119–23, and one or two ivory carvings can be associated with its style. A similar solemn, heavy, and stiff representation of human figures, closely grouped in repetitive patterns, with an emphasis on heads in profile, can be found on an ivory comb, probably a liturgical comb, on loan from the Lloyd-Baker Collection in the Victoria and Albert Museum (Plate 274).[4] The origins of this style have been sought, in the main, in German Ottonian art, and it has also been pointed out that elements of it, especially the frequent use of profile, were already developed in the ivory altar cross of Gunhild, carved before her death in 1076, probably in Denmark (Plate 176).[5] The comb is crowded with scenes from the life of Christ. On one side are the Massacre of the Innocents, the Annunciation to the Shepherds, and the Adoration of the Magi, the scenes spreading around on to the edges of the comb. On the other Christ washing the Apostles' feet, the Last Supper, and the Betrayal are shown in the centre, and in the four corners are the Nativity, the Flight into Egypt, the Crucifixion, and the Entombment. The comb must have been carved in the generation that produced the St Albans Psalter, and it is likely therefore to date from the 1120s. Another comb, very similar in style and iconography and almost certainly carved in the same workshop, was found in 1857 in the cathedral of Verdun, and is now in the Archaeological Museum there.[6]

A fragment of carved ivory with a human figure entwined in a foliage scroll, found at St Albans on the site of the infirmary of the abbey in excavations in 1920, is now in the British Museum (Plate 275).[7] A decorative carving, perhaps from a book-cover, it is

pierced and was originally nailed against a background, perhaps of gilt metal. The relief is much more substantial than that of the combs, and the figure is larger and handled with greater skill. In the linear treatment of the draperies and in the large oval head with arched eyebrows and widely spaced circular drilled eyes, as well as in the stringy tendrils and rather flabby cabbage-like leaves of the foliage, the carving is still derived from the St Albans style of illumination, but it is a little more mature in style, perhaps just a few years later than the Psalter.[8]

Towards the end of the first half of the century, the St Albans style of illumination developed a more indigenous form, more solid and three-dimensional in drawing and more varied and brighter in colour. The outstanding manuscript in this style is the Psalter in the British Museum written for a lady connected with Shaftesbury Abbey in Dorset between about 1130 and 1150.[9] An ivory carving of a king, one of the Three Magi bearing gifts, found at Milborne St Andrews, also in Dorset, and now in the Dorchester Museum, represents the same stylistic phase.[10] Something of the refinement, especially in the head, and the slim proportions of the earlier figure of a king in the British Museum (Plate 174)[11] is still to be seen in this carving, but the pose is stiffer and the pattern of drapery more regular, more contrived and mechanical – the humanism of the earlier classicizing style has given way to the full Romanesque. A somewhat less elegant version of this style, in which even less sensitivity is discernible and in which the heads are heavier and the proportions of the figures more squat, is seen in a carving of two closely grouped figures in the National Museum at Copenhagen.[12] The provenance of this carving is not known – it could easily have been imported from England, or have been carved in Denmark under strong English influence towards the middle of the century. In weight and proportion, and indeed in its very heaviness of detail, it comes close to four panels of whalebone which originally decorated the sides of a portable altar (Plate 276). The provenance of these panels also is not known, but they are related to the sculpture added to the west front of Lincoln Cathedral under Bishop Alexander between 1123 and 1146. It is perhaps this relationship to the larger-scale sculpture of Lincoln and incidentally also to one of the sources of Lincoln, the west front of Saint-Denis, carved between 1137 and 1140, which explains the relatively coarse style of this work.[13]

The close links with Denmark already noted earlier in the twelfth century continued throughout it. They are clearly demonstrated by a group of ivory carvings, all of walrus, or 'morse' ivory, among which the great hoard of more than seventy chessmen found in 1831 in the parish of Uig on the Isle of Lewis in the Outer Hebrides are of prime importance (Plate 277).[14] The group includes a slightly tapered piece of walrus ivory, 44·3 cm. (17½ in.) long, carved on all its four sides and the chamfered edges (Plate 278). Bronze-gilt mounts were added to the piece in the fourteenth century, when the hollow upper part seems to have been made into a receptacle, probably a reliquary, by adding a small hinged lid.[15] Its original use is by no means certain, but in shape and size it is remarkably like the leg of a chair, and it may well be a fragment from an episcopal throne.[16]

The Lewis chessmen are solid and compact, with large, severe heads and a hard and rigid linear treatment of strict drapery patterns. The kings sit with a sword held across their knee, the queens hold their right hand anxiously to their cheek. The bishops hold

croziers close to their bodies and the knights wear close pointed helmets, carry shields with simple heraldic patterns, and are mounted on tiny, compact horses. The 'warders' (rooks) are standing warriors with helmets, shields, and swords. The pawns, which complete the sets, are simple tombstone-like pieces of walrus ivory, either octagonal cones or flat pieces decorated with simple engraving with either foliate or interlaced strap patterns. It is not easy to relate this remarkably effective figure style to other work. Something of the same flat treatment of drapery with enriched borders and overlapping folds with zigzag edges is to be found on the Dorchester king, and in stone sculpture the figures on the chancel arch at Kilpeck and even the superb major reliefs that decorated the great choir screen at Chichester show something of the same self-conscious, rigid, and parallel patterns of folds.[17] But it is in the rich decorative panels on the backs of the kings, queens, and bishops that the chessmen are linked with the other pieces in the group, and reveal their stylistic origins more clearly. In the winged dragons, biting beasts, large pouch-like leaves and foliate scrolls, interlaced arches and strap patterns an ornamental vocabulary is seen which on the one hand finds its ancestry in Viking carvings like the stone cross fragments from West Marton in Yorkshire,[18] and on the other in the carvings on the Prior's Door at Ely Abbey and at Lund Cathedral, where southern sources, mainly from North Italy, were absorbed.[19] In date all these factors point to a period around the middle of the twelfth century.[20] The style seems to have been known over a wide area in northern Europe: it is found as far north as the Hebrides, as far south as the mouth of the Elbe, as far east as Lund and Munkholm, and as far west as Ely, or in other words, along the entire seaboard of the North Sea, across which the traditional links between Scandinavia and England continued to be maintained.[21]

A number of altar frontals in bronze-gilt survive from the second half of the century in Denmark, which show clearly that the close relationship with English art first noted earlier in the century remained important.[22] Perhaps the earliest in this later group of frontals comes from the church of Ølst; it is now in the National Museum at Copenhagen (Plate 285).[23] Christ is enthroned in a central quatrefoil, surrounded by twelve square scenes from his life in three horizontal registers, six to each side, with four more scenes surrounding the central quatrefoil. It is in this frontal that an influence from the other main stream of English Romanesque, first fully developed in the Bury Bible of c. 1135, can be discerned. The rigid and severe style is here replaced by curvilinear patterns and rhythms which betray some knowledge of the dampfold draperies of the Bury Bible. The Danish goldsmith made no direct use of dampfold patterns, but he achieved something of the same hard precision, clarity, and elegance of forms which characterizes the work of English illuminators around the middle of the century. Only here and there do the ornamental details of the framework of the Ølst frontal show signs of English influence,[24] and most of the framework is punched with the simple circular and semicircular patterns so popular towards the middle of the century in the Cologne and Mosan areas. Indeed, the figure style may be related to these areas as well as to England.[25] But when the group of Danish frontals is seen as a whole, English decorative details continue to predominate. On the frontal from Odder for example (Plate 284),[26] the framework is enriched with foliate patterns which are closely related to the elaborate,

open, cabbage-like leaves so popular among the English illuminators of the Bury St Edmunds or Lambeth Bibles. The figure style of this frontal, however, shows signs of the loosening of patterns and freer fall of cloth which would place it later in the twelfth or even possibly into the early thirteenth century.[27]

There can be little doubt that in the workshops in Jutland that produced this whole series of altar frontals throughout the second half of the twelfth century and in the earlier thirteenth century, we see a reflection, perhaps it may be claimed a somewhat provincial reflection, of metalwork predominantly inspired by English models. Only one frontal in Scandinavia is an exception to this rule: that at Lyngsjö in southern Sweden (Plate 286).[28] Of higher quality, it is perhaps the work of a travelling craftsman. If so, his training would almost certainly have taken place in the workshop that produced the shrine of St Servatius at Maastricht. Its design is very different from the Danish series. In the centre, in a hexagonal frame, are the seated Virgin and Child, with two prophets, Moses and Aaron, to each side in large circular frames. Above and below the Virgin, in semicircular fields, David and Solomon are represented, and four pairs of prophets carrying scrolls appear in rectangular fields above and below the circular frames. The simple, broad patterns of their robes, the large heads with almost globular eyes, and the strict foliage patterns in relief and *émail brun* can all be closely paralleled in the Servatius shrine at Maastricht (Plate 209), and the frontal must therefore date from around 1170.

In England, too, metalwork related to English illumination was being produced, as well as work which finds its closest comparisons in the Mosan area. The curvilinear dampfold style of the Lambeth Bible, with all its violence and vivid drawing, appears in champlevé enamel in the so-called Master's Plaque with the Last Judgement in the Victoria and Albert Museum,[29] and the rich ornamental foliage of the same manuscript is found in a series of enamelled ciboria. But it is two dished semicircular plaques now in the British Museum that are most closely linked with Mosan champlevé enamelling.[30] On one, originally at the top of a composition, two censing angels are represented, and on the other the donor of the object, Bishop Henry of Blois of Winchester (1129–71), is shown kneeling, with a shrine in his arms (Plate 279). It seems most probable that these two fragments were made to decorate the original of this shrine, which almost certainly contained the relics of St Swithun, translated at Winchester in 1150. Indeed, the pattern on the top (or perhaps side?) of the shrine includes semicircular plaques in the decoration at the top and bottom of the frames of the right-hand and central 'mandorlas'.[31] The engraved heads, filled with dark blue enamel, of both the angels and the bishop resemble the Mosan type, but are less stereotyped in character, and the colour is less rich – both paler and cooler in hue – than that used on Mosan enamels. The drapery, too, is close to Mosan practice in having, for example, a looped fold around the knee of the bishop, but it is sharper and harder, with more distortion in the figure than would be possible in the gently classicizing style of the Mosan workshops. Nevertheless, judging from the technique alone, there can be little doubt that the craftsman who was commissioned to make the new shrine of St Swithun at Winchester just before the middle of the century knew Mosan work well, and may even have been trained in the area.

In the first of the enamelled ciboria, the Warwick Ciborium,[32] now in the Victoria and

Albert Museum, the gentler Mosan style seems even better understood, but it is combined with unmistakably English foliage patterns. The large open blossoms, the rich twisting vine scrolls, are those of the Lambeth Bible. Within the medallions formed of these tendrils, six scenes from the Old Testament are represented.[33] Two more ciboria of very similar kind, most probably produced in the same workshop, have survived. One is known as the Kennet Ciborium and is now in the Victoria and Albert Museum; the other, said traditionally to have come from Malmesbury Abbey, is preserved in the Pierpont Morgan Library in New York (Plate 281).[34] Both still have their covers, and both have six scenes from the Old Testament on the bowl typifying the six scenes from the life of Christ on the cover. The iconographic programmes differ only a little in detail, and where the same scenes appear, all three ciboria seem to employ the same or very similar sources.[35] In style, the Kennet and Malmesbury Ciboria are very close to one another. In both, the stricter linear patterns of the Warwick Bowl are beginning to break up in favour of a more illusionistic use of light and shade. Hard patterns still survive here and there, but one can sense the change towards a modelling of the figure in light and shade, a change that was also taking place on the Continent in the 1170s – a date which seems entirely acceptable here. The same movement towards a freer drawing style, perhaps just a little earlier in the same decade, can also be seen in a series of seven plaques illustrating the life of St Paul (Plate 283) and St Peter.[36] Although the underlying patterns of Mosan drawing are still present, the same sketchy multiplication of lines begins to model the figure, and drapery begins to fall over the belt in gentle loops. In these enamels the same beginnings of the Transitional style were developed, and probably quite independently, which characterize the art of the seventies and eighties on the Continent.[37] The small enamelled casket in the Victoria and Albert Museum, with circular medallions containing representations of Arithmetic and Geometry, Astronomy and Dialectic, Rhetoric and Music, Grammar and Natural Sciences, shows the full development of naturalism towards the end of the century (Plate 280). The drawing is vivid and free, the modelling of volume entirely by light and shade.

Among the very rare survivals of the Transitional style in England, the silver ciborium now in the treasury of Saint-Maurice d'Agaune is the most outstanding (Plate 282).[38] Ten medallions, with nine scenes from the infancy of Christ and the Baptism, decorate the cup and cover (whose shapes resemble the earlier group of enamelled ciboria), and on the foot are three female figures in oval frames, probably representing the Virtues. On the lid a delicate, fully three-dimensional group of Chiron and Achilles serves as a handle. Both the iconography and the style of the figures can be compared to such examples of English manuscript painting of about 1200 as the Westminster Psalter in the British Museum.[39] Dramatic gestures, for example in the Journey of the Magi or the Annunciation to the Shepherds, are handled with consummate ease, and the figures are drawn in a gentler style, with soft and rich draperies no longer arranged according to preconceived patterns, but falling accidentally and naturalistically about them. The important part that England may have played in the Transitional period, so clearly to be seen in the illuminations of the Winchester Bible, can only be hinted at in the piteously fragmentary remains of her metalwork.[40]

CHAPTER 21

NICHOLAS OF VERDUN AND THE TRANSITIONAL STYLE

IF any precise date in the history of Romanesque metalwork, or indeed Romanesque art as a whole, may be considered of outstanding significance, it is the year 1181. In that year Nicholas of Verdun completed his great pulpit for the abbey of Klosterneuburg near Vienna. It is not only the first documented work by Nicholas, it is also among the first works in a new style called 'Transitional', which was to revolutionize art, and Nicholas of Verdun himself seems to have played a major creative part in this change. Although it has found general acceptance, the term 'Transitional' is unfortunately somewhat misleading. The 'Transitional' style does not, in fact, simply form the bridge from Romanesque to Gothic. It is a style, with its roots in the third quarter of the twelfth century, which runs parallel to the creation of Gothic, rather than being part of it. The 'Transitional' is a naturalistic style, while naturalism plays a relatively smaller part in the creation of Gothic.[1]

Before discussing Nicholas's sources and the part he played in the creation of the Transitional style, his œuvre must be established and his highly personal style analysed. Indeed, in his work we have the first opportunity, and a unique one, in the history of early medieval art of tracing the development of an individual artistic personality. Other medieval artists are known to us by name – Roger of Helmarshausen or Gislebertus, sculptor of Autun, for example – but in all other cases they stand before us as mature artists, enigmatic, complete, and characterized by a single work or a single, self-contained style. With Nicholas we have two signed works, one early and one late in his career, and a third, although only an attribution, that can be accepted with an unusual degree of certainty, all three together spanning a working life of at least twenty-seven years.

The early work is the Klosterneuberg pulpit, entirely decorated in champlevé enamel (Plate 288).[2] It bears an inscription in Leonine hexameters which records the patron Provost Wernher, head of the Augustinian Canons in 1168–86 and again in 1192–4, the artist's name, and the date of completion, 1181. Damage sustained in a fire at the abbey church on 14 September 1330 resulted in the complete remodelling recorded in an additional inscription in a different script, stating that it took place under Provost Stephen of Syrendorf in 1331,[3] and that it converted the original 'ambo' (pulpit) into an altar retable. This remodelling made it necessary to add six figure scenes in order to widen the central panel, so that the two wings, no doubt originally the sides of the ambo, could be closed over it without overlapping in the middle. Of the six subjects added, three were placed to each side of the central scenes of the Sacrifice of Isaac, the Crucifixion, and the Two Spies with the Grapes. In the inscriptions surrounding the additional large scenes themselves, and in the decorative panels and twelve spandrels with

busts of angels, prophets, and Virtues, an astonishing attempt has been made to imitate the twelfth-century style, but their fourteenth-century character is unmistakable.[4]

The forty-five original figure scenes, each on a plaque under a trefoil cover, are arranged in three registers and represent the most extensive typological programme to have survived from the twelfth century.[5] In the central horizontal register, a cycle of thirteen christological scenes appears with the relevant prefigurations from the Old Testament before the revelation of the Law to Moses above, and after the revelation below. The three registers are named six times on the vertical frame of each of the wings and on the centre panel: +ANTE LEGEM+SVB GRACIA+SVB LEGE+. The six scenes at the end of the programme on the right wing are devoted to the Last Judgement. Such an arrangement of subject matter, in which the prophetic content of the Old Testament is paralleled to New Testament events, had been known in Christian iconography from the earliest times, but it was only in the twelfth century that it achieved great popularity and became the basis of systematic theological study.[6]

The complicated theological programme of the Klosterneuburg ambo is unlikely to have been devised by Nicholas himself. In the restoration of the altar undertaken in 1949–51,[7] a preliminary engraving of the scene of the Three Maries at the Tomb was found on the reverse of the last panel of the Mouth of Hell. The most likely explanation of this is that the scenes were given to the artist in the form of short titles, and that Nicholas began engraving this scene for the title '*Sepulcrum Domini*' – the most obvious scene to choose for it. But it must then have been pointed out to him that the programme demanded not the Three Maries, but the Entombment to accompany the scenes of Joseph in the Well and Jonah and the Whale. This can also be taken as evidence that it is more than likely that Nicholas executed the ambo at Klosterneuburg under the supervision of his patron, who may have been responsible for devising the elaborate iconography.

The whole pulpit was a work of remarkable stylistic homogeneity. The figure drawing throughout, in the large panels and the small figures in the spandrels, is undoubtedly the work of one hand. One must suppose it possible that the minor decorative work and the inscriptions are in part by workshop assistants, but even these, in their extraordinary clarity of line and superbly polished enamelling technique, are of astonishingly even quality. Certainly one is left with the impression that the whole magnificent work bears the stamp of one individual and one individual only. It can, of course, be only hypothesis, but if the work was completed in 1181, Nicholas must have arrived *c.* 1178 – he is hardly likely to have been able to complete such a large-scale commission in less than two years.

Within the whole programme it is also possible to see some development of Nicholas's artistic personality. The figure style makes it likely that the scenes were executed in chronological order, beginning with the Nativity and the Annunciation scenes and ending with the Last Judgement panels, with the three scenes of the Crucifixion and its companion panels, perhaps because of their dominant central position, the very last to be completed.[8] In the Annunciation (Plate 289), the figures of both the angel and the Virgin are softly modelled, with draperies drawn in rhythmic, gentle lines, leaving large

areas of plain gilt. In panels which were probably executed later a far more dramatic and far more violent drawing of both the figures themselves and their internal draperies is developed. Among these later panels, the Sacrifice of Isaac in the top register of the central row is one of the most impressive (Plate 290). The sharp rising diagonal of the composition is emphasized by the leaping ram in the lower left corner, and this violent movement is arrested by the opposite diagonal of Abraham's sword caught in mid-action by the angel swooping down. The turmoil of the whole scene is underlined by the massed bunches of folds around the shoulders and the waist of the old man as well as by the rich detail of his head and beard. But even in a scene with far less violent movement, like the Crucifixion, the gentle lines of the earlier panels are replaced by a more vivid contrast of light and shade, and more jagged, sharper lines of internal folds.

Apart from the Klosterneuburg pulpit, the only documented work by Nicholas is the shrine of St Mary at Tournai Cathedral (Plate 294).[9] An inscription on its base, renewed in a very thoroughgoing restoration of the shrine in the late nineteenth century under the direction of the architect L. Cloquet, states that the work was created by Nicholas of Verdun in 1205.[10] It was probably made late in his life. The importance of the Klosterneuburg commission and the maturity of the artist's style by the time it was completed in 1181 would suggest that Nicholas could not have been born much after 1150. Nothing certain is known of him after 1205, and it can only be hypothetical that the Nicholas of Tournai whose son Nicholas was entered in 1217 as a glass painter in the roll of citizens of Tournai was our Nicholas of Verdun.[11]

The unusually small shrine is decorated with an arcade of triple arches, rising to a central point and carried on double columns, of one bay at each end and three bays on each side. The hipped roof – again a rare feature at this time – is decorated with three roundels each side, with scenes in relief: Noli me tangere, Christ in Limbo, and Doubting Thomas on the right, and the Crucifixion, the Flagellation, and the Three Maries at the Tomb on the left. Only the Christ in Limbo and the Three Maries roundels retain much original work: the Flagellation is almost entirely a Late Gothic restoration, and the Noli me tangere and the Doubting Thomas scenes are wholly of the nineteenth century, when the heavy cresting of the roof and its knops, as well as the major part of the decorative enamelling and filigree decoration, were replaced.[12] The clearest evidence of Nicholas's work is to be found in the large figure scenes in the arcades along its sides. At the head, Christ is enthroned between two angels carrying the instruments of the Passion; at the opposite end, the Adoration of the Magi appears. Along the right side the Flight into Egypt, the Presentation in the Temple, and the Baptism are depicted, and on the left side (Plate 294) the Annunciation, the Visitation, and the Nativity. Again, evidence of Late Gothic restoration as well as much detail of the nineteenth century can be seen. Extensive fourteenth-century traces are to be found in the Adoration of the Magi, and modern work includes the angel of the Annunciation, the Joseph and the arms of the Virgin in the Nativity, and the hands of both figures in the Visitation.

Despite so much restoration, in individual well-preserved scenes, like all three on the right side, or the Visitation, Nicholas's remarkable style makes an astonishing impact. Comparison with the Klosterneuburg enamels is difficult because of the long span of

time between them. The quiet, almost classical calm of the early panels in the pulpit and their solid, well-balanced figures are replaced here at Tournai by a loose, fluid structure, an almost transcendental, ethereal quality. The forms of both the Virgin and Elizabeth in the Visitation flow imperceptibly from one to the other, and upward towards their heads, raised in spiritual contemplation. The figures at Tournai bear all the hallmarks of an extremely personal expressive quality, found only rarely in the late work of really great creative personalities. Such beings do not obey any of the rules – they stand some-what apart from the developments of their time. It is also typical of such work that it does not seem to influence that of their contemporaries: the early thirteenth century seems entirely untouched by these remarkable creations, either in goldsmiths' work or in sculpture. Where reflections may be discerned in the sculpture of northern France – at Reims, or in the Job panels on the west front of the cathedral of Paris – it is Nicholas's mature 'classical' style of the eighties, and not his astonishingly personal creations of the Tournai shrine, which might have provided the inspiration.

The comparison with the Klosterneuburg enamels is made difficult not only by the more than twenty years that separate them, but also by the fact that one is attempting to relate two-dimensional to three-dimensional work. And yet the three-dimensional seated prophets on the shrine of the Three Kings at Cologne (Plate 291) can be compared very well to the later panels of the Klosterneuburg ambo. There cannot really be any doubt that Nicholas must have worked in the Cologne Cathedral workshop immediately after completing his work near Vienna in 1181. If any three-dimensional figures can be said to be foreshadowed in Nicholas's enamels at all, they are the prophets of the Cologne shrine. Moreover, they forge an unmistakable and necessary link between the ambo and the Tournai shrine.

The relics of the Three Kings were brought to Cologne by Archbishop Reinald von Dassel as a gift from the Emperor Frederick Barbarossa, who had acquired them at the Conquest of Milan in 1164.[13] According to tradition, the relics were enclosed in the new shrine by Archbishop Philip von Heinsberg, who ruled the see from 1167 to 1191 (Plate 293). Whereas in both the Klosterneuburg ambo and the Tournai shrine there is virtually no evidence of any other hand besides that of Nicholas himself, the huge shrine of the Three Kings, the largest to have survived from the Middle Ages, is clearly not the work of a single master.

The shrine has suffered much in its long history. Its first losses were recorded in 1574 and a restoration took place in 1597. It was most probably again restored in 1749–50 by the Cologne goldsmith J. Rohr, but sustained its most serious damage during the French revolutionary wars in 1794. At that time the original decoration of the roofs of both the 'nave' and the 'aisles' of its basilican structure were destroyed, and in the sub-sequent restoration in 1807 and again in 1820 by W. Pollack and his sons under the direction of F. F. Wallraf the whole shrine was shortened by one bay, and came to look substantially as we see it today. Its original design has been recorded for us in a pilgrim's print published by Schonemann in 1671 and in more detail in the drawings published by Vogel in 1781.[14] Originally on the front of the shrine, and still substantially the same, there was a Christ in Majesty above flanked by angels with the instruments of the

Passion, and in the centre below a seated Virgin and Child, with the Three Magi, titular patrons of the shrine, on her right, and the Baptism of Christ on her left. With the Three Magi, Otto IV is represented. On the back of the shrine (Plate 293), again much as today, Christ is shown above, crowning the martyrs Nabor and Felix. In the inverted triangular pediment below this is a bust of Archbishop Reinald von Dassel. In the centre below the prophet Isaiah (labelled Jeremiah) is represented with the Flagellation on his right and the Crucifixion on his left. On the upper roofs were eighteen scenes from the Apocalypse in three groups of three, each under a triple arch on each side; all these were lost in 1794 together with eighteen scenes in circular medallions from the two lower roofs, again grouped in threes, showing scenes from the life of Christ.

In the original seven bays on each side, the upper register had the twelve Apostles, six each side, with a seraph on the left and a cherub on the right in the centre, under an arcade of semicircular arches on double columns. Below, the same double columns carry triple arches, under which fourteen priests, kings, and prophets of the Old Testament were seated. All the twenty-four surviving figures, although often badly restored, are from the original shrine and only four – those of the one bay lost in shortening the shrine – have been totally lost.[15] Few, however, are in their original positions within their category, and two of the prophets, Habakkuk and Joachim, saved from the lost bay below, have been re-used as St Andrew and St Bartholomew in the upper register.

Stylistically, the shrine is not a homogeneous work. The earliest parts are undoubtedly the decoration of the two long sides. It is especially in the seated Old Testament figures that Nicholas of Verdun's style is most clearly seen. The prophet Habakkuk (Plate 291) shows precisely the kind of strong diagonal movement, with the upper part of the body twisted away from the lower, that characterizes figures like the Abraham in the Sacrifice of Isaac scene on the Klosterneuburg pulpit. Also in the deeply channelled bunched draperies, swept in strong curves about the body, with sudden contrasts of dark shadows and plain highlights and jaggedly cascading falls of cloth, the seated prophet seems a perfect realization of two-dimensional enamels in three-dimensional form. In the heads of the prophets Nicholas has developed a subtlety and insight into human physiognomy which goes well beyond that of the pulpit, where well established human types still, for the most part, predominate.

If there was ever any doubt about when the earliest work by Nicholas on the shrine of the Three Kings was done, a comparison with the Klosterneuburg pulpit proves quite conclusively that it is only after the internal developments towards a more violent and a more personal style had taken place in the pulpit that the magnificent figures of the prophets on the shrine could have been created. Nor can there be any real doubt that Nicholas himself designed the shrine immediately after his return to the Rhineland in 1181. The arcade of the lower register, with its triple arches carried on paired columns, is also used for the first time in the pulpit. Even the unusual and rather odd detail of small, short cylinders above the cushion capitals and below a kind of 'second abacus' is found over the capitals of the Klosterneuburg enamels (Plate 288, detail).[16] Also, the rather fat bases of the columns are similar in both works and have similar spurs at the corners. The decorative enamels on the shrine, however, lack the precision and the

clarity of large-scale motifs that characterize Nicholas's own work on the ambo. These and much other work, including some of the weaker figures, especially among the Apostles, show clearly that assistants played a prominent part in this large-scale effort.

More problematical is the shrine of St Anno, now at Siegburg (Plates 258–60),[17] which was completed in 1183, soon after Nicholas's arrival in Cologne. Of all the contemporary major shrines of the Rhineland, it is the only one to show close links with Nicholas, and indeed it is often attributed to his workshop.[18] While Nicholas's shrine of the Three Kings shows an undoubted advance of style on his great enamelled pulpit, the shrine of St Anno is conceivable only as an earlier phase in the artist's development. If only the major figures on the shrine had survived the evidence might have been clearer, but the figures on the spandrels of the right side and the nude youths enmeshed in the heavy cresting of the roof give the first indication of the kind of free, almost naturalistic handling of form that is developed in the art of Nicholas of Verdun. If indeed the Anno shrine was not completed until the saint's translation in 1183, then what are after all only early moves towards this style make any direct participation of Nicholas out of the question. If, on the other hand, work was begun on the shrine soon after the centenary of St Anno's death in 1175, as has been suggested,[19] it would just have been possible for Nicholas to have been involved in the beginning of the work, before departing for Klosterneuburg. However that might be, no better milieu could be suggested for the training of the young Nicholas than the workshop that produced the Anno shrine, even if that particular shrine is a later product of it. One thing would, however, seem certain: if the shrine was not made until 1181–3, Nicholas had then by far surpassed his masters.

From the year 1181 onwards Nicholas of Verdun played a major part in the sculpture that decorates the sides of the great shrine of the Three Kings. By the time the golden front was made, between 1198 and 1209, his personal participation is no longer clearly in evidence.[20] The Cologne goldsmith responsible for these scenes no doubt learned his craft from Nicholas, but the figures lack the authority of the master. By the time the back of the shrine was completed, probably around 1220–30, the goldsmith's work is no longer in the vanguard of sculptural development, as it had been forty years earlier, but is influenced by and rather weakly follows the trends set by the monumental sculptors of northern France, especially those working at Reims. In the early thirteenth century only Nicholas himself, in his personal work in the Tournai shrine, was able to continue to create in miniature a sculptural idiom which owed nothing to the high achievements of the Gothic masters.

Any attempt to define the sources of Nicholas of Verdun's work is bound to be difficult. There can be no doubt that we are dealing not only with a definable artistic personality, but also with a highly creative one. Nevertheless, the attempt should be made to see his art within the context of the creation of the Transitional style, in which three major sources played a part. The first is the indigenous classicizing tradition of North Western Europe, established since the Carolingian renaissance, fostered particularly in the Mosan area, and fused in the earlier twelfth century with the art of the Rhineland. The second is the art of Byzantium. The problems of Byzantium and the

West are always difficult. The idea that Byzantine art was rigid, never-changing, and hieratic and underwent no development of its own has long ceased to be tenable.[21] Nor is it at all clear what kind of influence was felt in the West. Was it the importation of objects, especially of the sumptuary arts, the effect of travelling Greek artists working in the West, or did western artists travel in the East? At any given time, the attempt should also be made to distinguish between an interest in the 'Byzantine Antique' of the sixth and seventh century, in the classical revival of the tenth-century Macedonian Renaissance, and in Byzantine art contemporary with the events taking place.

The third and perhaps most controversial element in the Transitional style is a possible interest in nature herself. What part did the observation of nature play in the creation of the style? That the observation, indeed the imitation, of nature became of increasing importance during the thirteenth century is demonstrated, for example, by the remarkable figures of the founders in the western choir of Naumburg Cathedral, or by the astonishing display of natural foliage at Reims or in the vestibule capitals of the chapter house of Southwell Minster.[22] Although it is obvious that it did play a part in the creation of these thirteenth-century works, it is more difficult to prove that such observation was a necessary ingredient in the creation of the early Transitional style. Nevertheless, it is equally difficult to believe that the subtle variety of drapery or the, at times, penetrating analysis of human physiognomy and expression in the art of Nicholas of Verdun could have been achieved without a direct reference to the way cloth really falls over the body, or lines are etched into the human face. It was precisely in the seventies of the twelfth century, the very decade during which Nicholas must have received his training, that artists were beginning to turn away from the preconceived patterns of figure and drapery structure, towards an appreciation of the optical rendering of form by light and shade and of accidental elements in the drawing of the figure.[23] It is, in the broadest sense, only against this background that Nicholas of Verdun's achievement can be understood.

However this may be, the first inspiration for artists of the twelfth century who were searching for the means to express a greater degree of humanity in their art was always the classical heritage, both in the indigenous classicizing style of North Western Europe and in renewed contact with the Byzantine classical tradition. In the case of Nicholas of Verdun, the northern classicizing tradition formed the very basis of his art: his style, his iconography, and his technique are all firmly rooted in that fusion of Mosan and Rhenish art of the third quarter of the century. In his enamels at Klosterneuburg, the gilt figures reserved against an enamelled background are basically in the tradition of the Stavelot portable altar, but his drawing of the human nude follows the style set in Mosan enamels of more than a generation earlier.[24] Among the earliest figures at Klosterneuburg, for example the figure of Samson's mother in the Annunciation of Samson, the whole pose, with knees slightly bent and draperies drawn diagonally across the legs, may still be compared to the figure of Caritas on St Heribert's right in the Deutz shrine (Plate 212). Details like the large bulbous bases of columns are clearly derived from the Mosan tradition and appear for example on the Coblenz retable in the Cluny Museum (Plate 208). The background to Nicholas's high skill in champlevé enamelling can

obviously only be found in the Mosan/Rhineland area, and technical details, like the speckled enamel employed as a background to all the paired columns of the framework of the pulpit and elsewhere, strongly suggest his training in that area. His ornamental vocabulary seems largely to be derived from the Heribert shrine workshop – the major workshop in this area early in the second half of the century – and also from a more direct contact with Ottonian traditions.[25]

Ancient western rather than Byzantine traditions also played a major part in the iconographical sources available to Nicholas, and particularly those that became part of the Mosan heritage.[26] These are obvious for example in the diamond-shaped 'halo' behind the cross in the Crucifixion scene, a motif found as a circle behind the crucifixion of St Philip on the portable altar from Stavelot and on the square Mosan plaque in the Hunt Collection, Dublin,[27] and perhaps derived from a diamond-shaped frame of the kind that totally encloses the Crucifixion scene on the Alton Towers triptych in the Victoria and Albert Museum, London (Plate 241). Perhaps the most obvious iconographic link with the Mosan area is Nicholas's use of a strange bird's eye view of Rainer of Huy's Liège font, supported on twelve oxen, for his plaque that illustrates the Brazen Sea below the Baptism of Christ on the Klosterneuburg pulpit. The earliest appearance of the corner motifs of small gilt foliate forms on a blue background in the same panel, which also appear on one decorative plaque on the pulpit and were later to become a very popular form of decoration in the Cologne workshop, also seems to have been derived from the same motif on the Hunt Crucifixion panel in Dublin.[28]

Although in a general sense there can be no doubt that Nicholas learned his craft in the Mosan/Rhineland region, the precise sources of his style are not at all easily documented. The rhythmic, easy movement of his figures and his rich flowing draperies reveal an astonishing degree of classically conceived naturalism far removed from any earlier attempts to break away from the stereotyped patterns of Romanesque classicism. Only in the traditional use of 'shorthand' miniature architectural settings is a strong link with his medieval traditions still to be seen.

Nicholas was, however, not the only artist of his generation to explore new ground in this direction: the Mosan enameller who made the six plaques now in the Diözesan Museum at Vienna, with four scenes from the Old Testament and two personifications of the winds, was clearly working towards a similar solution (Plate 287).[29] His figures, too, have grown in stature; they are easier, and conceived in the round, with rich drapery patterns creating deep shadows and areas of highlights. Even a figure turning away from the spectator, showing only the back of the head – found several times in Nicholas's pulpit – appears in one of the panels behind the figure marking the Tau Cross. The same master must have worked for Frederick Barbarossa, for whom he made two armlets, originally in the Imperial Treasury, which were lost in 1796. The careful drawings made of them by J. A. Delsenbach (d. 1765) show one decorated with the Nativity, the other with the Presentation in the Temple, in a style unmistakably from the same hand as the Diözesan Museum plaques (Plate 250).[30] Even if the figure style may be a little distorted by the eighteenth-century drawings, the border and the carefully copied inscriptions make the attribution a certainty. The shape of these armlets

follows those made earlier for Frederick, probably before 1165, as a gift for the Russian prince Andrei Bogoloubski,[31] but their style places them firmly into the seventies, the generation of Nicholas of Verdun.

Parallel in development to Nicholas as these enamels undoubtedly are, they are clearly not the source for his style. His personal solution was the creation of a drapery style, which has been called the 'Muldenstil' – 'trough-shaped fold' or 'softly-grooved' style.[32] The channelled folds are hollowed out, with a rounded termination to each 'trough'. Indeed, one can see a development towards a richer, deeper, and more rounded form of this style within the Klosterneuburg pulpit itself. In some of the earlier panels, like the Annunciation scenes, the 'troughs' appear only sparingly, and the folds are thin – often only hair lines – and rather sketchy. Later in the programme, for example in the Translation of Enoch, the Ascension, and the Sacrifice of Isaac, the channels are deeper and darker and the 'trough' folds fleshier, with more rounded terminations, as Nicholas realizes the potential of the style more fully. It reaches a peak in the figures on the shrine of the Three Kings; in his late work at Tournai it is much less in evidence, being for the most part replaced by more flowing draperies, with longer, curving lines, multiplied parallels, and fewer terminations.

The style, once developed by Nicholas (and it seems impossible to detect it anywhere in European art before 1180), was to become tremendously influential. In manuscript painting it is found in its purest form in the Ingeborg Psalter,[33] it is very common in stained glass of the late twelfth and early thirteenth centuries,[34] and in major architectural sculpture it was perhaps the most important single stylistic element to be developed in the Île de France and the Champagne, in the sculpture of Sens, Laon, Chartres, Reims, and further afield, and even more obviously, at Strasbourg.[35]

Any discussion of Nicholas of Verdun's sources for this element in his style has invariably invited comparison with Byzantine art, with which there can be no doubt that the West renewed contact in the second half of the twelfth century, with no less important consequences than the development of the 'dampfold' style in the late eleventh century. The full force and effect of this Byzantine influence was, however, to be felt only somewhat later, when reflections of the style of the mosaics of Monreale, created by Greek artists in the 1180s, were to be found in many areas of Europe, as far east as Austria and as far north as England.[36] Byzantine iconography also became enormously influential at that time.[37] Nevertheless there are undoubtedly already Byzantine elements in Nicholas's style. The angel of the Annunciation has been convincingly compared to the angel of the Expulsion from Paradise in the mosaics in the Cappella Palatina at Palermo of c. 1150–60,[38] though this comparison holds true mainly in the rhythmic outline of the angel and not in the interior drawing of it – there is no sign of Nicholas's 'Muldenstil' at Palermo. Some of the main lines of drapery are, however, echoed in Nicholas's angel, and such details as the small breaks of folds just over the knee of the right leg prove a more than coincidental relationship. In the head-types employed by Nicholas, this knowledge of Byzantine types is also obvious – one might almost call it 'general knowledge', and it was already widespread in the Mosan/Rhineland region by the late sixties.[39]

The 'Muldenstil' developed by Nicholas cannot have been the result of contacts with contemporary Byzantine art – and indeed the resemblances to the Palermo mosaics are perhaps of too general a nature to be entirely convincing evidence of such contacts. It is precisely in such stepping poses as that of the angel of the Annunciation that the conservatism and the long-lasting classical tradition of Byzantine art is most clearly demonstrated, and Nicholas of Verdun's knowledge of Byzantine art would indeed seem to have been far wider. The classical, almost majestic calm of some of his figures seems more closely related to the Macedonian renaissance of the tenth century, and indeed elements of the 'Muldenstil' can also be found for example in the figure of Hanah in prayer in the Paris Psalter.[40] But the Macedonian renaissance itself drew most of its inspiration from the so-called Byzantine Antique – the style of the sixth and seventh century. In work of this period, for example in the ivory chair of Maximian at Ravenna, the softly modulated drapery, the swaying poses, and the characterization of heads provide some of the closest parallels to Nicholas's style that can be found.[41] Moreover even earlier Late Antique work should be mentioned. Two small fragments of ivory carved with standing Apostles, probably dating from the early fifth century, in the Victoria and Albert Museum, show how deeply rooted the 'trough' style is in classical Antiquity, particularly the expressive head with wildly curling beard and hair.[42] All these pieces of the Antique, the Byzantine Antique, and even of the Macedonian renaissance provide a background for Nicholas of Verdun's neo-classicism, but none individually can account for his personal style. In the final analysis, his art is compounded of all these factors, besides being deeply rooted in the classicizing northern European tradition. His knowledge of Byzantine art must have been wide, deeply understood, and fully absorbed, no longer merely a source for the piecemeal or superficial adoption of classical motifs, but a means to reach a true understanding of the classical heritage. Only in his generation, when the observation of the natural world began to play a part, however small, was it possible to create a meaningful and real contact with that ancient heritage.

A few other works have been attributed to Nicholas of Verdun or his workshop,[43] but none is really close enough to justify it. Most important among them is the seven-armed candlestick from the Trivulzio Collection, in the cathedral of Milan (Plate 292).[44] It is a large structure, its parts cast in bronze, more than fifteen feet high, on a sixteenth-century base.[45] Nothing is known of its earlier history.[46] Its great foot is made up of four winged dragons with heads on the ground and foliate tails, in which four of the liberal arts – rhetoric, music, geometry, and dialectic – are represented with the four rivers of paradise backing on to them. In each of the four areas between the dragons, enmeshed in rich foliate scrolls, are three signs of the zodiac, two Virtues overcoming Vices, and two scenes from the Old Testament. These scenes symbolize sin (the Fall of Man and the Expulsion from Paradise), obedience (the Ark of Noah and the Sacrifice of Isaac), the elect (Moses and the Burning Bush and the Passing through the Red Sea), and grace (the Coronation of Esther and David slaying Goliath). Above the foot, on a large spherical knop, again in foliate scrolls, appear the seated Virgin and Child, with the Three Kings approaching on horseback. The Old Testament sequence ends with the

story of David, and out of David grows the Tree of Jesse – the symbolic meaning of the whole seven-armed 'tree' which rises above the foot.[47]

More than one master worked on the candlestick. The foliate scrolls in two of the four areas between the dragons differ from those of the other two fields: they are flatter and broader in two, and more detailed, thinner, and more sinuous in the other two. In the former two, the border at the bottom, in which originally gems were set, is edged by a further pearled border which in the latter is omitted. In the broader scrolls, the scenes represented are the Ark of Noah and the Sacrifice of Isaac, and the two Moses subjects. In the thinner, more tense scrolls, the Fall of Man and the Coronation of Esther and David slaying Goliath are shown. The differences in the figure style in these two pairs are of much the same character. In the one, the figures are broader, with larger heads and thicker, less detailed drapery; in the other the figures are more elegant, with smaller hands, more differentiated in character, and tenser, more varied treatment of drapery. The same two masters also made two of the large dragons each, two again with a pearled edge on the border of the foot below the dragon's heads and two without them. The superb large figures of the liberal arts and the rivers of paradise in the dragons' tails again portray clearly the differences between the two masters.

It is normally believed that the tenser, more elegant work is by a somewhat younger master and that earlier elements of style can still be seen in the other, more conservative craftsman.[48] It is true that the figure of geometry, for example, compared to that representing music, is tied more strictly into the plane of the scroll, and even its fairly violent movement is two- rather than three-dimensional, and yet both masters are astonishingly able to lace their figures into the foliate scrolls most intricately, placing the figures vertically into the areas between the dragons, while the scrolls pass them in a rising plane. Nor is the youthful nude river god of the 'conservative' master any less subtle in its appreciation of the human form than that of his more forceful contemporary. In both masters the observation of the human figure must surely have played a part in their artistic training. In the large knop above the foot, with the Three Kings on horseback bound for Bethlehem and the seated Virgin and Christ, the foliate forms are even richer and somewhat heavier. The equestrian figures are varied in their poses and the treatment of the draped figures is again extremely skilful. The heads are not all that different from those of the 'older master', and although it has been thought that a third hand was responsible for this masterpiece, it is not impossible to believe that it is indeed the work of the more 'conservative' man, who was perhaps the older and more experienced head of the workshop.[49]

In the highly naturalistic rendering of the human nude and in the soft and sweeping folds of the draped figures, these craftsmen not merely follow the innovations of Nicholas of Verdun but go well beyond them. They show little direct connexion with his personal style: the iconography of the Old Testament scenes is totally different from the same scenes of the Klosterneuburg pulpit, and none of Nicholas's 'trough' style in drapery appears; nor is the forceful characterization of heads in the shrine of the Three Kings present in the candlestick to the same degree. The heads in the Milan work come much closer to the idealized forms employed by the sculptors of the Île de France in

the late twelfth and early thirteenth centuries at Laon and Chartres, and the rich, thick, flowing drapery of the figures is also better paralleled in such sculpture, especially at Laon, than in the vivid, rippling, and thinly stretched draperies employed by Nicholas.[50]

In the museum at Reims are preserved two fragments of the large foot of a bronze candlestick that provided the model for the Trivulzio candlestick in all the main elements of its design and structure. The same winged dragons with foliate tails and the same elaborately pierced fillings between them made up the base of the candlestick – even the broad bands at the edges decorated with gem settings separated by rectangular fields, perhaps originally set in both pieces with enamelled decorative plaques, are the same.[51] The thicker, more abstract foliate scrolls and the figure style, with flat, overlapping folds, of the Reims fragment must clearly be dated considerably earlier, perhaps as early as the second quarter of the century, and, stylistically, strong English influences have been noted.[52]

In style and origin of design, the Trivulzio candelabrum therefore seems to have strong links with north-eastern France, rather than with the Mosan and Rhineland area, where the art of Nicholas was rooted.[53] But there is also some evidence that it may actually have been produced in northern Italy. The lively small figures of donors on the processional cross preserved in Santa Maria presso San Celso in Milan, much restored in 1539, were probably made by the same workshop. The silver gilt filigree framework of the cross is certainly the work of a North Italian craftsman of the early thirteenth century,[54] and the candelabrum is also likely to be early-thirteenth-century. Work much more directly influenced by the style of Nicholas of Verdun is, not surprisingly, to be found in the Mosan and Rhineland area. The work of the early-thirteenth-century craftsmen on the front and back of the shrine of the Three Kings at Cologne is an obvious and direct example of such influence. Virtually none of the workshops in that area at that time which continued the traditions of twelfth-century goldsmith's work escaped his overpowering influence.

In the eighties of the century, Nicholas of Verdun seems to have created at least one aspect of the Transitional style almost single-handed. When examining the term 'Transitional' and discussing its shortcomings as a term, it was said that it does not form a transition from Romanesque to Gothic, and this is true when one attempts to define the sources of the High Gothic sculpture of Paris or Amiens. The art of Nicholas and his contemporaries at Sens or Laon – or even somewhat later in the transepts at Chartres – did not create the material which might be said to lead logically to the sculpture of the coronation portal of the cathedral of Notre-Dame in Paris, and in this direct and immediate sense the 'Transitional style' does not add up to a transition from Romanesque to Gothic. But before jettisoning the term altogether, it should be remembered that any discussion of transition to Gothic needs a definition of Gothic to make sense. Is the naturalism of Naumburg or Southwell, or the classicism of Reims, not as much part of Gothic as the elegant, 'precious' style of the Apostles of the Sainte-Chapelle or the Vierge Dorée at Amiens? If we were to consider the latter stream of French 'court art' the only basis for a definition of Gothic, would it not be an unwarranted restriction to only one element in the Gothic style, which, incidentally,

would cut off the tributary that leads in the end to the expressive naturalism of Late Gothic? The Gothic style of the thirteenth century is no more one-sided than the Romanesque style of the twelfth century had been. Therefore, in the naturalism of the Transitional style there is, as indeed there is in all styles, an element of transition – the transition from a naturalism of the late twelfth century to a naturalism of the thirteenth century. In the final analysis it represents a transition from one kind of Late Romanesque to one kind of Gothic.

CHAPTER 22

CONCLUSION

THE work of Nicholas of Verdun formed a climax to the twelfth century. His is the case of so many artists of genius – they are not surpassed in the generation that follows them, or indeed even approached in quality. Their work is too overpowering, and at the end of their lives often too personal, to provide a fitting springboard for a new generation. But the phenomenon of Nicholas's achievement was in the end only a symptom of the remarkable revolution which, within the span of a single man's working life, had turned the abstractions of the twelfth century into an awareness of the natural world which had not been seen or felt in Europe since Antiquity. Romanesque art had finally given way to Gothic.

The great shrine of Our Lady at Aachen (Plate 296), begun in 1215 and completed in 1237, and the shrine of St Elizabeth at Marburg, probably completed in 1249,[1] in their general design and structure continue the traditions of the twelfth century, but in their figure style, both in the large fully rounded figures under arcades, and in the reliefs of their roofs, reveal their full acceptance of Gothic forms. Perhaps in the large figure of Charlemagne in the centre of one side of the shrine of St Mary, and to a lesser extent in the Apostles who flank him, and in the figure of Pope Leo III at one end something of the Transitional style can still be seen; indeed these figures were probably made by the master who completed the shrine of Charlemagne at Aachen in 1215, when Frederick II, according to Reiner of Liège,[2] closed the shrine with his own hand (Plate 295).

The relics of the Emperor Charlemagne were raised at Aachen in 1165 in the presence of Frederick Barbarossa, and it is likely that work on his shrine was begun reasonably soon after. The earliest figures, like that of the emperor himself on the narrow front of the shrine, flanked by Pope Leo III and St Turpin, the archbishop of Reims, can clearly be related to the shrine of St Servatius, especially the St Servatius end, made at Maastricht around 1170, or the reliquary of St Candide from the same workshop.[3] The draperies are rather hard, with regular parallel folds pulled across the figure, and the heads are somewhat rigid, with staring eyes. None of these figures has as yet any of the rich and flowing lines of the style introduced by Nicholas of Verdun in Cologne during the eighties. The architectural structure of the Charlemagne shrine, however, with double columns carrying a round-arched arcade set with champlevé enamels, resembles the early work on the shrine of the Three Kings at Cologne, and in the somewhat more richly conceived architectural detail advances beyond it. Among the seated kings and emperors, successors of Charlemagne, eight to each side of the shrine, some, like Henry II or Henry VI, begin to show a richer and more varied style, in keeping with the general developments towards the end of the century.[4] That work continued early into the next is proved by the fact that Otto IV is named 'emperor' in the inscription accompanying him, a title he did not receive until 1209. The latest work on the shrine,

no doubt done shortly before its completion in 1215, is the reliefs on the roof illustrating the life of Charlemagne. In the panel showing Charlemagne presenting the Palace Chapel to the seated Virgin and Child,[5] the style of the master responsible for the later figures of the seated emperors is to be seen, but in others, like Charlemagne receiving the Crown of Thorns, and Charlemagne getting ready for battle,[6] the Gothic style is unmistakable. The relief is sharp, almost angular, and draperies are soft and flowing. Although the quality of these reliefs is far from outstanding, they achieve a subtle illusionistic effect with movement into the third dimension, as well as along the picture plane. The firm pictorial structure of the Romanesque relief has been replaced by a glittering illusion of depth, painted in subtle light and shade.

The shrine of Charlemagne, begun in the formative years of the Transitional style, was completed when the High Gothic style was being fully established in France. Whereas Nicholas of Verdun in the eighties of the century had shown the way to architectural sculptors of his generation, one cannot deny that, compared to the achievements of the Île de France, the goldsmiths working at Aachen and elsewhere at the turn of the century are only of marginal importance in the history of early-thirteenth-century art. Shrines continued to be made in the thirteenth century, often based firmly on twelfth-century traditions, and sometimes, as with the shrine of St Taurinus at Évreux, making use of contemporary architectural inventions to great and delicate effect.[7] But perhaps something fundamental had changed. It is doubtful whether goldsmiths, metal workers, or ivory carvers were ever again to achieve the prominence which they had enjoyed in the early Middle Ages. These men had worked alongside the architect of Durham Cathedral, the sculptors of Autun and Vézelay, and the painters of Berzé-la-Ville and the Winchester Bible and could claim to be their equals. Those who followed them in their crafts in the thirteenth century, and indeed in the centuries thereafter, could never make such a claim again.

LIST OF THE PRINCIPAL ABBREVIATIONS

Art roman (1965)

G. Faider-Feytmans, S. Collon-Gevaert, J. Lejeune, and J. Stiennon, *Art roman dans la vallée de la Meuse aux XIe et XIIe siècles* (Brussels, 1965)

Dodwell (1971)

C. R. Dodwell, *Painting in Europe: 800–1200* (The Pelican History of Art) (Harmondsworth, 1971)

Elbern, I (1962); II (1964); Taf. (1962)

V. H. Elbern (ed.), *Das erste Jahrtausend*, Textbänder I and II (Düsseldorf, 1962 and 1964), and Tafelband (Düsseldorf, 1962)

Falke and Frauberger (1904)

Otto von Falke and H. Frauberger, *Deutsche Schmelzarbeiten des Mittelalters* (Frankfurt am Main, 1904)

Goldschmidt (or G.), I (1914); II (1918); III (1923); IV (1926)

A. Goldschmidt, P. G. Hübner, and O. Homburger, *Die Elfenbeinskulpturen aus der Zeit der karolingischen und sächsischen Kaiser, VIII–XI. Jahrhundert*, I and II (Berlin, 1914 and 1918); A. Goldschmidt, *Die Elfenbeinskulpturen aus der romanischen Zeit XI–XIII. Jahrhundert*, III and IV (Berlin, 1923 and 1926)

Karl der Grosse Exh. (1965)

Karl der Grosse. Exhibition catalogue (Aachen, 1965)

Koehler, I, 1 (1930); I, 2 (1933); II (1958); III (1960)

W. Koehler, *Die karolingischen Miniaturen*, I, *Die Schule von Tours* (Berlin, 1930 and 1933); II, *Die Hofschule Karls des Grossen* (Berlin, 1958); III, *Die Gruppe der Wiener Krönungsevangeliars* (Metzer Handschriften) (Berlin, 1960)

Mon. Germ. Hist., Scrip.

Monumenta Germaniae Historica, Scriptores

Palol and Hirmer (1967)

Pedro de Palol and Max Hirmer, *Early Medieval Art in Spain* (London, 1967)

Schnitzler, I (1957); II (1959)

H. Schnitzler, *Rheinische Schatzkammer*, I, and II, *Die Romanik* (Düsseldorf, 1957 and 1959)

Schramm and Mütherich (1962)

P. E. Schramm and F. Mütherich, *Denkmale der deutschen Könige und Kaiser, Ein Beitrag zur Herrschergeschichte von Karl dem Grossen bis Friedrich II. 768–1250* (Munich, 1962)

Steenbock (1965)

F. Steenbock, *Der kirchliche Prachteinband im frühen Mittelalter, von den Anfängen bis zum Beginn der Gotik* (Berlin, 1965)

H. Swarzenski (1967)

H. Swarzenski, *Monuments of Romanesque Art, The Art of Church Treasures in North-Western Europe*, 2nd ed. (London, 1967)

Volbach (1952)

W. F. Volbach, *Elfenbeinarbeiten der Spätantike und des frühen Mittelalters*, 2nd ed. (Mainz, 1952)

NOTES AND BIBLIOGRAPHY

NOTES TO PART ONE

CHAPTER I

p. 7 1. M. Rickert, *Painting in Britain: The Middle Ages* (Pelican History of Art), 2nd ed. (Harmondsworth, 1965), 13 ff., plates 4, 5, 7.

2. W. Holmquist, *Kunstprobleme der Merovingerzeit* (Stockholm, 1939).

p. 8 3. G. Haseloff, *Der Tassilo Kelch* (Munich, 1951); Steenbock (1965), no. 21. The cover originally came from St Gall, but by 1691 was in the possession of Lindau Abbey, on Lake Constance. After its dissolution in 1803, the cover changed hands a number of times. J. Pierpont Morgan purchased it in 1899 from the Earl of Ashburnham.

4. D. M. Wilson, *Anglo-Saxon Ornamental Metalwork, 700–1100* (London, 1964), 21.

5. The technique is of ancient origin, and was probably first used in the second millennium B.C. in the eastern Mediterranean, when it was employed at the same time as cloisonné inlay, which achieves much the same effect by laying glass or gems cold into the cell-work after being cut to shape (see R. Higgins, *Minoan and Mycenaean Art* (London, 1967), 172). Inlay work, almost always using red garnets, was also very popular in Germanic art, and an especially high level of technical skill was achieved by the Anglo-Saxons in the seventh century (cf. the Sutton Hoo jewellery; R. L. S. Bruce-Mitford, *The Sutton-Hoo Ship-Burial, A Provisional Guide* (London, 1948, and later eds.)). However, very few pieces of cloisonné enamelling, as distinct from inlay, survive between the works of Antiquity and the many pieces which testify to the renewed popularity of the technique in the ninth and tenth centuries.

6. The extreme left-hand gilt-bronze strip may be contemporary with the cover. The lower border, as well as scattered pieces with the same broad arabesque pattern and the right hand strip with the same arabesque engraved instead of enamelled, may date from the restoration of the cover in 1594, when the four corner plaques with the Evangelists, the centre gem setting, and three of the four gem settings in the field were added. Perhaps the manuscript, written at St Gall soon after the middle of the ninth century, was then already at Lindau, and the early cover was added to the back. If the back cover was only added to the book in the late sixteenth century, it might have been an early possession of Lindau which was founded between 810 and 820 – a very possible date for the cover, perhaps a foundation gift. See also pp. 65–6, Chapter 5.

7. The casket, known as the 'Caja de las Agatas', was given to Oviedo by Count Fruela II and his wife Nunilo in 910, as is shown by an inscription on its base. See V. H. Elbern, 'Ein fränkisches Reliquiar Fragment in Oviedo, die Engerer Burse in Berlin und ihr Umkreiss', *Madrider Mitteilungen*, II (1961), 183 ff. It is difficult to suggest what this plaque was originally. It has been called a 'brooch', and Elbern believes it to be a fragment from a reliquary. Without removing it from the casket and examining its back, no further progress can be made. Most of the gems, especially the three large central gems, are later replacements.

8. See jewellery found at Sutton Hoo (Bruce-Mitford, *op. cit.*, 50 ff. (chapter VIII)).

9. A circular Langobard brooch found near p. 9 Imola seems technically very close to the plaque; see J. Werner, *Langobardische Fibeln aus Italien* (Berlin, 1950), plate 36, C.I.

10. Y. Hackenbroch, *Italienisches Email des frühen Mittelalters* (Basel, 1938), 14. Dr Hackenbroch believes the Gisulf mount to be a Byzantine import (reproduced in M. Rosenberg, *Geschichte der Goldschmiedekunst auf technischer Grundlage*, III (Frankfurt am Main, 1922), Abb. 17, 17a). The piece is in the Museo Civico, Cividale. A drawing of it is reproduced in *Burlington Magazine*, XXIV (1914), 89.

11. The history of Byzantine enamelling is also far from clear, but its existence in the sixth century seems to be proved by the small reliquary of the True Cross, now at Poitiers, in the convent of the Holy Cross. Its hinged wings were lost during the French Revolution, but are known from an eighteenth-century drawing (Rosenberg, *op. cit.*, 16 ff., figures 31–3). In A.D. 569 Queen Radegund, who founded the convent, asked Justin II for a relic of the True Cross, and her wish was granted. The documentary evidence for the date of the relic has never been doubted, but the enamelled setting of

the reliquary has been dated as late as the tenth century. Not only is the design of the enamelling as difficult to parallel in the tenth century as in the sixth, but it is also difficult to see how a relic in the possession of Poitiers in the sixth century could have been mounted in Byzantium in the tenth. For details see D. T. Rice, *The Art of Byzantium* (London, 1959), 304, plate 70.

p. 9 12. V. H. Elbern, 'Der Adelhausener Tragaltar', *Nachrichten des deutschen Instituts für merovingische und karolingische Kunstforschung*, VI–VIII (1954), 6 ff.

13. J. Braun, *Der christliche Altar*, I (Munich, 1924), 419 ff.

p. 10 14. See J. Werner, 'Eine merovingische Scheiben-fibel mit Grubenemail aus Oberpöring', *Münchner Jahrbuch für bildende Kunst*, 3. Folge, V (1954), 23–8.

15. For the most complete list, see J. Braun, *Die Reliquiare des christlichen Kultes und ihre Entwicklung* (Freiburg im Breisgau, 1940), 163 ff., 198 ff.

16. See J. Hubert, 'Les Cryptes de Jouarre', *IVe Congress de l'art du haut moyen âge, 1952* (Melun, 1952).

17. See E. Hegel, *Werdendes Abendland am Rhein und Ruhr*, exhibition catalogue (Essen, 1956), map on p. 86, and pp. 83 ff.

p. 11 18. F. Henry, *Irish Art in the Early Christian Period (to 800 A.D.)* (London, 1965), 99 ff., plates 33, 34, and M. and L. Paor, *Early Christian Ireland* (London, 1964), 164 ff., plates 20, 21, 58–61, 65–7.

19. Elbern, Taf. (1962), no. 286.

20. See for example the burse-reliquary in the treasury of Saint-Maurice d'Agaune of the eighth century (see Elbern, Taf. (1962), no. 292).

21. J. Baum, *La Sculpture figurale* (Paris, 1937), plate 34, and *Karl der Grosse Exh.* (1965), no. 223, plate 22.

22. See J. de Borchgrave d'Altena, 'Reliefs carolingiens et ottoniens', *Revue Belge d'Archéologie et d'Histoire de l'Art*, XXIII (1954), figure 7.

23. J. Hubert, *Bulletin de la Société Nationale des Antiquaires de France* (1958), 98–102.

24. See C. A. Ralegh Radford, in C. F. Battiscombe (ed.), *The Relics of St Cuthbert* (Durham, 1956), 326 ff.

p. 12 25. See pp. 26–7, Chapter 2, and H. Schnitzler, 'Die Komposition der Lorscher Elfenbeintafeln', *Müncher Jahrbuch der bildenden Kunst*, 3. Folge, I (1950), 26 ff.

26. See also Elbern, *op. cit.* (Note 7), for an attempt to divine a Christian iconographical meaning in such animal ornament.

27. For a similar indiscriminate use of colour, however, see the small bronze brooches of the ninth century (Dinklage, *op. cit.*, colour plate and p. 2). They are sometimes known as 'Kettlach type' (see D. M. Wilson, *op. cit.* (Note 4), 37).

28. See M.-M. Gauthier, *Rouergue roman* (La Pierre-qui-Vire, 1963), 143–4, plate 60; J. Taralon and H. Jullien, 'La nouvelle présentation du trésor de Conques', *Les Monuments historiques de la France*, I (1955), 129.

29. Paris, Bib. Nat. lat. 12048 folio 143 verso; see J. Porcher, 'La Peinture provinciale', in Braunfels and Schnitzler (ed.), *Karl der Grosse*, III, *Karolingische Kunst* (Düsseldorf, 1965), plate XXIII.

30. For details of its later history, see p. 56, Chapter 4, and p. 132, Chapter 10.

31. Goldschmidt, I (1914), nos, 1, 2. p. 13

32. B. Bischoff, in a lecture delivered in London, mainly on the basis of palaeographic evidence in the inscriptions. See also Steenbock (1965), no. 13. The eyes are inlaid with glass, which is found again in the Harrach diptych, which might be attributed to the Court School (see Note 78, Chapter 2).

33. Trier, Stadtbib. cod. 31; first pointed out by Goldschmidt, I (1914), 9, Abb. 5.

34. *Karl der Grosse Exh.* (1965), no. 492.

35. See pp. 26–7, 30, Chapter 2.

36. See A. Boeckler, 'Formgeschichtliche Studien zur Adagruppe', *Bayerische Akademie der Wissenschaften, Abhandlungen* (*Phil. Hist. Klasse*), N.F., XLII (1965), 30.

CHAPTER 2

1. F. Kreusch, 'Kirche, Atrium und Portikus', in p. 14 Braunfels and Schnitzler (ed.), *Karl der Grosse*, III, *Karolingische Kunst* (Düsseldorf, 1965), 463–533. See 469, note 24, for older literature. Also E. Lehmann, *ibid.*, 301–19, and G. Bandmann, *ibid.*, 424–62.

2. For the Godescalc Pericopes (Paris, Bib. Nat. nouv. acq. lat. 1203), see Dodwell (1971), 25, 27, and Koehler, II (1958), 22 ff. For the Egino Codex

(Berlin, Staatsbib. MS. Phill, 1676), see *Karl der Grosse Exh.* (1965), no. 459. For the Cividale paintings, see H. Torp, 'Note sugli affreschi più antichi dell'oratorio di S. Maria in Valle a Cividale', *Atti del 2º Congresso Internazionale di Studi sull'Alto Medioevo* (Spoleto, 1953), 81–93.

3. B. Bischoff, 'Die karolingische Minuskel', in *Karl der Grosse Exh.* (1965), 207–10.

4. The Palace Chapel has been said to be based on early centrally planned buildings of a great variety of purposes including baptismal churches, churches dedicated to the Virgin, copies of the Holy Sepulchre in Jerusalem, 'martyria', 'reliquary' or 'burial' churches, and palace chapels. All this overlooks the obvious fact that Charlemagne had actually seen San Vitale at Ravenna, and must surely have had that church in mind when asking his architect to build his chapel. (See Lehmann, *op. cit.*, 303, 306, and W. Schöne, 'Die künstlerische Gestalt der Pfalzkapelle Karls des Grossen in Aachen', *Zeitschrift für Kunstgeschichte*, XV (1961), 97 ff.)

5. See H. Schnitzler, 'Das Kuppelmosaik der Aachener Pfalzkapelle', *Aachener Kunstblätter*, XXIX (1964), 1 ff.

6. Einhard (ed. S. Painter), *The Life of Charlemagne* (University of Michigan, 1960), 54.

p. 15 7. Einhard, *op. cit.*, 54.

8. In excavations in the Katschhof in 1911. See W. Braunfels, 'Karls des Grossen Bronzewerkstatt', in *Karolingische Kunst (op. cit.)*, 168.

9. W. Meyer-Barkhausen, 'Ein karolingisches Bronzegitter als Schmuckmotiv des Elfenbeinkelches von Deventer', *Zeitschrift für bildende Kunst*, LXIV (1930/1), 244 ff.

10. See Goldschmidt, I (1914), no. 152, and pp. 26–31 below.

11. Probably actually a bear, but known in the Middle Ages as a wolf. It is a Roman bronze of the fourth–fifth century, thought to have been brought to Aachen by Charlemagne. (See Schramm and Mütherich (1962), no. 5.)

12. See Braunfels, *op. cit.*, 192 ff. The lion handles of the Wolf's Door and the St Hubert chapel have lost their rings.

p. 16 13. Cesena, Biblioteca Malatestiana; see W. F. Volbach, *Early Christian Art* (London, 1961), no. 108.

14. For the Ascension ivory in Munich, Bayerisches Nationalmuseum, see Volbach (1952), no. 110. For the British Museum casket, *ibid.*, no. 116.

15. The pine-cone has been thought to be: (1) Antique, with Ottonian base; (2) Carolingian, with Ottonian base; (3) altogether Ottonian; (4) Antique, with Carolingian base. For the last and most recent view, see H. Cüpper, 'Der Pinienzapfen im Münster zu Aachen', *Aachener Kunstblätter*, XIX/XX (1960/1), 90–3. The inscription in four lines reads as follows:

Dant orbi latices quaeq incrementa gerentes
Fersilis Eyfrades Velox ut missile Tygris
Phison auriferis Gehon sed mitior undis
Aucton grates canit Udabrich prüs abbas

(The second half of the fourth line does not survive, but is recorded; the third line is entirely a nineteenth-century restoration.)

16. The fact that the base is believed to have been cast separately would not alter this fact substantially – both pieces are hollow casts.

17. The attribution of the cone to Antiquity seems entirely unacceptable. The cast is far too rough, and the shape of the leaves out of proportion to the size of the object when compared with classical examples. Also the small pattern on the lowest row of leaves seems far too crude for the work of classical Antiquity, and entirely in keeping with a Carolingian adaptation of a classical motif.

18. The Antique bronze itself has survived, and is now mounted in front of the Belvedere Palace in the Vatican, where it was placed during the rebuilding of St Peter's in the sixteenth century. See Cüpper, *op. cit.*

19. See V. H. Elbern, 'Liturgisches Gerät in edlen Materialien', in *Karolingische Kunst (op. cit.)*, 116 ff.

20. See Elbern, *op. cit.*, 124, for references. Also R. Hausherr, *Der tote Christus am Kreuz* (Bonn, 1963), 34.

21. Others have connected this cross with the p. 17 gifts made to St Peter's by Pope Leo III (795–816) or Leo IV (847–55), listed in the *Liber Pontificalis*. Professor G. Zarnecki has kindly informed me of the existence of a drawing of it, made before its destruction, in Rome, Vatican Library (MS. Barb. lat. 2733), where it is described as a gift of Pope Leo III. This late evidence is, of course, not proof of the original donor, but does at least support its early date.

p. 17 22. New York, Pierpont Morgan Library MS. 1. See pp. 65–6, Chapter 5.

23. The same style is also found on the Crucifixion page in the Coronation Sacramentary of Charles the Bald (Paris, Bib. Nat. MS. lat. 1141, folio 6 verso); see A. Grabar and C. Nordenfalk, *Early Medieval Painting* (Lausanne, 1957), 155.

24. Hausherr, *op. cit.*, 32.

25. K. Wessel, 'Die Entstehung des Crucifixus', *Byzantinische Zeitschrift*, LIII (1960), 95–111.

p. 18 26. Schramm and Mütherich (1962), no. 58. See also F. Mütherich, 'Die Reiterstatuette aus der Metzer Kathedrale', *Studien zur Geschichte der europäischen Plastik* (T. Müller Festschrift) (Munich, 1965), 9–15.

27. Volbach (1952), no. 48.

28. H. Hoffmann, 'Die Aachener Theoderichsstatue', in Elbern, I (1962), 318–35.

p. 19 29. The question whether it represents Charlemagne or one of the later Carolingian emperors will probably never be answered with certainty. Its alleged likeness in style to the later Carolingian 'Metz' School is not so close as to be convincing; in fact, its style is no less comparable to the ivories of the cover of the Dagulf Psalter, made before 795 at the Court School (see below, p. 28). Against this must be weighed Schramm's doubts about the use of the orb before the reign of Charles the Bald (P. E. Schramm, *Sphaira. Globus. Reichsapfel* (Stuttgart, 1958), 57–9). But see also J. Deér, 'Der Globus des spätrömischen und byzantinischen Kaisers', *Byzantinische Zeitschrift*, LIV (1961), 53 ff., 291 ff.

30. Einhard, *op. cit.*, 50.

31. Schramm and Mütherich (1962), no. 163.

32. For the ewer, see below, p. 23 and Plate 22. For the Avar treasure, see H. Fichtenau, *The Carolingian Empire* (Oxford, 1963), 80, and again below, p. 23. A Sassanid bowl now in the Cabinet des Médailles, Bibliothèque Nationale, Paris, might also have been acquired by Charlemagne with the same treasure (see A. Kollautz, 'Die Awaren', *Saeculum*, V (1954), 143).

p. 20 33. Schramm and Mütherich (1962), no. 57.

34. E. Panofsky, *Abbot Suger* (Princeton, 1948), 72.

35. *Ibid.*, 192.

36. Schramm and Mütherich (1962), no. 27. For illustration see P. E. Schramm, *Die deutschen Kaiser und Könige in Bildern ihrer Zeit* (Leipzig and Berlin, 1928), no. 18, or J. Hubert, J. Porcher, and W. F. Volbach, *L'Empire carolingien* (Paris, 1968), figure 296.

37. D. M. Wilson, 'An Inlaid Iron Folding Stool in the British Museum', *Medieval Archaeology*, I (1957), 39–56, figure 14.

38. The back, with its main ornament in three circles, may be in direct imitation of the ancient chair of St Peter in Rome (see P. E. Schramm, *Herrschaftszeichen und Staatssymbolik* (Mon. Germ. Hist., Scrip., XIII/3), III (Stuttgart, 1956), 694–707). Unfortunately, this wooden throne, decorated with ivory, has suffered so much alteration and restoration over the centuries that one cannot be certain that this particular feature of it is indeed as ancient as the core of the chair. Schramm believes the chair to be in the main of Carolingian date (*c.* 870), with earlier fragments re-used. Other details on the throne of Dagobert, like the little symmetrical plant motif on the two upper arms of the crossed members on the front and back (see plate 30, Abb. 37b, in Schramm, *op. cit.*, I (1954)), near the large round bosses at the centres, look typically Carolingian, and can be found in the manuscripts of the Court School, for example in the 'Initium Evangelii' page of the Arsenal Gospels above the centre stroke of the 'N' of Initium (see Koehler, II (1958), plate 19a).

39. Perhaps Charles the Bald acquired it with the p. 21 imperial treasure when he became Emperor in 875, and subsequently gave it to Saint-Denis. (See also the 'Escrain de Charlemagne', below, p. 24.)

40. Paris, Bib. Nat. fr. 10440. See *Karl der Grosse Exh.* (1965), 31–2, no. 9. The drawing, perhaps life-size, measures 28 cm. by 20·5 cm. (about 11 by 8 in.).

41. See also Bégon's reliquary in the treasury of the abbey of Conques, p. 56, Chapter 4.

42. In the Soissons Gospels, Lorsch Gospels, and p. 22 Harley Gospels, for example: see Koehler, II (1958), plates 54, 81, 105. Against this see A. Boeckler, 'Formgeschichtliche Studien zur Adagruppe', *Bayerische Akademie der Wissenschaften*, XLII (1956), 26–8, who sees eastern manuscripts as sources.

43. See Koehler, II (1958), plates 38, 39, 43, 54, 59, 75, 80, 84.

44. Jewellery other than Late Antique was also used. Very clear imitations of Frankish garnet inlay jewellery are obvious for instance in the Lorsch Gospels (see Braunfels (ed.), *The Lorsch Gospels* (New York, 1967), folio 26 verso and 27, 29, etc.).

45. See *Karl der Grosse Exh.* (1965), no. 557, and especially Bl. de Montesquiou-Fezensac, 'Le Talisman de Charlemagne', *Art de France*, II (1962), 66 ff.

46. See p. 193, Chapter 17, and p. 218, Chapter 18.

47. A. Grabar, *Les Ampoules de Terre Sainte* (Paris, 1958).

p. 23 48. Elbern, *op. cit.* (Note 19), 166–7.

49. A. Alföldi, 'Die Goldkanne von Saint-Maurice d'Agaune', *Zeitschrift für schweizerische Archaeologie und Kunstgeschichte*, X (1948), 1–27.

50. See H. Arbman, *Schweden und das karolingische Reich* (Stockholm, 1937), 151–2, 159, and plate 50:2.

51. Alföldi, *op. cit.*, 5 ff.

52. See for example the pieces illustrated by M. Rosenberg, *Geschichte der Goldschmiedekunst auf technischer Grundlage, Zellenschmelz*, III (Frankfurt, 1922), 22 ff.

p. 24 53. R. W. Hamilton, *Khirbat-al-Mafjar, An Arabian Mansion in the Jordan Valley* (Oxford, 1959), plates XX, 3; L, 1.

54. Schramm and Mütherich (1962), no. 47.

55. See H. Schiffers, *Karls des Grossen Reliquienschatz und die Anfänge der Aachenfahrt* (Aachen, 1951), 30.

56. Sir W. Martin Conway, 'The Abbey of Saint-Denis and its Ancient Treasures', *Archaeologia*, LXVI (1914–15), 128.

57. Schiffers, *op. cit.*, 82.

58. J. Hubert, 'L'Escrain dit de Charlemagne', *Cahiers Archéologiques*, IV (1949), 71 ff.

59. D. Du Cange, *Glossarium Mediae et Infimae Latinitatis* (Niort, 1885), IV, under 'gypseae' [Fenestrae].

p. 25 60. As a reliquary, the form of this object seems to have remained unique: we know of no later examples of such a splendid structure. The filling of a precious metal structure with thin plaques of moonstone is represented in the illumination showing St Erhard celebrating Mass in the Uta Codex (Munich, Bayr. Staatsbib. lat. 13601),

where the ciborium above the saint is painted to appear filled with thin semi-precious stone plaques. The manuscript was illuminated for the Abbess Uta of Regensburg between 1002 and 1025 (for colour reproduction see D. Talbot Rice (ed.), *The Dark Ages* (London, 1965), 313). The accuracy of the representation of the Arnulf Ciborium of the imperial treasure may be taken to suggest that this large ciborium also is accurately represented.

61. The one at the top consists of three letters: J(?).F.D.

62. See for example E. Steingräber, *Antique Jewellery: Its History in Europe from 500 to 1900* (London, 1957), figures 98, 46, 44, 77.

63. Steingräber, *op. cit.*, 141, figures 253, 251, etc. Only Moliner has suggested that these pearls were not Carolingian – he believed them to be fourteenth-century.

64. No special veneration of the Virgin existed at Saint-Denis – another reason for seeing it as a work originally intended for Aachen?

65. See below, p. 62, Chapter 5. p. 26

66. Goldschmidt attributed nearly forty carvings to the 'Ada' group and its influence (I (1914), nos. 1–39). The group is named after the Court School of manuscripts, which was known as the 'Ada' School (after the Trier MS. cod. 22 of the group), before being re-named 'Court School' by Koehler in *Miniaturen*, II (1958). Relatively few ivories, however, can be really closely linked with the Court School.

67. Steenbock (1965), no. 14, Abb.

68. The type is the one with full-length figures to p. 27 each side of the centre panel (e.g. Barberini diptych, Paris). The sloping frame at top and bottom is not known in the Late Antique models, but it might be noted that breaks frequently occur at this point, because the ivory is weakened by the groove and tongue joint. See, for example, the Barberini diptych itself, the diptych in the treasury at Milan (Steenbock (1965), no. 5), and many others. In the case of the back cover, it may be that the top panel with the flying angels (and possibly the lower panel with the Adoration of the Kings also) is a sixth-century original re-used by the Carolingian carver, as first suggested by R. Morey. The lower, plain frame of this panel is broken to each side of the centre, and a part of the angel on the left's right foot is missing. It may be that the large panels with standing angels had to be carved with rising edges

to fill these 'breaks'. The style of this panel certainly understands the articulation of the figure better than the larger figures, and would, if it is a sixth-century original, define the source of the style precisely.

p. 27 69. H. Schnitzler, 'Die Komposition der Lorscher Elfenbeintafeln', *Münchner Jahrbuch für bildende Kunst*, 3. Folge, I (1930), 26 ff.

70. Volbach (1952), no. 140. Much has been written about the origin of Maximian's chair, and the style of the various craftsmen, trained in different traditions, who worked on it. Perhaps it was made at Constantinople, where craftsmen from many parts of the Eastern Empire could have been assembled, although one cannot rule out the possibility that Maximian called such carvers to Ravenna.

71. Steenbock (1965), no. 9.

72. See below, p. 32.

p. 28 73. Schramm and Mütherich (1962), no. 11.

74. Koehler, II (1958), plates 40a, 100b, 102a.

p. 29 75. Goldschmidt, I (1914), no. 11a.

76. Possible exceptions are the square plaques with Christ and two Evangelist symbols (Goldschmidt, I (1914), nos. 32–4) and the fine diptych from the Harrach Collection, now on loan to the Schnütgen Museum, Cologne (see *Karl der Grosse Exh.* (1965), no. 527). The interesting inlay of blue glass in the eyes of the figure reappears in Insular ivories of the early eleventh century and Spanish ivories of the eleventh and twelfth centuries. This technique is probably of Antique origin, and is used also on the Genoels-Elderen plaques (see above, p. 13, Chapter 1, and below, p. 152).

77. Goldschmidt, I (1914), no. 10.

p. 30 78. J. Deér, 'Ein Doppelbildnis Karls des Grossen', *Wandlungen christlicher Kunst im Mittelalter*, II (Baden-Baden, 1953), 414 ff.

79. *Karl der Grosse Exh.* (1965), no. 519.

80. Volbach (1952), nos. 112, 113.

81. Goldschmidt, I (1914), no. 24; O. M. Dalton, *Catalogue of the Ivory Carvings . . .* (London, 1909), no. 42.

p. 31 82. *Karl der Grosse Exh.* (1965), no. 532, plate 100.

83. The only exception to this is the controversial Andrews Diptych in the Victoria and Albert Museum, London, in which many scholars see yet another Carolingian imitation. Stylistically, the Andrews Diptych is certainly not at all closely related to the Court School, but much, especially in its iconography, still stands in the way of accepting it as a fifth-century original. It is, for example, difficult to see how a quatrefoil could have been used in the pediment of the building in the scene of the Healing of the Leper, in the fifth century. For full discussion and bibliography see Steenbock (1965), no. 16.

84. Volbach (1952), no. 108.

85. K. Wessel, 'Das Mailänder Passionsdiptychon, ein Werk der karolingischen Renaissance', *Zeitschrift für Kunstwissenschaft*, V (1951), 125 ff. See also Steenbock (1965), no. 6.

86. In the same spirit of imitation, one more ivory object should be mentioned. It is a circular box in the British Museum, cut as a cross-section from a tusk, which is believed to have served as a pyx, to preserve the consecrated host (Dalton, *op. cit.*, no. 43). It is the only Carolingian example of a type of container of which many examples decorated with secular as well as Christian subjects have survived from the Early Christian period (Volbach (1952), nos. 89–106, 161–201). Its style, again no doubt related to the Court School, is all the same too crude to have been produced during the period of its greatest achievements, or, if at the same time, then not at its main centre. It is likely to be an example produced along with other pieces of less polished quality, under the influence of the emperor's workshop, some in other centres, others perhaps in the next generation under less illustrious patronage. There is little reliable evidence that helps us either to date or to give a provenance to pieces in this group.

87. Koehler, III (1960). The group used to be p. 32 known as the 'Palace School' (see for example R. Hinks, *Carolingian Art*, London, 1935), but was re-named by Koehler 'the group of the Vienna Coronation Gospels'. See Dodwell (1971), 28–9.

88. Schramm and Mütherich (1962), no. 13; Dodwell (1971), plates 25, 26. See also J. Porcher's very interesting suggestion that this group was painted for Louis the Pious during Charlemagne's lifetime (J. Hubert, J. Porcher, W. F. Volbach, *op. cit.*, (Note 36), 92 ff.).

89. In 802 an embassy from the Empress Irene appeared at the court at Aachen, and in the same year Charles sent an embassy to Constantinople also. Perhaps these friendly negotiations resulted in an introduction of Greek artists. (See W. Ohnsorge, *Das Zweikaiserproblem im früheren Mittelalter* (Hildesheim, 1947), 15 ff.)

CHAPTER 3

p. 33 1. H. Fichtenau, *The Carolingian Empire* (Oxford, 1963), 80 ff.

2. Thegan, *Vita Ludovici Imperatoris* (*Mon. Germ. Hist., Scrip.*, ii); G. H. Pertz, 'Thegani "Vita"', in R. Rau, *Quellen zur karolingischen Reichsgeschichte*, I (1956), 213 ff.

3. The table had engraved on it, among much else, a map of the world, and is described as being 'triple in the manner of three shields joined in one' – probably a table with two hinged leaves. The table was later cut up into small pieces by Lothar I, to pay his nobles for their military support against his brothers Charles the Bald and Louis the German. (See Schramm and Mütherich (1962), 92.)

p. 34 4. Koehler, II (1958), 70 ff. The manuscripts belonged to the Imperial Chapel, not to the Emperor personally. (See J. Fleckstein, *Die Hofkapelle der deutschen Könige*, I (Stuttgart, 1959), and Schramm and Mütherich (1962), 22.)

5. Koehler, I (1930/3), 259 ff.; Dodwell (1971), 32.

6. Nordenfalk, in A. Grabar and C. Nordenfalk, *Early Medieval Painting* (Lausanne, 1957), 147.

7. Elbern, Taf. (1962), nos. 220–2; Dodwell (1971), 30 ff. The whole beginning of the 'Reims' style and its centre of production is still somewhat mysterious; important though it is, one cannot attempt a detailed discussion of it here. Broadly, the attribution of the school to Reims is based on only the most slender and circumstantial evidence. The Ebbo Gospels were produced by Ebbo's friend, Abbot Peter, at Hautvilliers, and it is strange that one of the major books of the school should have been illuminated at Hautvilliers, if a famous scriptorium was then in existence at Reims.

8. D. Panofsky, 'The Textual Basis of the Utrecht-Psalter Illustrations', *Art Bulletin*, xxv (1943), 50 ff.

9. Dodwell (1971), 32, mentions the Terence manuscript from Reims now in Paris (Bib. Nat. MS. lat. 7899) as evidence of Late Antique source material; it is artistically not of a high standard, and seems to be a copy of the second half of the ninth century, only slightly influenced by the Utrecht Psalter style – surprising in itself if Reims was at the centre of the style. (See J. Hubert, J. Porcher, W. F. Volbach, *L'Empire carolingien* (Paris, 1968), figures 172–3.)

10. L. Delisle, *Le Cabinet des Manuscrits de la* p. 35 *Bibliothèque Impériale*, I (Paris, 1868), 4–5.

11. F. Wormald, *The Utrecht Psalter* (Utrecht, 1953).

12. Goldschmidt, I (1914), nos. 40–6.

13. See Dodwell (1971), 40, and below, p. 63, Chapter 5.

14. Although the measurements vary between p. 36 14·2 cm. (5½ in.) and 11·2 cm. (4⅜ in.) in height and 9·5 cm. (3¾ in.) and 8·3 cm. (3¼ in.) in width, they all come very close to about 13·5 by 8·5 cm. Moreover, the book-covers which they were used to decorate later vary very considerably in size.

15. In this case, the fact that the wooden front board still carries an indentation of the size of the ivory makes the link convincing (Goldschmidt, I (1914), no. 46).

16. With a 4 cm. (2 in.; metalwork?) border for mounting the panels, the measurements seem to fit remarkably well for an arrangement in which the smaller panels surround the larger, thus:

17. Discussion by O. K. Werkmeister, *Der Deckel des Codex Aureus von S. Emmeram* (Baden-Baden and Strasbourg, 1963), 14, 58, 62, 65. Other references are given. I am not convinced by the geometric arguments. The iconographic discussions are not affected if the assumption is correct that the ivory existed *before* the book was written. The Crucifixion on the back must have been rare? For the convincing suggestion (by H. Schnitzler) that the ivory decorated the front of the manuscript, kept in a book-box which now survives as the cover of the manuscript, see Steenbock (1965), no. 20. The front cover of this manuscript is one of the richest surviving book-covers of the ninth century (Plate 55) (see p. 63, Chapter 5).

18. See *Karl der Grosse Exh.* (1965), no. 506, plate p. 37 88, and Volbach (1952), no. 110.

19. Goldschmidt considered this group to be an 'outrunner' of the Liuthard style and therefore later than *c.* 860–70.

20. Goldschmidt, I (1914), no. 139.

p. 37 21. It probably came to Munich from Bamberg, and may therefore have been part of the imperial treasury, given to Bamberg by Henry II (*Karl der Grosse Exh.* (1965), no. 506, plate 88).

22. Goldschmidt, I (1914), no. 140.

23. The type is also found, presumably at the same time, in the Utrecht Psalter. See R. Hausherr, *Der tote Christus am Kreuz zur Ikonographie des Gerokreuzes* (Bonn, 1963), especially chapters v and VII.

24. It may have appeared on a panel that made a pair with the Munich Ascension. Hausherr, *op. cit.*, 143, believes it to be Carolingian invention.

25. Goldschmidt, I (1914), nos. 136, 131. The Ascension panel has been attributed to the tenth century (H. Swarzenski (1967), figure 34), but the copy of this panel now in the Schnütgen Museum, Cologne (*ibid.*, figure 35), clearly a work of the later tenth century, strongly supports the attribution of the Vienna panel to the ninth century.

p. 38 26. *Ibid.*, 36, 46 ff.

27. Both iconography and style prove conclusively the direct influence of the Vienna Treasury Gospels or its model on the small group of Gospels including the Cleve Gospels (Berlin, Preuss. Staatsbib. theol. lat. fol. 260), the Loisel Gospels (Paris, Bib. Nat. lat. 17968), and the Blois Gospels (Paris, Bib. Nat. lat. 265). See Dodwell (1971), 33, and J. Porcher, 'Les Manuscrits à peinture', in Hubert, Porcher, and Volbach, *op. cit.* (Note 9), 121.

28. V. H. Elbern, 'Liturgisches Gerät in edlen Materialien', in Braunfels and Schnitzler (ed.), *Karl der Grosse*, III, *Karolingische Kunst* (Düsseldorf, 1965), 122 ff.

p. 39 29. For example in the surviving fragment of the 'Escrain de Charlemagne' (Plate 24), p. 25, Chapter 2.

30. See p. 50, Chapter 4 (Plates 46–8).

31. K. H. Usener, 'Zur Datierung der Stephansbursa', in *Miscellanea Pro Arte* (Festschrift Schnitzler) (Düsseldorf, 1966), 40, note 8.

32. An exceptionally large cross (158 m., or just over 5 ft, high) closely related to Insular work, especially the Ormside Bowl in the York Museum. See *Karl der Grosse Exh.* (1965), no. 553, plate 107.

33. See Elbern, *op. cit.* (Note 28), 121–2. One must agree with Elbern that the Cross of St Eligius, of which a fragment survives in the Bibliothèque Nationale in Paris, cannot be the one represented mounted over the golden altar in the fifteenth-century painting of 'The Mass of St Gilles' in the National Gallery, London.

34. Elbern, *op. cit.*, 122, plate XXXI. See also p. 72, Chapter 6.

35. Usener, *op. cit.* (Note 31), 37–43.

36. See p. 11, Chapter 1.

37. For the core, see H. Fillitz, 'Neue Forschungen zu den Reichskleinodien', *Österreichische Zeitschrift für Kunst und Denkmalpflege*, XII (1958), 80–4. The cresting is a restoration of the fifteenth century.

38. Charlemagne also owned an important p. 41 relic of St Stephen given him by Pope Leo III in 799; see H. Schiffer, *Karls des Grossen Reliquienschatz . . .* (Aachen, 1951), 15.

39. See the analysis of the style by Usener, *op. cit.*, 37 ff.

40. *Ibid.*, 43.

41. See p. 49, Chapter 4.

42. See Schramm and Mütherich (1962), no. 23.

CHAPTER 4

1. M. Meurisse, *Histoire des evesques de l'église de* p. 43 *Metz* (Metz, 1634), 685.

2. Both Weber and Goldschmidt attempt a reconstruction of the correct sequence of the scenes. See L. Weber, *Einbanddeckel, Elfenbeintafeln, Miniaturen, Schriftproben aus Metzer liturgischen Handschriften*, I (Metz and Frankfurt am Main, 1913). Goldschmidt, I (1914), no. 74, follows Lenormant, *Trésor de numismatique et de glypt*, I (Paris, 1836), 13 ff.

3. Koehler, III (1960), 105 ff., 143 ff. p. 44

4. Steenbock (1965), no. 46.

5. Goldschmidt, I (1914), no. 72.

6. Traditionally it is associated with Louis the Pious (see Koehler, III (1960), 124 ff.). For the framework see p. 128, Chapter 10.

7. See also the obvious Late Antique influence in the astronomical MS., Madrid, Bib. Nac. cod. 3307 (Koehler, III (1960), 119 ff.).

8. The devil points to stones on the ground and invites Christ to turn them into bread (Matthew 4, 1–4); cf. Steenbock (1965), no. 18.

p. 45 9. Schramm and Mütherich (1962), no. 113; Steenbock (1965), no. 32. The MS., according to Mütherich, is mid-ninth-century, late Court School of Charlemagne (Mainz?). An inventory of 1743 of Bamberg treasury (to which it was probably given by Henry II) states that the back cover has an ivory carving showing the Crucifixion. This is perhaps an error, or the present ivory was added later to the MS. It is certainly a pair with the front Baptism, and of the same size. The goldsmith's work of the frame adds to the difficulties. Usener has rightly seen strong Carolingian elements in its style (*Kunstchronik*, II (1949), 248) – could it therefore be part of its original decoration of mid-ninth-century date? Alternatively, but perhaps less convincingly, it could have been added when Henry II gave it to Bamberg.

10. A. Boeckler attempted to date the Munich panel to the late tenth century (*Phoebus*, IV (1948/9), 145), but see Nordenfalk's entirely convincing analysis attributing it to the middle of the ninth century in 'Der Meister des Registrum Gregorii', *Münchner Jahrbuch*, III (1950), 73.

11. Goldschmidt, I (1914), 46 ff.

12. Steenbock (1965), no. 33. The Veste Coburg book-cover (Goldschmidt, I (1914), 87), dated 860 by Mütherich, may be another; see Schramm and Mütherich (1962), no. 63.

13. Koehler, III (1960), 103 ff., 128 ff. The cover has always been thought to be a tenth-century one. The highly complicated assumption was that this tenth-century cover was put on a mid-ninth-century manuscript, perhaps in the eighteenth century, while the ivory panel making a pair with it, now on the front of the tenth-century MS. lat. 9390, was moved from the back to the front of this manuscript. (See Goldschmidt, I (1914), no. 83.)

p. 46 14. See p. 22, Chapter 2.

15. R. Hausherr also dates the Crucifixion panel to *c.* 850, mainly on the basis of iconographic evidence (see *Der tote Christus am Kreuz* (Bonn, 1963), 118).

16. On p. 36, Chapter 3.

17. The scene of the Three Maries at the Tomb, which does not appear on this panel, is represented in other panels in this group (Goldschmidt, I (1914), nos. 86, 89). The iconography of this scene is in part linked with the same Liuthard Crucifixion panel in Munich, and even more closely with the Liverpool Crucifixion panel of the 'Court School' of Louis the Pious.

18. Schramm and Mütherich (1962), no. 25.

19. Goldschmidt, I (1914), no. 155. See also L. E. A. Eitner, 'The Flabellum of Tournus', *Art Bulletin*, Supplement I (New York, 1944). The fan itself is illuminated in a rather rough style related to both Tours and Metz (see Eitner, *ibid.*, 2 ff.).

20. E. Martène and U. Durand, *Voyage littéraire* p. 47 *de deux Bénédictins*, I (Paris, 1717), 231.

21. Eitner prefers a date of *c.* 836-40, when the community lived at Grandlieu, mainly because St Maxentiolus, who had a comparable position at Cunault to that which St Valerianus enjoyed at Tournus, is also absent (*op. cit.*, 13). The dedication to the Virgin, also patron of Cunault, and the possible identification of IOHEL with Abbot Gelo must be weighed against this. The connexion with Tours remains the same in both cases.

22. Volbach (1952), nos. 80, 81, 82.

23. Now in the cathedral treasury at Chur. See Volbach (1952), no. 89.

24. Goldschmidt, I (1914), no. 158.

25. An ivory panel, sometimes thought to be actually a Late Antique piece of the fifth century, may well also belong to this group. It shows the Denial of St Peter in the centre, and acanthus decoration above and below. It is preserved in the Museo Nazionale, Florence (Volbach (1952), no. 231). The rich acanthus foliage of the upper and lower panels certainly has much in common with these ivories, and the very close imitation of the Antique, which is a characteristic of the central scene of the Denial of St Peter, is typical of the inspiration of this whole group.

26. Goldschmidt, I (1914), nos. 156-7.

27. Goldschmidt, I (1914), nos. 183, 184, suggests 'oriental, 7th-8th century'.

28. See pp. 61-2, Chapter 5. p. 48

29. This was not the end of the affair. Lothar took up the fight again later and continued it until his death in 869.

30. Schramm and Mütherich (1962), no. 31. p. 49

31. For the extraordinary later history of the crystal until it was fished out of the river Meuse in the middle of the nineteenth century, see O. M. Dalton, 'The Lothar Crystal', *Archaeologia*, LIX (1904), 35.

32. See, for example, the Marmoutier Sacramentary of Abbot Raganaldus, now at Autun (Koehler, I (1930/3), plate 68b).

p. 49 33. The legend reads:
 XPE ADIUVA HLOTHARIUM REG[EM].

34. See p. 101, Chapter 9.

35. E. Babelon, *Histoire de la gravure sur gemmes en France* (Paris, 1902), 28, plate III.

36. See, for this and other examples, J. Baum, 'Karolingische geschnittene Bergkristalle', in *Frühmittelalterliche Kunst in den Alpenländern* (Olten and Lausanne, 1954), 111–17.

p. 50 37. For full bibliography see *Karl der Grosse Exh.* (1965), no. 559.

38. Angilbert's letter proving the commission to have been given in 835 has been shown to be a twelfth-century forgery. See N. Tarchiani, 'L'Altare d'oro di Sant'Ambrogio di Milano', *Dedalo*, II (1921/2), 14.

39. J. Braun, *Der christliche Altar*, I (Munich, 1924), 5, 9, 560 ff.

40. Three on the right, the Resurrection, Ascension, and Pentecost, and one on the left, the Transfiguration, were restored after 1598, when those parts of the altar were stolen.

41. See V. Elbern, 'Der Ambrosiuszyklus am karolingischen Goldaltar von Mailand', *Mitteilungen des Kunsthistorischen Institutes in Florenz*, VII (1953), 1 ff.

p. 51 42. It is possible that the top was originally carried on four slim columns at the corners. A representation of the altar is almost certainly to be seen on the twelfth-century stucco decoration in the crypt at Civate. The ciborium in the same church, also of stucco, made by the same craftsmen, is a copy of the tenth-century ciborium at Milan, and therefore the sculptors no doubt knew the golden altar in its original form.

43. G. B. Tatum, 'The Paliotto of S. Ambrogio in Milan', *Art Bulletin*, XXVI (1944), 25–45.

44. The extensive fresco cycle of St John at Müstair may well be of this date, but remains controversial; see L. Birchler, in *Frühmittelalterliche Kunst in den Alpenländern* (Olten and Lausanne, 1954), 167–252, and *Karl der Grosse Exh.* (1965), no. 658.

45. See p. 36, Chapter 3.

p. 52 46. See p. 37, Chapter 3.

47. See G. B. Tatum, *op. cit.*, who was the first to draw attention to this iconographic peculiarity.

48. See especially the iconographic connexion between the ivory bucket from the Basilewski Collection, now in the Victoria and Albert Museum, London, and the diptych in the treasury of Milan Cathedral (p. 93, Chapter 9).

49. John 9:6–7.

50. A. Grabar and C. Nordenfalk, *Early Medieval Painting* (Lausanne, 1957), 96.

51. O. Morisani, *Gli Affreschi di S. Angelo in Formis* (Naples, 1962), plate 10 (story of the hermits St Paul and St Anthony).

52. *Ibid.*, plate 25.

53. See p. 144, Chapter 12.

54. Christa Ihm, *Die Programme der christlichen* p. 53 *Apsismalerei vom vierten Jahrhundert bis zur Mitte des achten Jahrhunderts* (Forschungen zur Kunstgeschichte und christlichen Archäologie, IV) (Wiesbaden, 1960), 5–21.

55. *Ibid.*, 130–2.

56. *Karl der Grosse Exh.* (1965), no. 50.

57. H. Buchthal, 'Byzantium and Reichenau', in *Byzantine Art – A European Art* (Athens, 1965) (lectures given at the ninth Council of Europe Exhibition, Athens, 1964), 45–60.

58. One possibility still remains: that the Middle Byzantine cycles are themselves derived from Early Christian cycles which have not survived.

59. E. H. Kantorowicz, 'The Carolingian King in the Bible of San Paolo fuori le Mura', in K. Weitzmann and others (eds.), *Late Classical and Medieval Studies in Honor of Albert Matthias Friend Jr* (Princeton, 1955), 287 ff.

60. W. F. Volbach, *Early Christian Art* (London, 1957), nos. 110–15.

61. Volbach (1952), nos. 112, 113. p. 54

62. For the enamelling tradition, going back into the sixth century, see Y. Hackenbroch, *Italienisches Email des frühen Mittelalters* (Basel, 1938), 11 ff.

63. Where enamelling appears at all, as in the pieces mentioned in Chapter 1, I have tried to show that it must be based on links between North Italian and Merovingian art.

64. The small bronze-gilt reliquary casket discovered in excavations in the crypt of the church of St Vitus at Ellwangen is of interest in this connexion. Stylistically it is closely related to the Milan altar, and seems to be an example of the influence of the altar north of the Alps, *c.* 850. (See V. H. Elbern,

'Liturgisches Gerät in edlen Materialien', in Braunfels and Schnitzler (ed.), *Karolingische Kunst*, III (Düsseldorf, 1965), 139.) The iconography is said to include a representation of the seven planets (see W. F. Volbach, 'Das Ellwanger Reliquienkästchen', in Burr (ed.), *Ellwangen, 764–1964* (Ellwangen, 1964), 767); but could it be St Felicitas and her seven sons?

65. V. H. Elbern, *Der karolingische Goldaltar von Mailand* (Bonn, 1952), 25 (qualified later on p. 27).

66. See p. 45.

p. 55 67. See Chapter 8. For the school of Spanish enamelling of the early tenth century, under strong Italian influence, see Chapter 6.

68. Hackenbroch, *op. cit.*, 15–16.

69. *Ibid.*, 16–18.

70. If no other proof were forthcoming that cloisonné enamelling is fundamentally a technique introduced from the Christian East, this little cross helps to provide it. The whole shape of the cross, its size and function as a reliquary, and every detail of its iconography can be paralleled by a type of small pectoral reliquary, usually made of bronze, found in very large numbers in the Byzantine world from the sixth century onwards. (See M. von Bárány-Oberschall, 'Byzantinische Pektoralkreuze aus ungarischen Funden', *Forschungen zur Kunstgeschichte und christlichen Archäologie*, II (1953), 207–51.)

71. H. P. Mitchell, 'An Enamel of the Carolingian Period from Venice', *Archaeological Journal*, LXXIV (1917), 122–31, plate 1.

72. Schramm and Mütherich (1962), no. 39.

p. 56 73. On p. 12, Chapter 1.

74. The jewelled central horizontal strip on the back, the silver strips under the arcade, and the gold strip at the top are all of thirteenth-century date. See also p. 132, Chapter 10.

75. One might add that the obvious difficulty the goldsmith had who added the figures of the Crucifixion in allowing the niches to remain, though they perform no obvious function in the present design, also speaks for an adaptation in the eleventh century of an earlier core.

76. For the ninth-century attribution see Cabrol and Leclerq, *Dictionnaire d'architecture chrétienne*, III (1948), 2570 ff.; and for the eleventh-century, M.-M. Gauthier, *Rouergue roman* (La Pierre-qui-Vire, 1963), 141–2.

77. M. Pobé and J. Roubier, *The Art of Roman Gaul* (London, 1961), plate 76; A. Boëthius and J. B. Ward-Perkins, *Etruscan and Roman Architecture* (Pelican History of Art) (Harmondsworth, 1970), plate 187.

78. Cabrol and Leclerq, *op. cit.*, III (1948), 2573. p. 57

79. If the reliquary had been made for Bégon III (1087–1106) it would be surprising to find this addition to it so soon after its manufacture.

80. The paleography of the inscriptions has been compared to the fragmentary inscription surviving on the edge of the strange piece known as the 'A' of Charlemagne (Gauthier, *op. cit.*, 140, plate 52). The resemblance between these two inscriptions is undeniable, but a ninth-century rather than an eleventh-century date seems far more likely for both. The 'A' of Charlemagne is certainly for the most part decorated by embossed work, and particularly filigree, of the eleventh century, but that is no reason to suppose that it could not originally have been given by Bégon I, who is again named in the inscription. Early fragments are also found on it.

81. Schramm and Mütherich (1962), no. 44.

82. This is a comparatively rare motif. Although it is also known in the tenth and eleventh centuries, its form on the fibulas looks far more like the Milan altar example than the later versions. In the later versions, for example on the Gisela Cross in Munich, or the Imperial Altar Cross in the Vienna Treasury, the corrugations are much smaller and less distinct. Broader corrugations, more like those on the fibulas, are found on the Gauzelin chalice and the Sion book-cover in the Victoria and Albert Museum, both earlier-tenth-century pieces, in more direct contact with North Italian ninth-century traditions.

83. Folios 107 verso and 108 recto. p. 58

84. V. H. Elbern, 'Liturgisches Gerät ...' (*op. cit.*, Note 64), 136.

85. A. Merati, *Il Tesoro del duomo di Monza* (Monza, 1963).

86. See p. 51. See also the Ardenne Cross (Plate 36), p. 38, Chapter 3.

87. The small votive cross known as Agilulfo's Cross, also in the Monza treasury, and probably of the sixth century, is one; the Castellani brooch in the British Museum is another. (See D. Talbot Rice (ed.), *The Dark Ages* (London, 1965), 164, figures 21, 22.)

CHAPTER 5

p. 60 1. Schramm and Mütherich (1962), no. 52.

2. *Ibid.*, 130, no. 43.

p. 61 3. See p. 36, Chapter 3.

4. See D. M. Wilson, *The Anglo-Saxons* (London, 1960), figure 62.

5. One other book-cover should be mentioned here. The Gregorian Sacramentary in the Monza treasury has a cover decorated by two ivory panels surrounded by silver borders that have reminded scholars of the frames of Charles's Psalter (see Steenbock (1965), 89, no. 25). Certainly the handling of the heavy pearled wire panels is strongly reminiscent of the back cover of the Psalter. The Sacramentary itself is said to be of the late ninth century and the purely decorative ivories have been connected with St Gall or thought to be North Italian. In view of the connexion between late work at Charles's Court School and St Gall (to be discussed later), could this be a late work by one of the early goldsmiths employed by Charles, who worked in the seventies or eighties at St Gall?

6. B. de Montesquiou-Fézensac, 'A Carolingian Rock Crystal from the Abbey of St Denis', *Antiquaries' Journal*, XXXIV (1954), 38 ff.

7. Other important gifts transferred from Aachen to Saint-Denis by Charles the Bald included an important series of relics taken in 876, especially the Crown of Thorns, a nail from the Crucifixion, and a particle of the Holy Cross (see H. Schiffers, *Karls des Grossen Reliquienschatz und die Anfänge der Aachenfarht* (Aachen, 1951), 30). Along with these, Charles may well have given other parts of the Imperial Treasure to Saint-Denis, including the Throne of Dagobert and his 'Escrain de Charlemagne', discussed on pp. 20–1 and 24, Chapter 2.

8. The British Museum crystal is usually reproduced in reverse (for example in O. M. Dalton, *Catalogue of Engraved Gems in the British Museum* (London, 1915), no. 561), photographed from the curved 'cabochon' side of the gem instead of from the flat side from which it is meant to be seen.

9. O. K. Werckmeister, *Der Deckel des Codex Aureus von St Emmeram* (Studien zur deutschen Kunstgeschichte, CCCXXXII) (Baden-Baden and Strasbourg, 1963), 74–5. See also iconographic reasons given by A. M. Friend, 'Carolingian Art in the Abbey of St Denis', *Art Studies*, I (1923), 67–75.

10. For a short summary of the history of the abbey see S. McKnight Crosby, *The Abbey of St Denis, 475–1122*, I (Yale, 1942), 74 ff.

11. *Annales Bertiniani*, a. 876 (ed. Waitz, 132–4). p. 62

12. Suger's *De rebus in administratione sua gestis*, published by E. Panofsky, *Abbot Suger on the Abbey Church of St Denis* (Princeton, 1946), 60 ff., 179.

13. The fullest inventory of Saint-Denis, written in 1634 and in part based on an early-sixteenth-century inventory, has not been published in full. Three manuscripts of it survive: Bib. Nat. MSS. fr. 4611 and 18765, and in the Archives Nationales LL. 1327. See Sir W. M. Conway, 'The Abbey of Saint Denis and its Ancient Treasures', *Archaeologia*, LXVI (1914–15), 103 ff. For the painting see M. Davies, *Early Netherlandish School* (National Gallery Catalogue) (London, 1945), 72–4, no. 4681.

14. To take only one small example from those already quoted by Sir W. M. Conway (*op. cit.*), 135, the halo of the Christ in Majesty is described in the inventory as follows: Twenty-eight garnets, as well as three large sapphires, four plasmas and sixteen very fine pearls; also on the Cross of the nimbus, eight garnets, two plasmas and two knobs set with garnets; also eighteen more pearls. On the painting, however, we find only seven settings, a border of pearls(?), and three gems forming the cross.

15. The three additional sides of the altar provided by Suger in the twelfth century (see Panofsky, *op. cit.*, 60 ff.) were either left around the altar below and are covered up in the painting by the altar cloth, or were dismantled before the date of the painting.

16. J. Schlosser, *Schriftquellen zur Geschichte der karolingischen Kunst* (Vienna, 1896), no. 1003.

17. The inventory is, of course, mainly concerned p. 63 with the value of gems, and small plaques of decorative enamel of this kind might easily have been ignored by the compilers.

18. It should also be remembered that the frontal is seen on the painting in its early-sixteenth-century condition. Certain jewel settings, for example the triple gems joined by three pearls in the spandrels of the three main arches, look very like fourteenth-century additions.

19. For example 'Theodelinda's Crown' at Monza Cathedral Treasury. Very similar votive crowns also appear in the Codex Aureus (Munich, Clm. 14000), for example on each side of the seated Charles on folio 5 verso, but they are not at all

common in Carolingian manuscripts before this time. Again, only at the very beginning of the Carolingian period, when contact with Italy was strong, do we find them in any numbers, for example in the Evangelist portraits of the Cuthbert Gospels (Vienna, Nat. Lib. cod. 1224). Indeed, a fifth-century Italian manuscript is thought to have been the model for the Cuthbert Gospels. (D. Wright, 'The Codex Millenarius and its Model', *Münchner Jahrbuch der bildenden Kunst*, 3. Folge, xv (1964), 37 ff.)

20. *Annales Bertiniani*, a. 865 (ed. Waitz, 80).

21. Perhaps it seems less likely that he should have made the gift to Saint-Denis at a time when it was in his mind to establish his own new foundation at Compiègne.

22. Schramm and Mütherich (1962), no. 52. Now in Munich, Bayr. Staatsbib. Clm. 14000.

23. For a discussion of this and later restorations, see Werckmeister, *op. cit.*, (Note 9), 10–15, and Steenbock (1965), no. 20.

24. See p. 36, Chapter 3.

25. Now in Munich, Bayr. Staatsbib. Clm. 4452 (Steenbock (1965), no. 50).

p. 64 26. The subjects are: top left: Christ and the Adulteress; top right: the Expulsion of the Money-lenders from the Temple; bottom left: Healing of the Leper; bottom right: Healing of the Blind Man.

27. The earlier literature, which attempted to group the Milan altar with the Codex Aureus cover, the Arnulf Ciborium, and the Lindau book-cover as products of the Reims School (G. Swarzenski, 'Die karolingische Malerei und Plastik in Reims', *Jahrbuch der preussischen Kunstsammlungen*, XXIII (1902), 81–100), can no longer be supported. See Werckmeister, *op. cit.*, 74–5.

28. Paris, Bib. Nat. lat. 1 and lat. 9385, both produced under Abbot Vivian (843–51). See Werckmeister, *op. cit.*, 25.

29. The origin for this motif is to be found in the Vienna Treasury Gospels.

30. Koehler believes these buildings are based on a lost model (*Miniaturen*, 1, 2 (1933), 271). Evangelists with buildings are also known in later monuments, no doubt influenced by Charles's Court School or its models, for example on the Gauzelin book-cover in Nancy Cathedral (see p. 85, Chapter 8), the Innichen Gospels (late-ninth-century(?), Innsbruck Univ. Lib., cod. 484), and

more especially the one surviving Evangelist relief on Henry II's pulpit at Aachen. (See p. 125, Chapter 10.)

31. 'Rex Arnulfus amore Dei perfecerat istud ut fiat ornatus sc . . . tibus istis quem Christus cum discipulis componat ubique' (Schramm and Mütherich (1962), no. 61).

32. This is the normally accepted theory. See p. 65 *ibid.*, 138 and no. 61.

33. See p. 21, Chapter 2, and p. 56, Chapter 4.

34. Now in the Pierpont Morgan Library, New p. 66 York, MS. 1. See Steenbock (1965), no. 21.

35. Goldschmidt, 1 (1914), no. 8.

36. The flat, 'cabbage-like' acanthus is rare in goldsmiths' work. The only other at all similar example known to me is the large trefoil brooch of the Hon treasure found in Norway. This is attributed to a Carolingian workshop (see H. Arbman, *Schweden und das karolingische Reich* (Stockholm, 1937), 151, plate 48:1). It is also remarkably similar to the frame of the ivory panel with the Crucifixion and other scenes, now in Narbonne Cathedral (Goldschmidt, 1 (1914), no. 31). This curious panel has features, such as the pearled border around the Cross, that suggest that it is copied from a metal-work model. Its date and provenance are doubtful, but the highly individual (eclectic?) quality of its style might lead one to see some kind of connexion with the Court School of Charles the Bald; certainly the crucified Christ is dependent on the Court School of Charlemagne only to a slightly greater degree than the Christ on the Lindau cover. A link with the Court School of Charlemagne is also to be found in manuscript illumination, where in a border of the Lorsch Gospels, exactly the same strange 'cabbage-like' leaf appears. (See Koehler, II (1958), plate 114a.)

37. Paris, Bib. Nat. lat. 9383; see p. 45, Chapter 4.

38. The date of the Lindau manuscript itself, which has been attributed to St Gall, is given as soon after the middle of the century, which seems to be somewhat too early for the cover, which must surely be later than the covers of Charles's Psalter in Paris (Bib. Nat. lat. 1152).

39. The inscription on a metal mount on the foot, now lost, is recorded: 'Hoc vas, Christe, tibi [devota] mente dicavit tertius in Francos [sublima] regime Karlus.' It was probably added by Abbot Suger in the twelfth century. See Panofsky, *op. cit.* (Note 12), 76, 202.

p. 67 40. See p. 58, Chapter 4.

41. Goldschmidt, I (1914), nos. 111–14. Goldschmidt attributes them to a 'branch of the Metz School'.

42. These patterns are indeed related, as Goldschmidt already pointed out, to late Metz ivories, like the casket at Brunswick (*ibid.*, no. 96).

43. See for example the hexagonal inner frame of the folio at the beginning of the Gospel of St Matthew in the Codex Aureus, illustrated by Schramm and Mütherich (1962), no. 261.

44. *Ibid.*, no. 250.

CHAPTER 6

p. 69 1. See Goldschmidt, I (1914), 38–9 and nos. 81–119. Of these, according to Goldschmidt, nos. 99–101, 109–114, 116, and 119 are only more or less related to the Metz School. Goldschmidt dates the earliest of them late-ninth-century and the majority of them ninth–tenth-century.

2. See p. 45, Chapter 4.

3. Goldschmidt, I (1914), nos. 85, 86, 87, 88, 89, 100, 115.

4. *Ibid.*, nos. 92, 96.

5. *Ibid.*, no. 84, now mounted as the front cover of Bib. Nat. lat. 9390.

p. 70 6. There are four Crucifixions in the Utrecht Psalter, on folio 51 verso, folio 67, folio 85 verso, and folio 90. The side knot appears on folio 85 verso and probably (though not clearly) on folio 90. Folio 51 verso has the central knot and folio 67 the long colobium. See also R. Hausherr, *Der tote Christus am Kreuz* (Bonn, 1963), 111 ff.

7. Another instance of this connexion between the Court School of Charles the Bald and Metz is the placing of the personifications of the sun and moon above each other on the upper part of the Cross, which occurs only on the later Lindau book-cover and the two panels in the Victoria and Albert Museum, London (Goldschmidt, I (1914), nos. 85, 88).

8. Schramm and Mütherich (1962), no. 27.

9. Gospels from Gandersheim, now in Veste Coburg, MS. 1. The frame was added in 1555. The manuscript, closely related to the group of manuscripts connected with Archbishop Drogo, was later given to King Aethelstan (924–38) by his brother-in-law Otto I; see Schramm and Mütherich (1962), no. 63.

10. See p. 78, Chapter 7.

11. Typical of this fully developed tenth-century style is the panel in Nancy Cathedral (Goldschmidt, I (1914), no. 137) or that at Heiligenkreuz (*ibid.*, no. 122).

12. *Ibid.*, no. 108.

13. There may be a small element of influence at work here from ivories in the earlier Reims style like the British Museum panel with the Wedding at Cana. For further discussion of this style, see p. 79, Chapter 7.

14. Now in Würzburg, Universitätsbib., M.P. theol. fol. 65. Goldschmidt, I (1914), no. 82; Steenbock (1965), no. 26. For further discussion see p. 78, Chapter 7.

15. Goldschmidt, I (1914), no. 163; Steenbock p. 71 (1965), no. 23.

16. See detailed discussion in Goldschmidt, I (1914), no. 163, and E. T. De Wald, 'Notes on the Tuotilo Ivories in St Gall', *Art Bulletin*, XV (1933), 202–9.

17. See E. Staedel, *Ikonographie der Himmelfahrt Mariens* (Strasbourg, 1935), 16 ff.

18. *Mon. Germ. Hist.*, *Scrip.*, *rev. merov.*, IV, 263, 293.

19. De Wald, *op. cit.*, 85.

20. Goldschmidt, I (1914), no. 164.

21. *Ibid.*, nos. 125, 126, 127.

22. See p. 37; Goldschmidt, I (1914), nos. 131, p. 72 140.

23. As pointed out by Goldschmidt, *ibid.*, 63, Abb. 23.

24. H. Schlunk, 'The Crosses of Oviedo', *Art Bulletin*, XXXII (1950), 91–114.

25. *Ibid.*, 96–8. The comparative rarity of filigree in the eighth century may be no more than a sign of our comparative ignorance of personal jewellery in a century when grave goods no longer give us the rich information we have for the seventh century.

26. See p. 58, Chapter 4.

27. See p. 39, Chapter 3.

p. 73 28. See Agilulfo's Cross, Monza Treasury (p. 269, Note 87), or the Visigothic Guarraza Treasure, Madrid Archaeological Museum. Similar crosses are also represented on stone (Bishop Boethius's tomb slab, Carpentras, of 604) or in manuscripts (Gellone Sacramentary, Paris, Bib.

Nat.). (See D. Talbot Rice (ed.), *The Dark Ages* (London, 1965), 164, 180, 205, 206.)

29. See p. 8, Chapter 1.

30. See p. 11, Chapter 1.

31. See p. 38, Chapter 3. The Ardenne Cross has double lobes at the ends of the arms, while the Oviedo Cross is trilobed.

32. Schlunk, *op. cit.*, 103.

NOTES TO PART TWO

CHAPTER 7

p. 77 1. J. Fleckstein, *Die Sächsisch-Salische Hofkapelle* (Stuttgart, 1966).

2. See G. Barraclough, *The Origins of Modern Germany*, 2nd ed. (Oxford, 1948), 101. Also H. Löwe, 'Kaisertum und Abendland in ottonischer und frühsalischer Zeit', *Historische Zeitschrift*, CXCVI (1963), 529–62, and K. F. Werner, 'Das hochmittelalterliche Imperium im politischen Bewusstsein Frankreichs', *Historische Zeitschrift*, CC (1965), 1–60, especially 43–60.

p. 78 3. See Thietmar of Merseburg, *Chronik* (ed. W. Trillmich) (Berlin, 1966), book I, 3–33.

4. A. Grabar and C. Nordenfalk, *Early Medieval Painting* (Lausanne, 1957), 159.

5. A. Boeckler, *Abendländische Miniaturen* (Berlin, 1930), 42.

6. F. Mütherich, 'Observations sur l'enluminure de Metz', in O. Pächt (ed.), *Essais en l'honneur de Jean Porcher* (1963), 47–62.

7. H. Usener, in *Kunst und Kultur im Weserraum, 800–1600*, Corvey exhibition catalogue (Münster in Westfalen, 1966), 464 ff.

8. Universitätsbib., M. P. theol. fol. 65; see p. 70, Chapter 6.

9. Steenbock (1965), no. 26, p. 103, makes the point that the termination on the right is arbitrarily cut off. The smaller filigree scroll at the end would argue against this and would suggest that the design was adjusted to the smaller area available at the edge.

10. Goldschmidt, I (1914), nos. 81, 102, 103, 104, 105, 107, 108, 118.

p. 79 11. See p. 87, Chapter 8.

12. Dodwell (1971).

13. Goldschmidt, I (1914), nos. 58, 59–62; Schramm and Mütherich (1962), no. 101.

14. K. Weitzmann, 'Eine Fuldaer Elfenbeingruppe', in *Das Siebente Jahrzehnt* (Berlin, 1935), 14–18. Far less convincing is the homogeneity of the whole group assembled by Weitzmann.

15. In an earlier publication of the casket, M. p. 80 Creutz believed that only parts of the very tightly wound, more three-dimensional filigree dated from the early thirteenth century. He attributed the 'sprouting' kind of filigree to the tenth century, including all the metalwork of the back of the casket (*Zeitschrift für christliche Kunstgeschichte*, XXI (1908), 202 ff.).

16. This use of heavy wire may certainly be compared to the ninth-century tradition on the cover of Charles the Bald's Psalter (Paris, Bib. Nat. cod. lat. 1152) (Plate 30) and the North Italian book-cover of the early tenth century in the cathedral at Monza (Steenbock (1965), no. 25), and with parts of the Utrecht book-cover (ibid., no. 86), which was assembled in the twelfth century from earlier material. The round corner bosses on this cover, especially, may well be of early date.

17. See Goldschmidt, I (1914), 32, Abb. 16–18, for drawings.

18. *Ibid.*, no. 63. A modern copy of the comb is published in *ibid.*, no. 64.

19. A. Merton, *Die Buchmalerei in St Gallen vom neunten bis zum elften Jahrhundert* (Leipzig, 1912), plate XXIII, nos. 1, 2.

20. H. Thümmler, 'Karolingische und ottonische Baukunst in Sachsen', in Elbern, II (1964), 883. At Halberstadt, begun 965 (p. 882), the alternation appears to have been a highly sophisticated rhythm of a, b, a, c, a, b, a – hardly likely to be the earliest use of it. Unfortunately the excavation results are not as clear as we would like them to be.

21. Goldschmidt, I (1914), no. 147.

p. 81 22. In view of the connexion we have seen be-
tween our ivories and St Gall, it is of interest to
note that Boeckler also found strong links in orna-
ment between Fulda and St Gall (see A. Boeckler,
Der Codex Wittekindeus (Leipzig, 1938), 25).

23. For bibliography see Schramm and Mü-
therich (1962), no. 101.

24. Another strong and direct link might be seen
in the similarity of the Apostle figures on our cas-
ket to the figures of the Virgin and St John of the
late-ninth-century(?) book-cover, perhaps from
Reims (Steenbock (1965), no. 75).

25. See the analysis by H. Swarzenski, 'The Role
of Copies in the Formation of the Styles of the
Eleventh Century', in *Romanesque and Gothic Art*
(Studies in Western Art, 1) (1963), 7–18.

26. Goldschmidt, 1 (1914), nos. 67a, b and nos.
52–5. Nos. 44 and 45 probably also belong to this
group.

CHAPTER 8

p. 83 1. For a discussion of Theophanu's relationship
to the imperial family see F. Dölger, 'Wer war
Theophanou', *Historisches Jahrbuch*, LXII (1949),
546 ff.

2. An older theory, held by F. Bock and later by
A. Weixlgärtner ('Die Weltliche Schatzkammer in
Wien', *Jahrbuch der kunsthistorischen Sammlungen in
Wien*, N.F.I (1926), 49), that the crown was acquired
by the Emperor Conrad II from Rudolf III of
Burgundy after his death in 1032, is no longer ac-
cepted.

3. SS. rer. Germ. 1915$^{(-3)}$, 160 (ed. J. Becker).

4. F. Sprater, *Die Reichskleinodien in der Pfalz*
(1942). Later even more definitely stated by H.
Decker-Haupt, 'Die Reichskrone, angefertigt für
Kaiser Otto I', in P. E. Schramm (ed.), *Herrschafts-
zeichen und Staatssymbolik*, II (Stuttgart, 1955),
560–635. The same view is also taken by H. Fillitz,
*Die Insignien und Kleinodien des heiligen römischen
Reiches* (Vienna, 1954), based on his earlier careful
analysis of the crown, 'Studien zur römischen
Reichskrone', *Jahrbuch der kunsthistorischen Samm-
lungen in Wien*, L (1953), 23 ff.

5. J. Déer, 'Kaiser Otto der Grosse und die
Reichskrone', in H. Fillitz (ed.), *Beiträge zur
Kunstgeschichte und Archäologie des Frühmittelalters*
(Graz-Cologne, 1962), 261–77.

6. This is in fact the translation given in F. A.
Wright (ed.), *The Works of Liudprand of Cremona*
(London, 1930), 216, and Wright was not pre-
judiced by any argument about existing material
but kept strictly to the text. For further arguments
concerning Odilo of Cluny's poem about Henry II,
see Decker-Haupt, *op. cit.*, 626, and Déer, *op. cit.*,
271 ff.

7. Certainly historical events moved fairly p. 84
quickly towards the imperial coronation, and it is
very unlikely that Otto, who was called to Italy by
Pope John and the archbishop of Milan late in 961
and was crowned on 2 February 962, would have
had time to have had such an elaborate crown made
in Germany before his departure.

8. See Lord Twining, *A History of the Crown Jewels
of Europe* (London, 1960), 332, 294 ff. Both Henry
II and Conrad II subsequently donated the crowns
given them in Rome to the abbey of Cluny, where
they were destroyed in 1030.

9. H. Fillitz, 'Studien zur römischen Reichskrone'
(*op. cit.*), 23 ff. (For the inscription, see p. 134,
Chapter 11.)

10. *Ibid.*, 23–31.

11. See also p. 129, Chapter 10.

12. The inscriptions on the plaques are: Christ:
PER ME REGES REGNANT; Isaiah: ECCE ADICIAM
SUPER DIES TUOS QUINDECIM ANNOS; David:
HONOR REGIS IUDICIUM DILIGIT; Solomon:
TIME DOMINUM ET RECEDE A MALO. The texts
are taken from the coronation liturgy. See H. M.
Decker-Haupt and P. E. Schramm, in Schramm,
Herrschaftszeichen, II (*op. cit.*), 560 ff.

13. Only Otto von Falke wrote: 'it shows no
affinity to German workshops working in the
Byzantine manner' (in G. Lehnert, *Illustrierte
Geschichte des Kunstgewerbes*, I (Berlin, 1912), 235).

14. See p. 8, Chapter 1.

15. See p. 97, Chapter 9. A number of technical
differences between the Egbert enamels and those
of the imperial crown should be mentioned. The
very large number of blowholes on the crown are
largely eliminated on the St Andrew altar. The
small dots in the gold made with the point of a
graver around the symbols are not used on the
crown. The face of the angel on the altar is very
differently constructed, and indeed looks much
more like the kind of head found in German en-

graved work than the heads on the crown. The very frequently used 'wavy' cell-work is not found on the crown at all.

p. 85　16. See p. 101, Chapter 9.

17. See p. 8, Chapter 1.

18. For example on the Cross of Victory at Oviedo, of the early tenth century. See p. 73, Chapter 6 (Plate 66).

19. See p. 10, Chapter 1.

20. For a fuller discussion of this, see p. 101, Chapter 9.

21. Steenbock (1965), no. 29. One panel is missing and another, top left-hand edge, was replaced in the late twelfth century.

22. A. Boeckler, 'Bildvorlagen der Reichenau', *Zeitschrift für Kunstgeschichte*, XII (1949), 7 ff.

23. Steenbock (1965), 106. The iconography of the Virgin surrounded by the four Evangelists is unusual, which leads Dr Steenbock to assume that the little disc is an earlier one re-used. It is perhaps worth while to remember that the tenth-century ivory situla in Milan shows the Virgin (and Child) between the four Evangelists.

24. V. Elbern, 'Der eucharistische Kelch im frühen Mittelalter', *Zeitschrift des deutschen Vereins für Kunstwissenschaft*, XVII (1963), 34, 72; Abb. 36, 120.

25. Steenbock (1965), no. 42, and p. 98 below.

26. *Kunst und Kultur im Weserraum, 800–1600*, Corvey exhibition catalogue (Münster in Westfalen, 1966), no. 244, plate L, and figure 208.

27. Steenbock (1965), no. 55.

p. 86　28. See p. 71, Chapter 6.

29. See p. 55, Chapter 4.

30. *Cambridge Medieval History*, III (Cambridge, 1922), 134–40.

31. See J. Beckwith, *Early Christian and Byzantine Art* (Pelican History of Art) (Harmondsworth, 1970), 92, 97, plates 166–8, 178–9. See also K. Wessel, *Die byzantinische Emailkunst* (Recklinghausen, 1967).

32. Steenbock (1965), nos. 58, 57.

33. To my knowledge, it appears only once, in the scene of Solomon's Judgement in the Bible of San Paolo fuori le Mura, made in the Court School of Charles the Bald *c.* 870.

34. See, for example, the crown of Constantine Monomachos (1042–60), formerly at Budapest (Beckwith, *op. cit.*, 99).

35. The treasure is said to have been found while p. 87 a canal was being built at the corner of Schuster- and Stadthaus-Strasse in 1880. Excavations on the same site in 1904 produced another earring and a gold coin of Romanos III Argyros (1028–34). Unfortunately the treasure was dispersed by the finders and only later reassembled and is now in part in the Altertumsmuseum, Mainz, in part in the Staatliche Museen, Berlin. See O. von Falke, *Der Mainzer Goldschmuck der Kaiserin Gisela* (Berlin, 1913), and Schramm and Mütherich (1962), no. 144.

36. The two so-called eagle brooches, one in Berlin, the other in Mainz, have been attributed to the Carolingian period; see p. 57, Chapter 4.

37. See Falke, *op. cit.*, 6, and Schramm and Mütherich (1962), 168.

38. See O. M. Dalton, *Catalogue of Early Christian Antiquities . . . in the British Museum* (London, 1901), nos. 276 and 277. Also Marvin C. Ross, *Catalogue of the Byzantine and Early Medieval Antiquities in the Dumbarton Oaks Collection*, II (Washington, 1965), no. 87, etc. It might also be pointed out that the method of mounting pearls by a wire passed through the centre of them is an ancient tradition: see for example nos. I, E, G, D, of the fifth-century 'Piazza della Consolazione' treasure, from Rome, and the earring from Constantinople of the seventh century (no. 89).

39. See E. Meyer, 'Zur Geschichte des hoch-mittelalterlichem Schmuckes', in *Das siebente Jahrzent* (Berlin, 1935), 19–22.

40. D. M. Wilson, 'An Early Carolingian Finger-Ring', *British Museum Quarterly*, XXI (1957/9), 80–2.

41. Falke, *op. cit.*, nos, 8, 9, 10, and 11. Only four of the nine rings have survived the 1939–45 war; Falke's nos. 8, 7, 6, 13, and 14 are lost.

42. Goldschmidt, II (1918), nos. 4–16; III (1923), p. 88 nos. 301–3. Nos. 7, 13, 16, 301, 302, and 303 have had their broad frames trimmed and now average just over 10 cm. (about 4 in.) square; the carved pictorial area on each panel is approximately 9·5 by 9 cm. (3¾ by 3½ in.) throughout.

43. For an area about 108 cm. wide and 65 cm. high (about 44 by 26 in.), forty-five panels would have been required. This would have needed fairly

generous margins to make it large enough for an antependium. The golden altar of Milan measures 85 cm. in height and 220 cm. in width (about 33 by 87 in.). To cover that area, approximately one hundred and eight panels would have been required.

p. 88 44. Four of the panels (Goldschmidt, II (1918), nos. 4, 10, 14, 15) show no signs of previous fixing, no nail holes. These could only have been held in place by such a frame.

45. H. Fillitz, 'Die Spätphase des "langobardischen" Stiles', *Jahrbuch der kunsthistorischen Sammlungen in Wien*, LIV (1958), 69 ff.

46. Early pulpits were often heavily decorated – see eighth- and ninth-century examples in North Italy (and Saint-Maurice d'Agaune), as well as the later pulpit given by Henry II to Aachen (see p. 125, Chapter 10). A large number of relatively small, equal-sized panels also decorated the famous pulpit made by Nicholas of Verdun for Klosterneuburg in 1181 (see p. 240, Chapter 21).

47. Dodwell (1971), 72–3.

48. F. von Stosch, Berlin, Staatsbib. MS. lat. H.46890 (c. 1780–94), Bd I, no. 68.

49. P. M. Halm and R. Berliner, *Das Hallische Heiltum* (Berlin, 1931), no. 275b, 58, plate 153. The subjects on the four panels seen on the drawing are: the Miracle at Cana, Christ with a small Child(?), the Healing of the Blind Man, the Calling of the Apostles.

p. 89 50. Goldschmidt, II (1918), no. 2. (See p. 93, Chapter 9.)

51. *Ibid.*, 20.

52. L. Birchler, 'Zur karolingischen Architektur und Malerei in Münster-Müstair', in *Frühmittelalterliche Kunst in den Alpenländern* (1951), 167–252.

53. A. Grabar and C. Nordenfalk, *Early Medieval Painting* (Lausanne and Olten, 1957), 54–7.

54. Dodwell (1971), 53–5, 58.

p. 90 55. H. Fillitz, *op. cit.* (Note 45), 69 ff.

56. Goldschmidt, I (1914), nos. 170–3. These panels represent each of the two sides of what was originally in the form of a diptych, now cut in half, making four panels.

57. Steenbock (1965), no. 37.

58. The eventual origin of these patterns is probably pre-Carolingian, first found on objects of daily use like combs, and later, especially in the eighth century, as on the Werden reliquary casket

(Elbern, Taf. (1962), no. 270), in more ambitious decorative schemes. In these objects, usually in bone rather than ivory, these patterns were normally backed by gilt bronze too.

59. See p. 70, Chapter 6. It might also be mentioned that the very heavy, broad, plain frames of the Magdeburg panels are foreshadowed in the late Metz casket, now in the Louvre in Paris (Goldschmidt, I (1914), no. 95).

60. Goldschmidt, II (1918), no. 18, p. 20, figures 15, 16. A panel in the Louvre (A. Goldschmidt and K. Weitzmann, *Die Byzantinische Elfenbeinskulpturen*, II (1934), no. 100) shows six Apostles each side of Christ, but not restricted to busts only. See W. D. Wixom, 'An Ottonian Ivory Book Cover', *The Bulletin of the Cleveland Museum of Art*, LV (1968), 275–89.

CHAPTER 9

1. Schramm and Mütherich (1962), no. 78. p. 92

2. *Ibid.*, no. 76. The inscription runs 'Vates Ambrosi Gotfredus dat tibi sancte/vas veniente sacram spargendum caesare lympham'.

3. Goldschmidt, II (1918), no. 1; H. Fillitz, 'Die Spätphase des "langobardischen" Stiles', *Jahrbuch der kunsthistorischen Sammlungen in Wien*, LIV (1958), 69 ff.

4. This comparison and others with Byzantine panels were already made by Goldschmidt (II (1918), 20–1), although he believed that the Magdeburg panels belonged to the same group.

5. MS. Harley 2889. See D. Turner, 'The Siegburg Lectionary', *Scriptorium*, XVI, 1 (1962), 16–27; Goldschmidt, II (1918), no. 19. p. 93

6. Schramm and Mütherich (1962), no. 75.

7. A deed of gift to this abbey, dated 980, is known: MG, Dipl. II.1, Nr. 211. See Goldschmidt, II (1918), 15.

8. *Storia di Milano* (Fondazione Treccani degli Alfieri per la Storia di Milano), II, 667.

9. 'Auxit Ezechie ter quinos pater annos + Otoni Augusto plurima lustra legat: cernuus arte cupit memorare C[a]esar aliptes, K.I.' The last two letters of the inscription, K.I., are normally thought to be the carver's initials.

10. J. Beckwith, *The Basilewsky Situla* (London, 1963), 1.

11. H. Decker-Haupt, in P. E. Schramm (ed.), *Herrschaftszeichen und Staatssymbolik*, II (Stuttgart, 1955), 626.

12. It may not be of any great significance that the situla first appeared at Aachen in the nineteenth century, but it should also be remembered that the situla carved for Otto III or Henry II at Aachen follows in the same tradition and may have been carved there on the model of the Basilewski situla. For details, see Schramm and Mütherich (1962), no. 105.

p. 94 13. Two Maries appear here at the tomb and also on the Milan diptych and on a fifth-century panel in the Castello Sforzesco Collection, following Early Christian rather than the more common later iconography with three Maries.

14. Volbach (1952), no. 232; also Steenbock (1965), no. 6. See also p. 31, Chapter 2.

15. A. Goldschmidt and K. Weitzmann, *Die byzantinische Elfenbeinskulpturen*, II (1934), no. 85.

16. Schramm and Mütherich (1962), no. 71.

17. *Ibid.*, no. 81.

p. 95 18. Similar, but cruder and heavier decoration on the Ardenne Cross at Nuremberg (see p. 38, Chapter 3) is made of two crossed wires, not three strands, but is related technically.

19. See p. 87, Chapter 8.

20. *Ex vitae et miraculis S. Adalberti Egmondavi*, *Mon. Germ. Hist., Scrip.*, XV, 704.

21. For fuller details and references, see C. R. Dodwell and D. H. Turner, *Reichenau Reconsidered* (London, 1965), 18–19; Dodwell (1971), 54.

p. 96 22. Schnitzler, I (1957), 24–5, no. 13. Until the French Revolution it remained in Trier, and in 1827 it was given to the cathedral of Limburg an der Lahn.

23. Elbern, Taf. (1962), nos. 334–5. For the other half of the staff, still in Cologne, see *Werdendes Abendland*, exhibition catalogue (Essen, 1956), no. 457.

p. 97 24. Schnitzler, I (1957), no. 4.

25. Schramm and Mütherich (1962), no. 49.

26. Steenbock (1965), no. 20.

27. Schnitzler, I (1957), no. 5.

28. Small enamels on the cross of Theophanu at Essen (Plate 139) made between 1039 and 1056 are very similar, and were perhaps made at the same time. The shape of at least two of the enamels on

this cross certainly suggests that they were not made for it, but were re-used material available in the eleventh century. Perhaps there may be a link here with the decorative enamels employed in Sicily in the workshop active for the Emperor Frederick II in the early thirteenth century (see Schramm and Mütherich (1962), nos. 197, 198, 200). The similarities here suggest that we are dealing with an Italian tradition in which many of the chronological links are missing.

29. MS. lat. 9383; Steenbock (1965), no. 33 (see p. 45, Chapter 4).

30. The circular centre fibula was replaced here by an engraved plaque of the seventeenth century.

31. F. Rademacher has tried to argue that this brooch was made at Trier at the same time as the altar, in imitation of a Frankish brooch. Certainly the technical data he gives show that the brooch was adapted to serve its new purpose, but this cannot be said to prove that it is not basically a seventh-century piece. (See 'Der Trierer Egberts-schrein', *Trierer Zeitschrift*, XI (1936), 144–66.) It has been convincingly attributed to an East Anglian workshop which produced the bulk of the jewellery found in the Sutton Hoo ship burial. See R. L. S. Bruce-Mitford, 'The Sutton Hoo Ship-burial', *Proceedings of the Suffolk Institute of Archaeology*, XXV (1952), 37 ff.

32. Schnitzler, I (1957), no. 30, plate X; J. Beckwith, *Early Christian and Byzantine Art* (Pelican History of Art) (Harmondsworth, 1970), 99, plate 185.

33. Hildesheim, Cathedral Treasury no. 61, folio 1; see Elbern, Taf. (1962), plate 416.

34. O. M. Dalton, *Early Christian Antiquities* p. 98 (London, 1901), nos. 267 ff.

35. M. C. Ross, *Catalogue of the Byzantine and Early Medieval Antiquities*, II (Washington, 1965), nos. 4A, 34, 87, 90.

36. A Roman lion, carved in stone, with a column base still on his back survives in the collection of the Trier Landesmuseum.

37. Now in Nuremberg, Germanisches Museum, K.G. 1138. See Steenbock (1965), no. 42.

38. P. Metz (*Das goldene Evangelienbuch von Echternach* (Munich, 1956), note 130) has claimed that the ivory does not fit exactly into the available space. The one or two millimetres that the ivory is narrower than the space for it in the metalwork frame hardly justifies the consequences Dr Metz

tries to draw. If the ivory is later than the frame, and on stylistic grounds this is almost certain, then it is surely more convincing that it was carved for its present position about 1055 than that it was carved independently in the early eleventh century (as has been claimed: Elbern, II (1964), 1030) and happened to fit into the available space. For support for a dating c. 1055, see below, p. 139, Chapter 11.

p. 98 39. See P. O. Rave, 'Die Kunstsammlung Beuths', *Zeitschrift des deutschen Vereins für Kunstwissenschaft*, II (1935), 484, Abb. 8.

40. Elbern, II (1964), 1034.

41. Heart-shaped settings do, however, also appear earlier, on St Peter's staff at Cologne, probably enriched by Archbishop Bruno of Cologne before his death in 965. (See *Werdendes Abendland* (*op. cit.*, Note 23), no. 457.)

p. 99 42. Elbern, Taf. (1962), no. 365. The evidence for Gero's gift to Cologne is Thietmar, *Chronicon*, III, 2. See especially R. Hausherr, *Der tote Christus am Kreuz, Zur Iconographie des Gerokreuzes* (Bonn, 1963).

43. An example in illumination is the St Gereon Sacramentary in Paris, Bib. Nat. lat. 817; an example in sculpture the Benninghausen Crucifix (see Elbern, II (1962), nos. 351 and 364).

p. 101 44. Schnitzler, I (1957), 13.

45. For the interpretation of the imperial portrait at the centre of the cross, see J. Déer, 'Das Kaiserbild im Kreuz', *Schweizer Beiträge zur allgemeinen Geschichte*, XIII (1955), 48 ff.

46. This is a rare feature – see D. M. Wilson, 'The King's School, Canterbury Disc Brooch', *Medieval Archaeology*, IV (1960), 16–28.

47. Schnitzler, I (1957), no. 12. The small 'beehive' pyramids of pearled gold wire topped by a gold sphere, which also appear on this cross and on the small cross added to the imperial crown (Plate 81) and the book-cover of Otto III (Plate 103) and a number of later pieces, is probably also a Byzantine technique – see the small eleventh-century cross found at Garvan in Romania (*Studii si cercetări de istorie veche*, II (1951), 35–6; *Treasures from Romania*, exhibition catalogue (London, British Museum, 1971), no. 403, plate 101).

48. *Ibid.*, no. 32. The name 'Lothar Cross' is given it because on the lower part of the front, a crystal seal of King Lothar II (855–69) is re-used; perhaps this was part of an imperial gem collection, along with the great Antique cameo and other

gems used on the cross. For the occasion of the opening of Charlemagne's tomb, see Grauert, *Historisches Jahrbuch*, XIV, 302.

49. The only metalwork definitely commissioned by Otto III – the book-cover of the Gospel Book in Munich (Clm. 4453) – is very different from the Lothar Cross. (See p. 109 below.)

50. Schnitzler, I (1957), no. 44. As Schnitzler correctly points out, the reverse engraving of this cross was renewed in the second quarter of the twelfth century. This is particularly unfortunate as the original engraving would have been a great help in dating.

51. *Liber miraculorum Sancte Fidis*, cap. XIII (ed. p. 104 A. Bouillet, *Collection de textes*, tom. XXI (Paris, 1897), 46 ff.).

52. M. and L. de Paor, *Early Christian Ireland* (London, 1964), plates 20–1, 58–61, 65, figure 31, and p. 116.

53. Only a drawing by Peiresc survives, reproduced by C. Beutler, *Bildwerke zwischen Antike und Mittelalter* (Düsseldorf, 1964), 37 ff., plates 5, 6.

54. Quoted, among much other literary evi- p. 105 dence on early reliquaries, by H. Keller (in the original Latin from the same *Liber miraculorum Sancte Fidis*, lib. I, cap. XXVIII), in 'Zur Entstehung der sakralen Vollskulptur, etc.', *Festschrift H. Jantzen* (Berlin, 1951), 80–1, note 44. Also Beutler, *op. cit.*, 37 ff.

55. *Liber miraculorum*, lib. I, cap. XVI.

56. The restoration is probably of the sixteenth century. For a fuller analysis of added material and bibliography, see J. Taralon, 'La nouvelle présentation du trésor de Conques', in *Les Monuments historiques de la France*, I (1955), no. 3; M.-M. Gauthier, *Rouergue roman* (La Pierre-qui-Vire, 1963), 135–7; and *Les Trésors des églises de France*, exhibition catalogue (Paris, 1965), no. 534.

57. For St Césaire at Maurs, see *Les Trésors des églises de France* (*op. cit.*), plate 80. For the Beaulieu Virgin, *ibid.*, plate 82.

58. Schnitzler was as far as I know the first to p. 106 suggest this date, in *Schatzkammer*, I (1957), 31.

59. Dodwell (1971), 57 ff.; C. Nordenfalk, 'Der Meister des Registrum Gregorii', *Münchner Jahrbuch der bildenden Kunst*, 3. Folge, I (1950), 61–77. Although it is difficult to accept all Nordenfalk's attributions, a core of work bears the unmistakable stamp of an individual.

60. The evidence for a strong influence of Middle Byzantine iconography in the work of the Gregory Master is given by H. Buchthal, 'Byzantium and Reichenau', in *Byzantine Art – A European Art* (Athens, 1965) (lectures given at the ninth Council of Europe exhibition, Athens, 1964), but it seems particularly convincing to me mainly in illuminations such as the Adoration of the Magi in the Egbert Codex (folio 17 recto), which is not by the hand of the Gregory Master.

61. This model was used for the Egbert Codex, and even more extensively for the Gospel Books made for the court, like the Aachen Gospels (*c.* 980–983?) and the Gospels of Otto III (Munich, Clm. 4453). Perhaps Otto II's visit to Milan in 980 provided an occasion when an Early Christian Gospel Book might have been presented to the emperor. It could then have come north with the imperial insignia in 983. Byzantine models were, of course, almost certainly also known at the court and might have provided the source for full-page illuminations in one or two registers (e.g. the ninth-century Gregory of Nazianz in Paris, Bib. Nat. gr. 510).

62. See p. 52, Chapter 4, and G. B. Tatum, 'The Paliotto of S. Ambrogio in Milan', *Art Bulletin*, XXVI (1944), 25–45. Other scenes, like the Expulsion of the Moneylenders from the Temple, show strong similarities to the iconography in the same Ottonian group of manuscripts, usually known as the 'Reichenau' School; see Dodwell and Turner, *op. cit.* (Note 21). The use of 'disembodied' townscapes in the upper backgrounds may also have entered Ottonian iconography from the same source.

63. They are: New York, Pierpont Morgan Library no. 781, Cologne, Chapter Library MS. 218, and Hildesheim, Beverina Library no. 688. The Gospel Book from Poussay (Paris, Bib. Nat. lat. 10514) is related to this group (see Dodwell (1971), 56). It was made for Archbishop Egbert at Trier and shows both ox and ass in front of the crib.

64. A. Boeckler, *Ars Sacra*, exhibition catalogue (Munich, 1950), no. 264. This rather strange and late dating seems to be based mainly on palaeographical grounds.

65. C. Nordenfalk attributes these and even the more fully developed Ottonian style of the Mainz Virgin (see below, p. 122) to the Gregory Master's own hand (*op. cit.* (Note 59), 73–7).

66. Goldschmidt, II (1918), no. 41. Goldschmidt suggests that this rather extensive treatment of the Presentation scene may be connected with St Simeon of Trier, a hermit who lived under the obedience of the abbot of St Martin at Trier and who died there in 1035. The date of the carving would, however, seem to be too early to connect with this saint or his church, founded at Trier in the eleventh century.

67. Nordenfalk, *op. cit.*, figures 11, 10.

68. A single leaf, now at Würzburg (MS. theol. qu. 4), illustrated by Nordenfalk (*op. cit.*, figure 17), shows a style somewhat closer to the ivories, but is not by the hand of the Gregory Master. p. 107

69. Goldschmidt, II (1918), no. 39.

70. Perhaps, as the Trier connexion is not certain, the panel could be associated with the Chantilly Sacramentary written for the abbey of St Nazarius at Lorsch (see Schnitzler, 'Fulda oder Reichenau', *Wallraf-Richartz-Jahrbuch*, XIX (1957), 118).

71. Goldschmidt, I (1914), no. 123.

72. Goldschmidt, II (1918), no. 42.

73. What one might suppose to be a large crown carried by the first of the two kings seems on closer inspection to be a large toilet box(?).

74. Goldschmidt, II (1918), no. 44.

75. *Ibid.*, no. 45. Another Evangelist panel, not recorded by Goldschmidt, from the same workshop is in the collection of the Musée de Montpellier. See J. Wettstein (ed.), *Les Ivoires: Évolution décorative du 1er siècle à nos jours* (Paris, 1966), 22 (top left).

76. Kunsthistorisches Museum inv. no. 8399, acquired in 1928 from Stift Heiligenkreuz, Austria; Goldschmidt, I (1914), no. 122. p. 108

77. The beginning of the Mass, now in Frankfurt, is mounted on the cover of a fourteenth-century Lectionary (Stadtbib. MS. Barth. 181), the other is in the Fitzwilliam Museum, Cambridge; Goldschmidt, I (1914), nos. 120, 121.

78. See H. Fillitz, 'Die Wiener Gregor-Platte', *Jahrbuch der kunsthistorischen Sammlungen in Wien*, LVIII (1962), 7–22.

79. Chronicle of Novalesa (Lombardy), III.32. See H. Grauert, 'Zu den Nachrichten über die Bestattung Karls des Grossen', *Historisches Jahrbuch*, XIV (1893), 302–19.

80. Steenbock (1965), no. 43. p. 109

81. J. Beckwith, *The Art of Constantinople* (London, 1961), figure 117.

CHAPTER 10

p. 111 1. R. Wesenberg, *Bernwardische Plastik* (Berlin, 1955), 17–21, 165. The crozier was found in the tomb of Bishop Henry III (d. 1362) in 1788, where it had been used as a funerary crozier. It is now in the Hildesheim Cathedral Treasury. (See V. H. Elbern and H. Reuther, *Der Hildesheimer Domschatz* (Hildesheim, 1969), no. 7.) See also below, p. 129, for Erkanbaldus's Sacramentary.

2. According to the *Vita Bernwardi*, by Thangmar (*Mon. Germ. Hist., Scrip.*, IV). The account of the translation is of the normal kind, fraught with difficulty. It would certainly be unusual to find candlesticks and a censer as grave goods in a sarcophagus. It is perhaps more likely that they were added to the tomb the night before the translation to swell the number of relics of the saint. Since 1859, the candlesticks have been in the possession of the church of St Magdalen, Hildesheim. (See Wesenberg, *op. cit.*, 21–8, 165–6. For the stone sarcophagus and tomb slab, see *ibid.*, 159–62, 182–3.)

3. 'BERNIVARDUS PRESUL CANDELABRUM HOC PUERUM SUUM PRIMO HUIUS ARTIS FLORE NON AURO NON ARGENTO ET TAMEN UT CERNIS CONFLARE IUBEBAT.' 'Primo huius artis flore' seems to refer to the first (or early) flowering of this art. Even without this, there can be little doubt that the candlesticks are by the same hand as the crozier, and therefore made in the early years of Bernward's rule, c. 996–1000. See Wesenberg, *op. cit.*, 21.

4. The doors cast for Mainz Cathedral in the time of Archbishop Willigis (975–1011); see below, p. 118.

p. 112 5. Wesenberg, *op. cit.*, 18, figure 8. This particular example is, however, more likely to date from the twelfth century.

6. Thangmar, *Vita Bernwardi*, c. 5–6 (*Mon. Germ. Hist., Scrip.*, IV (ed. G. H. Pertz), 760: '. . . adeo ut ex transmarinis et ex Scotticis vasis, quae regali maiestati singulari dono deferebantur, quicquid rarum vel eximium reperiret, incultum transire non sineret'. It is to be remembered, however, that there may be some doubt about the reliability of Thangmar's life of St Bernward. Thangmar was a contemporary of Bernward and his tutor, but the surviving text may have been extensively re-edited in the late twelfth century (see R. Drögereit, 'Die Vita Bernwardi und Thangmar', *Unsere Diözese in Vergangenheit und Gegenwart*, XXVIII (1959), 2–46).

7. D. M. Wilson, *Anglo-Saxon Ornamental Metalwork 700–1100 in the British Museum* (London, 1964): the London Bridge censer (no. 9), the Canterbury censer (no. 44), the cruet (no. 147), a strap-end, Sandford, Oxon (no. 148), and the plaque with Christ in Majesty (Ashmolean Museum, Oxford), 112.

8. Wesenberg, *op. cit.*, 27, figure 65.

9. See p. 8, Chapter 1, H. Arbman, 'Die Kremsmünster Leuchter', *Middelanden från Lunds Universitets Historiska Museum* (Lund, 1958), 170–92, and Wilson, *op. cit.*, 46. One more piece survives that might be taken to support the Thangmar text's mention of 'overseas' gifts: a book box, now in the Germanisches National-Museum, Nuremberg, from Seitz Abbey (Untersteiermark) is decorated with cast gilt-bronze ornamental mounts that compare well with Anglo-Saxon metalwork. See Wilson, *op. cit.*, 46, but see also Steenbock (1965), no. 44, for reasons for an attribution of this piece to northern Italy.

10. See for example Elbern and Reuther, *op. cit.*, plate 6, and compare M. Rickert, *Painting in Britain: The Middle Ages* (The Pelican History of Art), 2nd ed. (Harmondsworth, 1965), plates 21B, 28A.

11. L. Stone, *Sculpture in Britain: The Middle Ages* (The Pelican History of Art), 2nd ed. (Harmondsworth, 1971), plate 27B.

12. It is, of course, not out of the question. The *Vita Bernwardi* speaks of Bernward calling to his court 'especially gifted and talented' craftsmen he met on his journeys. See Wesenberg, *op. cit.*, 12.

13. Goldschmidt, I (1914), no. 44.

14. *Ibid.*, no. 67a, b.

15. See pp. 79 and 81, Chapter 7. These comparisons have been made by Wesenberg, *op. cit.*, 20, 26. Weitzmann placed these ivories (G.I, 67a, b) at Fulda in the late tenth century ('Eine Fuldaer Elfenbeingruppe', in *Das Siebente Jahrzehnt* (Berlin, 1935), 14–18). See also Schnitzler, who emphasizes the Fulda sources for Bernward's art at Hildesheim in 'Fulda oder Reichenau', *Wallraf-Richartz-Jahrbuch*, XIX (1957), 61–2, note 149. p. 113

16. Dodwell (1971), 72.

17. Wesenberg, *op. cit.*, 29–35, 160–9; Elbern and Reuther, *op. cit.*, no. 6.

18. These relics may have been housed in the hollow back of the Christ figure, but it seems more likely that an original reliquary box, on which the

cross would have been mounted, is now lost. The inscription lists in addition a number of other relics, but engraved by a different, probably twelfth-century, hand. See Wesenberg, *op. cit.*, 167.

19. Goldschmidt, I (1914), no. 78. First to make this comparison was E. Panofsky, *Die deutsche Plastik des 11. bis 13. Jahrhunderts* (Munich, 1924), 73.

20. Z. Ameisenowa, 'Animal-Headed Gods, Evangelists, Saints and Righteous Men', *Journal of the Warburg and Courtauld Institutes*, XII (1949), 34–41.

21. R. Crozet, 'Les Représentations anthrozoomorphiques des évangelistes dans l'enluminure et dans la peinture murale aux époques carolingienne et romane', *Cahiers de Civilisation Médiévale Xe–XIIe Siècles*, I (1958), 182–7, and W. Cook, 'The Earliest Painted Panels of Catalonia (IV)', *Art Bulletin*, VIII (1925–6), 208–15.

22. See p. 160, Chapter 14.

p. 115 23. Goldschmidt, I (1914), 44. It might be added that the elegant figure style of these 'Utrecht style' ivories might also be responsible for refining the Metz figure style employed on the Adalbero relief.

24. P. Bloch, 'Der Stil des Essener Leuchters', in Elbern, I (1962), 534 ff., and, especially for the iconography of seven-armed candelabra, P. Bloch, 'Siebenarmige Leuchter in christlichen Kirchen', *Wallraf-Richartz-Jahrbuch*, XXIII (1961), 55–190.

25. See p. 99, Chapter 9. The inscription reads: MATHILD ABATISSA ME FIERI IUSSIT ET CHRISTO CONSECRAVIT.

26. The other three were Meridies (South), Oriens (East), and Occidens (West Wind). See P. Bloch, 'Siebenarmige Leuchter' (*op. cit.*), 103, 115–18.

p. 117 27. Nevertheless it is particularly unfortunate that the seven-branched candelabrum given by King Canute to Winchester in 1035 has not survived for comparison; O. Lehmann-Brockhaus, *Lateinische Schriftquellen zur Kunst in England, Wales und Schottland*, II (Berlin, 1956), 4702.

28. Herzog-August Bibliothek Cod. Helmst. 26 (cover). See P. Bloch, 'Siebenarmige Leuchter' (*op. cit.*), 108, figure 66.

29. H. Thümmler, 'Karolingische und ottonische Baukunst', in Elbern, II (1964), Abb. 4.

30. P. Bloch, 'Siebenarmige Leuchter' (*op. cit.*), 106–12.

31. P. Bloch (in 'Der Stil des Essener Leuchters', *op. cit.*) also sees connexions with the style of the Corvey school of illumination, and it should be remembered that a bronze-casting workshop existed there under Abbot Thietmar (983–1001) which supplied six bronze columns for the abbey church of Corvey. (See Usener, in *Kunst und Kultur im Weserraum 800–1600*, Corvey exhibition catalogue (Münster in Westfalen, 1966), 559.)

32. Wesenberg (*op. cit.*, 36–41) sees, I believe, a closer relationship with Bernward's silver crucifix than can be established.

33. *Ibid.*, 172–81, for a full discussion of the evidence. Certainly, according to Wesenberg, the rebate on both wings of the door on which they now close, is cut out of the bronze, not cast, which suggests that they were cut when placed in the cathedral.

34. On palaeographical grounds also, the inscription was no doubt added by Bernward's successor, Bishop Godehard (1022–38). It reads: AN(NO) DOM(INICE) INC(ARNATIONIS) MXV B(ERNVVARDUS) EP(ISCOPUS) DIVE MEM-(ORIE) HAS VALVAS FUSILES/IN FACIE(M) ANGELICI TE(M)PLI OB MONIM(EN)T(UM) SUI FEC(IT) SUSPENDI. I do not know whether any scientific examination has been made of the inscription – if it is cut out of the bronze, it could have been added. If on the other hand it was cast, then these panels must have been re-assembled in a new framework by Godehard.

35. An additional subtlety lies in the fact that p. 118 adjacent scenes on each wing are closely paired – for example, the Fall and Judgement of Adam and Eve (the Fall) or Christ before Pilate and Crucifixion (the Passion). Also the scenes form four groups, half on each door, beginning with four scenes in paradise (Creation of Adam, Eve presented to Adam, Fall, Judgement) followed by four post-paradise scenes (Expulsion, Adam and Eve working the land, Cain and Abel's sacrifice, Cain's murder of Abel) and four scenes from the youth of Christ (Annunciation, Nativity, Three Magi, Presentation), ending with four illustrating the Redemption (Christ before Pilate, Crucifixion, the Three Maries at the Tomb, Noli me Tangere). For full discussion see Wesenberg, *op. cit.*, 66–7.

36. A. Goldschmidt, *Die deutschen Bronzetüren des frühen Mittelalters* (Marburg, 1926), 12–13, plate 9.

37. *Ibid.*

p. 118 38. W. F. Volbach, *Early Christian Art* (London, 1961), nos. 103–5.

p. 119 39. For the text in the *Vita Bernwardi* about Bernward's visits to the workshop, see Wesenberg, *op. cit.*, 12. The identification of hands has led to the following results (numbering the reliefs in chronological order of events). Beenken (*Romanische Skulptur in Deutschland*, Berlin, 1924): three hands: I: 1, 2, 3, 4, 5, 6, 9, 11; II: 7, 8, 12, 13; III: 14, 15, 16. Panofsky (*op. cit.*, Note 19): four hands: I: 1, 2, 3, 4, 5; II: 12, 13, 14, 15, 16; III: 7, 8; IV: 6, 9, 10, 11. Wesenberg (*op. cit.*): six hands: I: 14, 16, 11; II: 3, 4, 5; III: 6, 10, 9; IV: 1, 12, 15; V: 7, 8, 13; VI: 2. Goldschmidt (*op. cit.*, Note 36): six to seven hands, closely followed by Wesenberg. Unfortunately none of these is an entirely satisfactory division. The stylistic evidence suggests that some panels (especially nos. 2 and 14) are not all by one hand. Individual features and individual figures seem to be by different hands in one panel. Basic divisions would seem to me to be I: 4, 5; II: 3, 12, 15, 16; III: 6, 7, 8, 9, 10, 11, 13, with no. 2 probably by hand I and the Crucifixion (no. 14) most difficult to fit in at all, except for the figure of St John, probably by hand I, and the Virgin, perhaps hand II. It is also necessary to emphasize the cross-influences from one hand to another, as Wesenberg has done, virtually reducing his six hands to four by linking hands I with IV and V with VI. If we further link Wesenberg's hand III with V and VI, his grouping comes very close to the one I put forward.

40. Dodwell (1971), 40–1, plate 43.

41. Wesenberg (*op. cit.*, 80) points to the fresco cycle originally in San Paolo fuori le Mura, Rome, where these scenes were represented, but doubts direct connexion with Late Antiquity.

42. *Ibid.*, 70–6.

43. Castellations in the Otto III Gospels (Munich, Clm. 4453), for example; three Magi (H. Jantzen, *Ottonische Kunst* (Munich, 1946), plate 44) and trees in the Egbert Codex (Trier, cod. 24), the Healing of the Blind Man (*ibid.*, plate 38).

p. 120 44. See H. Swarzenski, 'The Role of Copies in the XIth Century', in *Romanesque and Gothic Art, Studies in Western Art*, I (1963), 15, plate IV, figure 15. Carved for the cover of a manuscript by Framegaud, Paris, Bib. Nat. MS. lat. 17969.

45. See p. 36, Chapter 3.

46. Wesenberg, *op. cit.*, figures 57 and 58. See also two more striking comparisons in figures 59 and 60 and 61 and 62, and comparisons with the head of the Gero Crucifix, also in Cologne.

47. This has led some scholars, I think wrongly, to date the column after Bernward's death in 1022, to *c.* 1030: for example R. Hespe, *Die Bernwardsäule zu Hildesheim*, unpublished thesis (Bonn, 1949); A. Fink, 'Bernwardstür und Godehardsäule', *Zeitschrift für Kunstwissenschaft*, II (1948), 1–8; H. Swarzenski, *Monuments of Romanesque Art* (London, 1953), plates 52, 53.

48. Wesenberg, *op. cit.*, figures 91, 93. p. 121

49. Especially the onlookers at the Healing of the Blind Man (Plate 118) and the two men taking the Adulteress to Christ. See Wesenberg, *op. cit.*, 137, figures 277, 280.

50. The column is, of course, also by more than one hand. Wesenberg identifies six (*op. cit.*, 144–7).

51. See *ibid.*, 148–50, for detailed comparisons.

52. See pp. 78 ff., Chapter 7.

53. Goldschmidt, I (1914), no. 96.

54. Wesenberg (*op. cit.*, 126–7) attempts to show some dependence on the so-called 'Reichenau' models, but without convincing results.

55. *Ibid.*, 59–62. The group has been stripped of p. 122 its Baroque and later restorations (see figure 112).

56. Goldschmidt, II (1918), no. 40.

57. Elbern, Taf. (1962), no. 332; C. Nordenfalk, 'Der Meister des Registrum Gregorii', *Münchner Jahrbuch der bildenden Kunst*, N. F. III (1950), 73–7.

58. A panel with the Crucifixion and the Three Maries at the Tomb in Nancy Cathedral (Goldschmidt, I (1914), no. 137) may well be contemporary with the Mainz Virgin. The heads, fully three-dimensional, and the soft, heavy forms of the crucified Christ are close to it. The pair to this panel, in the Hermitage at Leningrad (*ibid.*, no. 138), is by a different hand. The iconography of both is linked strongly with the Carolingian tradition first introduced at the Court School of Louis the Pious.

59. Perhaps even more surprising is the complete absence of the influence of imperial illumination on Hildesheim, where the scriptorium is deeply involved in the earlier-tenth-century traditions of Lower Saxony.

60. F. J. Tschan, *St Bernward of Hildesheim*, III p. 123 (Notre-Dame, 1951), 91 ff., plates 82–8.

61. H. Schnitzler, 'Das sogenannte grosse Bernwardkreuz', in *Karolingische und ottonische Kunst* (Forschungen zur Kunstgeschichte und christlichen Archäologie, III) (Wiesbaden, 1957), 382–94.

62. Steenbock (1965), nos. 65, 66.

63. The St Matthew and St Mark symbols are certainly of the thirteenth century, while those of St John and St Luke (by a different hand) could be eleventh-century. See Steenbock (1965), 159.

64. For the small silver-gilt crucifix on this cover, see Wesenberg, *op. cit.*, 42–3.

65. +HOC OPU(S) EXIMIU(M) BERNVVARDI P(RAE)SULIS ARTE FACTU(M) CERNE D(EU)S MATER ET ALMA TUA.

66. A. Goldschmidt and K. Weitzmann, *Die byzantinischen Elfenbeinskulpturen*, II (Berlin, 1934), nos. 143–5.

p. 124

67. These manuscripts, usually called the Liuthard Group of the Reichenau School, show a clear dependence on one set of sources, which were, at least in part, also available to the Trier scriptorium's production of the Egbert Codex. This school may well have been a peripatetic one; it was certainly working exclusively for imperial patrons. Recent research has made the location of it on the island of Reichenau very doubtful. See C. R. Dodwell and D. H. Turner, *Reichenau Reconsidered* (London, 1965); Dodwell (1971), 51.

68. Munich, Bayr. Nat. Bib. cod. 4452. For the ivory see p. 63, Chapter 5, and also p. 36, Chapter 3, for the suggestion that it was commissioned by Louis the Pious and carved about 830–40. The dedication in the Pericopes is quoted in full in Schramm and Mütherich (1962), no. 110. See also Steenbock (1965), no. 50.

69. A narrow silver frame was added as an outer border in the fourteenth century. Another restoration took place in 1735, when some cut gems may have been added, in replacement of lost cabochons. See Steenbock (1965), 132.

70. Kallström argued that the inscription supported his thesis that it once formed a crown; it runs: +GRAMMATA QUI SOPHIAE QUAERIT COGNOSCERE VERAE HOC MATHESIS PLENAE QUADRATUM PLAUDET HABERE EN QUI VERACES SOPHIAE FULSERE SEQUACES ORNAT PERFECTAM REX HEINRIH STEMMATE SECTAM. His thesis depends on the translation of 'stemma' in this context as 'crown' (O. Kallström, 'Ein neuentdecktes Majestätsdiadem ottonischer Zeit', *Münchner Jahrbuch der bildenden Kunst*, 3. Folge, II

(1951), 62 ff.). Against this and for a more convincing translation, see J. Déer, 'Kaiser Otto der Grosse und die Reichskrone', *Beiträge zur Kunstgeschichte und Archäologie des Frühmittelalters* (1962), 272 ff.

71. See p. 109, Chapter 9. Of course, both covers do arrange their settings in a distinct numerical order, but the visual impact is nevertheless one of 'scatter', or at least much more so than on any other cover.

72. Now in Munich, cod. lat. 4454. See Steenbock (1965), no. 47.

73. See *ibid.*, 127 ff., for a summary of the meaning of this composition.

74. Schramm and Mütherich (1962), no. 86. p. 125

75. Munich, Clm. 4453 (Jantzen, *op. cit.* (Note 43), plates 74, 75). The animals also bear an uncanny resemblance to Anglo-Saxon animal art – especially the eighth-century silver-gilt Ormside Bowl in the Yorkshire Museum at York (T. D. Kendrick, *Anglo-Saxon Art to A. D. 900* (London, 1958), plate 60). Is it possible that such objects existed in the imperial treasury, perhaps acquired in the tenth century, when gifts were exchanged between Otto I and his brother-in-law, King Aethelstan of Wessex? Gifts received by Aethelstan are certainly still extant, see, for example, British Museum MS. Cotton Tiberius A.II (Schramm and Mütherich (1962), no. 64).

76. The full inscription reads: HOC OPUS AMBONIS AURO GEMMISQUE MICANTIS REX PIUS HEINRICUS CELESTIS HONORIS ANHELUS DAPSILIS EX PROPRIO TIBI DAT SANCTISSIMA VIRGO QUO PRECE SUMMA TUA SIBI MERCES FIAT USIA.

77. See E. Doberer, 'Studien zu dem Ambo Kaiser Heinrichs II im Dom zu Aachen', in *Karolingische und ottonische Kunst* (*op. cit.*, Note 61), 337–48.

78. For a longer discussion of the type and the documentary sources see Doberer, *op. cit.*, 318–37.

79. Many restorations, of which perhaps the one of 1815–17 was the most destructive, have left the ambo with only a portion of original work. Of the 'crux gemmata' only the top field mounted with an oval onyx dish and the two fields to the left and right mounted with a Fatimid crystal cup and dish are original. Of the filigree bands of the frame, only one small fragment, mounted since 1937 on the top left hand corner, survives (see

Doberer, *op. cit.*, figure 137 and p. 313, note 12). The suggestion of Schramm and Mütherich (*Denkmale* (1962), no. 137, p. 166) that the centre of the cross was originally occupied by a Christ in Majesty is unlikely, because the wooden core (Doberer, *op. cit.*, figure 138) shows a large circular hollow to take a circular dish of the kind mounted in 1937. Dr Doberer believes this cut-out hollow to be original.

p. 125 80. Steenbock (1965), no. 29.

81. See also H. Fillitz, 'Das Evangelistenrelief vom Ambo Kaiser Heinriches II im Aachner Münster', in *Karolingische und ottonische Kunst* (*op. cit.*, Note 61), 360–7.

p. 126 82. See Volbach (1952), nos. 72–7, and H. Stern, 'Quelques œuvres sculptées en bois, en os et ivoire de style Omeggade', *Ars Orientalis*, 1 (1954), 128 ff.

83. See p. 123 above, and Steenbock (1965), no. 66.

84. See p. 123 above, and Steenbock (1965), no. 65.

85. See Theophilus (ed. C. R. Dodwell), *De diversis artibus* (London, 1961), book III, chapter LXXI, 129.

86. Elbern, Taf. (1962), nos. 346–7.

87. See H. Schnitzler, 'Die Willibrordarche', in *Festschrift H. Lützeler* (Düsseldorf, 1962), 394 ff. The rather block-like, almost square drawing of the symbol of St Luke on the back does bear a resemblance to the symbol of St Luke on Bernward's 'Precious Gospels', which (cf. p. 283, Note 63) may be contemporary with the original design of the cover in the early eleventh century, and would link the reliquary with the same milieu. A mid-eleventh-century date has been suggested; this seems somewhat late in view of the strong Carolingian tradition of the reliquary, and more in character with work of the turn of the century.

88. Schramm and Mütherich (1962), no. 134. The inscription on the front runs: EN CESAR SOPHIAE RENITENS HEINRICUS HONORE CHRISTE, CREATORI DABIT HOC TIBI MUNUS HONORI, IN QUO SANCTA CRUCIS PARS CLAUDITUR AC DECUS ORBI(S) REDDE VICEM PATRIE DONANDO GAUDIA VERE. On the back: IN HOC ALTARI S(an)C(+)ORU(M) REL(iquiae) C(on)TINENTUR/QUORUM HIC NOMINA SCRIPTA HABENTUR/DE LIGNO D(omi)NI REL(iquiae) S(an)C(+)I GEORGII M(artyris) S.

PANCRATII M. S. SEBASTIANI M. S. STEPHANI M. S. LAURENCII M. DE CRATICULA S. LAUR.

89. Acquired by the Reiche Kapelle of the p. 127
Residenz, Munich, in 1803, after the secularization of Bamberg.

90. For a full examination of the evidence and previous theories, see H. Fillitz, 'Das Kreuzreliquiar des Kaisers Heinrichs II in der Schatzkammer der Münchner Residenz', *Münchner Jahrbuch der bildenden Kunst*, 3. Folge, IX/X (1958/9), 15–31.

91. J. Braun, *Das Reliquiar* (Freiburg, 1940). Only small fragments of the Holy Cross do sometimes appear behind thick crystals in altar crosses like the Enger cross (see p. 160, Chapter 14).

92. See J. Braun, *Der christliche Altar*, I (Munich, 1924), 468 ff., 472 ff. What is perhaps the most outstanding example is only just over a generation older than Henry's gift to Bamberg – the reliquary of St Andrew's sandal, given to Trier by Archbishop Egbert (see p. 97, Chapter 9).

93. Like the famous tenth-century Byzantine 'Staurothek' now in the treasury of Limburg Cathedral. See Fillitz, *op. cit.*, 23–31. Fillitz also shows clearly that parts of the decoration, although original, are not mounted in their original positions. He suggests that the inscription on the front was originally mounted around the four Evangelists surrounding the cross-shaped cavity on the inner panel, and that the strips with engraved foliate scroll, now very slightly trimmed in length, were also mounted originally on the inner leaf. He suggests a first alteration, I believe correctly, in the Early Gothic period. The reliquary was again very throughly restored in 1736–40. As Fillitz says (p. 31, note 33), only a thorough examination of the two wooden cores and the evidence of early nail-holes, etc., might solve these problems finally.

94. See p. 65, Chapter 5.

95. Bib. Nat. MS. lat. 9388. The ivory is mid- p. 128
ninth-century (see p. 44, Chapter 4; Steenbock (1965), no. 46).

96. See W. M. Schmid, *Der Bamberger Domschatz* (Munich, 1914), cat. no. 36, and Fillitz, *op. cit.*, 15.

97. Schramm and Mütherich (1962), no. 129.

98. When a second crown was placed on the reliquary in the fourteenth century, the crown suffered again, and perhaps lost its upper decoration, which may originally have taken the form of four fleur-de-lys. See Schramm and Mütherich (1962), 162.

99. Thietmar, *Chronik* (ed. Trillmich, 1957), book VII, 1, pp. 352–3. The pope provided the crown for the coronation of the emperor and Henry presented his own crown to the altar of St Peter.

p. 129 100. For example, the Abendhof Gospels (Kassel, Landesbib. MS. theol. 2º60) or the Wolfenbüttel Gospels (Herzog August Bib. cod. Guelf 16.1. Aug. 2º); see *Kunst und Kultur im Weserraum 800–1600* (*op. cit.*, Note 31), nos. 172, 173.

101. Steenbock (1965), no. 61.

102. For example in the Chantilly leaf with Otto II by the Gregory Master; see Dodwell (1971), 57–8.

103. For a fuller discussion of the development of this style, see T. Buddensieg, 'Die Baseler Altartafel Heinrichs II', *Wallraf-Richartz-Jahrbuch*, XIX (1957), 159 ff.

104. See p. 130.

105. See Chapter 11, p. 134.

p. 130 106. Buddensieg, *op. cit.* (1957), 133 ff. Also W. Messerer, 'Zur byzantinischen Frage in der ottonischen Kunst', *Byzantinische Zeitschrift*, LII (1959), 35 ff.

107. For a discussion of the legend of St Benedict's intervention, see W. Weisbach, *Religiöse Reform und mittelalterliche Kunst* (Einsiedeln, 1945), 31. For the usual date, see Schramm and Mütherich (1962), no. 138.

108. See Schnitzler, *op. cit.* (Note 15), 39 ff.

109. Earlier photographs show the frontal in a frame in Romanesque style, made in 1872 by the goldsmith A. Witte. See Schnitzler, *op. cit.* (Note 15), 39–43, whose reconstruction of the original frame is entirely convincing.

110. See P. Nørlund, *Gyldne Altre* (Copenhagen, 1926).

111. For example the sleeping soldiers at the tomb; see Schnitzler, *op. cit.* (Note 15), 42 and figure 17.

112. For the latest publication to emphasize this, see W. Otto, 'Reichenauer Goldtreibarbeiten', *Zeitschrift für Kunstgeschichte*, XIII (1950), 39 ff.

p. 131 113. For the full discussion of this see Schnitzler, *op. cit.* (Note 15), 39–132.

114. Steenbock (1965), nos. 51, 52. The front cover was less vigorously restored in the nineteenth century, when the symbols of St Matthew and St Mark were wrongly re-assembled. The silver back cover of the same manuscript was mounted as the front cover of the Ottonian Gospels in the Aachen treasury in 1870.

115. The same qualities can, for instance, be found in the Towneley brooch (see p. 87, Chapter 8).

116. Gospel Book, cod. lat. 837 (Steenbock (1965), no. 53). For the 'Fulda' ivory, see Weitzmann, *op. cit.* (Note 15), 16.

117. Catalogue (by S. Müller-Christensen), *Sakrale Gewänder des Mittelalters* (Munich, Bayerisches Nationalmuseum, 1955). See also Schramm and Mütherich (1962), nos. 130–3. The inscriptions are given there.

118. Now in Munich, Bayr. Staatsbib. cod. lat. p. 132 13601; Steenbock (1965), no. 59. There are many later additions to this poorly preserved piece. For detailed examination, see H. Schnitzler, 'Zur Regensburger Goldschmiedekunst', in *Forschungen zur Kunstgeschichte und christlichen Archäologie*, II (Baden-Baden, 1953), 171 ff.

119. Y. Hackenbroch, *Italienisches Email des frühen Mittelalters* (Basel and Leipzig, 1938), 35, Abb. 17.

120. For dedicatory inscriptions see Schramm and Mütherich (1962), no. 143.

121. Musée du Louvre, Orf. 13, acquired in 1795. This cover also has cloisonné enamels that link it to this group of works. See Steenbock (1965), no. 56, Abb. 78. Also Hackenbroch, *op. cit.*, 34, Abb. 16.

CHAPTER 11

1. Schramm and Mütherich (1962), no. 145. The p. 134 present silver-gilt foot was added in 1352 by Charles IV.

2. The inscription reads: ECCE CRUCEM DOMINI FUGIAT PARS HOSTIS INIQUI/HINC CHUONRADE TIBI CEDANT ONNES INIMICI. As Conrad is not given any title, the absence of his imperial title does not prove, but nevertheless makes it likely, that the cross was completed before 1027.

3. Schramm and Mütherich (1962), no. 62. The golden sleeve around it was added to the relic by Charles IV. It was considered not only a holy relic, but also a symbol of the rule over the Lombard Kingdom.

p. 134 4. Schramm and Mütherich (1962), no. 146. The crown used for the imperial coronation in Rome was, as was customary, supplied by the pope. Conrad gave this crown to the abbey of Cluny, where it was destroyed in 1030. See p. 84, Chapter 8.

p. 135 5. H. Swarzenski (1967), 44; Elbern, Taf. (1962), nos. 392–3.

6. H. Swarzenski (1967), 44.

7. See also Elbern, 85.

8. See p. 132, Chapter 10.

9. The style also relates very well to Late Ottonian illumination, for example Henry III's Codex Aureus (Madrid, Escorial cod. Vitr. 17) or the Codex Aureus from Echternach (Nuremberg, Germanisches Museum). Dodwell (1971), plate 72.

10. See p. 200, Chapter 18, and O. von Falke, R. Schmidt, and G. Swarzenski, *Der Welfenschatz* (Frankfurt, 1930).

11. Falke a.o., *op. cit.*, no. 5.

12. The inscription reads: GERTRVDIS XPO FELIXVT (*sic*) VIVAT IN IPSO OBTVLIT HVNC LAPIDEM GEMMIS AVROQ(VE) NITENTEM. This filigree scroll may originally have been backed by enamel, perhaps in black and white. In a recent examination of the original I believe I could see very small fragments of enamel surviving in the background of the scroll, for example opposite the first I in IN IPSO, and over the 'v' in AVRO, the former white, the latter black. It may be possible that areas in the small gold cross – the so-called first cross – of Gertrude were also enamelled, but without laboratory examination of these tiny surviving fragments one cannot be certain. If indeed such enamel existed, these two pieces would be unique early examples of a technique known as 'Drahtemail' (wire-enamel) used in the later Middle Ages.

13. The beginning of the inscription on the top also faces the onlooker if he views it from this side.

p. 136 14. The absence of St Blaise, the main patron saint of the new cathedral at Brunswick, suggests that the altar was a personal possession of Gertrude and might have been given to the cathedral at any time before her death in 1077.

15. See T. Buddensieg, 'Beiträge zur ottonischen Kunst in Niedersachsen', *Miscellanea pro Arte* (Schnitzler Festschrift) (Düsseldorf, 1965), 68–76, for an attempt to place a number of works in Lower Saxony, including the portable altar of Gertrude.

16. The use of broad gold frames as internal divisions of the design of the small enamels on the lower upright of the cross is more reminiscent of enamelling under Bishop Egbert of Trier than under Mathilde at Essen. The small curved pieces might be even older; they are like the enamels on the gold chalice of Gauzelin of Toul (see p. 85, Chapter 8). Only the 'sunk' enamel plaques on the extremities of the cross might be said to be in the earlier Essen tradition.

17. Schnitzler, I (1957), no. 46. Similar re-used enamels also appear in the second piece given to Essen by Theophanu, the Nail reliquary, which was considerably altered in the fifteenth century.

18. For a discussion of the relationship see p. 166, Chapter 15. The manuscript originally under Theophanu's cover is also related to Mosan illumination. See Steenbock (1965), no. 62.

19. R. Wesenberg, 'Der Werdener Bronzekruzi- p. 137 fixus und eine Essen-Werdener Schule des 11. Jahrhunderts', *Bewahren und Gestalten* (Festschrift für G. Grundmann) (1962), 157–63.

20. R. Wesenberg, 'Ein kleiner Bronzekruzifixus aus den Werkstätten der ehemaligen Benediktinerabtei Werden', in *Miscellanea pro Arte* (*op. cit.*, Note 15), 132–43.

21. F. Rademacher, 'Der Werdener Bronze-Kruzifixus', *Zeitschrift des deutschen Vereins für Kunstwissenschaft*, VIII (1941), 146 ff.

22. H. Swarzenski (1967), plate 99, figure 227.

23. E. Meyer, 'Der Kaiserstuhl in Goslar', *Zeitschrift des deutschen Vereins für Kunstwissenschaft*, X (1943), 183.

24. J. Braun, *Der christliche Altar* (Munich, 1924), 114. The name arose in post-medieval times when the altar was believed to be an altar of the German heathen idol 'Krodo'. The box is actually carried on four small corner towers in front of which the figures kneel. The top is covered by a sheet of marble, marked with the five dedication crosses usual on altars.

25. See *Kunst und Kultur im Weserraum, 800–1600*, Corvey exhibition catalogue (Münster in Westfalen, 1966), no. 29. The almost life-size figure was originally covered with gold and silver sheet, its borders set with filigree and gems. The head and hands were probably originally painted.

26. See above p. 122, Chapter 10.

p. 138 27. Goldschmidt, II (1918), nos. 102–36, 139–40, 142. Complete altars are nos. 102–5 and 128. Somewhat less convincing as part of this group are the rather flat panels in the Diocesan Museum at Münster (nos. 106–18).

28. Goldschmidt, II (1918), 9.

29. R. Hamann, *Die Holztür der Pfarrkirche zu St Maria im Kapitol* (Marburg, 1926). Evidence for the fourth panel is provided by an early plaster cast of the doors (*ibid.*, plate XLV). The nine figures might be intended to be Apostles – only nine Apostles appear in the Last Supper panel.

30. Hamann, *op. cit.*, 28.

p. 139 31. See p. 98, Chapter 9. Also Steenbock (1965), no. 42. It has been argued that the ivory is one or two millimetres too narrow, and that it was carved in the first quarter of the eleventh century and only added to the cover later (P. Metz, *Das goldene Evangelienbuch von Echternach* (Munich, 1956), note 130). It does, however, seem to fit far too well to have been only an accidental marriage.

32. K. Oettinger, 'Der Elfenbeinschnitzer des Echternacher Codex Aureus und die Skulptur unter Heinrich III (1039–56)', *Jahrbuch der Berliner Museen*, II (1960), 34–54.

33. The group was first assembled by W. Vöge, 'Ein deutscher Schnitzer des 10. Jahrhunderts', *Jahrbuch der Preussischen Kunstsammlungen*, XX (1899), 117–24; Goldschmidt, II (1918), nos. 23–7.

34. See p. 148, Chapter 13.

35. Attributed to the first half of the eleventh century by H. Swarzenski (1967), plate 67, figure 153. The double-line drawing on this ivory can also be found in Flemish manuscripts of the period, such as the Gospels from Gembloux (Brussels, Bib. Roy. MS. 5573), See also p. 165, Chapter 15, for the engraving on a contemporary book-cover, Oxford, Douce 292.

36. Psalter of St Hubert d'Ardennes, MS. Add. 37768; Hereford Troper, MS. Cotton Caligula A, XIV. See H. Swarzenski (1967), figures 152, 153, 154.

NOTES TO PART THREE

CHAPTER 12

p. 143 1. For the kind of stylistic distinctions that can be made, see L. Grodecki, *L'Architecture ottonienne* (Paris, 1958).

2. See p. 157, Chapter 14, for a discussion of the sources of 'panel' or 'dampfold' drapery, especially in the work of Roger of Helmarshausen.

3. Steenbock (1965), no. 57.

4. See p. 86, Chapter 8.

p. 144 5. Goldschmidt, IV (1926), nos. 126–46.

6. The Old Testament panels measure *c.* 25 by 14 cm. (10 by 5½ in.). Pieces in collections other than Salerno are: Old Testament: one panel, Louvre, Paris (Goldschmidt, IV (1926), 126,9); one panel in two halves, National Museum, Budapest (*ibid.*, 126,5), and Metropolitan Museum, New York (*ibid.*, 126,6); New Testament: one fragment, Staatliche Museen, Berlin (*ibid.*, 125,41); one fragment, Kunstgewerbemuseum, Hamburg (*ibid.*, 126 bis).

7. The throne of Maximian; see Volbach (1952), no. 140. Goldschmidt, IV (1926), no. 126, p. 38, thinks a throne the most likely.

8. See also the arguments given above, pp. 51 ff., Chapter 4; a similar source must have been available to the painters of the cycle of wall paintings at Sant'Angelo in Formis, only forty miles from Salerno. There are some surprisingly close affinities of iconography between the Salerno ivories and these wall paintings – for example the Deposition has a canopy, a motif rarely shown in western iconography. Also the same decoration of the sarcophagus – a purely classical type – is used.

9. Volbach (1952), no. 111.

10. First proposed by H. Graeven, *Römische Quartalschrift*, XIII (1899), 109 ff. Goldschmidt, IV (1926), nos. 112–24, added to the group and accepted Graeven's date. Others to have supported this early date are C. Nordenfalk, 'Eastern Style Elements in the Book of Lindisfarne', *Acta Archaeologica*, XIII (1942,) 157–69, and R. B. M. Bruce-Mitford, whose analysis is the most convincing (in T. D. Kendrick (ed.), *The Lindisfarne Gospels* (Lausanne, 1960), 168–73).

11. Volbach (1952), 102, no. 237; O. Belloni, p. 145
'Gli avori di San Mena . . .', *Rivista di Archaeologia Cristiana*, XXVIII (1952), 133 ff.; Bovini and Otto-lenghi, *Catalogo della mostra degli avori* (Ravenna, 1956), 115 ff.

p. 145 12. The whole group of ivories, with the rare subject matter of the life of St Mark, would, if the ivories were carved in the sixth or early seventh century, be appropriate for Alexandria, where St Mark was martyred. If the ivories were carved in the eleventh century, however, then Venice, where the body of St Mark was translated in the ninth century, could well have been the centre of production.

13. The comparison made by Bruce-Mitford with the Codex Rossanensis for these two panels is also particularly telling (see *Lindisfarne Gospels* (*op. cit.*), 169, plate 30d, e), not only for the architectural background but also for figure style.

14. Goldschmidt, IV (1926), no. 117. For the early iconography of the accompanied Evangelist portrait, see Bruce-Mitford, *op. cit.*, 162–4, where further references are given.

p. 146 15. R. Salvini, *Wiligelmo da Modena e le origini della scultura romanica* (Milan, 1956).

CHAPTER 13

p. 147 1. See É. Lambert, 'Ordres et confréries dans l'histoire du pélerinage de Compostelle', *Annales du Midi*, LV (1943), 369.

2. See J. Evans, *Monastic Life at Cluny, 910–1157* (Oxford, 1931); W. Weisbach, *Religiöse Reform und mittelalterliche Kunst* (Zürich, 1945); N. Hunt, *Cluny under Saint Hugh 1049–1109* (London, 1967), for full bibliography.

3. K. Häbler, *Das Wallfahrtsbuch des Hermannus König von Vach und die Pilgerreisen der Deutschen nach Santiago de Compostela* (Strasbourg, 1899), 20 ff. See also W. L. Hildburgh, *Medieval Spanish Enamels* (Oxford, 1936), 71 ff., for additional references to close trade contacts between Flanders and Verdun and northern Spain.

4. Hunt, *op. cit.*, 79.

p. 148 5. W. M. Whitehill, *Spanish Romanesque Architecture of the Eleventh Century* (Oxford, 1941), 149.

6. G. Gaillard, *Les Débuts de la sculpture romane espagnole* (Paris, 1938).

7. Goldschmidt, IV (1926), no. 81.

8. *Viaje santo* (1572), 46: 'Arcula Sanctorum micat hoc sub honore deorum/Baptistae Sancti Johannis sive Pelagii/Ceu Rex Fernandus Reginaque Santin fiori iussit/Era millena septena seu nonagena' (Era 1097 = A.D. 1059).

9. For example the Christian reliquary casket given by Alfonso III (866–910) to Astorga Cathedral or the casket known as the Caja de las Agatas in the Camara Santa at Oviedo (see p. 8, Chapter 1, and Palol and Hirmer (1967), 474, nos. 40 and 41 and plate X) or the eleventh-century Islamic ivory caskets in the Archaeological Museum, Madrid, the Archaeological Museum, Burgos, or Pamplona Cathedral (Hildburgh, *op. cit.*, plates VI, VII, X, XIII).

10. Palol and Hirmer (1967), plate XIX, no. 62, p. 478.

11. See also p. 139, Chapter 11. K. Oettinger, 'Der Elfenbeinschnitzer des Echternach Codex and die Skulptur unter Heinrich III (1039–56)', *Jahrbuch der Berliner Museen, Jahrbuch der Preussischen Kunstsammlungen*, N.F. II (1960), 34–54.

12. On the front: the Fall; on the left side: Adam p. 149 and Eve before God; on the right: the Creation of Adam; on the back: Ferdinand, God clothing Adam and Eve, and the Expulsion.

13. See p. 56, Chapter 4.

14. See p. 117, Chapter 10.

15. Goldschmidt, IV (1926), no. 100. p. 150

16. The text reads: et aliam (crucem) eburneam in similitudinem nostri Redemptoris crucifixi.

17. The one on the right is almost totally destroyed.

18. Goldschmidt, IV (1926), no. 94. Some mounts originally on the casket, but now removed, are said to have dated from the second half of the eighteenth century – the probable date therefore of the assembly of the pieces in their present form. The fourth side of the casket has Hispano-Mauresque fragments of the eleventh century mounted on it.

19. The Bible from Farfa in the Vatican and the Bible from San Pere de Roda in Paris (see Goldschmidt, IV (1926), 29).

20. For details see *ibid.*, nos. 84–91. p. 151

21. *Primera Parte de las Fundaciones de los Monesterios del glorioso Padre San Benito* (Madrid, 1601), 24.

22. The narrower panels are 16·5 cm. high and 7·5 cm. wide (about 6½ by 3 in.). The wider, lower panels, are 16·5 cm. high and 10·5 cm. wide (about 6½ by 4 in.).

23. For enamelling see p. 154.

24. Steenbock (1965), no. 25. See also p. 270, p. 152 Note 5.

25. See pp. 72 ff., Chapter 6.

26. For the full text and photographs of the Arca before its restoration after severe damage inflicted in 1934 see M. Gomez-Moreno. 'El Arca Santa de Oviedo documentada', *Archivo Español de Arte*, XVII (1945), 125-36. (The inscription survives only in parts, but the whole is given by Ambrosio de Morales.) For the list of remarkable relics which the Arca was made to contain, see Whitehill, *op. cit.* (Note 5), 230-1, note 4.

27. The upper part of Christ was restored after 1934. The two Apostles on the extreme left, lower register, are also restorations, perhaps of the sixteenth century. The reproduction on Plate 157 shows the Arca without these restorations.

p. 153 28. The unusual iconography of the sides (perhaps incomplete?) still awaits detailed examination.

29. See p. 148; University Library, Santiago de Compostela (Palol and Hirmer (1967), plate XIX).

30. Goldschmidt, IV (1926), nos. 98-9. The original shrine was described by Sandoval, *op. cit.* (Note 21), 38, and a sixth ivory panel is missing. The panels are 13 to 16·5 cm. (5 to 6½ in.) high, and 20 to 25 cm. (8 to 10 in.) wide. The panels show the following scenes. No. 98: two panels with uncertain miracle scenes; Entry into Jerusalem; the Last Supper. No. 99 (Vienna): Christ appearing to the Apostles.

31. The 'double line' folds are again very close to the major sculpture of the Pilgrimage Road style – for example in the panels of the ambulatory of Saint-Sernin at Toulouse.

32. Goldschmidt, IV (1926), no. 104. The monastery of Carrizo was not founded until 1176; the carving might therefore have been originally at León.

33. *Ibid.*, nos. 108, 109 (109 in the Hermitage, Leningrad).

p. 154 34. *Ibid.*, no. 107. Probably originally a bookcover, now in the Louvre, Paris.

35. The cover came from the cathedral of Jaca (see Steenbock (1965), no. 68). It is now in the Metropolitan Museum, New York.

36. See M. Gomez-Moreno, *El Arte romanico español* (Madrid, 1934), 31, and Palol and Hirmer (1967), 478, no. 77. Most of the strips joining the bowl and the foot to the central knop are later restorations.

37. This and other references are given by Hildburgh, *op. cit.* (Note 3), 74 ff. The reliquaries have not survived.

38. British Museum Add. MS. 11695, from Silos, completed in A.D. 1109, on folio 232 verso. The comparison was first made by Hildburgh, *op. cit.*, 69, and plate XII, figure 16c, and plate XIII, figure 16a and b.

39. See M. M. S. Gauthier, 'Le Trésor de Con- p. 155 ques', in *Rouergue roman* (La Pierre-qui-Vire, 1963), 145. Some of the almond-shaped plaques on the sides of the casket were added during the restoration of 1875-8.

40. The same imitation of cloisonné enamelling in a champlevé technique is found in North Western Europe; see for example the Eilbertus altar in Berlin (p. 179, Chapter 16).

41. The inscription reads: ANNO AB INCARNATIONE DOMINI MILLESIMO: C(entesimo)// SEXTO K(a)L(udas) IVLII DOMNUS PONCIVS BARBASTRENSIS//EPISCOPVS ET SANCTE FIDIS VIRGINIS MONACHVS. HOC ALTARE BEGONIS ABBATIS DEDICAVIT//ET DE+(Cruce)XPI ET SEPVLTRO (sic) EIVS MVLTASQVE//ALIAS SANCTAS RELIQVIAS HIC REPOSVIT. See Gauthier, *op. cit.*, 143.

42. G. Gaillard, *La Sculpture romane espagnole* (Paris, 1946).

CHAPTER 14

1. The document is in a thirteenth-century hand, p. 156 but historians accept its content as genuine. See references in *Kunst und Kultur im Weserraum 800-1600*, Corvey exhibition catalogue (Münster in Westfalen, 1966), no. 248.

2. C. R. Dodwell (ed.), Theophilus, *De Diversis Artibus* (London, 1961), xxxvi ff.

3. *Ibid.*, 4.

4. *Ibid.*, xviii ff., xxxiv ff.

5. It reads: (O)FFERT MENTE PIA DECVS HOC p. 157 TIBI MARIA HEINRICVS PRESVL NE VITAE PERPETIS EXVL FIAT DENT Q(VE) (sit senus) LYBORIVS ET KILIANVS GAUDET HONORE PARI QVIB(VS) & VOTO FAMVLARI.

6. The outermost frame of the top, and the two strips set with gems bordering the two shorter sides of the altar, are additions of the fifteenth century.

7. For example, the portable altar of Queen Gertrude (*c.* 1030) from the Guelph Treasure, now in Cleveland (see p. 135, Chapter 11), and the altars

with carved ivory sides at Melk, Darmstadt, and Osnabrück, all of the second half of the eleventh century (see p. 138, Chapter 11, and Goldschmidt, II (1918), nos, 102, 103, 104).

p. 157 8. See H. Schnitzler, 'Zum Spätstil der ottonischen Kölner Malerei', in *Festschrift Hans R. Hahnloser for 1959* (Basel and Stuttgart, 1961), 207–22.

9. E. B. Garrison, *Studies in the History of Medieval Italian Painting*, III (Florence, 1958), 200–10.

10. W. Koehler, 'Byzantine Art in the West', *Dumbarton Oaks Inaugural Lectures* (Cambridge, Mass., 1941), 61 ff.

11. For example O. Pächt a.o., *The St Albans Psalter* (London, 1960), 122, C. M. Kauffmann, 'The Bury Bible', *Journal of the Warburg and Courtauld Institutes*, XXIX (1966), 75 ff., and Garrison, *op. cit.*, 200.

12. Garrison, *op. cit.*, 200–10; Dodwell (1971), 173 ff., plates 200–2.

13. K. H. Usener, 'Vorgotische Goldschmiedekunst', in Corvey catalogue (*op. cit.*, Note 1), 560, 570; Dodwell (1971), plate 177.

14. See p. 163, Chapter 15, for a fuller discussion.

p. 158 15. J. Beckwith, *Early Christian and Byzantine Art* (Pelican History of Art) (Harmondsworth, 1970), 120–1, plates 215–20; O. Demus, *Byzantine Mosaic Decoration* (London, 1947), plates 4, 7, 10B, 12B, 15.

16. For B.N. gr. 64 see H. Omont, *Miniatures des plus anciens manuscrits grecs de la Bibliothèque Nationale du VIe au XIVe siècle* (Paris, 1929), plate LXXXV, especially folios 10 verso and 11. For Ohrid, see O. Bihalji-Merin, *Byzantine Frescoes and Icons in Yugoslavia* (London, 1960), plate 1. See also O. Demus, *Byzantine Art and the West* (London, 1970).

17. Garrison's conclusion that the 'clinging curvilinear' style, certainly of the most extreme kind found in England (Bury Bible), originated in the north may well be true, but the 'nested V-fold', and indeed the 'multilinear' style of Berzé-la-Ville, seem much closer to Italian models. See Garrison, *op. cit.*, 200–10, and Kauffmann, *op. cit.*, 76–81.

18. Grabar, in A. Grabar and C. Nordenfalk, *Romanesque Painting* (Lausanne, 1958), 25.

19. *Ibid.*, 41.

20. *Ibid.*, 26, 29, 37.

21. *Ibid.*, 190–1. Nordenfalk dates it as early as perhaps before 1077 – and sees in this codex a source for Mosan illuminators of the Lobbes and Stavelot Bibles, which would mean that both the Helmarshausen and the Mosan styles were parallel results of Italian influence.

22. See also the very convincing treatment of this problem by D. H. Turner, 'The Siegburg Lectionary', *Scriptorium*, XVI (1962), 16–27, especially 24–7.

23. Dodwell, *op. cit.* (Note 2), 4.

24. *Ibid.*, 20, 80.

25. Corvey catalogue (*op. cit.*, Note 1), no. 249. p. 159 The part of the plaque with St Felix and the altar stone are nineteenth-century replacements; the silver frame of the stone is fifteenth-century.

26. More telling may be the puzzling clue given by the large and deeply engraved roman numerals X, V, II, I, which are found on the inside of the four feet of the altar. These have been interpreted as the number XVIII, implying that the altar is therefore to be dated 1118. Why the III should be separated into II and I is difficult to understand, and one might therefore favour the reading XI VII for 1107, or have to accept that these numerals do not stand for a date at all, but are perhaps more likely to be only an inventory number.

27. Steenbock (1965), no. 79. The missing centrepiece of the composition, of which only a circular setting survives, probably held a large crystal or possibly an antique cameo, re-interpreted as Christ? (*ibid.*, 172). (Agnus Dei?)

28. *Ibid.*, no. 12.

29. *Ibid.*, no. 27.

30. See R. L. S. Bruce-Mitford, *Codex Lindisfarnensis* (Lausanne and Olten, 1960), 158, 161, for a full discussion of the Early Christian types. See also p. 53, Chapter 4.

31. For example, the treatment of wings and birds in the consular diptych panel with the apotheosis of an emperor and the heads and eyes in the Passion panels, all in the British Museum (O. M. Dalton, *Catalogue of Ivory Carvings in the British Museum . . .* (London, 1909), plates I and IV).

32. Dodwell, *op. cit.* (Note 2), 104–5. The much restored golden chalice of St Rémy is usually dated to the late twelfth century (see catalogue, *Les Trésors des églises de France* (Paris, 1965), no. 132), but is not only close to the one described by Theophilus but also employs a very similar, if somewhat more elaborate, style of filigree to that on Roger's portable altar of 1100. Without full knowledge of

the extent of the nineteenth-century restoration, a possible attribution to Roger's workshop would have to await more detailed study.

p. 160 33. Corvey catalogue, *op. cit.* (Note 1), no. 251, and H. Swarzenski (1967), plate 105, figure 239.

34. See, for example, the imperial cross in the Vienna Imperial Treasury (see p. 134, Chapter 11). See also H. Schnitzler, 'Das sogenannte Bernwardskreuz', in *Forschungen zur Kunstgeschichte und christlichen Archaeologie*, III (Wiesbaden, 1957), 382 ff.

35. Corvey catalogue (*op. cit.*), 573.

36. Now in Cologne, Schnütgen Museum; see *ibid.*, no. 252.

37. *Ibid.*, no. 250. The foot is fifteenth-century. Two panels of filigree on the back are missing.

38. Perhaps this is evidence of an influence from Lotharingia, where this iconography is used on the Adalbero ivory panel (see p. 113, Chapter 10).

p. 161 39. For example the large circular brooch in the so-called Gisela Treasure, Staatliche Museen, Berlin (see p. 87, Chapter 9).

40. For Hildesheim, see F. J. Tschan, *St Bernward of Hildesheim* (Notre Dame, 1942–52), III, plates 59 ff. For Corvey see Corvey catalogue (*op. cit.*), nos. 174 ff., Abb. 170.

41. In the Gospel Book in the Trier Cathedral Treasury, MS. 142 (see Corvey catalogue (*op. cit.*), no. 193, plate 187). See also G. Swarzenski, 'Aus dem Kunstkreis Heinrichs des Löwen', *Städel Jahrbuch*, VII–VIII (1932), 280 ff., and p. 212, Chapter 18.

CHAPTER 15

p. 162 1. S. Collon-Gevaert, in *Art roman* (1965), 172–80; K. H. Usener, 'Reiner von Huy und seine künstlerische Nachfolge', *Marburger Jahrbuch*, XII (1933), 77–134. The church of Notre-Dame was destroyed in 1794. The font was saved (although two of the original twelve oxen and the lid decorated with Apostles and prophets were probably lost then) and given in 1803 to the church of St Bartholomew.

2. See p. 246, Chapter 21.

3. M. Laurent, 'La Question des fonts de Saint Barthélemy de Liège', *Bulletin Monumental*, LXXXIII (1924), 327–48, discusses the documentary evidence fully. Usener, *op. cit.*, 132, also gives extracts of the relevant texts.

4. See III Kings 7, 23–9, and II Chronicles 4, 2–5.

5. The inscriptions are given in full by Usener, p. 163 *op. cit.*, 132–3.

6. See p. 37, Chapter 3. The popularity of such classicizing ivories in the Lorraine region in the late tenth century is shown by at least two copies of Carolingian ivories carved then in this region, probably at Liège itself. They are the copy of the British Museum Wedding at Cana, in the Cleveland Museum, and the copy of the Ascension panel in Vienna, in the Schnütgen Museum at Cologne. See H. Swarzenski, 'The Role of Copies in the Formation of the Styles of the Eleventh Century', in *Studies in Western Art*, I (Acts of the Twentieth International Congress of the History of Art) (Princeton, 1963), 7–18.

7. The name given to this group by Goldschmidt, II (1918), p. 6, nos. 46, 50–7.

8. The manuscript under this cover is dated tenth-century, and may well have belonged to Bishop Notger. The champlevé enamels of the frame are Mosan work of about the middle of the twelfth century. (See p. 191, Chapter 17.)

9. See U. Nilgen, *Der Codex Douce 292 der Bodleian Library zu Oxford. Ein ottonisches Evangeliar* (Bonn, 1967), 179 ff., giving all earlier references.

10. A close examination of the panel does not reveal any evidence that would support the theory that the halo was carved into the background at a later date – after the canonization of 1634 has been suggested. Had anyone wished to add a halo (and who would think of adding a halo to a medieval ivory in the seventeenth century?), it would have been far simpler to paint it on – or add gilding.

11. J. Lejeune, in *Art roman* (1965), 165–7. Against this theory, see J. Philippe, 'L'Évangéliaire de Notger et la chronologie de l'art mosan des époques préromane et romane', *Académie royale de Belgique*, 2e serie, X (1956). Also Nilgen, *op. cit.*, 186 ff.

12. Was the commission of the great bronze font p. 164 of Rainer's another chapter in the dispute?

13. The argument whether a codex or a rotulus (i.e. charter) is held in his hand is difficult to resolve with certainty. To me, I must admit, it looks more like a scroll than a codex, but charters, especially fine illuminated ones, are also sometimes in codex form.

p. 164 14. This similarity is not based only on the fact that both works are badly rubbed: the facial type, the small, even features, and the gently waved hair are identical.

15. Bodleian Library, MS. Douce 292.

16. Most recently by Nilgen, *op. cit.*, 186 ff.

17. See p. 107, Chapter 9, and also Nilgen, *op. cit.*, 97–100.

18. Goldschmidt, I (1914), nos. 41, 44, 83, 85, 88, 100, 132.

19. See p. 71, Chapter 6.

p. 165 20. The drapery of the Notger panel finds its closest parallel in a drawing in the Gregory Nazianzus manuscript, in the Bibliothèque Royale, Brussels (MS. II, 2570, folio 3 recto). The manuscript is not dated, but is sometimes identified with a manuscript listed in the Stavelot library in 1105 (J. Stennion, in *Art roman* (1965), 160–1). Usener dates the MS. *c.* 1020–30, in L. Fèbvre (ed.), *L'Art mosan* (Paris, 1953), 167–8.

21. All the arguments have been marshalled by Nilgen, *op. cit.*, 31 ff. Her own attempts to prove that it was given by the young Otto III to St Adalbert, Liège, and therefore to date the manuscript and the cover to *c.* 1000, I do not find convincing. Lejeune suggests the young French king Louis VI (1108–37) as the donor. The fact that the manuscript probably belonged to the abbey of Saint-Nicholas-aux-Bois (entered among a later list of places on folio I recto), founded in 1085 by Philip I (1060–1108), is strong support for the theory, but the date seems very late, if not for the ivory, then certainly for the engraving of the frame and the illuminations in the manuscript (Lejeune, in *Art mosan* (*op. cit.*), 168–71). Perhaps it might be considered a gift by Philip I to Saint-Nicholas.

22. Otto Pächt and J. J. G. Alexander, *Illuminated Manuscripts in the Bodleian Library, Oxford*, I (Oxford, 1966). The authors date the ivory into the first half of the eleventh century, however, without giving reasons.

23. Nilgen, *op. cit.*, plate 75, figure 161, and H. Swarzenski (1967), figure 183.

24. Lejeune, *Art roman* (1965), 150; Goldschmidt, II (1918), no. 57.

p. 166 25. See also pp. 113 and 120, Chapter 10.

26. See p. 291, Note 6. The panel in the Tournai Museum, first thought by Goldschmidt to be a fake, was later accepted by him as a genuine imitation of a Metz panel (*Elfenbeinskulpturen*, II, Abb. 2, p. 7). It is more difficult to follow Goldschmidt in accepting the elaborate border as medieval. Could it be a Renaissance addition?

27. See J. Lejeune, 'Genèse de l'art mosan', *Wallraf-Richartz-Jahrbuch*, XV (1953), 47–73, and *idem*, in *Art roman* (1965), 115, for the historical background, which makes any earlier date very unlikely.

28. Goldschmidt, II (1918), nos. 52, 53; Lejeune, in *Art roman* (1965), 114 ff.

29. Goldschmidt, II (1918), nos. 55, 56; Lejeune, *Art roman* (1965), 114 ff., 117, and 142.

30. Steenbock (1965), no. 62.

31. It is worth remembering that the Liège panel was mounted until 1926 on a manuscript dated by J. Stennion to *c.* 1060 (see Lejeune, 'Genèse de l'art mosan' (*op. cit.*), 59).

32. O. M. Dalton, *Ivory Carvings of the Christian Era in the British Museum* (London, 1909), no. 54; height 10·8 cm. (4¼ in.).

33. Unpublished.

34. H. Swarzenski (1967), figures 51, 227.

35. C. R. Dodwell, *The Canterbury School of* p. 167 *Illumination* (Cambridge, 1954), plates 13a, b; 15c, e.

36. L. Stone, *Sculpture in Britain, The Middle Ages* (Pelican History of Art), 2nd ed. (Harmondsworth, 1971), plate 25. The gold cross and its enamels of the same date are either German or under strong German influence.

37. Unpublished; purchased at Sotheby's, 17 March 1961, lot 48, from the collection of Countess S. Bernstorff Gyldensteen, Copenhagen. The head can also be compared very well to the head of Rudolf of Swabia on his tomb slab in Merseburg Cathedral (d. 1080). See H. Swarzenski (1967), figure 227.

38. W. Mersmann, 'Das Elfenbeinkreuz der Sammlung Topic-Mimara', in *Wallraf-Richartz-Jahrbuch*, XXV (1963), 1–102. This attempt to date the cross no later than *c.* 1060 is not convincing.

39. T. Hoving, 'The Bury St Edmunds Cross', *The Metropolitan Museum of Art Bulletin* (June 1964), 317–40, with the re-discovered fourth scene at the base of the cross.

40. The St Matthew symbol at the base is missing.

41. That the anti-semitic content of these inscriptions points exclusively to Abbot Samson of Bury St Edmunds (1182–1211) (Hoving, *op. cit.*) is

not convincing. S. Longland has made a start; see *The Connoisseur*, CLXXII (1969), 163–73.

42. Cambridge, Corpus Christi College MS. 2; see C. M. Kauffmann, 'The Bury Bible', *Journal of the Warburg and Courtauld Institutes*, XXIX (1966), 60–81. For the Byzantine sources of the Bury style see the early-twelfth-century wall paintings at Asinou, Cyprus; O. Demus, *Byzantine Art and the West* (London, 1970), figure 186.

p. 168 43. The earlier dating of English monuments in the twelfth century, the Bury Bible to *c.* 1135 and the St Albans Psalter before 1123, agreed by scholars (Kauffmann, *op. cit.*, and O. Pächt, C. R. Dodwell, and F. Wormald, *The St Albans Psalter* (London, 1960), 279), seems to make a date of *c.* 1100–20 very possible. Another small feature, the decorative use of groups of dots on the figure of the Virgin in the Deposition, can be paralleled in the Canterbury Codex of Augustine's *De Civitate Dei*, in the Laurenziana Library, Florence, of the early twelfth century (M. Rickert, *Painting in Britain: The Middle Ages* (Pelican History of Art), 2nd ed. (Harmondsworth, 1965), plate 54).

44. H. Schnitzler, 'Das sogenannte Grosse Bernwardskreuz', in *Karolingische und ottonische Kunst* (Wiesbaden, 1957), 382–94, especially 393.

45. For the Madrid cross, see p. 149, Chapter 13; for the Copenhagen cross, Goldschmidt, III (1923), no. 124.

46. *Ibid.*, 36. For a fuller discussion, see Pächt, Dodwell, and Wormald, *op. cit.*, 173, note 3.

47. For a very full discussion of these sources see Pächt, Dodwell, and Wormald, *op. cit.*, 115 ff.

CHAPTER 16

p. 169 1. L. Straus, *Zur Entwicklung des zeichnerischen Stils in der Cölner Goldschmiedekunst des 12. Jahrhunderts* (Studien zur deutschen Kunstgeschichte, CCII) (Strassburg, 1917).

2. See, for example, the Adalbero plaque of the late tenth century (p. 113, Chapter 10), which is in a Metz style refined by contact with Utrecht Style ivories.

3. H. Swarzenski (1967), 21.

4. H. Schnitzler, 'Zum Spätstil der ottonischen Kölner Malerei', in E. J. Beer (ed.), *Festschrift Hans R. Hahnloser* (Basel and Stuttgart, 1961), 207–22.

5. F. Wormald, 'The Survival of Anglo-Saxon Illumination after the Norman Conquest', *Proceedings of the British Academy*, XXX (1944), 127–45; M. Rickert, *Painting in Britain: The Middle Ages* (Pelican History of Art), 2nd ed. (Harmondsworth, 1965), 47 ff.

6. P. Nørlund, *Golden Altars* (Copenhagen, p. 170 1926).

7. Inscribed as such. For full inscriptions see Nørlund, *op. cit.*, 227.

8. For example at Hopperstad (Sogn). See M. Blindheim, *Norwegian Romanesque Decorative Sculpture 1090–1210* (London, 1965), 45 ff., plates 164–5.

9. See p. 50, Chapter 4.

10. See p. 130, Chapter 10. p. 171

11. According to an old tradition given by Pope Celestine II in 1144 – a very acceptable date. See *Trésors d'art du moyen âge en Italie*, exhibition catalogue (Paris, 1952), no. 146.

12. Rickert, *op. cit.*, plate 57B.

13. L. Stone, *Sculpture in Britain: The Middle Ages* (Pelican History of Art), 2nd ed. (Harmondsworth, 1971), 61 ff., plate 39; A. Harris, 'A Romanesque Candlestick in London', *Journal of the British Archaeological Association*, 3rd series, XXVII (1964), 32–52; also C. Oman, *The Gloucester Candlestick* (Victoria and Albert Museum Monograph no. 11) (London, 1958).

14. See p. 111, Chapter 10 (Plate 108).

15. See Harris, *op. cit.*, plates III, IV; Oman, *op. cit.*, plates 29, 30.

16. Harris, *op. cit.*, plate V; Oman, *op. cit.*, plate 18.

17. The suggestion of German manufacture, sometimes made, cannot be supported. No Mosan or German work of the early twelfth century is anything like as accomplished. Hollow cire-perdue casting was already in use in England before the end of the tenth century (see p. 112, Chapter 10), and the practice of inserting black beads into eyes used on the candlestick is unknown in Germany, but popular in pre-Conquest ivories in England, for example in the Nativity panel, Public Museums, Liverpool (see M. H. Longhurst, *English Ivories* (London, 1926), no. XIII).

18. See p. 167, Chapter 15 (Plates 177 and 178).

19. The probable origin of this feature is in the Grimbald Gospels of the early eleventh century; see Rickert, *op. cit.*, plate 36B.

p. 171 20. The Broddetorp frontal is now in the National Museum, Stockholm; see Nørlund, *op. cit.*, 231 ff., figures 13, 89–93 (for the 'Winchester' border and flying drapery, see especially figure 92). Nørlund's opinion that 'what is new in the Broddetorp altar bears no decisively English stamp' is difficult to understand – where else could such clear 'Winchester' ornament have come from?

p. 172 21. Stone, *op. cit.*, 64, plate 41. Measuring 36·5 cm. by 16 cm. (about 14¼ by 6¼ in.), it is the largest single piece of medieval ivory carving. See also J. Beckwith, *The Adoration of the Magi in Whalebone* (Victoria and Albert Museum Monograph no. 28) (London, 1966).

22. Goldschmidt, III (1923), nos. 18–23, 25–6.

23. Illustrations in *Die Sammlungen des Baron von Hüpsch*, exhibition catalogue (Cologne, 1964), no. 51, plates 60, 61.

24. It reads: 'Omnibus exuta/tua iussa Sibilia/ secuta/ut sibi sis lumen/dedit hoc tibi Christe/ Volumen.'

25. Goldschmidt, III (1923), no. 18. The inscription reads: 'Nate maris stelle veniam concede Sibille.'

26. P. Bloch, in Hüpsch catalogue (*op. cit.*), no. 51.

27. H. Swarzenski, 'Der Stil der Bibel Karilefs von Durham', in H. Wentzel (ed.), *Form und Inhalt, Kunstgeschichtliche Studien für Otto Schmidt* (Stuttgart, 1950), 89–95. The most outstanding 'Anglo-Norman' work of the 'linear style' is the famous Bayeux Tapestry – an embroidered record of the Norman Conquest. See Rickert, *op. cit.*, 59–60.

28. Unpublished Ph.D. thesis by M. M. Farquhar, *A Catalogue of Illuminated Manuscripts of the Romanesque Period from Rheims 1050–1130* (University of London, 1968).

p. 173 29. Farquhar, *op. cit.*, 170 ff., points out that 'at least one artist of the St Hubert Bible was trained at St Rémy'. For the Bible of Saint-Hubert, see also K. H. Usener, 'Das Breviar Clm. 23261 der Bayrischen Staatsbibliothek und die Anfänge der romanischen Buchmalerei in Lüttich', *Münchner Jahrbuch der bildenden Kunst*, III. Folge, I (Munich, 1950), 78 ff. One manuscript of the 'Reims' group (Reims, MS. 294 folio 191) is illustrated by J. Porcher, *French Miniatures* (London, 1960), plate XXIII.

30. Durham, MS. A.II.4., folio 187 verso; see Rickert, *op. cit.*, plate 57B.

31. Cf. H. Swarzenski (1967), 57. MS. reproduced in Hüpsch catalogue (*op. cit.*), figure 58. See also E. Meyer, 'Goldschmiedekunst des 9. bis 13. Jahrhunderts', *Zeitschrift für Kunstgeschichte*, X (1941–2), 201 ff.

32. O. von Falke, R. Schmidt, and G. Swarzenski, *Der Welfenschatz* (Frankfurt am Main, 1930), no. 17. The altar is now in the Staatliche Museen, Berlin. See pp. 201–2, Chapter 18.

33. O. Pächt a.o., *The St Albans Psalter* (London, 1960), 116 ff.

34. For instance in the Echternach Gospels, initial 'L' on folio 23 recto. See P. Metz, *Das Goldene Evangelienbuch von Echternach* (Munich, 1956), plate 36.

35. See A. Grabar and C. Nordenfalk, *Romanesque Painting* (Lausanne, 1958), 191, dated here before 1077. See also D. H. Turner, 'The Siegburg Lectionary', *Scriptorium*, XVI (1962), 24 ff., proposing an early-twelfth-century date.

36. See Grabar and Nordenfalk, *op. cit.*, 41, 31.

37. At the top: + DOCTRINA PLENI FIDEI p. 174 PATRES DVODENI + TESTANTVR FICTA NON ESSE PROPHETICA DICTA +. At the base: + CELITVS AFFLATI DE CRISTO VATICINATI + HI PREDIXERVVT QVE POSTVENTVRA FVERVNT. One pilaster and one prophet on the right-hand short side are missing.

38. These step patterns also appear, for instance, on the Limburg reliquary; see J. Beckwith, *Early Christian and Byzantine Art* (Pelican History of Art) (Harmondsworth, 1970), 97–8, plate 179; Schnitzler, I (1957), no. 12.

39. P. Bloch, in Hüpsch catalogue (*op. cit*), no. 50. Bloch mentions the relationship with the Eilbertus altar in his discussion of no. 58 (Hessische Landesbibliothek, cod. 530), which, though also related, is not as close to the altar as the museum cod. 508 (AE.680). For the ivories mounted on the cover of cod. 508 and originally on cod. 530, see below p. 79.

40. See below, p. 200, Chapter 18.

41. This date is not absolutely certain. A document found inside the shrine states: 'A.D. 1129 . . . corpus B. Victoris repositum est in hoc scrinio', but the relics may have been kept in the plain wooden coffin inside the shrine. However, the date 1129 is usually accepted as very likely. See H. Schnitzler, *Die Goldschmiedeplastik der Aachner Schreinwerkstatt* (Düren, 1934), 24 ff.

p. 175 42. A major restoration is recorded on one gable by the date 1749.

43. Falke and Frauberger (1904), 126. Some of the relief decoration of the roof may be basically of the twelfth century, but it has been badly worked over in the nineteenth century. The results of a recent restoration have yet to be published.

44. K. H. Usener, 'Reiner von Huy und seine künstlerische Nachfolge', *Marburger Jahrbuch für Kunstwissenschaft*, VII (1933), 103. See also p. 184, Chapter 17.

45. See also the shrine of St Hadelin at Visé, p. 181, Chapter 17.

46. See pp. 148–9, Chapter 13.

47. Unpublished, about 60 cm. (2 ft) long.

48. The silver shrine of St Sigismund at Saint-Maurice d'Agaune, although of mid-twelfth-century date, may well be a late survival of a type of shrine which existed late in the eleventh century. It is smaller in scale, and its architectural articulation lacks precision. See R. Schnyder, 'Das Kopfreliquiar des h. Candidus in St Maurice', *Zeitschrift für schweizerische Archäologie und Kunstgeschichte*, XXIV (1965/6), 65 ff., plates 46–7.

49. See p. 9, Chapter 1.

50. O. von Falke, 'Die Inkunabeln der romanischen Kupferschmelzkunst', *Pantheon*, XVII (1936), 166.

p. 176 51. Falke, Schmidt, and Swarzenski, *op. cit.* (Note 32), no. 23.

52. The whole group of some nine caskets is analysed and listed by P. Nørlund, *Acta Archaeologica*, IV (1933). No origin for the large decorative nail-heads has been put forward, but the absence of any such nails in the Early Romanesque altar frontals in Scandinavia does not inspire confidence in the attribution of the group to Denmark. Large nail-heads used decoratively are, however, more often found in a northern context; see, for example, the fragments of a silver tenth-century house-shrine and the eleventh-century Isle of Ely disc-brooch, both from England and both now in the British Museum (D. M. Wilson, *The Anglo Saxons* (London, 1960), plates 18, 78). The decorative use of very simply interlaced snakes in the caskets also shows connexion with the north, but the timid use of the motif suggests only contact, rather than a direct northern provenance.

53. G. Zehnder, 'Der Siegburger Servatius-schatz', *Heimatbuch der Stadt Siegburg*, II (Siegburg, 1967), 422–6, no. 6.

54. Small gilt studs in the enamel, perhaps a technical device for keeping large areas of enamel to the surface, is also known in the early enamels in Spain (see p. 154, Chapter 13).

55. It is normally dated no earlier than *c.* 1170 (H. Swarzenski (1967), figure 438) and no later than *c.* 1200 (Schnitzler, II (1959), no. 40).

56. The inscription refers to the Apostles' rela- p. 177 tionship to Christ, and to his function as teacher. See Freerk Valentien, *Untersuchungen zur Kunst des 12. Jahrhunderts im Kloster Komburg* (Freiburg University, 1963), 49 ff.

57. Roundels for example on the eleventh-century enamelled chalice in the treasury of St Mark's in Venice, and on the large series of tenth- and eleventh-century secular ivory caskets.

58. See p. 93, Chapter 9.

59. See also p. 53, Chapter 4, and p. 159, Chapter 14.

60. Valentien, *op. cit.*, 195 ff., and for insignificant restorations probably mainly of the seventeenth century, see drawing on p. 31.

61. P. von Baldass, W. Buchowiecki, and W. p. 178 Mrazek, *Romanische Kunst in Österreich* (Vienna, 1962), 60 ff., plate VII.

62. For this important contribution, see Valentien, *op. cit.*, 65 ff.

63. *Ibid.*, 13 ff.

64. For full text, see *ibid.*, 97 ff.

65. For full discussion, see *ibid.*, 97 ff.

66. There are three types of towers, each type regularly repeated four times. Type 1 is a round tower, with standing figures only, both inside and out. Type 2 has a square base and two square storeys above, in which a bust appears in the lower on the outside. Type 3, the most elaborate, has busts on both sides of the tower in the second storey.

67. Often represented in Byzantine manuscripts and ivories, for example in the dedicatory illumination of the eleventh Psalter of Basil II, Biblioteca Marciana, Venice (cf. Beckwith, *op. cit.* (Note 38), 105).

68. It is said to have been begun by Bernward and p. 179 completed by Hezilo. The surviving piece was very

drastically restored in 1818. It measures 6 m. (20 ft) in diameter, has twelve towers and twelve gates, and carries seventy-two candles. None of its figure decoration, originally sixty figures, including twelve Apostles (in the gates) has survived. See F. J. Tschan, *Saint Bernward of Hildesheim*, II, *His Works of Art* (Notre Dame, 1951), 79-83.

p. 179 69. Valentien, *op. cit.*, 170; for the inscription on the cross see 166, 168.

70. One might also mention the fact that the head of the central figure of Christ shows a remarkable resemblance to the head of the Gero Crucifix in Cologne.

71. It is unfortunate that no metalwork of the second or third decade made at Salzburg has survived.

72. Goldschmidt, III (1923), nos. 1-14, 16-17. No. 15, also included in the group by Goldschmidt, is more likely to be of Mosan origin, perhaps related to the Adalbero plaque. See p. 165.

73. This peculiarity, albeit in a less consistent form, already appears on Ottonian ivories of the group around the Crucifixion plaque mounted in the cover of the Codex Aureus at Nuremberg, and the Spanish ivories related to them. See p. 139, Chapter 11, and p. 148, Chapter 13 (Plate 92).

p. 180 74. Goldschmidt, III (1923), nos. 1-5. For the Salerno antependium, see p. 144, Chapter 12.

75. All about 14 by 10·8 cm. (5½ by 4¼ in.) (Goldschmidt, III (1923), nos. 6, 7, 10, 11). Schnitzler makes this interesting suggestion in *Schatzkammer*, II (1959), 32. The four scenes – Nativity, Crucifixion, Ascension, Three Maries – would form the same group of subjects that appear on the golden book-cover of the eleventh-century Aachen Treasury Gospels (see p. 131, Chapter 10). The only objection might be that the size of Gospel Book such a cover would need, with framework, would be about 36 by 31 cm. (14 by 12 in.), somewhat too square in proportion. Given the minimum width necessary, it would be unusually large.

76. H. Beenken, 'Die Kölner Plastik des 12. Jahrhunderts', *Jahrbuch für Kunstwissenschaft*, I (1923), 128, suggests 1110-30, and Goldschmidt, III (1923), gives second half of the twelfth century. Schnitzler, II (1959), suggests *c*. 1140.

77. Hüpsch catalogue (*op. cit.*), nos. 50, 58.

78. Dodwell (1971), 58 ff. Other capitals on the Adoration panel, of cushion type, emphasize the sculptor's Rhenish background.

79. Compare almost any head with those on the Early Christian panels with scenes from the Passion in the British Museum (O. M. Dalton, *Ivory Carvings in the British Museum* (London, 1909), no. 7). The whole treatment of the human figure derives ultimately from this kind of source.

CHAPTER 17

1. K. H. Usener, 'Reiner von Huy und seine p. 181 künstlerische Nachfolge', *Marburger Jahrbuch für Kunstwissenschaft*, VII (1933), 89-90; H. Schnitzler, *Das Schnütgen-Museum, Eine Auswahl*, 2nd ed. (Cologne, 1961), no. 37. Only H. Swarzenski (*Art Bulletin*, XXIV (1942), 299) calls the attribution a 'little too audacious'.

2. M. Jansen, *Art chrétien jusqu'à la fin du moyen âge* (Brussels, 1964), no. 14, dates the figure *c*. 1165 and attributes it to the school of the Stavelot portable altar, which is surely too late.

3. P. Nelsen (then the owner), 'A Crucifix-figure of the School of Reiner of Huy', *Antiquaries' Journal*, XVIII (1938), 182-3.

4. Jansen, *op. cit.*, nos. 12, 13.

5. Usener (*op. cit.*, 116 ff.) and Collon-Gevaert (*Art roman* (1965), 218) suggest *c*. 1165; Schnitzler (*op. cit.*, 30) attributes it to Rainer of Huy, *c*. 1107-18. The inscription reads: HOC EGO REINER' DO SIGNVM/QUID MICHI VESTRIS EXEQUIAS SIMILES/DEBETIS MORTE POTITO/ET REOR ESSE PRECES VRAS TIMIAMATA XPO. See also E. Beitz, *Rupertus von Deutz* (Cologne, 1930), 123 ff.

6. Collon-Gevaert, *Art roman* (1965), 136.

7. In older reproductions the first line of the p. 182 inscription in each case was transposed, probably in a later restoration, so that the names of St Remaclus and St Hadelin appeared below the triumphant Christ. See Usener, *op. cit.*, 134. They have now been restored to their proper position.

8. This is the generally accepted view; see Collon-Gevaert, *Art roman* (1965), 68, and Usener, *op. cit.*, 92.

9. If the end pieces were re-used from a totally different kind of reliquary, the inscriptions, whose *émail brun* is far cruder than that on the sides of the shrine, would have to be of the twelfth century.

10. See p. 174, Chapter 16; for both kinds of decorative strip in one part of this frame, see the left edge of the scene of the Miracle of the Spring (Collon-Gevaert, *Art roman* (1965), figure 5).

11. See p. 148, Chapter 13.

p. 183　12. See J. Lejeune, 'Genèse de l'art mosan', *Wallraf-Richartz-Jahrbuch*, xv (1953), 50.

13. Usener, *op. cit.*, 91, pointed out that the proportion of length to height is unusual; this would be less true if the roof-line of the shrine was originally somewhat higher.

14. Collon-Gevaert, *Art roman* (1965), 3, and Lejeune, *op. cit.*, 50 ff. The heads of the Virgin and the Child are restorations of the seventeenth century.

15. It has lost its covering of precious metal and dates from *c.* 1060; see p. 137, Chapter 11.

16. See p. 163, Chapter 15; Goldschmidt, ii (1918), no. 50.

17. Usener, *op. cit.*, 92, and H. Swarzenski (1967), plate 98, figure 226. The comparison made there with the figure of King Cyrus (figure 225) of the Stavelot Bible, dated 1097, also helps to support a date in the second half of the century rather than in the first half, as suggested by Collon-Gevaert, *Art roman* (1965), plate 2.

p. 184　18. This division of hands follows that proposed by Usener, *op. cit.*, 93–103.

19. The far more developed architectural forms of the St Godehard shrine at Hildesheim, also dated soon after 1132, are additional evidence for the rapid development of the type during the thirties (see p. 197, Chapter 18).

20. See W. V. Giesebrecht, *Geschichte der deutschen Kaiserzeit* (Leipzig, 1929–30), iv and v; W. Ohnsorge, *Abendland und Byzanz* (Darmstadt, 1958), 411–33.

p. 185　21. Now in the Musées Royaux, Brussels; Jansen, *op. cit.* (Note 2), no. 118. For documentary evidence, see also K. H. Usener, 'Sur le chef-réliquaire du pape Saint Alexandre', *Bulletin des Musées Royaux d'Art et d'Histoire*, 3e ser., 6e année (1934), 57.

22. Only two of them, in front, survive.

23. See J. Squilbeck for a discussion of this iconography, 'Le Chef-Réliquaire de Stavelot', *Revue belge d'Archéologie et d'Histoire de l'Art*, xiii (1943), 17–27.

24. Martène and Durand, *Voyage littéraire etc.* (Paris, 1724), 151–4 (second journey). For the Gothic shrine see *Trésors des abbayes de Stavelot, Malmédy et dépendances*, exhibition catalogue (Stavelot, 1965), no. A12.

25. This is lost also. The attempts to identify this retable with the Pentecost retable said to come from Coblenz, now in the Cluny Museum, Paris, cannot be accepted; the inscriptions given by Martène and Durand are different from those on the Paris retable (see Martène and Durand, *op. cit.*, 151–2; S. Collon-Gevaert, 'L'Origine du retable, dit de Coblence, au Musée de Cluny', *Bulletin de la Société Royale d'Archéologie de Bruxelles*, i (1934); P. Bloch, 'Zur Deutung der sogenannten Koblenzer Retabels im Cluny Museum', *Das Münster*, 14. Jahr, Heft vii/viii (1961), 256–61).

26. The drawing was made to support a court case about Stavelot's possessions, which are listed in the inscriptions on the retable. If the retable was still in existence in 1661, it is difficult to explain why the inscription on the drawing states that it copies a drawing, not the original retable. The suggestion that this earlier drawing was the original drawing made by the goldsmith who made the retable is, of course, impossible and was only intended to strengthen the lawyer's hand in the seventeenth century. The earlier drawing might have been produced in 1628, when Wibald's retable was restored and re-erected (on a different altar?) (see J. Deér, 'Die Siegel Kaiser Friedrichs I. Barbarossa und Heinrichs VI. in der Kunst und Politik ihrer Zeit', in *Festschrift Hahnloser for 1959* (Basel and Stuttgart, 1961), 74).

27. Original drawing in the Archives de l'État, Liège. See D. van de Casteele, 'Dessin authentique du retable en argent doré que l'abbé Wibald fit faire pour l'abbaye de Stavelot', *Bulletin des Commissions Royales d'Art et d'Archéologie*, xxi (1882), 232 ff. For the latest discussion see Deér, *op. cit.*, 71 ff. Deér believes that the Remaclus retable in the drawing is the one published by Martène and Durand, and that they described it erroneously (cf. also the opinion of E. Rensens in a note published by de Casteele). It is impossible to believe that the two learned Benedictines could confuse the Pentecost and scenes from the Passion and Resurrection, with scenes from the life of St Remaclus. I owe thanks to Mr D. H. Turner of the Department of Manuscripts, British Museum, for his help with the difficulties surrounding this retable.

28. The one with Faith is in the Robert von Hirsch Collection, Basel, the other, with Charity, in the Museum für Kunsthandwerk, Frankfurt (see Deér, *op. cit.*, 73, Abb. 32, 34.)

29. They are (from bottom left to right): (1) p. 186 Remaclus as a child given into the care of St

Eligius; (2) King Siegbert handing the crozier of the see of Maastricht to Remaclus; (3) an angel appearing to St Trudo; (4) Remaclus receives St Trudo; (from top left to right): (5) Siegbert granting Stavelot to Remaclus; (6) the foundation of the church of Malmédy; (7) construction of the church of Stavelot; (8) the death of Remaclus.

p. 186 30. Collon-Gevaert, *Art roman* (1965), 74.

31. J. Deér, *op. cit.*, 74. See also the summing up of the problems in D. Kötzsche's review of *Art mosan* in *Aachener Kunstblätter*, XXIX (1964), 241.

32. This retable was, in the late seventeenth century, above the shrine of St Babolenus, not on the high altar. See de Casteele, *op. cit.*, who quotes from a lost late-seventeenth-century MS., the *Paratibla . . . Abbatine Stabulatus*.

To sum up: it is difficult to resolve the confusion which exists in the literature, but it is surely obvious (see p. 185 above) that Martène and Durand could not have confused the Pentecost retable with the retable of St Remaclus, and could therefore not have seen the retable in Brouck's drawing of 1661. This is not surprising, because it was no longer in existence in 1661, when an earlier drawing had to be copied instead of the original. When was the Remaclus retable destroyed then? De Casteele refers to another document drawn up by Brouck, in which he refers to a transcript of a document in the abbey register dated 27 July 1550. But this reference again does not make clear to which of the two retables it refers. One thing only seems certain to me, that the drawing copied by Brouck cannot be any earlier than the sixteenth century, and that the Remaclus retable must have been destroyed between 1550 and 1661. Perhaps it fell victim to the religious wars of the late sixteenth century, when Malmédy was badly damaged by the Huguenots in 1587. Unfortunately no record is known to me of any similar catastrophe at Stavelot.

33. See Falke and Frauberger (1904), 61–87.

34. The most complete reappraisal was undertaken by H. P. Mitchell, *Burlington Magazine*, XXXIV (1919), 82–92, 165–71; XXXV (1919), 34–40, 92–102, 217–21; XXXVI (1920), 18–27, 128–34. For arguments against the whole concept, see H. Beenken, 'Schreine und Schranken', *Jahrbuch für Kunstwissenschaft*, III (1925–6), 70 ff., and P. Lasko, 'The Pentecost Panel and Godefroid de Claire', *The Connoisseur Year Book, 1966* (London, 1966), 45–51.

35. A re-examination of the problem by J. Deér, introducing for the first time the imperial seals

of Frederick I, has led to much more restricted, and much more convincing, results, in *op. cit.* (Note 26) (see p. 300, Note 64). A new reference to a goldsmith Godefroid, who finished the shrine of the patron saint of the abbey of St Vitonus at Verdun in 1146, has been published by F. Röhrig, 'Godefridus von Huy in Verdun', *Aachener Kunstblätter*, XXXII (1966), 83. Unfortunately the shrine has not survived.

36. It would appear likely that the shrine was that of St Remaclus, whose life is shown in the scenes on the retable, but after 1263 the shrine of St Remaclus at Stavelot was the Gothic shrine which still survives in the abbey. As the shrine on this drawing must have survived into the sixteenth century, it suggests the unusual fact that the abbey possessed two major shrines for their patron saint, and one may have to consider the possibility that the earlier house-shrine was made for the second patron of the abbey, St Peter. The abbey owned important relics of St Peter: two teeth (obtained by Remaclus through angelic aid), and pieces of his beard, hair, cross, and table. The teeth were, however, in the Gothic shrine of St Remaclus when it was opened in 1610 (*History of Stavelot*, Brit. Mus. Add. MS. 24147), perhaps after the destruction of the twelfth-century shrine?

37. The oval mandorla most probably originally p. 187
held a Christ in Majesty, surrounded by the four Evangelist symbols. H. Schnitzler (*Die Goldschmiede-plastik der Aachener Schreinwerkstatt* (Düren, 1934), 4) makes a clear distinction between the Xanten and Deutz shrines of the 'Cologne' area and the 'Mosan' shrines of Visé and St Servatius, Maastricht. The former are 'architectural', the latter 'pictorial' in their structure. He includes the Stavelot shrine in the Mosan group (and does not doubt that it is a shrine of St Remaclus), but both the roof and the base project as much as those of the Cologne area. It is, of course, true that for the second half of the century, his analysis holds good – especially the fact that pierced cresting surrounds the entire head and foot ends of the Maastricht shrine, which clearly distinguishes it from the architectural build-up of the contemporary Rhineland shrines (except for the upper part of the Cologne shrine of the Three Kings). The close links between the Rhineland and the Mosan area in the second quarter of the century, and the shortage of surviving material, seem to make any attempt at a clear-cut distinction in the earlier part of the century impossible, perhaps even unwise.

38. Collon-Gevaert, *Art roman* (1965), 198. The Byzantine triptychs were restored by Mosan craftsmen; see *Early Christian and Byzantine Art*, exhibition catalogue (Baltimore, 1947), no. 530.

39. P. Verdier has pointed out that these two small Byzantine reliquaries have been said to have come from the church of St Maximin (or St Maria ad Martyres) at Trier (see 'Un monument inédit de l'art mosan du XIIe siècle', *Revue belge d'Archéologie et d'Histoire de l'Art*, xxx (1961), 169, note 1, and again in a review in *Cahiers de civilisation médiévale, X-XII siècle* (1966), 405). Photographs of the two reliquaries are published in H. Bunjes a.o., *Die kirchlichen Denkmäler der Stadt Trier* (1938) (P. Clemen (ed.), *Die Kunstdenkmäler der Rheinprovinz*, XIII, part III), with the note that these reliquaries are said to come from the Trier church and that their present whereabouts are not known. This does not seem to me to prove that those reliquaries were not originally part of the New York triptych, where they were already before 1904, when Falke and Frauberger published the triptych (at that time in a private collection in Hainault), whereas the photographs used by Bunjes were not published till 1938. One can only assume that photographs of the two reliquaries (which can be easily removed from their frame) were wrongly labelled. It might be added that the iconography of the wings is clearly intended to frame a relic of the True Cross, and if these two reliquaries were no longer extant, one would have to imagine them.

p. 188 40. See William H. Forsyth, 'Around Godefroid de Claire', *The Metropolitan Museum of Art Bulletin*, XXIV, no. 10 (1966), 304–15. The Louvre panel with three saints may not belong to this group. It differs somewhat technically.

41. A speckled mixture of all these colours, producing almost a kind of grey, is found on the Stavelot Holy Cross triptych and becomes more popular in later enamels – for example on the Klosterneuburg pulpit by Nicholas of Verdun (see p. 240, Chapter 21).

42. E. Panofsky, *Abbot Suger on the Abbey of St Denis and its Art Treasures* (Princeton, 1946), 58–9.

43. Translation (and original text) in Panofsky, *op. cit.*, 58–9.

44. This inventory (Paris, Bib. Nat. fr. 4611) has never been published in full. Extracts from it, concerning the cross foot, can be found in Rosalie B. Green, 'Ex Ungue Leonem', in M. Meiss (ed.), *Essays in Honor of Erwin Panofsky* (New York, 1961).

45. This translation from the original text has p. 189 been kindly prepared for me by Mr T. A. J. Burnett, of the Department of Manuscripts, British Museum.

46. The Samson/Limbo parallel is used on the Klosterneuburg pulpit (see p. 241, Chapter 21). Rabanus Maurus used the image of the man riding the camel as a symbol of Christ's humility, and it might have served as a parallel for the scene of Christ carrying the Cross (Migne, *Patrologia Latina*, III, 211). The centaur could be Sagittarius and be part of a Zodiac cycle. See Forsyth, *op. cit.*, 314.

47. The man slaying the dragon – a popular p. 191 symbol for the victory of Virtue over Vice – may be one such panel (but cf. Note 40 above).

48. H. Swarzenski (1967), plate 180. The panel with the Ascension (figure 400) on the same plate is larger, and does not belong to this group but to another a little later in date. See also J. Breck, 'Notes on some Mosan Enamels', *Metropolitan Museum Studies*, I (1928–9), figures 6, 7.

49. Stylistically, these enamels resemble the St Trond Lectionary of the Eric Millar Collection, now in the Pierpont Morgan Library in New York, MS. 883. The date *c.* 1140 suggested by H. Swarzenski (1967), plate 154, figure 340, for this manuscript would also support an early date for the enamels.

50. For the ivory panel see p. 163, Chapter 15.

51. Collon-Gevaert, in *Art roman* (1965), 162. The bulging ovoid gilt copper panels between the enamels are thought to be the result of a restoration between 1608 and 1637, but in style, an early-fifteenth-century date would seem to be possible.

52. Collon-Gevaert, in *Art roman* (1965), 208.

53. This base has a vertical handle under the p. 192 lower hemispherical part, and was clearly intended to be used both as an altar cross and as a processional cross. It is believed to be broadly based in its design on the great cross commissioned by Abbot Suger for Saint-Denis (see p. 188, and Panofsky, *op. cit.* (Note 42), 176–8). The iconography of the foot is also concerned with types and anti-types. The crucifix originally fixed into the top of the Saint-Omer foot is lost.

54. K. H. Usener, 'Zur Datierung des Kreuzfusses von St Omer', in *Festschrift R. Hamann* (Burg, 1939), 163 ff.

55. This is also held by Schnitzler, *op. cit.* (Note 37), 19 ff. and 32, note 73. The style of the cross foot seems to be rooted in the fifties, although the

piece might well not have been acquired by Saint-Bertin until the time of Abbot Simon in the early seventies, exactly as the Godefroid shrines at Huy, dated 1173, are rooted in the style of the fifties or even forties.

p. 192 56. See Usener, *op. cit.* (Note 1), 124 ff.

57. The iconography of Christ instead of the Holy Ghost as a source of the holy message is unusual. Usener (*op. cit.*, 124, note 2) points to the early-twelfth-century Cluny Lectionary (Paris, Bib. Nat. MS. lat. 2246 folio 79 verso) as a parallel (Dodwell (1971), plate 202). The St Trond Lectionary (New York, Pierpont Morgan Library MS. 883 folio 62 verso) of about 1140, already mentioned for its resemblance, both in style and iconography, to the Pentecost enamel plaque in the Metropolitan Museum, New York, shows that this iconography was known in the Mosan area. For full discussion, see P. Bloch, *op. cit.* (Note 25), 256–61.

58. The haloes are clearly too large, and cover parts of the central inscription and even parts of two of the raised hands. The decorative enamels and filigree panels on the central segment of an arch below Christ were probably also added then.

59. The retable may well have been intended for the new choir of St Castor at Coblenz, thought to have been completed around 1160. See F. Vermeulen, *Handboek tot de Geschiedenis der Nederlandsche Bouwkunst* ('s-Gravenhage, 1928–41), 294.

60. Collon-Gevaert, in *Art roman* (1965), 188. The haloes of the major figures are here made of *émail brun*, as on the Visé shrine, and it might be suggested that the original, probably smaller, haloes of the Coblenz retable were the same.

p. 193 61. It is close to the Eilbertus altar. It may be significant that the somewhat later Mosan triptych of the Holy Cross, now in the Petit Palais, Paris (Collon-Gevaert, *Art roman* (1965), 192), and the St Andrew triptych contemporary with it (central panel seventeenth-century) in the Trier Cathedral treasury (*ibid.*, 200), both accept this 'fleshy leaf' border.

62. See Deér, *op. cit.* (Note 26), 47–102. See especially the documentary details concerning Wibald quoted 68 ff.

63. The emperor's body was translated on 29 December 1165, and he was canonized on 8 January 1166. For references, see Deér, *op. cit.*, 48. See also p. 218, Chapter 18.

64. Deér's careful analysis is by far the most convincing contribution to the Godefroid de Claire problem. He also makes the important distinction between this group of works of 'Godefroid's'(?) workshop and that around the Stavelot portable altar, a contemporary workshop of quite different, and incidentally less conservative, stylistic tendencies (see Deér, *op. cit.*, 71 ff.). For a complete list of work which might be attributed to this workshop, see *ibid.*, 77.

65. Schnitzler, *op. cit.* (Note 37), 36.

66. Falke and Frauberger (1904), 64. For the shrine of St Servatius, see Collon-Gevaert, *Art roman* (1965), 232, and Schnitzler, *op. cit.*, 35 ff.

67. The double colonnettes are reminiscent of the arm-reliquary of Charlemagne (*c.* 1166), where double colonnettes separated by a pearled centre strip are employed. The pilasters of the Maastricht shrine have a small leaf issuing from underneath the base, a traditional Mosan element found on the Visé shrine and still in the later Stavelot reliquary triptych.

68. The major figure of Christ in Majesty on the major end of the shrine, although somewhat more elongated, is probably also by the same older master. The rather small head of the figure, and probably also the curious plants to each side, are Gothic restorations.

69. H. Schnitzler has compared the reliefs of two p. 194 angels carrying candlesticks in the treasury of St Servatius with the embossed reverse of the small silver Byzantine reliquary of the eleventh century, still preserved in the church of Our Lady at Maastricht (Schnitzler, *op. cit.*, 40). The parallel developments in major architectural sculpture, especially in the Île de France, have been studied carefully by W. Sauerländer in recent years, particularly in 'Die Marienkrönungsportale von Senlis und Mantes', in *Wallraf-Richartz-Jahrbuch*, XX (1958), and in *Von Sens bis Strassburg* (Berlin, 1966), where his other important articles are listed. The author often pays tribute to the importance of the part played by Mosan craftsmen in the development of architectural sculpture.

70. Collon-Gevaert, *Art roman* (1965), 202. For a full bibliography, see Schnitzler, II (1959), 32 ff.

71. See *Mon. Germ. Hist.*, *Scrip.*, XIV, 565 ff.

72. J. Braun, 'Der Heribertusschrein zu Deutz, seine Datierung und seine Herkunft', *Münchner Jahrbuch der bildenden Kunst*, N.F. VI (1929), 109–23.

73. The inner wooden sarcophagus is illustrated in *ibid.*, 111, Abb. 2. It is very similar to the one that also exists inside the St Victor shrine at Xanten, where scholars usually accept that the whole shrine cannot be much later than the translation of the saint in 1129.

74. Schnitzler, *op. cit.* (Note 37), 36–7.

75. The shrine is in superb condition, partly due to careful nineteenth-century restoration. The following are modern: head and shoulders of Peter, Philip, and Paul, and probably the whole of Matthew; much of the embossed work on the roof (although it appears to have followed the original design carefully – see S. Troll, 'Funde zum Heribert Schrein', *Wallraf-Richartz-Jahrbuch*, XI (1939), 26). The roundel of Christ above the Virgin is a late-thirteenth-century 'Limoges' enamel, and a fairly large number of the decorative enamelled strips seem to have been replaced in the nineteenth and/or twentieth(?) century.

p. 195 76. Schnitzler (*op. cit.*, 17, note 38) further subdivides each into two separate groups, making four hands.

77. *Ibid.*, 4.

78. In the shrine of St Servatius and in both shrines at Huy. In the Cologne area it is never used in this form.

p. 196 79. See p. 214, Chapter 18 (Plate 240).

CHAPTER 18

p. 197 1. The shrine was robbed in 1538 and restored in 1767. See *Kunst und Kultur im Weserraum 800–1600*, Corvey exhibition catalogue (Münster in Westfalen, 1966), no. 264.

2. For detailed discussion of this see E. Meyer, 'Neue Beiträge zur Kenntnis des Roger von Helmarshausen und sein Kreis', *Westfalen*, XXV (1940), 6 ff.

3. Also found in Roger's work, e.g. the Modoaldus cross, now in the Schnütgen Museum, Cologne (see p. 160, Chapter 14).

4. Behind the figure of St John, a fragmentary eleventh-century relief of Christ in Majesty was mounted, probably as part of a late restoration.

p. 198 5. J. Braun, *Die Reliquiare* (Freiburg, 1940), 622.

6. See E. Meyer, 'Die Hildesheimer Rogerwerkstatt', *Pantheon*, XXXII (1944), 1–11. Such fans, also known as 'flabelli', were used during the Mass to keep flies away from the Sacraments.

7. Meyer (*ibid.*, 5) compares the forms of the p. 199 leaves and blossoms to the Hezilo candelabrum made at Hildesheim before 1079 and believes that the similarity proves the Hildesheim provenance of the flabelli. The resemblance is close, but one suspects that such forms were widely known in Lower Saxony and Westphalia by the early twelfth century.

8. Another remarkable work, obviously linked with Hildesheim, should be mentioned – the small portable altar of engraved copper-gilt with an *émail brun* background, preserved in the Victoria and Albert Museum (*Romanesque Art*, Small Picture Book no. 15, Victoria and Albert Museum (London, 1950), plate 3). On the base, a Crucifixion in the form of a Trinity is accompanied by SS. Boniface, Paul, Peter, and Pancratia(?). At the foot of the cross, SS. Simplicius and Faustinus appear in roundels. Among the saints represented on the top in roundels about the porphyry altar stone, Bishop Godehard of Hildesheim appears without a halo, which would seem to prove that the altar was made before his canonization in 1132. The engraving of the figures is remarkably fluid for such an early date – it is a puzzling piece. It was acquired in 1873 by the museum, which ought to be too early for it to be a fake, and yet it has features that strongly suggest it. The personifications over the Crucifixion seem to be two moons instead of the sun and moon. The saint inscribed as 'PANCRATI' is a female martyr, but St Pancratius would be the more obvious recorded name. Simplicius and Faustinus are rare saints – and there must be a doubt that they were ever represented in military guise. The facial types also look suspiciously modern, and the drawing quite impossible at a date of *c.* 1130.

9. See p. 176, Chapter 16.

10. See p. 175, Chapter 16. p. 200

11. J. H. von Hefner-Alteneck, *Die Kunstkammer . . . von Hohenzollern-Sigmaringen* (Munich, 1866), Taf. 41–2.

12. See *Ars Sacra, Kunst des frühen Mittelalters*, Exhibition catalogue (Munich, 1950), no. 359.

13. O. von Falke, 'Hildesheimer Goldschmiedewerke des 12. Jahrhunderts im Welfenschatz', *Pantheon*, V (1930), 266–74.

14. For a detailed discussion of this subject, see G. Swarzenski, 'Aus dem Kunstkreis Heinrichs des Löwen', *Städel-Jahrbuch*, VII–VIII (1932), 241–397.

p. 200 15. For a full history of the treasure, see O. von Falke, R. Schmidt, and G. Swarzenski, *Der Welfenschatz* (Frankfurt, 1930). The bulk is now preserved in the Staatliche Museen, Berlin, and other important pieces are in the Cleveland Museum, Ohio, U.S.A.

16. It appears in the 1482 inventory.

p. 201 17. It was replaced by a new building, begun under Henry the Lion in 1173.

18. Swarzenski's attempt to see a continuing workshop at Helmarshausen is more convincing for manuscript painting than for metalwork (see *op. cit.* (Note 14), 254 ff., 279 ff.). See also F. Jansen, *Die Helmarshausener Buchmalerei zur Zeit Heinrichs des Löwen* (Hildesheim and Leipzig, 1933).

19. In this, one is reminded of the 'Winchester School' of the tenth–eleventh century in England, now descriptive of a style instead of a provenance. G. Swarzenski seemed to reach a somewhat similar conclusion (cf. *op. cit.*, 288 ff., 340 ff.).

20. Falke, *op. cit.* (Note 13), 270.

21. The trial drawing on the back of one of the panels shows this style most clearly. See H. Swarzenski (1967), figure 441.

22. G. Swarzenski, *op. cit.*, 279 ff., especially 288 ff. For the pieces possibly related to this group, see 289, note 91.

23. G. Swarzenski, *op. cit.*, figure 230.

p. 202 24. Corvey catalogue (*op. cit.*, Note 1), nos. 266, 265, plates 224C, 225.

25. G. Swarzenski, *op. cit.*, figures 202–5.

26. Steenbock (1965), no. 96.

27. See especially the first two strips on this roof, at the Heribert end.

28. Falke, Schmidt, and Swarzenski, *op. cit.* (Note 15), no. 21.

29. Falke and Frauberger (1904), 108.

p. 203 30. Steenbock (1965), no. 99. (The Evangelist symbols of St Matthew and St Mark have been exchanged at some time.)

31. See p. 179, Chapter 16.

32. Steenbock (1965), no. 98. This Crucifixion was remounted in the fourteenth century, when the present plain background and narrow frame were added. Another ivory, a Deposition in the Schnütgen Museum (catalogue no. 9), though of higher quality, is related to this group.

33. Falke, Schmidt, and Swarzenski, *op. cit.*, no. p. 204 20; G. Swarzenski, *op. cit.* (Note 14), 343 ff.

34. G. Swarzenski, *op. cit.*, 346 ff.

35. Falke and Frauberger (1904), 105 ff.

36. G. Swarzenski, *op. cit.*, 251 ff. See p. 210 below.

37. The eleventh-century emperor and the duke's namesake Henry had been canonized in 1146.

38. R. Rees, *An Essay on the Welsh Saints* ... (London, 1836), 107–8.

39. The presence in many of the so-called p. 205 'Hildesheim' enamels of a speckling of bronze-gilt studs, believed to be a purely technical device for binding large areas of enamel to the copper base, is also found in the Henry reliquary (see also the St Andrew reliquary, Siegburg, p. 176, Chapter 16). In the present state of our knowledge, it is not possible to draw convincing conclusions from the presence or absence of this feature, about attribution to individual workshops in Lower Saxony, Westphalia, or indeed elsewhere in Europe.

40. *Sub. Mon. Germ. Scrip.*, XXI, 124 ff.

41. All three are carved of pear wood and covered in sheet-silver, with various die-stamped borders at the wrist and along the edges of the oversleeve, some repeated on more than one of these reliquaries (for a detailed analysis of which see G. Swarzenski, *op. cit.*, 316 ff.).

42. Falke, Schmidt, and Swarzenski, *op. cit.*, no. 31.

43. The chequerboard rosette patterns of the St Lawrence arm further link this group with the precentor's staff in the treasury of Cologne Cathedral, and two ciboria without covers, one in the Metropolitan Museum in New York, the other, excavated at Dune, Gotland, now in the National Museum, Stockholm, which again have nielloed spiral backgrounds. (See H. Swarzenski (1967), plate 198.)

44. See H. Klapsia, *Jahrbuch der kunsthistorischen* p. 206 *Sammlungen*, N.F. XII (1938), 7 ff. For valid criticisms of this see E. Meyer, 'Goldschmiedekunst des 9. bis 13. Jahrhunderts', *Zeitschrift für Kunstgeschichte*, X (1941–2), 192 ff.

45. For references see G. Swarzenski, *op. cit.*, 390–1. The inscription naming Berthold is found on the edge of the foot: + PARCE CALIX ISTE PER QVOS DATVS EST TIBI XPE' BERTOLDI MONITIS CVI SIS MITISSIME MITIS. For the other inscriptions see Klapsia, *op. cit.*, 8 ff.

46. See p. 201. See also Meyer, *op. cit.* (Note 44), 195 ff.

47. In the matter of foliate background setting of figures, it is a parallel development to the so-called earlier 'Fredericus' group at Cologne (see p. 221), but no really close relationship exists between these two decorative methods.

48. D. Barrett, *Early Islamic Metalwork in the British Museum* (London, 1949), viii–xi.

49. See R. Harari, 'Metalwork after the Early Islamic Period', in A. U. Pope (ed.), *Survey of Persian Art* (London and New York, 1939), VI, plates 1311, 1312. It is not possible, in the present state of our knowledge, to explain this curious link with the metalwork of eastern Persia. One possible clue is given by a decorative band on the chalice, just above the knop. The chased decoration here is very close indeed to the 'vermiculé' bands behind the standing figures of Apostles on the so-called altar frontal from Silos, in the Burgos Museum (Plate 264) (see p. 230, Chapter 19), and the common source may well be Islamic or Byzantine metalwork. Such nielloed vermiculé decoration was also used in Byzantine work such as the Anastasius reliquary (see below, p. 221) and also, perhaps significantly, on the Paderborn portable altar of SS. Kilian and Liborius, especially on the lid (see Falke and Frauberger (1904), plate 11), although the looped roundels are found only on Islamic work (see M. Gauthier, 'Les Émaux limousins champlevé', *L'Information d'Histoire de l'Art*, III (1958), 75 ff.: '. . . les éléments byzantins et musulmans sont indissociables en une telle région, à une telle date'.) How and by what route these influences might have entered Germany remains a problem. Imported works might be the answer; certainly Islamic crystal carvings were imported and highly prized, see for example the small crystal flask mounted in the centre of the reliquary altar cross of Bertha in Borghorst church, Westphalia (see p. 135, Chapter 11). The use of decorative cufic lettering below the rim of the silver-gilt chalice from St Peter, Salzburg, now in the Kunsthistorisches Museum, Vienna, dating from *c.* 1160–70, should also be mentioned.

50. Klapsia's date (*op. cit.*) of *c.* 1180 is certainly too late. See Meyer, *op. cit.* (Note 44), 195.

p. 207 51. Z. Swiechowski, *Budownictwo Romάnskie w Polsce* (Wrocław, 1963), 292–6.

52. They are: Moses and the Burning Bush, the Staff of Aaron, Annunciation, Nativity, Baptism, and Last Supper. See V. Elbern, 'Der eucharistische Kelch im frühen Mittelalter, II', *Zeitschrift für Kunstwissenschaft*, XVII (1963), 169 ff.

53. See V. H. Elbern and H. Reuther, *Der Hildesheimer Domschatz* (Hildesheim, 1969), no. 23. The head is normally believed to be a fourteenth-century addition. It is true that it is clumsily fitted to the apex, but the style of it can hardly be claimed to be convincingly of the fourteenth century, and seems to me far more acceptable for the twelfth century; perhaps an old head was mounted on the reliquary in the early fourteenth century, when the inscription on the bevelled base was added. The original inscription below the dome proves that it always contained the head of St Oswald. It reads: REX PIVS OSWALDVS SESE SEDIT ET SVA CHRISTO LICTORIQVE CAPVT QVOD IN AVRO CONDITVRISTO. The crown is made up of eight links. (The cresting on three of them is post-medieval.) The central panel facing the front and three others, all decorated with gems, date from the twelfth century – perhaps contemporary with the reliquary. Two of the remaining four panels are early-eleventh-century and are decorated with cloisonné enamels related to Mathilde's workshop at Essen; they probably originally formed a bracelet. Of the other two panels like the latter in shape and size, one was made in the twelfth century and one is a post-medieval restoration. The whole crown was therefore assembled in the twelfth century – what was its use, if it was not put on the head of St Oswald until the early fourteenth century? Surely such material would not have been used *c.* 1300!

54. H. Swarzenski (1967), plate 208, figure 484, where 'England(?)' is put. G. Swarzenski, *op. cit.*, 372 ff., also discusses the possibility. For full bibliography, see *Hildesia Sacra*, exhibition catalogue (Hannover, Kestner-Museum, 1962), no. 13. Here also 'Braunschweig oder England(?)'.

55. G. Swarzenski, *op. cit.*, 371 ff. p. 208

56. Probably in 1336 (now in the west front of St Sophia). They are 3·60 m. high and 2·40 m. wide (about 12 by 8 ft). See A. Goldschmidt, *Die Bronzetüren von Nowgorod und Gnesen* (Marburg, 1932).

57. The centre of the three pieces that now make up this panel is the *Traditio Legis*, which has been exchanged with the ascending Christ, low on the right wing of the door. The present third rectangular panel is the result of removing the upright decorative frames of the lowest panel, left wing, in the fourteenth century, when the figure of the

craftsman Adam was added. The Sagittarius panel, the lowest one on the right, was also added then, as well as one other narrow panel on the right wing, on the right in the third register from below.

p. 208 58. Two craftsmen (one holding the tools of their trade) named Riquinus and Waismuth are also represented.

59. H. Beenken, *Romanische Skulptur in Deutschland* (Leipzig, 1924), 50 ff.

p. 209 60. A. Boeckler, *Die Bronzetüren von Verona* (Marburg, 1931), 5. The only other doors north of the Alps to use it were the eleventh-century doors at Augsburg (see p. 118, Chapter 10).

61. For details, see Boeckler, *op. cit.* The present stone door jambs and lintel seem to date from the fifteenth century. It is tempting to see two doors of different dates amalgamated in the fifteenth century, but the fact that there are no fifteenth-century details of any kind in the metalwork of the doors seems to preclude such a theory.

62. See K. J. Conant, *Carolingian and Romanesque Architecture: 800-1200* (Pelican History of Art) (Harmondsworth, 1959), 247. The rather provincial Italian sculpture that has been compared to them, like the pulpit on the island of Santa Julia in Lake Orta, and dated by Beenken to the late eleventh century, should also be dated to *c.* 1120-30.

63. Of the forty-eight major panels on the Verona doors, twenty-seven are in the earlier style, and twenty-one are in the later style. That a rather thoughtless enlargement, perhaps by combining two doors then in existence, took place is proved by the fact that some of the scenes from the Old and New Testaments on the door now are found twice. For a discussion of the theory that the Verona doors were the product of a northern workshop, and the detailed arguments for the existence of an Italian tradition, of which the fragmentary large candlestick at Klosterneuburg is also a part, see P. Bloch, 'Siebenarmige Leuchter in christlichen Kirchen', in *Wallraf-Richartz-Jahrbuch*, XXIII (1961), 131-4.

64. The last dedication, after extensive alterations, took place in 1097. For the doors see M. Walickiego and others, *Drzwi Gnieźnieńskie*, I-III (Wrocław, 1956-9) (résumés in French). The wings are 3·28 and 3·23 m. high and 0·83 and 0·84 m. wide (about 10 ft 9 in. and 10 ft 7 in., and 32½ and 33 in.).

65. Goldschmidt, *op. cit.*, 27, and H. Swarzenski (1967), 59.

66. M. Morelowski, in *Drzwi Gnieźnieńskie* (*op. cit.*), I, 212 ff.

67. P. Francastel ('La Porte de bronze de Gniezno', in L. Febvre (ed.), *L'Art mosan* (Paris, 1953), 203 ff.) has even suggested that some scenes were designed in the 1130s but not cast till 1160-70, when the others were modelled.

68. This date for the 'later' style is also suggested by Morelowski, *op. cit.*, 218. See also Bloch, *op. cit.*, 138.

69. See G. Swarzenski, *op. cit.* (Note 14), 250 ff. p. 210 Although lions in Italian architecture normally act as supporters of columns and are recumbent (also in Germany at Königslutter), the whole idea of a free-standing piece of sculpture on a monumental scale is similar.

70. H. Swarzenski (1967), 77-8.

71. Beenken, *op. cit.*, 116-17.

72. H. Schnitzler, 'Das sogenannte grosse Bernwardkreuz', in *Karolingische und ottonische Kunst* (Forschungen zur Kunstgeschichte und christlichen Archäologie) (Wiesbaden, 1957), 390, figures 161-2.

73. Schnitzler, *op. cit.*, 390 ff.

74. See p. 160, Chapter 14 (Plate 165).

75. See p. 200 (Plate 216).

76. See A. Fuchs, *Von Kreuzen, Madonnen und* p. 211 *Altaren* (Paderborn, 1940), 44.

77. See Corvey catalogue (*op. cit.*, Note 1), no. 258.

78. The use of *émail brun*, it has been suggested, might be linked with the Rhine/Meuse region (Falke, in Lehnert (ed.), *Illustrierte Geschichte des Kunstgewerbes*), but the technique had already been used at Hildesheim in the early eleventh century, and is, of course, also fully described by Theophilus, who even advises the use of a graver to outline the design before firing (book 3, chapter LXXI).

79. A work of stucco, usually dated *c.* 1160. See Beenken, *op. cit.*, 130-3.

80. See p. 185, Chapter 17 (Plate 199). For this connexion, see H.-A. von Stockhausen, 'Das romanische Scheibenreliquiar in Fritzlar', in *Festschrift Hamann* (Burg, 1939), 136 ff.

81. Even the sculptural style of the Erfurt stucco can be related to metalwork. The head of the centrally seated Virgin (Beenken, *op. cit.*, 133) closely resembles the head-reliquary of much the same

date in the Kestner Museum, Hannover (see H. Swarzenski (1967), plate 165, figure 362) – see, for instance, the strange, flat treatment of the eyelids.

82. R. Gaettens, *Das Gold- und Münzwesen der Abtei Fulda im Hochmittelalter* (Fulda, 1957), 148 ff.

83. *Ibid.*, plate 12, figure 47; plates 16/17, figure C; and p. 91.

84. *Ibid.*, 145 ff., 150–1.

p. 212 85. Without making precise comparisons, Beenken (*op. cit.*, 76) also believed that these stone panels were influenced by metalwork.

86. Goldschmidt, III (1923), nos. 61–80. Goldschmidt's date of *c.* 1200–50 is probably, in view of this evidence, somewhat too late for at least the earliest appearance of this type of rather crude carving.

87. Gaettens, *op. cit.*, 156 ff. The knop and the foot rim decorated with pierced quatrefoils were added in the Gothic period.

88. The long-lasting influence of this style can also be seen in the Helmarshausen manuscripts illuminated as late as c. 1190 (Trier, cod. 142). For cover see Steenbock (1965), no. 108.

89. Schnitzler, II (1959), nos. 39, 36.

p. 213 90. Schnitzler (*ibid.*, 44, 47) suggests that it may be by the same hand, but the different decorative vocabulary and the poorer handling of the cast dragon feet argue against this. (Three of the feet of the Siegburg altar are copies made by P. Beumers in 1901–2 of the one original left.)

91. Falke and Frauberger (1904), 77, plate 79; H. Swarzenski (1967), plate 186, figure 423.

92. The use of such bands on the St Andrew reliquary at Siegburg is totally ungeometric (see p. 176, Chapter 16).

93. Falke and Frauberger (1904), 77.

94. *Trésors d'art de la vallée de la Meuse*, exhibition catalogue (Paris, 1951), 71, plate 31, and S. Collon-Gevaert, *Art roman* (1965), no. 28.

p. 214 95. The whole framework is of rather poor quality, with poor transitions from one strip to another, especially where the arches begin; this might be taken to suggest that the whole framework is modern. However, the piece was acquired as early as 1858, and this makes me think it more likely that an old frame, probably too large, was cut down in height and adapted to take these enamels, rather than that a whole new frame was made. If the wings were originally fitted directly

to the centre panels, the reverse of the wings might be decorated; removal of the panels from the frame would be worth a try.

96. See p. 194, Chapter 17. H. Schnitzler (*Die Goldschmiedeplastik der Aachner Schreinwerkstatt* (Düren, 1934), 31) has written: '. . . the Meuse and Rhine regions are so closely related in this early period, that a clear division is not possible'.

97. H. Swarzenski (1967), figure 411, plate 183.

98. This is missing now (G. Zehnder, 'Der Siegburger Servatiusschatz', *Heimatbuch der Stadt Siegburg* (Siegburg, 1967), 445, no. 11).

99. See F. Mütherich, *Die Ornamentik der rheinischen Goldschmiedekunst in der Stauferzeit* (Würzburg, 1941), 28 ff. Also M.-M. Gauthier, 'Les Décors vermiculés dans les émaux champlevés limousins et méridionaux', *Cahiers de Civilisation Médiévale. Xe–XIIe siècles*, I (1958), 349 ff. See also p. 206 above.

100. See Rosy Schilling, 'Studien zur deutschen p. 215 Goldschmiedekunst des 12. und 13. Jahrhunderts', in *Form und Inhalt* (Festschrift Otto Schmitt) (Stuttgart, 1950), 73 ff., and D. H. Turner, *Romanesque Illuminated Manuscripts in the British Museum* (London, 1966), 17 ff.

101. Schnitzler, II (1959), 46, suggests *c.* 1180.

102. *Ibid.*, 34; Mütherich, *op. cit.*, 34.

103. One panel with Jonah is now in the Victoria and Albert Museum, another, showing Nahum, is in the Schnütgen Museum, Cologne. Only seven survive on the twelve-sided Darmstadt reliquary itself. See *Die Sammlungen des Baron von Hüpsch*, exhibition catalogue (Cologne, 1964), no. 24.

104. This same, more 'optical' and less linear approach to form was also noticed in Lower Saxony (see p. 203) in the same decade, *c.* 1170–80.

105. See Didron, *Annales Archéologiques*, VIII (Paris, 1848), plate 1. According to Schnitzler (*Schatzkammer*, II (1959), 46) it was probably the top of a portable altar; Mütherich (*op. cit.*, 28) suggests a book-cover, because no altar stone could have been accommodated. A reliquary casket, like the casket of St Andrew at Siegburg, is also a possibility.

106. See Falke and Frauberger (1904), 30.

107. *Ibid.*, 29. Restored, according to an inscription, in 1725.

108. For the remaining attributions, the portable altars in Berlin, Staatliche Museen, and in Munich, from Bamberg, see *ibid.*, 31.

p. 216 109. See p. 193, Chapter 17, and J. Deér, 'Die Siegel Kaiser Friedrichs I. Barbarossa ...' in *Festschrift H. R. Hahnloser for 1959* (Basel and Stuttgart, 1961), 47 ff.

110. See p. 178, Chapter 16. The circumference of the Aachen candelabrum is 13·62 m. (about 45 ft), two metres smaller than the Gross-Komburg one.

111. Schnitzler, II (1959), no. 10.

112. Schnitzler suggests (*ibid.*, 18) that Beatitudes 2, 3, and 4 are the finest, and that 5 is by the hand of a somewhat less skilled assistant.

113. Schnitzler suggests the following comparisons: Brussels, Bib. Roy. 9916–17; Berlin, Kupferstichkabinett HS. 78.A.6; Cologne, Cath. Library cod. 157; and influenced from Liège: Saint-Omer, MSS. 12 and 30.

114. Collon-Gevaert, *Art roman* (1965), no. 25.

115. For the inscription see Schramm and Mütherich (1962), no. 177.

p. 217 116. *Ibid.*, no. 172 (now in the Staatliche Museen, Berlin). Also H. Swarzenski (1967), figure 428, plate 188.

117. The words used are: 'Caput argenteum (*sic*) ad imperatoris formatum effigiem.' See H. Fillitz, 'Der Cappenberger Barbarossakopf', *Münchner Jahrbuch der bildenden Kunst*, 3. Folge, XIV (1963), 39 ff. It is still preserved in the Schlosskirche, Cappenberg.

118. See H. Grundmann for an attempt to make comparisons with contemporary descriptions of Frederick in *Der Cappenberger Barbarossakopf und die Anfänge des Stiftes Cappenberg* (Köln and Graz, 1959).

119. Schnitzler, II (1959), no. 42. The Christ in Majesty panel on its front resembles in iconography the Vorau casket, for both have anthropomorphic Evangelist symbols.

120. H. Swarzenski (1967), 68, plate 165.

121. *Ibid.*, plates 114–15.

122. The one with the Crucifixion is now in the R. von Hirsch Collection in Basel, the other in the Louvre. See Schramm and Mütherich (1962), no. 175.

p. 218 123. See H. Lenzen and H. Buschhausen, 'Ein neues Reichsportatile des 12. Jahrhunderts', *Wiener Jahrbuch für Kunstgeschichte*, XX (XXIV) (1965), 53–4. The drawings, by Delsenbach (Mappe 7), in the Stadtbücherei, Nuremberg. Description by C. G.

von Murr, *Beschreibung der sämtlichen Reichskleinodien und Heiligthümer* (Nuremberg, 1790), 52 ff. Although it is difficult to make stylistic judgements on the basis of these drawings, they relate to the plaques in the Vienna Diocesan Museum, as suggested by Lenzen and Buschhausen. See p. 247, Chapter 21.

124. Only on the Resurrection panel, which also has inscriptions of pure Mosan form.

125. P. E. Schramm, *Herrschaftszeichen und Staatssymbolik* (*Mon. Germ. Hist.*, 13 II) (Stuttgart, 1955), 547 ff.

126. See p. 245, Chapter 21.

127. See p. 193, Chapter 17, and J. Deér, *op. cit.*, 47 ff. Preserved at Aachen until 1804, when it was given to the Empress Josephine. Now in the Louvre.

128. Deér, *op. cit.*, 54 ff., 48 ff.

129. Mütherich, *op. cit.* (Note 99), 35 ff. p. 219

130. H. Schnitzler, *Das Schnütgen Museum* (Cologne, 1961), nos. 2, 39. For the ivory, now in Darmstadt, see Goldschmidt, II (1918), no. 72.

131. For an excellent detailed discussion of the ornament, see Mütherich, *op. cit.* (Note 99). For the colour of the Schnütgen book-cover, see especially 37 and 58.

132. Schnitzler, *op. cit.* (Note 130), no. 26. The central Virgin and Child, and for the most part the saints of the upper register painted in black on a gold ground, are work of the fourteenth century. The remainder were added by the Cologne museum curator J. A. Ramboux in the early nineteenth century.

133. Schnitzler, II (1959), no. 27. p. 220

134. Falke and Frauberger (1904), 39, plate 43.

135. See p. 243, Chapter 21.

136. The name St Pantaleon, now to the right, was added in restorations undertaken in 1950–1, but very likely always appeared there. See Schnitzler, II (1959), 34. For photographs of the shrine before restoration, see Falke and Frauberger (1904), plates 44–8.

137. Falke and Frauberger (1904), 26 ff., 42. p. 221

138. See Schnitzler, II (1959), 34, and under FRIDERICVS, *Neue deutsche Biographie*, V (1960), 438–9.

139. Schnitzler, II (1959), no. 17.

140. The Nativity and the Three Magi are restorations, made *c.* 1855, based on mirror images of the

same subjects on the Guelph Treasure reliquary. See Schnitzler, II (1959), 25.

141. *Ibid.*, no. 16.

142. Goldschmidt, III (1923), nos. 47–54, 87, and the series of rather poor bone carvings, nos. 61–81.

143. *Ibid.*, nos. 52 and 53.

p. 222 144. Falke, Schmidt, and Swarzenski, *Der Welfenschatz* (Berlin, 1930), no. 22, and Schnitzler, II (1959), 25.

145. Those on the right of the roof, and (perhaps) the enamelled quatrefoils also, were replaced later. SS. Paul and Andrew and St Maurinus, in a circular frame within the quatrefoil, were probably added about 1200. The last two scenes resemble the broken drapery style seen, for example, in the sculpture of Reims of around 1220, and must have been replaced in the second quarter of the thirteenth century. See Schnitzler, II (1959), 35.

146. *Ibid.*, no. 28.

p. 223 147. F. Bock, *Das heilige Köln* (Leipzig, 1858), Maria in der Schnurgasse, 3 ff. Restorations were undertaken by P. Beumers in Düsseldorf in 1900–2 and again by C. Kesseler in 1949–50. The latter were published by Kesseler, 'Die Wiederherstellung des Albinusschreines', in *Rheinische Kirchen im Wiederaufbau* (Mönchen-Gladbach, 1951), 41 ff.

148. See p. 240, Chapter 21 (Plates 288–90).

149. Falke and Frauberger (1904), plate XVII.

150. Zehnder, *op. cit.*, 400–7.

p. 224 151. Falke and Frauberger (1904), 52 ff.

152. Schnitzler, II (1959), no. 37. Both the drawing by J. W. Fischer of shortly before 1764 (now in Paris, Bib. Nat.) and two panel paintings of 1764 (now in the parish church of Belecke in Westphalia) are reproduced by H. Peters, *Der Siegburger Servatiusschatz* (Siegburg, 1952), plates I–V, and Zehnder, *op. cit.*, plates 143–7. Restorations by C. Beumer in 1901–2 are signed.

153. See p. 244, Chapter 21.

p. 225 154. See Schnitzler, II (1959), 45.

155. See also p. 245, Chapter 21, for discussion of Nicholas of Verdun and the Anno shrine.

CHAPTER 19

p. 226 1. Sir M. Conway, 'The Abbey of Saint-Denis and its Ancient Treasure', *Archaeologia*, 2nd series, XVI (1914–15), 103–58.

2. E. Panofsky, *Abbot Suger* (Princeton, 1946). According to Suger the 'Liber de rebus in administratione sua gestis' was written in the twenty-third year of his administration. See *ibid.*, 144.

3. Chapters I–XXIII deal with the revenues of the abbey. The discussion of the building and its contents begins with chapter XXIV. Only chapters XXV and XXVIII deal with the building works, and chapter XXIX speaks of the 'Continuation of both works'. Chapters XXVII and XXX–XXXIV deal with the ornaments and furnishings of the church.

4. Translation by Panofsky, *op. cit.*, 47–9. p. 227

5. See p. 188, Chapter 17 (Figure 7).

6. See Conway, *op. cit.*, 139 ff. After the losses suffered in the French Revolution, more was lost when thieves broke into the Cabinet des Médailles of the Bibliothèque Nationale in Paris in 1804.

7. This was reported lost by Conway, but was re-discovered in 1922. See Panofsky, *op. cit.*, 205, figure 24.

8. The other four were replaced after 1633. See Panofsky, *op. cit.*, 205.

9. The inscription on the foot reads: HOC VAS SPONSA DEDIT ANOR REGI LVDOVICO, MITADOLVS AVO MIHI REX SANCTISQVE SVGERVS. Eleanor's grandfather was thought to have been given the crystal by one Mitadolus, who may have been an emir of Spain. See Conway, *op. cit.*, 142, plate XV, figure 2. The cover is lost.

10. Panofsky, *op. cit.*, 79.

11. See the story of a cheap purchase of gems proudly told in his 'Liber de rebus . . .' (Panofsky, *op. cit.*, 59).

12. See p. 188, Chapter 17; Panofsky, *op. cit.*, 59. p. 228 Suger also states that goldsmiths had to be 'summoned' to open compartments for relics in the 'Holy Altar' (p. 69).

13. See for example O. von Falke, 'Aus der Fritzlarer Goldschmiedeschule des XII. Jahrhunderts', *Pantheon*, IV (1929), 551, and 'Ein Emailbild der Fritzlarer Werkstatt', *ibid.*, XII (1938), 278. It is estimated that somewhat over 7,500 pieces of Limoges enamelling still survive today. Every kind of shrine, reliquary, and altar furniture as well as pieces for secular use like simple candlesticks and hand-bowls (*gemellions*) is represented in this material. See M.-M. Gauthier, 'Émaux champlevés méridionaux d'après l'Exposition internationale d'art roman', in *Actes du quatre-vingt-septième Congrès national des sociétés savantes, Poitiers, 1962* (1963), 371–81.

p. 228 14. For the Spanish case, see W. Hildburgh, *Medieval Spanish Enamels* (Oxford, 1936); for the French, E. Rupin, *L'Œuvre Limoges* (Paris, 1890–2), and later M. C. Ross, 'An Enamelled Reliquary from Champagnat', in *Medieval Studies in Memory of A. Kingsley Porter*, II (Cambridge, Mass., 1939), 467 ff., and the review of Hildburgh's book in *Speculum*, XVI (1941), 453 ff.

15. M.-M. Gauthier, 'Les Émaux limousins champlevés', *L'Information d'histoire de l'art*, 3 année, no. 3 (1958), 67–78.

16. See p. 155, Chapter 13, and M.-M. Gauthier, *Rouergue roman* (La Pierre-qui-Vire, 1963), 144. There are signs of later restoration, especially in the embossed silver frame immediately next to the altar stone.

17. See pp. 154–5, Chapter 13.

18. *Les Trésors des églises de France*, exhibition catalogue (Paris, 1965), no. 544. The cells of the cloisons were then placed into the interior of each figure. A number of other panels constructed in the same way survive, including a vesica-shaped plaque with a standing saint (St Valerie?) in the Louvre (cat. no. 84), also from Conques and no doubt from the same workshop (see M.-M. Gauthier, *Émaux limousins des XII, XIII et XIV siècles* (Paris, 1950), plate 2). The four corner pieces with Evangelist symbols from the Hoentschel Collection in the Metropolitan Museum, although still employing this technique, show a more highly developed style and may be just a little later in date (see Hildburgh, *op. cit.*, 62, for this and other pieces of the group).

p. 229 19. The three medallions originally on the back of the reliquary are missing – see Gauthier, *op. cit.* (Note 18), 151, plate 4.

20. The inscription around the medallion with Christ reads IHESVS SVTƧIRX: 'Christus' is reversed, which does not inspire confidence in the enameller's literacy.

21. Another important proof of such enamels at this time in the Limoges region is the small ferrule decorated with birds against a hatched gilt background, probably a fragment from a crozier, found in excavations at Limoges in 1940; see Gauthier, *op. cit.* (Note 18), plate 14.

22. Ross, *op. cit.* (Note 14), 467–77.

23. See p. 152, Chapter 13, and p. 171, Chapter 18. See also Hildburgh, *op. cit.*, 55 ff., and plates VI, figure 7A, VII, figures 7B, 7C.

24. Palol and Hirmer (1967), plates 121, 125. p. 230

25. The decorative effect of this technique is clearly the same as *émail brun*, but seems to be a painted imitation of it, not fired. See Hildburgh, *op. cit.*, 53.

26. It is 254 cm. (8 ft 4 in.), whereas the Burgos piece measures only 235 cm. (7 ft 8½ in.). The nineteen centimetres missing might account for the missing portions of the two incomplete lower arches on the Burgos panels.

27. M. Gómez-Moreno, 'La Urna de Sto Domingo de Silos', *Archivo Español de Arte*, XLVIII (1941), 493–502. For illustrations of the Ávila tomb see Ricart and Nuño, *Ars Hispaniae*, V (1948), 324, figure 487.

28. The fact that they leave an awkward-shaped p. 231 gap at the top might be taken to support the view that they were not originally made for the position. The Burgos panel seems certainly to be the first of any surviving enamels where heads in relief were used. The interesting stone heads carved in full relief on the walls of the chapel of St Michael of the Camara Santa at Oviedo probably date from the sixties. They were part of a Crucifixion scene, where the bulk of the scene was painted; the painting is now lost. This is no doubt an imitation enamelling which must by that time have been practised. (For illustration, see Palol and Hirmer (1967), plate 197.)

29. The Crucifixion panel in the Instituto de Valencia de Don Juan in Madrid seems to date from around the middle of the century, somewhat later than the Burgos enamels and a little earlier than the Silos casket (see Hildburgh, *op. cit.*, plate XVII, figure 23a). The magnificent plaque with a Christ in Majesty surrounded by the four Evangelist symbols, now in the Cluny Museum, may also be related to this group. It is true that something of the powerful presence of this figure is found in Limoges illumination too (see Ross, *op. cit.*, figures 9 and 10). However, the Evangelist symbols, the clarity of colour, and the head of Christ, as well as the tooling of the mandorla (also found on the Madrid Crucifixion), all link the panel more closely with the 'Silos' group.

30. The text unfortunately does not allow us to identify the enamel with certainty: 'Ibi siquidem effigiati comitis reverenda imago, ex anno et lapidibus decenter impressa superbis ruinam, humilibus gratiam gratiam distribuere videtur' (L. Halphen and R. Poupardin, *Chroniques des contes d'Anjou* (Paris, 1913), 224). M.-M. Gauthier (*op. cit.* (Note

18), 29) does not doubt that the enamel comes from this tomb and suggests a date between 1155 and 1180, probably soon after *c.* 1160.

31. H. Swarzenski (1967), plate 129, figure 293.

p. 232 32. See also pp. 233–4.

33. J. Porcher, in *Les Manuscrits à peintures en France du VIIe au XIIe siècle*, exhibition catalogue (Paris, Bib. Nat., 1954), no. 231.

34. G. François-Souchal, 'Les Émaux de Grandmont au XIIe siècle', *Bulletin Monumental*, CXX (1962), 339–57, CXXI (1963), 41–64, 123–50, 219–35, 307–29, and especially CXXI, 131, 138, 139–40, 150.

35. *Ibid.*, CXX (1962), 345 ff. The sense is suggested to be: 'The seigneur Hugo Lasert speaks with the seigneur Stephen of Muret.'

36. See François-Souchal, *op. cit.*, for thorough and detailed arguments, and a discussion of all the evidence about the altar, the ciborium, the enamelled altar cross, and the six shrines known to have been at Grandmont.

p. 233 37. See P. Thoby, *Les Croix limousines de la fin du XIIe siècle au début du XIVe siècle* (Paris, 1953).

38. M.-M. Gauthier, *op. cit.* (Note 18), 25, plate 6. This cross is signed 'Johannis Garnerius Lemovicensis'. The foliate scroll which decorates the cross itself seems to be derived from the chased foliate scroll on the cross of the Crucifixion plaque in the Don Juan Institute in Madrid (see above, Note 29).

39. See H. Schnitzler, *Grosse Kunst des Mittelalters aus Privatbesitz*, exhibition catalogue (Cologne, Schnütgen-Museum, 1960), no. 85, plate 72, for the Kofler panel and references.

40. See M.-M. Gauthier, *op. cit.* (Note 15), 67–78. It remained popular in Spain also; see the great retable, originally an altar frontal at Pamplona Cathedral, now in San Miguel in Excelsis, dating from the end of the twelfth century (Gauthier, 'Le Frontal limousin de San Miguel in Excelsis', *Art de France*, III (1962), 34 ff.).

41. See p. 238, Chapter 20 (Plate 279).

42. Gauthier, *op. cit.* (Note 18), plate 10.

43. François-Souchal, *op. cit.*, CXXI (1963), figures 6, 5.

p. 234 44. *Ibid.*, 307 ff.

45. See p. 240, Chapter 21.

46. Gauthier, *op. cit.* (Note 18), plate 36 and plates 35 and 53. Much detailed work needs still to be done on the vast material of Limoges enamelling. It is to be hoped that M.-M. Gauthier will succeed in publishing the corpus of Limoges enamelling for which her devoted researches fit her uniquely.

CHAPTER 20

1. For England see also L. Stone, *Sculpture in* p. 235 *Britain, The Middle Ages* (Pelican History of Art), 2nd ed. (Harmondsworth, 1971), and M. Rickert, *Painting in Britain, The Middle Ages* (Pelican History of Art), 2nd ed. (Harmondsworth, 1965).

2. By Nicholas Sander: see J. D. Mackie, *The Earlier Tudors 1485–1558* (Oxford, 1962), 396.

3. O. Pächt a.o., *The St Albans Psalter* (London, 1960). For the Bury Bible (giving earlier references) see C. M. Kauffmann, 'The Bury Bible', *Journal of the Warburg and Courtauld Institutes*, XXIX (1966), 75 ff. Also Rickert, *op. cit.*, 64–6, 70–3.

4. M. H. Longhurst, *English Ivories* (London, 1926), 92–3. For a discussion of the liturgical use of combs see P. Lasko, 'The Comb of St Cuthbert', in C. F. Battiscombe (ed.), *The Relics of St Cuthbert* (Durham, 1956), 342 ff.

5. See O. Pächt a.o., *op. cit.*, 115 ff., and Goldschmidt, III (1923), no. 124; see also p. 168, Chapter 15.

6. Goldschmidt, IV (1926), no. 176. The connexion with Verdun is interesting. Another manuscript by the 'Alexis' master of the St Albans Psalter, written and illuminated at St Albans, is also preserved at Verdun, MS. 70. See O. Pächt a.o., *op. cit.*, 165, and 'The Illustrations of St Anselm's Prayer and Meditations', *Journal of the Warburg and Courtauld Institutes*, XIX (1956), 75 ff. Pächt mentions that it is 'tempting' to see a connexion between St Albans and Verdun in the fact that from 1117 to 1129 the episcopal chair of Verdun was occupied by Henry, archdeacon of Winchester.

7. Longhurst, *op. cit.*, 89.

8. Very close to this fragment, and perhaps from p. 236 the same workshop, is the head of a 'Tau-cross' crozier, now in the Victoria and Albert Museum (Longhurst, *op. cit.*, 88). Two figures on a foliate scroll decorate one side, and two winged dragons, also in a foliate scroll, the other. Other pieces that can be attributed to this group are Goldschmidt, IV (1926), nos. 177–80, 71.

p. 236 9. Lansdowne MS. 383; see Rickert, *op. cit.*, 69–70, plate 68B. Also D. H. Turner, *Romanesque Illuminated Manuscripts in the British Museum* (London, 1966), 8, plate I.

10. Longhurst, *op. cit.*, 85, plate 2b.

11. See p. 166, Chapter 15.

12. Longhurst, *op. cit.*, 86, plate 26; Goldschmidt, III (1923), no. 40.

13. These panels are the only surviving fragments of an English Romanesque portable altar – see P. Lasko, 'An English Romanesque Portable Altar', *Apollo*, LXXIX (1964), 489–95. The panels were in the possession of Lord Vernon, at Sudbury Hall in Derbyshire, as early as 1870, when they were exhibited at Derby, and are now in the British Museum (1963, 11–7, 1).

14. Sixty-seven pieces are in the British Museum, and eleven in the National Museum of Antiquities at Edinburgh. See Goldschmidt, IV (1926), nos. 182–239.

15. Now in the British Museum (1959, 12–2, 1). See P. Lasko, 'A Romanesque Ivory Carving', *British Museum Quarterly*, XXIII (1960/1), 12–16, for a fuller discussion of the whole group.

16. The small re-used fragment found at Munkholm, near Trondheim in Norway, and now in the National Museum at Copenhagen (Goldschmidt, III (1923), no. 143; Lasko, *op. cit.*, 13) may well have been a part of the upper back-rest of such a throne. It is carved in the same style.

p. 237 17. Stone, *op. cit.*, 244, note 14, plates 46B, 40.

18. T. D. Kendrick, *Late Saxon and Viking Art* (London, 1949), plate LXXXVIII.

19. G. Zarnecki, *The Early Sculpture of Ely Cathedral* (London, 1958), 26–36.

20. The bishops' mitres of the Lewis chessmen are worn with the point to the front, which has led scholars to attribute them to a period around 1200, when this fashion, it was believed, became common. It appears on seals, however, at least as early as 1144. See Lasko, *op. cit.*, 15.

21. Pieces of ivory carving that belong to the group, apart from those already mentioned, are: a pommel and quillon on a sword (the blade perhaps fifteenth-century), National Museum, Copenhagen (cf. *Zeitschrift für historische Waffenkunde*, N.F. VI (1957/9), 25–31), and a knife with an ivory handle found in the river Elbe, now in the Kunstgewerbemuseum, Hamburg (cf. Goldschmidt, III (1923), no. 153).

22. See p. 170, Chapter 16.

23. P. Nørlund, *Golden Altars* (Copenhagen, 1926), 234, plate IV.

24. For example in the *émail brun* ornament at the lower edge of the outer frame.

25. Nørlund (*op. cit.*, 235) sees a close relationship to the group of 'pricked' ivories from Cologne (Goldschmidt, III (1923), nos. 1–12).

26. Now also in the National Museum, Copenhagen (see Nørlund, *op. cit.*, 234–5). The upper, retable part of this altar is of an earlier date.

27. The Visitation on the Odder frontal can, for p. 238 example, be compared to the Visitation in a spandrel of the south transept at Worcester Cathedral of *c.* 1225.

28. E. Cinthio, *Frontalet i Lyngsjö* (Lund, 1954).

29. Stone, *op. cit.*, 82, plate 51A.

30. They were attributed by H. P. Mitchell to the workshop of Godefroid de Claire (*Burlington Magazine*, XXXV (1919), 92). For a full description and inscription see M. Chamot, *English Medieval Enamels* (London, 1930), 34–5, no. 17.

31. The diameter of the existing plaques being 17·9 cm. (about 7 in.), the whole shrine would have been very approximately 125 cm. (4 ft) long – a reasonable size.

32. Stone, *op. cit.*, plate 70B. It was found in a brazier's shop in 1717, purchased by the Earl of Warwick in 1851, and acquired by the Victoria and Albert Museum in 1919. The lid has not survived.

33. They are: 1. Moses and the Burning Bush. p. 239 2. Sacrifice of Cain and Abel. 3. Circumcision of Isaac. 4. Isaac bearing the wood for his sacrifice. 5. Sacrifice of Isaac. 6. Jonah issuing from the whale. Inside the bowl: Agnus Dei. For inscriptions see Chamot, *op. cit.*, 30.

34. *Ibid.*, no. 11, plates 5 and 6, and no. 12, plate 7.

35. The scenes on the Kennet Ciborium are: O.T. 1. Circumcision of Isaac. 2. Isaac bearing wood for sacrifice. 3. Sacrifice of Isaac. 4. Samson at Gaza. 5. David slaying a bear. 6. Ascension of Elias. N.T. 1. Baptism. 2. Christ carrying the Cross. 3. Crucifixion. 4. Three Maries at the tomb. 5. Descent into Limbo. 6. Ascension. The Malmesbury scenes are: O.T. 1. Aaron with ark and rod. 2. Sacrifice of Cain and Abel. 3. Circumcision of Isaac. 4. Sacrifice of Isaac. 5. Brazen Serpent. 6. Samson fighting the Philistines. N.T. 1. Nativity. 2. Circumcision. 3. Baptism. 4. Christ carrying the Cross. 5. Crucifixion. 6. Resurrection.

36. See Chamot, *op. cit.*, no. 18. 1. St Paul seated among Disciples (Metropolitan Museum, New York). 2. Conversion of St Paul (Lyon Museum). 3. St Paul escaping from Damascus. 4. St Paul disputing (both Victoria and Albert Museum). 5. Christ giving the keys to St Peter. 6. St Peter and St Paul before an emperor (both Dijon Museum). 7. St Peter attempting to walk on the waters (Germanisches Nationalmuseum, Nuremberg). The panel with the seated St James and St Jude in the British Museum (Chamot, no. 19), judging by the similarity of the drawing of heads, was most probably produced in the same workshop.

37. See p. 215, Chapter 18, and Chapter 21.

38. O. Homburger, 'Früh- und hochmittelalterliche Stücke im Schatz des Augustinerchorherrenstiftes von Saint-Maurice und in der Kathedrale zu Sitten', in *Frühmittelalterliche Kunst in den Alpenländern* (Actes du IIIᵉ Congrès International pour l'étude du Haut Moyen Âge, Septembre 1951) (1954), 352–3.

39. Royal MS. 2.A.XXII (Rickert, *op. cit.*, plate 91). See Homburger, *op. cit.*, 352–3.

40. See O. Homburger, 'Zur Stilbestimmung der figürlichen Kunst Deutschlands und des westlichen Europa im Zeitraum zwischen 1190 und 1250', in *Formositas Romanica* (Gantner Festschrift) (Frauenfeld, 1958), 29 ff.

CHAPTER 21

p. 240 1. For a discussion of this see W. Sauerländer, *Von Sens bis Strassburg* (Berlin, 1966), 1 ff., which also gives references to earlier work, especially W. Vöge, 'Die Bahnbrecher des Naturstudiums um 1200', *Zeitschrift für bildende Kunst*, N.F. XXV (1914), 183 ff. (reprinted in *idem, Bildhauer des Mittelalters* (Berlin, 1958), 83 ff.), and O. Homburger, 'Zur Stilbestimmung der figürlichen Kunst Deutschlands und des westlichen Europa im Zeitraum zwischen 1190 und 1250', in *Formositas Romanica* (Gantner Festschrift) (Frauenfeld, 1958), 29 ff.

2. For a full bibliography see *Der Meister des Dreikönigenschreins*, exhibition catalogue (Cologne, Diocesan Museum, 1964), 24.

3. For a discussion of the confusion that exists in the documents about the precise date of the fire see F. Röhrig, *Der Verduner Altar* (Klosterneuburg, 1955), 20–2.

4. For a schematic drawing of fourteenth-century p. 241 additions and restorations undertaken in 1949–51, see Cologne catalogue (*op. cit.*), 12–13. At the same time, the entire wooden base of the work must have been replaced, but there can be little doubt that the five layers in depth of the original must have been repeated precisely. On the back, four large figure scenes were also painted in 1331: the Crucifixion, the Three Maries at the Tomb and Noli me tangere, the Dormition, and the Coronation of the Virgin (see *Gotik in Österreich*, exhibition catalogue (Krems, 1967), 88).

5. A larger number of scenes originally decorated Suger's cross at Saint-Denis (see p. 189, Chapter 17). Another larger cycle was painted in the choir of Peterborough Cathedral (see M. R. James, 'On the Paintings formerly in the Choir at Peterborough', *Proc. Cambridge Antiquarian Soc.*, IX (1895), 178–94).

6. Especially in the writings of Rupert of Deutz, Honorius Augustodunensis, and Abbot Suger of Saint-Denis, as well as in the *Glossa Ordinaria* of the School of Laon. (See B. Smalley, *The Study of the Bible in the Middle Ages*, 2nd ed. (Oxford, 1952). See also bibliography in Röhrig, *op. cit.*, 90.)

7. O. Demus, 'Neue Funde an den Emails des Nikolaus von Verdun in Klosterneuburg', *Österreichische Zeitschrift für Denkmalpflege*, V (1951), 6 ff.

8. H. R. Hahnloser ('La Technique et style du retable de Klosterneuburg', *L'Art mosan* (Paris, 1953), 187 ff.) discusses briefly the internal stylistic development. He also (in 'Nicholas de Verdun ...', *Comptes rendus de l'Académie des Inscriptions et Belles Lettres* (1952), 448) points out that only three figure scenes have notches engraved in their border, producing something like the pearled border so common on earlier Mosan enamels, and suggests that these panels (Nativity, Nativity of Samson, and Adoration – and three ornamental plaques) may have been produced as samples to obtain this commission, and are therefore the earliest panels executed.

9. Cologne catalogue (*op. cit.*. Note 2), 29–30. p. 242

10. Report on the restoration: L. Cloquet, 'La Châsse de Notre-Dame de Tournai', *Revue de l'Art Chrétien*, XLI (1892), 308 ff. The inscription (there is little doubt that it replaces and restores the original one) runs: HOC OPVS FECIT MAGISTER NICOLAVS DE VERDVN-CONTINENS ARGENTI MARCAS CIX AVRI MARCAS VI ANNO AB INCARN · DOMINI MCCV CONSVMMATVM EST OPVS AVRIFABBRVM.

p. 242 11. J. Braun, 'Nikolaus von Verdun', *Thieme-Becker Künstler Lexicon*, xxv (1931), 452.

12. The design copies the cresting of the shrine of St Mary at Aachen (Plate 296).

p. 243 13. Cologne catalogue, *op. cit.* (Note 2), 15–18.

14. J. P. N. M. V(ogel), *Sammlung der prächtigen Edelgesteinen womit der Kasten der dreyen heiligen weisen Königen ausgeziert ist* (Bonn, 1781). Illustrations in Cologne catalogue, *op. cit.*, (Note 2) figures 3, 4.

p. 244 15. They are SS. Andrew, Simon, and Philip, and the cherub. For more details, see Cologne catalogue (*op. cit.*), 16. The shrine has recently been restored, but details of this await publication. The photograph on Plate 291 shows that St Andrew has once more become the prophet Habakkuk. The description here applies, therefore, to the state of the shrine as published in the Cologne catalogue (*op. cit.*, Note 2).

16. The cushion capitals of the shrine of the Three Kings are probably for the most part, and perhaps all, nineteenth-century restorations, but the columns are at least in some cases original, and their length would necessitate a similar arrangement in the original.

p. 245 17. See pp. 223–4, Chapter 18.

18. Most recently in Cologne catalogue (*op. cit.*), 25.

19. H. Peters, *Der Siegburger Servatiusschatz* (Honnef/Rhein, 1950), 19 ff.; but see review by H. Schnitzler, *Kunstchronik*, VI (1953), 55.

20. The dates are given by the appearance of Otto IV inscribed as 'Rex' (to the left of the Three Kings of the Adoration), whose claim to the succession was supported by Archbishop Adolf of Cologne after 1198, and who was crowned emperor in 1209. Otto's growing unpopularity between 1204 and 1209 might narrow the likely date to 1198–1204.

p. 246 21. E. Kitzinger, 'The Byzantine Contribution to Western Art of the Twelfth and Thirteenth Centuries', *Dumbarton Oaks Papers*, no. 20 (1966), 38 ff. See also O. Demus, *Byzantine Art and the West* (London, 1970).

22. W. Schlesinger, *Meissner Dom und Naumburger Westchor* (Münster and Cologne, 1952); N. Pevsner, *The Leaves of Southwell* (London, 1945). See especially L. Behling, *Die Pflanzenwelt der mittelalterlichen Kathedralen* (Cologne, 1964), 28 ff., 50 ff., for precise evidence of an interest in naturalistic representation.

23. See Chapter 18.

24. For example in the figure of Faith, one of the surviving fragments of the St Remaclus altar, now in Frankfurt Museum (Plate 200).

25. See F. Mütherich, *Die Ornamentik der rhein-* p. 247 *ischen Goldschmiedekunst in der Stauferzeit* (Würzburg, 1941), 39 ff.

26. The iconography of the Klosterneuburg pulpit still awaits detailed study. Some attention was paid to it by V. Griessmaier in his unpublished thesis *Der Emailaltar des Nikolaus von Verdun im Stifte Klosterneuburg bei Wien* (Vienna, 1928). N. Morgan (in an unpublished M.A. thesis, University of East Anglia, 1968) was able to reach the tentative conclusions that Nicholas's iconography is almost entirely derived from the western rather than the Byzantine tradition, and that ancient Carolingian traditions and a number of twelfth-century innovations played a part. Also that several scenes (e.g. Annunciation, Nativity, Brazen Sea, and Crucifixion) show particular Mosan features not found elsewhere.

27. From the Stoclet Collection; see Sotheby's catalogue, 8 July 1965, lot 11.

28. The same foliate motifs are also used, again in the corner, on the Brazen Sea panel at Klosterneuburg.

29. See an interesting attempt to account for the irregular shape of these panels by the reconstruction of a portable ciborium by H. Lenzen and H. Buschhausen, 'Ein neues Reichsportatile des 12. Jahrhunderts', *Wiener Jahrbuch für Kunstgeschichte*, XX (XXIV) (1965), 21–73.

30. *Ibid.*, 53 ff., plates 31, 32; Schramm and Mütherich (1962), no. 174; and p. 217, Chapter 18.

31. See p. 218, Chapter 18. p. 248

32. The latter term is used by Kitzinger, *op. cit.* (Note 21), 41 ff.

33. F. Deuchler, *Der Ingeborgpsalter* (Berlin, 1967).

34. Especially at Soissons, Braisne (now Soissons), Laon, Saint-Quentin, Bourges (clerestory), Chartres (St Eustace group), and Troyes Cathedral.

35. Most recent discussion and earlier references in Sauerländer, *op. cit.* (Note 1), and Kitzinger, *op. cit.*, 42 ff.

36. Kitzinger, *op. cit.*, 38–9.

37. For example the Ingeborg Psalter, the Speyer Evangelistary, the strange enamelled shrine of St Mark at Huy (c. 1190?), and especially the *Hortus Deliciarum* (see Dodwell (1971), 171–2).

38. Kitzinger, *op. cit.*, 39.

39. See, for example, the head of Christ in the Resurrection on the enamelled armlet in the Louvre of *c.* 1165 (see p. 218, Chapter 18).

p. 249 40. Bib. Nat. MS. gr. 139, illustrated by D. T. Rice, *The Art of Byzantium* (London, 1959), plate VIII.

41. Kitzinger, *op. cit.*, 41.

42. Volbach (1952), nos. 122, 123. The connexions of this style with carved sarcophagi are mentioned there.

43. Summary by J. Braun, *op. cit.* (Note 11), 452.

44. P. Bloch, 'Siebenarmige Leuchter in christlichen Kirchen', *Wallraf-Richartz-Jahrbuch*, XXIII (1961), 153 ff., 187–8.

45. An inscription on the base records that the candlestick was given to the cathedral by John Baptista Trivulzio, Archipresbyter of the cathedral from 1538 to 1540, and restored in 1562. The inscription reads: (western cartouche) IO. BAPT. TRIVVLTIVS HV ECCL ARCHIPBR. D.D.; (eastern cartouche) PRAEFECTI FABRICAE PERFECER. ET HIC PO. VIII C.APR. M.D. LXII.

46. On the suggestion that it replaced the great bronze candlestick taken to Prague in 1162 by King Wladislaw I, see Bloch, *op. cit.*, 135 ff., 187. C. Oman believed it to be of English provenance on stylistic grounds, and to have been taken to Milan after the Dissolution (see 'The Trivulzio Candlestick', *Apollo Magazine*, LVI (1952), 53 ff.).

p. 250 47. For a more complete analysis of the iconography, see Bloch, *op. cit.*, 161–3.

48. *Ibid.*, 154 ff.

49. *Ibid.*, 157. The two seated prophets, Moses and Aaron (?), in the Ashmolean Museum, Oxford, may well be the work of the same hand. See *ibid.*, 158, and H. P. Mitchell, 'Two Bronzes by Nicholas of Verdun', *Burlington Magazine*, XXXVIII (1921), 157 ff. Two more figures based on these two medieval casts were added to make a set of four figures in the early sixteenth century (attributed to A. Riccio by L. Planiscig, *Andrea Riccio* (Vienna, 1927)), which might be taken to support the attribution of the medieval work also to northern Italy – they were certainly in Italy *c.* 1500.

p. 251 50. The way figures are placed three-dimensionally into the foliate scrolls of the Tree of Jesse in the voussoirs of the west front of Laon also resembles the placing of the Old Testament scenes on the candlestick.

51. Bloch, *op. cit.*, 140 ff., Abb. 80, and p. 189.

52. Parallels to the style are, however, not easy to find. H. Swarzenski (1967), figure 329, convincingly compares the figure of an 'Anglo-Norwegian' candlebearer in the Oslo Museum. Bloch (*op. cit.*, 142–3) perhaps somewhat less convincingly compares the scrolls in the Reims (window?) tympanum in the Musée Lapidaire. Bloch suggests a date *c.* 1160 – perhaps a little late, although in Saxony, for example, the Magdeburg doors of the fifties still show similar very conservative stylistic elements rooted in the late eleventh century (see p. 209, Chapter 18).

53. The iconographic sources seem to point in the same direction – to north-eastern France and/or England. The scenes of the Passing through the Red Sea and the Slaying of Goliath are related to the late-twelfth-century copy of the Utrecht Psalter produced at Canterbury (Paris, Bib. Nat. lat. 8846 folios 2 verso and 2 recto) and the Psalter of St Louis at Leyden (Univ. Bib. lat. 76A folios 13 recto and 16 verso) and may be compared with the Sacrifice of Isaac and the Journey of the Three Magi. See Bloch, *op. cit.*, 154.

54. *Ibid.*, 159–60.

CHAPTER 22

1. E. Grimme, *Aachener Goldschmiedekunst im* p. 253 *Mittelalter* (Cologne, 1957), 48, 51 ff. See also E. Dinkler von Schubert, *Der Schrein der heiligen Elizabeth in Marburg* (Marburg, 1964).

2. 'Reinere monachi s. Jacobo Leodiensis Continvatio chronici Lomberti parvi', in *Mon. Germ. Hist., Scrip.*, XVI, 673.

3. See p. 193, Chapter 17.

4. E. Stephany, *Der Karlsschrein* (Mönchen-Gladbach, 1965), plates 54, 59.

5. *Ibid.*, plate 44. p. 254

6. *Ibid.*, plate 35.

7. *Les Trésors des églises de France*, exhibition catalogue (Paris, 1965), no. 217, plate 113.

SELECT BIBLIOGRAPHY

Only major works are listed. For more detailed references see notes. Cf. also the fundamental works quoted in the List of the Principal Abbreviations, p. 255.

1. GENERAL

Ars Sacra (exhibition catalogue). Munich, 1950.

BECKWITH, J. *Early Medieval Art.* London, 1964.

BEUTLER, C. *Bildwerke zwischen Antike und Mittelalter.* Düsseldorf, 1964.

BOECKLER, A. *Abendländische Miniaturen.* Berlin, 1930.

BRAUN, J. *Der christliche Altar,* I–II. Munich, 1924.

BRAUN, J. *Die Reliquiare des christlichen Kultes und ihre Entwicklung.* Freiburg im Breisgau, 1940.

CHAMOT, M. *English Medieval Enamels.* London, 1930.

FALKE, O. VON, SCHMIDT, R., and SWARZENSKI, G. *Der Welfenschatz.* Frankfurt, 1930.

GOLDSCHMIDT. A. *Die deutschen Bronzetüren des frühen Mittelalters.* Marburg, 1926.

GRABAR, A., and NORDENFALK, C. *Early Medieval Painting.* Lausanne, 1957.

GRIMME, E. *Aachener Goldschmiedekunst im Mittelalter.* Cologne, 1957.

HACKENBROCH, Y. *Italienisches Email des frühen Mittelalters.* Basel, 1938.

HALM, P. M., and BERLINER, R. *Das Hallische Heiltum.* Berlin, 1931.

HILDBURGH, W. L. *Medieval Spanish Enamels.* Oxford, 1936.

Karolingische und Ottonische Kunst (Forschungen zur Kunstgeschichte und christlichen Archäologie, III). Wiesbaden, 1957.

Kunst und Kultur im Wesserraum, 800–1600 (Corvey exhibition catalogue). Münster in Westfalen, 1966.

LEHMANN-BROCKHAUS, O. *Lateinische Schriftquellen zur Kunst in England, Wales und Schottland,* I–V. Munich, 1955–60.

LEHNERT, G. *Illustrierte Geschichte des Kunstgewerbes,* I–II. Berlin, 1912.

LONGHURST, M. H. *English Ivories.* London, 1926.

PANOFSKY, E. *Abbot Suger on the Abbey Church of St Denis.* Princeton, 1946.

PANOFSKY, E. *Die deutsche Plastik des 11. bis 13. Jarhrhunderts.* Munich, 1924.

PANOFSKY, E. *Renaissance and Renascences.* Stockholm, 1960.

PORCHER, J. *French Miniatures.* London, 1960.

RICE, D. TALBOT (ed.). *The Dark Ages.* London, 1965.

RICKERT, M. *Painting in Britain: The Middle Ages* (Pelican History of Art). 2nd ed. Harmondsworth, 1965.

ROSENBERG, M. *Geschichte der Goldschmiedekunst auf technischer Grundlage.* Frankfurt am Main, 1910–25.

Sakrale Gewänder des Mittelalters (exhibition catalogue). Munich, Bayrisches Nationalmuseum, 1955.

SCHMID, W. M. *Der Bamberger Domschatz.* Munich, 1914.

SCHRAMM, P. E. *Herrschaftszeichen und Staatssymbolik* (Mon. Germ. Hist. Scrip., XIII). Stuttgart, 1954–6.

SCHRAMM, P. E. *Sphaira, Globus, Reichsapfel.* Stuttgart, 1958.

STEINGRÄBER, E. *Antique Jewellery: Its History in Europe from 500 to 1900.* London, 1957.

STONE, L. *Sculpture in Britain: The Middle Ages* (Pelican History of Art). Harmondsworth, 1955.

THEOPHILUS (ed. C. R. Dodwell). *De diversis artibus.* London, 1961.

Les Trésors des églises de France (exhibition catalogue). Paris, 1965.

WEISBACH, W. *Religiöse Reform und mittelalterliche Kunst.* Einsiedeln, 1945.

Werdendes Abendland an Rhein und Ruhr (exhibition catalogue). Essen, 1956.

WILSON, D. M. *Anglo-Saxon Ornamental Metalwork, 700–1100.* London, 1964.

2. EARLY CHRISTIAN AND BYZANTINE

BECKWITH, J. *Early Christian and Byzantine Art* (Pelican History of Art). Harmondsworth, 1970.

BECKWITH, J. *The Art of Constantinople.* London, 1961.

GOLDSCHMIDT, A. and WEITZMANN, K. *Die Byzantinischen Elfenbeinskulpturen*, I–II. Berlin, 1930–4.

VOLBACH, W. F. *Early Christian Art*. London, 1961.

3. PRE-CAROLINGIAN (CHAPTER 1)

BRUCE-MITFORD, R. L. S. *The Sutton-Hoo Ship Burial, A Provisional Guide*. London, 1948 (and later eds.).

HENRY, F. *Irish Art in the Early Christian Period (to 800 A.D.)*. London, 1965.

HOLMQUIST, W. *Kunstprobleme der Merovingerzeit*. Stockholm, 1939.

HUBERT, J. *L'art préroman*. Paris, 1938.

KENDRICK, T. D. *Anglo-Saxon Art to A.D. 900*. London, 1958.

PAOR, M. and L. DE. *Early Christian Ireland*. London, 1964.

WILSON, D. M. *The Anglo-Saxons*. London, 1960.

4. CAROLINGIAN (CHAPTERS 2–6)

ARBMAN, H. *Schweden und das karolingische Reich*. Stockholm, 1937.

BRAUNFELS, W., and SCHNITZLER, H. (eds.). *Karl der Grosse*, III, *Karolingische Kunst*. Düsseldorf, 1965.

BULLOUGH, D. *The Age of Charlemagne*. London, 1965.

EINHARD (ed. S. Painter). *The Life of Charlemagne*. University of Michigan, 1960.

ELBERN, V. H. *Der karolingische Goldaltar von Mailand*. Bonn, 1952.

FICHTENAU, H. *The Carolingian Empire*. Oxford, 1963.

HASELOFF, G. *Der Tassilo Kelch*. Munich, 1951.

HINKS, R. *Carolingian Art*. London, 1935.

HUBERT, J., PORCHER, J., and VOLBACH, W. F. *L'Empire carolingien*. Paris, 1968.

Karl der Grosse (exhibition catalogue). Aachen, 1965.

SCHIFFERS, H. *Karls des Grossen Reliquienschatz und die Anfänge der Aachenfahrt*. Aachen, 1951.

SCHLOSSER, J. *Schriftquellen zur Geschichte der karolingischen Kunst*. Vienna, 1896.

WEBER, L. *Einbandeckel, Elfenbeintafeln, Miniaturen, Schriftproben aus Metzer liturgischen Handschriften*, I. Metz and Frankfurt am Main, 1913.

WERKMEISTER, O. K. *Der Deckel des Codex Aureus von S. Emmeram*. Baden-Baden and Strasbourg, 1963.

5. TENTH AND ELEVENTH CENTURIES (CHAPTERS 7–11)

BARRACLOUGH, G. *The Origins of Modern Germany*. 2nd ed. Oxford, 1948.

BECKWITH, J. *The Basilewski Situla*. London, 1963.

DODWELL, C. R., and TURNER, D. H. *Reichenau Reconsidered*. London, 1965.

FALKE, O. VON. *Der Mainzer Goldschmuck der Kaiserin Gisela*. Berlin, 1913.

FLECKSTEIN, J. *Die Sächsisch-Salische Hofkapelle*. Stuttgart, 1966.

HAMANN, R. *Die Holztür der Pfarrkirche zu St Maria im Kapitol*. Marburg, 1926.

HAUSHERR, R. *Der tote Christus am Kreuz; zur Ikonographie des Gerokreuzes*. Bonn, 1963.

JANTZEN, H. *Ottonische Kunst*. Munich, 1946.

KENDRICK, T. D. *Late Saxon and Viking Art*. London, 1949.

NILGEN, V. *Der Codex Douce 292 der Bodleian Library zu Oxford, Ein ottonisches Evangeliar*. Bonn, 1967.

THIETMAR OF MERSEBURG (ed. W. Frillmich). *Chronik*. Berlin, 1966.

TSCHAN, F. J. *St Bernward of Hildesheim*, I–III. Notre-Dame, 1942–52.

WESENBERG, R. *Bernwardische Plastik*. Berlin, 1955.

6. ROMANESQUE (CHAPTERS 12–22)

El Arte románico (exhibition catalogue). Barcelona and Compostela, 1961.

BECKWITH, J. *The Adoration of the Magi in Whalebone*. London, 1966.

BEENKEN, H. *Romanische Skulptur in Deutschland*. Berlin, 1924.

BOECKLER, A. *Die Bronzetüren von Verona*. Marburg, 1931.

DEMUS, O. *Byzantine Art and the West*. London, 1970.

ELBERN, V. H., and REUTHER, H. *Der Hildesheimer Domschatz*. Hildesheim, 1969.

GAILLARD, G. *La Sculpture romane espagnole*. Paris, 1946.

GAILLARD, G. *Les Débuts de la sculpture romane espagnole*. Paris, 1938.

GAUTHIER, M.-M. *Émaux limousins des XII, XIII et XIV siècles*. Paris, 1950.

GOMEZ-MORENO, A. *El Arte romanico español*. Madrid, 1934.

GRABAR, A., and NORDENFALK, C. *Romanesque Painting*. Lausanne, 1958.

Der Meister des Drekönigenschreins (exhibition catalogue). Cologne, Diocesan Museum, 1964.

MÜTHERICH, F. *Die Ornamentik der rheinischen Goldschmiedekunst in der Stauferzeit.* Würzburg, 1941.

NØRLUND, P. *Gyldne Altre.* Copenhagen, 1926.

OMAN, C. *The Gloucester Candlestick.* London, 1958.

RÖHRIG, F. *Der Verduner Altar.* Klosterneuberg, 1955.

Romanische Kunst in Österreich (exhibition catalogue). Krems, 1964.

RUPIN, E. *L'Œuvre Limoges.* Paris, 1890–2.

SCHNITZLER, H. *Die Goldschmiedeplastik der Aachner Schreinwerkstatt.* Düren, 1934.

STEPHANY, E. *Der Karlsschrein.* Mönchen-Gladbach, 1965.

STRAUS, L. *Zur Entwicklung des zeichnerischen Stils in der Cölner Goldschmiedekunst der 12. Jahrhunderts* (Studien zur deutschen Kunstgeschichte, CCII). Strassburg, 1917.

THOBY, P. *Les Croix limousines de la fin du XIIe siècle au début du XIVe siècle.* Paris, 1953.

VALENTIEN, F. *Untersuchung zur Kunst der 12. Jahrhunderts im Kloster Komburg.* Freiburg University, 1963.

THE PLATES

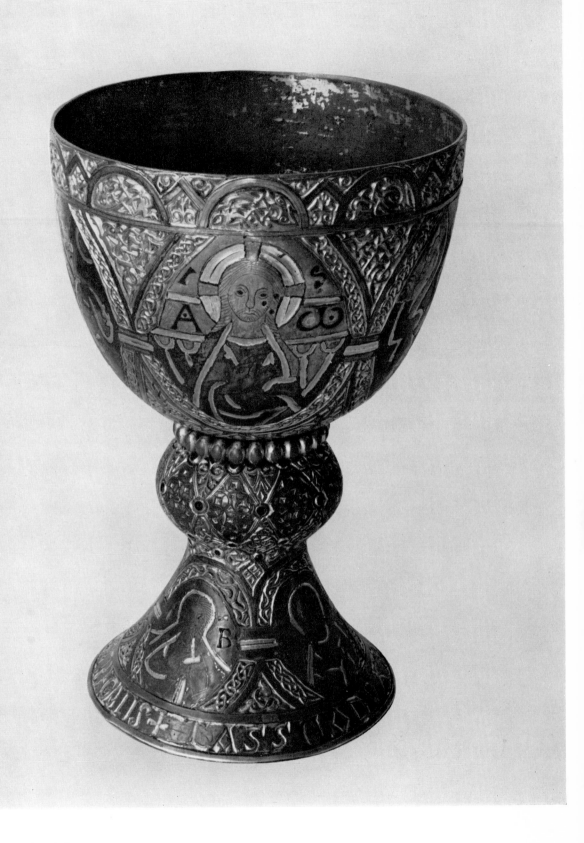

1. Tassilo Chalice, 777/88. *Kremsmünster*

2. Book-cover of the Lindau Gospels (back), early ninth century(?). *New York, Pierpont Morgan Library*

3. Caja de las Agatas (top), eighth century (first half). *Oviedo, Camara Santa*

4. Enamelled gold mount from the tomb of Count Gisulf (d. 611). *Cividale, Museo Civico*

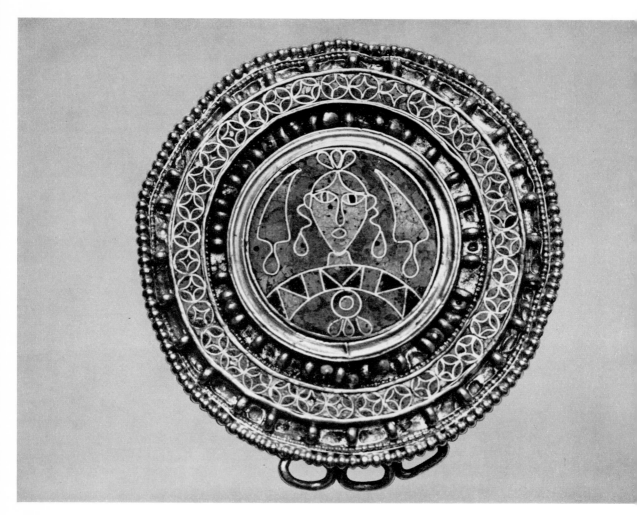

5. Castellani brooch, seventh century.
London, British Museum

6. Brooch from Westheim, later
seventh century(?). *Speyer,
Historisches Museum der Pfalz*

7. Enger reliquary (front), early ninth
century(?). *Berlin, Staatliche Museen*

8. Christ between angels (*above*), Virgin
and Child between saints(?) (*below*). Enger
reliquary (back), early ninth century(?).
Berlin, Staatliche Museen

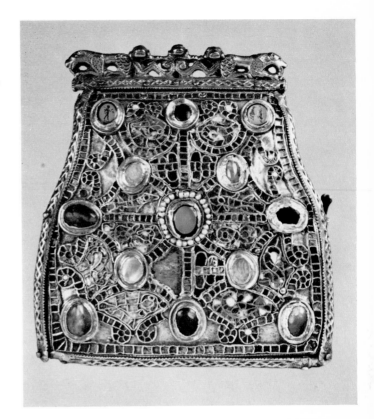

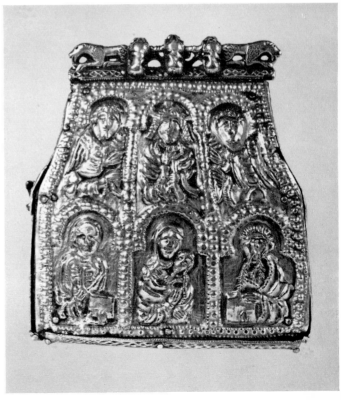

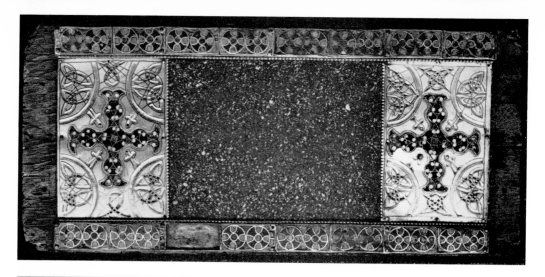

9. Portable altar from Adelhausen, late eighth century. *Freiburg, Augustinermuseum*

10. Altheus reliquary, 780/99. *Sion (Sitten) Cathedral, Treasury*

11. Christ treading on the beasts. Plaque from Genoels-Elderen, early ninth century(?). *Brussels, Musées Royaux*

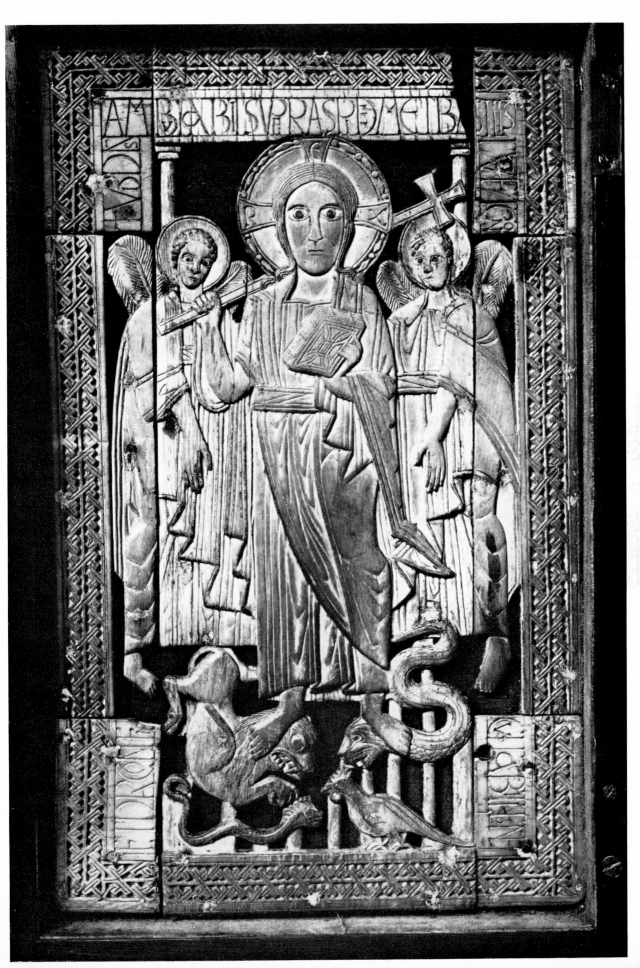

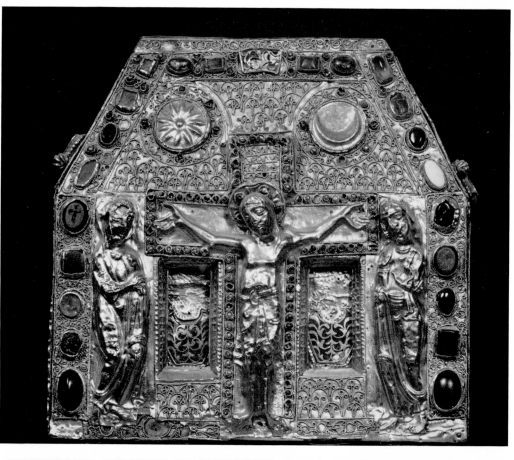

12. Pepin reliquary, mid ninth and eleventh centuries. *Conques Abbey, Treasury*

13. Bronze railings (detail), late eighth century. *Aachen, Palace Chapel*

14. Chalice of St Lebuinus, late eighth century. *Deventer, Broerenkerk*

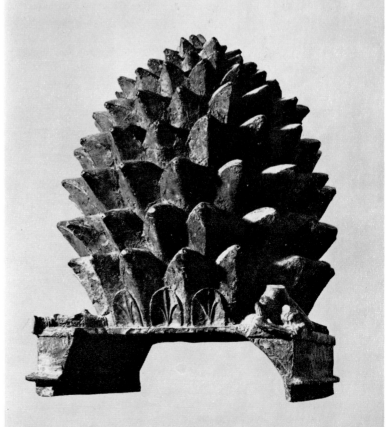

15. Bronze doors, late eighth century. *Aachen, Palace Chapel, west front (north side)*

16. 'Throne of Dagobert', late eighth century(?). *Paris, Bibliothèque Nationale, Cabinet des Médailles*

17. Bronze pine-cone, late eighth century. *Aachen, Palace Chapel*

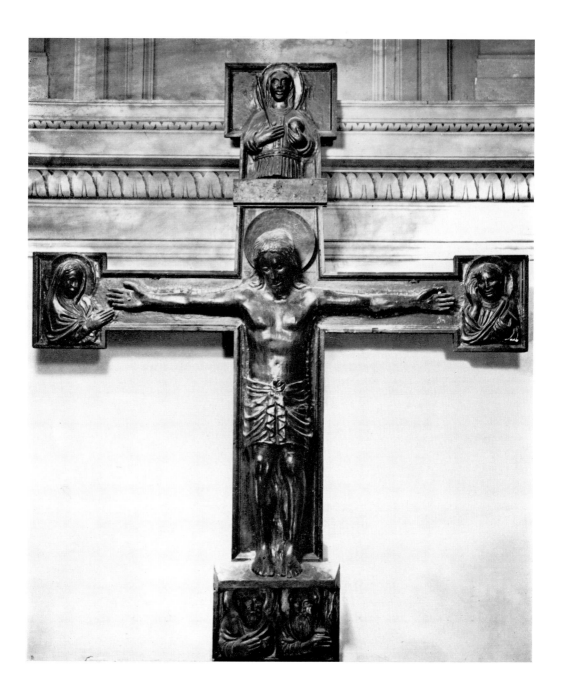

18. Leather copy of 1540 of a silver crucifix, *c.* 800. *Rome, Museo Sacro Vaticano*

19. Equestrian figure of Charlemagne(?) from Metz, early ninth century. *Paris, Louvre*

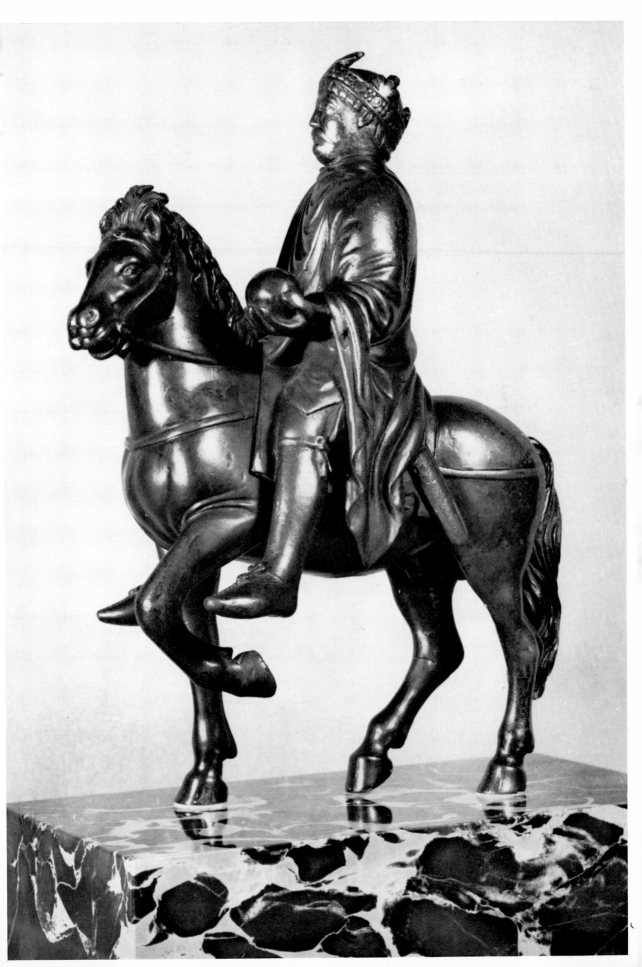

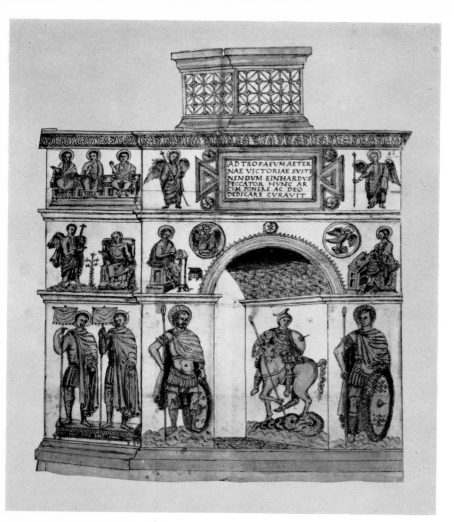

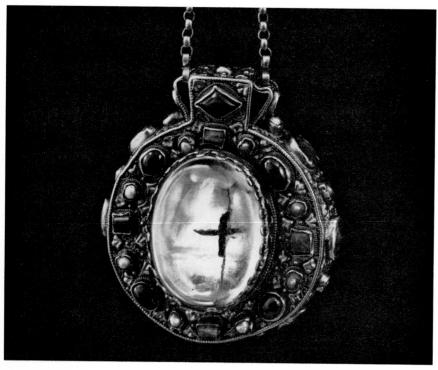

20. Drawing of the silver base of a crucifix in the form of a triumphal arch (Einhard's Arch) from Maastricht, *c.* 820. *Paris, Bibliothèque Nationale*

21. 'Charlemagne's Amulet', late eighth century. *Reims Cathedral, Treasury*

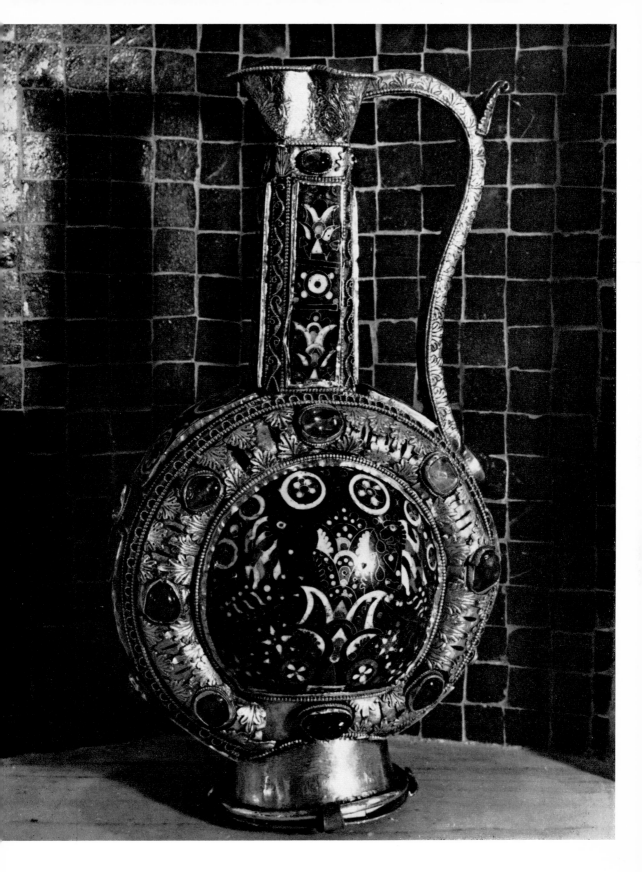

22. Ewer-reliquary, eighth century(?). *Saint-Maurice d'Agaune Abbey, Treasury*

23. Drawing by Labarre (1794) of the 'Escrain de Charlemagne' with detail of crest, early ninth century. *Paris, Bibliothèque Nationale, Cabinet des Estampes*

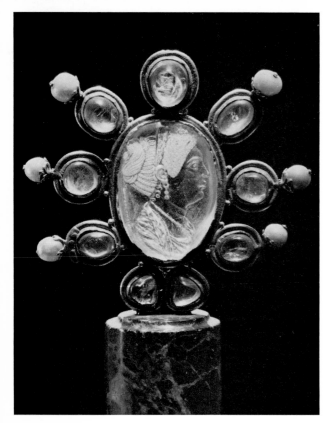

24. Crest of the 'Escrain de Charlemagne', early ninth century. *Paris, Bibliothèque Nationale, Cabinet des Médailles*

25. Christ treading on the beasts between angels, the Magi before Herod, and the Adoration (*below*). Book-cover (back) of the Lorsch Gospels, early ninth century. *Rome, Museo Sacro Vaticano*

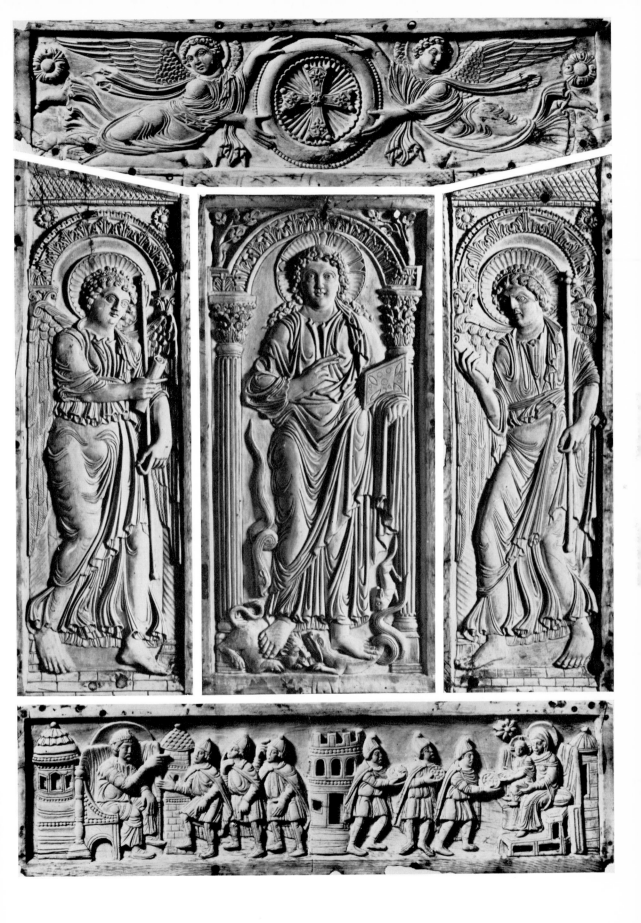

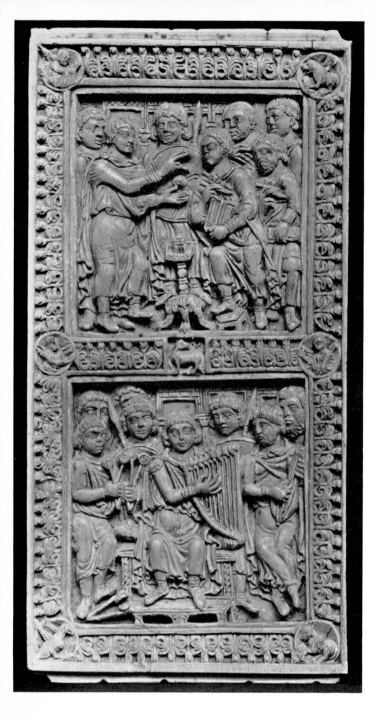

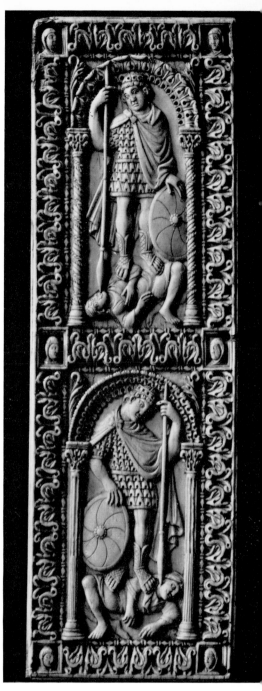

26. Book-cover of the Dagulf Psalter, before 795. *Paris, Louvre*

27. Charlemagne victorious over the barbarians(?). Ivory panel, early ninth century. *Florence, Museo Nazionale*

28. Christ treading on the beasts and scenes from the life of Christ. Book-cover, *c.* 800. *Oxford, Bodleian Library*

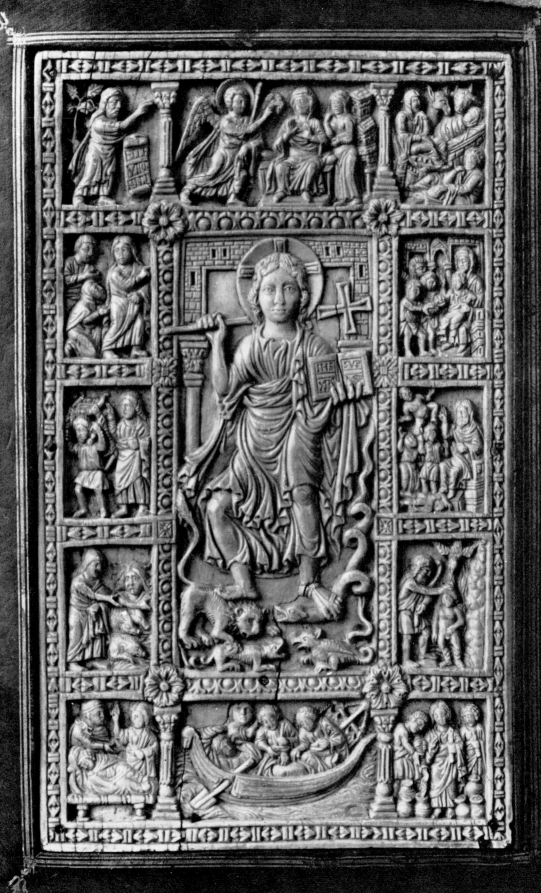

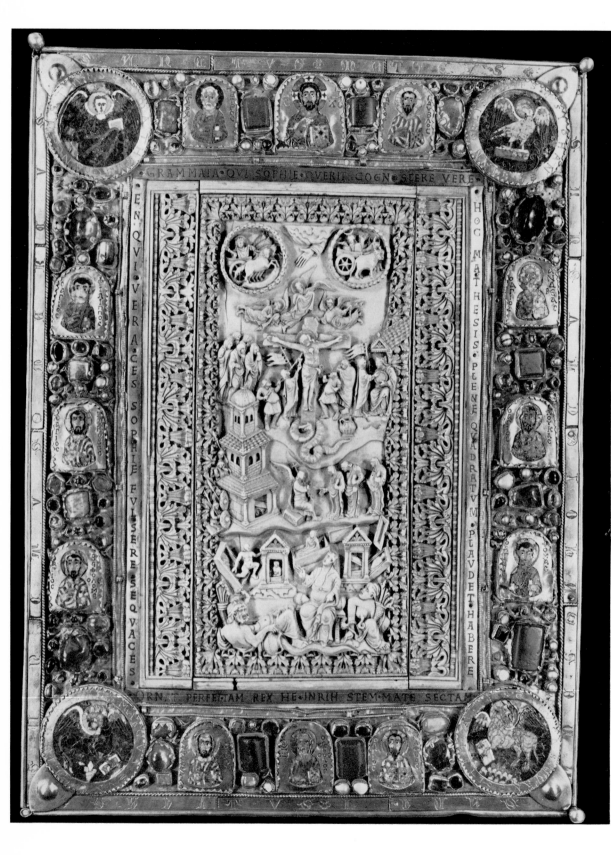

29. Crucifixion, ivory, *c.* 820/30, on a book-cover of the early eleventh century. *Munich, Bayerische Staatsbibliothek*

30. Illustration of Psalm 56, ivory, *c.* 820/30, on the book-cover (front) of the Psalter of Charles the Bald, *c.* 850/60. *Paris, Bibliothèque Nationale*

31. Crucifixion and Three Maries at the Tomb. Ivory panel, *c.* 820. *Liverpool, Public Museums*

32. Illustration of Psalm 26, *c.* 820/30, from the book-cover of the Prayer Book of Charles the Bald, *c.* 850/60. *Zürich, Schweizerisches Landesmuseum*

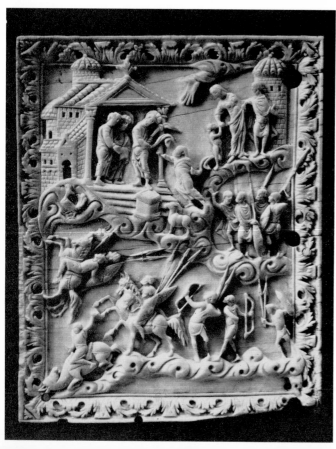

33. Crucifixion. Ivory panel, *c.* 820. *London, British Museum*

34. Ascension. Ivory panel, *c.* 830. *Vienna, Kunsthistorisches Museum*

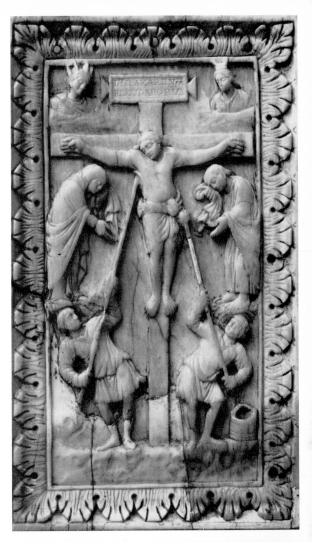

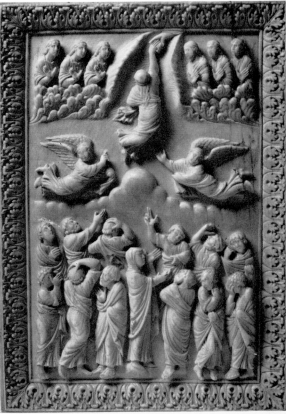

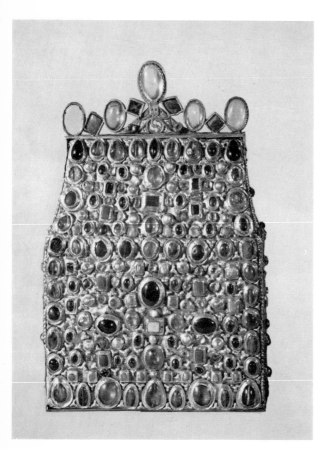
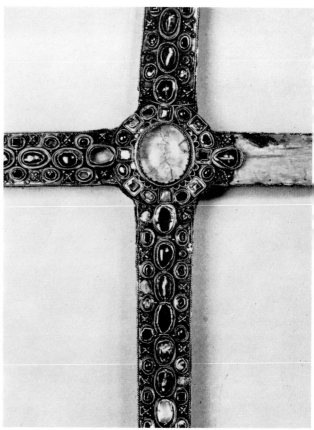

35. Burse-reliquary of St Stephen, *c.* 830. *Vienna, Weltliche und Geistliche Schatzkammer*

36. 'Ardenne' processional cross (detail), *c.* 830. *Nuremberg, Germanisches National-Museum*

37. Book-cover (front) of the Drogo Sacramentary, *c.* 845. *Paris, Bibliothèque Nationale*

38. Annunciation, Adoration of the Magi, and Massacre of the Innocents. Book-cover, *c.* 840/5. *Paris, Bibliothèque Nationale*

39. Temptation of Christ, surrounded by other scenes of the life of Christ. Book-cover, *c.* 840/50. *Frankfurt, Stadtbibliothek*

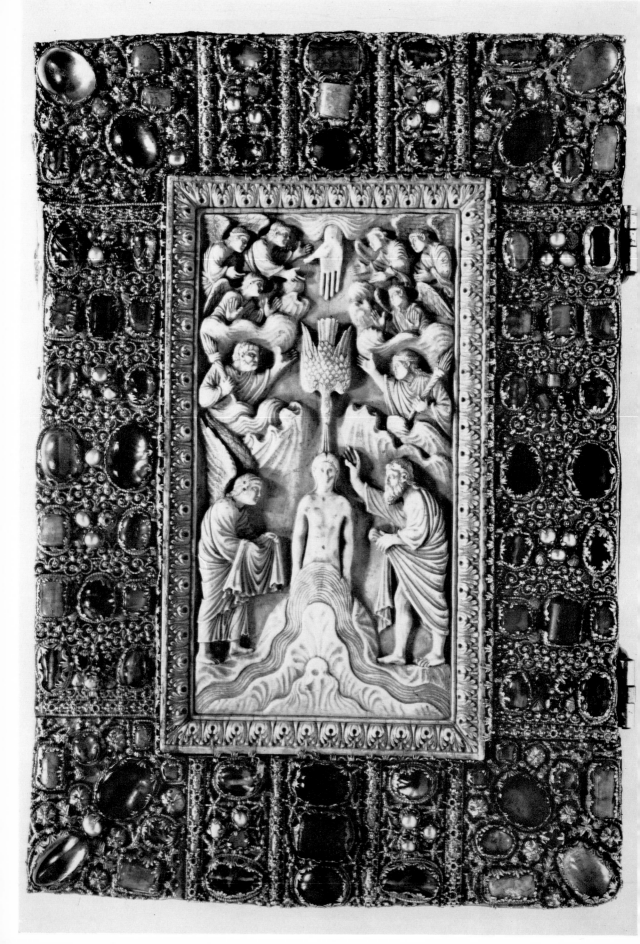

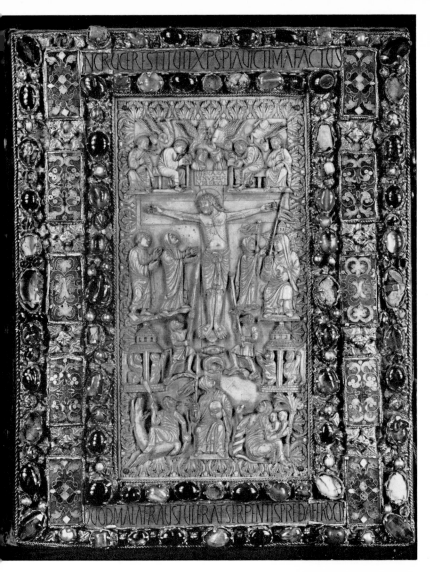

40. Baptism of Christ. Book-cover (front),
c. 840/50. *Munich, Bayerische Staatsbibliothek*

41. Crucifixion. Book-cover (front),
c. 840/50. *Paris, Bibliothèque Nationale*

42. Illustrations of the Eclogues of Virgil.
Flabellum handle, c. 850. *Florence, Museo Nazionale*

43. Adam and Eve. Diptych (detail), c. 850.
Paris, Louvre

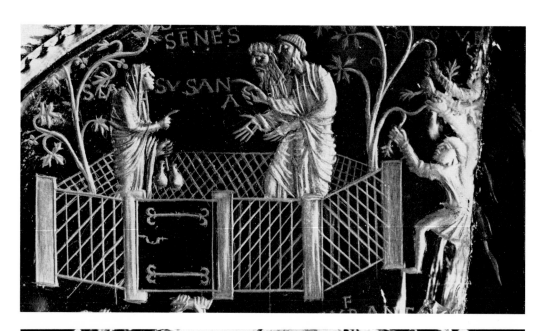

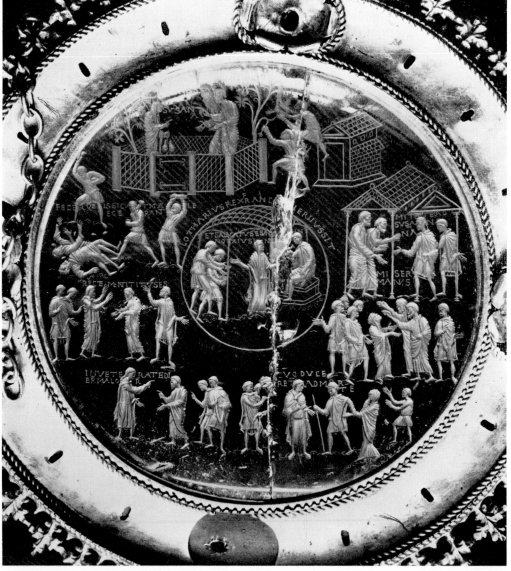

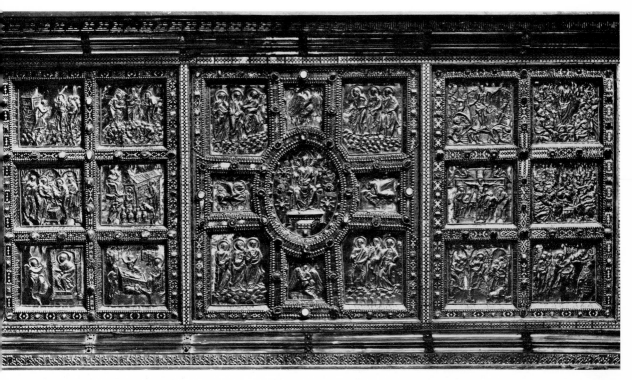

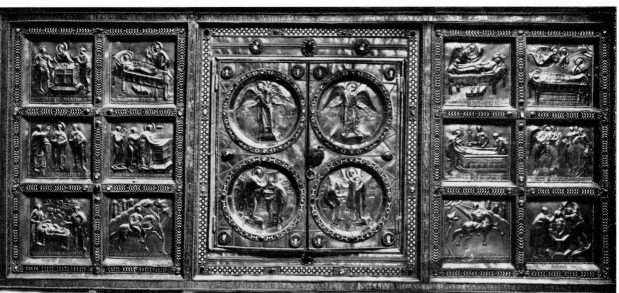

44. Susanna before the Elders. Lothar Crystal (detail), 865(?). *London, British Museum*

45. The Story of Susanna. Lothar Crystal, 865(?), set in a bronze gilt frame of the fifteenth century. *London, British Museum*

46. Christ in Majesty and scenes from the life of Christ. Golden Altar (front), *c. 850. Milan, Sant'Ambrogio*

47. Dedication scenes and scenes from the life of St Ambrose. Golden Altar (back), *c. 850. Milan, Sant'Ambrogio*

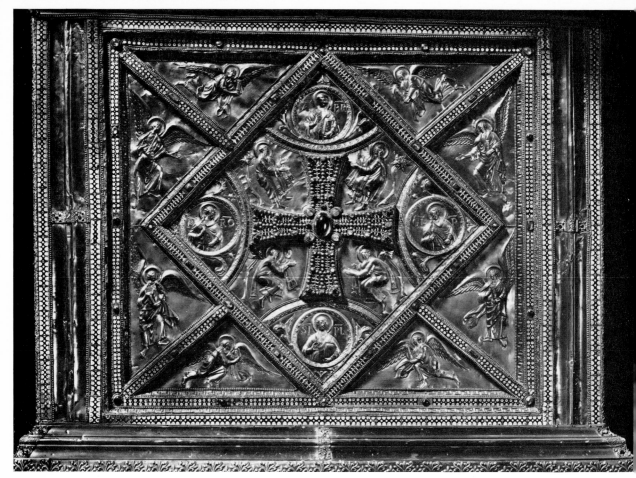

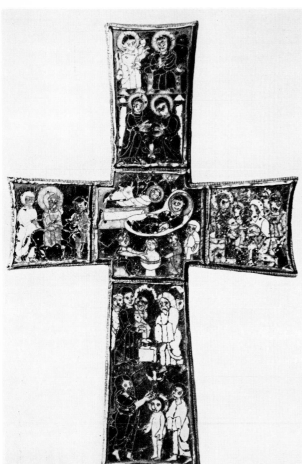

48. Adoration of the Cross. Golden Altar (side panel), *c.* 850. *Milan, Sant'Ambrogio*

49. Scenes from the Annunciation to the Virgin to the Baptism of Christ. Enamelled reliquary cross from the Sancta Sanctorum Chapel of the Lateran, 817/24. *Rome, Museo Sacro Vaticano*

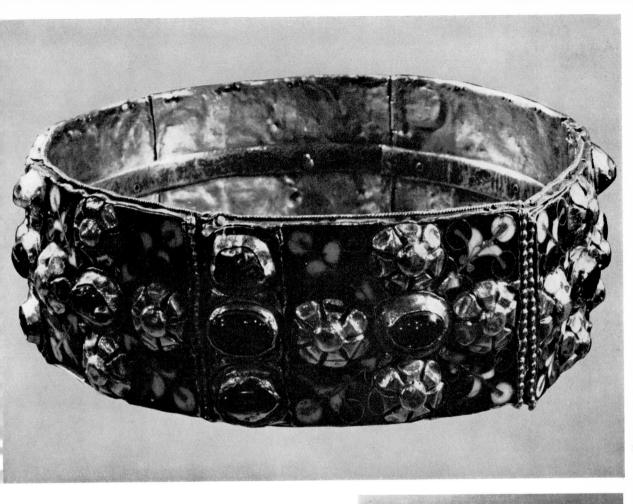

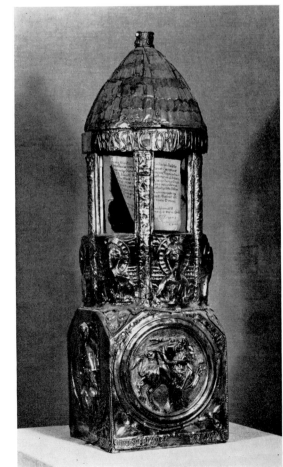

50. 'Iron Crown', *c.* 850. *Monza Cathedral, Treasury*

51. Bégon 'lantern' reliquary of St Vincent, *c.* 860(?).
Conques Abbey, Treasury

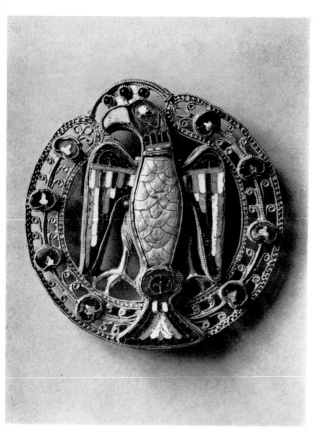

52. Fibula from the 'Gisela Treasure', *c.* 850(?). *Mainz, Altertumsmuseum*

53. Burse-reliquary of the tooth of St John the Baptist (front), ninth century (second half). *Monza Cathedral, Treasury*

54. Crucifixion. Burse-reliquary of the tooth of St John the Baptist (back), ninth century (second half). *Monza Cathedral, Treasury*

55. Christ in Majesty, the four Evangelists, and scenes from the life of Christ. Book-cover (front) of the Codex Aureus from St Emmeram, Regensburg, 870. *Munich, Bayerische Staatsbibliothek*

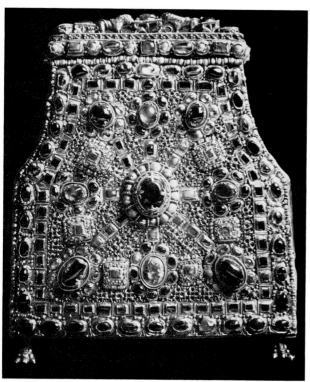

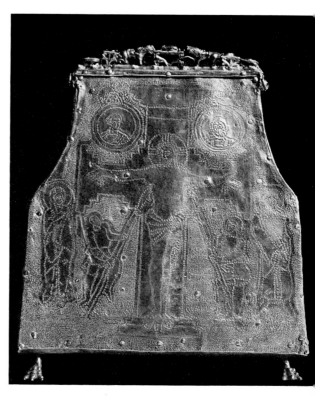

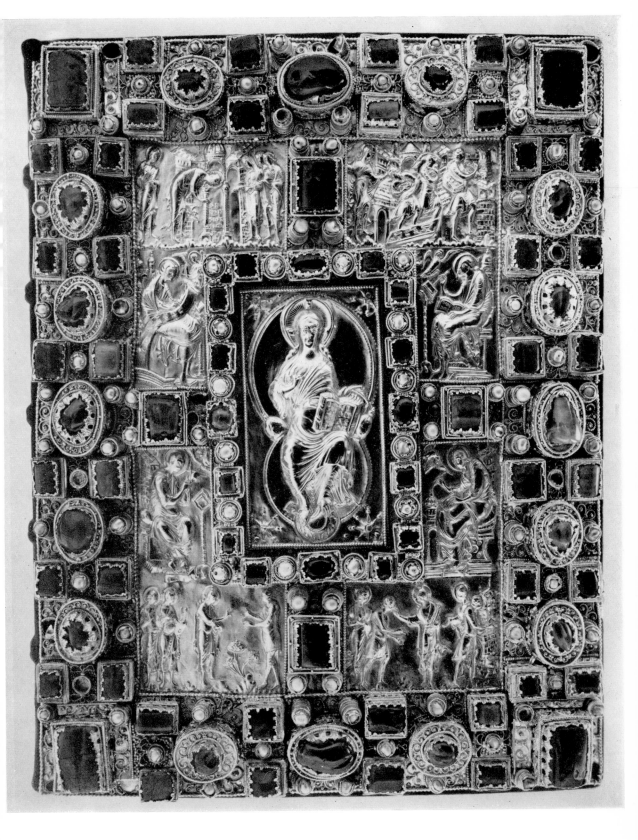

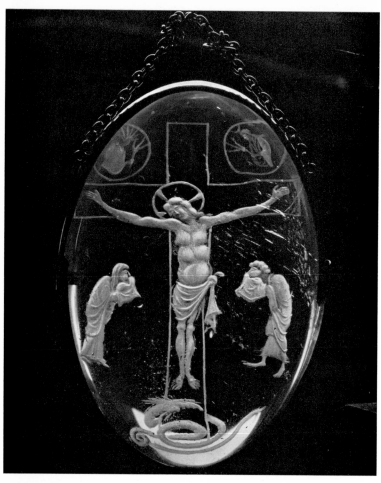

56. Crucifixion. Crystal from the abbey of Saint-Denis, soon after 867(?). *London, British Museum*

57. Mass of St Giles (detail). Painted panel, *c.* 1500. *London, National Gallery*

58. Arnulf Ciborium, with detail from the roof of the Risen Christ appearing to St Peter, 887/96(?). *Munich, Residenz, Treasury*

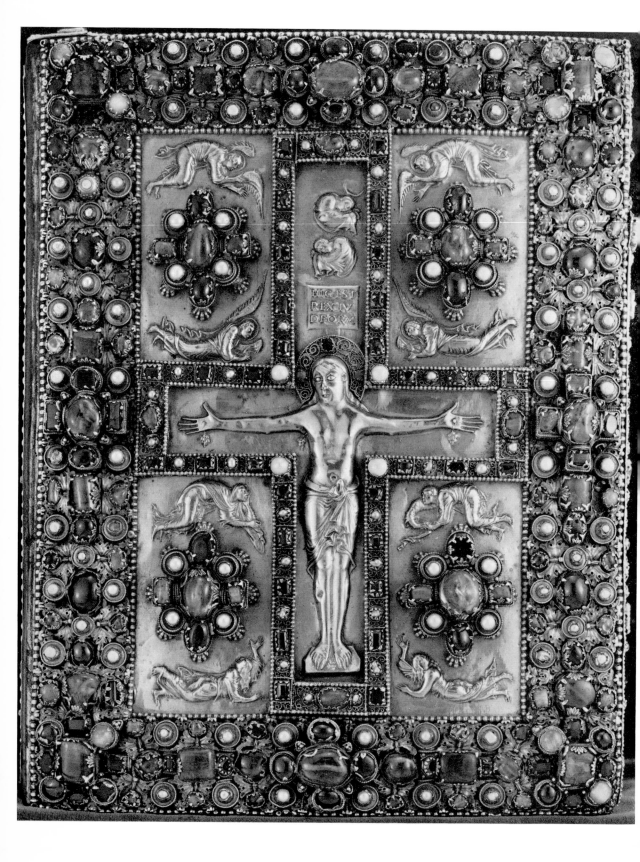

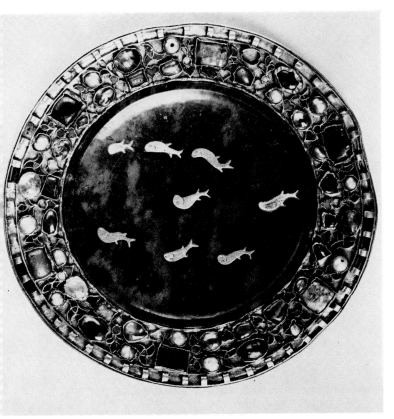

59. Crucifixion. Book-cover of the Lindau Gospels (front), *c.* 870. *New York, Pierpont Morgan Library*

60. Paten of Charles the Bald. Antique dish, mounted *c.* 870. *Paris, Louvre*

61. Crucifixion. Ivory panel, *c.* 870(?). *London, Victoria and Albert Museum*

62. Crucifixion, ivory, *c*. 860/70, on a book-cover (front) of the early eleventh century(?). *Paris, Bibliothèque Nationale*

63. St Peter preaching and baptizing. Ivory panel, *c*. 900(?). *Florence, Museo Nazionale*

64. Tuotilo: Christ in Majesty and the four Evangelists. Book-cover (front), *c*. 900. *St Gall, Library*

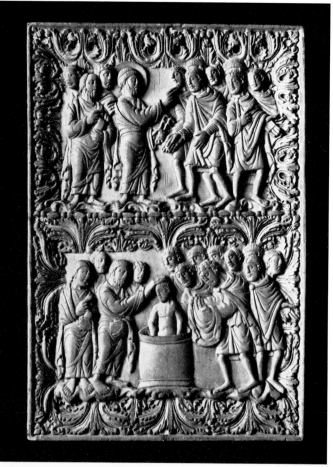

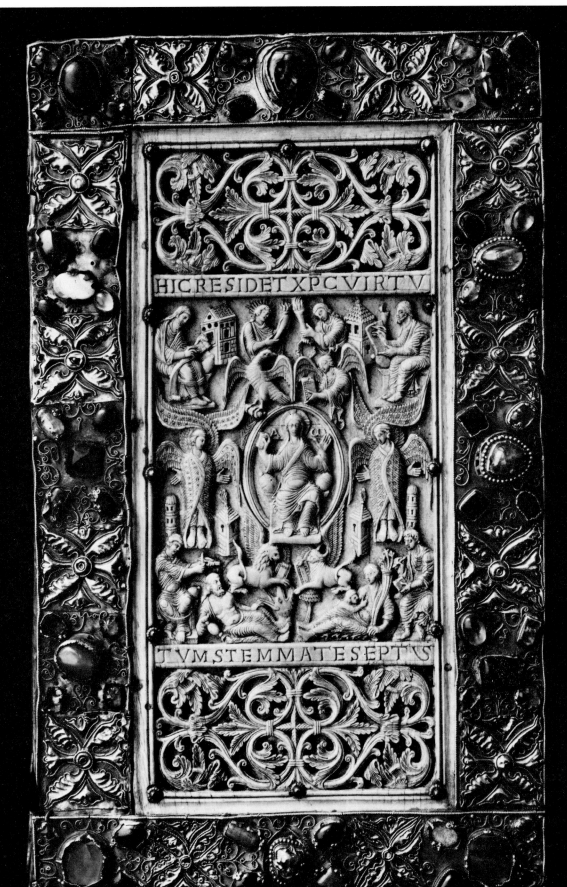

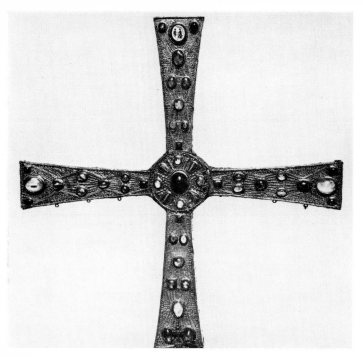

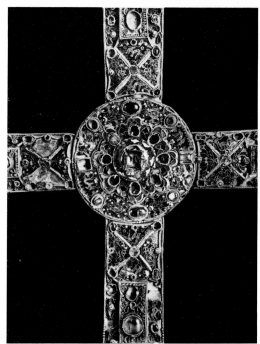

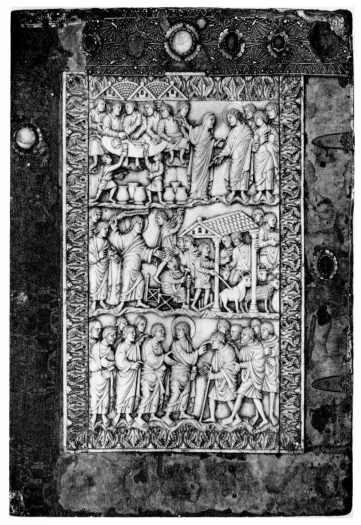

65. Cross of Angels, given by Alfonso II in 808. *Oviedo, Camara Santa*

66. Cross of Victory (detail), given by Alfonso III in 908. *Oviedo, Camara Santa*

67. Marriage at Cana, Expulsion of the Moneylenders, Healing of the Blind Man. Book-cover (front), *c.* 860/70(?). *Würzburg, Universitätsbibliothek*

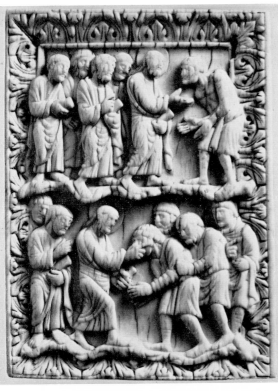

68. Healing of the Leper and the Blind Man. Ivory panel, early tenth century. *London, Victoria and Albert Museum*

69. Raising of Lazarus and Healing of the Blind Man. Ivory panel, *c.* 925/50. *London, British Museum*

70. Ascension and Entry into Jerusalem. Ivory panel, *c.* 925/50. *London, British Museum*

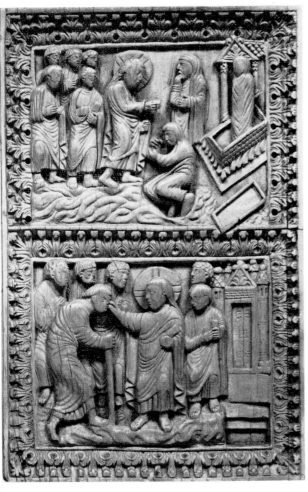

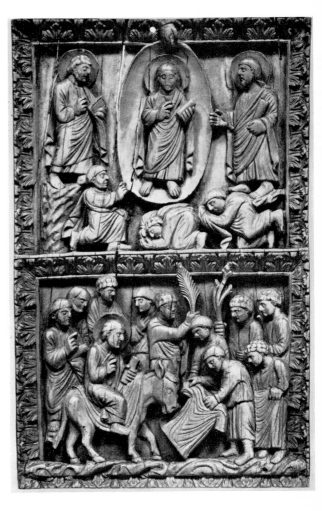

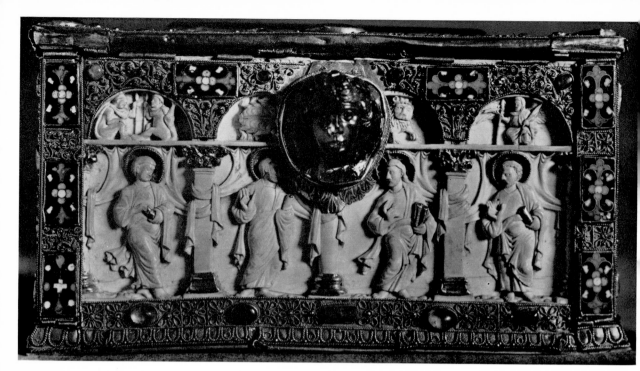

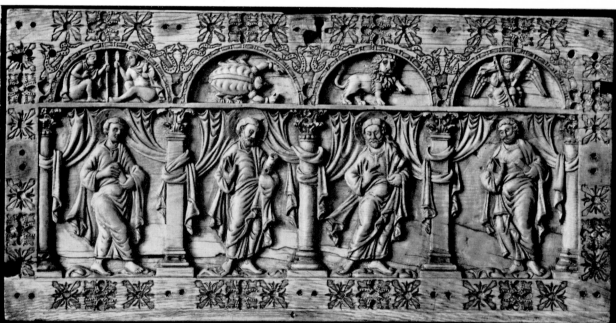

71. Casket (front panel), *c.* 930(?). Quedlinburg, *Stiftskirche*

72. Ivory panel from a casket from Bamberg, *c.* 930(?). *Munich, Bayerisches Nationalmuseum*

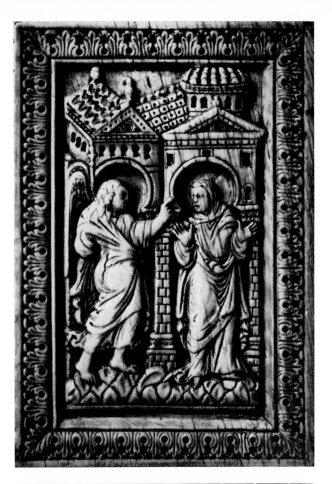

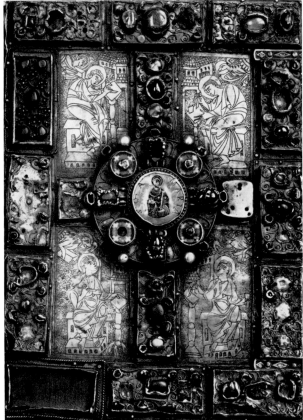

73. Annunciation. Ivory panel, early tenth century(?). *Formerly Berlin, Staatliche Museen*

74. Book-cover of Bishop Gauzelin, 922/62. *Nancy Cathedral, Treasury*

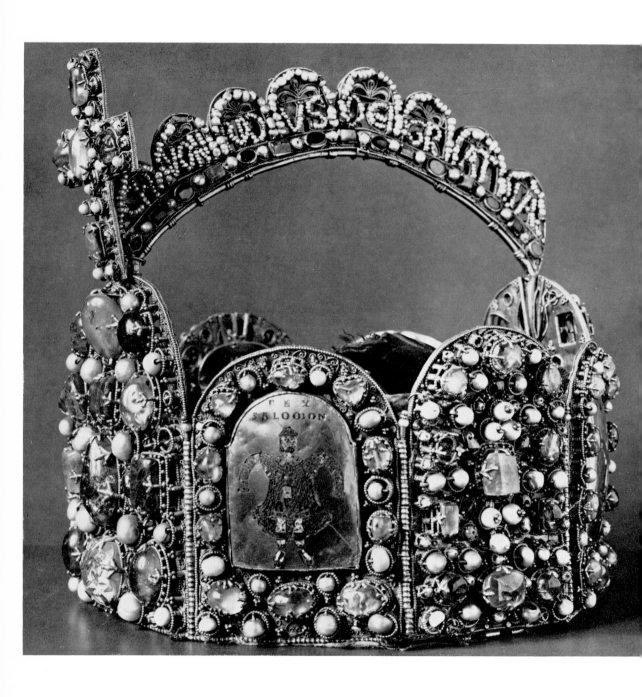

75. Imperial Crown, 961/2 with later additions. *Vienna, Weltliche und Geistliche Schatzkammer*

76. Book-cover of Archbishop Aribert, 1018/45. *Milan Cathedral, Treasury*

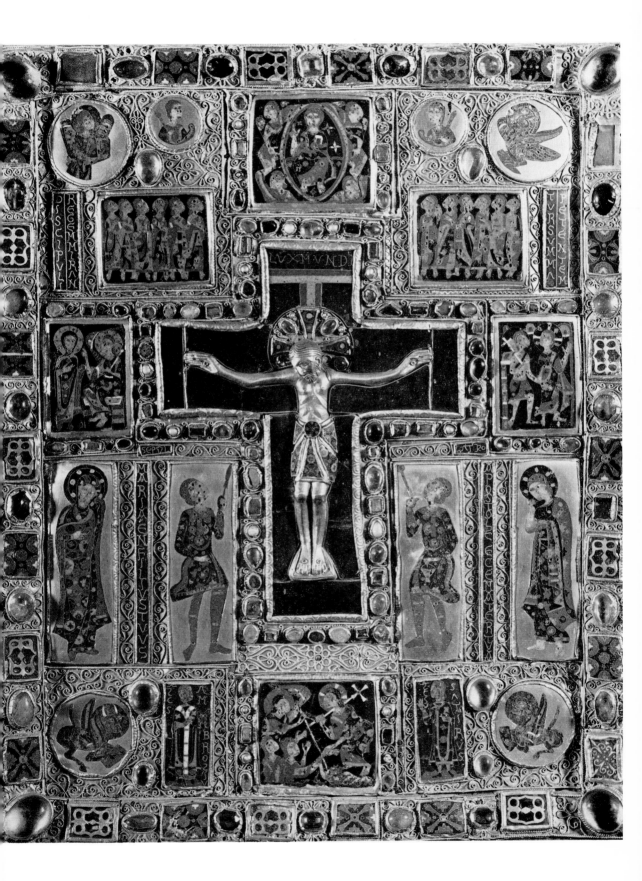

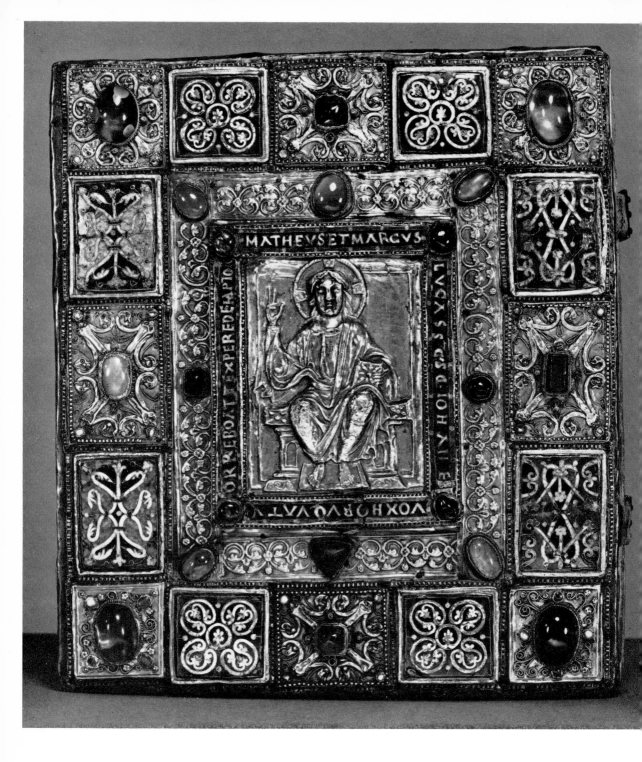

77. Book-cover from Sion Cathedral, *c.* 922/37(?) with late-twelfth-century additions. *London, Victoria and Albert Museum*

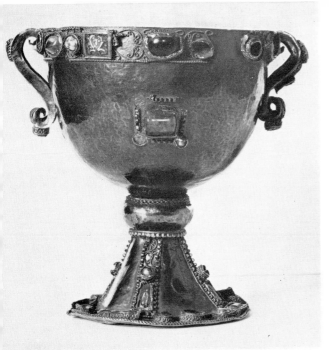

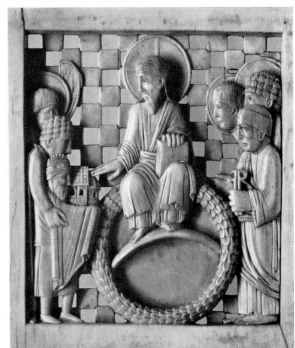

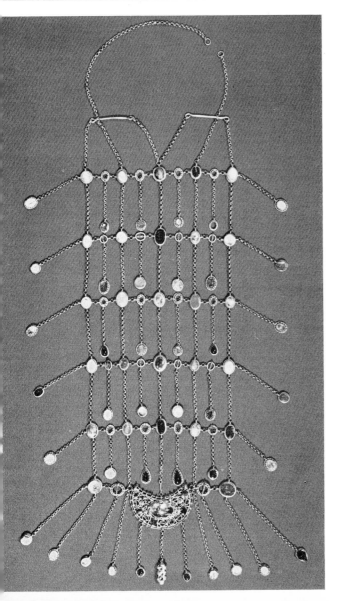

78. Chalice of Bishop Gauzelin, 922/62.
Nancy Cathedral, Treasury

79. Dedication panel from the
'Magdeburg antependium', *c.* 955/68.
New York, Metropolitan Museum of Art

80. Breast ornament (lorum) from the
'Gisela Treasure', *c.* 972/80. *Berlin,
Staatliche Museen*

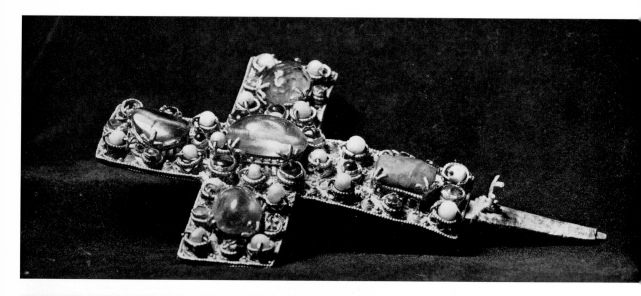

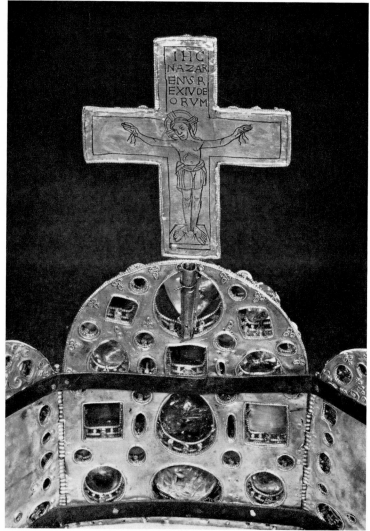

81. Cross on the Imperial Crown (front), *c.* 973/83(?). *Vienna, Weltliche und Geistliche Schatzkammer*

82. Cross on the Imperial Crown (back), *c.* 973/83(?). *Vienna, Weltliche und Geistliche Schatzkammer*

83. Virgin and Child between the four Evangelists. Situla, 979/80. *Milan Cathedral, Treasury*

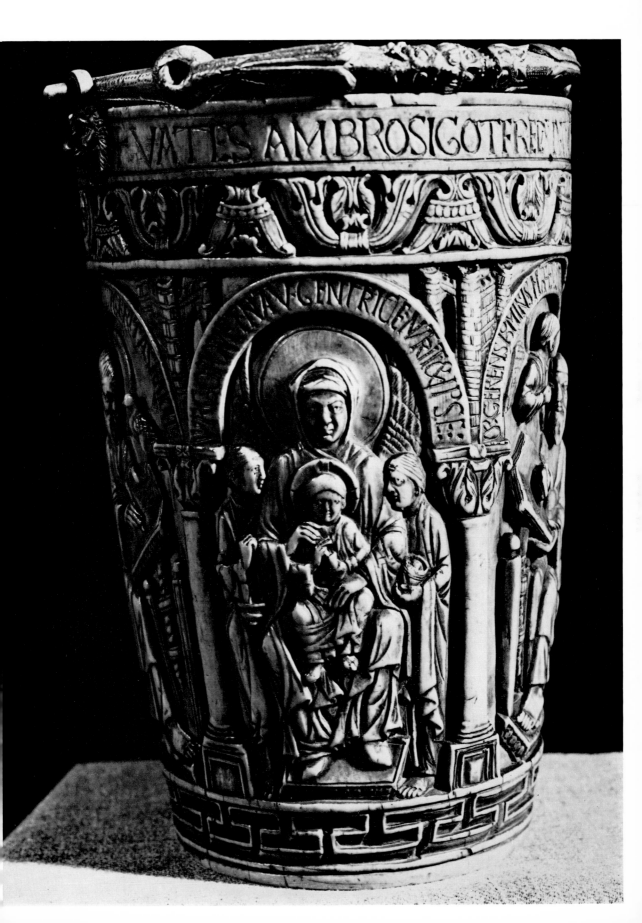

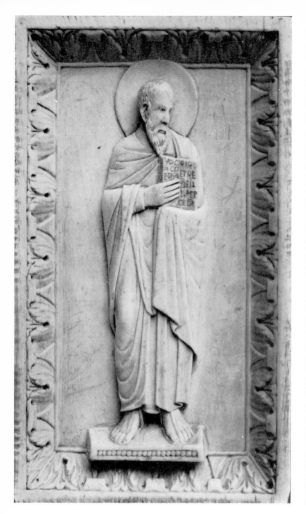

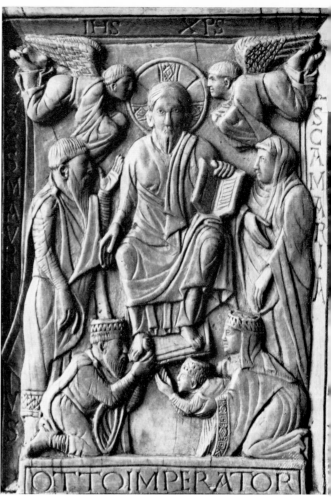

84. St Matthew. Ivory panel on the book-cover of Harley MS. 2889, *c.* 980. *London, British Museum*

85. Christ in Majesty, with St Mauritius and the Virgin, adored by Otto II and Theophanu and their infant son. Ivory panel, 980/3. *Milan, Castello Sforzesco*

86. Scenes of the Passion and Resurrection. Basilewski Situla, 983(?). *London, Victoria and Albert Museum*

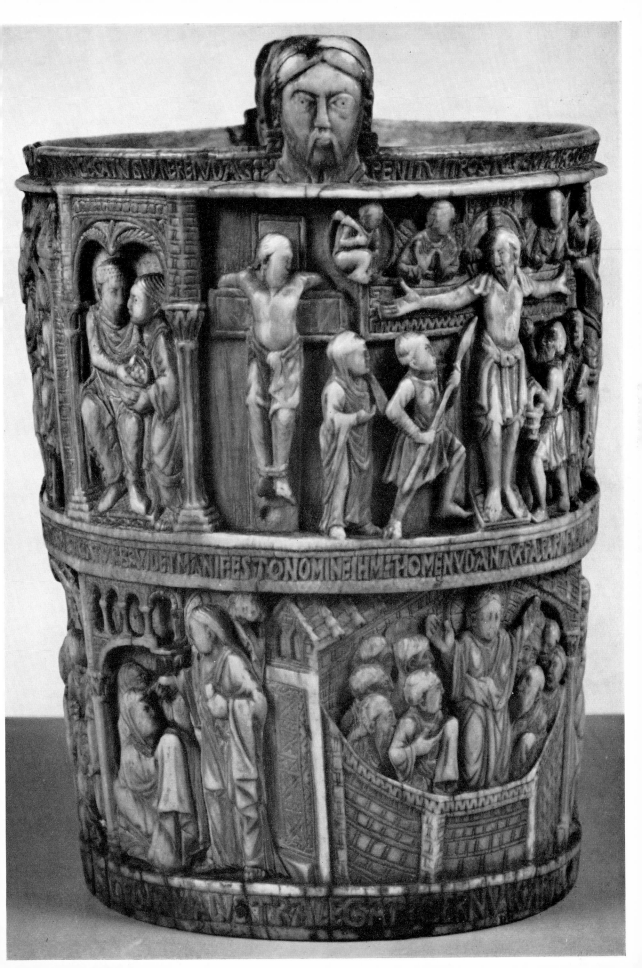

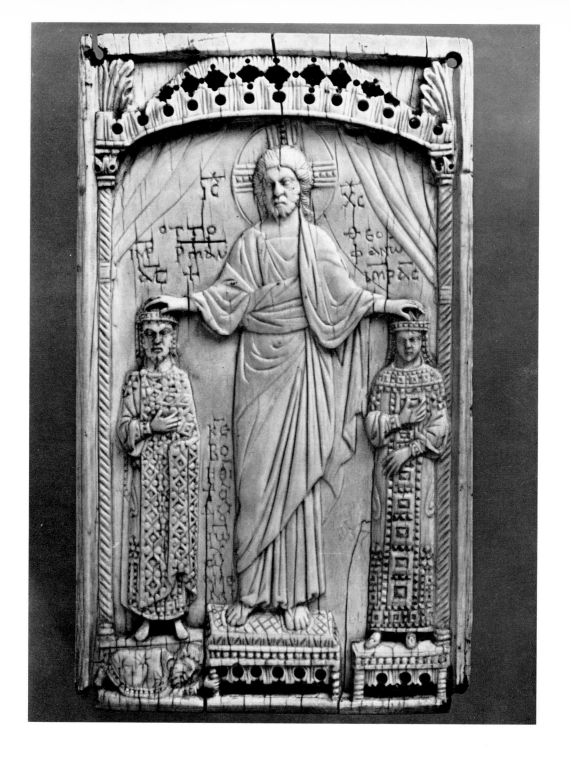

87. Christ crowning Otto II and Theophanu. Ivory panel, 982/3. *Paris, Musée de Cluny*

88. Crown of the Golden Virgin, *c.* 983(?). *Essen Minster, Treasury*

89. Portable altar and reliquary of St Andrew's Sandal, 977/93. *Trier Cathedral, Treasury*

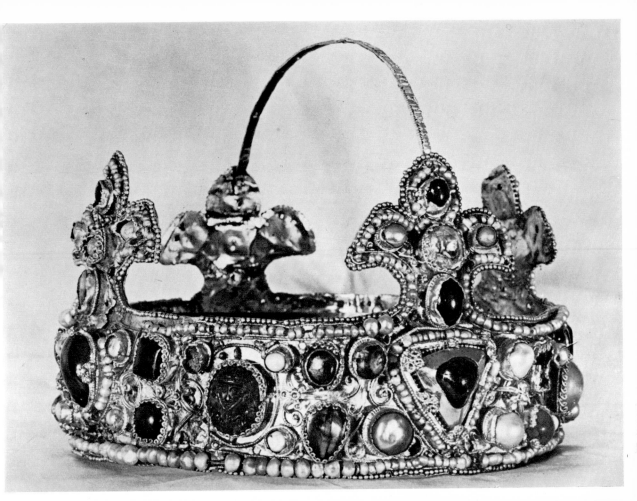

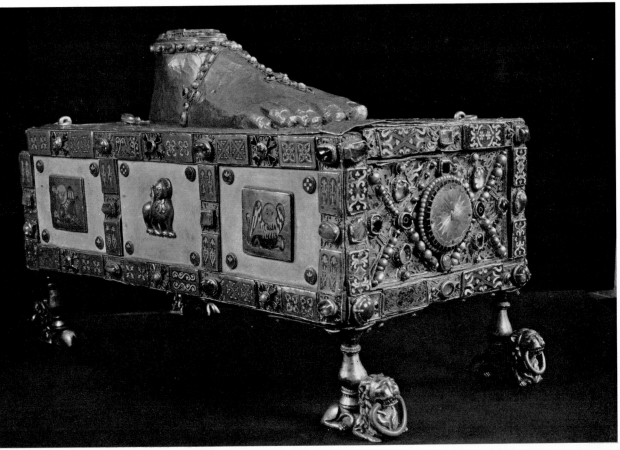

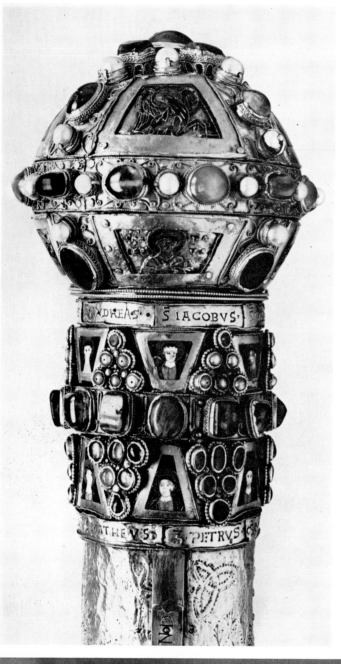

90. Staff-reliquary of St Peter (top), 988.
Limburg Cathedral, Treasury

91. Reliquary of the Holy Nail, 977/93.
Trier Cathedral, Treasury

92. Book-cover of the Codex Aureus from
Echternach, 983/91, with ivory
Crucifixion, 1053/6. *Nuremberg,
Germanisches National-Museum*

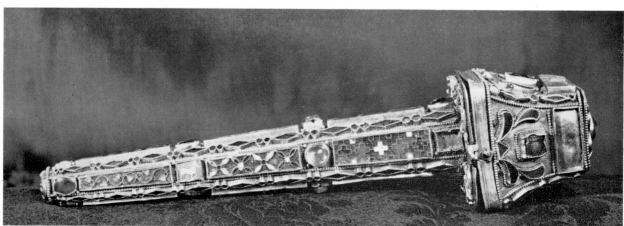

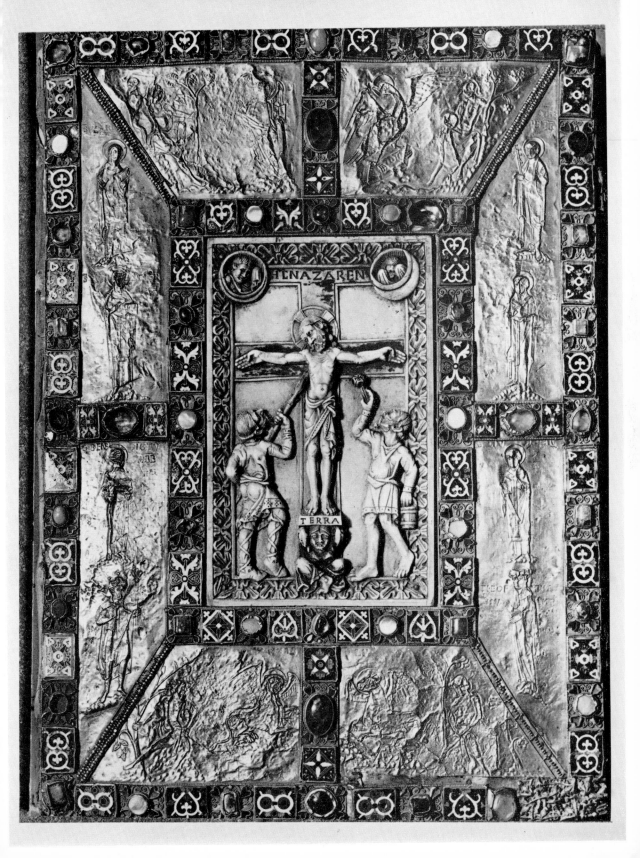

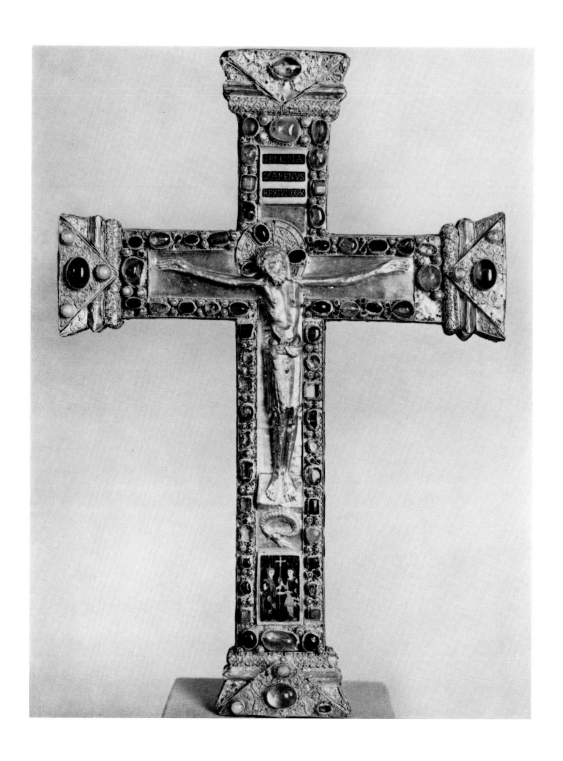

93. Altar cross of Abbess Mathilde and Duke Otto (front), 973/82. *Essen Minster, Treasury*

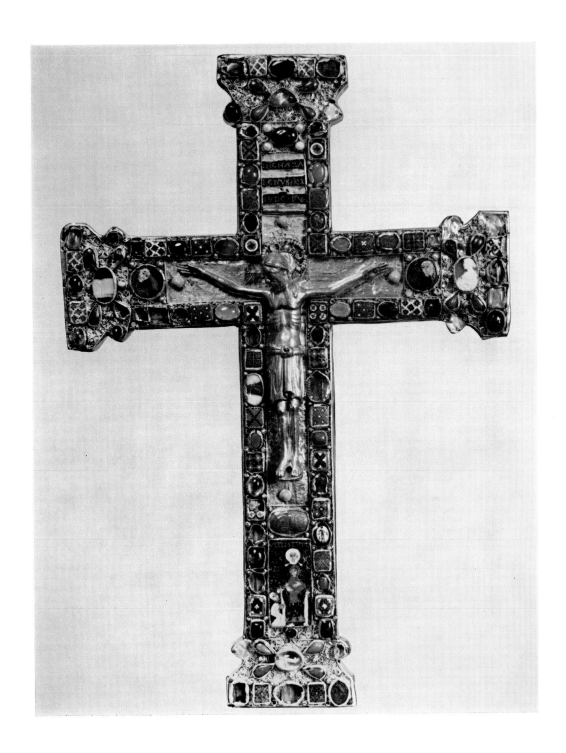

94. Altar cross of Abbess Mathilde (973/1011) (front), early eleventh century, corpus eleventh century (second half). *Essen Minster, Treasury*

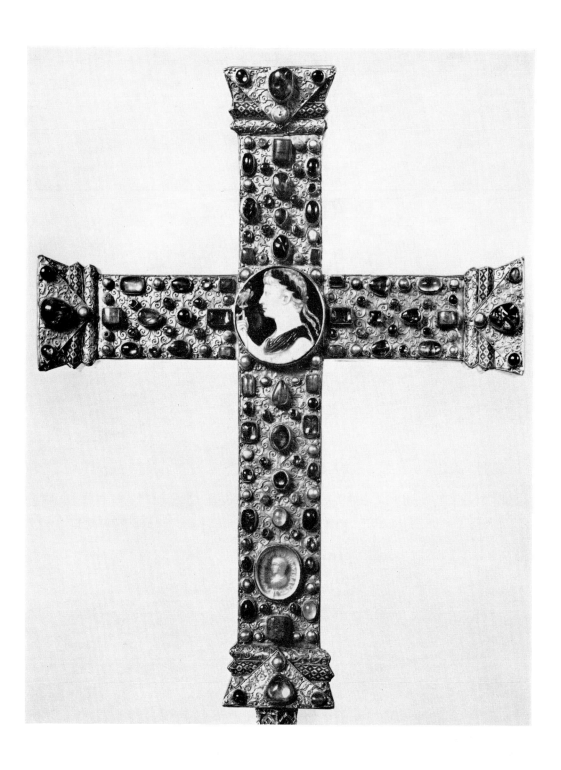

95. Lothar Cross, with central Antique cameo of Augustus and Carolingian crystal of Lothar, *c.* 985/91. *Aachen, Palace Chapel, Treasury*

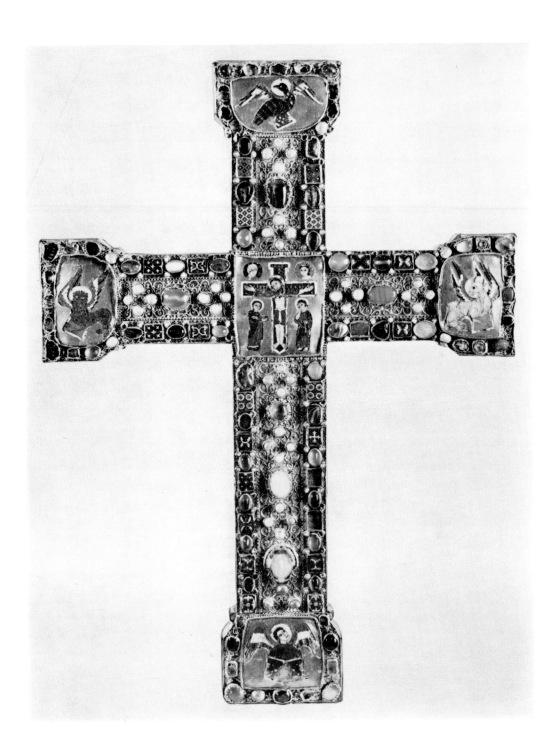

96. Altar cross, *c.* 985(?). *Essen Minster, Treasury*

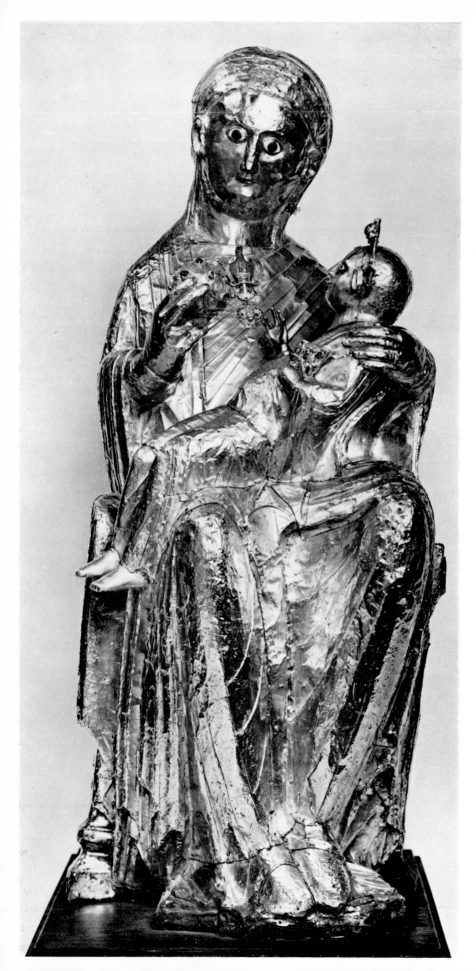

97. Golden Virgin and Child, *c.* 980. *Essen Minster*

98. Reliquary of St Faith (employing a Late Antique parade helmet for the head), mid tenth century and later additions. *Conques Abbey, Treasury*

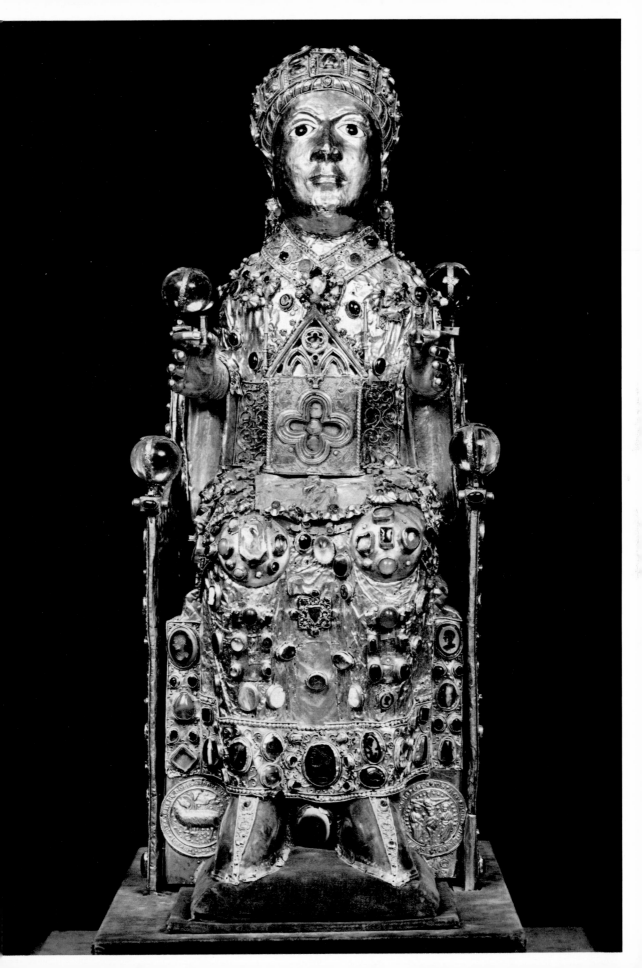

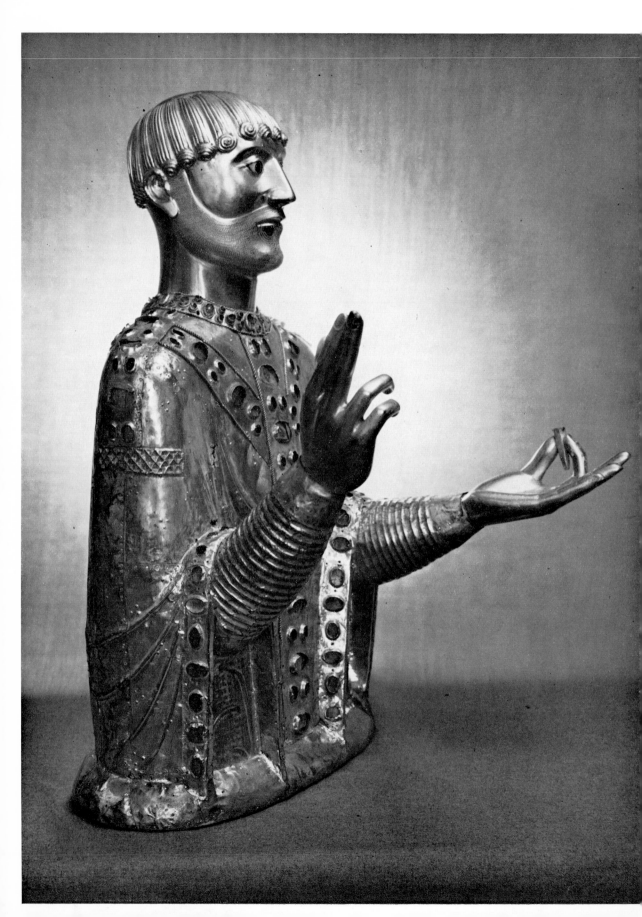

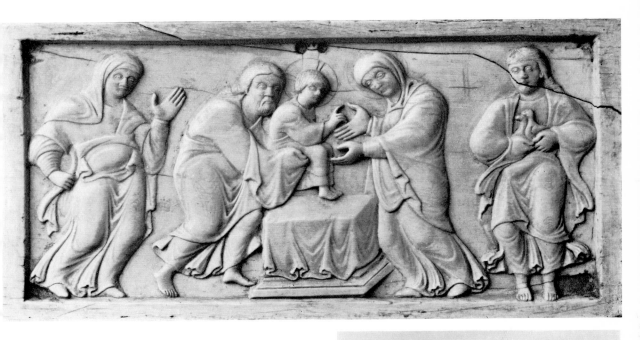

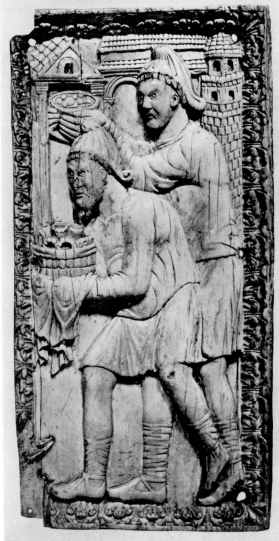

99. Reliquary-bust of St Baudime, tenth century (second half?) with twelfth-century restoration of the head and later hands. *Saint-Nectaire, parish church*

100. Presentation in the Temple. Ivory panel, *c.* 985/90. *Berlin, Staatliche Museen*

101. Two Magi. Ivory panel, *c.* 985/90. *London, British Museum*

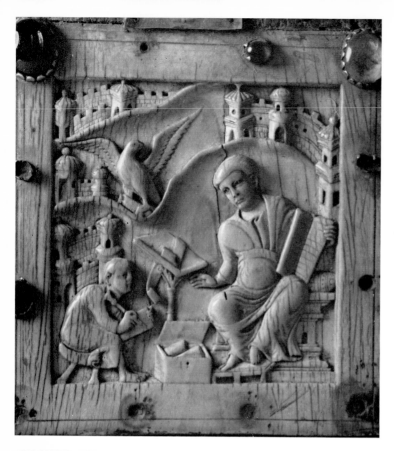

102. St John the Evangelist. Ivory panel, set with later gems, on a cover of a Gospel Book, *c.* 985/90. *Halberstadt Cathedral, Treasury*

103. Book-cover of the Gospels of Otto III, *c.* 1000; central ivory with Dormition of the Virgin Byzantine, tenth century. *Munich, Bayerische Staatsbibliothek*

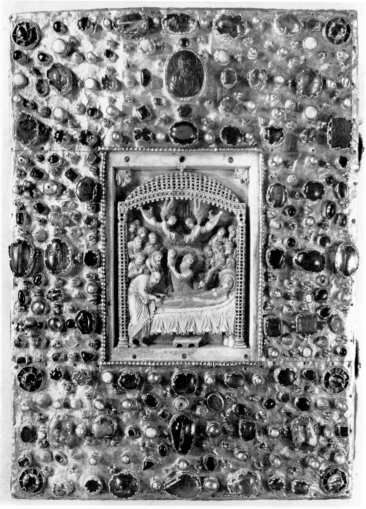

104. St Gregory. Ivory panel, *c.* 990/1000. *Vienna, Kunsthistorisches Museum*

105. Celebration of the Mass. Ivory panel on the cover of a Lectionary, *c.* 990/1000. *Frankfurt, Stadtbibliothek*

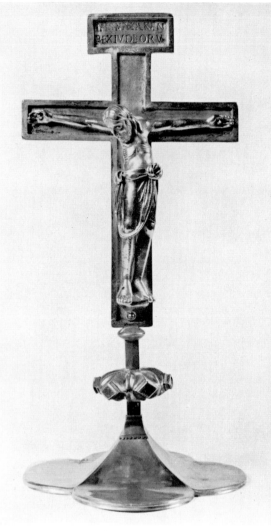

106. Silver crozier head of Abbot Erkanbaldus of Fulda (997–1011), *c. 996*. *Hildesheim Cathedral, Treasury*

107. Silver crucifix of Bishop Bernward (front), 1007/8, foot fourteenth-century. *Hildesheim Cathedral, Treasury*

108. Silver candlestick of Bishop Bernward, one of a pair, with two details, *c. 996/1000*. *Hildesheim, St Magdalen*

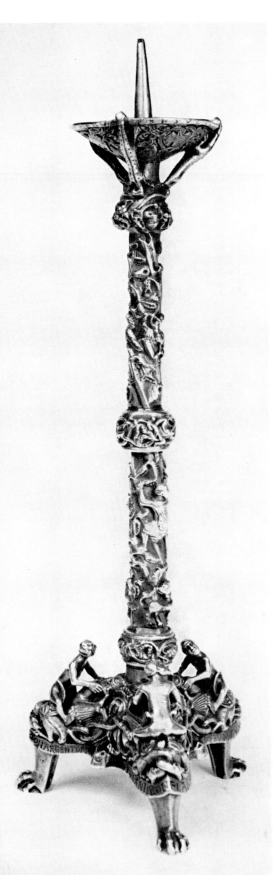
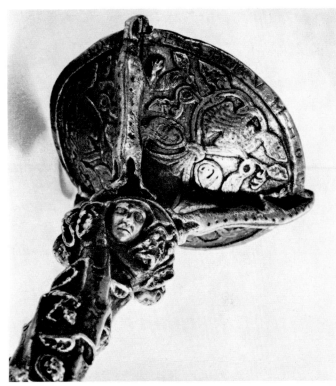
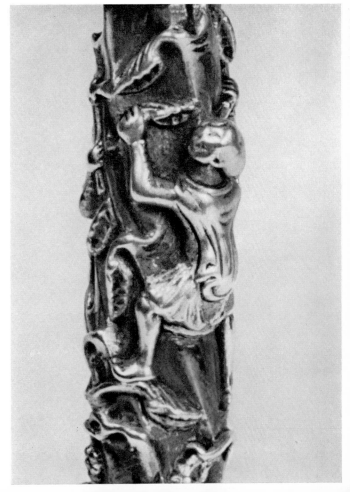

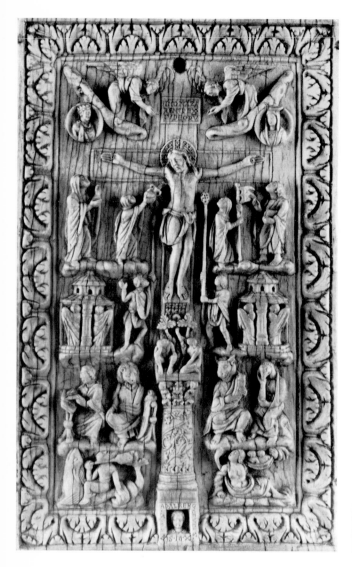

109. Crucifixion. Ivory panel of Bishop Adalbero, 984/1005. *Metz, Museum*

110. 'Aquilo', detail from the foot of the seven-armed candelabrum, early eleventh century. *Essen Minster*

111. Bronze doors from St Michael's, 1015. *Hildesheim Cathedral*

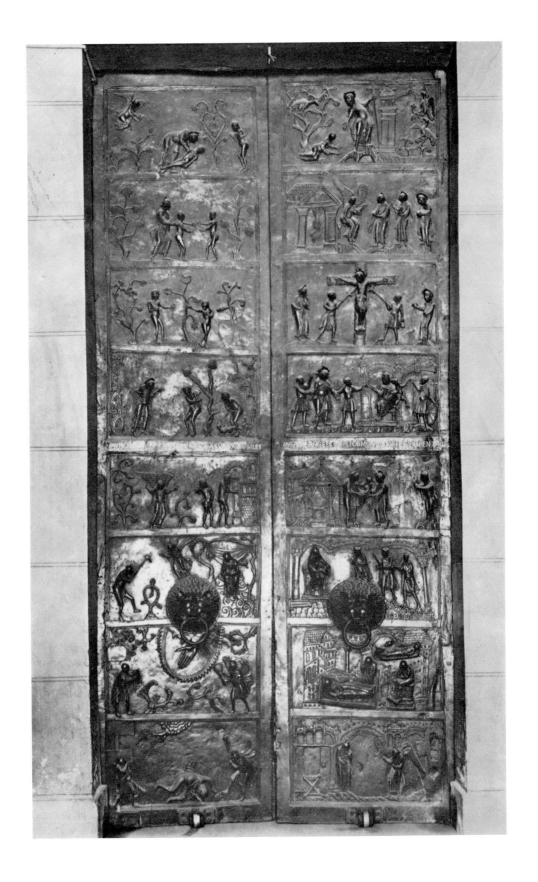

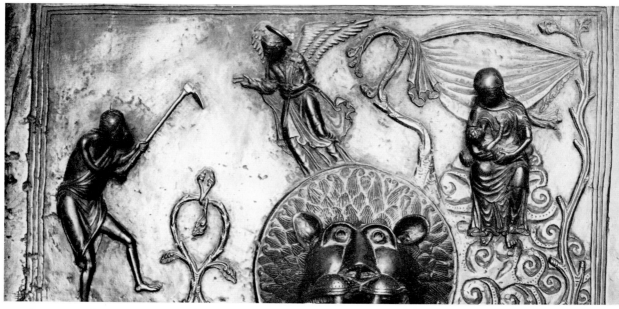

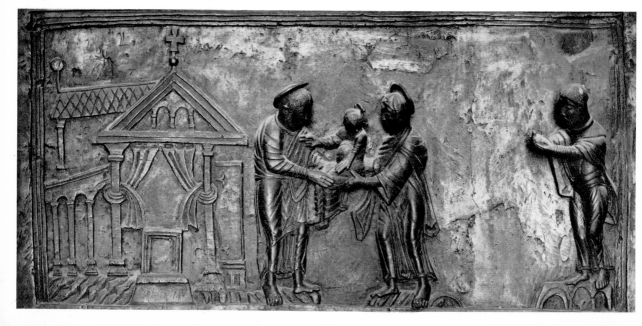

112. Creation of Adam, detail of the bronze doors. *Hildesheim Cathedral*

113. Labours of Adam and Eve, detail of the bronze doors. *Hildesheim Cathedral*

114. Presentation in the Temple, detail of the bronze doors. *Hildesheim Cathedral*

115. Marriage at Cana. Ivory panel, *c.* 1000, in a fourteenth-century silver gilt frame. *Cleveland Museum of Art*

116. Marriage at Cana. Ivory panel, *c.* 820/30. *London, British Museum*

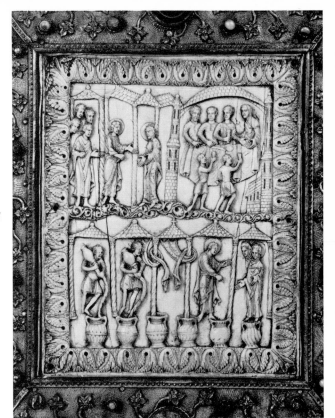

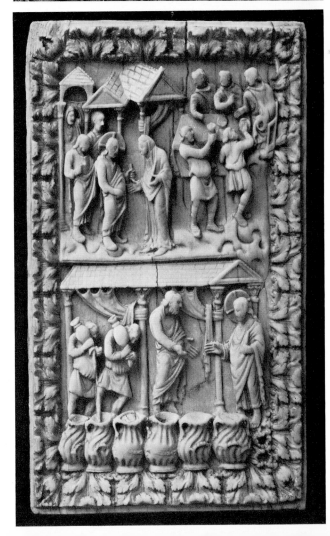

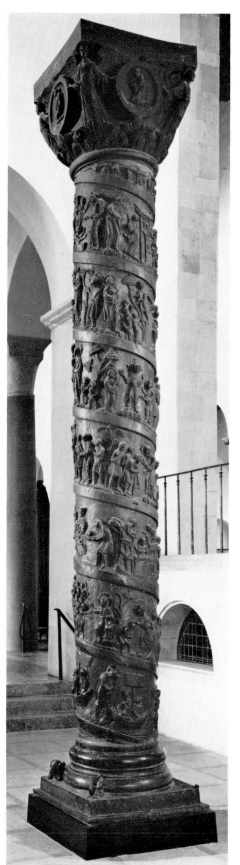
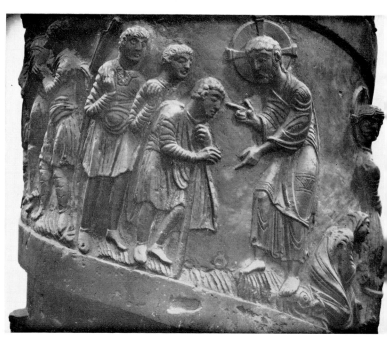

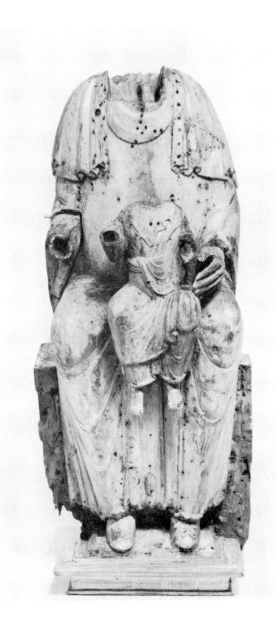
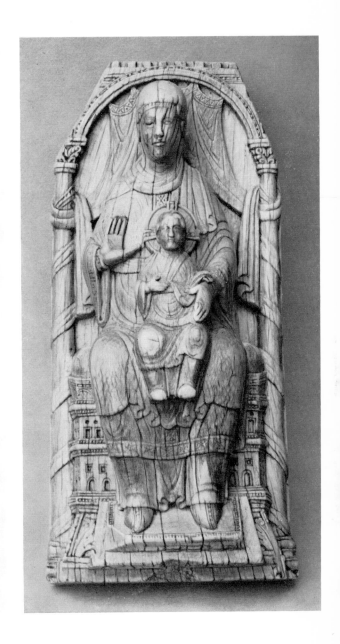

117. Scenes from the life of Christ. Bronze column, *c.* 1000/10(?). *Hildesheim Cathedral*

118. Healing of the Blind Man, detail of the bronze column. *Hildesheim Cathedral*

119. River of Paradise, detail of the base of the bronze column. *Hildesheim Cathedral*

120. Virgin and Child. *c.* 1010. *Hildesheim Cathedral, Treasury*

121. Virgin and Child. *c.* 1010. *Mainz, Altertumsmuseum*

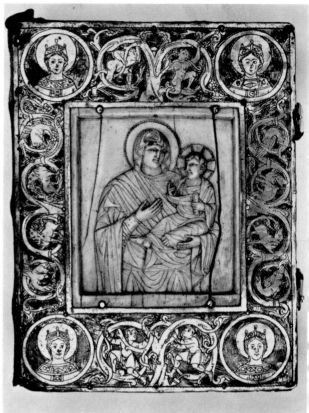

122. Deesis. Book-cover of Bishop Bernward's 'Precious Gospels' (front), *c.* 1000/10 and later additions; central ivory Byzantine, late tenth century. *Hildesheim Cathedral, Treasury*

123. Book-cover of the Sacramentary of Abbot Erkanbald of Fulda (997–1011), *c.* 1000; central ivory of the Virgin and Child Byzantine, late tenth century. *Bamberg, Staatliche Bibliothek*

124. Book-cover of a Gospel Book, *c.* 1000–10. *Munich, Bayerische Nationalbibliothek*

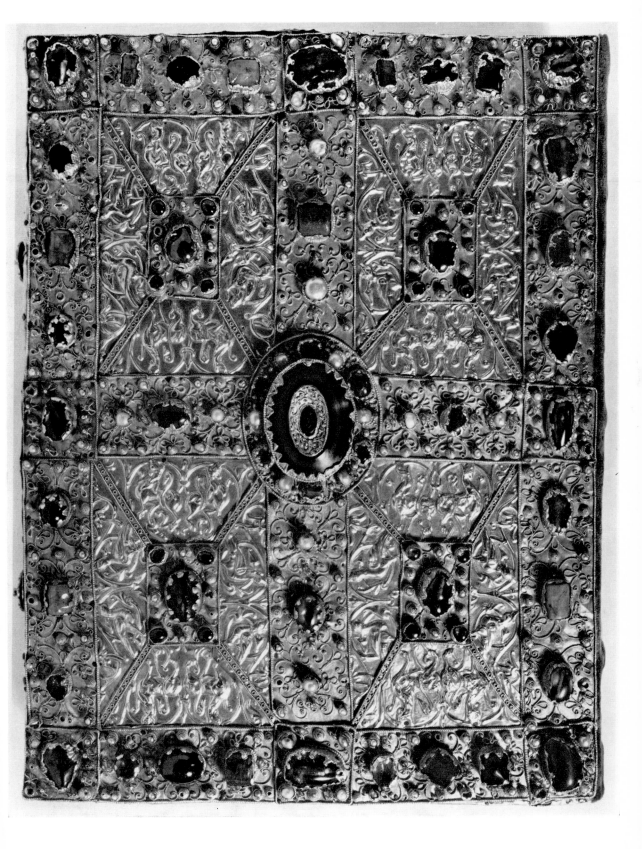

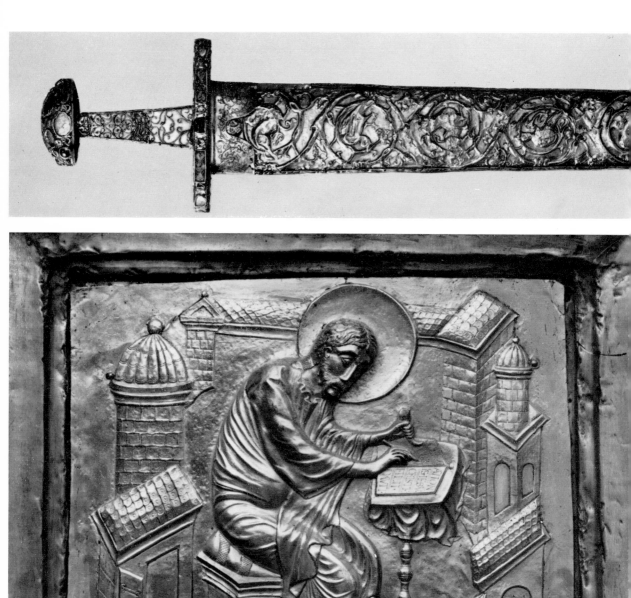

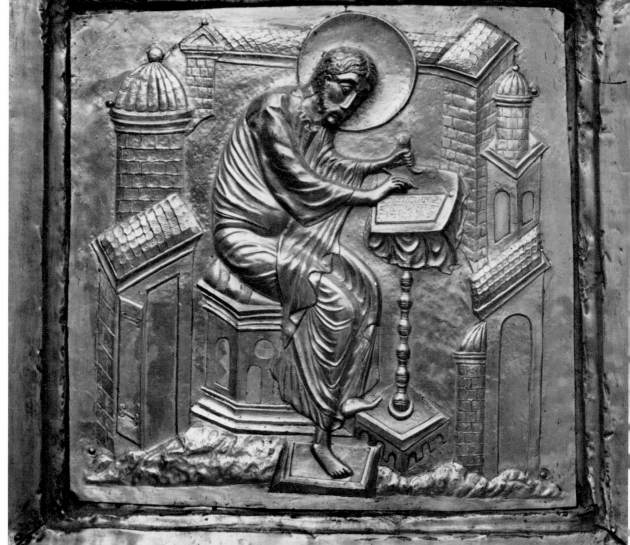

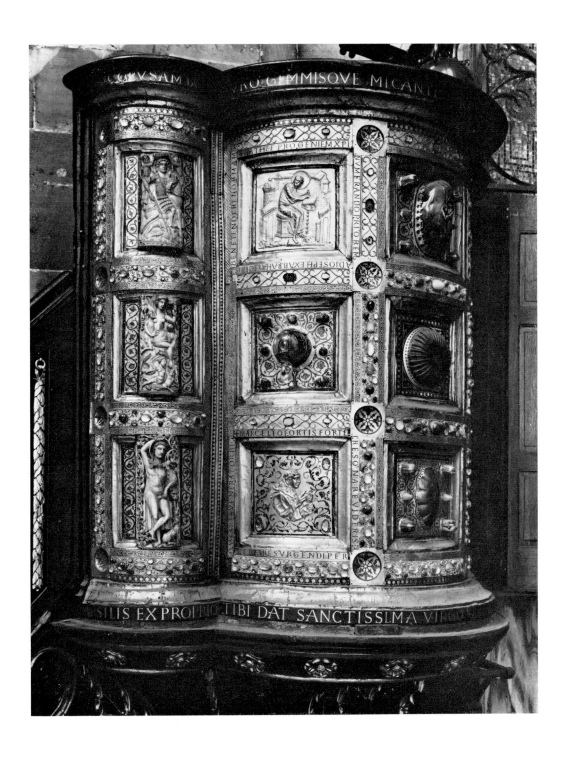

125. Sword (detail), *c.* 1000, later additions at the top of the scabbard. *Essen Minster, Treasury*

126. St Matthew, detail of the pulpit of Henry II, *c.* 1002/14. *Aachen, Palace Chapel*

127. Pulpit of Henry II, *c.* 1002/14. *Aachen, Palace Chapel*

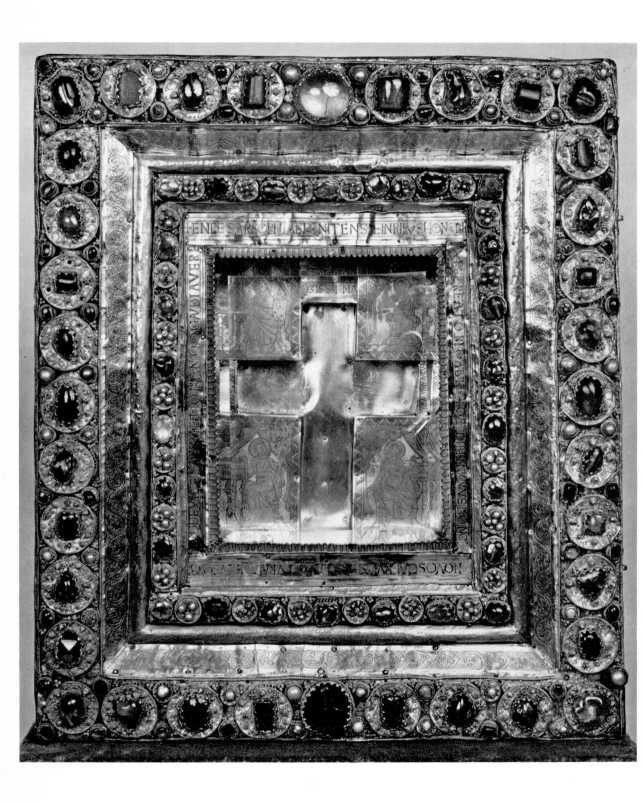

128. Portable altar of the Holy Cross (front), *c.* 1015/20. *Munich, Residenz, Treasury*

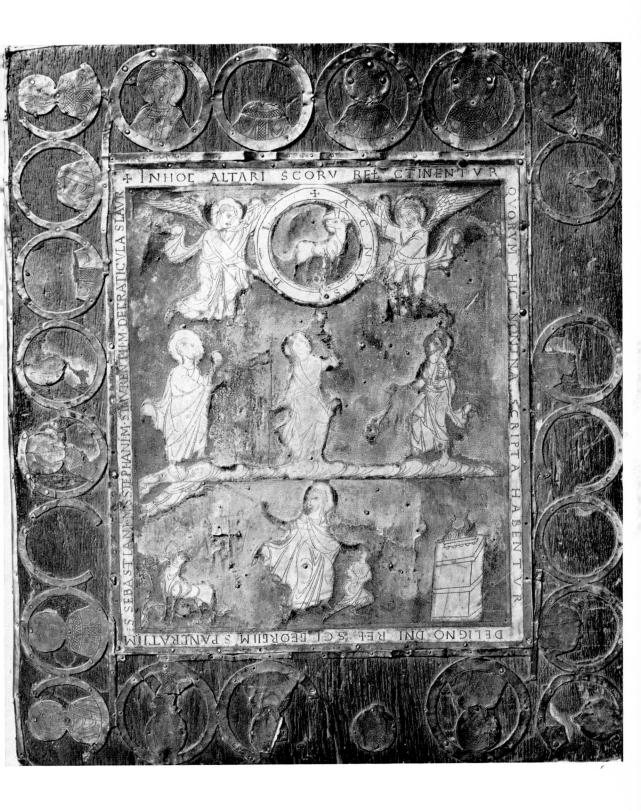

129. Portable altar of the Holy Cross (back), *c.* 1015/20. *Munich, Residenz, Treasury*

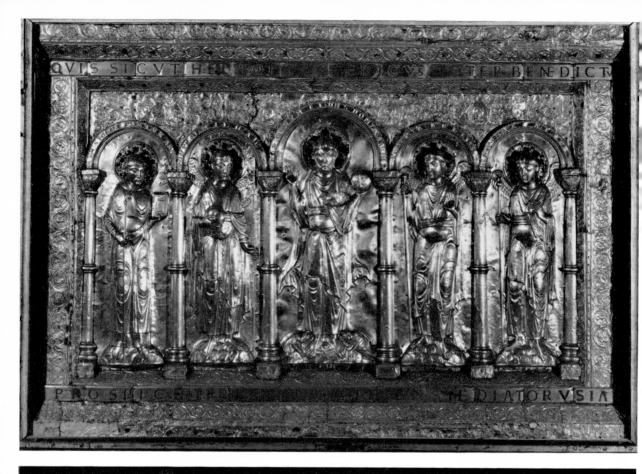

QVIS SICVT HERMAN... FELICVS ...TER BENEDICTV

PRO SPE CSAT... M... DIATOR VSIA

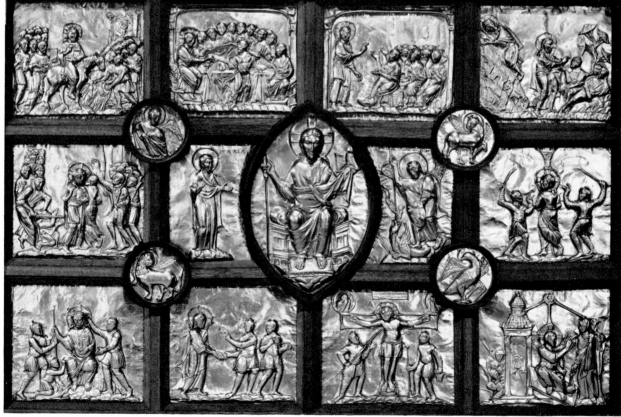

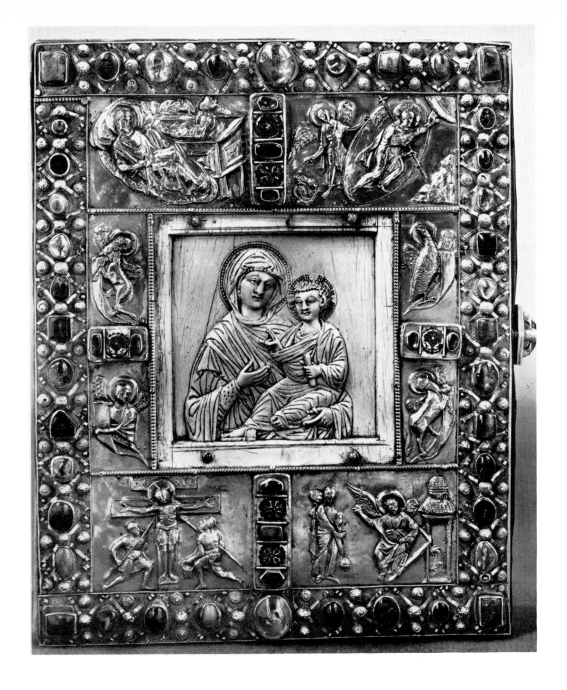

130. Christ between Gabriel and Raphael and St Michael and St Benedict. Golden altar frontal of Basel Cathedral, 1022/4(?). *Paris, Musée de Cluny*

131. Christ in Majesty and scenes from the life of Christ. Golden altar frontal, *c.* 1020. *Aachen, Palace Chapel*

132. Book-cover of the Carolingian Aachen Gospels, *c.* 1020; central ivory of the Virgin and Child Byzantine, late tenth century. *Aachen, Palace Chapel, Treasury*

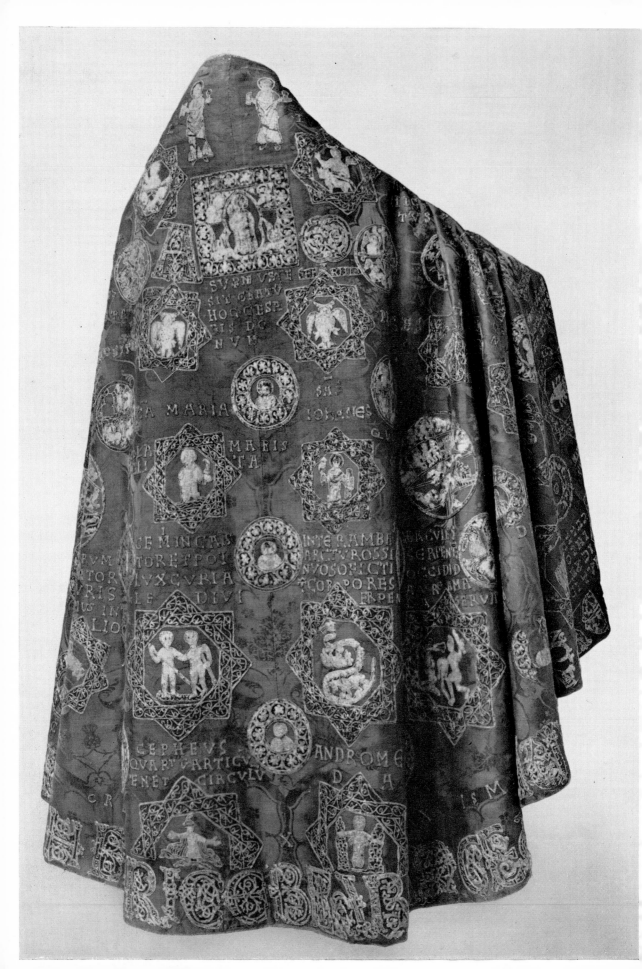

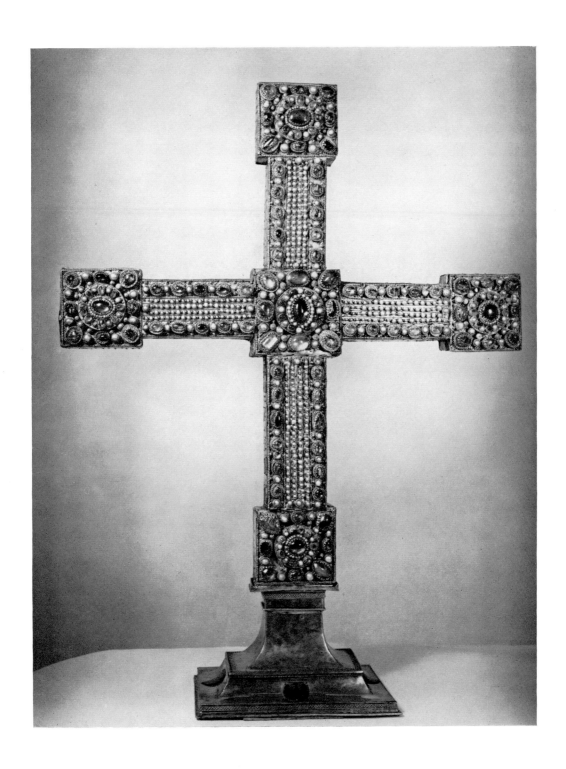

133. 'Sternenmantel' of Henry II, c. 1020. *Bamberg Cathedral, Treasury*

134. Imperial altar cross (front), c. 1023/30, foot fourteenth century. *Vienna, Weltliche und Geistliche Schatzkammer*

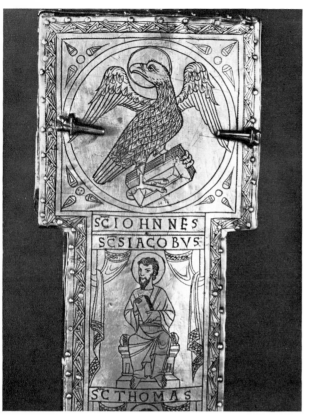

135. Imperial altar cross (detail of back), c. 1023/30. *Vienna, Weltliche und Geistliche Schatzkammer*

136. Portable altar of Svanhild, c. 1050/75. *Melk, Stiftskirche*

137. Altar cross of Queen Gisela, c. 1006. *Munich, Residenz, Treasury*

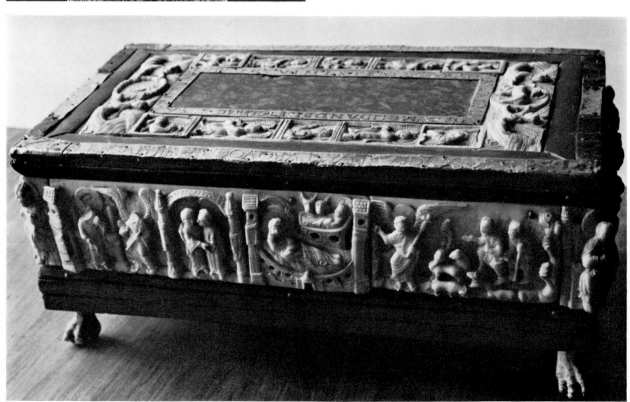

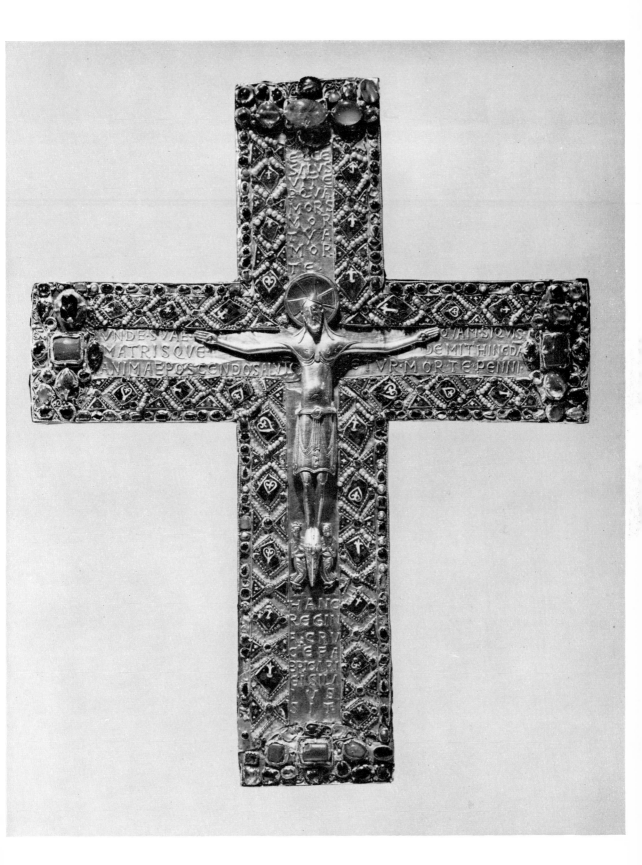

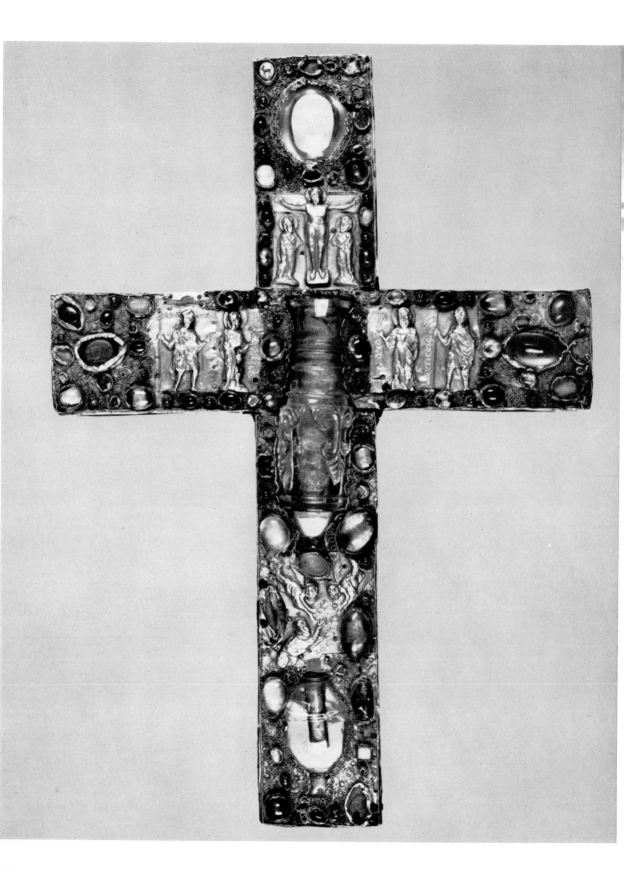

138. Altar cross, *c.* 1024/39; in the centre a Fatimid crystal, tenth century. *Borghorst, St Nicomedes*

139. Altar cross of Abbess Theophanu (1039–56), *c.* 1040 and later additions. *Essen Minster, Treasury*

140. Portable altar of Gertrude, *c.* 1030. *Cleveland Museum of Art*

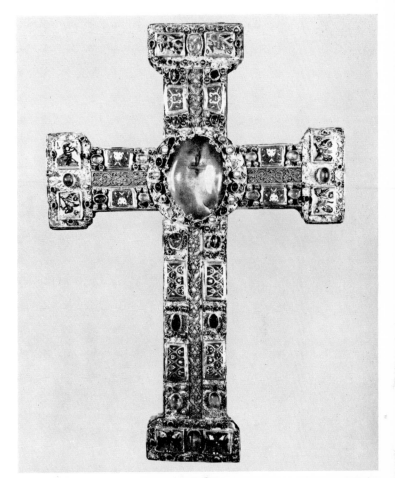

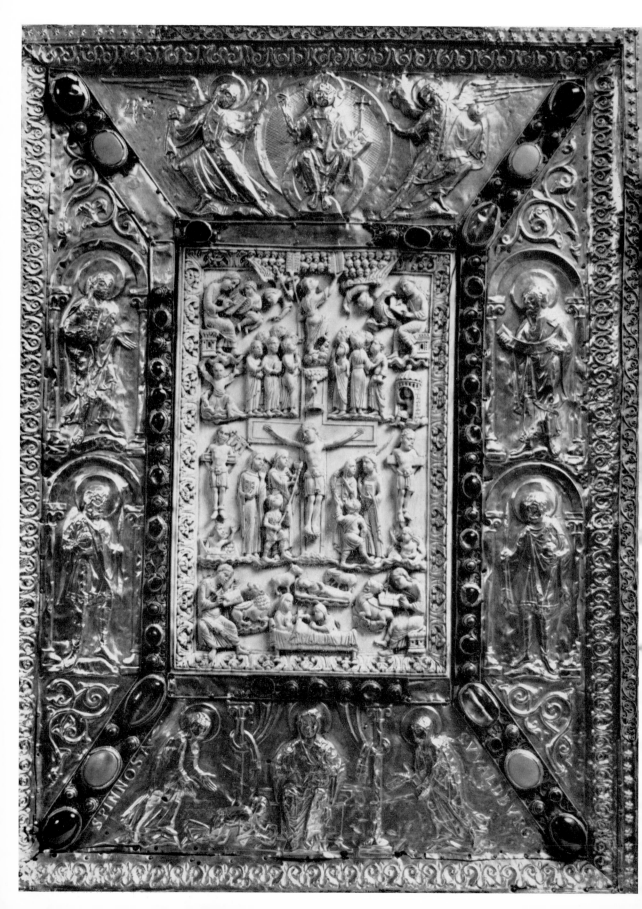

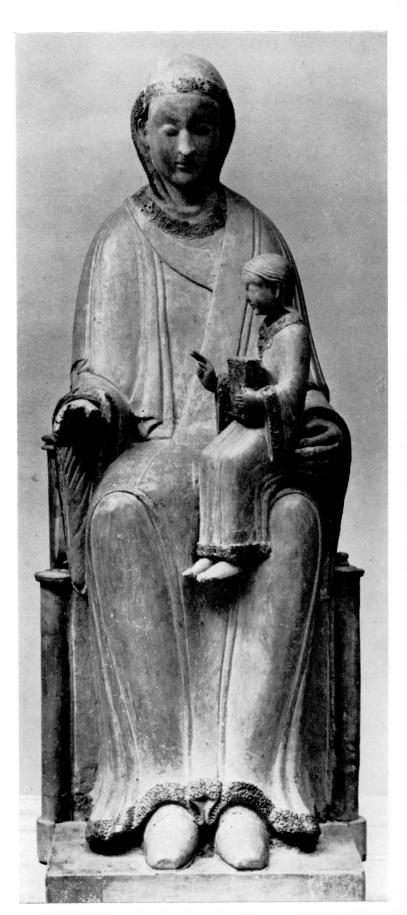

141. Book-cover of Abbess
Theophanu (1039–56), c. 1050. *Essen
Minster, Treasury*

142. Virgin and Child of Bishop
Imad of Paderborn (1051–76),
c. 1060 with later restorations.
Paderborn, Diözesan Museum

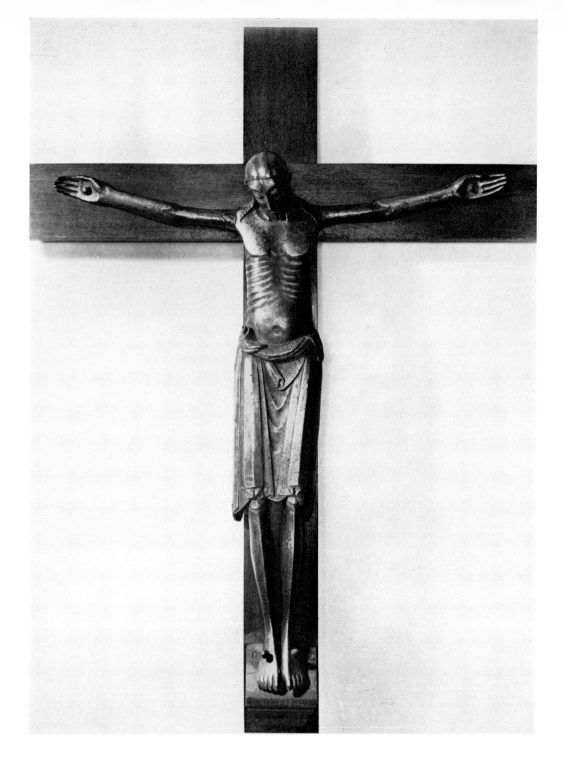

143. Bronze crucifix from Helmstedt, late eleventh century. *Essen-Werden, St Liudger*

144. Presentation and Baptism. Detail from the painted wooden doors, installed in 1049 or 1065(?). *Cologne, St Maria im Kapitol*

145. 'Krodo Altar', late eleventh century. *Goslar, Museum*

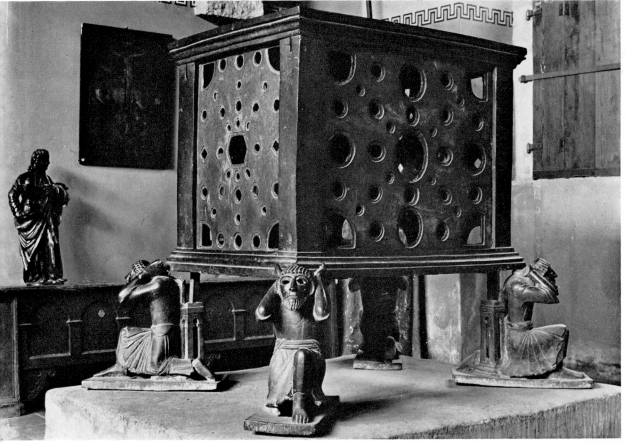

146. Healing of the Blind Man and the Three Maries at the Tomb. Ivory panel from the antependium, *c.* 1084. *Salerno Cathedral*

147. St Peter and St Mark. Ivory panel, late eleventh century(?). *London, Victoria and Albert Museum*

148. St Menas between camels. Ivory panel, *c.* 600(?). *Milan, Museo d'Arte Antica*

149. St Menas(?). Ivory panel, late eleventh century(?). *Paris, Musée de Cluny*

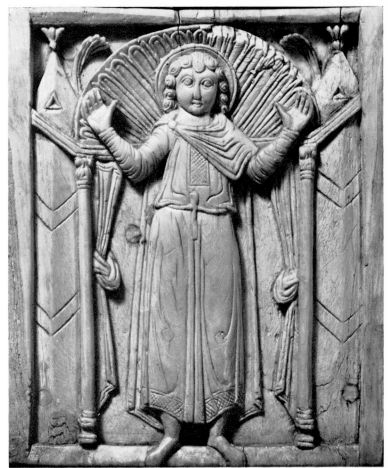

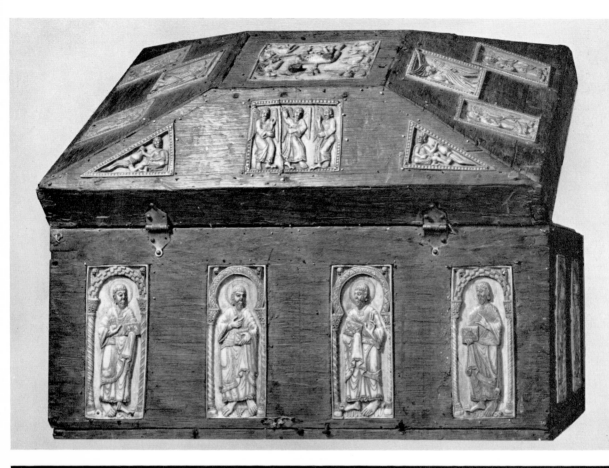

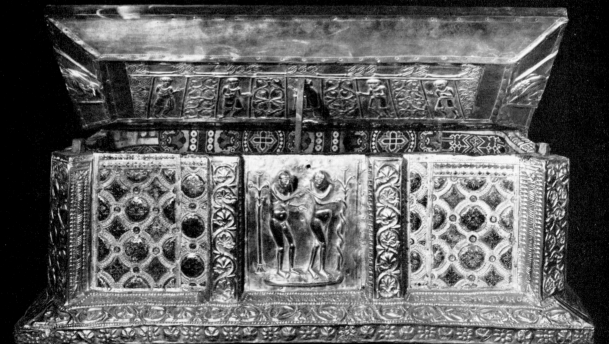

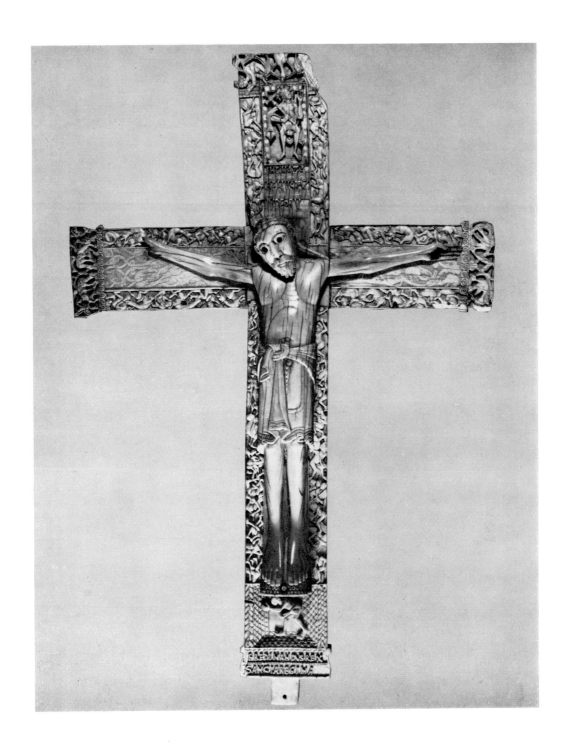

150. Reliquary casket of St John the Baptist and St Pelagius, given in 1059. *León, San Isidoro*

151. Shrine of St Isidore, given in 1063, with later additions. *León, San Isidoro*

152. Altar cross of King Fernando and Queen Sancha (front), given in 1063. *Madrid, Museo Arqueológico Nacional*

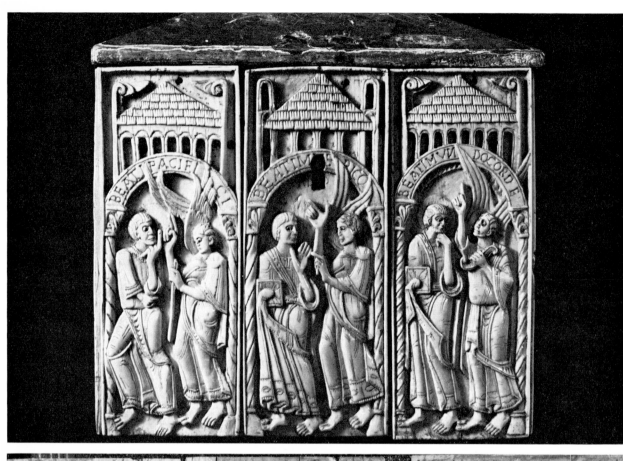

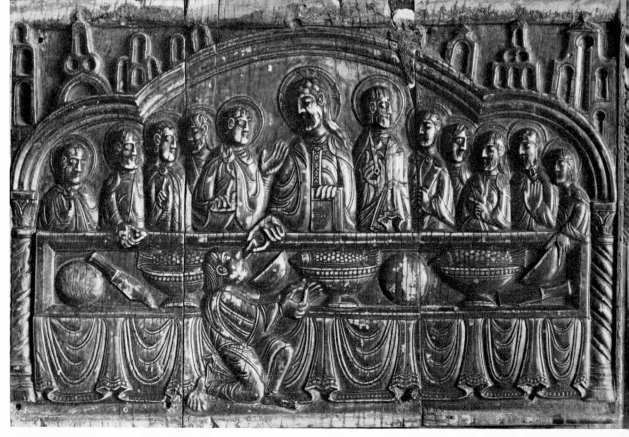

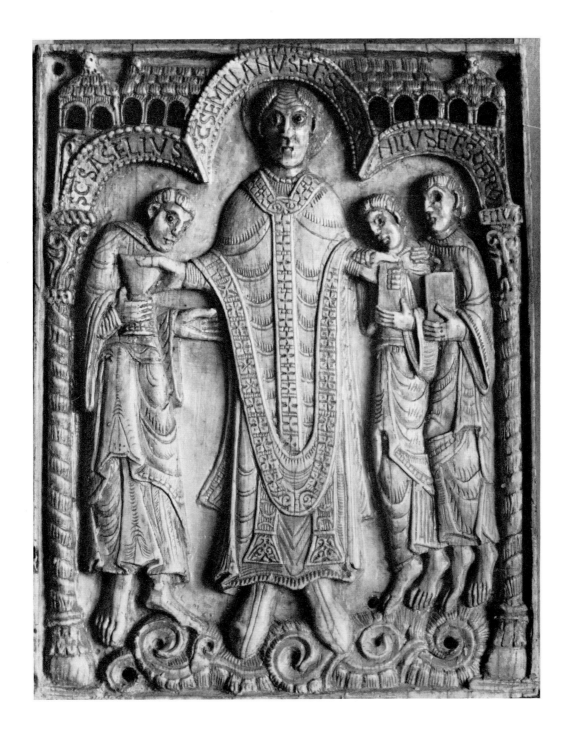

153. Beatitudes. Ivory, on wooden casket, c. 1063. *Madrid, Museo Arqueológico Nacional*

154. Last Supper. Ivory panel from the shrine of St Felix, late eleventh century. *San Millán de la Cogolla Abbey*

155. St Millán between saints. Ivory panel from the reliquary of St Millán, c. 1070/80(?). *San Millán de la Cogolla Abbey*

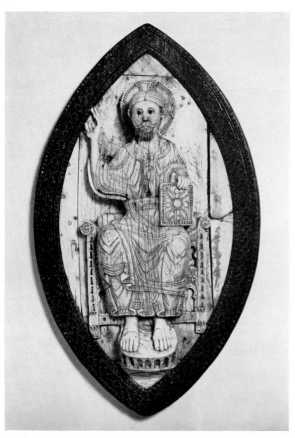

156. Christ in Majesty. Ivory panel from the reliquary of St Millán, *c.* 1070/80(?). *Washington, D.C., Dunbarton Oaks*

157. Christ in Majesty with angels and apostles. Arca Santa (front), 1075. *Oviedo Cathedral, Treasury*

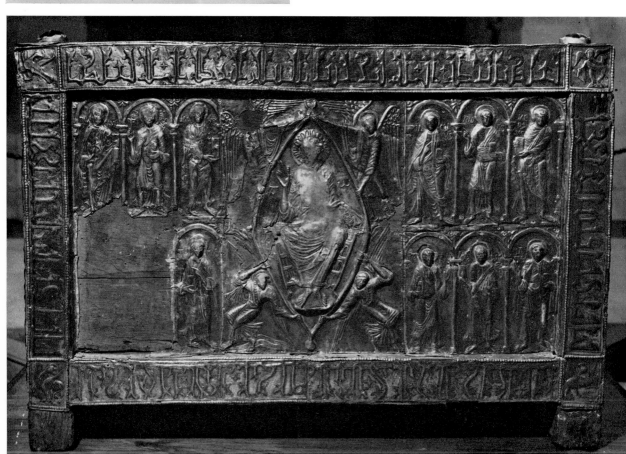

158. Enamelled roundel from the reliquary chest of Abbot Boniface, 1107/18. *Conques Abbey, Treasury*

159. Road to Emmaus and Noli me tangere. Ivory panel, late eleventh century. *New York, Metropolitan Museum of Art*

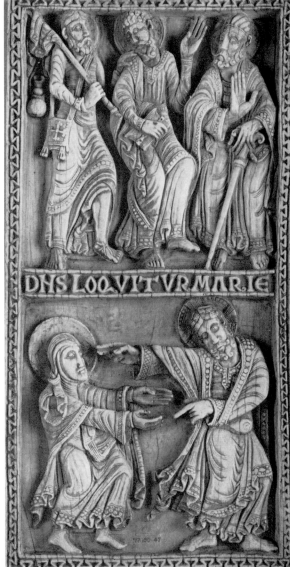

160. Portable altar of
Bégon III, 1100.
*Conques Abbey,
Treasury*

161. Roger of
Helmarshausen:
Portable altar of
Henry of Werl,
bishop of Paderborn
(1084–1127), 1100
with later additions.
*Paderborn Cathedral,
Treasury*

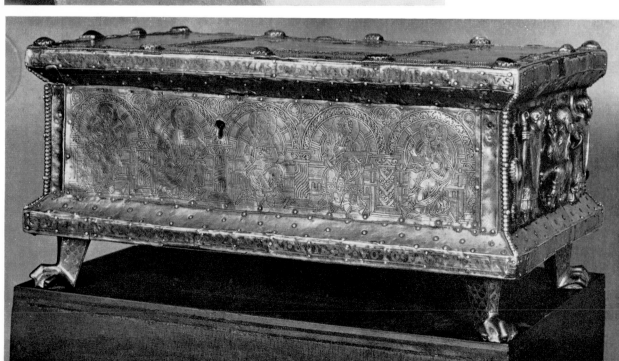

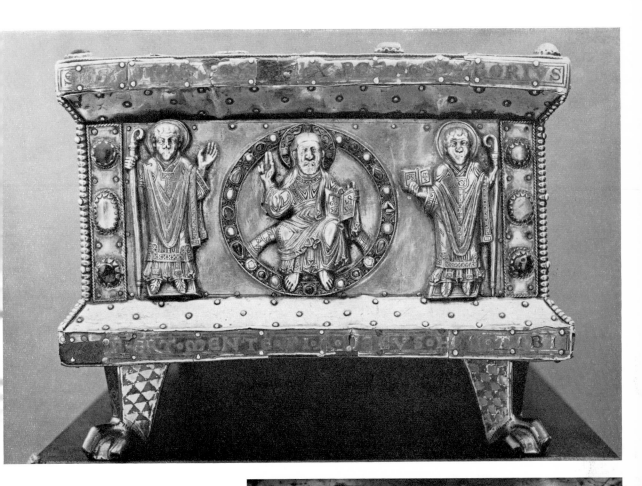

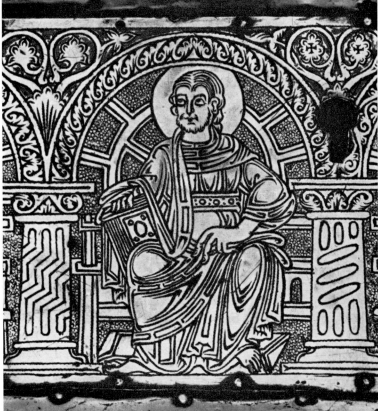

162. Roger of Helmarshausen:
Christ in Majesty between St
Kilian and St Liborius, and
St Philip, details of Bishop Werl's
portable altar, 1100 with later
additions. *Paderborn Cathedral,
Treasury*

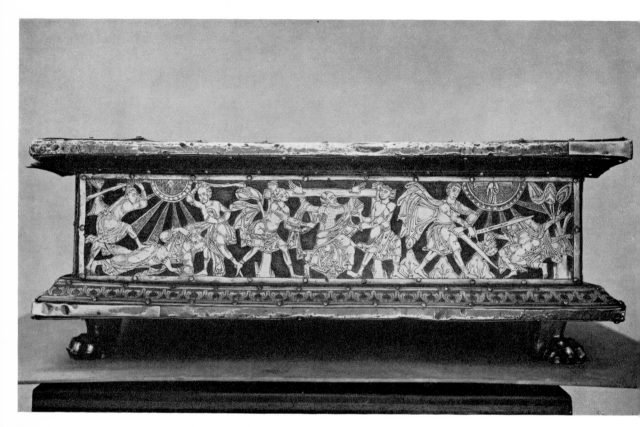

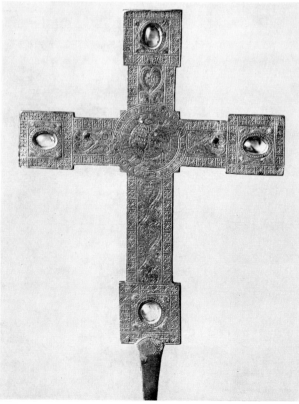

163. Roger of Helmarshausen: Martyrdom of St Blaise. Portable altar from Abdinghof Abbey, before 1100 or 1107(?). *Paderborn, Franciscan church*

164. Roger of Helmarshausen(?): Altar cross (back), *c.* 1100/10. *Frankfurt, Museum für Kunsthandwerk*

165. Roger of Helmarshausen(?): Altar cross of St Modoaldus (back), *c.* 1107. *Cologne, Schnütgen Museum*

166. Enger reliquary cross (front), late eleventh century, central crystal Carolingian. *Berlin, Staatliche Museen*

167. Enger reliquary cross (back), late eleventh century. *Berlin, Staatliche Museen*

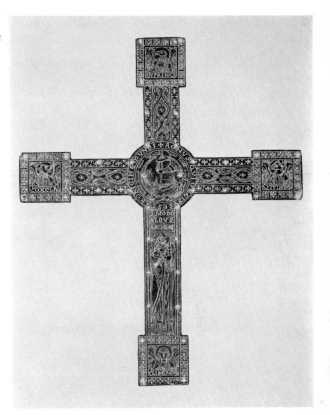

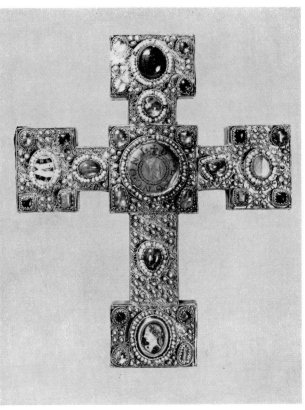

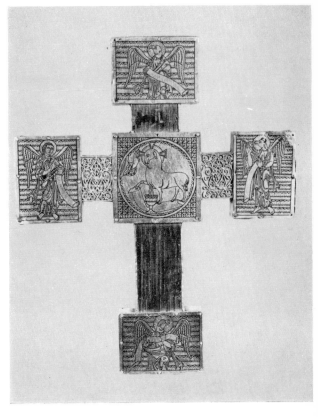

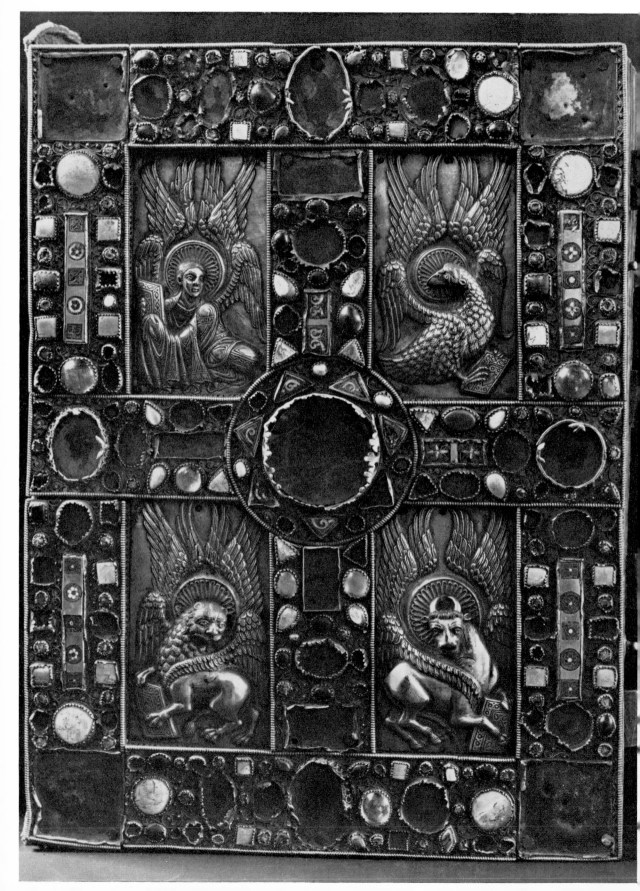

168. Roger of Helmarshausen: Book-cover of a Gospels from Helmarshausen, *c.* 1100. *Trier Cathedral, Library*

169. Rainer of Huy: Baptism of Christ. Font from Notre-Dame-aux-Fonts, 1107/18. *Liège, Saint-Barthélémy*

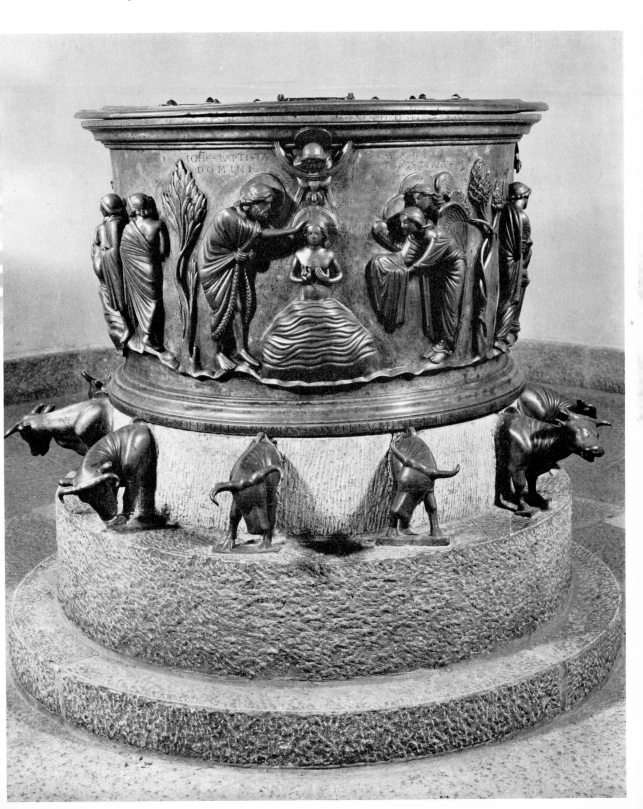

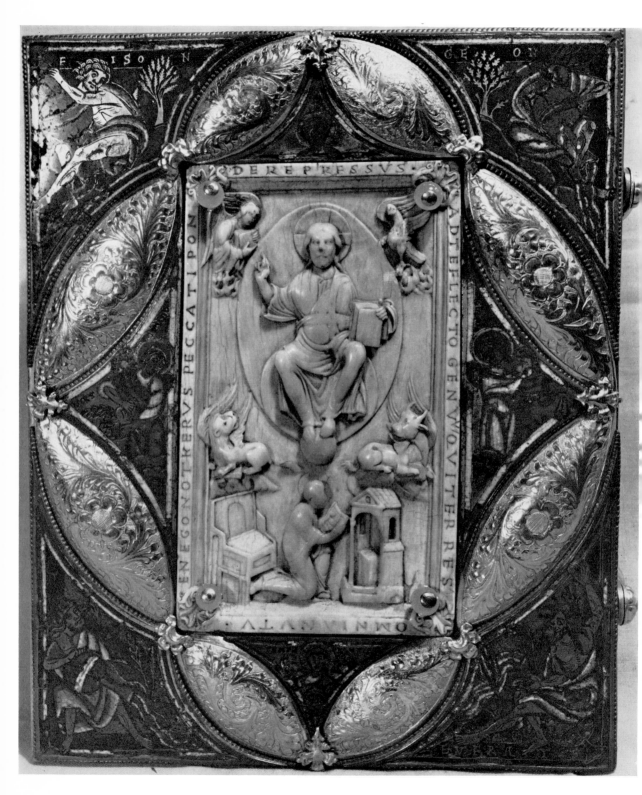

170. Book-cover of the Gospels of Bishop Notger of Liège (971–1008), ivory 1101/7(?), enamels *c.* 1150. *Liège, Musée Curtius*

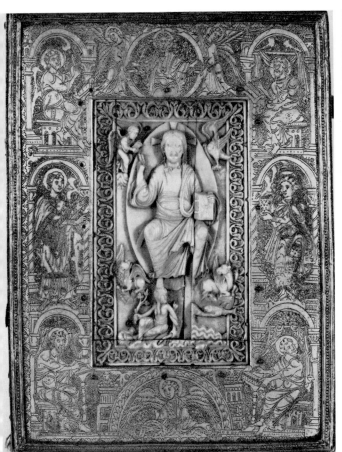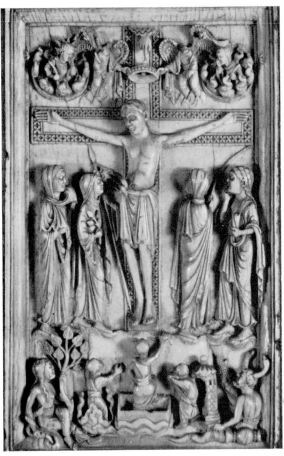

171. Book-cover of a Gospel Book, *c.* 1050/60. *Oxford, Bodleian Library*

172. Crucifixion. Ivory panel mounted on the cover of a Gospel Book, eleventh century (last quarter). *Tongeren (Tongres), Notre-Dame*

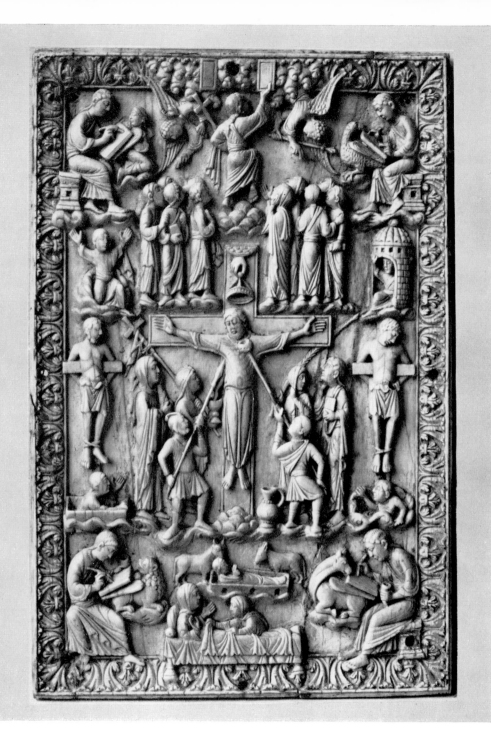

173. Crucifixion. Ivory panel, *c.* 1050. *Brussels, Musées Royaux*

174. King. Ivory panel from a portable altar(?), late eleventh century. *London, British Museum*

175. Reliquary cross (front), late eleventh century. *Dublin, Hunt Collection*

176. Altar cross of Queen Gunhild, before 1076. *Copenhagen, Nationalmuseet*

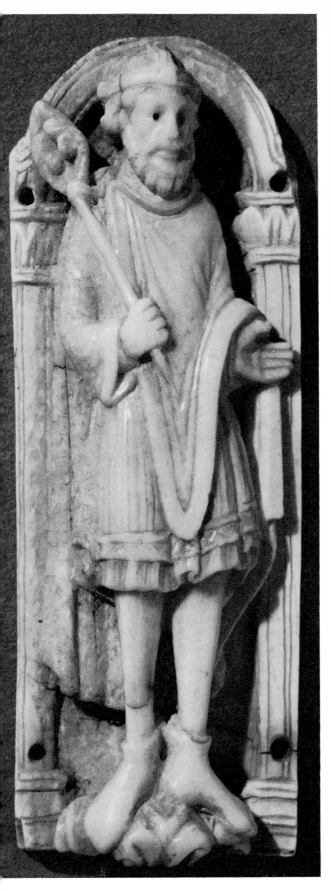
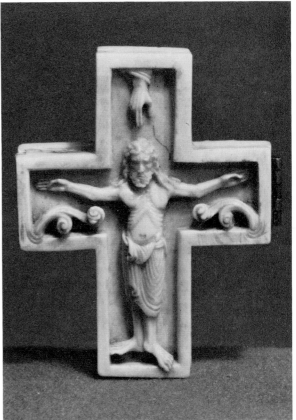
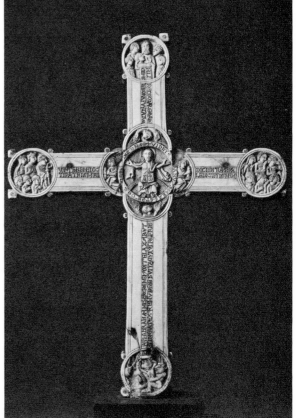

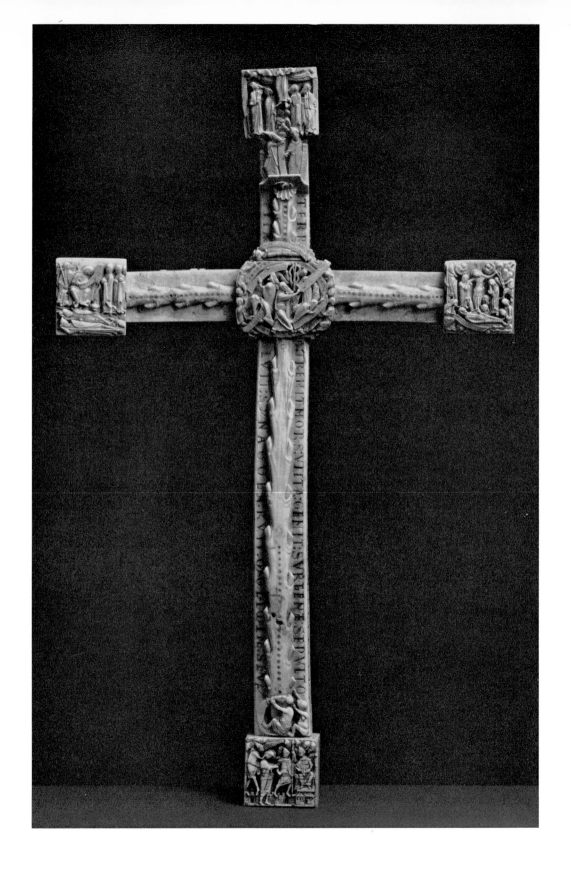

177. Altar cross (front), *c.* 1100/30(?). *New York, Metropolitan Museum of Art*

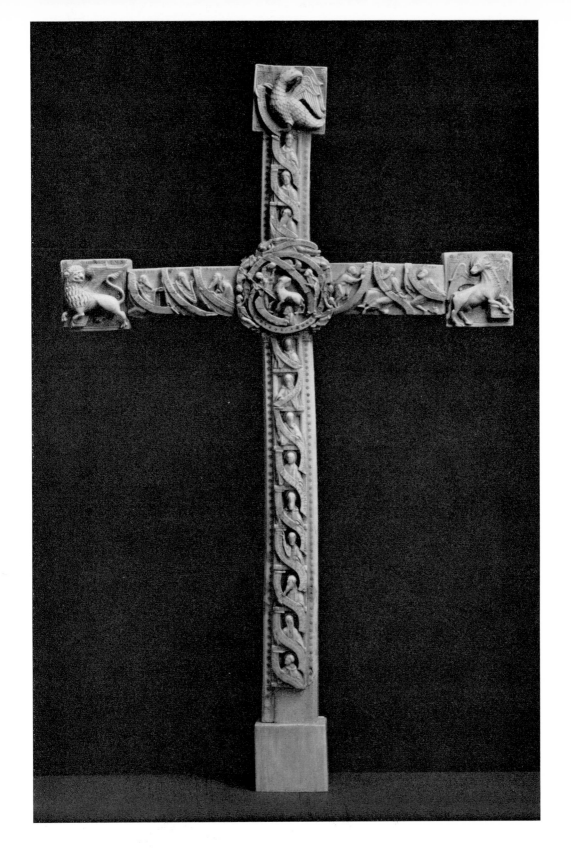

178. Altar cross (back), *c.* 1100/30(?). *New York, Metropolitan Museum of Art*

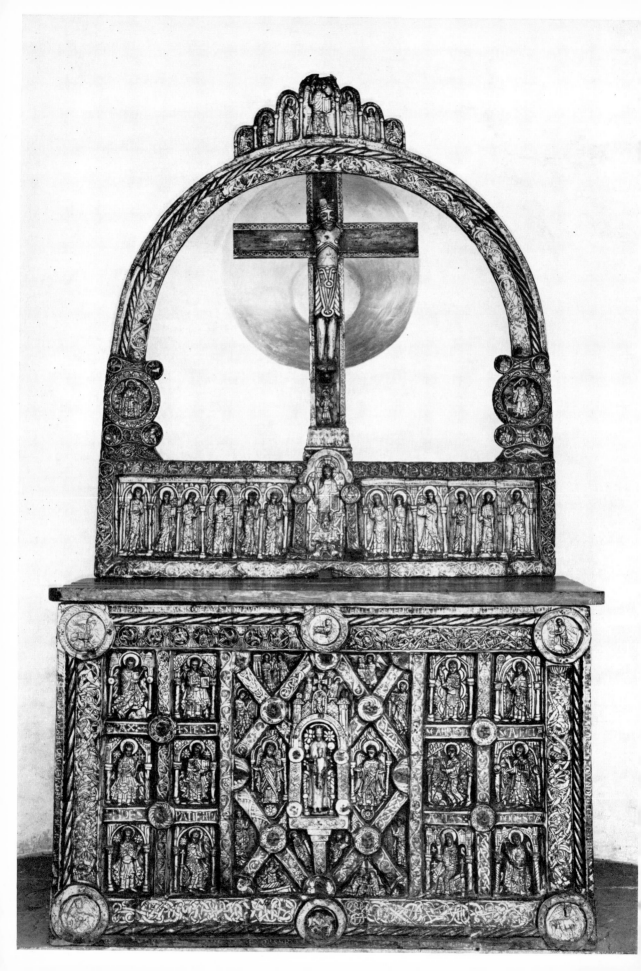

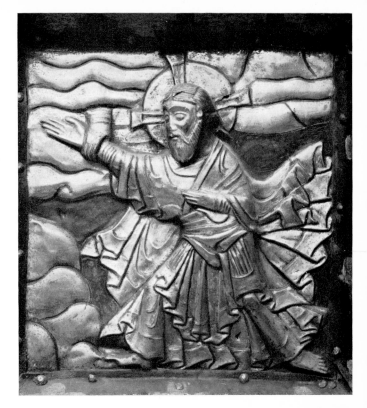

179. Altar frontal and retable from Lisbjerg, bronze gilt and *émail brun c.* 1140, crucifix *c.* 1100. *Copenhagen, Nationalmuseet*

180. Christ. Detail of the altar frontal from Broddetorp, *c.* 1150. *Stockholm, Statens Historiska Museet*

181. Crucifixion. Ivory panel mounted on the back cover of a Gospel Book from St Gereon, Cologne, *c.* 1130/40. *Darmstadt, Hessisches Landesmuseum*

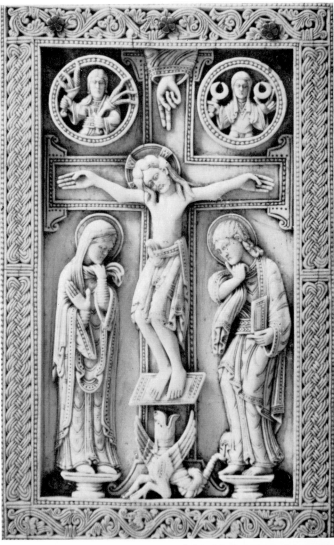

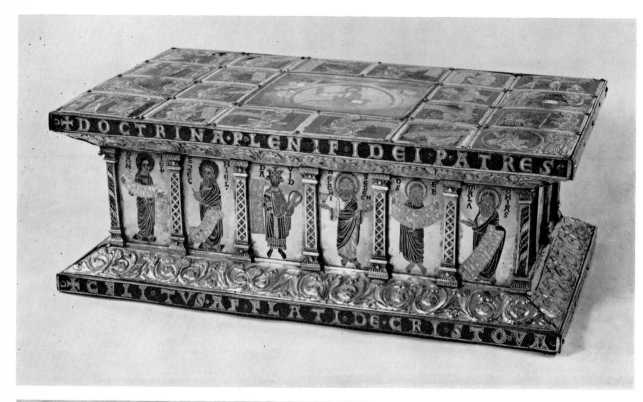

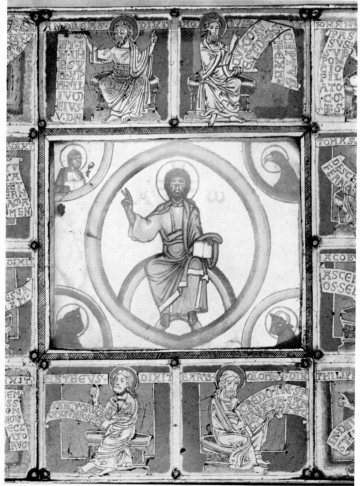

182. Eilbertus of Cologne: Portable altar, c. 1130/40. Berlin, Staatliche Museen

183. Eilbertus of Cologne: Portable altar (detail of top), c. 1130/40. Berlin, Staatliche Museen

184. Shrine of St Victor, c. 1130 and later additions. Xanten, St Victor

185. Reliquary casket, early twelfth century. Berlin, Staatliche Museen

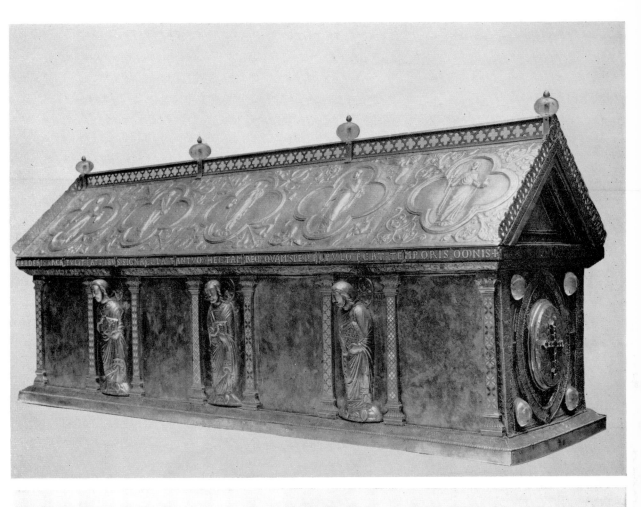

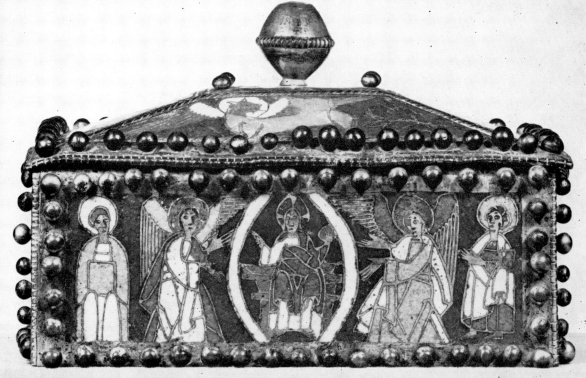

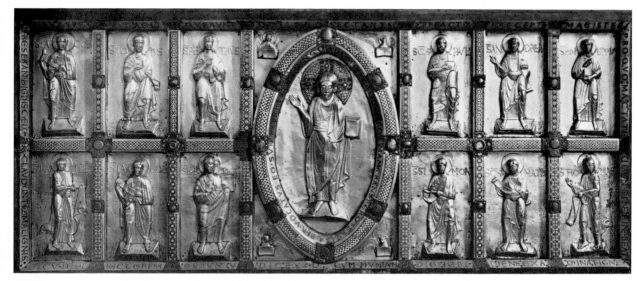

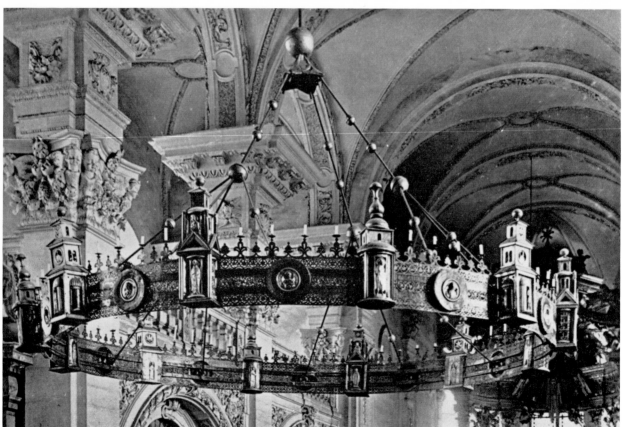

186. Antependium, *c.* 1120/30 and later additions. *Gross-Komburg, Stiftskirche*

187. Candelabrum given by Abbot Hertwig, *c.* 1130. *Gross-Komburg, Stiftskirche*

188. Female saint with jar of ointment, detail of the candelabrum, *c.* 1130. *Gross-Komburg, Stiftskirche*

189. Saintly bishop, detail of the candelabrum, *c.* 1130. *Gross-Komburg, Stiftskirche*

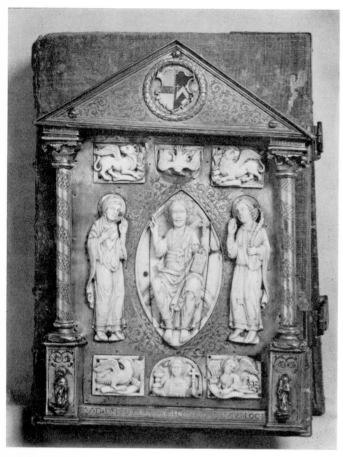

190. Christ in Majesty between the Virgin and St Vitus, *c.* 1130/40, mounted on a book-cover by Abbot Jacobus de Heggen (1574–83). *Darmstadt, Hessisches Landesmuseum*

191. Nativity. Ivory panel, *c.* 1130/40. *Cologne, Schnütgen Museum*

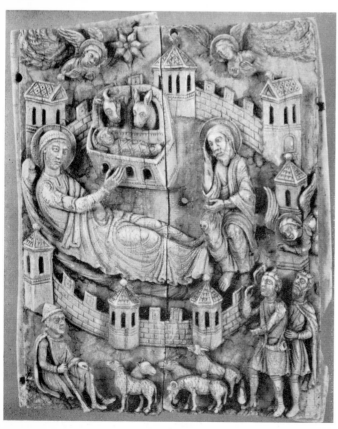

192. Rainer of Huy: Crucifix, *c.* 1110/20. Cologne, *Schnütgen Museum*

193. Christ in Majesty and scenes from the life of Christ. Reliquary casket of St Andrew (top), *c.* 1100/30(?). *Siegburg, St Servatius, Treasury*

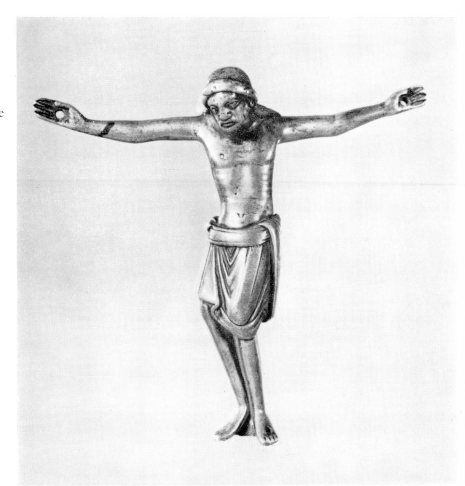

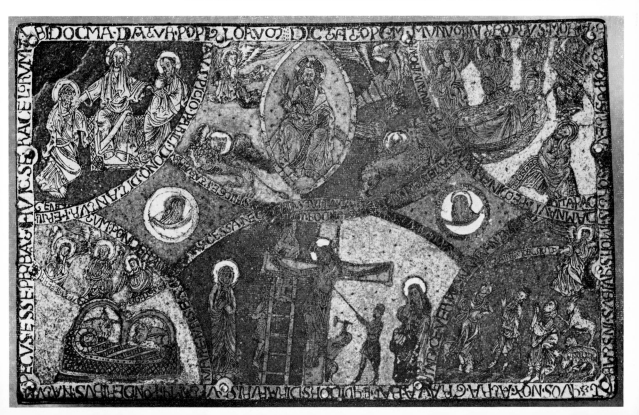

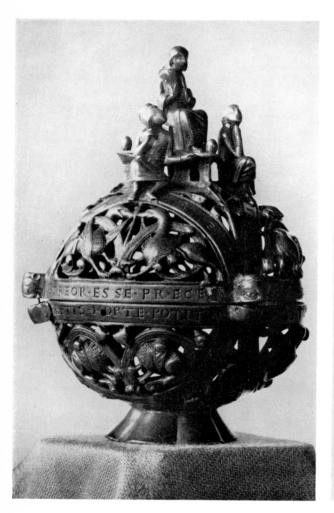

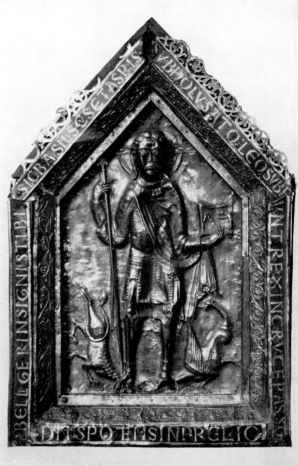

194. Rainer of Huy(?): Censer, *c.* 1130(?). *Lille, Musée des Beaux-Arts*

195. Christ treading on the beasts. Gabled end of the shrine of St Hadelin from Celles, *c.* 1075(?). *Visé, Saint-Martin*

196. Scenes from the life of St Hadelin. Detail from the shrine of St Hadelin, remodelled *c.* 1130. *Visé, Saint-Martin*

197. Miracle of the Spring. Detail from the shrine of St Hadelin, *c.* 1130. *Visé, Saint-Martin*

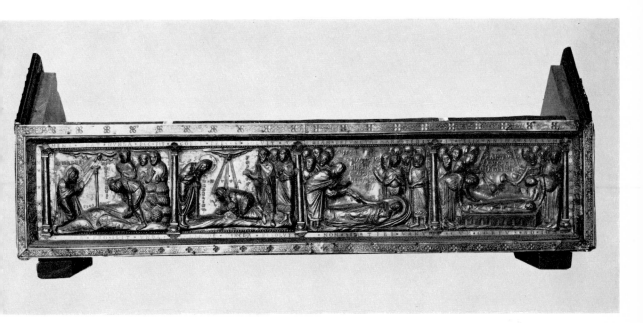

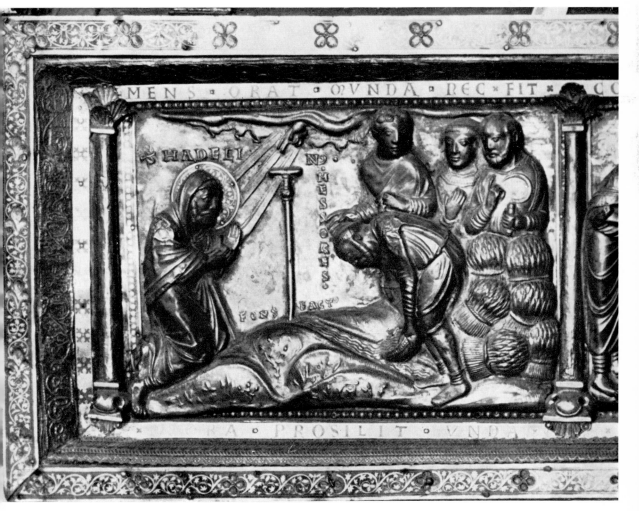

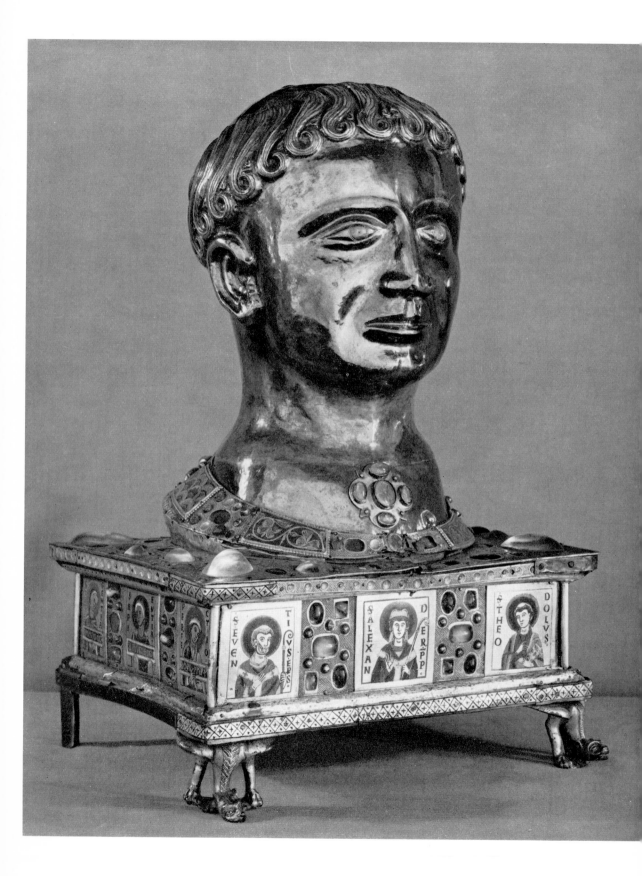

198. Head-reliquary of St Alexander from Stavelot Abbey, 1145. *Brussels, Musées Royaux*

199. Drawing made in 1661 of the St Remaclus retable of Stavelot Abbey, also showing the end of the shrine of St Remaclus, *c.* 1145/58. *Liège, Archives de l'État*

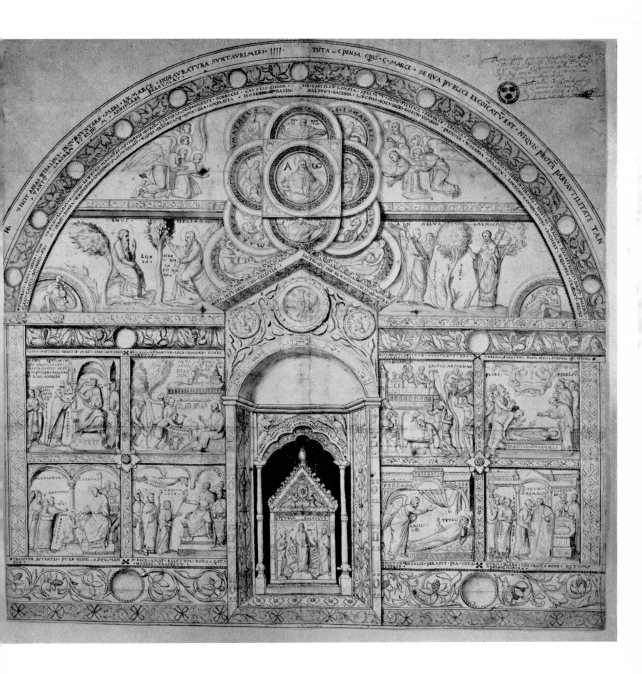

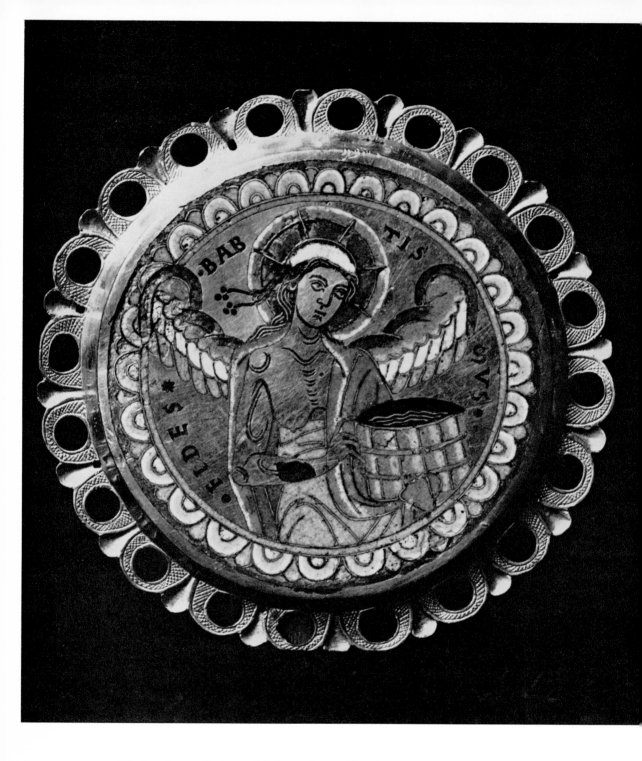

200. Charity. Enamelled roundel from the retable of St Remaclus from Stavelot, *c.* 1145/58. *Frankfurt, Museum für Kunsthandwerk*

201. The Last Judgement. Detail of the roof of the shrine of St Servatius, *c.* 1170. *Maastricht, St Servatius*

202. Scenes from the life of Constantine and Helen. Triptych from Stavelot Abbey, *c.* 1156/8, with two small gold triptychs mounted in the centre, Byzantine, eleventh century, with twelfth-century Mosan additions. *New York, Pierpont Morgan Library*

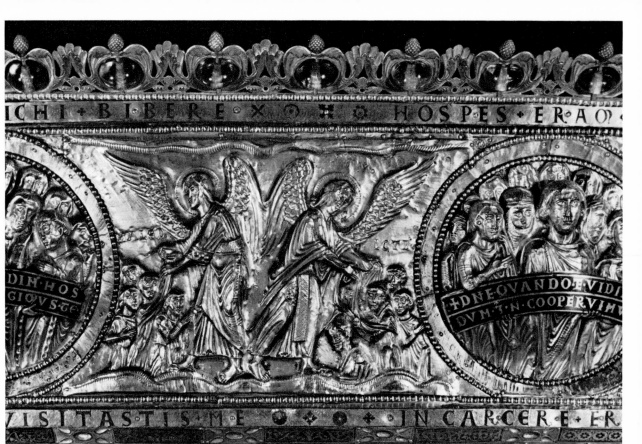

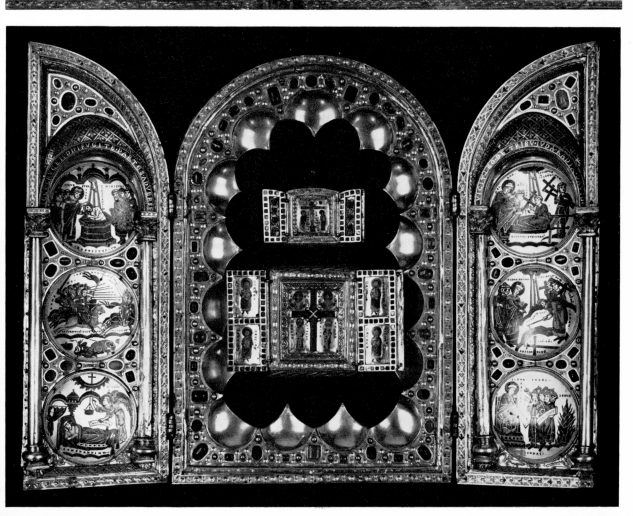

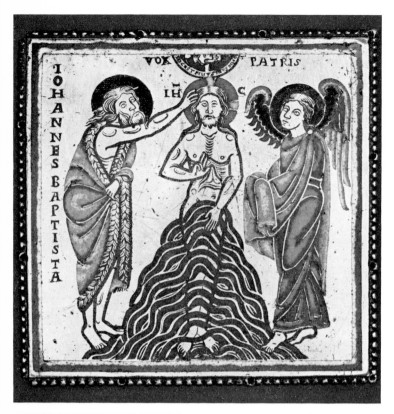

203. Baptism of Christ. Enamelled plaque from Saint-Denis Abbey(?), c. 1145/7. *New York, Metropolitan Museum of Art*

204. The Cleansing of Naaman in the River Jordan. Enamelled plaque from Saint-Denis Abbey(?), c. 1145/7. *London, British Museum*

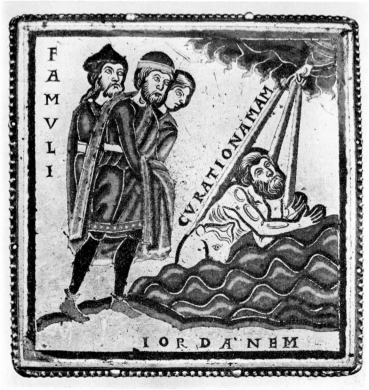

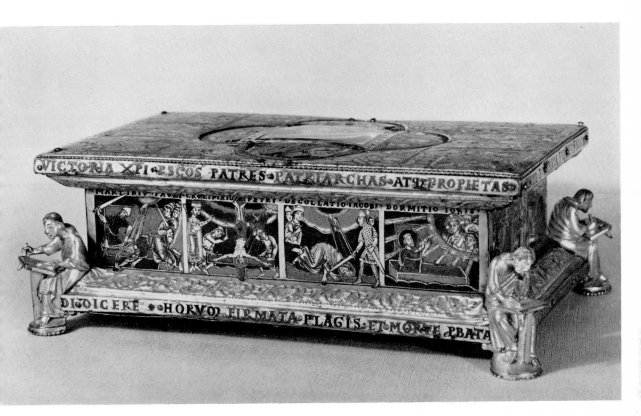

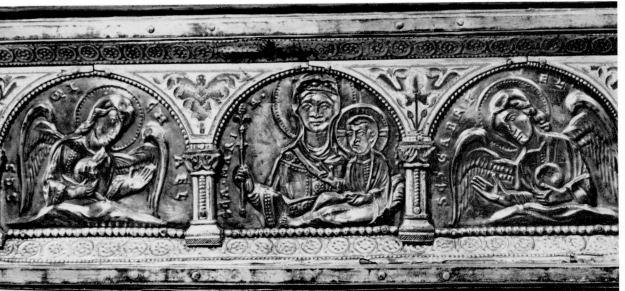

205. Portable altar from Stavelot Abbey, *c.* 1160. *Brussels, Musées Royaux*

206. Virgin and Child between archangels. Detail of the arm-reliquary of Charlemagne from Aachen, *c.* 1166. *Paris, Louvre*

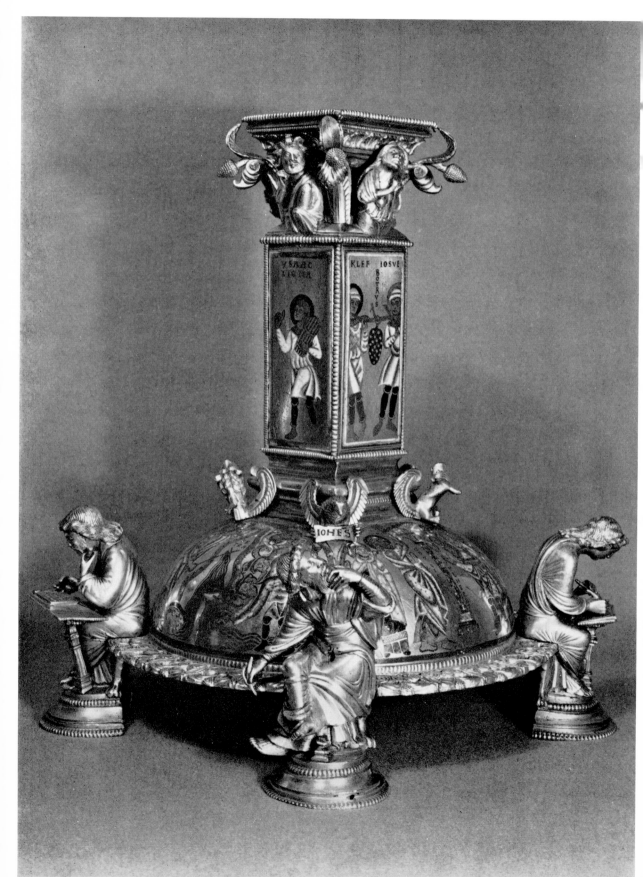

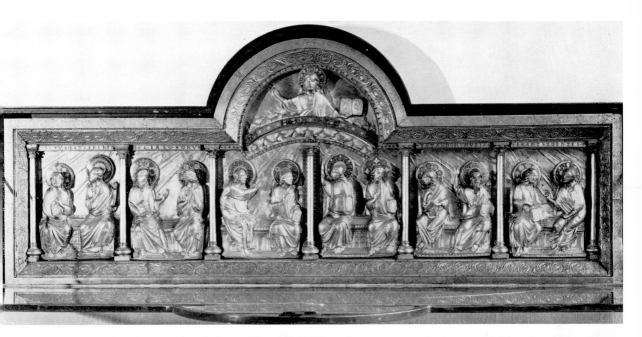

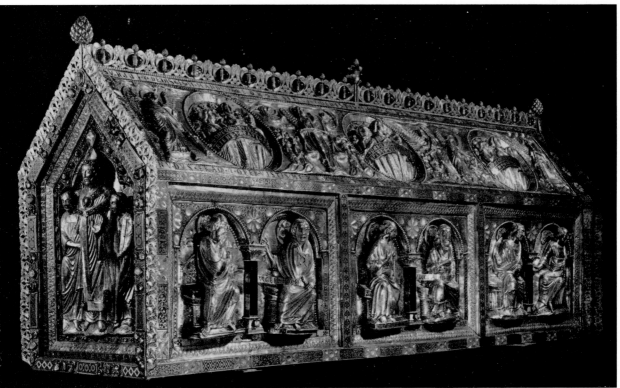

207. Foot of a crucifix from the abbey of Saint-Bertin, *c.* 1150/60. *Saint-Omer, Musée*

208. Pentecost. Retable from St Castor, Coblenz(?), *c.* 1155/60 and later additions. *Paris, Musée de Cluny*

209. Shrine of St Servatius, *c.* 1160/70. *Maastricht, St Servatius*

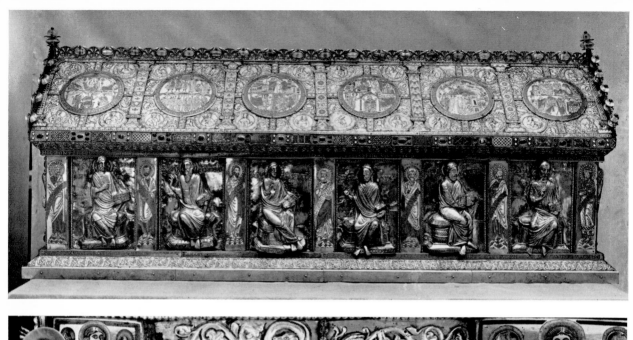

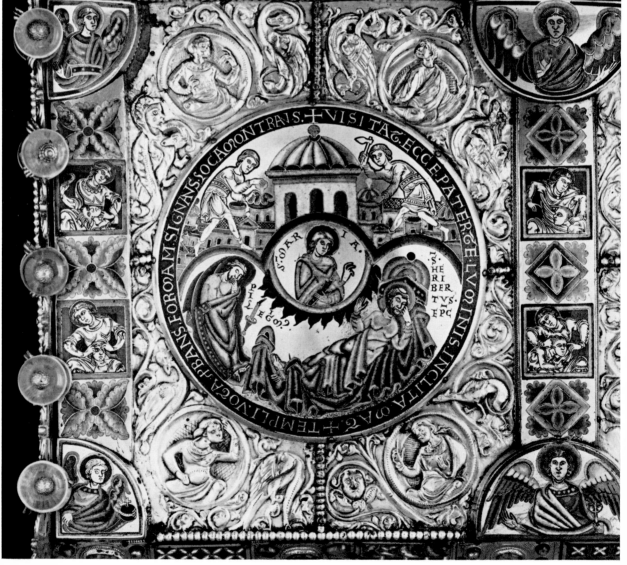

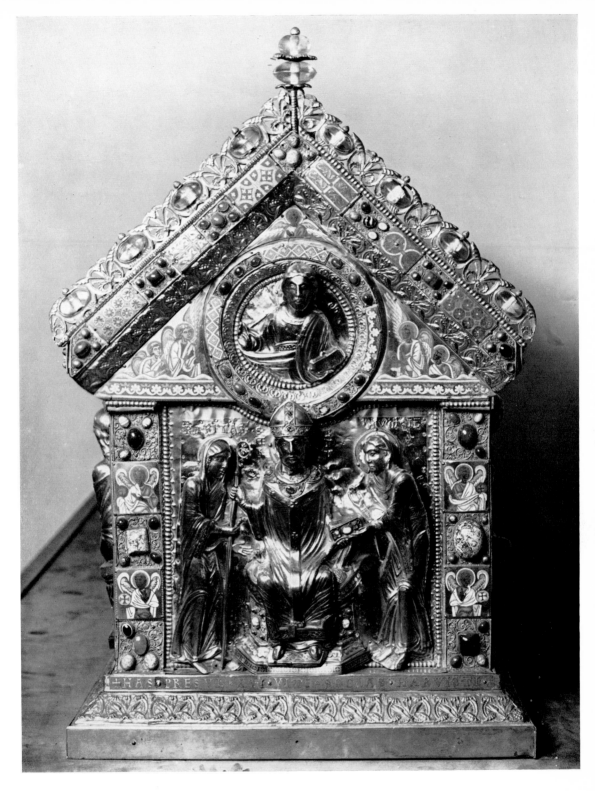

210. Shrine of St Heribert, *c.* 1150/60. *Cologne-Deutz, St Heribert*

211. Building of the abbey, etc. Detail from the roof of the shrine of St Heribert, *c.* 1150/60. *Cologne-Deutz, St Heribert*

212. St Heribert between Virtues. Gable end of the shrine of St Heribert, *c.* 1150/60. *Cologne-Deutz, St Heribert*

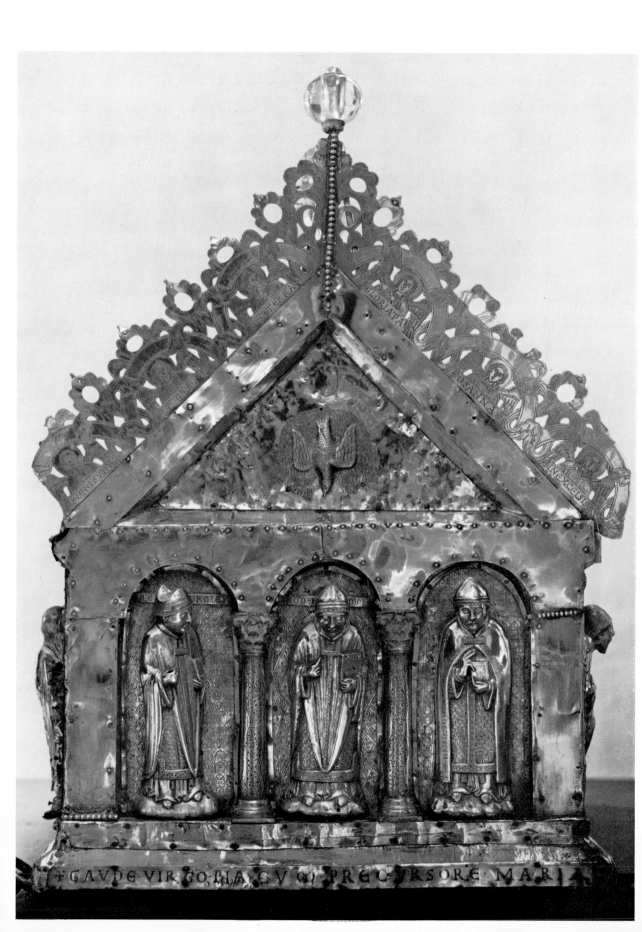

213. Gable end of the shrine of
St Godehard, *c.* 1132 *Hildesheim
Cathedral*

214. St Matthew. Detail of the side of
the shrine of St Godehard, *c.* 1132
and later additions. *Hildesheim
Cathedral, Treasury*

215. Flabellum, *c.* 1110/30. *Hildesheim
Cathedral, Treasury*

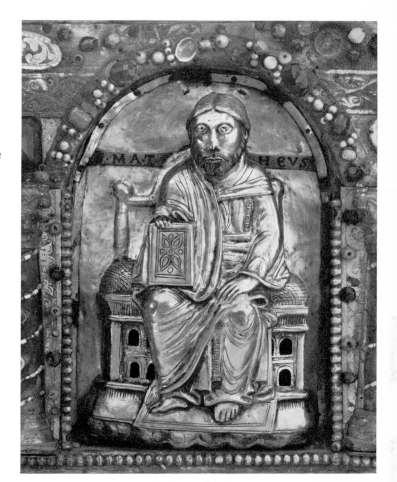

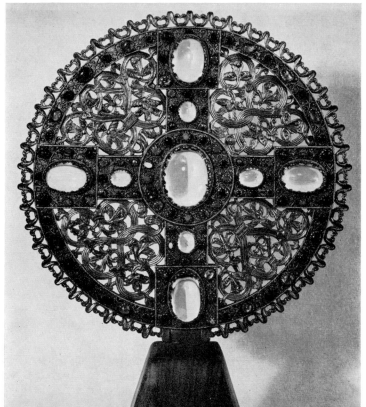

216. Portable altar with the
Cardinal Virtues, *c.* 1150/60.
Berlin, Staatliche Museen

217. Annunciation and
Nativity. Detail of the front of
an enamelled casket from
Gruol, *c.* 1130/50(?). *Frankfurt,
Museum für Kunsthandwerk*

218. Annunciation and
Nativity. Detail from one of
six enamelled plaques, *c.* 1150.
Hildesheim Cathedral, Treasury

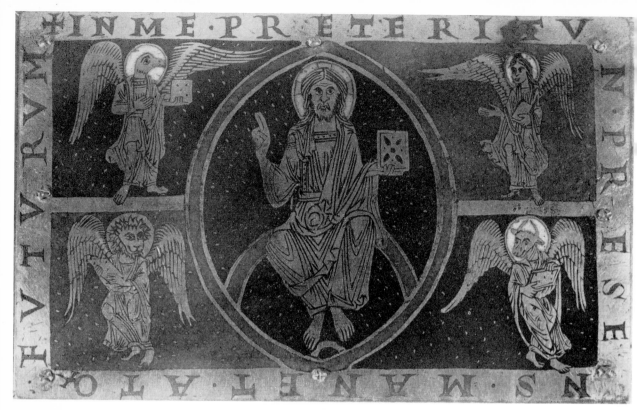

219. Christ in Majesty. Top of reliquary
casket from Stift Vorau, *c.* 1150/60.
*Vienna, Österreichisches Museum für
angewandte Kunst*

220. Christ treading on the beasts.
Book-cover of the Ratmann
Sacramentary, 1159. *Hildesheim
Cathedral, Treasury*

221. Crucifixion. Enamelled plaque from a reliquary, c. 1160/70. *Paris, Musée de Cluny*

222. Book-cover of a Gospel Book from Hildesheim, c. 1170. *Trier Cathedral, Treasury*

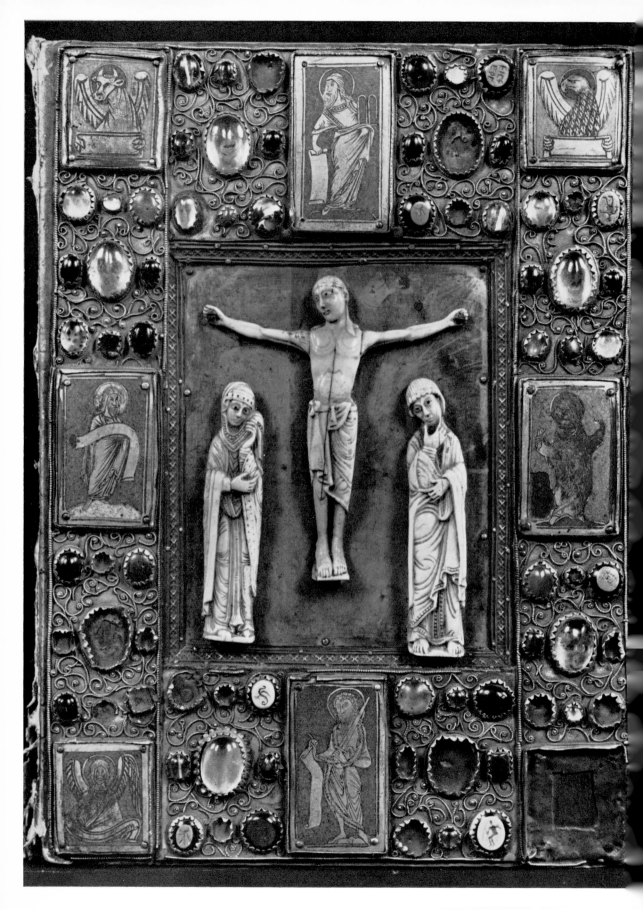

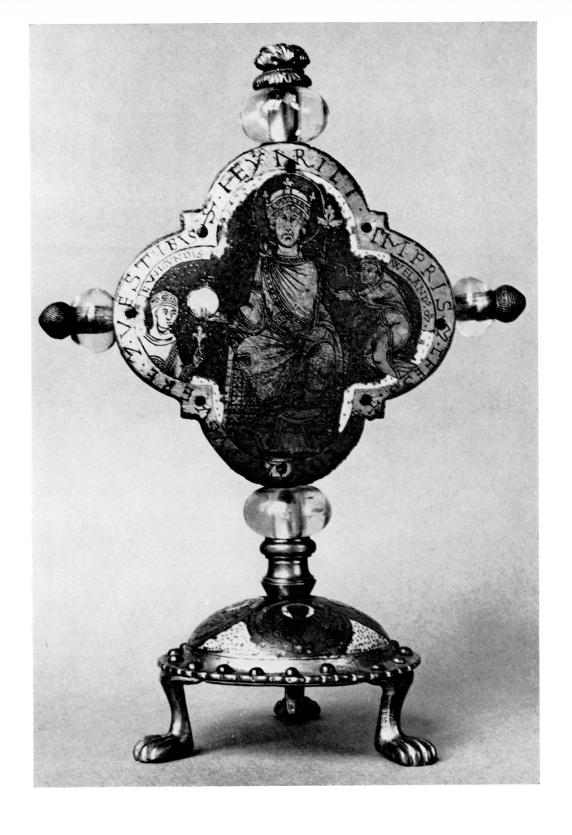

223. Book-cover of a Gospel Book from Hildesheim, *c.* 1170. *Trier Cathedral, Treasury*

224. Reliquary of Henry II, *c.* 1168(?). *Paris, Louvre*

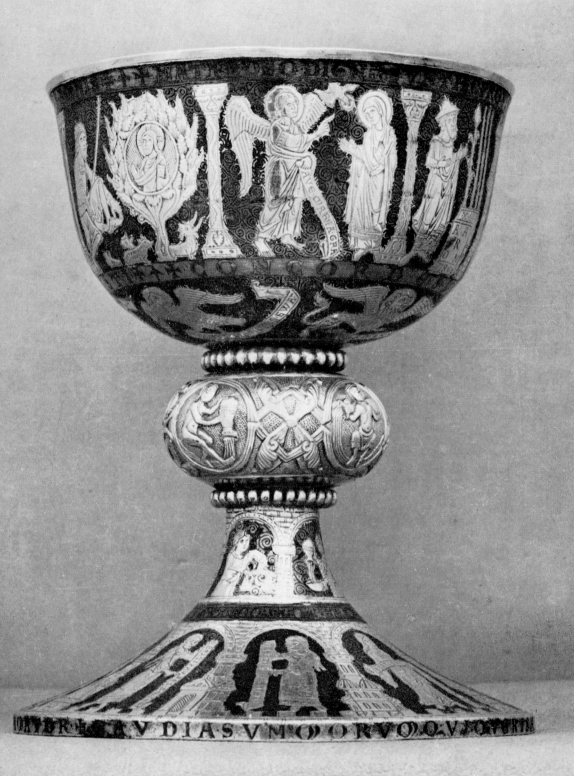

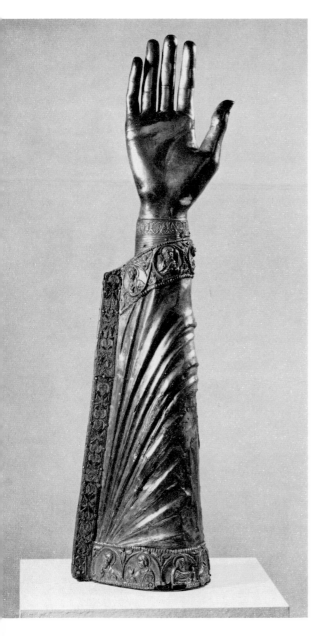
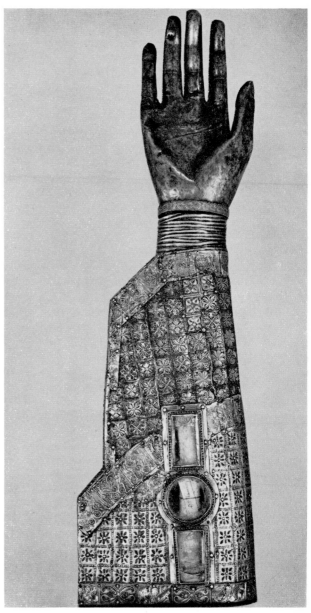

225. Chalice from Trzemeszno, *c.* 1170. *Gniezno Cathedral, Treasury*

226. 'Apostles' arm-reliquary, *c.* 1185/95(?). *Cleveland Museum of Art*

227. Arm-reliquary of St Lawrence, *c.* 1170/80. *Berlin, Staatliche Museen*

228. Chalice from Stift Wilten, made for Abbot Berthold of Zähringen (1148–84), *c.* 1160/70. *Vienna, Kunsthistorisches Museum*

229. Reliquary of St Oswald, *c.* 1170/80. *Hildesheim Cathedral, Treasury*

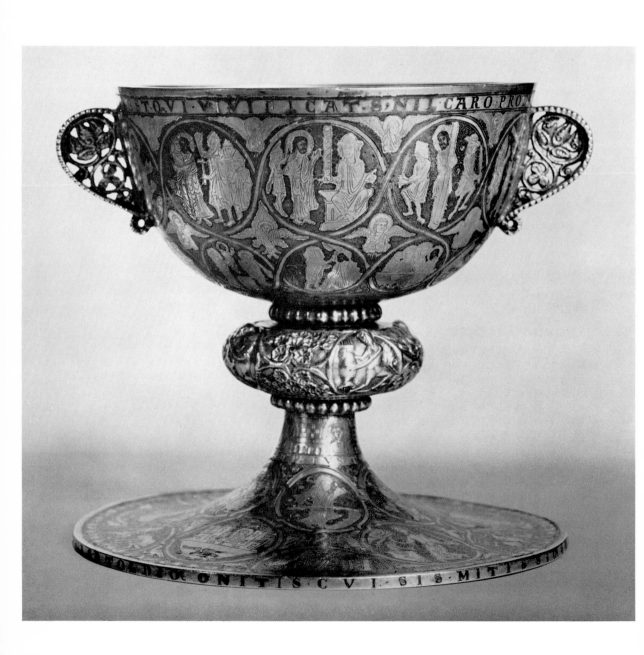

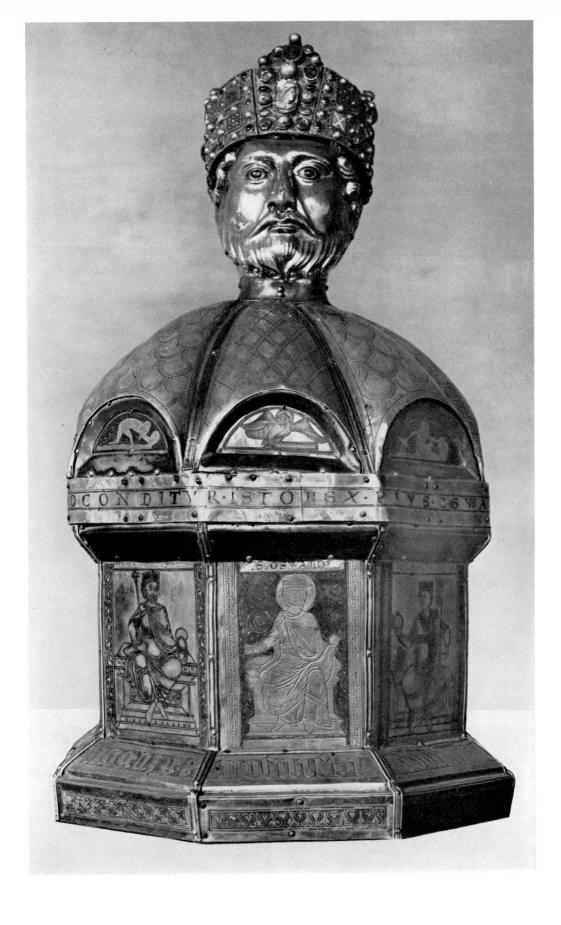

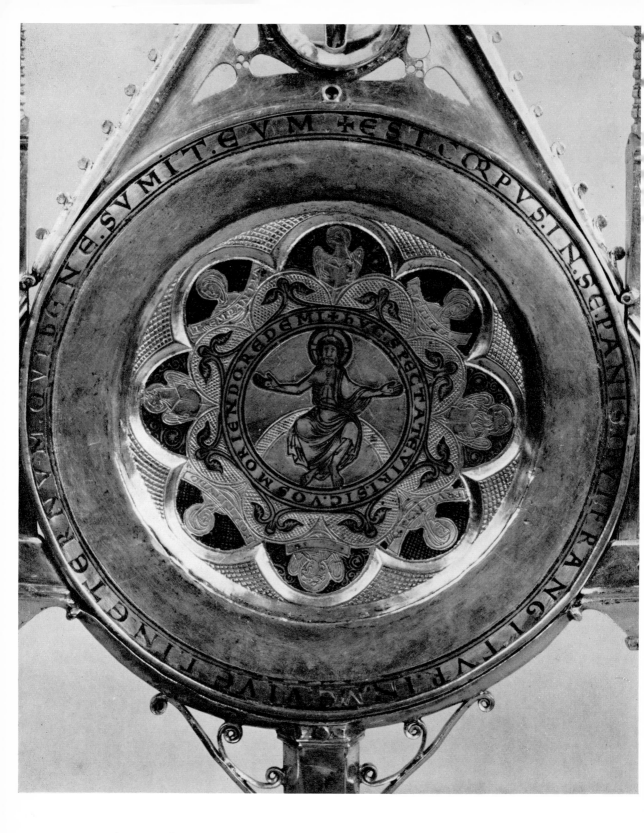

230. 'Bernward' paten, *c.* 1180, mounted in a fourteenth-century monstrance. *Cleveland Museum of Art*

231. Bronze doors from Plock Cathedral, 1152/4 and later additions. *Novgorod Cathedral*

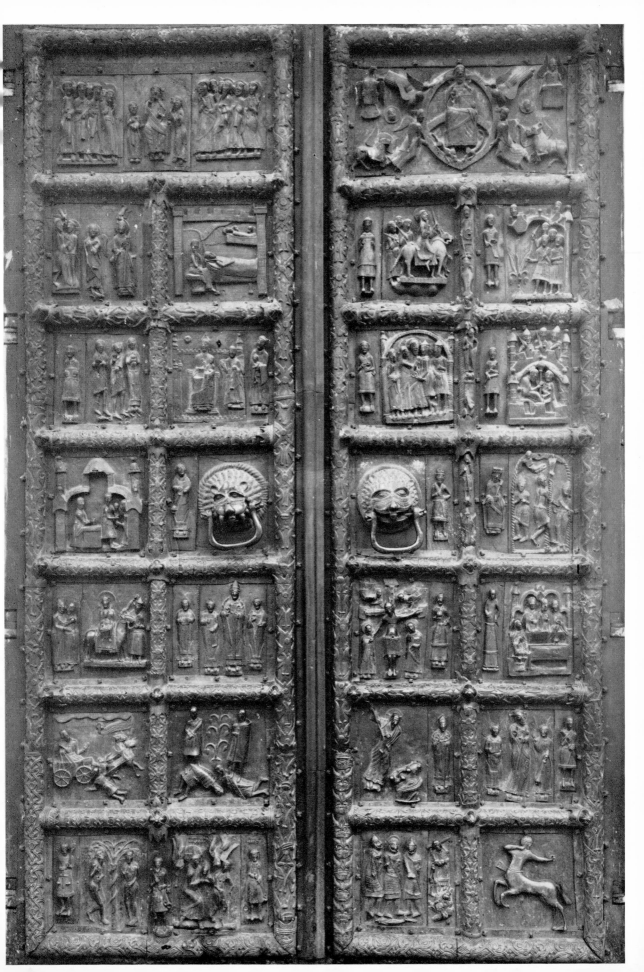

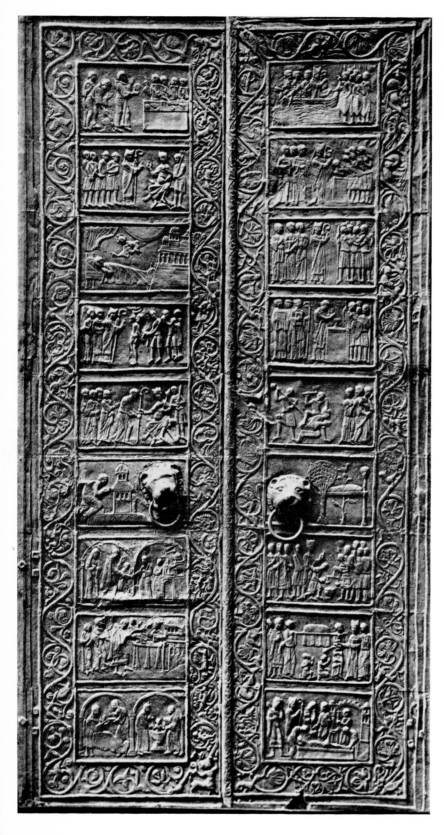

232. Bronze doors, *c.* 1175. *Gniezno Cathedral*

233. Bronze doors, *c.* 1135/40, enlarged in the late twelfth century. *Verona, San Zeno*

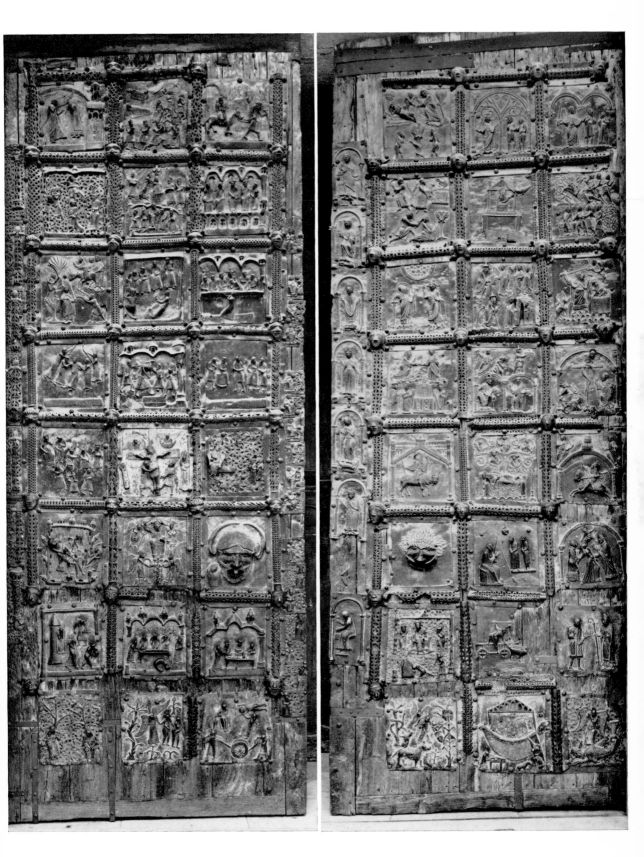

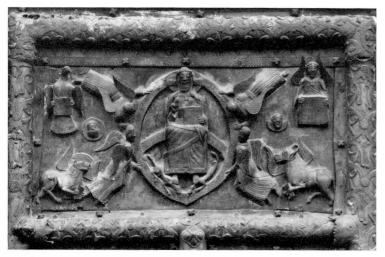

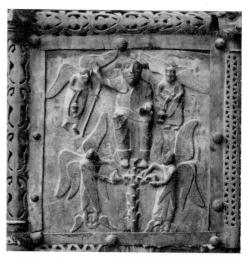

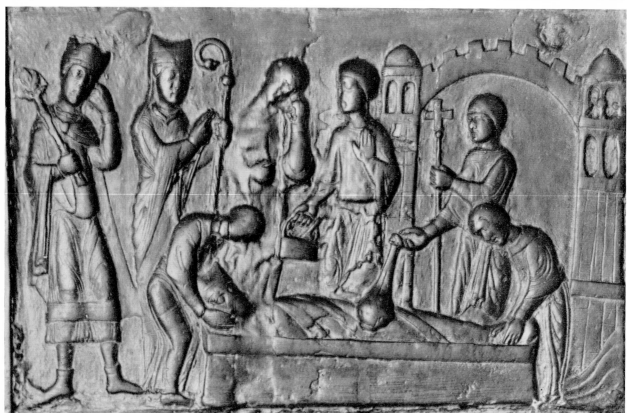

234. Christ in Majesty. Detail of the bronze doors from Plock Cathedral. *Novgorod Cathedral*

235. Christ in Majesty. Detail of the bronze doors. *Verona, San Zeno*

236. Death of St Adalbert. Detail of the bronze doors. *Gniezno Cathedral*

237. 'Disc' reliquary, *c.* 1170/80, the top of the crest a re-used fragment of an eighth-century reliquary. *Fritzlar, St Peter*

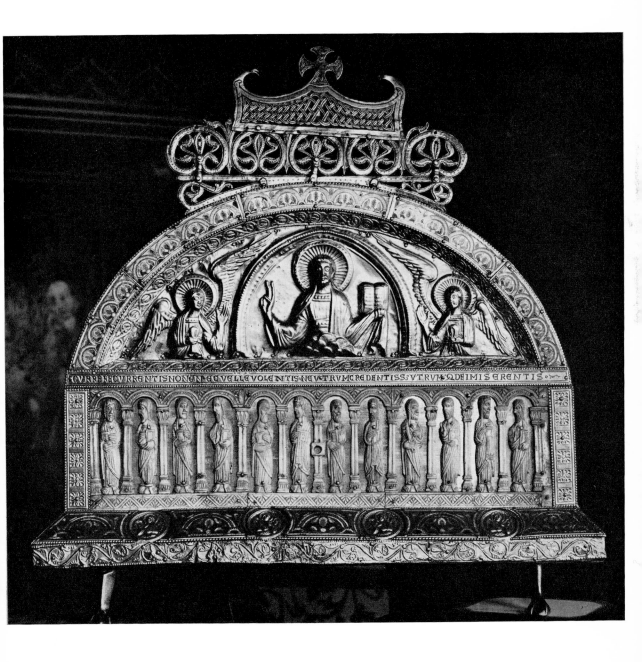

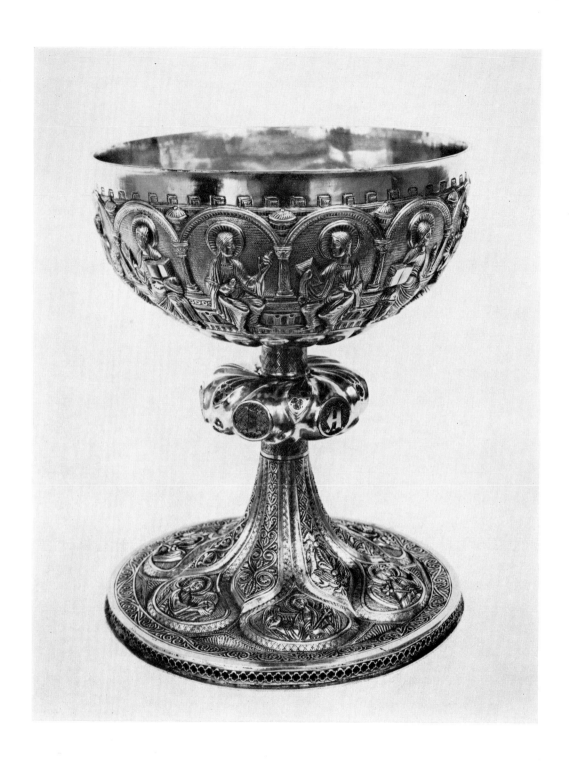

238. Chalice, c. 1180, central knop and base rim fourteenth century. *Fritzlar, St Peter, Treasury*

239. Portable altar of St Mauritius, c. 1160. *Siegburg, St Servatius, Treasury*

240. Portable altar of St Gregorius, c. 1160/70. *Siegburg, St Servatius, Treasury*

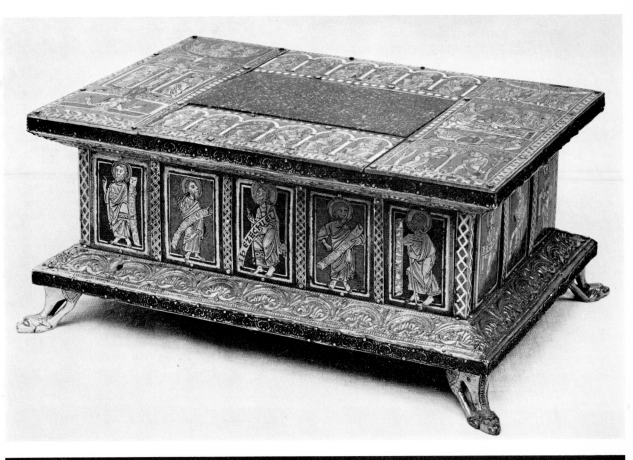

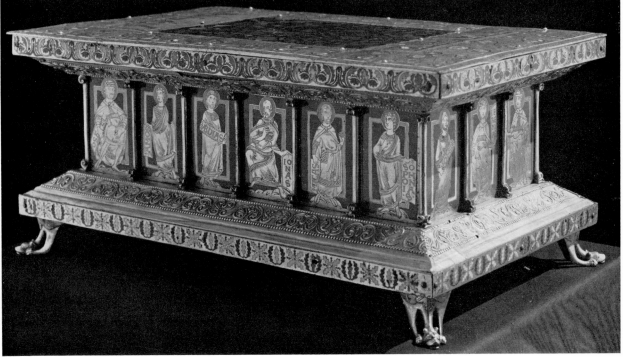

241. 'Alton Towers' triptych, *c.* 1150. *London, Victoria and Albert Museum*

242. Tower reliquary, *c.* 1170/80. *Darmstadt, Hessisches Landesmuseum*

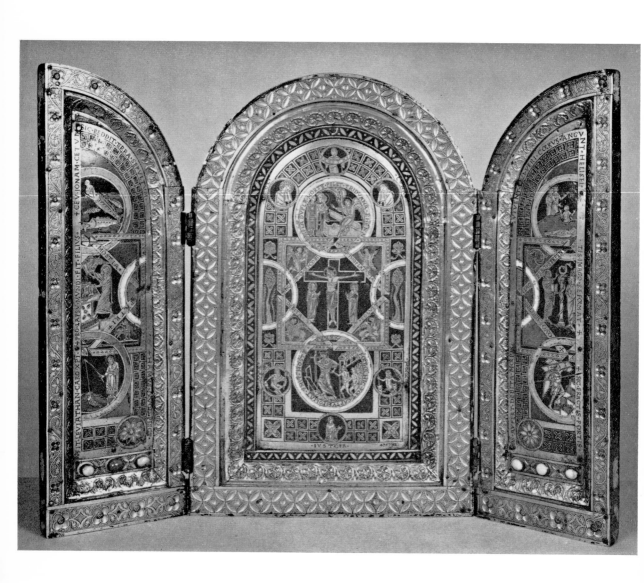

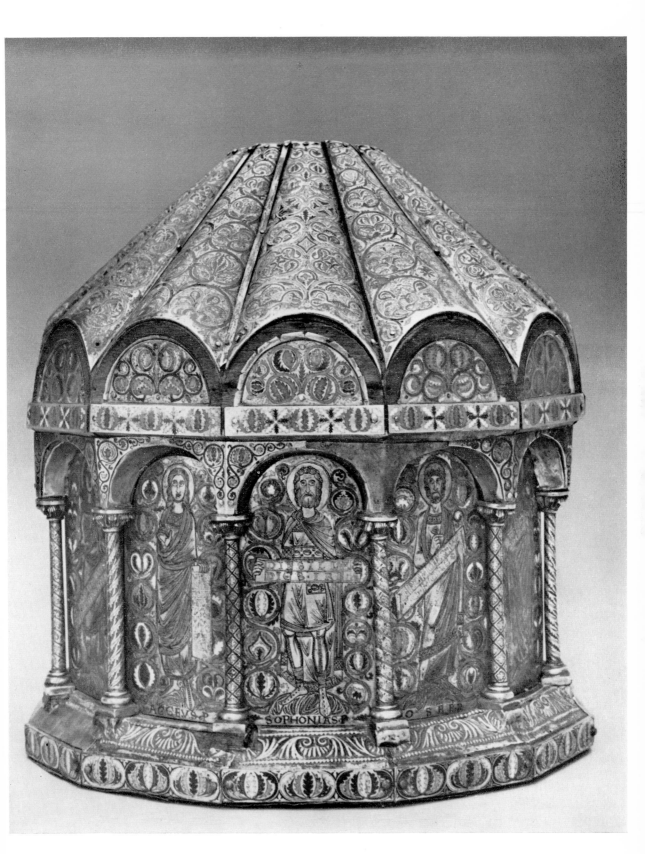

243. Enamelled plaque, top of a portable altar (?), c. 1160/70. *Chantilly, Musée Condé*

244. Portable altar of St Victor (detail), c. 1175/80. *Xanten Cathedral, Treasury*

245. Portable altar from the former abbey of St Vitus, c. 1160. *Mönchen-Gladbach, St Vitus*

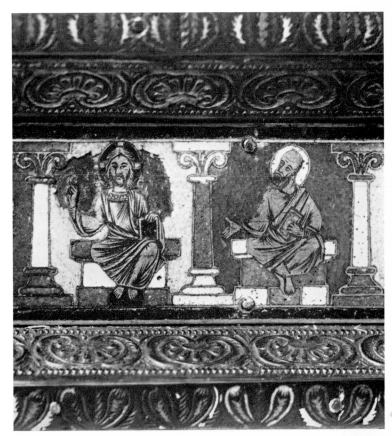

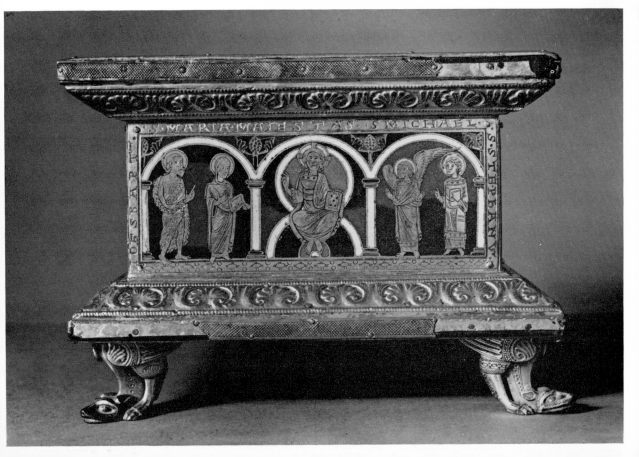

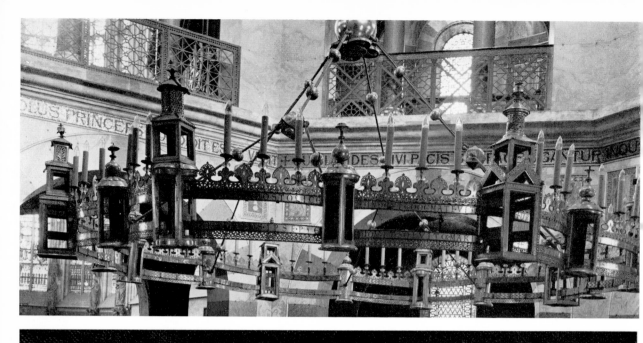

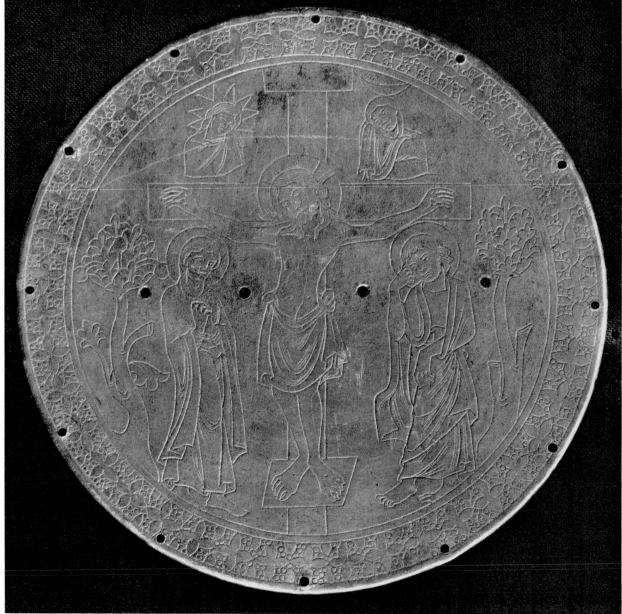

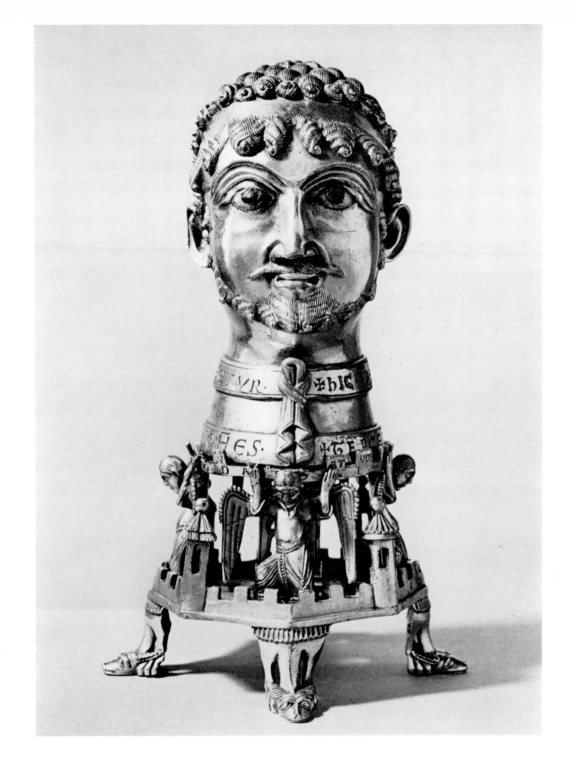

246. Wibertus of Aachen(?): Candelabrum, *c.* 1166. *Aachen, Palace Chapel*

247. Crucifixion. Detail of the base of one tower of the candelabrum, *c.* 1166. *Aachen, Palace Chapel*

248. Head–reliquary of St John the Evangelist, *c.* 1150/60, base added *c.* 1170(?). *Cappenberg, Schlosskirche*

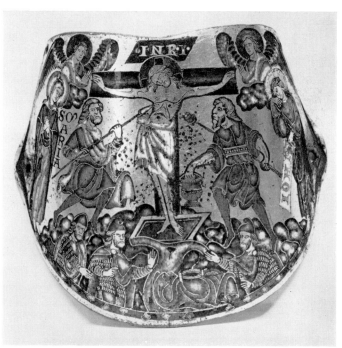

249. Crucifixion. Armilla from Vladimir Cathedral, *c.* 1165(?). *Basel, Robert von Hirsch Collection*

250. Nativity. Drawing by J. A. Delsenbach (d. 1765) of an armilla in the Imperial Treasury, *c.* 1170/80. *Nuremberg, Stadtbibliothek*

251. Shrine of St Aetherius, *c.* 1170 with later additions. *Cologne, St Ursula*

252. Shrine of St Maurinus, *c.* 1165/70 with later additions. *Cologne, St Pantaleon*

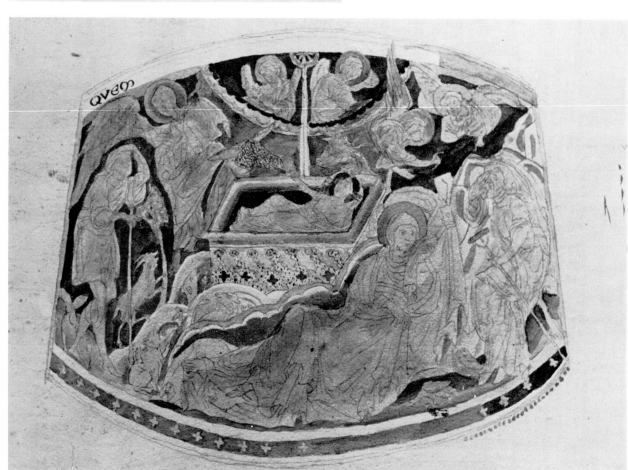

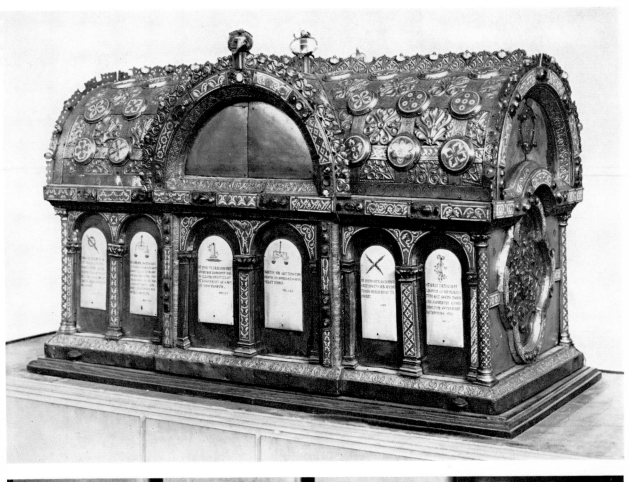

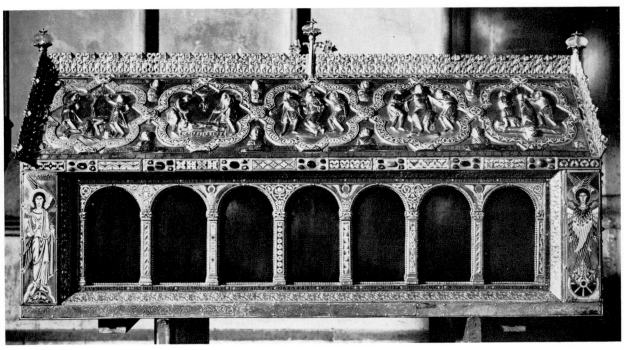

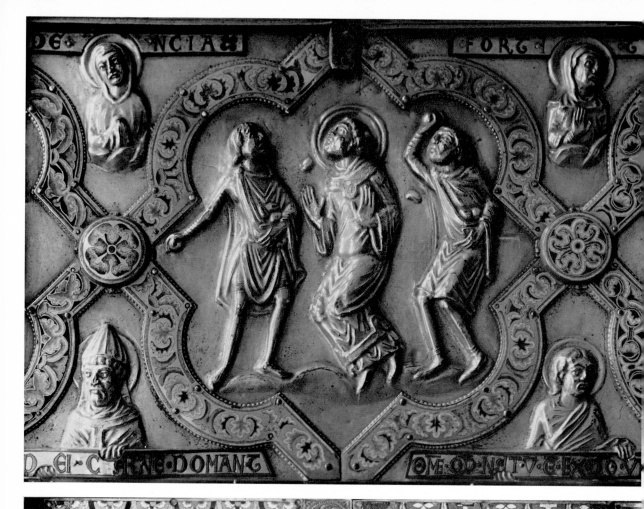

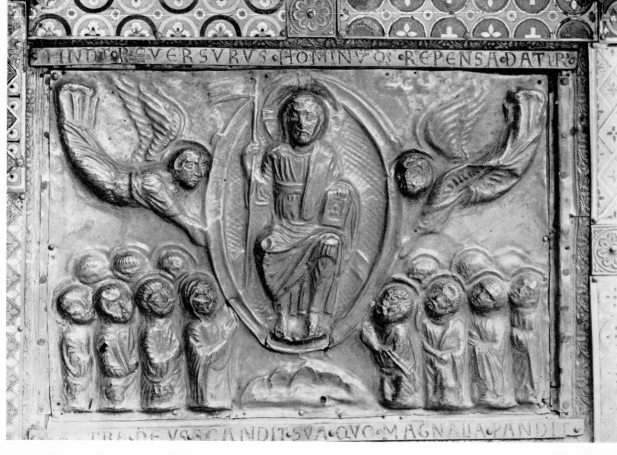

253. Martyrdom of St Stephen. Detail of the roof of the shrine of St Maurinus, *c.* 1165/70. *Cologne, St Pantaleon*

254. Ascension. Detail of the roof of the shrine of St Alban, 1186. *Cologne, St Pantaleon*

255. Domed reliquary from Hochelten, *c.* 1170(?). *London, Victoria and Albert Museum*

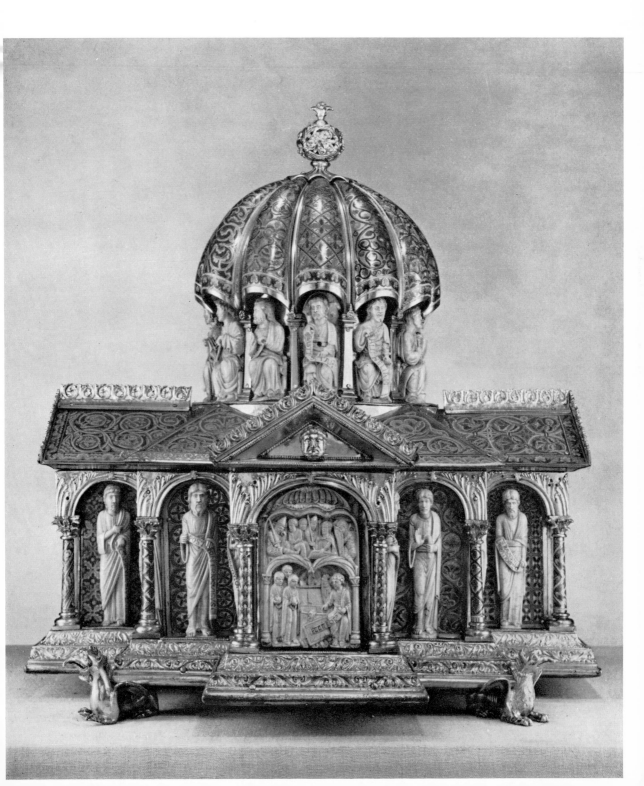

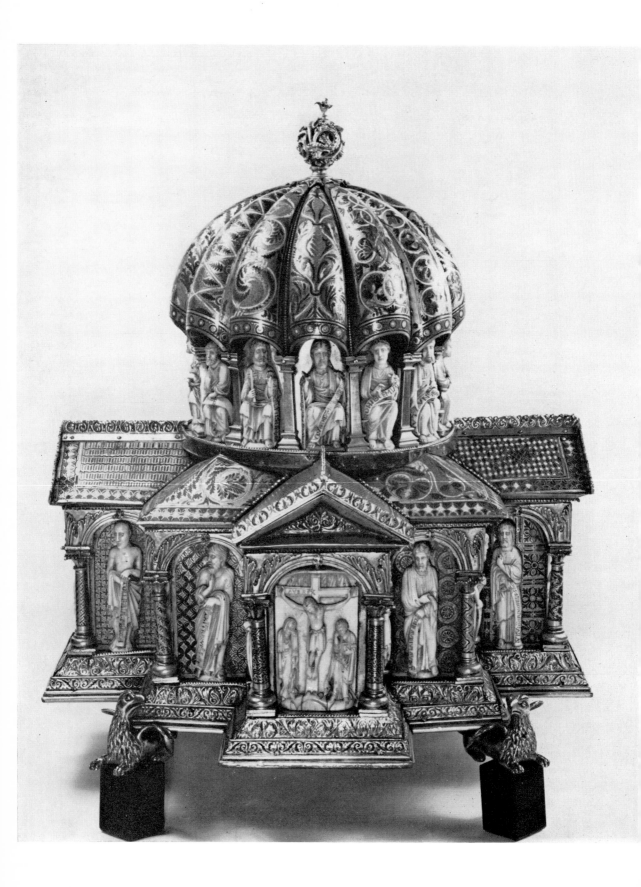

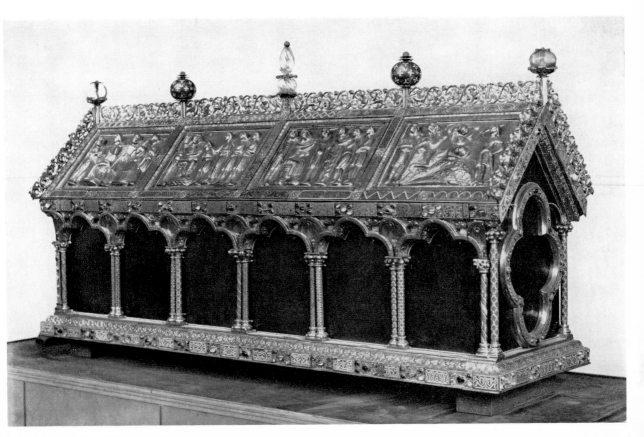

256. Domed reliquary, *c.* 1175/80. *Berlin, Staatliche Museen*

257. Shrine of St Alban, 1186. *Cologne, St Pantaleon*

258. Painting of 1764, probably by J. W. Fischer, of the shrine of St Anno from the abbey of St Michael, Siegburg, 1183. *Belecke, parish church*

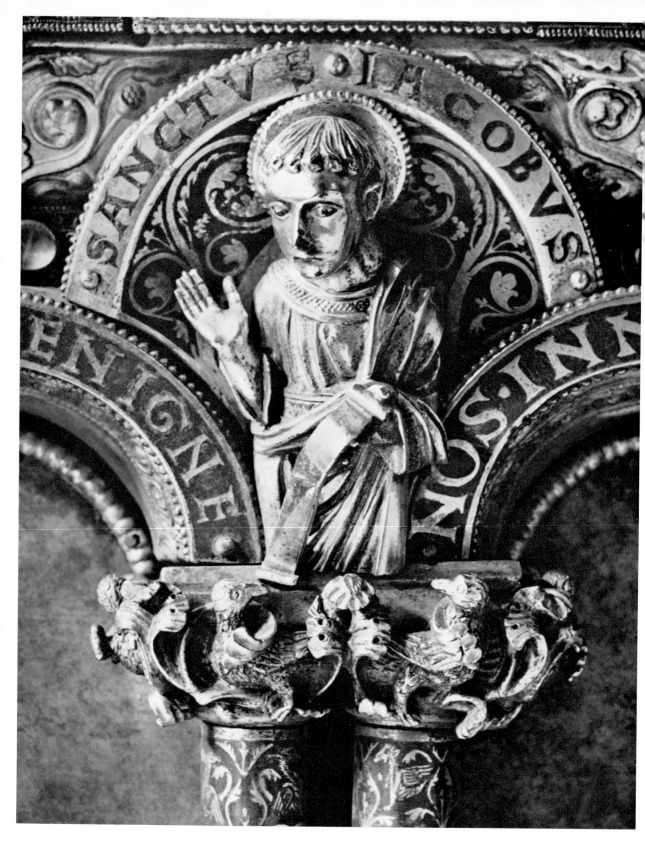

259. St James the Younger. Spandrel figure of the shrine of St Anno, *c.* 1183. *Siegburg, Abtei Michaelsberg*

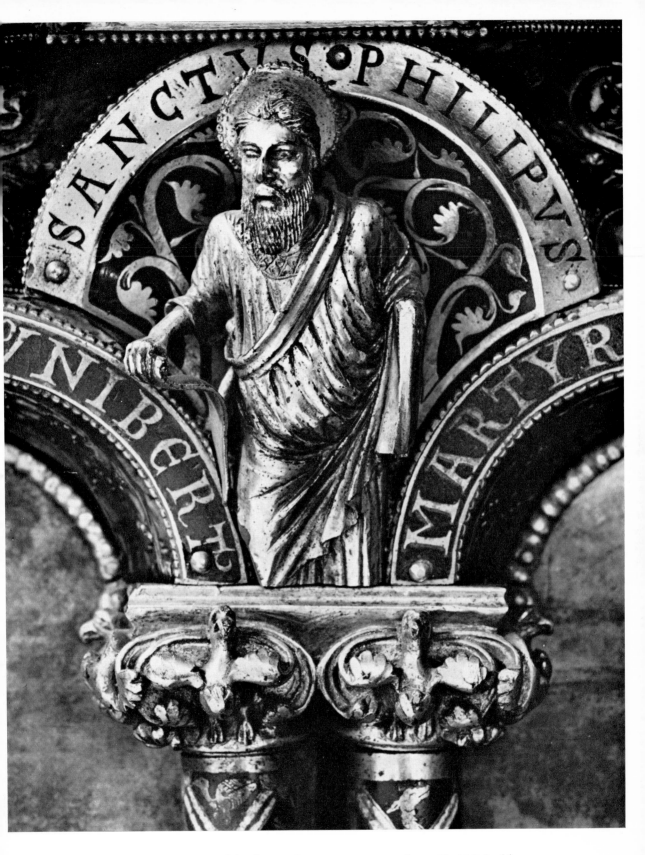

260. St Philip. Spandrel figure of the shrine of St Anno, 1183. *Siegburg, Abtei Michaelsberg*

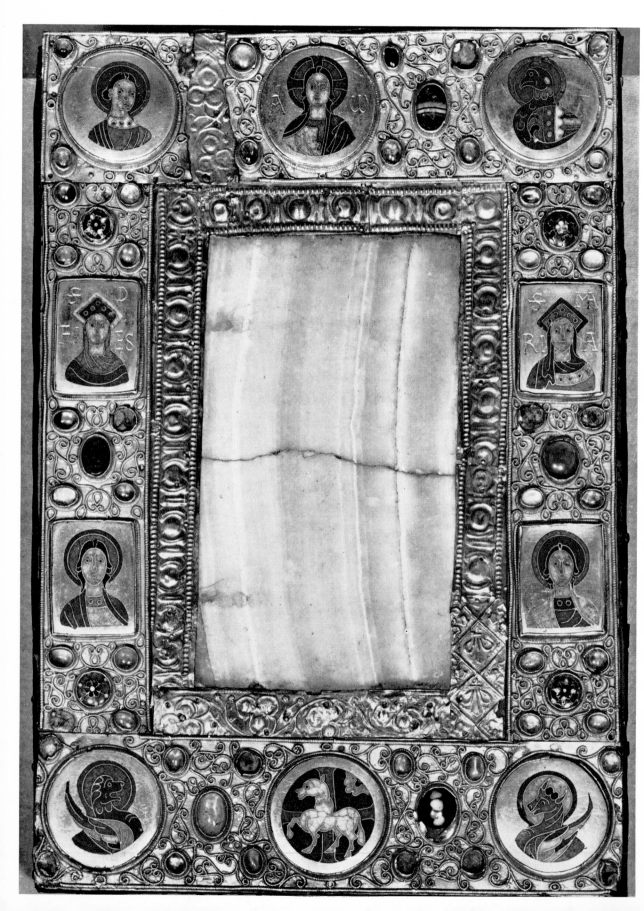

261. Portable altar of St Faith, early twelfth century. *Conques Abbey, Treasury*

262. Reliquary casket from Champagnat, *c.* 1150(?). *New York, Metropolitan Museum of Art*

263. Enamelled top of the casket of Santo Domingo, *c.* 1150(?), ivory casket 1026. *Burgos, Museo Arqueológico*

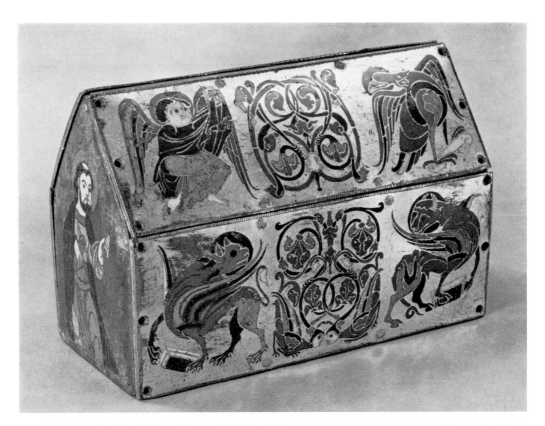

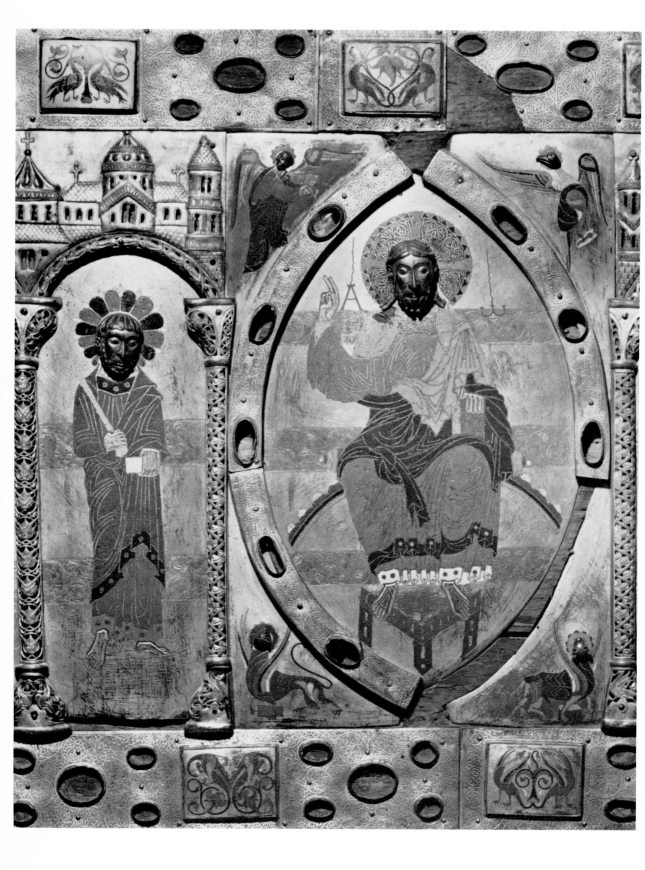

264. Christ in Majesty and St Paul. Detail of the front of the shrine of Santo Domingo from Silos Abbey, *c.* 1140/50(?). *Burgos, Museo Arqueológico*

265. Apostle. Detail of the roof of the shrine of Santo Domingo, *c.* 1170/80(?). *Silos Abbey, Treasury*

266. Shrine of Santo Domingo from Silos Abbey (front), *c.* 1140/50(?). *Burgos, Museo Arqueológico*

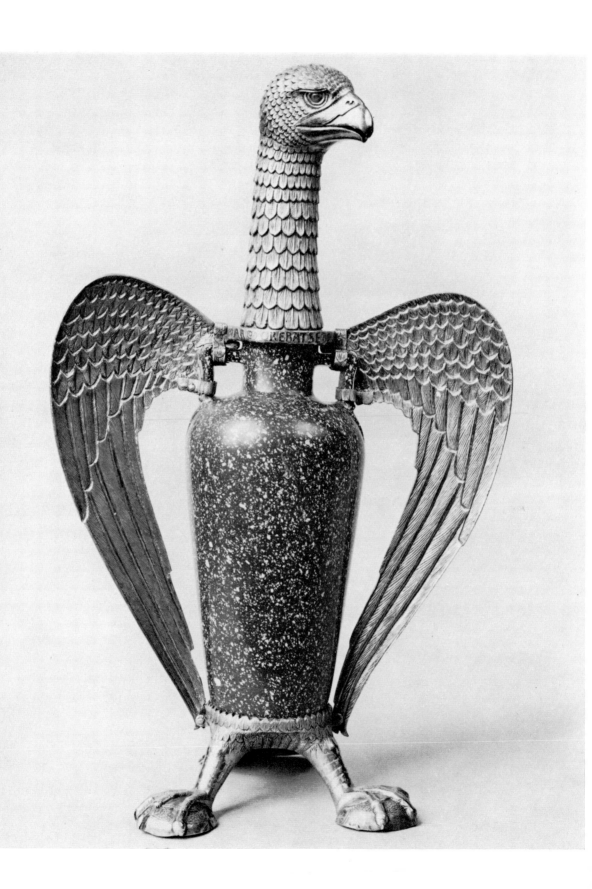

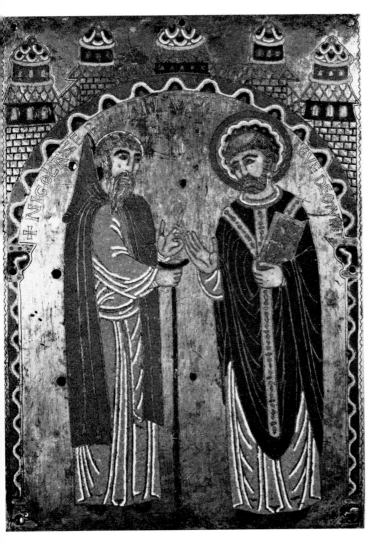

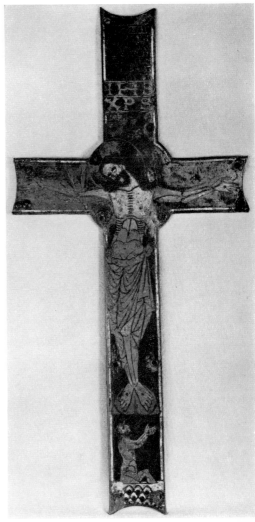

267. Antique vase mounted to resemble an eagle *c.* 1130/40. *Paris, Louvre*

268. Hugo Lasert and St Stephen of Muret. Panel from the altar frontal(?) from Grandmont Abbey, *c.* 1189. *Paris, Musée de Cluny*

269. John Garnerius of Limoges: Altar cross, *c.* 1190. *Paris, Louvre*

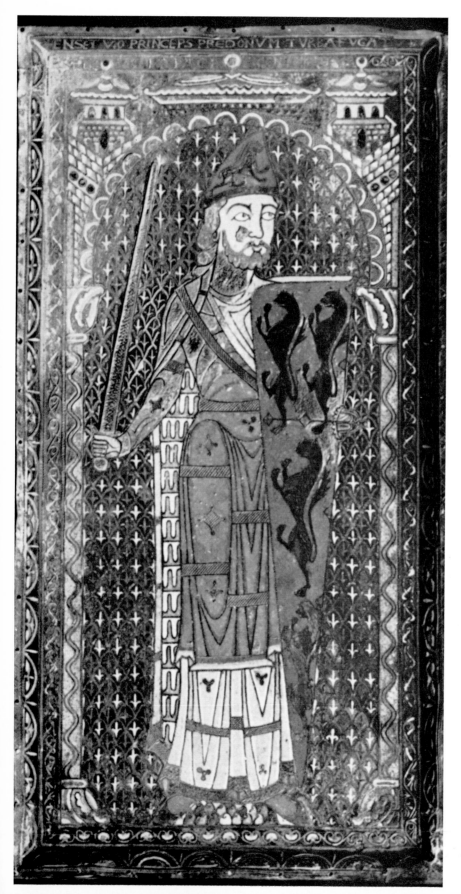

270. Plaque from
the tomb of Geoffrey of
Anjou (d. 1151),
c. 1151/60. *Le Mans,
Musée*

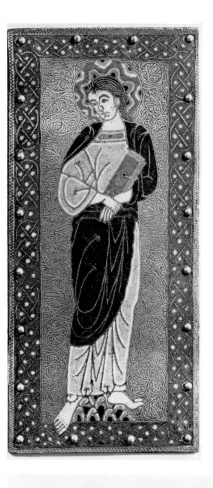

271. St John. Enamelled panel, *c.* 1200. *London, British Museum*

272. Reliquary shrine, *c.* 1150/70. *Nantouillet, parish church*

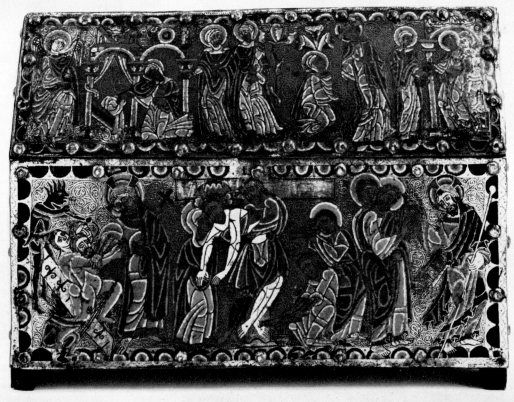

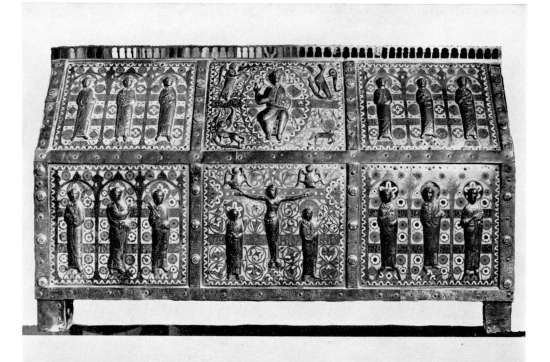

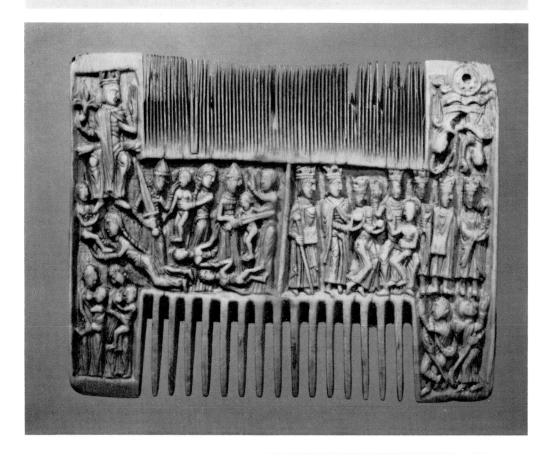

273. Shrine of St Calmine, made for Abbot Peter (1168–81), c. 1170/80. *Mozac, parish church*

274. Scenes from the life of Christ. Ivory comb, c. 1120/30. *London, Victoria and Albert Museum*

275. Fragment of an inhabited scroll, pierced ivory, c. 1130. *London, British Museum*

276. Portable altar (restored), c. 1140/50. *London, British Museum*

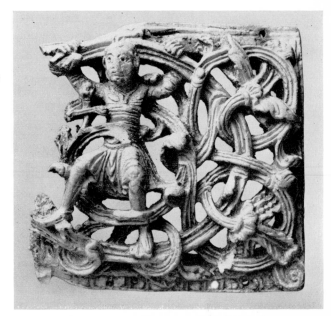

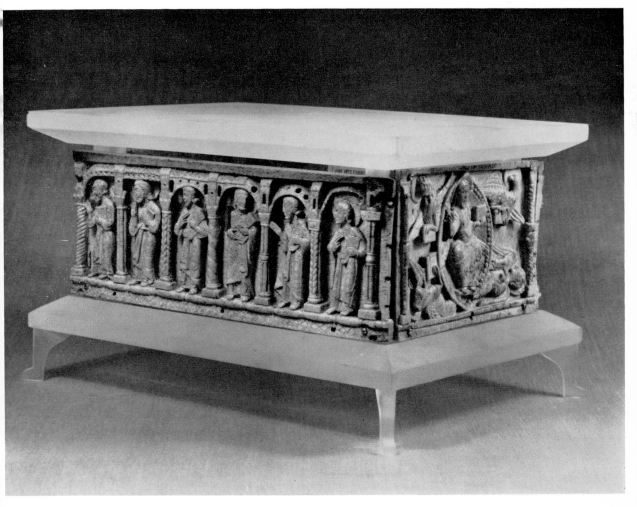

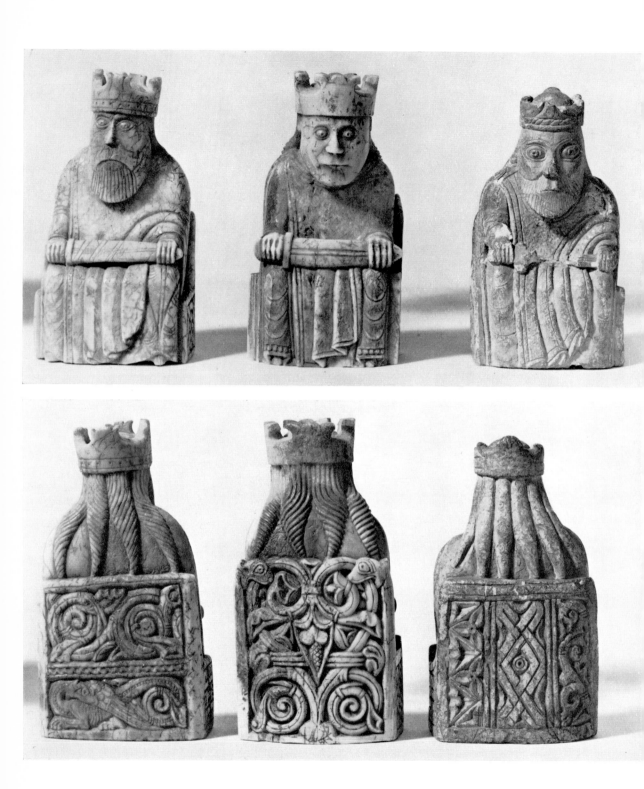

277. Kings. Chessmen from the isle of Lewis, *c.* 1150. *London, British Museum*

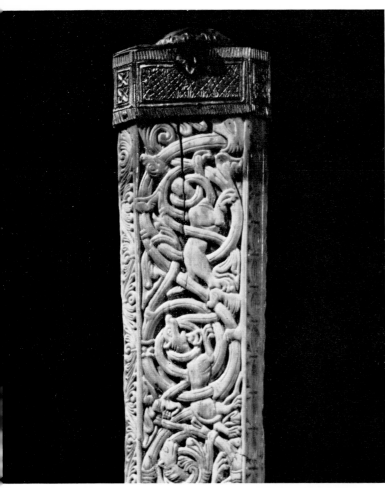

278. Ivory carving, fragment of a chair(?), *c.* 1150, with bronze-gilt mount, fourteenth century.
London, British Museum

279. Henry of Blois, bishop of Winchester (1129–71). Fragment from the shrine of St Swithun, *c.* 1150.
London, British Museum

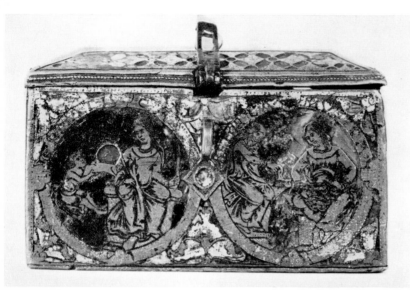

280. Grammar, Rhetoric, and Music. Casket, *c.* 1170/80. *London, Victoria and Albert Museum*

281. Carrying of the Cross. Detail of the lid of the ciborium from Malmesbury Abbey, *c.* 1170/80. *New York, Pierpont Morgan Library*

282. Ciborium, *c.* 1200. *Saint-Maurice d'Agaune Abbey, Treasury*

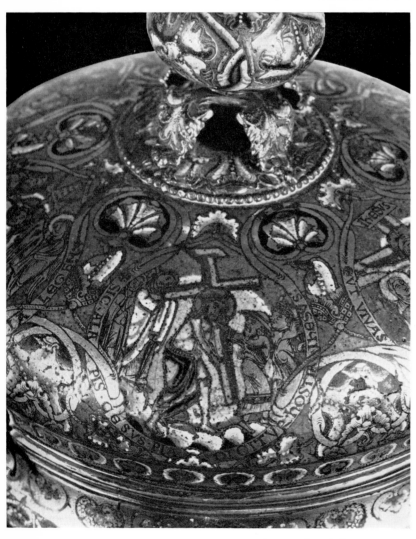

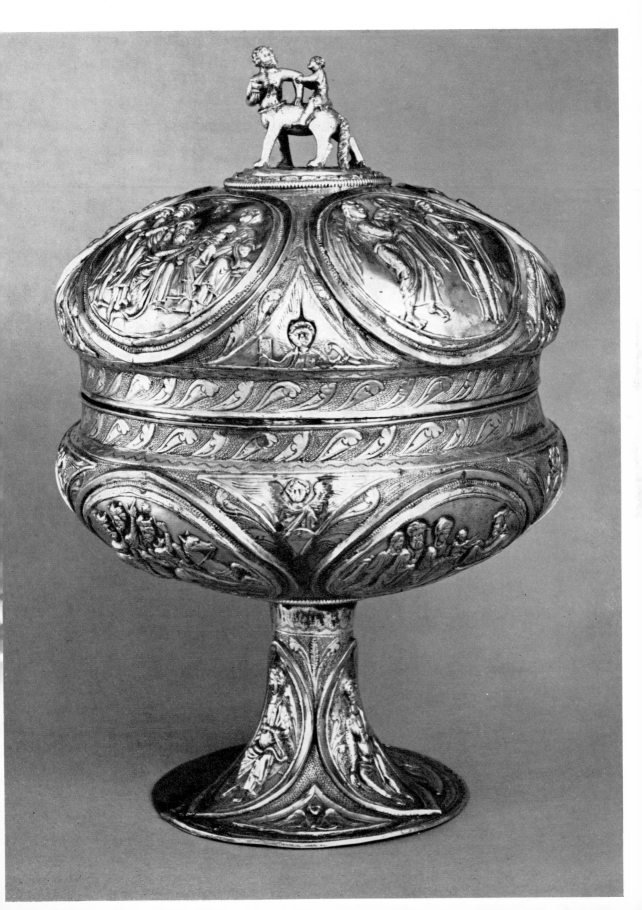

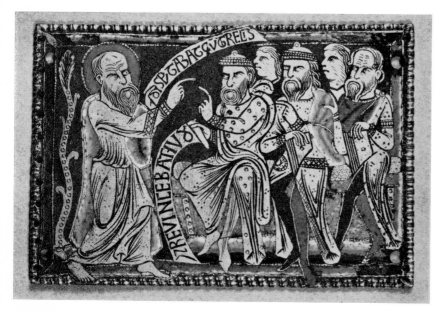

283. St Paul disputing.
Bronze gilt and enamel
plaque, *c.* 1170/80. *London,
Victoria and Albert Museum*

284. Christ in Majesty.
Detail of the centre of the
altar frontal from Odder,
c. 1200. *Copenhagen,
Nationalmuseet*

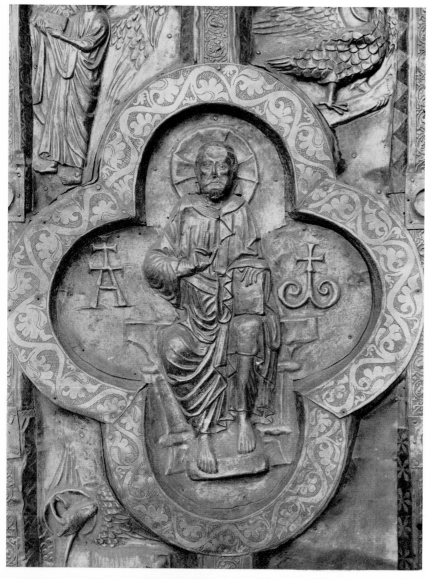

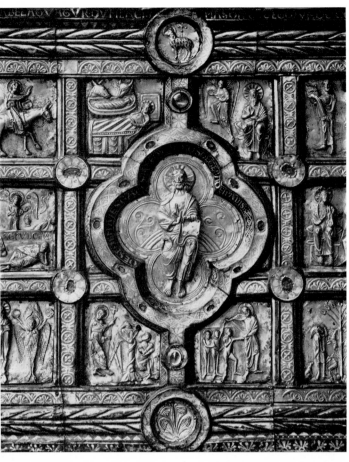

285. Christ in Majesty and scenes from the life of Christ. Detail of the centre of the altar frontal from Ølst, *c.* 1150/60. *Copenhagen, National-museet*

286. Altar frontal, *c.* 1170. *Lyngsjö, parish church*

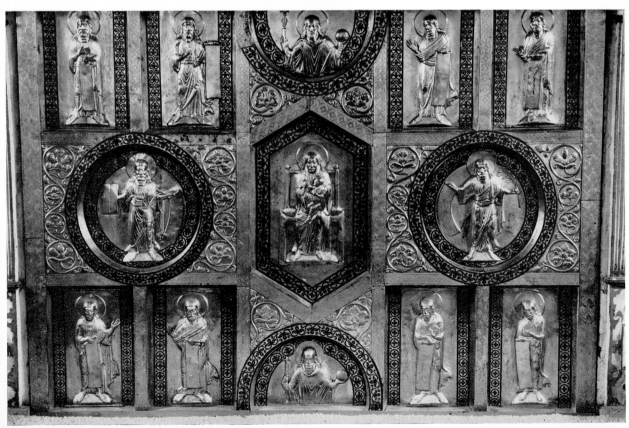

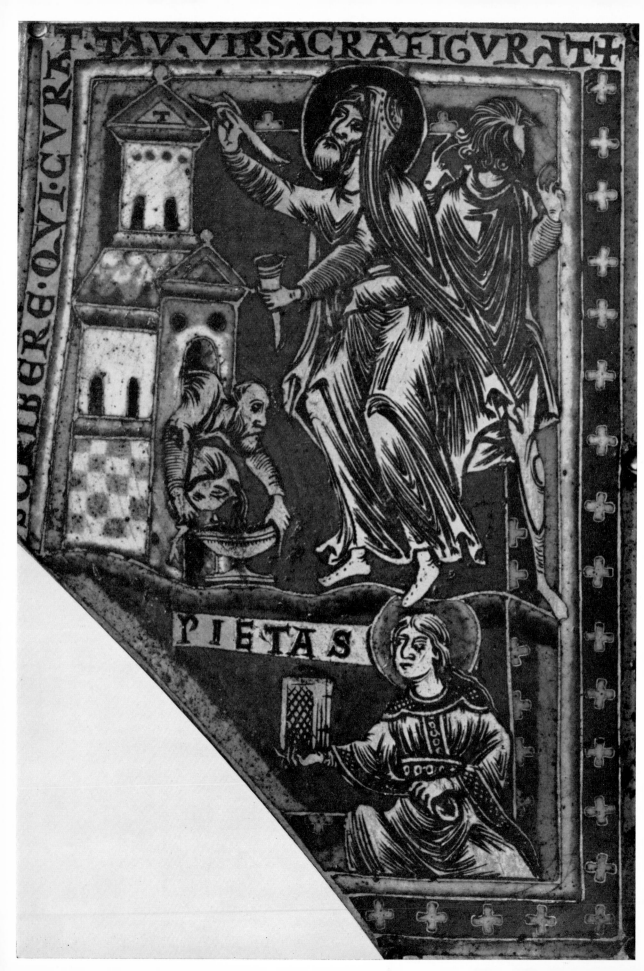

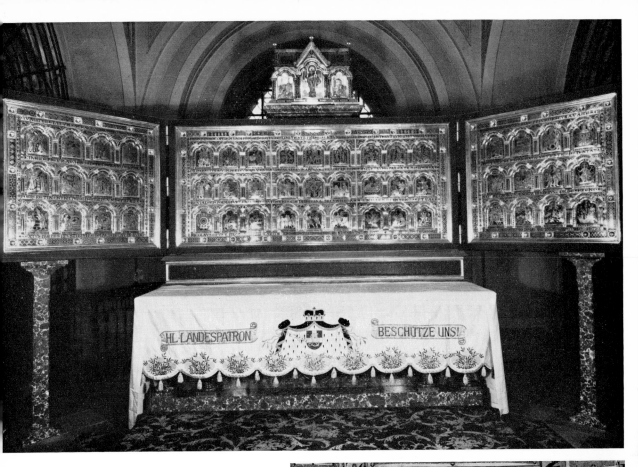

287. Making of the 'T' cross.
Plaque from the roof of a portable
ciborium(?), *c.* 1170/80. *Vienna,
Diözesan Museum*

288. Altar retable (with detail), remodelled
c. 1331 from a pulpit made for Provost
Wernher by Nicholas of Verdun, 1181.
Klosterneuburg, Stiftskirche

289. Nicholas of Verdun: Annunciation. Detail of the pulpit, 1181. *Klosterneuburg, Stiftskirche*

290. Nicholas of Verdun: Sacrifice of Isaac. Detail of the pulpit, 1181. *Klosterneuburg, Stiftskirche*

291. Nicholas of Verdun: The Prophet Habakkuk (after recent restoration). From the shrine of the Three Kings, *c.* 1182/90. *Cologne Cathedral*

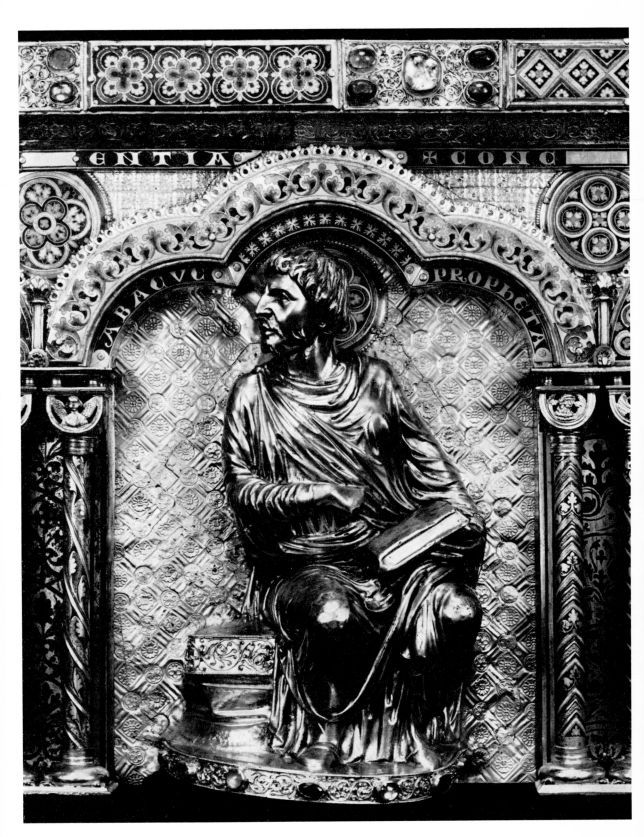

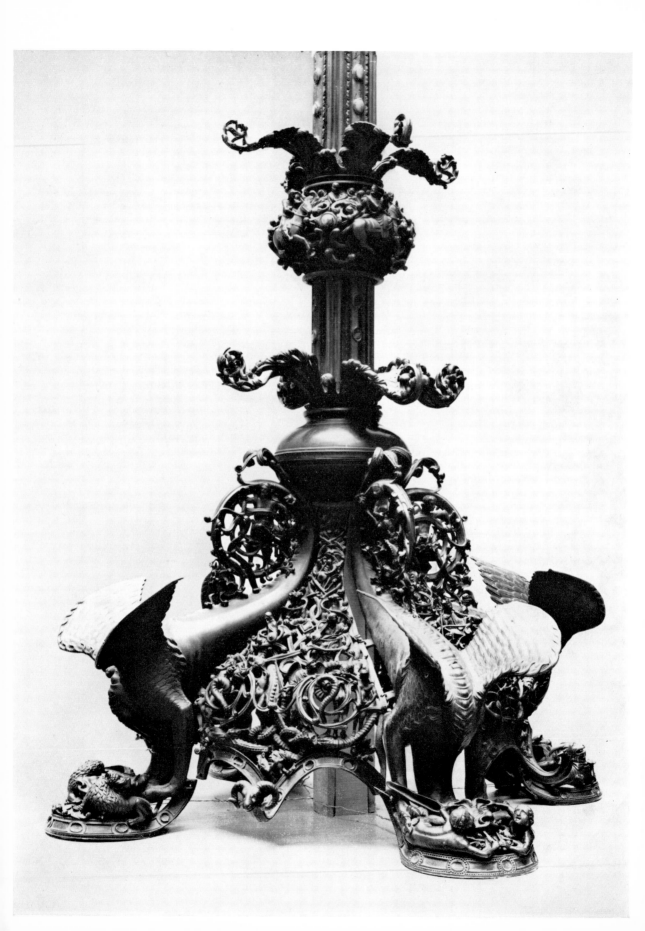

292. Trivulzio Candelabrum, early thirteenth century. Details of the foot and lower part. *Milan Cathedral*

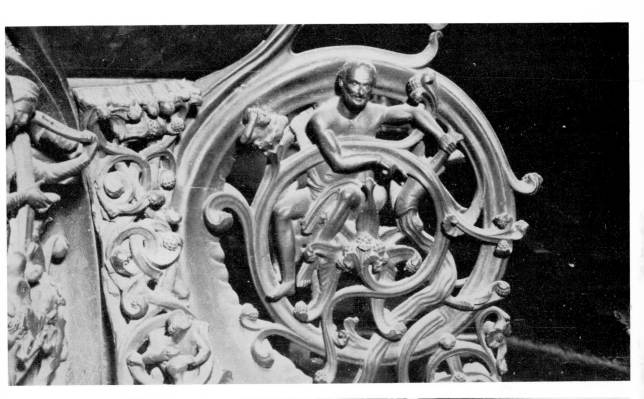

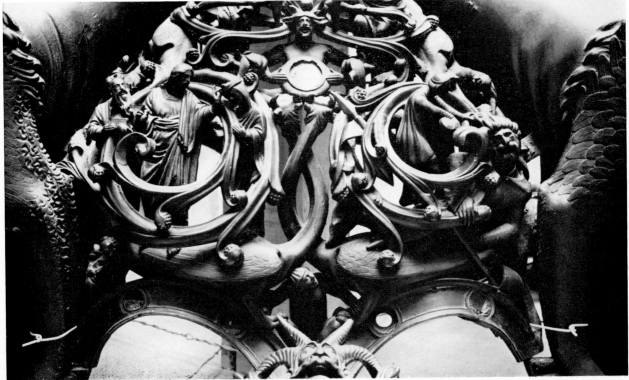

293. Shrine of the Three Kings (back and side), *c.* 1170(?)–1230 and later additions. *Cologne Cathedral*

294. Nicholas of Verdun: Shrine of St Mary, 1205 and later additions. *Tournai Cathedral, Treasury*

295. Shrine of Charlemagne, *c.* 1170–1215. *Aachen, Palace Chapel*

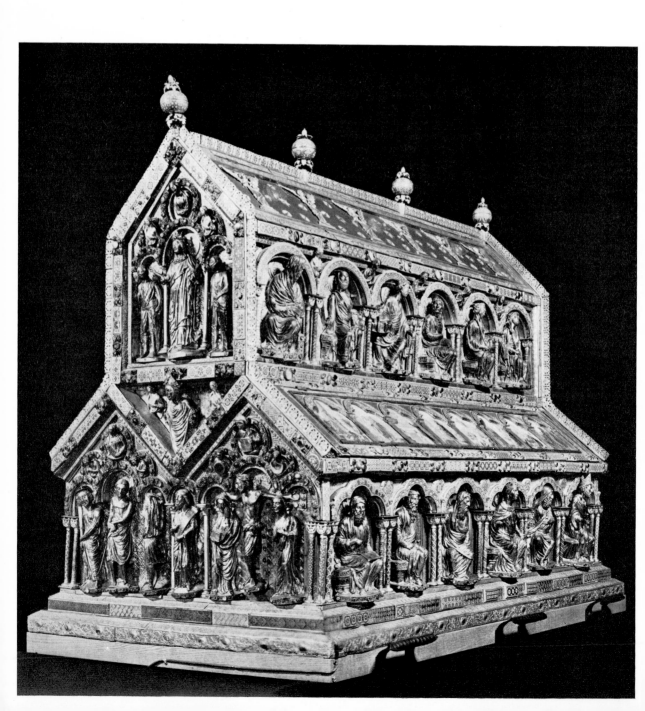

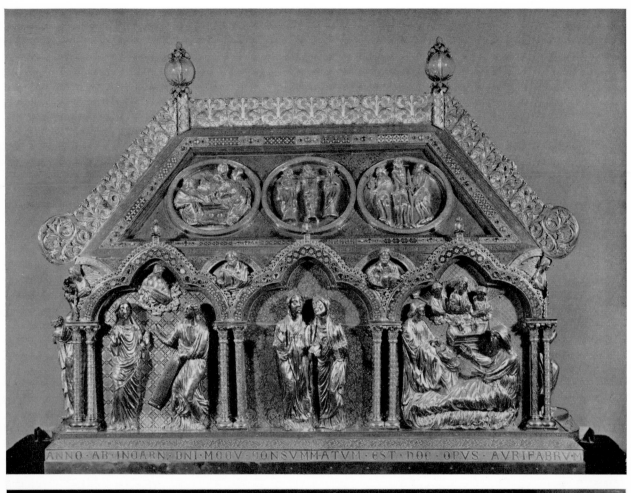

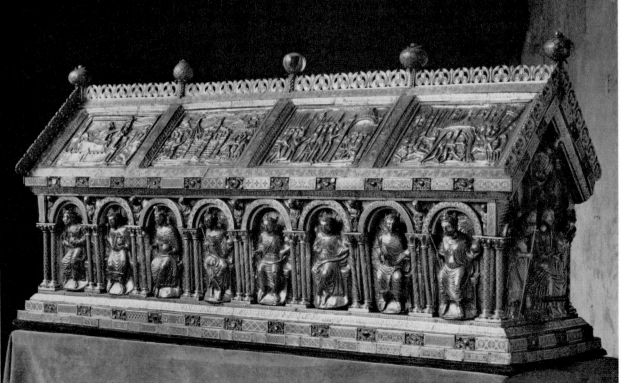

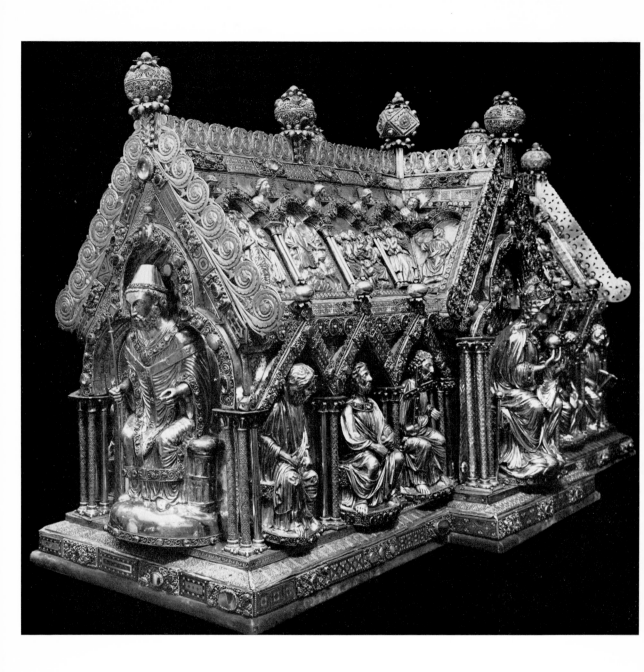

296. Shrine of St Mary, 1215–37. *Aachen, Palace Chapel, Treasury*

Numbers in *italics* refer to plates; numbers in **bold** type indicate principal entries.
References to the notes are given to the page on which the note occurs, followed
by the number of the note; thus 269[80] indicates page 269, note 80.

C